Bloomsbury and France: Art and Friends

Bloomsbury
and France

WITHDRAWN

*Art
and Friends*

MARY ANN CAWS AND SARAH BIRD WRIGHT

With a Preface by Michael Holroyd

OXFORD
UNIVERSITY PRESS
2000

OXFORD
UNIVERSITY PRESS

Oxford New York

Athens Auckland Bangkok Bogotá Buenos Aires Calcutta
Cape Town Chennai Dar es Salaam Delhi Florence Hong Kong Istanbul
Karachi Kuala Lumpur Madrid Melbourne Mexico City Mumbai
Nairobi Paris São Paulo Singapore Taipei Tokyo Toronto Warsaw

and associated companies in
Berlin Ibadan

Published by Oxford University Press, Inc.
198 Madison Avenue, New York, New York 10016

Oxford is a registered trademark of Oxford University Press, Inc.

Library of Congress Cataloging-in-Publication Data
Caws, Mary Ann.
Bloomsbury and France : art and friends / Mary Ann Caws,
Sarah Bird Wright.
p. cm. Includes bibliographical references and index.
ISBN 0-19-511752-2 1. Bloomsbury group.
2. Great Britain–Relations–France. 3. France–Realtions–Great Britain.
4. Artists–Great Britain–Biography. I. Wright, Sarah Bird. II. Title.
NX543.C38 1999 820.9'00912–dc21 98-54638

1 3 5 7 9 8 6 4 2

Printed in the United States of America
on acid-free paper

To Frances Partridge

Contents

Preface by Michael Holroyd

No reader of the Bloomsbury Group house journal, *The Charleston Magazine*, can have failed to notice how, during the 1990s, France began to invade its pages. Contributions ranged from investigations into Bloomsbury's appearances at the *Entretiens de Pontigny* in the 1920s, to reviews of Simon Bussy's paintings, including a major exhibition of his work at Beauvais; from articles reminding us of Bloomsbury's championing of Cézanne and involvement with Gide, to Roger and Margery Fry's experiences working for the Quaker War Victims Relief Fund in the districts of Marne and the Meuse, and a scholarly account of various ways in which to prepare *boeuf-en-daube*.

"Much of our French culture began with gastronomic experience,"[1] remembered Angelica Garnett. Her three-part essay for *The Charleston Magazine* during the early 1990s, entitled "The French Connection," may be seen as a curtain raiser for this book. For it illustrated as never before how necessary France and the French were to so many members of Bloomsbury. "My life has been loosely, but pervasively mixed up with France for as long as I can remember," she wrote, "and I can go so far as to say that nothing in it would be the same or have the same flavour, without this connection."[2]

But there was little cultural appropriation by Bloomsbury. Lytton Strachey, author of *Landmarks in French Literature*, despite his encyclopaedic knowledge of France, was never incautious enough to be heard speaking its language. His sister Dorothy, who lived much of her life in the south of France with her husband Simon Bussy and who translated the writings of her friend André Gide, also remained on all occasions an austere and quintessential Strachey. It is true that Clive Bell, his social ambitions over-extended perhaps by his love of Proust, strove to imitate French manners, but he demonstrated all the more glaringly his "damned Englishness." His wife, Vanessa Bell, had no heady social ambitions. With her lover and fellow-painter Duncan Grant, she reconstituted Charleston, their house under the Sussex Downs, at Cassis and made there a tiny French colony of Bloomsbury. But she was on intimate terms with few painters in France and went there largely for seclusion. What she enjoyed when reaching these familiar yet foreign surroundings was an evaporation of responsibilities in the gorgeous heat, and the gaining of another light in which to see things—what her daughter was to describe as "the dazzling purity of the light, the mixture of the blue, ochre and silver in the landscape accentuated by the black trunks of vine and olive."[3] They benefited too from the feeling that they were closer in that climate to French painting, and from the knowledge that France valued her painters as a civilized country should. For they had been influenced by Roger Fry who, Angelica Bell reminds us, "did most, beyond the confines of social life, to make French and English artists aware of each other."[4]

"On the whole I don't care much about England's being victorious (apart from personal questions)," Lytton Strachey had written to his brother James at the beginning of the Great War, "—but I should object to France being crushed. Mightn't it be a good plan to become a Frenchman"?[5] Though a few members of Bloomsbury went further for their inspiration—E. M. Forster to Italy, Gerald Brenan to Spain, and Maynard Keynes in some degree to the United States—most of them believed that Britain would gain from an injection of French culture, and to an extent exemplified this belief in their work. But with the exception of Virginia Woolf's novels, France itself until recently showed little interest in Bloomsbury. Frances Partridge remembers going with Raymond Mortimer to the British Embassy in Paris in the 1970s, and seeing the French Arts Minister, "a very chic lady," put on an expression of utter blankness when the Bloomsbury Group was mentioned.

But all this has been changing in the last two decades. In the early 1980s a splendid two-volume Life of Lytton Strachey appeared—*Biographie et Critique d'un Critique et Biographe*, by the French scholar Gabriel Merle; and in the early 1990s all Bloomsbury was surveyed by Jean Blot in his *Histoire d'une Sensibilité Artistique et Politique Anglaise* which gave a generous evaluation of the Bloomsbury writers—E. M. Forster, Roger Fry, Maynard Keynes, Lytton Strachey, Leonard and Virginia Woolf. During these years a number of scholarly essays appeared on Bloomsbury publications in *Études Anglaises*. Then, in the mid-1990s, Christopher Hampton's Anglo-French film *Carrington* won two prizes at the Cannes Film Festival and brought Bloomsbury lives to a wider French audience. This process, revealing ever more clearly the French spirit at the heart of Bloomsbury, now has a look of inevitability to it, and is brought to a climax by Mary Ann Caws and Sarah Bird Wright's magnificently-illustrated and exhaustive study.

"It was France," the authors shrewdly observe, "that prevented Bloomsbury from remaining insular." *Bloomsbury and France: Art and Friends* is partly a collage of writings by and about the Bloomsbury Group, partly a conversation carried on through their published and hitherto unpublished letters. By providing a francophile dimension to the life and work of a group that too often has been portrayed as merely inward-looking, this book will open up Bloomsbury to fresh insights. In this respect it is essential reading.

Notes

[1] Angelica Garnett, "The French Connection. Part 3," *The Charleston Magazine*, Issue 8 (Winter/Spring 1993–94): 5, col. 1.

[2] Angelica Garnett, "The French Connection. Part 1," *The Charleston Magazine*, Issue 6 (Winter/Spring 1992–93): 9, col. 1.

[3] Ibid., p. 10, col. 2.

[4] Angelica Garnett, "The French Connection. Part 2," *The Charleston Magazine*, Issue 7 (Summer/Autumn 1993): 13, col. 2.

[5] Lytton Strachey to James Strachey, 27 September 1914. Quoted in Michael Holroyd, *Lytton Strachey. The New Biography* (New York: Farrar, Straus and Giroux, 1994), p. 307.

Acknowledgments

We are very grateful to many people who have helped, directly and indirectly, with this project. First, we want to thank most warmly Frances Partridge, Angelica Garnett, Henrietta Garnett, Alice Mauron, Anne Olivier Bell, and Annabel Cole for their warm welcome and helpfulness over these many years. Without their counsel, their encouragement, their attention, and their multiple, renewed, and generous permissions, this book would not have reached completion. The manuscript was immeasurably improved by their readings; the faults are ours alone. In permitting the reproduction of pictures from her own photograph albums and those of Lytton Strachey and Dora Carrington, and in writing a memoir of the relationship she and Ralph Partridge continued to have with France after the death of Carrington, Frances Partridge surpassed even herself in generosity—an enormously difficult feat.

We want to express our gratitude to the late George Rylands for his kindness and encouragement, to Germaine Taillade for her help with the documents of André Derain, to Betty Taber for her interest, and particularly to the late Quentin Bell for his initial and unfailing enthusiasm over the book, and for reading many preliminary drafts.

We want to offer our thanks to Richard Shone for his understanding and counsel, particularly concerning the art involved here; to Frances Spalding for her knowledge and encouragement; to Geoffrey Harris for his hospitality from always; to Michael Holroyd for his encouragement from the beginning; to Tony Bradshaw for his long-standing and friendly aid; to Patrick Mauron-Roumanille for his welcome, and to Sandra Lummis for her excellent advice on many matters. We are also grateful to Nigel Nicolson for his kind assistance and concern, and to Deborah Gage for her cousinly and knowledgeable help.

We are much indebted to the Camargo Foundation and to Michael Pretina, who has been an invaluable friend from the beginning of this project, whose hospitality has enabled visits to Cassis and Fontcreuse over the years, and who has provided invaluable information about Jerome Hill and his relation to Bloomsbury. We are very grateful to Catherine Gide for generous permission to cite material related to André Gide. We also want to thank Jennifer Booth and her colleagues of the Tate Archives; to Jacky Cox of the Modernist Archives, King's College, Cambridge, and her colleagues; to Yves Peyré of the Bibliothèque littéraire Jacques Doucet; to the Bibliothèque de l'Arsenal; and to the Lilly Library and the Institute for Advanced Study at Indiana University, especially to Lisa Browar, to Henry Remak, and to Rosemary Lloyd. We would like also to record our gratitude to the Harry Ransom Humanities Research Center, especially to Kathy Henderson; to Anne Baldassari and Sylvie Fresnault of the Musée Picasso; to Anne Angremy of the Bibliothèque Nationale and her assistants; to David Lambert, for his patience and more than

intelligent assistance with the photographs from the albums of Lytton Strachey and Carrington; to Craufurd and Nancy Goodwin for their welcome, to Jeremy Crowe from the Society of Authors; to everyone at the Artists Resource and the Artists Rights Society for their truly remarkable patience with this project; to Alistair Upton and Shaun Romain for their kindness in helping with the photographs of the works at Charleston; and to Seth Young, whose good humor prevented chaos on several occasions.

It is a special pleasure to acknowledge the continuing help of our agents, Gloria Loomis, Octavia Wiseman, and Stella Wilkins, as well as our editor, T. Susan Chang, of Oxford University Press, and her assistants, Susan Barba and Chris Kelly. We wish especially to thank Helen B. Mules for her instant grasp of the things that mattered most.

We are grateful also to Yves Bonnefoy for his long understanding and friendship; to Alain Malraux for his gracious help in regard to André Malraux and Roquebrune, to Janet and Malcolm Swan, to Ann Aslan and Clive Blackmore, in France and England, and Rémy Labrusse; to Jack Flam for his advice on Matisse, to Gaetana Matisse, for her friendship, and to Rosalind Krauss for her particular enlightenment about the "Picasso Papers"; to Gerhard Joseph and Patricia Laurence for their most helpful suggestions; to Mason Cooley for his indispensable talent for organization, in the final reading of the manuscript; to Judith Mallin for Proust matters; and especially to Carolyn Heilbrun, for all the walks and talks that sustained this project. We greatly appreciate the prompt assistance with photographs given by Dr. Milo Keynes.

We have a special debt to Shirley Uber, who initially informed Sarah Bird Wright about the possibility of leasing Monks House in the summer of 1979, stimulating her interest in Bloomsbury and indirectly bringing about our enterprise. Bet Inglis, of the University of Sussex library, has also assisted in many ways and taken an interest in the project. Margaret L. Rorison has been a perceptive sounding board, always, and encouraged both of us in countless ways, large and small. We would also like to thank Jane and Oscar Grant for their hospitality and material assistance with the illustrations, and Nan Graham, to whom we are greatly indebted for many of the Garsington photographs. Lewis Wright provided unfailing support and shared his home with Bloomsbury for many months. We are very grateful to Bart Lahr of the Netherlands Maritime Museum for discovering the photograph of the *Arequipa*, to William Fitzhugh Mayo for imparting his maritime knowledge, to Rita Holt for photographic research, and to Vicky and Lynn Fischer for assistance with the dialects of India.

We are also indebted to the Faculty Research Program of the City University of New York for their help with this project; to the Getty Center for the History of Art and the Humanities for their welcome during some of the first stages of composition; and to the Rockefeller Foundation at Bellagio for their hospitality during its continuation.

Without the most generous help and enthusiasm of the Florence Gould Foundation, and its invaluable support in the permissions for and preparation of the works of art, and for their publication, this book would have lacked a major portion of the illustrations we considered essential; our deepest gratitude to John Young and to the Foundation.

New York City and Midlothian, Virginia Mary Ann Caws and Sarah Bird Wright
September 1998

Sources

All unpublished letters from and to Clive Bell, Vanessa Bell, Duncan Grant, and Carrington, unless otherwise attributed, are from the Bloomsbury Archives at the Tate Gallery: our warmest thanks to Jennifer Booth, archivist, and her assistants; also for the photographs from the *Vanessa Bell Family Album,* with thanks to Angelica Garnett and Henrietta Garnett.

All unpublished letters from and to Desmond and Mary MacCarthy, Vita Sackville-West and Harold Nicolson, and Ottoline Morrell are from the Lilly Library, University of Indiana: our warmest thanks to all the archivists of that library; also for the photographs included in their archives.

All unpublished letters from and to Roger Fry except the Vanessa Bell correspondence are from the Modernist Archives at King's College, including the letters to and from Charles, Marie, and Alice Mauron, except for those kindly provided for our consultation by Alice Mauron; all letters from and to Julian Bell, including the unpublished correspondence with Charles Mauron and Edward Playfair, and the unpublished correspondence from E. M. Forster: our warmest thanks to Jacky Cox, archivist, and her assistants; also for the photographs included in their archives.

All unpublished letters from and to Lytton Strachey from the Strachey Papers, British Library: our thanks to the archivists.

All unpublished letters and journal entries of Dorothy Strachey Bussy and André Gide, from the Manuscript Division of the Bibliothèque Nationale: our thanks to Annie Angiramy and her assistants.

For material relating to Virginia Woolf, Leonard Woolf, Vanessa Bell, and Vita Sackville-West, we are grateful to the staff of the New York Public Library for use of the Berg Collection.

For the photographs in the albums of Lytton Strachey, Dora Carrington, and Frances Partridge, our warmest thanks to Frances Partridge, and to David Lambert, photographer.

For all published letters and material, see the bibliography.

Every possible effort has been made to locate sources for permissions for each of the illustrations and quotations used. We apologize for any errors or omissions, and welcome corrections for future printings.

Abbreviations and Archives

Published Sources

DBAG	*Selected Letters of André Gide and Dorothy Bussy*
DVW	*Diary of Virginia Woolf*
LDC	*Letters and Diary of Dora Carrington*
LRF	*Letters of Roger Fry*
LVW	*Letters of Virginia Woolf*
VBL	*Letters of Vanessa Bell*

Unpublished Sources

CMEMF	Letters of Charles Mauron to Edward Morgan Forster, Modernist Archives, King's College, Cambridge University
CMRF	Letters of Charles Mauron to Roger Fry, Modernist Archives, King's College, Cambridge University
DC	Letters of Carrington (to Gerald Brenan), Harry Ransom Humanities Research Center, University of Texas, Austin
DG	Letters of Duncan Grant, Tate Archives, London
DGVB	Letters of Duncan Grant to Vanessa Bell, Tate Archives, London
EMF	Letters of E. M. Forster, Modernist Archives, King's College, Cambridge University
EP	Letters of Sir Edward Playfair, Modernist Archives, King's College, Cambridge University
JBCM	Letters of Julian Bell to Charles Mauron, Modernist Archives, King's College, Cambridge University
LSL	Letters of Lytton Strachey, Strachey Papers, British Library, London
MMRF	Letters of Marie Mauron to Roger Fry, Modernist Archives, King's College, Cambridge University
RFCM	Letters of Roger Fry to Charles Mauron, Modernist Archives, King's College, Cambridge University

RFMM	Letters of Roger Fry to Marie Mauron, Modernist Archives, King's College, Cambridge University
RFVB	Letters of Roger Fry to Vanessa Bell, Tate Archives, London
VBCB	Letters of Vanessa Bell to Clive Bell, Tate Archives, London
VBDG	Letters of Vanessa Bell to Duncan Grant, Tate Archives, London
VBLT	Letters of Vanessa Bell, Tate Archives, London
VBRF	Letters of Vanessa Bell to Roger Fry, Tate Archives, London
VBVW	Letters of Vanessa Bell to Virginia Woolf, Tate Archives, London
VSWHN	Letters of Vita Sackville-West Nicolson to Harold Nicolson, Nicolson Papers, Lilly Library, Bloomington, Indiana
VNL	Letters of Vita Nicolson and Harold Nicolson, Nicolson Papers, Lilly Library, Indiana University Bloomington, Indiana

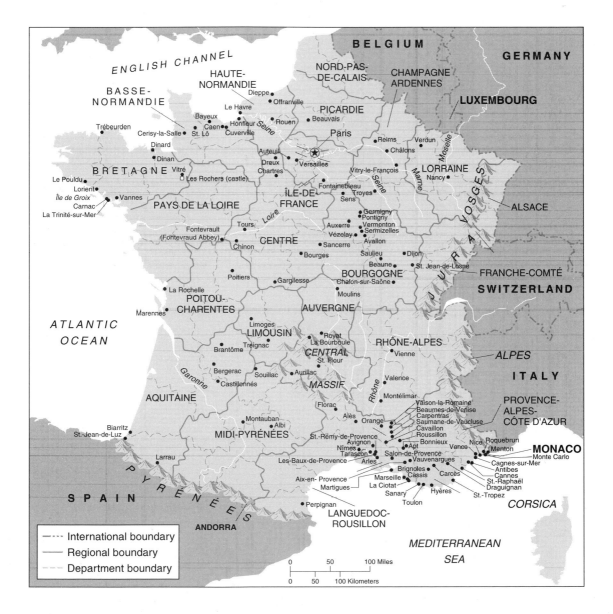

ENGLISH CHANNEL

BELGIUM

GERMANY

LUXEMBOURG

BASSE-
NORMANDIE

HAUTE-
NORMANDIE

NORD-PAS-
DE-CALAIS

CHAMPAGNE
ARDENNES

Dieppe

Offranville

PICARDIE

Le Havre

Beauvais

Trébeurden

Bayeux

Honfleur

Rouen

Reims

Verdun

Caen

Seine

Cerisy-la-Salle

St. Lô

Cuverville

Paris

Châlons

Dinard

Auteuil

Versailles

Vitry-le-François

LORRAINE

Dinan

Dreux

Chartres

Nancy

BRETAGNE

Vitré

Les Rochers (castle)

Fontainebleau

Troyes

Seine

Marne

Le Pouldu

Lorient

Île de Groix

Carnac

La Trinité-sur-Mer

Vannes

PAYS DE LA LOIRE

ÎLE-DE-
FRANCE

Sens

Germigny
Pontigny

ALSACE

VOSGES

Fontevrault
(Fontevraud Abbey)

Tours

Loire

CENTRE

Auxerre

Vézelay

Vermonton
Sermizelles

Chinon

Sancerre

Avallon

Saulieu

Dijon

JURA

FRANCHE-COMTÉ

Bourges

Beaune

St. Jean-de-Losne

Poitiers

Gargllesse

BOURGOGNE

SWITZERLAND

ATLANTIC
OCEAN

La Rochelle

POITOU-
CHARENTES

Chalon-sur-Saône

Moulins

Marennes

AUVERGNE

Limoges

LIMOUSIN

Royat

RHÔNE-ALPES

Brantôme

Treignac

La Bourboule

CENTRAL

Vienne

ALPES

St. Flour

Bergerac

Souillac

Aurillac

Valence

ITALY

Garonne

Castillonnés

MASSIF

Rhône

Montélimar

AQUITAINE

Florac

Vaison-la-Romaine
Beaumes-de-Venise

PROVENCE-
ALPES-
CÔTE D'AZUR

Montauban

Albi

Alès

Orange

Carpentras
Saumane-de-Vaucluse
Cavaillon

Biarritz

St.-Jean-de-Luz

MIDI-PYRÉNÉES

St.-Rémy-de-Provence

Roussillon
Bonnieux

Vence

Nice

Roquebrun

MONACO

Larrau

Avignon

Nîmes

Tarascon

Apt

Salon-de-Provence

Vauvenargues

Menton

Monte Carlo

Cagnes-sur-Mer

PYRÉNÉES

Les-Baux-de-Provence

Arles

Brignoles

Carcès

Antibes

Cannes

Aix-en-
Provence

Cassis

St.-Raphaël

SPAIN

Martigues

Marseille
La Ciotat

Sanary

Hyères

Draguignan

St.-Tropez

ANDORRA

Perpignan

Toulon

CORSICA

LANGUEDOC-
ROUSSILLON

MEDITERRANEAN
SEA

- - - - International boundary

——— Regional boundary

– – – Department boundary

0 50 100 Miles

0 50 100 Kilometers

xvii

Map Locations in Paris

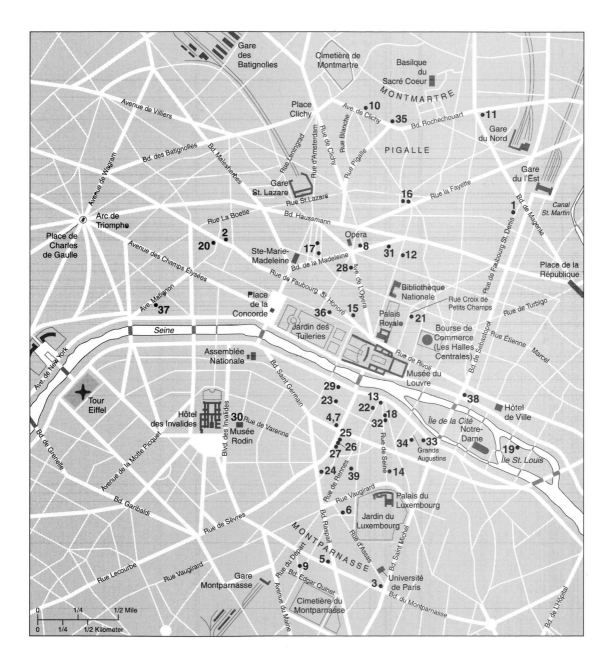

Gare
des
Batignolles

Cimetière de
Montmartre

Basilque
du
Sacré Coeur

MONTMARTRE

Avenue de Villiers

Place
Clichy

Ave. de Clichy •10

•35 Bd. Rochechouart

•11

Gare
du Nord

Bd. des Batignolles

Bd. Malesherbes

Rue Leningrad

Rue d'Amsterdam

Rue de Clichy

Rue Blanche

Rue Pigalle

PIGALLE

Rue la Fayette

Gare
du l'Est

Avenue de Wagram

Gare
St. Lazare

Rue St. Lazare

•16

Bd. de Magenta

Canal
St. Martin

Arc de
Triomphe

Rue La Boetie

Bd. Haussmann

Opéra

•1

Rue de Faubourg St. Denis

Place de
Charles
de Gaulle

•2

•20

Ste-Marie-
Madeleine

•17

Bd. de la Madeleine

•8

•31 •12

Place de la
République

Avenue des Champs Élysées

28• Ave. de L'Opéra

Bibliothèque
Nationale

Rue Croix de
Petits Champs

Rue de Turbigo

Ave. Matignon

Rue de Faubourg St. Honoré

•15

Place
de la
Concorde

Palais
Royale

•21

•37

Seine

•36

Jardin des
Tuileries

Bourse de
Commerce
(Les Halles
Centrales)

Bd. de Sébastopol

Rue Étienne Marcel

Ave. de New York

Assemblée
Nationale

Rue de Rivoli

Musée du
Louvre

•38

Hôtel
de Ville

Tour
Eiffel

Hôtel
des Invalides

Bd. Saint Germain

29•

•30 Rue de Varenne

Musée
Rodin

23•

4,7•

13•

22• •18

32•

Île de la Cité

Notre-
Dame

Bd. de Grenelle

Avenue de la Motte Picquet

25•

26•

•34 •33

Grands
Augustins

•19

Île St. Louis

27•

Rue de Seine

•24

39•

•14

Bd. Garibaldi

Rue de Sèvres

Rue de Rennes

Rue Vaugirard

Palais du
Luxembourg

Bd. Raspail

Rue d'Assas

Bd. Saint Michel

Rue Lecourbe

MONTPARNASSE

•6

Jardin du
Luxembourg

Rue Vaugirard

Gare
Montparnasse

Rue du Départ

Bd. Edgar Quinet

•9

•5

•3

Université
de Paris

Avenue du Maine

Cimetière du
Montparnasse

Bd. du Montparnasse

Bd. de L'Hôpital

0 1/4 1/2 Mile

0 1/4 1/2 Kilometer

1

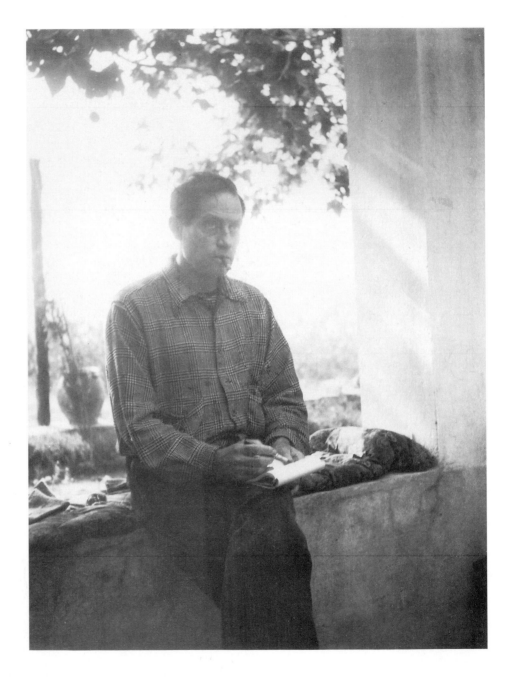

Duncan Grant
sketching at La
Bergère, Cassis
(1928).

Introduction

It is August 1928 at La Bergère, a restored farmworkers' cottage on the Fontcreuse estate, near Cassis, in the south of France. A table on a covered terrace has been set with three places, two for regular inhabitants and another for a visitor, all three of whom have spent the morning painting the vineyards behind the main house. Vanessa Bell is seated between Duncan Grant and Roger Fry, their visitor. They discuss painting—what colors to get, what exhibitions to see in Paris as they return to England, and whose studios they have most recently visited. In the afternoon, they plan to visit artist friends in Marseilles and La Ciotat. The light of the Midi falls streaked through the leaves overhead onto their bright ochre plates from Aubagne, filled with black and green olives, pale yellow cheese from the Lubéron, and tomato slices with freshly picked basil. The gloom of London is far away. For the three artists such a retreat joins art and instinct.

Bloomsbury on the Mediterranean

In the nineteenth century, France was often viewed by the English as a place of delightful sin, or at least temptation. The English painters and writers we associate with the Bloomsbury group, however, had a different perspective. Vanessa Bell, Duncan Grant, and Roger Fry spent long periods living and painting in southern France, particularly during the 1920s, and believed their work to be more appreciated in France than it was in England. To them "Bloomsbury on the Mediterranean," as Vanessa put it in a letter to her sister, Virginia Woolf, was less a source of pleasure than of aesthetic inspiration and a stimulus to hard work. There were fewer interruptions of the social and professional kind that often impinged on their time in London and Sussex. The style and essence of France illuminated and enriched the painting of the Bloomsbury artists and, to a lesser degree, influenced the work of the writers, even though they remained English to their marrow, as the French would say. In 1923, Virginia Woolf wrote the painter Jacques Raverat, "I felt a kind of levity and civility and frivolity and congeniality upon me with the first sight of Dieppe. How much more enjoyable in some queer way France is than England!"[1] Lytton Strachey, Virginia and Leonard Woolf, Roger Fry, Clive and Vanessa Bell, Duncan Grant, Molly and Desmond MacCarthy, John Maynard Keynes, E. M. Forster, Vita Sackville-West, and Ottoline Morrell were all, in various ways, stimulated by that civility and congeniality.

The Bloomsbury artists and writers welcomed the vigor and light, the colors and delicacy, of France. They contrasted them both with what Vanessa called the "fatal prettiness" of English art, and with the drab insularity of England, neither of which are reflected in the avant-garde abstract constructions she and Duncan made between

RIGHT. Duncan Grant, *Vanessa Bell Painting at La Souco* (1960).

BELOW. Roger Fry painting at Studland Bay, Dorset, England (1911).

1911 and 1914. Gerald Brenan spoke for all of them in 1924 when he wrote Dora Carrington: "It is delightful to be in France … to be in a country where everyone, not a handful of men only, are civilized and intelligent. One sees alertness and good nature in most faces …"[2]

Crossings

The literal crossings of the Bloomsbury group between England and France began as early as 1892, when Roger Fry, who had begun painting in France two years earlier, spent two months studying art at the Académie Julian in Paris. The same year Ottoline Morrell, then nineteen, was taken by her mother to Paris and given a pearl necklace that had once belonged to Marie Antoinette; not believing in worldly ornaments, she declined to wear it.[3] In 1896 Virginia and Vanessa first visited France, going to Normandy. In 1898 Lytton Strachey spent a summer in France, and in 1904 Clive Bell

The agnostic Strachey family in a prayerful position.

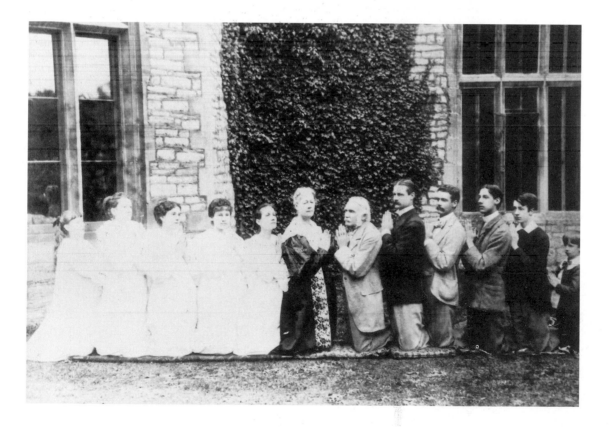

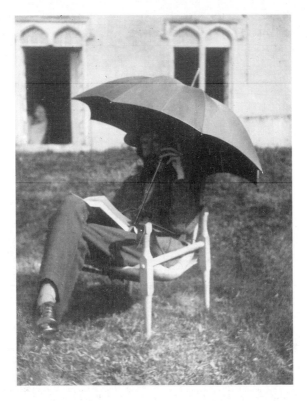

began his life in Paris, coming to know painters and studying the history of art. Duncan Grant began studying art in Paris in 1906, also going to the Académie Julian. More than a century later the exchanges have not ceased. Duncan Grant's daughter, Angelica Bell Garnett, and granddaughter, Henrietta Garnett, still live and work in France. Angelica Garnett, daughter of Vanessa Bell and Duncan Grant, notes that the maternal French ancestry of the Stephens children was "a fact of romantic importance to Vanessa."[4]

The intellectual interchanges between the Bloomsbury group and France had begun long before the 1890s. The ten Strachey children, who had a French governess, seem to have been fluent in French from their childhood. In May 1887 Lytton wrote his mother, "I have just begun French, it is very exciting." Lady Strachey helped him write French verses and sing French songs; she introduced him to the fables of La Fontaine.[5] She also read aloud from Racine and other French authors every night. Her eldest daughter, Elinor, recalled that once when she and her mother arrived by train in the gray suburbs of Paris, her mother rose from her seat, stood to her full height, and saluted the great city.[6] Vita Sackville-West's mother was raised in France, and Vita was fluent in the language even as a toddler. Maynard Keynes knew French well, as he did German. Virginia Woolf read French, although she was inept at speaking it. E. M. Forster had almost a native

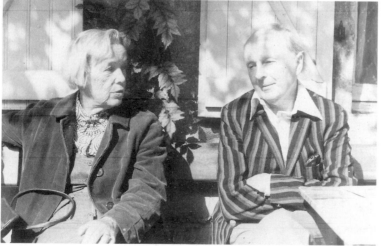

LEFT. Frances
Partridge and
Desmond Shawe-
Taylor in France.

proficiency in the spoken and written language, according to Alice Mauron (widow of his translator, Charles Mauron). After living in Paris for more than a year, Clive Bell was able to speak and write French fluently, although with a strong accent. Roger Fry spoke and wrote the language in a far more elegant fashion than the others, even though his enthusiasm and rapidity stood in the way of perfection. The extensive correspondence between Fry and his French friends, and between Clive Bell and Picasso and other painters and writers, leaves no doubt as to the ease of their communication. Frances Partridge, working in the London bookshop of David Garnett and Frankie Birrell, never saw any of the group order a French book in translation.

The central element of the Bloomsbury figures was their sense of belonging to an artistic and intellectual community. Little note, however, has been taken of what that imagined community owed to France or, conversely, of the way French intellectuals conceived of Bloomsbury. It has been said that this circle, "like that of Pascal, remains impossible to pin down; its center is everywhere and its circumference nowhere."[7] About 1910 it appeared to be a group, one with roots in Cambridge and in the philosophy of G. E. Moore; Lytton Strachey was the principal figure.[8] That literary and philosophical circle was augmented in the post-Cambridge years by artists and by other writers, both male and female. The closest French entity corresponding to Bloomsbury during the era before and after World War I was the group around the *Nouvelle Revue Française*, the journal founded by André Gide, Jacques Copeau, and Jacques Rivière in 1909.[9] Bloomsbury, of course, was less cohesive and had no journal, but its members shared with Gide, Copeau, and other French intellectuals a belief in permanent aesthetic values that transcended a particular trend. Gide was in fact often regarded as the French equivalent of the Bloomsbury intellectual. When he died in 1970, E. M. Forster wept at the disappearance of one of the chief supports of his own civilization. Both Bloomsbury and the *N.R.F.* placed a premium on thinkers such as Lytton Strachey, Roger Fry, Leonard Woolf, Virginia Woolf, Maynard Keynes, Jean-Paul Sartre, Albert Camus, and André Malraux.

Despite their lifelong attachment to France and periodic residence there, the Bloomsbury group as a whole were not particularly integrated into the principal political and intellectual currents of French life. As Henrietta Garnett has suggested, they were "as remote from the vigorous French intellectual movements of the period as the British were from Indian culture during the Raj."[10] As ardent pacifists, they had held themselves as aloof as possible from World War I, in which 1.3 million French soldiers died and an equivalent number were wounded. Maynard Keynes, who held an important post in the British Department of the Treasury, was an exception, as was Roger Fry, who took a keen interest in his sister Margery's Quaker relief efforts and traveled to France to write about her work.

Modes of Life and Art

What the Bloomsbury figures valued in France was not just the climate and the visual delights of the seasons—a Louis XII château in a village, walnut trees frostbitten to a purple-brown, cornfields studded with red poppies—but a certain way of looking at art, of treating artists, and of living. As quasi-settlers, they appropriated French cuisine, ate from regional pottery, drank their breakfast coffee from French bowls, and brought casks of table wine back to England for bottling. Roger Fry traveled not only with his box of colors and easel, but also with a *diable*, an enormous cooking vessel rather like a chimney, occasioning a good deal of laughter on both sides of the channel. On a deeper level, what Fry loved about France was an intellectual climate of *justesse*, of measure, the antithesis of what he considered English irrationality and lack of interest in art.

England, of course, attracted French artists and imported French art. André Derain, who would later be a friend of many in the Bloomsbury group, especially Clive Bell, had painted in London during his Fauve period. Roger Fry and Clive, assisted by Ottoline Morrell, selected paintings in Paris and organized the two famous Post-Impressionist Exhibitions of 1910 and 1912, which had an immense impact on the English public and on certain artists.

In their own criticism and creation, the Bloomsbury artists were at times avant-garde, although not always. Roger Fry's art criticism was innovative as far as primitivism was concerned, but he was far more influential in his work on the early Italians than in his studies of artists of his own period. On the other hand, the paintings of Vanessa Bell and Duncan Grant in the years between 1912 and 1914, done in the abstract mode, are far more forward looking than anything done by their contemporaries at the time. Angelica Garnett has observed that the Bloomsbury painters maintained an "attitude to French art [that] was ... one of feeling, immense admiration and affection. Both French and Italian art were the breath of life to them." They had, however, different outlooks:

> Roger Fry was both emotionally and intellectually fascinated by and connected to France ... Duncan Grant and Vanessa Bell had not much time for the intellectuals.... They went to France for the visual beauty, landscape, as did Roger Fry, and for the warmth and vitality, the sense it gave them of being on holiday. Also for the "sérieux" with which artists in general were, or seemed to be regarded, which made a blessed change from being thought eccentric.... They enjoyed the reminders of history, the sense of the past so evident in France.... They also went for the Louvre—and for all those associations, artistic, literary and artistic, aroused by Paris.[11]

At times they were oblivious of or unsympathetic toward the intellectual and aesthetic currents prevailing in France. Duncan Grant, who had been in Paris at the time of the Fauve excitement and exhibitions around 1905–1906, wrote in his memoir that he had not been even conscious of the movement. Roger Fry, Duncan Grant, and Vanessa Bell seem not to have taken notice of the excitement in Paris from 1911 to 1914 about the "simultanist" or "nowist" movements associated with Blaise Cendrars and Guillaume Apollinaire, nor did they pay much attention to the abstract experimentation of Robert and Sonia Delaunay. Nor, later, were they any more knowledgeable about or sympathetic to the work of such surrealist poets as André Breton or to the art connected with the movement, or any other contemporary movements. In 1925, Roger Fry saw the paintings of Joán Miró and André Masson and lamented to Gerald Brenan about the avant-garde surrealists: "The positive classic spirit is dead for a moment. And with everything is mixed an element of violence and fascism."[12] They continued to remain sensitive to the painters they had long known and revered, ranging from the seventeenth-century artists Jean-Baptiste Chardin and Nicolas Poussin to Henri Matisse, André Derain, André Segonzac, and Pablo Picasso. Garnett notes that they admired the latter not only for his art but also for his "wit, vitality, and visual imagination."[13] Their Francophilia was selective. The "positive classic spirit" of ancient tradition remained alive for the English painters who migrated to the south of France. Their intensely visual consciousness found its response in the congenial Provençal landscape, however, rather than in the north. They sought England's opposite. On returning from St.-Tropez and Cassis they found the luminosity of the Midi carrying over to their lives in a gloomier England. Similarly, the lights of Paris, if not its weather, were transmitted to the cultural life of London. In good Arnoldian fashion, they had assimilated into their own thought, creativity, and way of being a strong infusion of something outside their familiar setting that could renew them. Dedication to hard work, sensuous living, a reorientation of vision: these were of infinite and lasting value to them.[14]

Verbal Interchanges

The exchange between England and France was both public and private, including endless conversation, frequent performances for small and larger groups, published criticism, and two-way translation and travel. One of David Garnett's earliest introductions to the Bloomsbury circle was a gathering in 1915, when Duncan Grant made life-size marionettes for a reading of Racine's *Bérénice*, staged at the home of Vanessa and Clive at 46 Gordon Square.[15] The works of Virginia Woolf were widely translated into French by various well-known authors, as they continue to be, and the novels of E. M. Forster were translated by Charles Mauron. Lytton Strachey's *Landmarks in French Literature,* which

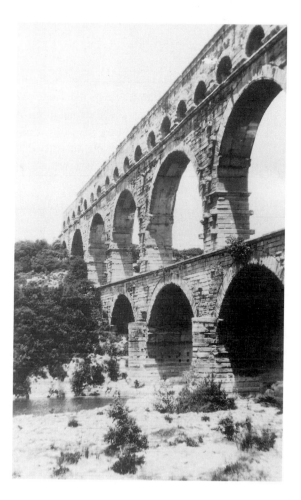

emphasized the seventeenth and eighteenth centuries, was a great success and was praised by T. S. Eliot as the best and most serious small book on the topic. His sister, Dorothy Strachey Bussy, was the English translator of André Gide.

Even for members of the group brought up on Racine, Marcel Proust became the most revered French writer. The Bloomsbury circle plunged into the Proustian text, as Lytton's friend Dora Carrington put it, "with extreme emotion." The original members of the group had embraced G. E. Moore's emphasis on states of mind and the importance of momentary impressions in recapturing the sense of the whole. It was almost a given, therefore, that Proust would have an enduring impact on the work, reading, and lives of many members of Bloomsbury. Never was there a group of painters, writers, and thinkers for whom the sense of the moment counted more: it had a lasting power.

For example, Virginia Woolf, noticing the "tremendous experience" others were hav-

Pont du Gard, Vaucluse; photograph by Lytton Strachey.

ing as they read Proust, finally began reading *A la recherche du temps perdu* (*In Search of Lost Time / Remembrance of Things Past*).[16] In February 1925 she wrote Margaret Llewelyn Davies that she had read three of the ten volumes then published but found it "difficult French."[17] More than two years later she wrote Vanessa Bell that he was "the greatest modern novelist" and advised her that it would repay her "one of these days if you should take to book reading to look at him."[18] In 1922 she wrote Roger Fry:

> My great adventure is really Proust. Well—what remains to be written after that? … How, at last, has someone solidified what has always escaped—and made it too into this beautiful and perfectly enduring substance? One has to put the book down and gasp.[19]

Marie and Charles Mauron at Charleston (1936).

Woolf's own approach to fiction is not unlike that of Proust. After she began reading his work, she praised his "combination of the utmost sensibility with the utmost tenacity." She reflected that he "searches out these butterfly shades to the last grain. He is as tough as catgut & as evanescent as a butterfly's bloom."[20] Woolf was also, of course, influenced by the work of Mallarmé, as is particularly evident in *The Waves* (1931).[21] In 1922 Fry wrote André Gide to propose a small testimonial volume to Proust. "You know how many old and devoted admirers he has in this country and I hoped perhaps that this small recognition of the fact might help in the *rapprochement* of English and French culture, which I have so much at heart …"[22]

Clive Bell presented a lucid account of Proust's methodology in *Proust* (1928), in which he termed *A la recherche du temps perdu* the "memoirs of my age." He analyzed Proust's approach to fiction: "It is in states, not action, he deals. The movement is that of an expanding flower or insect…. Fact remains suspended while we watch it gradually changing its shape, its colour, its consistency."[23] Bell also wrote several critical studies of French art that helped introduce the British public to modern French literature and art.[24] In 1936 the French government honored him with the Légion d'Honneur. Of all the Bloomsbury friends, it was Clive who most clearly aspired to *be* French.

A Group Biography

In this collective biography we depict a miscellany of figures, all of whom were connected with France, and devoted to it, in different ways. For the painters, Vanessa Bell

and Duncan Grant and Roger Fry, the most important aspects of the country were the landscape and the light, so different from English "gloom." For Virginia Woolf, it was the intensity and kind of thought she believed was, in some sense, dependent on the language. Leonard Woolf, in his travels, admired the civilized attitude toward life he found in France. Lytton Strachey, Clive Bell, Roger Fry, and Vita Sackville-West wrote critical studies and biographies of French artists, writers, and historic figures. Maynard Keynes wrote a classic analysis of French political policy at the 1919 Paris Peace Conference that is still studied today. The Bloomsbury group as a whole recognized the premium the French placed on art and creativity.

We have organized our book in three parts. We begin with an account of the early visits of Bloomsbury figures to France, followed by a discussion of Lytton Strachey and his artist companion, Dora Carrington. Next we consider the French travels of Virginia and Leonard Woolf and of Virginia and Vita Sackville-West, the settling in Paris of Clive Bell, and the visits of John Maynard Keynes and Ottoline Morrell to France. The initial crossings of the group by ferry from Newhaven to Dieppe were eased by the hospitality offered by the American artist Ethel Sands, who lived with another American painter,

Georges Duthuit with Duncan Grant and Angelica Bell at Charleston, (c. 1924).

Nan Hudson, at the Château d'Auppegard near Dieppe and often welcomed Blooms-
bury figures for dinner and an overnight stay. Ethel Sands and Nan Hudson were far less
influenced by French painting than were Vanessa Bell, Duncan Grant, and Carrington.
We conclude the first section with the memoirs of Frances Partridge, written especially
for this book by the surviving member of the Bloomsbury group as it was in the 1920s
and 1930s.

The second section is devoted to the painters who settled for long periods each year
in the south of France: Duncan Grant, Vanessa Bell, and Roger Fry. These three artists
were in close touch with various important painters in France, including André Derain,
André Dunoyer de Segonzac, Henri Matisse, and Pablo Picasso. They were always hop-
ing to find the perfect curve of a Mediterranean bay, the perfect light for a landscape,
the perfect arrangement on a Provençal table. Duncan and Vanessa were the only
Bloomsbury artists to establish a longtime French pied-à-terre. Taking a lease on La
Bergère, the farm cottage on the Fontcreuse estate at Cassis, and remodeling it, they
spent several months a year living and working there from 1927 to 1931, revisiting it in
1937 and 1938.

The third section is concerned with little-known but profoundly meaningful relation-
ships between certain writers of the group and French intellectuals. Roger Fry, for exam-
ple, was the first to meet Charles Mauron, whom Virginia Woolf called France's greatest
critic. He introduced Bloomsbury to the attractive possibility of living near the Mediter-
ranean for part of the year, became Forster's translator, and was a good friend of Julian
Bell, son of Clive and Vanessa Bell. In this context we also emphasize English–French
and French–English translation, focusing particularly on Mauron and Dorothy Bussy,
wife of Simon Bussy and sister of Lytton Strachey. She not only translated the works of
André Gide but was also hopelessly in love with him for many years. Although French,
he was said to have all the mannerisms of Bloomsbury. We also discuss the significance
of the gatherings at Pontigny, a twelfth-century Cistercian abbey southeast of Paris, on
the Yonne River, near Auxerre. Here eminent intellectuals from France and England
gathered each summer for ten-day meetings, or *décades*, on a particular subject. Roger
Fry, Lytton Strachey, and Lytton's sisters participated in some of these sessions, as did
Charles Mauron and Gide. A chapter on French–English textual translation follows,
emphasizing translations of E. M. Forster, Virginia Woolf, and Stéphane Mallarmé.

France mattered to the Bloomsbury group, perhaps more than to any other English
circle, as a model they might internalize in certain ways. During the first three decades
of the twentieth century the initial group of Cambridge intellectuals evolved from an all-
male, closely knit set of friends to a much larger circle with members of both sexes,
more open to new contacts and relationships. They were diligent at painting and/or
writing and shared an ironic wit and a distaste for prudishness. But it was France that

prevented Bloomsbury from remaining insular. For example, Dorothy Strachey's marriage to Simon Bussy, a French artist, brought her siblings and cousins to their home, La Souco, at Roquebrune, near Menton, on the French Riviera. Ottoline Morrell's French friends came to her country estate, Garsington, and French artists often stayed at Charleston Farmhouse, the holiday home of Vanessa Bell and Duncan Grant near Lewes, in Sussex. There are still many examples of French art hanging at Charleston evoking the decades of cross-Channel hospitality: works by Simon Bussy, André Derain, Othon Friesz, Marcel Gimond, Jean Marchand, Charles Vildrac, and others. The crossings and crisscrossings among friends, relatives, and domiciles are typical of modernism. Of particular interest are the moments where one of the characters in our story reflects on another who is seemingly distant. Dorothy Strachey Bussy, who spent most summers in England, unexpectedly comments on Ottoline Morrell's yellow outfit. Maynard Keynes leaves a financial conference in Paris during World War I, buys a Cézanne painting at an auction, and hastens to Charleston, depositing it in the hedge at the bottom of the road. David Garnett writes him that Vanessa and Duncan are very proud of him and that he has been given "complete absolution and future crimes also forgiven."[25] During the occupation of France Vanessa agonizes over the plight of the Bussys. After the deaths of Dorothy and Janie Bussy, Frances Partridge, Vanessa Bell, Duncan Grant, and Angelica Bell Garnett go to Roquebrune to evaluate Simon Bussy's paintings (the visit is discussed in the chapter "Simon and Dorothy Bussy, André Gide").

We have not attempted to define the circumference of Bloomsbury, but instead have chosen to concentrate on the relations between its principal figures and France in the first three decades of the twentieth century. They began, of course, long before that period and have continued in the years since, although the principal period of the French exchange was during the decades between 1910 and 1940.

Much of this book is based on the letters, published and unpublished, exchanged between these friends. Their correspondence both initiated and continued discussions about art and life: Roger Fry and Vanessa Bell about painting, Dorothy Bussy and André Gide about translation, Roger Fry, Julian Bell, and Marie and Charles Mauron about aesthetics and philosophy, Maynard Keynes and Duncan Grant about art, Virginia Woolf, Jacques and Gwen Raverat and Vanessa Bell about the culinary and aesthetic delights of France, Lytton Strachey and Clive Bell about criticism and literature, and Duncan Grant and Jacques Copeau about the theater. The intersections between these two groups of persons in Bloomsbury and France, in spite of their disparate languages and cultural heritage, resulted in a remarkable reshaping of their aesthetic and literary ideals. What was most vital about this interchange has endured in their work and in their letters and writings.

We have wanted to pass on something of their spirit as captured in what might be called a modernist moment, an extraordinary convergence of chance and good fortune. In February 1914 Duncan Grant discovered some rolls of wallpaper in the closet of his Parisian hotel that Pablo Picasso was able to use in seven collages, now considered to be among his most significant creations. Duncan's gift, described in the chapter "Painters in France 1910–1921: Duncan Grant, Vanessa Bell, Roger Fry," added a new dimension to Picasso's work and symbolized the significant interchange between the artists and friends of Bloomsbury and France, their joint and spirited history.

I Founding Bloomsbury in France

Vanessa's "instinct for life," as Roger Fry put it in 1914, was right. For a long time, it was closely linked with her feeling for France, shared by the other artists and friends of Bloomsbury. The significant relations between the English painters and writers we associate with Bloomsbury and the landscape of France, as well as its painters and writers, depended on a vital exchange.

Almost everything about France appealed to the persons associated with Bloomsbury coming over from England between 1892 and 1938. They were escaping, however briefly, its mixture of seasonal gloom and constant awareness of its glorious past, its particular culture and aesthetic insularity. These first chapters deal with a few of the individual figures as they went over to the continent and settled into a French life either in Paris or in the south. Their itineraries, habits, and friends, as well as their dealings with French culture, language, and art, introduce what we think of as Bloomsbury in France, and, specifically, Bloomsbury on the Mediterranean.

The interchange between French artists and writers and those of Bloomsbury was immensely fruitful and of long duration. The Bloomsbury figures counted among their

close friends some of the artists and writers who shaped European culture during the Belle Époque: Henri Matisse, André Derain, Jacques Copeau, Sergei Diaghilev, Marcel Proust, Pablo Picasso, Gertrude Stein, Jacques Cocteau, Erik Satie, and André Dunoyer de Segonzac. Their relationships continued in some cases long after World War I: Lytton Strachey made a final journey to France only a few months before he died in 1932. Clive Bell corresponded with Matisse in 1936 and as late as 1958 lunched with Picasso in Antibes. In 1947, Vanessa Bell saw Segonzac and Georges Duthuit in Paris. Leonard Woolf revisited Cassis and the adjoining coastal areas in 1951, although he found it marred by development. E. M. Forester visited Alice and Charles Mauron in St.-Rémy in 1963 and 1964. Alice Mauron, Angelica Garnett, and Henrietta Garnett chose to live permanently in France, as did David Garnett.

The aesthetic dialogue between Bloomsbury and France was at its height during the decades immediately before and after World War I. During these years the artists were invigorated by their months on the coast of the Midi and in Paris; the writers, similarly, were stimulated not only by their travels but also by the new theories and techniques developed by French novelists, poets, and critics. In our account we seek to delineate and, to some extent, interpret these intersections.

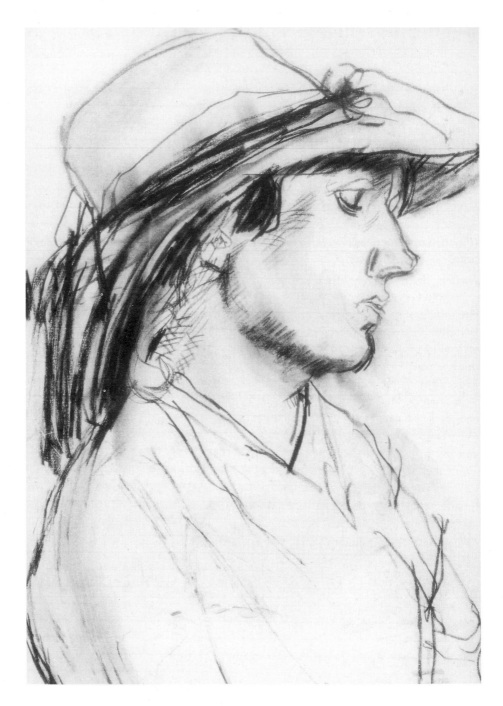

Duncan Grant,
*Portrait of Vanessa
Bell* (1914).

Beginnings: Friends in France, 1896–1910

[I had] … a sort of visionary experience … I was painting with orange and yellow and crimson. I was working from the window of my small bedroom looking down the village street.… "You must go out into the world" my inner voice said—"to learn all that there is to know and be seen in the world of painting. The Impressionists you must see and learn from and then there are other things going on at this very moment of which you know nothing." I realised that all this was true and made up my mind to follow the advice of this inner voice. I also remember that I assumed that in order to do this I must go to France.

—Duncan Grant, "A Paris Memoir"

Duncan Grant, who spent several brief holidays in France before moving to Paris to enter the world of painting, was not the only member of the Bloomsbury group to react strongly to the country. For many of them, the experience amounted to what was termed by James Joyce an "epiphany," a sudden revelation of the essential nature of a thing, situation, or person. Lytton Strachey, Clive and Vanessa Bell, Virginia Woolf, and Roger Fry were also profoundly affected by their early contacts with France. All except Roger were in their early or mid-twenties when they first stayed independently in Paris and on the Riviera. Their spirits were emancipated and their usual pursuits underwent something of a sea change. France validated their natural irreverence toward authority and attraction to casual living.[1]

In December 1901, Lytton and two of his sisters visited their aunt and uncle, Lady Colvile (née Frances Elinor Grant) and Sir James Colvile, at the Villa Henriette they had leased in Menton. He described it, with much enthusiasm, to Lumsden Barkway: "This is heavenly! Yes, heavenly! The best of what one imagines the Riviera! … Mountains! Yes! And some with snow! They tower! The sea glows and shimmers and swells!" The food was "all quite absolute," especially after a precipitous ascent by donkey.[2] Although he wrote his friend Leonard Woolf that "idleness is the first necessity," he and his sister Dorothy climbed the steep slopes to explore nearby villages, such as the hilltop Eze-en-haut and Castellar.[3] This experience stood Dorothy in good stead when she married the French painter Simon Bussy (in 1903) and settled in the mountain village of Roque-brune.

In May 1904 Virginia, Vanessa, Thoby, and Adrian Stephen went to Italy and Paris after the death of their father, Sir Leslie Stephen. Virginia wrote her friend Violet Dickinson of

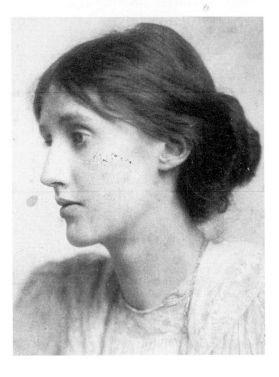

the good time they had had with Clive Bell, who was supposed to be doing archival research in Paris. They stayed up late, talking about music and art in a café. The same week, Vanessa wrote Margery Snowden that, although it was tiresome, going around to see paintings by other people (in studios and at the Paris Salon) had not really depressed her: "I think I am beginning to know what I want to do, and as it's not the same quite as what I think I can see that these other people are trying to do, I don't mind how well they succeed!"[4] Clive soon abandoned his plan to carry out historic research, instead visiting the Louvre every day and mingling with artists rather than historians. He had met Gerald Kelly and several other artists, and soon spent his time lunching and dining with them, discussing art, and visiting their studios.

Lytton went again to the south of France in April 1904, staying at La Souco, the villa at Roquebrune presented by his father, Sir Richard Strachey, to his sister Dorothy and her husband, the artist Simon Bussy, as a wedding present. He sketched their home and described its setting to Leonard with an artist's eye: "The house is 3 inches square—and a dream of beauty. The floors are tiled with smooth red hexagonal tiles, and partially covered with matting: the walls are white, the furniture replete with every beauty."[5]

In 1905, after Duncan finished his art studies at the Westminster School of Art, he leased a London studio and was introduced by his cousin Pippa Strachey to Vanessa Bell. That summer he went to France on vacation, but returned to England for the autumn. He then decided to use a coming-of-age gift of a hundred pounds from Lady Colvile for a year's study in Paris. In February 1906 he set out for Paris with his cousin Lytton, who had fallen in love with him and praised him extravagantly: "He's a *genius*—a colossal portent of fire and glory."[6] They spent one night at what Duncan later described as the "Balzacian" Hotel de L'Univers et du Portugal, on the Left Bank near the Palais Royal. While Lytton went on to Menton to stay with the Colviles at the Villa Henriette, Duncan continued to live at the same hotel and to study art throughout the year. He wrote Lytton in March 1906, "I sometimes think Paris the most lovely place in the world … walking up the Tuileries through the Arc du Carrousel into the Louvre in my grey suit." He added, however, that in his ordinary clothes on the ordinary wet day the city was "the most depressing place on earth."[7]

Each morning Duncan had his coffee and brioche at a nearby *crèmerie* in the rue Delambre, just behind le Café du Dôme in the Boulevard Raspail, at a small marble-topped table. Often the only other customer was the painter and writer Wyndham Lewis, the future founder of the Vorticist art movement. The two had little respect for each other. Duncan said of Lewis, "My gorge simply rises whenever I see him," and Lewis described Duncan as "a little fairy-like individual who would have received no attention in any country but England."[8]

Afterward, Duncan would hurry to La Palette, Jacques-Émile Blanche's newly formed academy that his friend Simon Bussy had recommended, to begin painting by eight o'clock. At twelve, after the morning's work was finished, he would lunch at a small restaurant in the Boulevard St. Germain.[9] At lunch he would sometimes read, as he wrote Lytton, such books as Balzac's *Le Lys dans la vallée* ("suitably sentimental") or the works of the nationalist Maurice Barrès ("tedious").[10] In the afternoons the students would visit the Louvre, copying paintings by old masters as Blanche had taught them to do. Duncan's particular favorites were Chardin's still lifes ("the drama of it!" Blanche would say to the students, as he stood before one).[11] Duncan wrote Lytton that he had "developed a passion" for Poussin, especially his drawings. "I usually think they suggest everything that's heavenly in this world. And they are so grand and splendid and at the same time so intimate in some mysterious way."[12] He also admired Degas, whose intense scholarship weighed on him, but managed to set every item in a room "quivering with the most vital importance."[13]

Lytton Strachey, Duncan Grant, Clive Bell at Asheham, Sussex (1913).

Duncan was particularly passionate about the theater. At the Comédie française, he saw Molière's play *Le Misanthrope* and revised his opinions of the characters. He was "carried away" upon hearing a gramophone recording of the final tirade of the Misanthrope given by the actor Silvain. He also saw Sarah Bernhardt ("la divine Sarah") making the famous confession speech to the nurse in Racine's *Phèdre*. He heard the actor Coquelin Aîné as well as the chanteuse Yvette Guilbert in her latest song.[14] He saw all the classical productions he could manage, which would benefit him enormously in his later work with Jacques Copeau, the famous theater director. He

called ~~the~~ "Her Spangled Tights" much applauded.
and a fine piece called "Why should a poet Not"
all very superb. He's less drunk tonight
but more witty; I'm afraid it's rather lost on
these American Boys.

who sometimes dress like this. Rather
superb, dont you think?

Friday night.

Mondieu! Walter's brother Henry has turned up
here! & what do you even think? is living in
the same street. cum concubine.

I went to see Sarah in "Les Bouffons" last
night rather a silly romantic sort of play
à la Rostand. Sarah's no actress I'm afraid,
a very superb person all the same, charming dressed
up as a bouffon.
I am reading Tartuffe & like it better even so far than
The Misanthrope, there so many heavenly people in it.
Dorine, Cléante!
I must really post this tomorrow or it will never
reach you. although I have another letter to thank you
for & a sonnet! wh. I read with admiration. yr
Duncan.

Duncan Grant,
letter to Lytton
Strachey about
costume of
American boys,
seeing Sarah
Bernhardt in
"Les Bouffons"
and reading
Molière (1906).

would later design sets and costumes for Copeau's productions of Shakespeare's *Twelfth Night* in 1914, Maurice Maeterlinck's *Pelléas et Mélisande* in 1918, and the set for André Gide's *Saül* in 1922. He also attended the famous Quatz-arts Ball of the Beaux-Arts' students and indulged in tea at Rumpelmayer's, which he found "preposterous," packed with people he found absurd.[15] Duncan read widely, and examined the space on his bookshelf, where the works of Molière jostled those of Shakespeare, William Blake, Racine, and the fables of La Fontaine.

In February 1907 Duncan began a watercolor of a Rubens in the Louvre, "a superb youth with wings flying through the air."[16] In March Maynard Keynes, who for some time had been, like Lytton, in love with Duncan, came to Paris in order to visit him, accompanied by Harry Norton and James Strachey. Duncan noted in his memoir the same year that

> early Bloomsbury arrived one day in the persons of Clive Vanessa Adrian & Virginia. They get a mention. Through Clive I met the painters he has himself described—the Irishman O'Conor & the Canadian Morrice.[17]

It was Roger Fry who, as a critic and painter and the eventual lover of Vanessa Bell, was responsible for the sustained and intimate relations of the group as a whole with French art, architecture, literature, and thought. He had studied in Paris at the Académie Julian in 1892 and began his art criticism in 1893. In 1904 he saw the French Primitives exhibition in Paris, writing about it for the *Burlington Magazine*. In January 1906 he accepted the curatorship of the Department of Paintings at the Metropolitan Museum in New York and also visited Paris. He saw his first Cézanne still life in the 1906 Exhibition of the International Society at the Grafton Galleries, London. In a review for the *Athenaeum*, he confessed that he had not previously appreciated Cézanne's work but now found it contained a power that was "entirely distinct and personal." He explained the way in which Cézanne had returned to Manet and praised the "frankness and force" with which he used "local color, developing one side of his art to the furthest limits."[18] In 1907 he translated Maurice Denis's essay on Cézanne that was first published in *L'Occident*; his translation appeared in the *Burlington Magazine* in December 1910. His own masterly *Cézanne: A Study of His Development* was published in 1927.

For the four years following his Metropolitan Museum appointment, Roger's visits to France were largely ordered by the possibility of acquisitions he might make for that institution. In August 1906 he traveled to Calvados in Normandy to see a house and chapel he thought might be available for the Metropolitan; he returned the next April to Paris to purchase Renoir's *La Famille Charpentier*. In 1909, when his association with the museum was nearing termination, he accepted the joint editorship of the *Burlington Magazine*, with Lionel Cust.

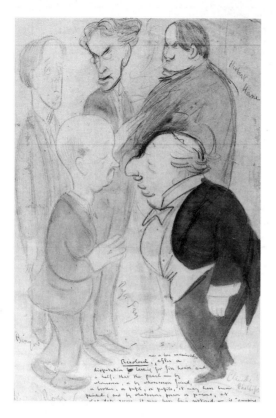

FOUNDING BLOOMSBURY IN FRANCE

Max Beerbohm, "Roger Fry and His World."

The year 1910 was a momentous one for Fry. In January he, Vanessa, and Clive Bell found themselves waiting for the London train on a Cambridge station; she and Fry had met before at a dinner, but she suspected he would not remember her. They discovered a mutual devotion to modern French art, and continued their conversation on the train. At that time Fry discussed presenting the work of the new French painters in England. Later in the year he had the distinction, as Clive put it, of introducing "the modern movement in French painting to the British public" by mounting the first Post-Impressionist Exhibition in the Grafton Galleries, London.[19] At the same time he was dismissed as adviser to the Metropolitan Museum because of a "difference" with the President, J. Pierpont Morgan.[20] He had also had to consign his wife, Helen, who had become increasingly ill, to a mental institution, after which he began painting in the French provinces. It was Roger's early sojourns in France that endowed him with an extraordinary sensitivity to French ways of thinking and creating. His informed enthusiasm joined with his mental and conceptual flexibility to yield the most efficacious bridge pos-

sible between the culture of France and that of England. From 1892, when he first studied painting in Paris, to 1934, the year of his death, when he began his translation of Charles Mauron's *Aesthetics and Psychology* and visited both Paris and Royat, he demonstrated a remarkable understanding of France and of French traditions and art.

By 1910, then, many of the Bloomsbury artists and writers who are central to our story had developed enduring affinities with France: Vanessa and Clive Bell, Duncan Grant, Lytton Strachey, Dorothy Strachey Bussy, Maynard Keynes, Virginia Woolf, and Roger Fry. There is little doubt that their lives and work would be profoundly enriched by these early visits, particularly to Paris.

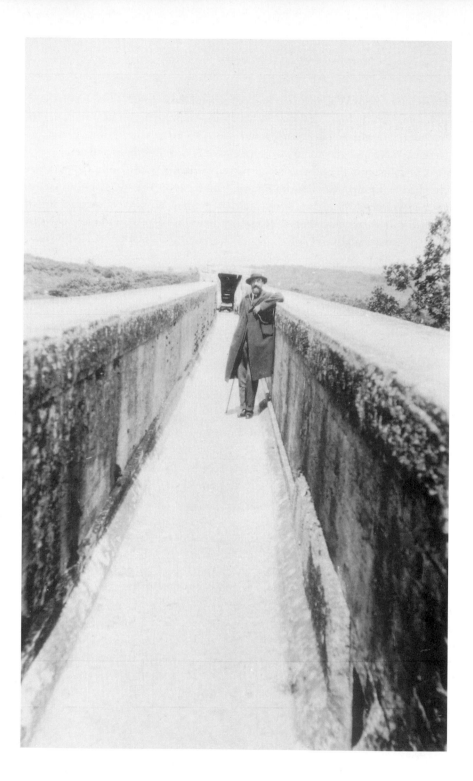

Lytton Strachey
on the Pont du
Gard (1928).

Lytton Strachey, Dora Carrington, Ralph Partridge

It is April 1920 in Versailles. Lytton Strachey, the painter Dora Carrington, and Ralph Partridge, who have stopped in Paris en route to England from a visit to Gerald Brenan in Yegen, Spain, are touring the palace. Its beauty "amazed me every moment," Carrington wrote her brother Noel. "Lytton was of course in his element. And gave us a superb History of the French Kings and their intrigues."[1]

Led by Lytton, the party went on to visit the Louvre, browse in bookstores, dine at Foyot's restaurant, and attend a concert. Carrington and Ralph were married the next year, although she was in love with Lytton, who, in turn, passionately adored Ralph. After Lytton's death in 1932 from cancer, Carrington committed suicide. Ralph then married Frances Marshall, whom he had loved for several years.

More, perhaps, than most Bloomsbury figures, Lytton had long been an ardent Francophile. Lady Strachey had read the works of Racine and other French authors aloud to all her children since they were toddlers. He read French fluently and could speak it, although he hated doing so. Frances Partridge notes than when she, Lytton, Carrington, and Ralph were together in Paris in 1924, he refused to speak French but "left all such matters to Ralph." Even when his sister Dorothy married a French artist, Simon Bussy, Lytton refused to address Simon in his language.

In 1898, while still at Liverpool University College, Lytton had spent the summer vacation in Paris, Tours, and Loches (at the latter he stayed with the Renon family). Having failed to gain admission to Balliol College, Oxford, his mother's choice, Lytton went to Trinity, the largest college at Cambridge, which he had actually preferred. Soon after arriving for the Michaelmas (fall) term, 1899, he met Leonard Woolf, Saxon Sydney-Turner, A. J. Robertson, and Clive Bell (whom he termed "a curious mixture of sport and reading"). The next February the five undergraduates formed the Reading Club, the nucleus of the Bloomsbury Group; they had added Thoby Stephen, brother of Vanessa and Virginia Stephen, who, Lytton wrote his mother, "looked a charmer." Thoby wrote Mrs. Stephen that Lytton was "rather strange but I think sensible and the best I have yet met."[2] The group evolved into the Midnight Society, which, fortified with punch or whiskey, would meet Saturday nights at 12:00 to read aloud and discuss a classic work such as *Comus*.

Lytton's health was never robust, and as early as the summer of 1900 he suffered from

heart "palpitations," which Holroyd believes may have been a form of tachycardia that could now be easily controlled by medication.[3] He did not return to Cambridge for the fall term but was treated at home, where he improved. In December, doctors advised Lady Strachey to take him to St.-Jean-de-Luz, near Biarritz in southwestern France. Here, through his mother's cousins, he met a number of local people and benefited from the beaches, sun, and climate, recovering completely. Doctors suggested that Lady Strachey make sure that he spend part of every vacation either in the country, abroad, or at the seaside. As a result, he went to France many times in the next few years. In 1901 he and his sisters Dorothy and Marjorie visited Paris and Menton, where his mother's sister, Lady Colvile, called "Aunt Lell," had taken the Villa Henriette.

Pernel Strachey, who was staying in Paris with the in-laws of the painter and writer Auguste Bréal, introduced Lytton to Bréal, who would remain a good friend of the group. In 1903 Bréal gave the French artist Simon Bussy a letter of introduction to the Strachey family in London; he took a studio in Kensington and eventually became engaged to Lytton's sister Dorothy, who translated Bréal's book on Velázquez. This was an upsetting attachment for the Strachey family because of Bussy's unpromising financial prospects, but they came to accept it. Sir Richard Strachey presented the couple with a handsome wedding present, a villa, La Souco, in Roquebrune, near Menton on the French Riviera.

Bréal, who had a sense of humor that appealed to Lytton, and a sense of morality, was in agreement with him on a proposal that France erect a monument to Oscar Wilde, sculpted by Jacob Epstein. He wrote him on the subject, scrawling the note from his sailboat waiting for the wind to rise, just off the port of Martigues, one August day:

> My dear Lytton:
>
> I am writing you lying down on the edge of my boat: just excuse the wavering writing—and the pitch and toss of the ideas. Gide is being, as usual, artfully non-committal. That's the word. For from the point of view of *art* you are also on his side, and the real monument to Wilde, Wilde has done himself. But we are thinking from the point of view of sculpture now, and not art…. The breeze is lifting: I am going to drift towards Martigues and toss this letter in the post…. Will you be able to read this scribble? (There's a bit of mistral.)[4]

In April 1904 Lytton returned to Paris and met the legendary Mlle Marie Souvestre, whose elite school for girls, Les Ruches, near Fountainebleu, his sisters Elinor and Dorothy had attended.[5] He went on to Menton, staying again with Lady Colvile. He often visited La Souco, the home of the Bussys at Roquebrune, looking toward Monte Carlo bay. He found the house, with its terraced gardens and impressionist pictures,

"perfectly divine" with "the best view in Europe."[6] On May 5, 1909, Duncan wrote Lytton, "Will you allow me to be fond of Maynard? … this singularly trying letter to beg that the rest of life may not be silence. I hope you will fill in the lost sentences."

In September 1911 Lytton went to Studland Bay, Dorset, to stay with Clive and Vanessa Bell. It was an ill-fated holiday, since he found the Bells and their other guests very trying. Virginia Stephen was not well mentally and Roger Fry was in love with Vanessa, who was preoccupied with her children. He wrote James Strachey that Clive was a "study in decomposing psychology," Vanessa "stark blind and deaf" to Roger's affection, and Julian "half-witted." Impetuously he fled to Brittany to see the artist Henry Lamb, taking the Plymouth–Brest boat and going on by train to Quimperlé. Life was no better there; he disliked the food, the countryside, and the models Lamb was using, writing Ottoline Morrell that he felt "like a white man among savages in Central Africa." After a few days he departed for Paris, via Nantes, staying at the Hôtel des Saints-Pères and wandering through the Luxembourg Gardens. It was, as Holroyd puts it, "all that he loved best in France—crowded, happy, well-ordered," and a relief after the chaos and hardship of Studland and Brittany. He was thirty-one at the time, had just finished *Landmarks in French Literature*, and experienced "a spring of self-confidence … he felt able to face, to outface, the world."[7]

Lytton went again to France, via Folkestone and Boulogne, in March 1913. He recorded his speculations about his fellow passengers in a brief diary, identifying two brothers from Eton "born to command … [but] none of their commands would ever be of any good to anybody." He also saw some "pedantic French youths" along with an Oxford don and an "Academician with a grizzled beard" who might have actually been a Russian prince. He began to feel "sickish" and his soul felt "disembodied." As he seemed diminished, he realized the "English Upper Classes remained life-size to the end."[8]

During World War I, Lytton registered as a conscientious objector. Holroyd emphasizes, however, that he would not have been eligible for active duty because of his poor health. He could have done clerical work to support the war effort, but wrote James that, had he undertaken such an effort, he would have been convinced he was doing wrong. With the exception of the war years, Lytton made frequent journeys to France until his death in 1932. He continued, however, to dislike the use of French, particularly with people he did not know well. Holroyd recounts his "rigidly uncompromising" demeanor when Clive Bell invited some French friends to Gordon Square. Resenting the strangers, he "stubbornly pretended to be incapable of understanding a word of the French language, and retreated into one of his grim spells of non-communication."[9]

In 1915 Lytton met Dora Carrington through David "Bunny" Garnett, whom Carrington had first encountered at a London party she attended with Mark Gertler. In February 1915 she and Garnett, together with Oliver Strachey, Vanessa Bell, and Duncan

Grant, along with Barbara Hiles and John Nash, went to the World's Fair at Islington. This was the first known instance of their meeting, but later that year they met again when they were both houseguests at Asheham, the first Sussex home of Virginia and Leonard Woolf, near Lewes, which Vanessa and Duncan had borrowed.[10] Others in the party were Barbara Hiles and Mary Hutchinson.

Lytton found Carrington attractive at first sight, given the boyish nature of her looks. He gave her a kiss and she crept into his room the next morning to take revenge by cutting off his beard. He opened his eyes and she fell completely in love with him. "How I long to steal away from here," she wrote later, "& climb the height of Firle Beacon, & one day perchance you would come walking up & I hidden in a hillock would see you pass. And after whisper to the April Hare in his hole—*That* man I love. For he is Lytton Strachey."[11] Lytton fell in love with Carrington to the extent that it was possible for him to do so.[12]

In March 1919 Carrington and her brother Noel made a trip to Spain with Ralph Partridge and his sister, Dorothy.[13] Ralph was then invited to Tidmarsh, where Lytton gradually became attached to him. Later, in order not to lose Lytton, Carrington would marry Ralph, of whose heterosexuality Lytton was well aware. They all remained close friends. Ralph had been working at the Hogarth Press for the Woolfs, but took up bookbinding, which he could do at Tidmarsh and, later, at Ham Spray House, which Lytton purchased in 1924. Carrington decorated these two houses in her inimitable manner. Ralph contributed funds from a legacy toward improvements.

Gerald Brenan, a friend of Noel's, had been introduced to the group in the spring of 1919, and in early 1920 settled in a remote region of Andalusia, Spain. He had fallen in love with Carrington, but she was unable to reciprocate. In April of that year Lytton, Ralph, and Carrington made an arduous journey to Spain to visit him, returning by way of Paris. Ralph had organized the trip as efficiently as possible, but Gerald had been ill with influenza before their arrival and failed to meet them as planned. They had almost turned back before he appeared. The final stage involved a twelve-hour mule trip, which, combined with the Spanish food, were very hard on Lytton's delicate constitution. They returned via Paris, where they stayed at the Hôtel d'Orléans in the rue Jacob. Soon after their arrival

Dora Carrington; photograph by Lytton Strachey (1924).

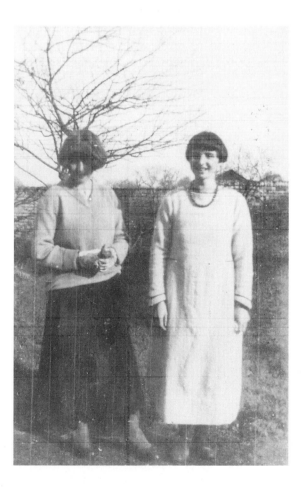

LEFT. Ralph Partridge, Gerald Brenan, and Lytton Strachey in Spain (1920).

BELOW. Dora Carrington and Barbara Bagenal in France.

they met Nick and Barbara Bagenal, and the five visited Versailles. Lytton had recovered from his Spanish malaise, and Ralph termed him an "incalculable asset" to their party. He was witty and eloquent, lecturing on French history and escorting them to the Louvre, bookstores, and a concert. Ralph was called back to England because his mother was ill, but he was able to meet Lytton and Carrington in London when they arrived from Dieppe three days later. They had dinner and drank "to the memory of the most glorious of holidays," as Lytton put it.[14]

Carrington and Ralph Partridge were married in 1921, although she wrote Lytton on the eve of her marriage of her unshakable love for him. They went to the Continent for their honeymoon. They stayed in Paris, where they saw an exhibition of the paintings of Jean Auguste Ingres, and then walked over the Italian Apennines. In 1922 Ralph and Carrington, accompanied by Gerald Brenan, went on a holiday to France. They visited Valentine and Bonamy Dobrée in Larrau in their home in the Basque Pyrenées. Here Carrington painted the village church and houses against the snow-covered slopes.

In March 1923 Lytton, Carrington, and Ralph left on a journey to France, Tunis, and Italy. Carrington wrote Gerald Brenan from Marseilles on March 21, describing the bustling seaport: "It makes one feel very Voltairean, or Tolstoyian perhaps, to see all these halfcasts with wooden legs, poxfaced sailors, clapfaced Whores, and debased sodden faced business men."[15] At this point, she was trying to arrange her life around painting, but her efforts were not always successful.

That August the three returned to France with Barbara Bagenal. Lytton was to attend one of the *décades* at Pontigny. On August 2 they took the Newhaven–Dieppe ferry, then motored to Rouen with Sebastian Sprott, a friend of Lytton's, attired in an enormous black sombrero, violet socks, and orange tie, set off by the emerald and topaz rings he customarily wore.[16] Ralph was called back to England because of his father's death, but Carrington and Barbara stayed in the Hôtel du Commerce at Vermonton on the Yonne River. Carrington occupied herself painting, writing Lytton on August 27: "I was so excited at painting again. Do you know I am never quite so happy as when I can paint. Everything else seems to fade miraculously."[17] The same day she wrote Gerald Brenan:

> I don't very much care for central France. It is too cultivated and trim and far too industrious. Real Burgundy is different. The vines on the Hills are very beautiful, and there are true romantic forests, and grey rocky gorges near Beaune…. Dijon is a lively town, a perfect combination of civilisation and beauty. Superb cake shops and cafés and wonderful 18th century buildings.[18]

Carrington, although far from fluent in the language, could muster up enough French to speak with the salesgirls in the little shops.[19]

In January 1924 Carrington and Ralph went again to Spain to see Gerald, spending a

few days in Paris on their return. Frances Marshall met them in Paris; she and Ralph had fallen in love. Frances's family, however, was not to know that she was in Paris with a married man, his wife acting as chaperone. Carrington, overhearing them from the next room, was miserable. As she wrote to Gerald Brenan, everything she had formerly enjoyed was going sour for her. Now she found the French revolting: "Their faces are made of soap and their hair looks false. My depression grew worse and worse. R[alph] and F[rances Marshall] grew gaier and gaier, in the next room of the hotel." Fortunately, Lytton wired that he was coming to Paris. Until his arrival, Carrington spent her time in the Louvre, leaving Frances and Ralph to their happiness, which she had the generosity to enjoy despite her natural resentment.[20] Lytton's arrival redressed the emotional balance. Frances, according to Carrington, took her side in various small disputes. Lytton still refused to speak French, leaving practical matters to Ralph. Carrington came to be extremely fond of Frances, and believed she had a good

influence on both Ralph and Lytton. At this point, Carrington was eager to leave the Paris she had once loved: "We leave this city of rain and mud tomorrow night. I've turned against the Frogs. They are too barbaric in their behaviour."[21] She preferred England.

On their return to England, the impending move from Tidmarsh to Ham Spray House preoccupied the ménage à trois (Lytton, Ralph, and Carrington). This was a large house near Hungerford, in Wiltshire, for which Lytton had been negotiating while the others were in Spain. He paid £2,300, which, up to that point, was the largest purchase he had ever made. The sale had not been completed when they returned from Paris, as there were many details about various buildings on the property to be worked out. He believed it would be a home for himself, Carrington, and Ralph. The three settled in, joined by Frances Marshall on most weekends.

In April 1925 Carrington, Frances, and Ralph went to Paris, and, with Harry Norton's sister, went on a walking tour in Provence. Carrington described the journey to Gerald on April 16: "We saw Arles, Nimes [*sic*], and the Pont du Gard, Saint-Rémy, Cavaillon and Tarascon. I climbed a mountain 2,500 feet high, and walked 20 miles the same day."[22] In Provence, they visited both well-known and obscure towns. During the day they usually climbed to a mountaintop, where they would have a picnic. Occasionally they stayed in one of the many provincial railway hotels. One night in the Hôtel Terminus et de la Gare at Cavaillon, after a great deal of wine at dinner, Carrington wrote Gerald that the last mountain she climbed had in fact been 3,500 feet high:

> I suppose your grandmother also visited Arles, Les Baux, Bonnieux, Apt, and even Cavaillon. No, she did *not* visit Bonnieux, of that I am certain. Nobody but Missie Moffat and her companion have ever seen that ancient city, where lavender is grown and distilled into precious lavender oil.[23]

She noted that, climbing in the Lubéron hills, it was possible to smell rosemary and

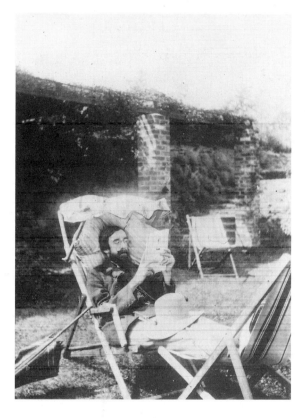

ABOVE. Lytton Strachey at Ham Spray House.

OPPOSITE. Carrington, *Vermonton* (1923).

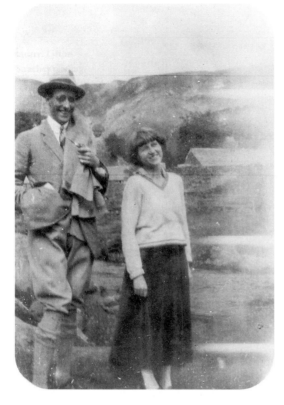

ABOVE. Carring-
ton with friend,
Alan McIver;
photograph by
Lytton Strachey.

RIGHT. Les Baux;
photograph by
Frances Par-
tridge.

thyme on the wind. Blue irises, she continued, "very low, and with an exquisite smell grew on the top of our mount Luberon [*sic*]. Grape hyacinths, rockroses are everywhere … pheasant-eyes Narcissus … I still hold to my opinion that the French are cruel and very antipathico, but the *beauty of Provence is beyond everything that one could dream of.*" Sensing a danger in such a lyrical style of writing, she forced herself to "move quickly to a coarser aspect of life." She commented on the character of the natives: "The Provincials are very dark, rather austere." Near Les Baux they slept in St.-Rémy, then walked from Gordes to Bonnieux over the mountains, and slept in Bonnieux on their way to Apt. One calamity on a daily picnic was the loss of the opener for the sardine tin, which she reported to Gerald ("Ugh, Ugh"). There were snapdragons, however, and all the leaves were blowing in the mistral.

England seemed quite distant as the three went by train to Tarascon, the Pont du Gard, Nîmes, and on to Paris. Carrington was delighted to discover how remote "such a solid empire as Bloomsbury, or the exotic Raymond Mortimer, or the fantastic V. Woolf" could seem. In Provence, she reflected, "I never cease for a moment being in raptures over some little rock cluster or a pale saffron butterfly."[24] In Paris, they stayed in the Hôtel du Bon La Fontaine (always original in her spelling, Carrington writes "Bonlafountain") on the rue des Saints-Pères. Here, as always, they spent much of their time in galleries, this time seeing the Douanier Rousseau, some works of Picasso (whom she found to be "a very formidable artist"), a "superb Matisse of some pink Fish on a red marble table," and two excellent Derain paintings of nude women. In the Louvre, Carrington considered the paintings of Giorgione to be the most appealing.[25]

Lytton, meanwhile, had gone to Lyme Regis on a health trip. When Carrington returned from France, she brought back a few displeasing memories of the art world she found corrupt and cynical. On the positive side, she imported several casks of wine for bottling. She admitted that she loved French wine, even if she was often enraged by French painters:

> … they are fifty times worse, I think, than any other painters, English or German. Because they are morally wicked, being charlatans, cheats and imitators and outwardly they produce hideous, vulgar pictures…. I shall be interested to hear what Roger and Clive have to say on these most modern monsters when they come back.[26]

Roger Fry and Clive Bell did not, of course, share her views about France or French art. Carrington was not, except for her attachment to Lytton, a part of the Bloomsbury group; she differed from them not only by her views but by her entire character. Yet, from the beginning, she had been attracted to Virginia Woolf, who at times had great affection for Carrington.

Pippa Strachey
as a Land Girl.

Lytton went to Paris with his sister Pippa in June 1926; Carrington missed him greatly but invited friends to stay with her at Ham Spray House and found some consolation in the beauties of the property. In November, Ralph loaned her £8 to go to Paris to meet Gerald; this was her first trip alone to the Continent, and she had new clothes purchased for the trip. She wrote Alix Strachey she felt "rather weak, (in spite of my apparent dash, & courage,) being alone in a train bound for France."27

In late 1924 Lytton met, at Garsington, an Oxford undergraduate of whom he became fond, Philip Ritchie. Through Ritchie he met Roger Senhouse; the three became close friends. Lytton's attachment to Senhouse grew stronger and more enduring over the next few years.28 He and Roger went to Paris in January 1928 to meet the novelist and travel writer Norman Douglas, who had come to Paris specifically to meet Lytton. Douglas's hedonistic, skeptical novels appealed to Lytton, who had originally written him in 1923 to praise his work, including *Siren Land* (1911), *South Wind* (1917), and *Alone* (1921). They had exchanged photographs and corresponded for several years. Douglas, who was living in Italy, arranged the weekend, which Lytton found "a truly frantic project." He worried about whether Douglas would be a "womanizer after all" or "too talkative, too vague, or what?" Douglas was thinking of preparing a volume of obscene limericks, and Roger Senhouse was invited along as a consultant. They enjoyed a congenial dinner at Foyot's. Lytton found him to be older than he expected, and belonging to a different generation. His novels had paid little, and he was in reduced circumstances. It was through Lytton that Chatto and Windus became his publishers and his work more lucrative.

In May 1928, Lytton and Carrington traveled to southern France. On May 10, they stayed in the Hôtel Nègre-Coste in Aix-en-Provence, where Carrington wrote Gerald about the mistral that "fills one's lungs with dust and makes one's nose run." But the town appealed to her, and to Lytton, for different reasons: "I like Aix extremely. It is very

ABOVE. Salon de Provence; photograph by Lytton Strachey.

LEFT. Aix-en-Provence; photograph by Lytton Strachey.

beautiful, and full of gay young men & women who parade up and down the Boulevard Mirabeau [*sic*; it is actually the Cours Mirabeau].... Lytton has an infinite capacity for 'flanning,' and sitting in cafés." They went to the market and saw local sights. Life seemed livable to Carrington and the country paintable. She wrote Gerald,

> I'd like to stay in the country and paint.... High grey rocks, and olive trees.... What a pity English towns have nothing like this life. One's head instantly becomes filled with a hundred ideas for painting and even if one doesn't paint it is pure pleasure to watch these curious black widows, old men with white moustaches, and portfolios, nuns herding petites peuples in white dresses to confirmations and the students of the University of Aix arguing with each other outside the cafés."[29]

At Aix Lytton became ill; they called Vanessa Bell in Cassis, whose physician, Dr. Agos-

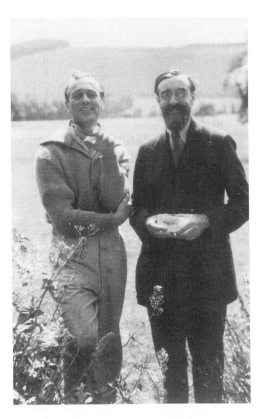

Wogan Philipps and Lytton Strachey; photograph by Carrington.

FOUNDING BLOOMSBURY IN FRANCE

tini, was also away. Vanessa, having no car, could not manage to go over to see about him and was irritated that Carrington's French was not more adequate. Lytton still refused to speak French. Vanessa believed Carrington had a "funereal effect" on him. Despite his illness, their stay in Provence was one of their happiest times abroad. After Lytton's death in 1932, Carrington addressed him in agony in her diary:

> Everything I look at brings back a memory of you. Your brown writing case that I bought you in Aix. Your clothes that I chose with you at Carpentier and Packer. All our pictures and furniture that we chose together. Oh darling did you know how I adored you. I feared often to tell you because I thought you might feel encumbered by your "incubus." I knew you didn't want to feel me dependent on you.[30]

In 1929 Carrington traveled again to France, leaving on September 18 with Augustus and Dorelia John and their two Siamese cats. They made a trip around the Côte d'Or and visited a number of cathedral towns. The journey was luxurious; they would have

champagne for breakfast with oysters on the side, wine at lunch with their cheese and salad, more wine and a brioche at teatime, and a bottle of wine at dinner. Carrington's paintings *Fishing Village in the Mediterranean* and *Fishing Boat in the Mediterranean* probably date from this period.[31]

Roger Fry's second Post-Impressionist Exhibition of 1912 had a powerful effect on all the Bloomsbury painters, including Carrington. Her brother Noel has recalled that Walter Sickert and Augustus John came to have far more prestige after the exhibition than before, although "even these were not to be mentioned in the same breath as Cézanne."[32] Carrington's 1915 portrait of her father, for example, resembles in its pose and feeling Cézanne's own *Portrait of the Artist's Father Reading L'Evénement*.[33] Owing to Bloomsbury's patent Francophilia, Carrington's own style of highly personalized art did not receive the recognition it might have at another time and in another context. In 1919, for example, André Derain returned to London with the Ballets Russes for the presentation of *La Boutique fantasque* and greatly admired her work.

In September 1931 Lytton went alone to France. He was already afflicted with the stomach cancer that would kill him in January 1932, and sought "solitude, plenty of comfort, good food and travel from one place to another." He kept a diary of his trip.[34] Arriving in Paris, the first stage in what he termed his "rather preposterous journey," he stayed at the Hôtel Berkeley, 7 Avenue Matignon, and strolled along the Champs-Élysées toward the Place de la Concorde, coming to the "really magical scene; the enormous Place— the surrounding statues … the astonishing spectacle of the obelisk … the Arc de Triomphe, brightly lighted, with the avenue of lamps leading to it. A most exhilarating affair!" (163).[35] He mocks the conventional travel account while suggesting a romantic nostalgia for the Paris he had possessed twenty years earlier. In September 1911, after abruptly departing from Brittany and his disastrous visit to Henry Lamb, he had restored his spirits with several days in Paris.

Lytton immediately went to Foyot's for lunch, a restaurant that by this time had many old associations. In 1920 Ralph, Carrington, and he had lunched there after visiting Versailles. After a brief visit to the Louvre, Lytton went on to Reims in the rain. He was shocked to find that the entire town had been "wrecked" by the war and that only a "patched-up remnant" remained. The food in his hotel, though, was "almost impressive," and he enjoyed coffee at the Brasserie de Strasbourg. He reflected that "weeks" seemed to have passed since he departed from Victoria, but was relieved that boredom did not figure in the "multitude and complications" of his mental stage.

During his remaining days in France, most of which were cold and rainy, Lytton went on to Nancy, making a brief stop in Châlons. His journal is an erudite montage of his actual reading (a Victorian biography of Lord Salisbury), meditations on King Stanislas,

who embellished Nancy, comments on Racine, and accounts of gourmet meals consumed at the Café Stanislas and the Grand Hôtel. He wrote Alistair MacDonald (nicknamed "the Mooncalf"), who was nearby in Strasbourg, confessing he would like to see him. MacDonald promised to come to Nancy the next Saturday, as he was in the midst of examinations; Lytton then rushed to Strasbourg to tour it privately. He found it completely German; the Cathedral having an "Edinburgh rock effect" next to the palace of the Cardinal de Rohan.

As Lytton was waiting for MacDonald's visit to Nancy in the late morning, Lady Diana Cooper and her companion, a Mr. Kommer, drove by, en route to Calais from Venice, and recognized him. They insisted that he join them at the Café Stanislas, probably for an aperitif, but could not stay for lunch.[36] By September 14 he was back in Paris at the Hôtel Foyot, nostalgic for Nancy, the Café Stanislas, the Café of the Trio, where he and MacDonald drank coffee and played chess. He faced his "solitary bed," half provoked because he could not think where to go or what to do and did not "understand Montparnasse."

The next day, his last in Paris, there was no mail from England. He perceived himself as a "buzzing chimera" in a "strange vacuum," leading a "singularly visionary" life. Despite the two weeks of invigorating travel, he became seriously ill within six weeks. He

Frances Partridge and Duncan Grant, on the occasion of Grant's ninetieth-birthday party, given by Lady Lindy Dufferin (née Guinness).

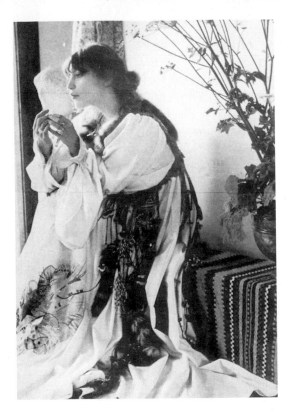

died in January after two months of suffering. "If this is dying," he remarked, "then I don't think much of it."[37]

In February 1932 Carrington wrote Virginia Woolf that she had just been reading the diary Lytton had kept in Nancy. "It is a comfort because he was so happy, sometime James will give it to you to read. His emotional troubles were over and it was a perfect holiday by himself, enjoying all the accumulated pleasures of his lifetime."[38]

On Thursday, March 10, Virginia and Leonard Woolf arrived at Ham Spray House for lunch. Afterward, the Woolfs strolled in the garden while Carrington wrote notes. She invited them to stay for tea, and she and Virginia went up to the study Lytton had used. She collapsed in Virginia's arms. Virginia later recorded the scene in her diary. "There is nothing left for me to do," Carrington sobbed. "I did everything for Lytton. But I've failed in everything else. People say he was very selfish to me. But he gave me every-thing." She presented Virginia with a small French box decorated with a picture of the Arc de Triomphe.[39] The Woolfs were the last people to see Carrington alive. Virginia asked if Carrington would come to see them the next day. "Yes, I will come. Or not," she answered after a pause. She did not, but received a letter from Virginia the next day say-ing, "Oh but Carrington we have to live and be ourselves…. and I feel it is more for you

to live than for any one; because he loved you so, and loved your oddities and the way you have of being yourself."[40] Carrington, however, chose another way to escape her despair. On Friday, March 11, wearing Lytton's purple dressing gown, she shot herself with a gun she had borrowed earlier under the pretense of shooting rabbits on the lawn. Her death haunted Virginia for months, as it did Lytton's sister, Dorothy Bussy.

The next year Ralph Partridge and Frances Marshall were married. For more than thirty years they lived at Ham Spray House, raising their son, Lytton Burgo, there. He later married Henrietta Garnett, daughter of Angelica Bell and David Garnett, granddaughter of Vanessa Bell and Duncan Grant, and great-niece of Virginia Woolf. Less than a year after their marriage, soon after their daughter Sophie's birth, Burgo died very suddenly of heart disease.

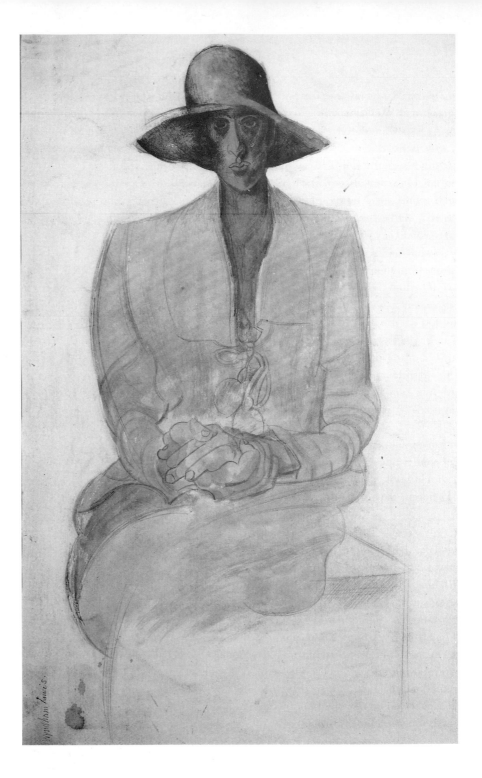

Virginia Woolf;
portrait by Wyn-
dham Lewis
(1921).

Virginia Woolf, Leonard Woolf, Vita Sackville-West

Virginia and Leonard Woolf are sitting on the rocks at the harbor on their first visit to Cassis, a small Mediterranean port near Marseilles, in March 1925. Virginia later writes in her diary, "Nobody shall say of me that I have not known perfect happiness, but few could put their finger on the moment, or say what made it. Even I myself, stirring occasionally in the pool of content, could only say: But this is all I want; I could not think of anything better ... "[1]

Early Visits, 1896–1911

Although she visited France at least sixteen times between 1896 and 1939, and knew it better than other foreign countries, Virginia Woolf feared becoming a "travel bore" and avoided conventional description. Perhaps because she was far from fluent in French, she felt distanced from the country. She read French easily and even tried to become proficient at speaking it. At one time she wanted to keep a diary in French, and she later studied the language with Janie Bussy, the bilingual daughter of Simon and Dorothy Strachey Bussy. As a writer, she was more dependent on language than were the Bloomsbury painters: Vanessa Bell and Duncan Grant seem to have had little difficulty communicating with French artists. Virginia had to be satisfied, in her travels, with a visual rather than verbal idiom. In her 1923 essay "Going to France," she saw herself as a "disembodied spirit fluttering at the window" of the boat train from Dieppe. En route to Paris, she wished to join the "new society" where houses are painted in "lozenges of pale pink and blue; women wear shawls; trousers are baggy; there are crucifixes on hilltops... cobbles—gaiety, frivolity, drama, in short."[2]

Virginia first visited France in 1896, at the age of fourteen, when she, Vanessa, their stepbrother George Duckworth, and his aunt Minna Duckworth went to Normandy. No letters survive from this journey. After Sir Leslie Stephen's death in 1904, Virginia went to Italy with Vanessa, Thoby, Adrian, and Violet Dickinson; they returned via Paris, arriving there in early May. She wrote Violet that they had enjoyed a "real Bohemian party" with Clive Bell, who was in Paris studying art and pursuing historical research. They stayed up smoking and "talking of Art, Sculpture and Music till 11.30" in the "common café." They spent time with Clive Bell and his friend Gerald Kelly (later Sir Gerald Kelly, president of the Royal Academy), conversing until all hours one night and, the next morning, visiting Rodin's studio with Bell and Kelly.[3] Shortly thereafter the Stephen sisters returned to England.

Perhaps their stay in Paris, with its convivial evenings, masked the state of Virginia's mental health. She wrote Violet from Paris that work was essential for her mental well-being, but also insisted that she had "forgotten everything" and was unable to write. Yet she hoped Violet could find her a solid bit of work to do in England. Violet, who had been a close friend of Virginia's half sister Stella Duckworth, was a continual source of encouragement for her writing but could do little to forestall the serious breakdown that took place the day after their return from Paris. This was Virginia's second severe mental illness. Violet cared for her in her home at Welwyn with round-the-clock nurses, but Virginia attempted suicide by throwing herself from a window. She did not recover until September. At that time she seemed to have some insight into her illness, and wrote Violet to apologize for the voices she had heard telling her to "do all kinds of wild things"; Vanessa had assured her they were imaginary.[4]

Virginia's next four visits to France were also in the company of one or more of her siblings. In late March 1905 she and Adrian stopped at Le Havre and Rouen en route by ship to Portugal and Spain. In September 1906 she, Vanessa, and Violet Dickinson traveled through France and Italy en route to Greece, joining Thoby and Adrian there. Thoby and Violet contracted typhoid fever in Greece and Thoby died November 20 at the age of twenty-six, a fact that Virginia concealed from Violet lest she become worse. She recovered, as did Vanessa, who had also been ill with appendicitis in Greece.

After Vanessa's marriage to Clive Bell in February 1907, Virginia made two trips with them to the continent, apparently finding some compensation there for the losses she had suffered: Thoby, Vanessa (through her marriage), and life with her siblings in the house at 46 Gordon Square they had shared. She wrote Violet that she wanted to make a "cheerful place" for Adrian, who had lost his brother. In late March 1907, accompanied by Adrian, the Bells and Virginia made a brief visit to Paris. On April 2 Virginia wrote Madge Vaughan from the Hôtel Rastadt on the rue Daunou, where she and Adrian were staying, that she was about to get ready for dinner with Vanessa and Clive in "some eccentric tavern in Montmartre." She added that Vanessa and Clive "talk a great deal about beauty and Art, and meet various old bachelors who have known Whistler, and play the violin, and cant [*sic*] paint."[5] While she may have envied Vanessa the satisfaction she apparently derived from the marriage, Virginia seemingly had little respect for the intellectual level she and Clive had attained. On their return to London, Virginia and Adrian moved into the house they had let at 29 Fitzroy Square.

The following year was marked by Virginia's last trip to the Continent before her marriage to Leonard Woolf. Julian Bell was born in February 1908, and in September she, Vanessa, and Clive set off for Tuscany. Their journey culminated in a week in Paris in which the evenings, at least, appear to have been relatively frivolous and carefree. The week was spent in "mild Bohemian society," as she wrote Lytton Strachey. "We drank an

immense amount of coffee and sat out under the electric light talking about art. I wish we were 10 years younger, or 20 years older, and could settle to our brandy and cultivate the senses," she continued, but admitted that she sometimes thought of "other things—novels and adventures."[6]

With Leonard Woolf, 1912–1939

After their marriage in August 1912, Virginia and Leonard Woolf went on a wedding trip to the Continent, visiting France, Italy, and Spain. No letters or diary entries from either Leonard or Virginia appear to have survived from France, but from Saragossa, Spain, Virginia wrote Katherine ("Ka") Cox, "we go from town to town, investigating the back streets and the rivers and the market places, wandering along the avenues at night until we find a place to drink at." She wrote Saxon Sydney-Turner from Pisa that she had read Stendhal's *Le Rouge et Le Noir* and was enchanted by the first volume but found the second somewhat heavy.[7] By October Virginia was busy getting herself and Leonard settled in rooms at 13 Cliffords Inn, while Leonard was spending his time at the Grafton Galleries; he had accepted Roger Fry's invitation to be secretary of the Second Post-Impressionist Exhibition.

Virginia did not visit France again until after World War I. In 1919, she wrote Janet Case that the Bussys wanted to set up a press in France but it was "a great bore; I can't speak a word of French; and how to describe printing when one cant [*sic*] even talk about the weather I don't know."[8] She wrote later that the Bussys would ruin the party at Ottoline Morrell's because Simon would speak French and she and Leonard had to answer in English. Dorothy Bussy always spoke to her husband in English, but apparently Virginia did not trust her own comprehension of French.

In the next few years Virginia's attachment to France grew stronger; it had become not only a stimulus to her writing but also a refuge from the strain of dealing with writers and production matters at the Hogarth Press, which they had founded in 1917. She and Leonard made a number of trips to France together. Her letters and diary entries are fanciful and poetic, yet astute, containing observations that would not be out of place in her fiction. Leonard's perspective is more global and less personal. He may not have kept a diary along the way, but his 1967 memoir of their journeys during the two decades between 1919 and 1939 shows an almost photographic recall of certain incidents. His concerns are, as might be expected, more political and philosophical than those of Virginia.

On March 27, 1923, Virginia and Leonard sailed to Dieppe from Newhaven and continued to Spain, via Paris, staying with Gerald Brenan in Yegen; they returned by way of Valencia, Perpignan, and Montauban. On March 30, from Madrid, Virginia wrote

Hôtel Cendrillon, Cassis, now the Cassitel; photograph by Sarah Bird Wright (1990).

Jacques Raverat, the French painter who had married her friend Gwen Darwin and settled in the Alpes Maritimes, how much she had enjoyed the journey from Paris and regretted that they would not have time to stop for a visit in Vence. She had been more impressed by the south of France than by the midlands; it was, overall, a "superb country." The language, however, was still a problem; she was determined to learn it in order to know "how the French think," since they seemed very natural, compared with the English, and "so much akin to all one likes."[9] On their return, the Woolfs stayed in Paris; Leonard went on to London on April 24, but Virginia remained in Paris until April 27, visiting the Louvre and Notre Dame. Her solitary stay was "by way of facing life," she wrote in her diary: "I clap the spurs to my flanks & see myself taking fences gallantly."[10] She failed, however, at the language, and resolved once more to become more fluent. In August of 1924 Virginia was suffering from recurrent depression. She considered France to be therapeutic in itself, and was sure she would be better if she stopped writing for a week and crossed over to Dieppe. "I want to see something going on busily without help from me: a French market town for example."[11]

In 1925 Virginia and Leonard paid their first visit to Cassis, the little port town near Marseilles where Vanessa and Duncan were eventually to spend so much time. They

made the journey by train, leaving Newhaven by boat for Dieppe and Paris on March 26, then continuing by sleeper to Marseilles and Cassis. They stayed at the Hôtel Cendrillon, which housed about eight people at that time. (Now enlarged and renamed the Cassitel, it still stands on the same spot in Cassis, near the harbor.)

Virginia recalled their stay with great pleasure, writing in her diary on April 8, "I am waiting to see what form of itself Cassis will finally cast up in my mind." They would sit on the rocks after breakfast and take an afternoon walk into the woods; here, one day, they discovered the rocky steep road to La Ciotat. There the tulips were out in the fields, which were "little angular shelves cut out of the hill, & ruled & ribbed with vines; & all red, & rosy & purple here and there with the spray of some fruit tree in bud." She admired the orange sails in the bay at La Ciotat and the tall pale shuttered houses, with clothes sometimes hung out to dry. She had, she felt, found happiness in Cassis, and wrote, in her diary, "Nobody shall say of me that I have not known perfect happiness, but few could put their finger on the moment, or say what made it. Even I myself, stirring occasionally in the pool of content, could only say: But this is all I want; I could not think of anything better …"[12]

Leonard discusses the trip in *Downhill All the Way*, recalling its setting by the Mediterranean and the fact that it was extremely quiet. "Cassis still belonged to the people of Cassis." There was no sound of motorcar; people talked in cafés or were silent for hours; by the water they leaned against boats and talked. In the evening, the men played *boules*

Game of *boules* in
Cavaillon,
Provence
(1921).

in the square. He and Virginia walked east over the headland, where they had a view of the sandy coast as far as La Ciotat, Sanary-sur-Mer, and Toulon: "It was open, flat country, with scarcely a house to be seen until you go to Sanary." But returning to Cassis in 1951, he was horrified by the encroaching line of villas and moving cars along the coast, littered rocks, and sense of perpetual motion.[13]

They left on their return journey to London April 6, arriving April 7. Vanessa and her family had not been in Cassis while the Woolfs were there; she and Duncan had just added a large studio to the Charleston house and were busy overseeing the construction and painting the interior. Virginia and Leonard spent most of their days either in Cassis or on exploratory journeys; she sent Vanessa a postcard on March 31 describing some of their fellow hotel guests, and a letter on April 3 saying that Cassis had excellent food, and everything good about it, with its harbor, its olives, and its vineyards.[14]

Jacques Raverat died at Vence on April 7, 1925, the day of the Woolfs' return to London. Virginia wrote Gwen, his widow, that she could still imagine him among the terraces and vineyards at Cassis, "where it is all so clear cut, and logical and intense."[15] She was so charmed by the town that, during the dark winter in London, she longed to throw it all over and move to France. As she wrote from Monks House in September, she would like to spend every summer in the south of France, free of the press, of Nelly Boxall, of "polar blasts," and of the *Nation*.[16] Despite this impulse, the Woolfs did not go abroad in 1926. In September Virginia had tentatively planned to visit Ethel Sands at the Château d'Auppegard, in Offranville, near Dieppe, Normandy, and wrote to ask if she might come September 27 or 28. She learned, however, that Ethel would be in Paris at that time.

The Woolfs next went to Cassis in the spring of 1927. Vanessa had gone there because Duncan had become ill while staying with his mother and her sister, the explorer and guidebook writer Miss Margaret ("Daisy") M. McNeil, at Les Mimosas, the villa Aunt Daisy had let from Roland Penrose, an English art collector. Duncan had contracted bronchitis, which turned into pneumonia; it was suspected that he had typhoid fever. On January 22 Vanessa hastened down with Grace, her housekeeper, and Angelica, in order to care for him. The villa was crowded, and she took a flat across the road in the Villa Corsica for herself, Grace, and Angelica. On January 26 she wrote to Virginia about Cassis: "You'll have to come out here later ... It is really absurd not to for the light & sun are even now astonishing after London & I can see the spring is soon going to burst upon us."[17] They could read French books, drink good cheap wine, walk among the olive trees and vineyards, and enjoy excellent meals. Virginia and Leonard could stay in the comfortable nearby Cendrillon, if only they would come.

The Woolfs arrived in Cassis on March 30, 1927, traveling via Paris. In Cassis they again stayed at the Hôtel Cendrillon but spent most of their days with the Bells and Dun-

can Grant at the Villa Corsica before leaving for Sicily and Rome on April 6. On April 5 Virginia wrote Vita Sackville-West from a balcony where everything appeared "divided into brilliant yellow and ink black." Clive was writing on a "rickety table on huge sheets of foolscap, which he picks out from time to time in red ink. This is The history of Civilisation." It was dedicated to Virginia, who, "alone of my friends were in at the birth and have followed the fortunes of this backward and ill-starred child."[18] On the next balcony Vanessa and Duncan were painting pictures of bottles of wine, oranges, and rolls of bread. Virginia described the gardener hoeing against the distant background of the Mediterranean and the gray mountain range. Leonard, she said, was determined to buy a farmhouse and spend half the year there, but she urged Vita to persuade him not to embrace "the religion of solitude in Provence." She suggested that Vita live near her in Provence; they could sit beneath the cypress trees and Vita could compose poetry.[19]

On this stay in Cassis, as well as on her 1929 visit, Virginia was taken with the idea of living in Provence, although for her the idea lasted far less long than for Vanessa, who absorbed and reflected the generous light. It was a light that banished almost entirely the gloom of London and the darkness of that obsessive melancholy to which Virginia was heir. She wrote Vanessa from Syracuse (Sicily) on April 14, "You have cast out so many of the devils that afflict poor creatures like me—Ever since Cassis I have thought of you as a bowl of golden water which brims but never overflows."[20] The Woolfs did not buy property at this time, although they would come close to doing so on a later visit, in 1929.

On July 27, 1927, Virginia went to Dieppe from Newhaven in order to spend three days with Ethel Sands and Nan Hudson at the Château d'Auppegard; she returned to Monks House on July 30. A week later, on August 8, she described in her diary the view of the broad Seine with foreign steamers and the house, narrow so that one could see from one window through to the other side, strewn with rugs and all its blue and greens and flowers, all carefully designed.[21] She criticized herself, however, for not having written the clever account of her visit she had intended. During the visit she met the portrait painter Jacques-Émile Blanche, whose summer home was a small stone manor house in Offranville, near Dieppe. He interviewed her at Auppegard and, a few weeks later, sent her a copy of the sketch he had written about her.[22] She was pleased and wrote at once to thank him, saying if she had known what notes he had been taking she would have done her best to "say something more intelligent. But indeed you have seen so much more than there was to see, and have said it so much more brilliantly than I could have done had I tried that I am glad to leave well alone."[23] He had included his translation of a few pages of *To the Lighthouse* as well as the short story "Kew Gardens."

In January 1928 Duncan and Vanessa went to Cassis for their first visit to La Bergère, the small villa they had leased and remodeled on the Fontcreuse estate. The estate was

owned by Colonel Peter Teed, a retired British cavalry officer, formerly with the Bengal Lancers, who lived there with his companion, Miss Jean Campbell, a former nurse. They had a vineyard there and made excellent wine. Vanessa and Duncan had met the couple through Roger Fry. Virginia wrote Vanessa how painful it was to see them "completely, absolutely, and eternally happy," sitting in their vineyard in the sun.[24] Vanessa wrote from Cassis urging them to come down: "you should have a warm sitting room with sun & fire all day & you could wander about in the fields & woods & ride a donkey if you liked." Colonel Teed would give them a room at Fontcreuse for fifteen francs, with a bath & breakfast, and they would have all the other meals together. "You will have the car so it wouldn't matter much if you weren't at Fontcreuse." (In September of 1927, the Woolfs had acquired their first automobile, a Singer, which Leonard quickly learned to drive; they nicknamed it "Old Elephant.") Vanessa could not see that there was any case to be made for Virginia or any of them to stay in the northern climates. They should all settle in Cassis. "I'm sure this climate would be good for your brains. They sound to me very feeble & in need of a change," she wrote Virginia on March 9.[25]

On March 26, 1928, Virginia and Leonard crossed to Dieppe in their Singer and drove down to the coast via Beauvais, Troyes, Beaune, Vienne, Valence, Montélimar, Carpentras, and Aix to Cassis, arriving April 1. Going by road emphasized to Leonard the truth of Montaigne's saying, "It is not the arrival, but the journey which matters."[26] Virginia described the journey down to Vita Sackville-West in a letter written March 31 at Orange. She had decided that driving all day, with an hour or so for lunch, a bit of sight-seeing, having wine and dinner in one's inn, was the perfect way to live. En route to the south she had to replace her woolen jersey with a silk one because of the increasing heat. Virginia had learned just before leaving England that she had been awarded the *Fémina Vie Heureuse* prize for *To the Lighthouse*, but added that it was the "most insignificant and ridiculous of prizes." In the car, she felt herself to be not a writer but, rather, a creature who "sits 8 hours a day looking out of the window," having "lost all touch with language."

They did stay with Peter Teed and Jean Campbell at the Château de Fontcreuse. Leonard thought a great deal of Teed, remarking in his autobiography that "beneath the immaculate surface of the colonel of a crack Indian regiment Teed was fundamentally an intellectual who liked artists and intellectuals. He was also a charming man."[27] The Woolfs had breakfast in the château but took their other meals with Duncan and Vanessa. Virginia wrote enthusiastic letters to friends in England about the surroundings and meals. On April 3 she wrote Jack Hutchinson from Cassis that they were in Vanessa's vineyard; the artists were hard at work painting "endless pictures." She assured him that there was no greater pleasure in life than driving through France, except that one was tempted to eat far too much.[28] To Angus Davidson, on April 7, she wrote that

driving through France was "undoubtedly what one will do in Heaven—motoring all day, and eating vast meals, and drinking red wine and liqueurs."[29] And the same day she wrote Gwen Raverat at Vence about the drive from Dieppe to Cassis: "Absolute heaven, I think it. Everything looks odd and new, coming along the road to it gradually. I'm half inclined to buy a barn here in a vineyard. The sun and hills put my dear London rather in the shade—and then one does exactly what one likes here."[30]

Before their return to Dieppe Leonard mapped what he thought would be a pleasant route through the middle of France. He confessed he was "fairly ignorant of geography," having been a classical scholar at school. He was quite unaware that the mountains of the Cévennes and Auvergne, the massif central, lay in the center of France, nor did he realize that in April the peaks were subject to severe snowstorms. After spending the first night at Tarascon, where Vanessa had recommended the Hôtel Les Empereurs on the Avenue de la République, the Woolfs began driving through Alès and Florac to St.-Flour and Aurillac. They followed the road up a "formidable, black mountain," and were soon in the midst of a violent snowstorm. The scenery reminded him of Wagner and Covent Garden, "those absurdly melodramatic Valkyries' Rocks and Brünhilde's cave." Suddenly a tunnel opened before them; they progressed through the Massif du Cantal and into sunshine.

But since Leonard had paid little attention to his tires, and those on the Singer were badly worn, they found themselves having to repair a puncture every twenty-five miles between Cantal and Dreux, where they were finally able to buy new ones. Their troubles, however, led to friendly encounters; in Auvergne they were invited into a cottage. There they discovered a sixteen-year-old French schoolgirl writing a letter to a pen pal, the daughter of a bus driver in Brighton, a coastal city only ten miles away from their home. Leonard found the "internationalism of the savagely nationalistic world of the 1920s" remarkable. They continued on their way "on terms of warm friendship with the whole family."[31]

The next year the Woolfs again went to Cassis, this time later in the season, taking the train on June 4, 1929. They stayed for a second time at Fontcreuse, as suggested by Vanessa. Vanessa and Duncan had now come to know more members of the expatriate English colony in Cassis. Virginia wrote Margaret Llewelyn Davies how pleasant life was, with much wine, conversation, and "the society of curious derelict English people, who have no money and live like lizards in crannies, sometimes keeping a few fowls or breeding spaniels."[32] While in Cassis they became extremely interested in buying La Boudarde, a three-room hut in the woods near Vanessa's villa, and went so far as to add windows and ship furniture from England by sea. They returned to England June 14. On June 15, Virginia recorded the negotiations in her diary. This holiday had been different from the previous ones in that it had been very hot and she had almost become a

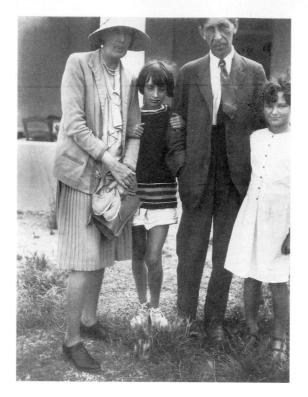

Virginia Woolf, Angelica Bell, Leonard Woolf, and Judith Bagenal at La Bergère, Cassis (1929).

landowner—"a window owner, anyhow. Yes, I almost bought La Boudarde & have a contract, to go there at the cost of L-2.10 a month." She envisioned her hut with its three windows as an "island," apart from Vanessa's household, from which she and Leonard might drive to Aix, eat cakes at the new hotel at La Ciotat, buy French books at Toulon and keep them in her "lovely cool room in the wood," and have an "Eastern private life."[33]

In September she was still thinking of La Boudarde with longing and wrote Desmond MacCarthy, "I have a wild desire to rush over to France and furnish my peasants [*sic*] hut"; she also wanted to sit in the sun, drink coffee, and consume large quantities of the wine made by Colonel Teed.[34] By December, however, she wrote Vanessa that Leonard had "taken against Cassis" and she would have to give up her house near her sister.[35] In *Downhill All the Way* Leonard explained that they changed their minds because, at that time, the "procedure for an Englishman to buy a house in Provence was an unending labyrinth.[36] They also realized that with the responsibility of the Hogarth Press, writing, politics, and other London commitments they could not spend much time in Cassis. Instead they decided to snatch a few weeks whenever they could and go there. Leonard also may have thought it impractical to maintain three residences, and they never com-

pleted the purchase. By 1930 the dream had evaporated.[37] Virginia gave her sheets to Miss Campbell at Fontcreuse, disposed of the rest of the furnishings, and rarely looked back.

Angelica Garnett has remarked that "Cassis wasn't really a place that Virginia and Leonard came to a great deal, not like Vanessa and Duncan at all. They came on very short visits, and not, I think, every year we went there. Because Leonard wasn't really so keen on going abroad, whatever Virginia felt about it; they spent much less time abroad than we did anyway. They were very busy people."[38] The Woolfs' journeys abroad for the next few years were limited to a few weeks each year; their responsibilities with the Hogarth Press, their writing, and the care of two homes in England prevented their taking very long holidays.

It was not until April 1931 that Virginia and Leonard returned to France. They left England April 16 for a fortnight's holiday, driving to the Dordogne, visiting La Rochelle, Marennes, Bergerac (with an expedition south to Castillonnès), and Brantôme. On this journey they were serious sightseers. Virginia wrote Ethel Smyth from La Rochelle that they had seen the Plantagenet tombs at "Fontevrault" [Fontevraud Abbey], "lying red and blue in a superb scraped abbey—the tombs like the sitwells." The south was "beginning to warm and tumble."[39] They ate fresh oysters at Marennes in honor of Vita Sackville-West and, on April 23, visited the Château of Michel de Montaigne west of "Chastillon" [Castillonnès]. The castle had been destroyed by fire, but the tower, with his saddles, chair and table, survives. Leonard was a particular admirer of Montaigne and his essays, considering him the first civilized man of modern times. He sent Lytton Strachey a picture postcard from Bergerac, noting that they had just visited the tower and the prospect from his windows was glorious.[40] Virginia wrote Ethel Smyth she should like this life "to go on forever." This and Joan of Arc's castle at Chinon were Virginia's favorite sites on this trip. She sent spirited cards and letters to Ethel Smyth Vita, Vanessa, and Quentin Bell and went for a "mad scramble" along the banks of the Drôme. "Why don't we live here—far lovelier, lovelier far, than Cassis—plains, heights, poplars, vineyards, of a subtlety and distinction like a moth's wing compared with the shell of a lobster," she wrote Quentin.[41]

Virginia wrote Vita from Dreux about the way time seemed to be prolonged: "This 4t night [fortnight] … seems at least 4 4t nights."[42] Lytton Strachey had a similar attitude on his last stay in France. Both perhaps sensed a certain isolation when letters from loved ones did not arrive or the land was foreign. Virginia and Leonard were not born travelers in the way Clive Bell and Roger Fry were. At the same time, Virginia realized that one of the principal pleasures of France was the lack of visitors and social obligations. As she explained to Vita, "not being in at 5 to see Sibyl; to see Eddy; to dine out. Thats [sic] the horror of our lives. I intend to stop it; I cant get back into that squirrel

cage again." In any case, and in part because the weather was cold and rainy for several days, she had unusual leisure for reading, devouring D. H. Lawrence's *Sons and Lovers*, and writing Ethel Smyth she had realized with regret that "a man of genius wrote in my time and I never read him." She blamed John Middleton Murry, Katherine Mansfield's husband, for deflecting her from Lawrence with his "obscene objurgations." The Woolfs returned to Dieppe April 30.

Leonard recorded the details of the journey in his diary, including the itinerary and the hotels at which they stayed. Virginia later pasted in her own diary pages she had scribbled along the way. Although the weather had been bad, she believed the fact that she and Leonard had so many companionable days driving along wet roads in the rain "speaks well for the state of our souls … how moving to find this warmth, curiosity, attachment in being alone with L."[43] She jotted down observations that might become fictional nuggets, notations about "biblical" old women sitting near sheep in fields, cave dwellings in Brantôme inhabited from the time of Charlemagne, a racing boat on the Dordogne River, a "thick slab of a man" consuming an enormous meal. The meals, with a few exceptions, were relatively disappointing on this trip, comparing unfavorably with the White Hart in Lewes, near Rodmell.

Both in 1932 and 1933 the Woolfs took continental holidays that were longer than usual; France was an incidental rather than a primary destination. In April 1932 they went to Greece for a month's holiday in Greece with Roger Fry and his sister Margery, which Virginia termed "the best holiday we've had for years." They had traveled by train through Paris to Venice, where they boarded the *Lloyd Triestino S.S. Tevere*. In Paris, she wrote Vanessa, they had dinner at a restaurant where Roger had taken his wife, Helen Coombe, thirty-six years earlier.[44]

The following year, the Woolfs left Rodmell on May 5 for a three-week automobile tour to Italy, through France, via the Grande Corniche. They spent one night at Carpentras, near Avignon, where Virginia recorded her impression of a servant girl, about eighteen, with an "odd little honest face" and one black tooth, "without hope; poor, not weak but mastered—yet not enough mastered but to desire furiously travel, for a moment, a car. Ah but I am not rich she said to me—which her cheap little stockings & shoes showed anyhow. Oh how I envy you—able to travel."[45] They stopped to call on Dorothy, Simon, and Janie Bussy at La Souco, their home in Roquebrune, near Menton. Virginia was offended because Simon would not permit her to visit his studio and called him "more of an organ monkey than ever." She wrote Vanessa from Lucca that the entire Riviera "seems to me Raymonds [Mortimer] country—a pink pyjama country," and added that, on their return through France, the car had reached "unparalleled speed."[46]

On May 1, 1935, Leonard and Virginia, accompanied by their marmoset, Mitz,

embarked on a long continental holiday. Crossing from Harwich to Hook of Holland, they spent a week in Holland and three days in Germany, going on to Austria, Italy, and France via the Brenner Pass. They returned to Dieppe and Rodmell by way of Nice, Draguignan, Aix-en-Provence, Vienne, Moulins, and Chartres. Leonard, who was Jewish, had taken the precaution of getting a letter of introduction from Prince Bismarck at the German Embassy in London in order to travel without difficulty in Germany. Bismarck gave him an elaborate official document they could present along the way, calling on German officials to show to "the distinguished Englishman, Leonard Woolf, and his distinguished wife, Virginia Woolf, every courtesy and render them any assistance which they might require." Leonard dryly remarks that the marmoset made it unnecessary to use the letter for protection against the anti-Semitism of the Nazis. Mitz was always on his shoulder or in his waistcoat and was welcomed in Holland, Germany, Austria, Italy, and France. In the first four countries, she was mistaken for many small animals; dozens of people inquired about her, making "one or two of five or six standard remarks or asked one or two of five or six standard questions." France, however, was altogether different. In Draguignan, the woman hotel proprietor refused to allow Mitz in the hotel, so that, to his dismay, Leonard had to leave her overnight in the car. The next morning he found her on the steering wheel, guarded by a soldier who "talked about her in an adult, intelligent way—he was the first man, woman, or child who had done so in 2,469 miles." Leonard believed that the reaction of the "man in the street" to Mitz was quite revealing about the intellectual heritage of a given country; consequently, France was given top marks. Whereas there were many things he did not like in the French tradition, "its scepticism and respect for intelligence seem to me admirable," he concluded.[47]

In Aix, Virginia noted in her diary that all day in the car she had been thinking of Roger Fry—"Brignolles [Brignoles]—Corgès [Carcès]—my word, the olives & the rust red earth, & the flat green & the trees."[48] These are the most memorable elements of Fry's provençal landscapes. He was an enthusiastic devotee of the Provençal food and countryside, and wanted to paint the elements he found so "exactly right"—the old walls, the tiled roofs, the streets on market day, and the trees with their gnarled limbs.[49] It must be said, however, that Roger often had difficulty with landscapes, which he realized. He wrote Vanessa at La Bergère in 1929, "I don't know why I *can't* make landscapes except out of certain kinds of material but I know when I can & when I can't at least I do after a little while."[50]

Virginia wrote Victoria O'Campo from Moulins that, although it was a relief escaping the press of business and social obligations in England, they had seen so many different civilizations that her brain was crowded. "I want to subside into a coma, like a spinning top and cease spinning."[51] By the time they reached Chartres, Virginia was exhausted by car travel. She felt she was behind a "pane of glass that is pressed firm over the mind,"

positively "vitreated" on her seat. The rainy weather conspired to make final part of the trip all but intolerable. When they visited the cathedral with its blazing blue windows framed against the night, it was

> ... like seeing the skeleton & eyes of the cathedral glowing there. Mere bones, & the blue red eyes. The windows are all blue & red, & at one end there's the jewel burning—the great rose jewel, burning blue in coal blackness.... Never had we seen it so bare, so architectural, a statement of proportions, save for the fiery & deep blue glass, for the glass varied from gloomy to transcendent."[52]

The Woolfs went to France again with Mitz in 1937, from May 7 to May 25, this time to the Dordogne, south as far as Albi. Virginia wrote Vanessa from their "perfect small Inn" (ironically called the Grand Hotel) in Souillac, in the land of Romanesque sculptures: "Why we dont live in France I cant think. The mere silence of the telephone is alone enough." They visited the caves at Les Eyzies and saw a castle at Meyronne, where Virginia asserted in her diary that she wished to live. They also went to Rodez, Najac, Treignac, and Uzerche. On the return trip they saw George Sand's château at Nohant; she sent Vita Sackville-West a postcard of Charpentier's portrait of Sand, suggesting it was rather like Vita. "I mean to buy a house and live here," she added.[53]

In the summer of 1939 the Woolfs went to Brittany and Normandy for what was to be Virginia's final journey to France. She looked forward to it, noting in her diary that the two-week trip ramble would fill her "dry cistern of a head."[54] Leaving on June 5, they visited Carnac and Vitré, where they saw Mme de Sévigné's château at Les Rochers. They continued to Dinan, Bayeux, and Vannes, which she found a "most sympathetic dignified town, with a quay, blue ships, old walls, old women marching about in black velvet robes with white caps, and in short all that one needs.... Yes, I dont think England can compare for amenity or space and composition with France."[55] At Bayeux they found a midsummer-night celebration, with gypsies, young men in medieval costume, and girls in lace caps. Virginia wrote Ethel Smyth they had seen an old man playing a bagpipe "such as the Druid shepherds must have played to Iberian goats." At times like this, she very much did not want to return to England.[56]

In her French travels Virginia waxed alternately enthusiastic and despondent, her mood varying according to the weather, food, people, particular sights, and atmosphere. When these elements conjoined perfectly in a seemingly ideal location, she often wanted to move there, as she had to Cassis. To some extent this would have been a logical choice for a third residence, as she had never lived more than a few miles from Vanessa until she and Duncan began spending several months a year in the south of France. It seems unlikely, however, that Leonard would finally have been at ease in Cassis for more than a week or two. He may have thought, on first partaking of the relaxed,

productive life Vanessa and Duncan had made at La Bergère, that he and Virginia could replicate it for part of the year. He might well have been bored, however, without the stimulation of the city and the Hogarth Press, balanced as they were with weekends at Monks House. Moreover, his concern was always for Virginia's mental health. More levelheaded than she, he may have doubted whether Virginia could have come to terms with a country where she did not speak the language. She had tried unsuccessfully to become fluent in French at various times. As a writer attuned to every nuance of speech, with remarkable ability to weave half-overhead fragments of conversation into her fiction and to plumb the consciousness of her characters, it seems questionable whether Virginia could have been completely content while living and writing for long periods of time in France. In her essay "Pictures," she states that painters

> lose their power directly they attempt to speak. They must say what they have to say by shading greens into blues, posing block upon block. They must weave their spells like mackerel behind the glass at the aquarium, mutely, mysteriously. Once let them raise the glass and begin to speak and the spell is broken.[57]

Vanessa and Duncan, not dependent on speech, were happy working in France; Virginia and Leonard were far less so. For all four work mattered a great deal, but France could not be, for the Woolfs, the optimum environment for creativity. It can be argued that, just as Virginia, as a novelist, needed to be in a country where she knew the language, Leonard also needed the stimulus of England for his work. In 1923 he had become literary editor of the *Nation & Atheneum*, edited by Maynard Keynes, and was also working on several political books.[58] The Hogarth Press, of course, was very demanding and a principal obstacle to their living abroad; both needed, as well, their friends and professional associates in London, Sussex, and Cambridge.

Although the Woolfs decided against a French pied-à-terre, the country as a whole, and particularly Cassis, had made a great impression on both of them. In her diary entry of October 15, 1920, Virginia recalled Cassis in the warmest and most nostalgic of terms:

> I say to myself "But I cannot write another word." I say "I will cut adrift—I will go to Roger in France—I will sit on pavements & drink coffee—I will see the Southern hills; I will dream; I will take my mind out of its iron cage & let it swim—this fine October…. Oh to walk among vineyards I cry again.[59]

It was not a place in which Virginia felt finally centered. The writer, committed to her own language and way of being, gave up the place where Vanessa the painter was more at ease. But the memory of the light remained, and "something about canvasses glowing in a studio."[60]

In France Virginia Woolf was unable to emulate Proust and capture the crucial

moment from within the welter of existence. On November 28, 1928, which would have been Sir Leslie Stephen's ninety-sixth birthday, she meditated on life, conceiving of it as a silver globe: "I should like to take the globe in my hands & feel it quietly, round, smooth, heavy. & so hold it, day after day. I will read Proust, I think. I will go backwards & forwards."[61] She was determined to form such a globe of her own in her next book, which would be *The Waves* (1931). At this point it was still called "The Moths" in remembrance of Vanessa's letter from the Villa Corsica the previous year when the mammoth Emperor moth tapped on their window and smaller moths circled her lamp.[62] Virginia envisioned the development of the novel: it would "grow heavy mind my mind like a ripe pear; pendant, gravid, asking to be cut or it will fall."[63] In the same way Virginia's French experience took its own time to ripen.

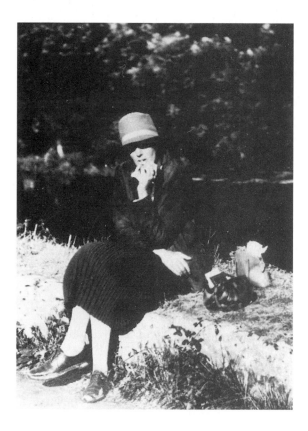

Either Vita Sackville-West in France, photograph by Virginia Woolf, or Virginia Woolf, photographed by Vita Sackville-West (1928). [Nigel Nicolson and Anne Oliver Bell have not been able to determine the identity of the subject of the photograph.]

FOUNDING BLOOMSBURY IN FRANCE

Virginia and Vita Sackville-West, 1928

The novelist, poet, and critic Victoria Mary ("Vita") Sackville-West (later Mrs. Harold Nicolson) had been born in 1892 at Knole Castle in Kent, a complex of ancient buildings making up one of the most historic and imposing estates in England. Her mother, Victoria, was one of five illegitimate children of a Spanish dancer and of Lionel Sackville-West, the third Lord Sackville. She and her two sisters were raised in southwest France, then, on the death of their mother, sent to a convent in Paris. Her father became a diplomat in Washington, taking Victoria along as his official hostess. She was a great success, but refused all suitors until she returned to England. In 1890 she married her first cousin, also named Lionel Sackville-West, who would eventually inherit Knole. She lived there with the two Lionels, both of whom were entranced by her. Vita, her only child, was born two years after the wedding. She had the run of Knole and was adored by her parents and grandfather; she spoke and read French from childhood.

Vita was taken to France from an early age. When she was nine, she went with her mother to La Bagatelle, the park on the Norman coast that had once been the playground of Marie Antoinette. Here she admired the lakes, bridges, statues, and ornamental urns; many years later she acquired the urns for her garden at Sissinghurst.[64] A solitary child, she learned early to take visitors on tours of Knole and to amuse herself with reading and writing. She was absorbed by the history of the castle and occupied herself writing ballads about her ancestors. She wrote three plays in French between 1906 and 1908. In 1907, she noted in her diary:

> This morning I received the & ti [prize] I had won in the verse competition. This is the first money I have got through writing. [Then in code:] I hope, as I am to restore to fortune of the family! that It will not be the last.

[Code:] zh R zn gl invhgliv gsv religfmvh hi gsv uznrob![65]

Vita visited Paris throughout her life. In 1909, at the age of seventeen, she and her mother stayed in the city at 2 rue Laffitte, where her mother ordered dresses for her from Worth's. They saw an aeroplane exhibition at the Grand Palais and also went to the Louvre. On another visit, in 1913, she visited the Rodin museum on the rue de Varenne. At the age of twelve Vita was asked to tea at the home of Violet Keppel, whose mother had been the mistress of Edward VII, the former Prince of Wales. This early friendship developed into a lesbian relationship that endured for some time after both Vita and Violet were married. They often corresponded in French.

Vita married Harold Nicolson in 1913, but continued to have affairs with women just as he did with men. She and Violet Keppel continued their affair, going together to

France in November 1918, where they stayed until late March 1919. Vita was often unhappy, however, and wrote in her diary, "I am broken with misery, and if things were as bad as I at first thought I should put an end to myself."[66] Harold, attending the Paris Peace Conference, was increasingly worried about Vita's behavior. She eventually returned to Long Barn to live with him and her two young sons, and Violet became engaged to Denys. Vita wrote in her diary:

> I had to go, I should have killed her if I had stayed an instant longer. I have told her I cannot even see her for two months. She calls it banishment—it is not, it is simply the impossibility of bringing myself to see her for the present.[67]

The affair eventually ended, with great reluctance on Violet's part.

Vita and Virginia Woolf met in December 1922 at a London dinner party given by Clive Bell. Virginia, intrigued by Vita's androgynous beauty and presumably knowing of her Sapphist tendencies, was also impressed by her lineage, and later called her "an aristocrat of ancient race."[68] They had a brief sexual relationship beginning in 1925, which seems to have distressed neither husband. Apparently Virginia was not deeply in love with Vita, possibly because she knew of her other relationships with women, and also, perhaps, because she could not revere her literary ability in the way she did Leonard's.[69]

Virginia and Vita planned to take a holiday in France together, although it did not come about until the fall of 1928. It was to be a week's trip to Burgundy. Because Vita had to be in London for a BBC radio broadcast, they returned after six days. Both women had anxieties at the outset of the journey. Virginia had rarely spent a night apart from Leonard and was unsure whether she would be able to cope with their separation. She wrote in her diary before her "alarming holiday" that she was "afraid of 7 days alone with Vita: interested, excited, but afraid—she may find me out, I her out."[70] Vita had often lived apart from Harold, since he was at the Berlin Embassy for part of each year, but she worried about taking responsibility for Virginia's fragile emotional and physical health.

The journey could not be scheduled until after the middle of September, when Vita returned from Berlin and took her son Ben to his public school, Eton. Before leaving, she wrote "Hadji" (Harold) in Berlin, asking him to find Saulieu and Vézelay on a map. She expressed doubts about the expedition, and worried whether he approved, although she thought it would be "rather fun, in the vintage and Virginia and all." She insisted she would rather be walking through Burgundy with him, feeling "one long ache" without him.[71] The journey would be the only one she would make without Leonard, but thanks to Vita's diligence in writing Harold and in recording their itinerary and conversations in her diary, it may be reconstructed in some detail.

Vita and Virginia agreed to set out on Monday, September 24. That morning Vita

drove from Long Barn to Monks House, Rodmell, where she admired Pinker's puppies. Leonard drove them down to Newhaven, where, accompanied by two marmosets belonging to the Woolfs, they took the steamer to Dieppe and went on to Paris. They had booked a first-class cabin that Virginia didn't think worth the thirty-seven shillings. Their progress was recorded in daily letters both sent their husbands; sometimes they wrote more than once, and Virginia also wrote Harold Nicolson, praising Vita as a protective traveling companion.

When they reached Paris, they stayed at the Hôtel de Londres, which had been an early favorite of Vanessa Bell's and Duncan Grant's; Clive also liked staying there. That evening they went to a bookstore on the Boulevard Raspail, where, according to Vita's five-page diary of their trip, Virginia bought *J'adore* by Jean Desbordes and Vita bought André Gide's *L'immoraliste*.[72] After dinner they wrote their husbands as they sat at the Brasserie Lutétia on the rue de Sèvres, across from the Bon Marché department store.[73] Virginia reported to Leonard that the first day had been ruined for her by their parting, which had, she told Vita, been preceded by a quarrel. The marmosets had cried for "Dadyka," she wrote. "Lord, how I adore you, and how little you do!"[74] Vita, at the same time, was writing Harold a fuller account of their stay:

> My darling, This is not where we are staying. No. It's where we are sitting on the pavement, Virginia drinking coffee and me Benedictine, after dinner. We have no writing paper so as you see have had to devastate the books we bought in a nice bookshop where the lady proprietor expatiated on the beauty of Proust—and an old gentleman, hearing me ask for *J'adore*, growled out: "Ce livre a tant de succès que Cocteau sera bientôt jaloux de la renommée littéraire de Desbordes—même s'il n'en est pas jaloux pour d'autres raisons." ["This novel is selling so well that Cocteau is going to get jealous pretty soon of Desbordes' literary renown—even if he isn't jealous for any other reason."] A civilised country. I feel a transformation taking place in me: I see that I might quite easily want to live abroad. Not in diplomacy, but in a little house in the sun. One ought to have several lives....[75]

Since they were writing their letters in the books they had just bought, they could choose which pages to tear out: Vita's letter was written on a page that said "Je t'adore." They retired early in order to start at six A.M. for Burgundy.

They departed early Tuesday morning by train for Saulieu, where they stayed at the Hôtel de la Poste and consumed what Virginia insisted was the most delicious luncheon she had ever had. Vita wrote Harold it was "as good as Boulestin" [proprietor of the well-known underground restaurant in Covent Garden].[76] Afterward they wandered through a local fair, but looked in vain for the *vendange*, or vintage (the grape harvest). Vita wrote Harold:

I am lying on the grass in a field, with Burgundy spread out before me. It is warm, it is sunny…. I feel very much tempted, with the south lying so to speak just over the hill … and if it were not for the BBC on the 2nd [Vita's broadcast] I would go on down into Provence. I foresee that if we stay here for two days eating *canneton en croûte* and *crème double*, washed down by *Bourgogne mousseux*, we shall get dyspepsia…. I feel amused and irresponsible. I can talk about life and literature to my heart's content—and it amuses me to be suddenly in the middle of Burgundy with Virginia. I like doing expeditions with you. But failing you, I could not wish for a better companion than Virginia.[77]

She continued with practical details, such as how to get Harold's letters, on which she depended, as Virginia did on Leonard's. In her diary of the journey she noted that Virginia was reading *J'adore*, and remarked that there was "a tendency in young Frenchmen of today towards religion and simplicity."[78] In the meantime, Virginia bought a green corduroy coat for Leonard and wrote him, as they sat in the field, that she could not stand more than a week away from him. There were too many things she wanted to say to him and couldn't say to Vita, "though she is more sympathetic and more intelligent than you think." She reported that they had not quarreled, although Vita had never asked the price of rooms and Virginia worried they might be overcharged, in fact, "rooked."[79] She hoped she and Leonard could return to Burgundy and make a slow circuit by car through the small towns, and was glad he was dining that night at Charleston.

On Wednesday, September 26, they breakfasted in Vita's room and began arguing about men and women. "Virginia is curiously feminist," Vita noted in her diary. "She dislikes the possessiveness and love of domination in men. In fact she dislikes the quality of masculinity. Says that women stimulate her imagination, by their grace and their art of life."[80] Vita then went out and purchased a corduroy coat for herself. After dinner, Virginia read her the memoir of "Old Bloomsbury" she had written and "talked a lot about her brother" (presumably Thoby Stephen, who had died in 1906).

On Thursday they went to Avallon, arriving at nine-thirty. They looked about the town and visited the church of St.-Lazare. Vita received a letter from Harold, but there was none from Leonard; Virginia was "very much upset." While Vita tried to hire a car to take them to Vézelay, Virginia sat in a café in a melancholy mood. She wrote Leonard and then sent him a telegram asking him to wire her at the Hôtel de la Poste, Vézelay; there, to her great relief, she heard from him early the next morning.

They spent two nights at Vézelay, enjoying the food and the cleanliness of what Virginia thought a modest hotel. Vita wrote Harold from there: "Still here…. it is an absolutely delicious place, and so real. There was a thunderstorm last night, but not right overhead; as the patronne of the hotel said to me at breakfast, "L'orage n'a pas su

grimper la butte" ("the storm couldn't get up the hill") which I thought rather a charming notion!"[81] In her diary she noted that she had been afraid Virginia would be frightened by the storm and had gone to her room. "We talked about science & religion for an hour—and the ultimate principle—and then as the storm had gone over I left her to go to sleep again."[82]

On Friday it was still raining, but when the weather cleared they took a walk and went to an antiquarian shop, although they bought nothing. Vita took photographs in the "fitful sunshine." They walked to a small village, sat in a vineyard, and watched local women doing their washing before climbing back up the hill to Vézelay. Vita asked Virginia to lie down for a rest and went out again alone. She wrote Harold that she had

> walked right round the ramparts watching the sunset; oh darling, it was so lovely; all Burgundy turned pink and golden, and then grew deep blue as the dusk came. It was very warm, and smelt good after the rain. I longed for you. It is a country we would love to walk through.... The owls are hooting all round the town.[83]

Virginia wrote Leonard, scolding him for not writing but insisting she had been in good hands. Vita was a "perfect old hen, always running about with hot water bottles, and an amazingly competent traveller, as she talks apparently perfect French."[84] Vita wrote Harold that she had felt "extraordinarily protective" toward Virginia. "The combination of that brilliant brain and fragile body is very lovable. She has a sweet and childlike nature, from which her intellect is completely separate. I have never known anyone who was so profoundly sensitive, and who makes less of a business of that sensitiveness."[85]

They left Vézelay on Saturday morning at ten, going by hired car to Sermizelles, where they caught a train to Auxerre in time for lunch; they stayed at the Hôtel Touring. During the afternoon they visited the Abbey of St.-Germain, which is often considered the city's most venerable building but which Vita termed "not very interesting." After having hot chocolate in a tea shop, Virginia bought a looking glass. Later they discussed Edith Sitwell and, according to Vita, Virginia told her "the history of her early loves— Madge Symons, who is Sally in Mrs. Dalloway."[86]

The next day, Sunday, September 30, they went by train to Paris, lunching at the Gare St.-Lazare, and continuing on to Rouen and Dieppe. Ethel Sands sent her car to Dieppe to meet them on their return journey. They dined with her and Nan Hudson at the Château d'Auppegard, although they spent the night in Dieppe. On Monday, October 1, they returned home. Virginia wrote Harold their week had been perfect, that Vita had been angelic to her, "perpetually sweet tempered, endlessly entertaining," and had shown "the most generous and magnanimous nature." She generously wished that Vita could be less modest about her work.[87]

Virginia's novel *Orlando: A Biography*, in large part a portrait of Vita, was published

later that month and was an immediate success. Vita, who had not read it before, was enchanted, finding that Virginia had "invented a new form of Narcissism," since, as Orlando, she had fallen in love with herself. She found it overwhelming that Virginia could have hung "so splendid a garment on so poor a peg."[88]

Four days after their return, Vita wrote Virginia from Long Barn that "Burgundy seems a dream. 'Before, a joy proposed; behind, a dream.'"[89] She had read Walter Pater on Vézelay in his *Studies in the History of the Renaissance* of 1873, and discovered that they had never seen the narthex there that was supposed to be one of the chief glories of France (the twelfth-century Romanesque narthex in the Basilique Ste-Madeleine). However, she felt as though she had seen enough "to make up for a dozen narthexes" and had come home a "changed being … vigorous and sturdy again, and ravenous for life once more." Virginia replied from Tavistock Square that Vita had soothed her own anguish, as if she had become a little ball "bubbling up and down on the spray of a fountain: the fountain is you; the ball me. It is a sensation I get only from you. It is physically stimulating, restful at the same time…."[90]

Virginia did not travel with Vita again or go abroad without Leonard. Clearly, however, the stock of each woman went up in the eyes of the other. Vita's fluency in French and careful concern for her well-being added a new dimension to Virginia's image of her. Vita, conversely, had not fully realized that vulnerability and innocence were an important component of Virginia's psyche, juxtaposed against her brilliant and perceptive intellect. Virginia articulated certain feelings about masculinity and femininity that she had possibly withheld from Leonard and Vanessa. Their intimacy continued for several years after they went to France, and then "quietly evaporated," as Quentin Bell puts it, by early 1935.[91] Perhaps the most striking aspect of their holiday is the extent to which their respective husbands were present, in letters, conversation, and memory. France provided delightful yet neutral ground in which their passionate relationship could flourish—but it also illuminated the degree to which each was dependent on her spouse. Leonard had been reluctant for Virginia to go, although Harold, being himself away in Berlin, was more sanguine.

After their trip to France, Virginia apparently did not seek relationships with women other than Vita; she was content with Leonard, Vanessa, and less intimate friendships. In March 1935 she wrote in her diary, "My friendship with Vita is over. Not with a quarrel, not with a bang, but as a ripe fruit falls…. there is no bitterness, only a certain emptiness."[92] They continued, however, to see each other intermittently.

Vita, on the other hand, had had many woman lovers before she knew Virginia Woolf, and would have others in the future. One of her last relationships was with the Englishwoman Evelyn Irons, who lived in Chelsea with another Englishwoman, Olive Rinder. Theirs was a triangular relationship. When Evelyn left Olive for another woman, Vita

continued to support Olive for the remainder of her life, arranging for her to occupy a bungalow at Sissinghurst. In 1931 Vita and Evelyn walked the twelve miles from Tarascon to Les Baux-de-Provence, then went on to Arles and Nîmes; Vita wrote poetry during the journey. She disguised the location of her travels in her diary: "Egypt! Egypt! Egypt!" she wrote from Les Baux, and, in her letters from this trip, omitted the name of her traveling companion from her letters to Harold. In 1935, while writing her biography of Joan of Arc, Vita made two trips to France with Gwen St. Aubyn, one of the women to whom she became attached after Evelyn Irons. They explored the region where Joan of Arc had lived.[93] Evelyn Irons, author of an unpublished manuscript about Cassis, was a friend of the American painter and filmmaker Jerome Hill, who was heir to a railroad fortune; he was to establish the Camargo Foundation in Cassis, a residential program for visiting scholars. It was Hill who, after the death of Colonel Peter Teed, bought some of the furnishings of Fontcreuse and sold others in order to provide for Jean Campbell's remaining years.

Clive Bell and
Barbara Bage-
nal, with Rosetta,
at the Clos du
Peyronnet; pho-
tograph by
Frances Par-
tridge (1960).

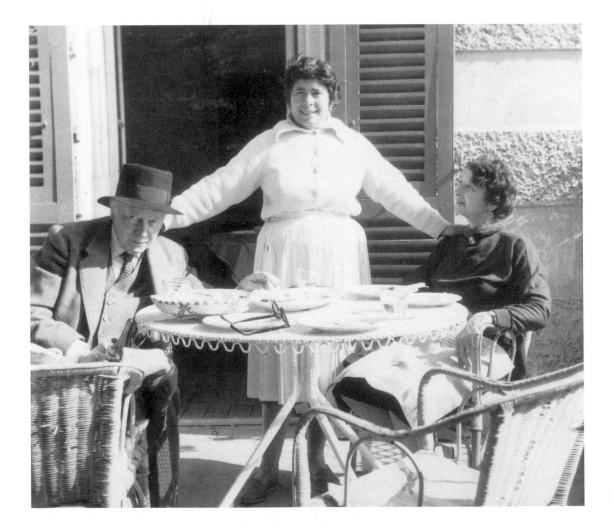

Clive Bell and His Circle

Above all races I know or ever heard of, the French love life.
—Clive Bell, *An Account of French Painting*

Clive Bell spent more time in France than any other member of the Bloomsbury group except Roger Fry. Although he remained "ineluctably English" and saw Frenchmen *couleur de rose* without understanding them, as Angelica Garnett puts it, he was an ardent admirer of French art and letters. When he was made a Chevalier of the French Légion d'Honneur, it was a just reward for his having spread the culture of contemporary France to England. David Garnett argues that he "provided an essential element in the formation of Bloomsbury" because his "hospitality and love of the good things of life" saved it from becoming "another Clapham Sect, devoted to aesthetics rather than evangelical religion."[1] His associations with France and French art were among the earliest and most enduring of any of the Bloomsbury figures.

When Clive first arrived at Trinity College, Cambridge, in 1899, it was with a large photographic reproduction of a painting by Edgar Degas. He was thus immediately at an advantage over his fellow students Lytton Strachey, who, as his son Quentin later put it, "might know all Racine by heart," and Saxon Sydney-Turner, who "read Pindar as you or I would read the morning paper." Neither, however, could have "told a Degas from a Renoir," as Clive's son Quentin later put it.[2] Lytton disliked Clive, calling him "that little canary-coloured creature," an opinion shared by Leonard Woolf. Although Clive was not elected to the elite secret society of the Apostles to which Woolf, Strachey, and Maynard Keynes belonged, he was convinced that he would become a man of letters and not the country gentleman for which his upbringing at Cleeve House, Seend, had fitted him.

He took his bachelor's degree at Trinity in 1902 and began work on a dissertation about British policy at the Congress of Verona, a subject requiring research in the Paris archives. He first went to Touraine to study French in January 1904, and arrived in Paris at the age of twenty-two, where he made many friends among artists. He later confessed that, once in Paris, he went daily to the Louvre and visited the archives infrequently. Nevertheless, he considered the year there highly profitable, and indeed his "second formative period" after Cambridge.

Bell's memoir *Old Friends*, published in 1956, gives a glimpse of the Paris he first knew. At first, he recounts, he lived in a pension in the Trocadéro quarter, where he began to acquire a smattering of French and saw Sarah Bernhardt in *La Sorcière* ("a shocking bad

play," he recalled). He came to know the Englishman Gerald Kelly, who had been at Trinity Hall, Cambridge, and to whom Clive had a letter of introduction. His studio was in a cluster of studios off the Boulevard Montparnasse on the rue Campagne-Première. A few years later many cubist painters would have a similar group of studios in the Bateau Lavoir. Although Kelly was later to serve as the president of the Royal Academy, Clive found he never fulfilled his promise. Other artist friends were J. W. Morrice from Canada and Roderick O'Conor from Ireland. Morrice was an impressionist artist who had been influenced by Manet, Monet, Whistler, and Matisse. He and Clive visited some disreputable places, such as the Olympia, where he might not have ventured alone.[3] When Morrice was alone, he would continue painting into the night in his studio at number 35 on the quai des Augustins and have a main dish and a bottle sent up from the restaurant Lapérouse. At other times, they might have a drink at the Café de Versailles. Clive kept up with Morrice and O'Conor for the next decade, until about 1914. After World War I, he tried unsuccessfully to find Morrice, who had gone to North Africa with Matisse about 1911, and returned there often. Clive later discovered that he had died in Tunis in 1924.

Roderick O'Conor, *Flowers* (1911).

Roderick O'Conor was an Irish Breton and had been included in the Pont-Aven art school of the Nabis. He had been close to Paul Gauguin in his days at the nearby town of Le Pouldu, and in spite of his brusqueness, he became Clive's closest friend. O'Conor seldom discussed art unless he could ridicule artists with "overblown reputations" such as Whistler or Sargent. He was "gruff and disobliging" about people and enjoyed making "grim jokes."[4] Clive believed that only one human being had ever impressed O'Conor; this was Virginia Woolf, who, O'Conor declared, "put the fear of God into me." He would mock Morrice's musical taste as deplorably romantic. "After a scolding from O'Conor, Morrice would say to me 'let us go tomorrow and hear some lenient music,' and off he would take me to hear *Traviata* at the Opéra Comique," Clive remarked. As a rule O'Conor remained in his quarter, grim and uncompromising.

Clive and his friends would have an aperitif or a coffee at the Versailles near home, or a Pernod at the Café de la Paix or the Concert Rouge, across from Foyot's, Lytton Strachey's favorite restaurant, on the right bank. They might also lunch on the left bank near the Luxembourg Gardens and saunter through them, as Lambert Strether does in Henry James's *The Ambassadors* (1903). Later Clive and his companions might take a horse-drawn omnibus, an Impérial, from the Left Bank on an hour's drive across Paris, up to the artists' quarter, Montmartre. Here they would visit several studios and dine, surrounded by French chatter, or drop in on the music hall called La Cigale (The Cricket). Clive noticed how many English-speaking artists of the period, regardless of their ability to function in French, spoke English with each other. They might have French mistresses, but, traditionally, took little part in the intellectual life of the city.

Clive moved from his pension to the Hôtel de la Haute-Loire, at the angle of the Boulevard Montparnasse and the Boulevard Raspail. It was near the Café de Versailles, and separated from the restaurant Lavenue and its smaller companion, the Petit Lavenue, only by the rue d'Odessa. Le Chat Blanc was on this street; this was an eating place then frequented by such famous figures as Auguste Rodin, whom Clive found both "pompous" and "generally unwashed." Farther along the Boulevard was the celebrated Closerie des Lilas, a café patronized by the group associated with *Vers et prose*, a symbolist journal edited by Paul Fort. André Gide, the neo-symbolist Jean Moréas, and other symbolists met there on Tuesday evenings. These evenings were a continuation of Stéphane Mallarmé's famous "Mardis," or Tuesdays, the day when the poet would be at home and hold forth leaning on a marble mantelpiece.[5]

Gradually, as his French improved, Clive acquired a number of Parisian friends. They included Jacques Copeau and Jean Cocteau, both men of the theater, and Charles Vildrac, a Parisian poet, dramatist, and gallery owner whose house in St.-Tropez the Bell family and Duncan Grant were to rent in 1921, a few years before they began going to Cassis.

In 1907 Clive and Vanessa Stephen were married, enjoying a strong mutual interest in art, artists, and France. In April of that year, Virginia and Adrian Stephen were in Paris with the Bells. Virginia wrote Madge Vaughan that they were about to meet Vanessa and Clive in Montmartre for dinner, and that the Bells talked "a great deal about beauty and Art."[6] While living in England, the Bells purchased French art and entertained French painters and writers. They came to know Henri Matisse and Charles Vildrac about 1912, and, later, André Dunoyer de Segonzac ("one of the most charming men alive") and André Derain with his "extraordinarily happy disposition." Segonzac was particularly fond of Vanessa (he called her "la grande Vanessa"); they would sometimes dance and continue on to small traveling fairs. On Saturdays, Jean Cocteau might invite Erik Satie and the composer Francis Poulenc to dinner or to the club Le Boeuf sur le Toit. At other times the group would dine in a small restaurant near the wine market, talking for hours

Letter from
Henri Matisse to
Clive Bell (Nice,
March 2, 1936).

Nice 2 Mars 1936

Cher Monsieur Clive Bell,

Merci chez nos bons amis Bussy,
où j'ai eu le plaisir de ren-
contrer votre charmante jeune
fille; j'ai pris connaissance de
votre article par une bonne
et claire traduction — Je
tiens à vous dire combien je
suis touché d'avoir été si bien
compris de vous; et d'autant
que l'apparence de mes derniers
dessins exposés à Leicester galleries,
prête peu à ce qu'on y voit leur
"substantifique moëlle".

and occasionally bursting into song. In October 1911, Vanessa and Clive purchased
Pablo Picasso's painting _Cruche, bol et citron_ (_Pitcher, Bowl and Lemon_). The same year,
Roger gave Clive letters of introduction to Gertrude Stein and the Byzantinist Matthew
Stewart Prichard, a friend of Matisse. Clive and Vanessa eventually grew apart, each
going on to have other relationships, but they never divorced.

[Handwritten letter in French from Henri Matisse]

J'ai toujours essayé de cacher mes pénibles efforts, pour que le ~~spectateur~~ spectateur touché par l'apparente facilité de mon travail, puisse goûter avec aisance le meilleur de la vie que je désire exprimer dans mes œuvres. Je pense cette fois avoir modestement mais ~~extrêmement~~ clairement commencé ma réussite.

Cher Monsieur Clive Bell, vous l'avez compris, vous l'avez très bien dit, et vous en suis profondément reconnaissant

Votre dévoué

Henri-Matisse

NB. ne viendrez-vous pas par ici?

Clive was vigorously opposed to World War I, spending the war years in England. He viewed the war as "the end of civilization" and wrote a pamphlet called *Peace at Once*. Edel regards this as an act of courage, since it "went against the grain of a nation already plunged into mourning for lost husbands and sons." The pamphlet was ordered burned by the Lord Mayor of London.[7]

ABOVE. André
Derain, *Head of a
Woman*
(c. 1922).

RIGHT. Henri
Matisse, *Portrait
of André Derain*
(1905).

By 1919, after the Armistice, Clive was enjoying himself enormously in Paris, seeing a good deal of Picasso, Derain, the Vildracs, and Gide. What mattered most to him was the company of other cultivated people. Frances Partridge puts it succinctly: "The two things Clive cared about were art and friends."[8] In *Old Friends* Clive remarks that after the horror of the war years "civilized people in England would once again be allowed to lead appropriate lives," regaining "contact with civilized people in other countries."[9]

In the summer of 1919 continental civilization did cross over to England with the arrival of Sergei Diaghilev's Ballets Russes to perform *La Boutique fantasque* and *Le Tricorne.* They were accompanied by Léonide Massine, Igor Stravinsky, Ernest Ansermet, and the two painters to whom Clive was the closest, Derain and Picasso. Derain was staying at Vanessa's empty flat in Gordon Square and Picasso was at the Savoy Hotel with his wife, Olga Kokhlova. Clive had called upon Roger Fry to bring out the artistic and literary luminaries of London to welcome the visitors from France, and Roger obliged. He entertained them at his home, but nothing equaled the famous dinner party Clive, Maynard Keynes, and Duncan Grant, at 46 Gordon Square, to which the invitation read:

André Derain, *Portrait of Henri Matisse* (1905).

Madame Picasso
Savoy Hotel
Mr. Keynes and Mr. Clive Bell
At Home
Tuesday July 29, at 10 p.m.
RSVP

It was one of the most celebrated banquets in the legend of the avant-garde. Diaghilev's company of dancers, musicians, and artists, together with many of the younger painters and students and writers of Upper Bohemia, gathered at 46 Gordon Square, about forty in all. As Clive recalled it, "Maynard, Duncan Grant, our two maids and I waited on them…. We rigged up a couple of long tables: at the end of one we put

Ansermet, at the end of the other Lytton Strachey, so that their beards might wag in unison."[10]

It was in 1919 that Clive met André Gide through Jacques Copeau, as he recalls in *Old Friends*. Clive then invited Gide to lunch at the Voltaire in the Place de l'Odeon, and Gide brought with him a young student Clive calls "Henri." He had been reading one of Clive's books and asked to discuss it with him further. Clive invited "Henri" to lunch, but on the day fixed, Gide appeared at Clive's hotel for a morning visit. Clive invited Gide to join them for lunch, which he did, but the conversation was strained. Apparently, Gide harbored a suspicion that Clive's prior luncheon engagement implied that he had designs on the young man, which was far from the case. It took many years and the intervention of friends before the relationship between Gide and Clive was repaired.[11]

Clive was a close friend of Picasso, whom he often visited on the rue La Boétie in Paris. On February 25, 1920, Picasso wrote him from the rue La Boétie:

> Dear Bell,
>
> I introduce to you my friend the painter Canals and ask you to guide him around a little in the painting world of London. When are you coming back to Paris? we are waiting for you.
>
> My wife and I send you our best wishes,
>
> Picasso[12]

In *Old Friends* Clive is careful, however, not to put him in the category of those with whom he "lived on terms of perfect familiarity," such as Lytton Strachey, Roger Fry, Maynard Keynes, and Virginia Woolf. He considered Picasso an "intimate" friend rather than an old one. He was an "emiment" contemporary, of whom he could only offer "random recollections."[13] He observes in his memoir that even in 1912 his paintings would have been too expensive for art lovers of "moderate means."[14] Clive's letters to Picasso reflect his diffidence and respect. Always careful not to presume on his friendship, he would write to inquire what times would be the best for him to call. He would sometimes send a letter or, at other times, a picture postcard; he once sent him one signed by Mary Hutchinson, Maynard Keynes, Duncan Grant, and Vanessa.[15] At other times he might dispatch "un petit bleu," missives sent in pneumatic tubes that arrived almost instantly at their destination. These were familiar to inhabitants of an earlier Paris. Invited to dinner at the home of Picasso, Clive remembered his host's having worn evening dress at the Savoy Hotel in London and responded that he had not brought proper evening clothes with him but hoped Picasso would be dressing informally.

23 R. La Boétie PARIS

8010.2.408

25 Février 1920

DCB 5

cher Bell

Je vous presente
mon ami Canals peintre
et vous prie de le
piloter un peu dans
les milieux peinture
à Londres.

Quand revenez vous
à Paris ? on vous
attend.
Avec ma femme
nous vous envoyons
les très bons souvenirs
Picasso

Letter from Pablo Picasso to Clive Bell (February 25, 1920).

When Clive was in Paris, he would stay at the Hôtel de Londres, 3 rue Bonaparte, or, if the Londres was full, at the Hôtel Voltaire on the quai Voltaire. He would invite Picasso and his wife to lunch at 1:00 at La Régence or the Café Weber, or dinner at 8:00 or 8:15, at Lapérouse, La Crémaillère on the Place Beauvais, or Le Boeuf sur le Toit. The latter was a favorite of Jean Cocteau, whom they would meet there. Clive liked keeping his friends in contact with each other, which must have been one of the things Picasso most appreciated about him. Their friendship was particularly close in the 1920s. Clive would often be accompanied by Mary Hutchinson, wife of the barrister St. John Hutchinson; he had begun an affair with Mary in 1915 that would continue for about twelve years. He once wrote Picasso that Mary might be willing to pose for him as a model. Clive promoted the Spanish painter's friendship with Vanessa and Duncan. After Picasso designed the sets for the ballet *Parade*, he read him the letter Vanessa and Duncan had written him about it, "a wonderful description of the wild success of the *première* of the ballet *Parade*." They were not, he told Picasso, prey to an easy enthusiasm, so it should count all the more. One September he sent Picasso a postcard signed by himself, Mary Hutchinson, Duncan, and Vanessa, showing a congenial group of four people in a rowboat with the caption: "We're a happy crew!"

On June 18, 1920, after Clive had returned to England from Paris without calling on Picasso to say goodbye, bears abundant witness to his determination not to impose on Picasso's time:

My Dear Picasso,

Several friends have given me the impression that you were somewhat surprised, not to say annoyed, that I didn't come to tell you goodbye—especially after that marvelous letter you were good enough to write. You know, Picasso, that seeing you is a real joy for me. Speaking in all sincerity, I would gladly make the trip from London to Paris in order to spend a few hours with you. But I know how besieged you are by tiresome people, and I would hate to be one of them.

And then, perhaps this is something you don't think about—it is a tricky thing to go bother Picasso in the morning, or the afternoon, when he might be working. Because I believe you to be a great—a very great—artist ... well ... to visit a great artist in the daytime really means my supposing that an hour of my chitchat is worth an hour of his work. You just cannot imagine how this intimidates me. Just the idea is enough to stop me.

With Derain, for instance, it is very simple: if he comes to the café to have an apéritif, it is because it is a good time for him, and that he wants company. But to climb up to see someone who is perhaps doing something important, you have to admit how serious that is. More than once, I have arrived at the bottom of your

André Derain
and his Bugatti
at his house in
Chailly-en-Bière
(c. 1925–1926).

stairs and then been suddenly overcome by that idea. I would become aware of the impertinent exchange I was about to set up: one hour of my company for one hour of your work. Take it at its very lowest denominator, and in practical terms: five hundred francs…. That is paying rather dearly for the pleasure of my conversation! You should have a special hour and day to receive guests, like a lovely lady, and I could come then. Or then tell me frankly just the time when I wouldn't be intruding.

He signed the letter, "Ever yours affectionately."[16]

On December 20, 1920, Clive sent Picasso a note about the preface he was about to write for the exhibition of his work at the Leicester Galleries. He was not sure exactly how many works the dealer Rosenberg was going to send, or which ones, or how large they were. But he wanted to ask Picasso to come to London for the opening if he could. A room would be waiting for him at Clive's home, whether or not Madame Picasso was well enough to come along. He noted that he often saw their mutual friend Rubenstein in London and added, "Naturally, from time to time we say bad things about you. What a charming man! now that is someone who likes you a lot, but still, not as much as I do."[17]

Picasso did write Clive from time to time. Their relationship was that of a world-renowned genius, protective of his time, and a friendly writer and critic. Occasionally Clive would put Picasso in contact with other critics and publishers, such as the editor of *The Dial,* who was to publish some reproductions of Picasso's work. Clive was sometimes able to do him favors in England, or even occasionally in France. Once, in the fall of 1923, Clive was chagrined at a request from Picasso that had followed him to France,

then back to England, in a horrendous storm. Clive deplored the delay, which had been caused by his visit to the Château d'Auppegard, near Dieppe, in order to visit Ethel Sands and Nan Hudson. He wrote that he would have loved to be of use, and hoped he might still be at some future time.[18] After 1923, contacts between Clive and Picasso were less frequent, but continued intermittently for the remainder of Clive's life.

Clive enjoyed an active social life in the Paris of the 1920s. His friend Derain and his beautiful wife, Alice, usually gathered around them at the Café Deux Magots a group called "la bande à Derain," including the Braques, the poet André Salmon and his wife, and Jean Oberlé. Occasionally there were also the artists Jean Marchand, Moïse Kisling, and Louis Marcoussis. Clive would often dine first in the rue Bonaparte with Stravinsky and Ansermet, the two musicians, and later join the artists Jacques Lipchitz, Fernand Léger, and Jules Pascin. He also enjoyed the company of the painters Maurice Vlaminck and Othon Friesz, who lived in the rue Notre-Dame-des-Champs; neither, according to Clive, fulfilled his initial promise. Clive knew the art dealer Leopold Zborowski, who sometimes frequented the Deux Magots; he thought him "cultivated and comely." Zborowski wrote poetry and often befriended poets and painters. One of their mutual friends was the poet and painter Max Jacob, who was associated with the Cubist movement and was a Jewish convert to Catholicism. Jacob would later appeal to Cocteau and

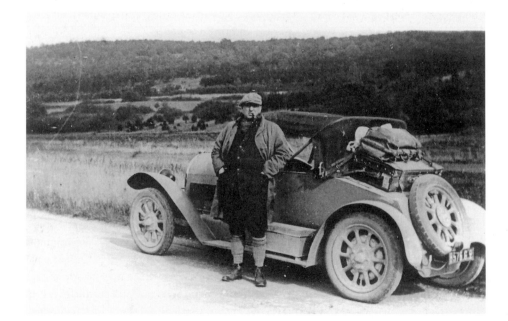

André Derain and his car "la Lorraine" in Provence (c. 1927).

Picasso in vain for their help during the Nazi occupation of France. He died from typhoid fever at the camp of Drancy just before deportation.[19]

Clive once met both James Joyce and Marcel Proust when he attended an evening celebrating the productions of Diaghilev. Joyce arrived well after midnight, while Proust arrived later still. Clive also knew the painter Raoul Dufy, the learned Georges Duthuit, and the dancer Isadora Duncan. The latter, somewhat intoxicated, played up to him after a Montmartre lunch, running one of his hands over her body and assuring him of her nonfemininity: "Je ne suis pas une femme, je suis un génie." ["I am not a woman, I am a genius."][20]

Many of the small Parisian hotels associated with the Bloomsbury group during these years are still in existence on the narrow streets just off the Boulevard St.-Germain. Clive usually stayed at the Hôtel de Londres on the rue Bonaparte, which Vanessa and Duncan also liked, while Roger Fry preferred the hotels on the rue des Saints-Pères such as the Pas de Calais and the Hôtel des Saints-Pères. Dora Carrington, Ralph Partridge, and Frances Marshall liked the Bon LaFontaine, also on the rue des Saints-Pères. After World War I Clive's favorite hotel was the Voltaire on the quai Voltaire. He liked Le Dôme café, on the Boulevard Raspail, which Duncan Grant patronized when studying art in Paris, and the café Le Fleurus, on the rue de Fleurus. This was the street where Gertrude Stein and Alice B. Toklas lived, surrounded by the collection of paintings both Clive and Duncan would come to know. Clive also became acquainted with the expensive restaurant Paillard, and, at the other end of the scale, L'ange Gabriel and the workingmen's restaurants in Les Halles, the famed market area, which were open all night.

Although Vanessa had begun living with Duncan Grant during World War I, and in 1918 had given birth to his daughter, Angelica, she and Clive were still on friendly terms and in close communication. In October 1921 Vanessa wrote him of her journey to St.-Tropez, accompanied by Julian, Quentin, and Angelica, along with Grace Germany, their Charleston housekeeper, and Nellie Brittain, Angelica's nurse. She and Duncan Grant were letting Rose and Charles Vildrac's villa there. In May 1922, when she was back in London, she wrote Maynard that Clive was trying to find a house in France for the summer holidays, but he did not find one at that time.[21]

Between the wars, Clive lived for long periods in France, particularly in the spring and the late autumn. In January and February of 1930, he stayed at Cannes in a flat belonging to Madge Garland, an editor and fashion writer, with Benita Jaegar, his companion of the early 1930s. His days were profitable. He would work on his current book in the morning winter light, with the sun coming in through the windows. After lunch he would write letters, then work on his book again from five to eight, before going out for dinner and evening dancing.[22]

Clive's affinity for France grew still greater when, in 1936, he was made a Chevalier of the French Légion d'Honneur. Roland de Margerie, first secretary at the French Embassy in London from 1933 to 1939, had been responsible for this honor. Julian Bell's friend Eddie Playfair (later, Sir Edward Playfair) wrote Julian that he had teased him about it:

> Clive looks ten years younger than when I first knew him; he was in very good form, stood us drinks, and talked away like fun, very full of his forthcoming trip to France and his legion d'honneur. I worked off, with some little success, a joke which I had rather prepared; I said, "congratulations, Clive; I hear you've been given the palmes." His face dropped for a minute when he thought that was the story that was going around.[23]

Clive would have viewed the "Palmes académiques" as a much lesser honor. It might be said that receiving the Légion d'Honneur almost made him an honorary Frenchman.

In February 1936 Clive wrote Picasso that he was coming to Paris with Raymond Mortimer and hoped to see him and his new paintings. If Picasso were free Friday or Saturday or Sunday, could he do what he never liked doing, and just drop Clive a word to the Hôtel Londres?

Clive came to know Matisse better at this time, when the painter was living in the Régence in Nice, near Simon and Dorothy Bussy, who brought them together. He had admired Matisse's work since first seeing it, and had early realized its importance. The Bussys' daughter Janie translated Clive's work on Matisse into French. Janie came by her translating skills naturally: not only had she grown up as the bilingual daughter of a French father and an English mother, but Dorothy was a well-known translator, the author of the novel *Olivia*, and an expert on grammar. Matisse greatly appreciated Clive's work, and wrote him on March 2, 1936:

> Dear Mr. Clive Bell,
>
> Yesterday at the Bussys, my good friends, where I had the pleasure of meeting your charming daughter, I came across your article in a good and understandable translation. I want to tell you how greatly I am touched at having been so well understood by you, and all the more since the way my last drawings were exhibited in the Leicester Gallery was not conducive to anyone seeing in them their "real substance."
>
> I have always tried to hide my painful efforts, so that any viewer who might be moved by the apparent facility of my work can easily enjoy the best of the life that I want to express in my work. I think this time I have modestly but clearly begun to succeed.

Dear Mr. Clive Bell, you have understood it, you have said it very well, and I am deeply grateful to you for it.

Your devoted

Henri Matisse

N.B. Aren't you coming this way soon?[24]

Clive and Vanessa's son Julian was killed in the summer of 1937 while fighting as a volunteer in the Spanish Civil War. This was a devastating blow for both of them, but Clive carried on, dividing his time between London, Charleston, and France.

In 1947, while staying at the Hôtel Condé, Clive again tried to see Picasso, but this time before dinner, for an aperitif. Clive wrote Picasso from Menton, where he and his companion Barbara Bagenal were staying at the Hôtel Brittania. He explained that their mutual friend Graham Sutherland had told him Picasso was living in Cannes now. He hoped the Picassos could dine with them at La Provence in Antibes. It had been, Clive reminded him, a long time since he had just turned up at Picasso's pottery in Vallauris, but he would like very much to see him again.

Clive saw much of Picasso in later years in Antibes, when the painter was married to Jacqueline Roque. She would often telephone Clive to confirm lunch plans, since Picasso avoided letter writing. "I know you don't like to write letters—although you have written some admirable ones in oil paint," Clive once wrote the painter (letter undated).[25] Clive liked to describe the seemingly spontaneous way in which Picasso would order various objects on a table—a few crusts, some matches, one or two cigar bands, some cigarette ends—to form a still life. Clive was both connoisseur and critic, acutely tuned to the transformation of the casual into art.

In January of 1958, Clive again wrote Picasso from Menton. He observed that he was feeling old ("the sand is running out in the hourglass"), but would very much like to see him for lunch. Barbara Bagenal would drive him down. In December of the same year, Clive thanked Picasso for sending him some drawings, not yet seen by anyone but Duncan, and for having sent Barbara a drawing of Pompeii. Knowing that Picasso loved gossip, Clive told him of a lunch with Lydia Lopokova Keynes (widow of Maynard, who had died in 1946). She was adorned with a feathered hat, and "aging a bit, but aging well," except for a strange sore spot on her face: perhaps the effect of age, or just an excess of powder? "The only way to see would be to kiss her.... You can try it the next time you are in England."[26]

In the spring of 1959 Clive was about to leave for Roussillon and Menton with Barbara

RIGHT. Clive Bell at the Hôtel des Anglais, Menton; photograph by Barbara Bagenal (1960).

BELOW Clive Bell and Janie Bussy near Menton.

Bagenal. He would be going on to Aix for Easter, but wrote Picasso that he hoped to see him at Vauvenargues, where he had once been shown the garden by a hunter unsuccessfully seeking pigeons to shoot. The next year, in early December, he sent Picasso and Jacqueline some photographs he wasn't fond of, as he wrote Jacqueline, since he looked so "dominating" in them; they were also unflattering to her and Picasso.[27]

Among members of the Bloomsbury group Clive was second only to Roger Fry in his development of critical theories about art. His major works include *Art* (1914), *Since Cézanne* (1922), *Landmarks in Nineteenth-Century Literature* (1927; a title evidently referring back to Lytton Strachey's *Landmarks in French Painting*), and *An Account of French Painting* (1931). He saw France most clearly through its art, its literature, and its society.

Pablo Picasso (l.) and Clive Bell at Mougins; photograph by Barbara Bagenal (1959).

The Bloomsbury painters, Vanessa Bell, Duncan Grant, and Roger Fry, might lose themselves in technical details and in the light of specific places and projects, but Clive's attitude toward conversation and toward culture was to conflate French art and French national characteristics. The French temper, he observed, disliked extremes, and even the most reasonable French artists refused to lose contact with everyday things, choosing instead to keep their eyes upon the object, incorporating "that world of significance which hangs like autumn mist above the soil."[28] Such an approach appealed to Clive, hunter of fox and quail, man of the country and the table. He was, at the same time, an accomplished art critic whose works are incisive and well argued, and he managed to divide his life between France and England in a way highly satisfactory to him.

In *Since Cézanne*, Clive discusses certain theories about art prevailing in the early twentieth century, and gives an account of the leading painters of the contemporary movement, including Pierre Renoir, Pierre Bonnard, and Albert Marquet as well as Matisse, Picasso, Friesz, and Derain. In his chapter on Duncan Grant, whom he calls the "best Eng-

lish painter alive," he asserts that Piero della Francesca, Thomas Gainsborough, and the Elizabethan poets had been Duncan's first aesthetic ancestors, until he came under the influence of Cézanne, Matisse, and Picasso. He regrets that Duncan had not held a one-man show and had rarely sent pictures to exhibitions, giving the public little chance to know his work.[29] In *Landmarks in Nineteenth-Century Painting* Clive discusses Jean Géricault, Eugène Delacroix, Jean-Baptiste Corot, Honoré Daumier, Jean-Dominique Ingres, Edouard Manet, and Georges Seurat. He also presents a readable account of Impressionism in an easy manner that is recognizably different from that of Roger Fry. Reading both of them on any topic (for they wrote on many of the same artists) makes clear the substantial difference in style, viewpoint, and final evaluation of a work.

Bell's critical style is clearer than that of Fry, whose idea of significant form he explained and made popular.[30] Fry's criticism, on the other hand, is marked by direct intuitions and specific analyses of the details of those works of art he discusses. Yet Bell's studies of nineteenth-century art, and specifically of French art, are cogent reflections, if at first they appear to lack the profundity and brilliance of Fry's better-known works. For example, he traces the development of French art from the Italianate Avignon *Piétà*, in which

> each limb should take the direction it does…. But the man who painted that *Pieta*, though dead these five hundred years, still waits for us and imposes on unwilling moods his own…. Here is the greatest painting produced during the Middle Ages in what is now the land of France.[31]

He gives a sense of the *justesse* of the work, and of the sweep of the vision it embodies, without entering into more detail than the lay public, readers without specialized art training, could welcome. He is often amusing in his criticism, and many of his prejudices evoke a sympathetic response today: "We may think of Corot if we like, especially if it will save us from speaking of Jean François Millet."[32] The artist he most admired may have been Cézanne, the renowned painter of Aix (called "the holy man" by the Aixois). To Clive he was the most revered painter of what he called "that nineteenth century, which is the most splendid in the history of French painting, the strangest, and the most completely French." It was Cézanne who, along with Seurat, composed "one of those familiar points in history which are at once full stop and capital, the end of one sentence and the beginning of another."[33]

Both Clive and Roger, as critics, manifest a classicizing passion together with a kind of sobriety that is the distinct opposite of painters they did not esteem highly. For example, Clive, in particular, dislikes the Fontainebleau painters with their mannerist paintings of twisted bodies, or their many bath and toilet scenes. He is also firmly opposed to the "hard unfriendly supermen" from Italy such as Francesco Primaticcio and the mannerist

painter Rosso il Fiorentino. The prurience of Rosso's *The Deposition of Christ* annoys him, as do the anonymous bath scenes such as *Gabrielle d'Estrées et la Maréchale de Balagny* (Ecole de Fontainebleau) and the portrait of *Diane de Poitiers* at her dressing table by Jean Clouet. He imagines them provoking "titters and giggles." This is not to say that the sensual displeases him altogether. Even as he regrets the part that "le chic" plays in the works of François Boucher, he remarks that a room by this decorative artist may cause humans to be pleased withthemselves.[34]

His chapter on Jean-Baptiste Chardin is one of the most readable; in a fine phrase, Clive says he makes "the least of himself." Chardin was "astonished by what he saw. He was in love. Could the world really be so full of such wonderful things? Was the visible universe, the interior for instance of an exceptionally dark scullery, really thus packed with miracles of beauty? He must tell someone about it."[35] This is Clive's writing at its best, offering a straightforward and appreciative view as he shares his convictions.

Chardin was also important to Duncan, who would spend hours before his paintings. The influence of Chardin's domestic still lifes, with fruit and gleaming copper kitchen vessels, is clear in some of Duncan's own painting. They pay tribute to the joys of work

*The Avignon,
Piétà.*

Jean-Baptiste
Siméon
Chardin,
Still Life.

and domestic quiet and proper arrangement. Clive comments that Chardin depicts "such good peaches that they make the mouth water."[36] The adjective "good" is well-chosen, expressing both the sensual and the moral.

Clive Bell seems, in a sense, unlike the other principal figures in what we think of as Bloomsbury Central. He has been variously described by those who knew him as a country squire and good sportsman, liking to tramp through fields, and as an excellent conversationalist, able to bring out the best in others, a man fond of formal dinners and at ease in the world. He might, for example, move through an art exhibition as if he owned it, greeting others in loud jovial tones, as he did in cafés and restaurants. He reminds us, from this distance, of his own description of Clouet: "Like the good Frenchman he was, he loved the good things of life—wine, women, well-laid tables, gardens, rivers, and the sky …"[37] Yet Clive was also an astute critic, a graceful and sensitive writer, and, we may deduce, a loyal and witty friend. The Bloomsbury circle was clearly enriched by his long periods of residence in France and his enduring friendships with the artists and writers of his adopted country.

Gwendolen Rav-
erat, *John May-
nard Keynes*
(*Baron Keynes)*
(1908).

John Maynard Keynes

I have to admit that, brilliant as Lytton was, Maynard was the more brilliant.
—Sir Stephen Runciman

Of all the members of the Bloomsbury group, John Maynard Keynes was, in his youth, the least sympathetic to France. The son of a Cambridge economist and administrator, John Neville Keynes, Maynard grew up in a pro-German household, in part because Germany was considered by his father to be particularly relevant to philosophy and science. The atmosphere in the Keynes home was scholarly and intellectual. The Keynes children had German governesses. Maynard won a scholarship to Eton, where he achieved high academic honors. In 1901, while still at Eton, he attended the funeral of Queen Victoria and admired the "small band of picked Germans" more than the French representatives, who "chatted and strolled along as if they were smoking cigarettes on their native boulevards."[1] Later, he was less puritanical about France.

It was at Cambridge that Maynard came to know those who would later form the nucleus of the Bloomsbury group and with whom he would make numerous trips to France. In 1902, while still in his first year, he was introduced to the writings of G. E. Moore by Lytton Strachey and Leonard Woolf. At the time he was being considered as a candidate for the Apostles and was elected in February 1903, an unusual honor for a first-year man. This elite secret society, with members throughout the university, had existed from before Tennyson's day and played an important role in forming and preserving friendships.[2] At the time Maynard was elected, members included E. M. Forster and Saxon Sydney-Turner, but not Thoby Stephen or Clive Bell. Roger Fry had also been a member. They met Saturday evenings after dinner in rooms either in Trinity or King's College. A member, known as the "moderator," would read an essay from the "hearthrug" (an actual rug was not necessary). In an order determined by lot, the other Apostles then moved to the hearthrug and spoke. Keynes spoke to the Memoir Club in 1938 of his days as an Apostle in 1903, when he was much under the influence of George Moore's recently published *Principia Ethica*:

> ... it was exciting, exhilarating, the beginning of a renaissance, the opening of a new heaven on a new earth, we were the forerunners of a new dispensation, we were not afraid of anything.... one's prime objects in life were love, the creation and enjoyment of aesthetic experience and the pursuit of knowledge."[3]

The Apostles had a tradition of what has been called the "higher sodomy," a form of platonic homosexuality.[4] Maynard's homosexual inclinations were reinforced by his relationships as a member of the Apostles. For some time he was a rival of Lytton's for the affections of Arthur Hobhouse, and, later, for those of his cousin Duncan Grant (successfully by 1908). After graduating from Cambridge, Keynes sat for the Civil Service examinations and obtained a post in the India office, his second choice after the Treasury.

In March 1907 Maynard, accompanied by James Strachey and Harry Norton, spent a long weekend in Paris with Duncan Grant, who had been studying art there for over a year. Both he and Lytton Strachey had been in love with Grant for some time. Maynard might have been particularly attracted to Duncan as an artist, one who, it has been said, had "an inner integrity" but "an outward need for protection."[5] Duncan assured Lytton that the visit had been only a qualified success, writing from Atelier 459 on the rue Campagne Première, "Keynes and Norton's visit charming (but I was feeling sick with the world, sordid and mean)." In July 1907 Maynard went mountaineering with his father, his brother Geoffrey, and his close friend C. R. Fay in the Pyrenees. He and Fay went on to Biarritz; he confided to Lytton that he had lost the "most appalling sums" at the gambling table.[6] In 1908 he resigned from the India Office and accepted a lectureship in economics at Cambridge, where he began his dissertation, published in 1921 as *A Treatise on Probability*.

Maynard's friendship with Duncan Grant, meanwhile, grew more intimate, and he eventually replaced Lytton as Grant's closest friend, an attachment that was to last the remainder of their lives and form one of the central relationships within the Bloomsbury group. In August 1908 he and Grant vacationed on the island of Hoy, in the Orkneys, where, warmed by peat fires, they read Jane Austen's *Northanger Abbey* aloud. Duncan painted a portrait of Maynard, and Maynard worked on his thesis. Duncan believed that Maynard first began to appreciate painting at this time. As he later recalled,

> Maynard with his writing board was a good subject, so while he was immersed in the "Theory of Probability" I … was immersed in trying to figure out the shape of his face. The result of this I think was that Maynard gradually accepted the fact that painting had its difficulties too, a fact he accepted, without me having to point it out, that the painter had a serious job on hand.[7]

Lytton Strachey continued to be jealous of Maynard's affair with Duncan, and mounted a campaign against him, calling him "Pozzo di Borgo" to their mutual friends and writing spitefully of him as a "malignant goblin" to Leonard Woolf, then serving the British government in Ceylon. It is possible that the later antipathy of the Woolfs and

certain other Bloomsbury figures toward Keynes had its roots in Lytton's attack. In March 1909 Keynes was elected a Fellow of King's College, Cambridge; he kept his rooms there for the remainder of his life, although he always retained a flat in London. Lytton managed to congratulate him on the honor, apologizing for his attitude and asking him always to think of him as his friend.[8] Many of Maynard's major trips abroad were made during the Easter Vacation for the ensuing years. During this holiday in 1909 he and Duncan spent two weeks at Versailles. That summer Maynard and his family again went climbing in the Pyrenees.

The year 1910 opened with one of the more notorious Bloomsbury escapades and closed with one of its most noted achievements. In February Virginia Woolf, Adrian Stephen, Duncan Grant, and others, led by Horace de Vere Cole, took part in the *Dreadnought* hoax, boarding the powerful battleship in disguise as Ethiopians, pretending to be Prince Makalen and his suite arriving in England to visit Eton College. The affair led to questions in Parliament and revealed the cavalier attitude of Bloomsbury toward "the state, the empire, and the navy."[9] Maynard did not take part in the prank, but worried about the consequences. "What a lunatic affair!" he wrote Duncan; "Are you going to jail for it?"[10] None of the participants was punished. Soon afterward Duncan told Maynard he was falling in love with Adrian Stephen, a confession Maynard did not take seriously. In March 1910 he and Duncan set off for Marseilles, where they embarked on the S. S. *Danube* for Greece and Asia Minor.

The autumn of 1910 brought the first Post-Impressionism exhibition in London, "Manet and the Post-Impressionists" (*see* "Painters in France 1910–1921: Duncan Grant, Vanessa Bell, Roger Fry"). There were twenty-one Cézannes, thirty-seven Gauguins, twenty van Goghs, and several paintings by Matisse and Picasso. The British public was appalled at the contorted shapes and shrill colors; one critic dismissed the show as "the output of a lunatic asylum."[11] Keynes wrote Duncan on November 15 to ask what his final view of "the Frenchmen" was, adding, "they don't find much favour here—even Dickinson was rather outraged."[12] He was, nevertheless, delighted by the vitalism and aesthetic innovation of the exhibition. Despite the furor it caused, Keynes began to invest in works by the painters represented; he would eventually become the first private owner of a Cézanne in Britain. Duncan encouraged his collecting, frequently sending him telegrams from France about paintings by Cézanne, Seurat, Segonzac, Matisse, Derain, and Braque that were coming up for sale at auctions.

In March 1911, a Post-Impressionist ball was held in London. Vanessa and Clive Bell and Virginia Stephen attended (Vanessa and Virginia were attired as savages Gauguin might have painted), along with Adrian Stephen, Roger Fry, and Duncan Grant. In June 1911 Sergei Diaghilev first brought his ballet troupe, the Ballets Russes, to London. London audiences, including Keynes and other members of Bloomsbury, found Nijin-

sky's performance particularly electrifying.[13] It was at this time that Leonard Woolf returned from Ceylon, where he had served the colonial government since 1904. He wrote, in *Beginning Again,* of the prevailing sense of optimism in the country at large, particularly evident in the arts: "In painting we were in the middle of the revolution of Cézanne, Matisse, and Picasso ... night after night we flocked to Covent Garden, entranced by ... the Russian ballet in the greatest days of Diaghilev and Nijinsky."[14]

In 1911 Keynes became editor of the influential *Economic Journal,* a position he retained for thirty-three years.[15] The same year he took rooms at 38 Brunswick Square, a house in which he had as fellow tenants Adrian and Virginia Stephen, Duncan Grant, and Leonard Woolf. (In August 1912 Leonard and Virginia would marry.) Maynard and Duncan went to Tunis, Sicily, and Florence during the Easter Vacation of 1911, although their affair was coming to a close, finally ending in 1912.[16] Maynard had a holiday on the French during the Easter holiday of 1912 with Gerald Shove, an economist who was also a fellow of King's. In late December 1912 he and Duncan went to stay at La Souco, the home of Dorothy and Simon Bussy, at Roquebrune. They were to return to England in early January, but Maynard became ill with diphtheria and was taken to a nursing home in Menton. Mrs. Keynes came down to be with him. His illness was misdiagnosed at first, but eventually he was given the proper antitoxin and recovered.

Keynes came into prominence on a national level during World War I through his fiscal negotiations on behalf of Britain. He hated the violence of the war, although he was not a conscientious objector, as were Lytton, Duncan, and David Garnett, but continued his work at the Treasury. He wrote Lytton from Cambridge in November 1914 that he was devastated by seeing the youths going to war, and in April 1915, after learning of Rupert Brooke's death, he wrote Duncan that the war was "too horrible, a nightmare to be stopt anyhow. May no other generation live under the cloud we live under ..."[17]

In December 1915 Keynes traveled to Versailles to visit his brother Geoffrey, who was on medical duty at a hospital there. On his return he was installed at the Treasury as a regular staff member. In this capacity, he was sent to Nice in June 1915 to negotiate financial matters with the Italian government. He became a leading authority on both external and internal finance, and was soon an indispensable member of his department. In the past, when Britain had made loans to the Allies, no accounting had been kept of their dispersal, but, during the war, Keynes made sure that expenditure of the loans Britain made to France were itemized and controlled. It has been said that he contributed more than any other person in civil life to the winning of the war.[18]

In September 1916 Maynard moved to a flat at 46 Gordon Square, a house in which Vanessa and Clive Bell kept four rooms for visits to London. Harry Norton became a co-tenant in March 1917. For the rest of his life Maynard would, when in London, live in

this hearth of Bloomsbury.[19] At the same time, Virginia Woolf discovered Charleston, a farmhouse near Firle, Sussex, on the estate of Lord Gage, that would be available in September. Vanessa quickly went down and sublet it; she arranged for Duncan and David ("Bunny") Garnett to work there as laborers, since conscientious objectors could not be self-employed. Maynard arrived for the weekend at the end of October and was delighted with "Duncan's new country house." As a result of the Bells' occupation of Charleston, the management of the house at 46 Gordon Square and the Bloomsbury group's London life was largely left in Maynard's hands. He delighted in coming to Charleston for weekends.

It was in March 1918 that Maynard learned from Duncan that there was to be an auction in Paris of paintings from Degas's studio. He recognized a rare opportunity for the National Gallery to acquire valuable French paintings and for France to obtain the British sterling they badly needed. As he was already scheduled to attend a financial conference in Paris at the time of the auction, he persuaded the government to allocate £20,000 for the purchase of art. He attended the auction with Charles J. Holmes, director of the National Gallery, who came in disguise lest his bidding be too overt. Germany was shelling Paris that very day with "Big Bertha," a powerful gun used by the Germans in World War I that had a range of ninety miles for a 240-pound shell. As a result the noise level was quite high and bids were low. Among the works Keynes and Holmes acquired for the Gallery were a Corot, a Gauguin, four paintings by Ingres, two by Delacroix, two Manets, a Rousseau, and several drawings; unfortunately Holmes would not consider purchasing a Cézanne. Maynard did purchase a Cézanne for himself, as well as an Ingres drawing and Delacroix painting. In addition, he bought a Delacroix drawing for Duncan. He telegraphed the results of the auction to Vanessa Bell at Charleston, who replied, "We are fearfully excited by your telegram and are longing to know more.... Duncan says be as professional as possible in the buying and get at the right people—otherwise some German or Scandinavian will trick you.... We have great hopes of you and consider that your existence at the Treasury is at last justified."

After Maynard returned to London with the paintings and several other bundles, Austen Chamberlain, Chancellor of the Exchequer, gave him a lift down the main road, about a mile from Charleston. Maynard, fatigued with his luggage, deposited a suitcase containing the Cézanne and other paintings in the hedge at the bottom of the lane and, when he entered the house, told Duncan and Bunny Garnett. They were stunned and rushed down to fetch them.[20]

The Cézanne was a small still life with seven apples, simply called *Pommes*. Vanessa wrote Roger Fry that the "Cézanne is really amazing and it's most exciting to have in the house." At the time there were no Cézannes in private English collections.[21] Fry was eager to make a copy, and so wanted the painting to be kept as long as possible. It was

transported to 46 Gordon Square, where Virginia Woolf saw it a few days later. In her diary she pondered, in a rather metaphysical way, the attributes of the apples, and related the artists' reactions to the painting:

> Theres [*sic*] their relationship to each other, and their colour, and their solidity. To Roger and Nessa, moreover, it was a far more intricate question than this. It was a question of pure paint or mixed; if pure which colour: emerald or veridian [*sic*]; and then the laying on of the paint; and the time he'd spent, and how he'd altered it, and why, and when he'd painted it—We carried it into the next room, and Lord! how it showed up the pictures there, as if you put a real stone among sham ones; the canvas of the others seemed scraped with a thin layer of rather cheap paint. The apples got redder and rounder and greener.[22]

Paul Cézanne, *Still Life with Apples.*

The Cézanne painting, now in the Fitzwilliam Museum, Cambridge, was the cornerstone of a large collection of valuable works by French artists that Keynes assembled over

the ensuing years. These included *Study for "La Grande Jatte"* by Georges Seurat, a still life by André Derain, a landscape by Othon Friesz, and a number of other paintings and drawings. His nephew Milo Keynes recalled, a half-century later, his early visits to Tilton, the farmhouse in Sussex where Keynes lived with his wife, and seeing a Degas drawing in the lavatory. In addition, he purchased Duncan Grant's *Paper Flowers* and Vanessa Bell's *Gulf of St.-Tropez*; the latter was from her first show in 1922. Vanessa advised him to buy a painting by Walter Sickert, *The Bar-parlour*, which would be the first of several he eventually owned.[23]

During this period Maynard was gradually becoming less attracted to men and more interested in the opposite sex. Although he had close friendships with several Cambridge men, including Sebastian Sprott, during the early 1920s, he also had a flirtation with Barbara Hiles which continued after she married Nicholas Bagenal. He was also interested in his secretary, Naomi Bentwich.[24]

In January 1919, the Paris Peace Conference at Versailles opened. Keynes was one of the principal representatives from England, and had spent two months preparing a paper on the problem of a German indemnity for the war. The protracted negotiations left him completely disillusioned. He believed Woodrow Wilson was "a fraud" and that the treaty would lead to Europe's complete devastation. He did take time to spend a weekend in Fontainebleau Forest and to attend a Matisse exhibition, writing Duncan that he liked the "latest least" and felt him becoming "almost academic." He added that he was sending two reproductions of Bonnard "to prove that he is not the least like you."[25]

Keynes also went to stay at La Souco with Dorothy and Simon Bussy. A measure of his frustration with the conference is indicated by a letter from Dorothy to her sister-in-law, Ray Costelloe Strachey, written February 21, 1919:

> Keynes fled from Peace conference to spend a week's convalescence by our shores & in our house. We found him a very nice inmate and my thirst for B [Bloomsbury] gossip was refreshingly ministered to by the fountain head so to speak… Conference quite as black as one imagined it must be. M. Clemenceau a sinister figure in grey gloves. Mr Balfour whose only interest appeared to be in Tiepolo. Pres. Wilson oleaginous and uncultured, and the peoples of all careering madly to a bottomless pit of bankruptcy, famine, & Bolshevism. She reported that Maynard had been gambling heavily at Monte Carlo with no luck.[26]

In the last stages of preparation of the Draft Treaty, which Keynes believed to be both unjust and "inexpedient" to the Germans, he moved from the Majestic Hotel to a small flat that had been loaned to him on the edge of the Bois where he was looked after by a cook and a "soldier servant." He had become ill, he wrote Beatrice Webb in March 1918, "partly out of misery for all that's happening, and partly from prolonged overwork."[27]

The Treaty of Versailles, which Keynes deplored, was signed June 28, 1919. By this time he had resigned from the Paris Peace Conference, in a very depressed and nervous state, and had returned to England. On June 25 he began writing a book about his experiences at Charleston, *The Economic Consequences of the Peace*, considered a polemical masterpiece, which denounced the reparations agreed upon at the conference as entirely unrealistic. He spent the summer at Charleston, bringing along his two servants from Gordon Square. He worked on his book every morning, gardened after lunch until teatime, and dealt with correspondence after tea.

Keynes continued to divide his life between Cambridge, London, and Charleston during the ensuing year. During the Easter Vacation of 1921 he went to Rome with Duncan and Vanessa; they occupied themselves painting while he spent his time seeing various diplomatic acquaintances, going on to see the Berensons at the Villa i Tatti, their estate near Florence. On his return to London, he continued to attend parties and to meet his old Bloomsbury friends. His rooms at 46 Gordon Square were adorned with French impressionist paintings.[28]

Keynes spent most of his time at Cambridge, however, where he was a sensitive and well-liked don. Duncan Grant and Vanessa Bell decorated his rooms at King's with eight large panels, four each, of male and female figures. They represented the Cambridge triposes, the females draped and males undraped, but it is somewhat unclear which arts and sciences are assigned to which figures. The panels were completed at Charleston and installed in 1922.[29]

In September 1918 an event had occurred that was to have extreme significance in Keynes's personal life. Sergei Diaghilev brought his ballet company, impoverished by the war, back to London for an engagement at the London Coliseum. The Russian ballerina Lydia Lopokova was one of the stars, appearing on September 16 in *Prince Igor* and *La Princesse enchantée*. Keynes saw her performance and was impressed enough to write Duncan Grant about it. On October 10 he met her at a party for the corps given by the Osbert Sitwells in their home on Carlyle Square. At the time Lydia was unhappily married to Randolfo Barocchi, Diaghilev's business manager, whom she left the next year. In June 1919 Lydia and Léonide Massine starred in *La Boutique fantasque*, a London production in which they were sketched by Pablo Picasso.[30] She resigned from Diaghilev's ballet company in July 1919. Little is known about her disappearance from view from 1919 to 1921.

In May 1921 she rejoined Diaghilev, whose company returned to London to open a season at the Prince's Theatre, staging *The Sleeping Princess* with Lydia as the Princess. Keynes became increasingly interested in her, and invited her to take a flat at 41 Gordon Square. His serious courtship began about 1922, when he was thirty-nine and Lydia thirty. He was at Cambridge much of the week, but returned each week to his flat at 46 Gordon Square.

Lydia, although performing regularly in London, not only wrote him frequently but studied his writings on economics and his *Tract on Monetary Reform*. Gradually she came to be familiar to his Bloomsbury friends, who at first found her modest, charming, and witty. Later, however, they regarded her good humor and simplicity as a defect. Many in the Bloomsbury circle, including Virginia Woolf, were at times hostile toward her and jealous of Maynard's relationship with her, but she never criticized any of the group. Warmhearted and artistic, yet discreet, it has been said that she "outwitted Bloomsbury in their attempts to dissuade Maynard from his love." They were "outclassed as performers" by her occasional lively pranks, according to Keynes's niece and nephew.[31] A more serious difficulty, however, was what one of Keynes's biographers has described as her inability to contribute to the "delightful dissection, gentle mockery being piled on top of mockery … the *reductio ad absurdum* achieved with great merriment." Lydia, instead, pursued the thread of her own thinking, and spoiled their collective "flow of reason." Not responding to their accustomed irony, she proved to have an entirely different attitude, not consonant with theirs. As a result, Bloomsbury evolved from the background of Keynes's life into a "delightful recreation." Yet, on balance, Lydia, with her cheerful and optimistic nature, was an ideal antidote for his earlier cynicism.[32]

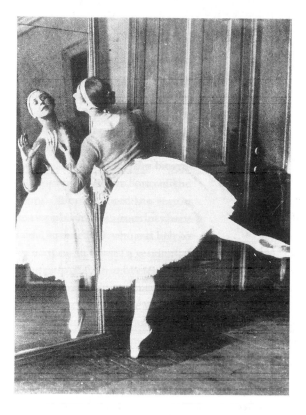

Lydia Lopokova practicing, probably at 46 Gordon Square, London (1925).

By December 1923 Maynard had no doubt that he wanted to marry Lydia; they had by then attempted to clarify the problem of her divorce. On Christmas Day they went to France for several days. Lydia and the dancer/choreographer Léonide Massine were discussing her appearance in Paris in the spring at the music hall La Cigale (The Cricket), which he was organizing under the patronage of the Count and Countess Etienne de Beaumont. (La Cigale had been a favorite haunt of Clive Bell.) In April she went to Paris to perform in *Les Soirées de Paris*. Maynard made a two-day visit to see her in late May. In June he sent her a poem in French from Cambridge:

J'ai calculé mon âge [*sic*],
J'ai presque trente ans

Ne suis-je pas dans l'âge
D'y avoir un amant?[33]

She wrote to ask what his "poème" meant; was he advising her to become "naughty" in Paris? The letters exchanged at this time contain many references to physical affection. Lydia was, at the time, waiting for her divorce case to be settled, but the hearing was postponed for several months. Lydia had many difficulties with Massine, however, and received Maynard's full sympathy. On June 21 he returned to Paris after exchanging almost daily letters with Lydia. She wrote him that she did not have to perform on the Saturday he would be there, but that *Romeo and Juliet* was to be given: "would you not like to see it, if it is too long and boring we might come out of the theatre before death survives the lovers."[34]

In July they went together to Tilton, a farmhouse beneath Firle Beacon, near Charleston, which Maynard had arranged to rent for the summer.[35] Tilton was owned by Lord Gage (also owner of Charleston), and they were able to continue renting it from him for over half a century. When Keynes had to return to Cambridge briefly, Lydia signed one of her letters, "A miely kiss to you from my Tilton planet." Maynard responded, "I send pulsations to your planet."[36]

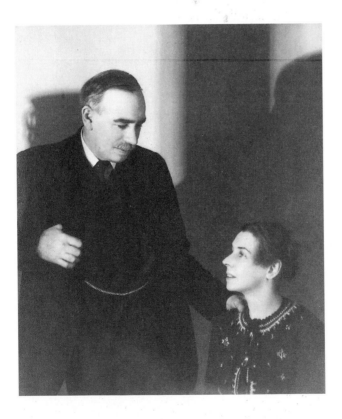

Lydia Lopokova and John Maynard Keynes (probably 1925).

Lydia's divorce, meanwhile, was stalled, and Diaghilev had not engaged her for the autumn season in London, although she did appear at the Coliseum in November. On December 24 she and Maynard dined with the Woolfs. Virginia wrote Jacques Raverat, "the poor sparrow is already turning into a discreet, silent, serious, motherly, respectable fowl, with eggs, feather, cluck cluck clucking all complete. A melancholy sight indeed, and I foresee the day when she dislikes any reference to dancing."[37] It turned out that there was an irregularity in Randolfo Barocchi's own divorce from Mary E. Hargreaves, and in 1925 the marriage between him and Lydia was annulled,

leaving her free to marry Maynard Keynes. Her nullity decree was made absolute on July 27; that afternoon they went to St. Pancras Registry Office to give notice that they would be married there on August 4. Duncan Grant and Vera Bowen were the witnesses.[38]

After their marriage, Lydia and Maynard divided their time between Tilton, London, and Cambridge; Lydia accompanied him on many of his professional travels. It was one of the most successful marriages within the Bloomsbury circle. The Keyneses led a balanced and productive life. Contrary to Virginia Woolf's prophecy, Lydia continued her dancing for a time, appearing with the Ballets Russes during the season of 1925 and 1926 (in July 1926 she danced in *La Boutique* on the last night). She realized she could not participate fully in the company, however, which would have required many absences from home. She was an excellent character actress and in July 1926 took the leading role in a private performance of Prosper Mérimée's *L'Amour africain*.[39]

Maynard continued to be an avid collector of books and works of art. In 1937 he acquired another Cézanne painting, *Sous-Bois*, along with two Delacroix drawings. During World War II he generously loaned his collection to the Council for the Encouragement of Music and the Arts (later the Arts Council of Great Britain) in order to raise the spirits of the British people.[40] He also contributed his time and his organizational abilities to the London Artists Association, which was founded in 1925, the Contemporary Arts Society, and the Cambridge Arts Theatre. He was involved as well with the ballet. In 1937 he commissioned, from Derain, set and costume designs for the ballet *Harlequin in the Street*; these drawings are preserved in the Keynes papers, King's College, Cambridge. Richard Shone emphasizes the importance of another project at Cambridge, one originally proposed by Duncan Grant. This was the establishment of a picture-lending library at King's for undergraduates. For a small sum, paid each term, they could borrow lithographs and drawings for their rooms. Keynes endorsed the scheme and Grant did much of the buying; it is still in operation today.[41] In 1939 Lydia and Maynard went to Royat on their last Continental holiday.

Lydia and Maynard remained very much, at least on the surface, a part of Bloomsbury, whether they were at 46 Gordon Square or at Tilton. Lydia was invited to appear before the Memoir Club in the late 1930s, a hallmark of her acceptance within the group, and she sometimes took part in theatricals at Charleston. It must be said, however, that Vanessa Bell was at times reluctant to enter into social exchanges with the Keyneses (in December 1944 she wrote Angelica that they were giving a large party "to which we all have to go").[42] After Maynard's death from his second heart attack in 1946, Lydia lived at Tilton until 1977. In 1958 Vanessa visited the farm to search for paintings by Duncan for an exhibition at the Tate and wrote Janie Bussy of her concern that Lydia was not caring properly for the valuable works in his collection. Lydia died in the nearby coastal town of Seaford in 1981.[43]

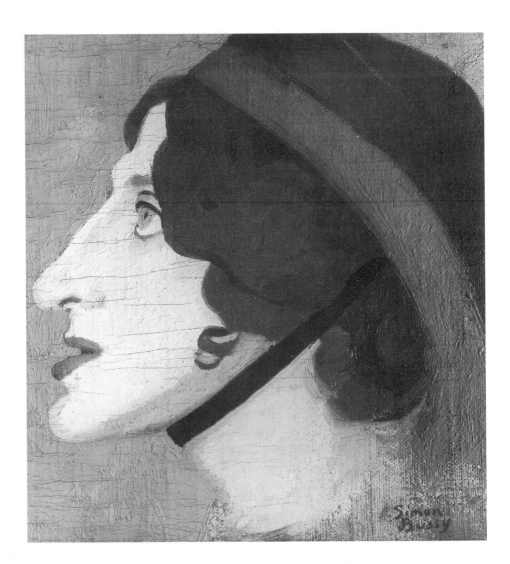

Simon Bussy,
*Lady Ottoline
Morrell* (1920).

Ottoline Morrell

It is an afternoon in Paris in October 1910. Roger Fry, Desmond MacCarthy, Clive Bell, and Ottoline Morrell, who is wearing a crimson hat shaped like a tea cosy and trimmed with miniature hedgehogs, are visiting galleries and artists' studios. Fry has persuaded her to stop in Paris on her way home from Italy and assist with the final selection of pictures for the exhibition "Manet and the Post-Impressionists." The show will open in London in early November and cause a virtual earthquake in the art world. Ottoline, Fry tells a friend, "is quite splendid … she'll face anything."[1]

Lady Ottoline Morrell, who was born Ottoline Violet Anne Cavendish-Bentinck, was the sister of the Duke of Portland and, in Lytton Strachey's phrase, "the daughter of a thousand earls."[2] She had a privileged upbringing, first at East Court, a Georgian home in Berkshire where her family was on intimate terms with Charles Kingsley. It was Kingsley who instilled in Ottoline's mother both piety and a concern for the poor and underprivileged, which she passed on to her daughter. Her father, Lt. Gen. Arthur Bentinck, died when Ottoline was four, and when she was six her stepbrother, Arthur, became the Sixth Duke of Portland. The family, including Arthur, Mrs. Bentinck (later given the title of Lady Bolsover), her three sons, and Ottoline moved to Welbeck Abbey in Nottinghamshire. This was an enormous neglected estate badly in need of restoration, which her mother courageously undertook. One improvement was the conversion of an indoor riding school into a library and chapel.

Ottoline was a rather lonely and isolated child who took solace in reading and religious studies. She delighted, however, in visits to another of her half brother's properties, Bolsover Castle in Derbyshire, half an hour's ride away. Much smaller than Welbeck, the castle had rooms painted with mythical divinities. Ottoline became fascinated by one of its former mistresses, Margaret Lucas, wife of the First Duke of Newcastle, a Restoration poet and playwright whose exotic appearance she emulated. She later persuaded Virginia Woolf to depict her in *The Common Reader*; the somewhat contradictory portrait Woolf gives of a devout, generous, and intellectually curious woman, yet one addicted to fantastic clothes, applies also to Ottoline.

In 1889 the Duke married and Lady Bolsover and her daughter, then sixteen, left Welbeck at once. Ottoline was something of a misfit. She held Bible classes for gardeners and grooms at their new home on St. Anne's Hill, Chertsey, and showed little interest in marrying within the aristocracy. In 1892 she and her mother went to Italy, where Ottoline contracted typhoid fever. She recuperated in the Villa Capponi, her aunt Louise's summer residence near Florence, where she began to perceive a way of life in which beautiful things were taken for granted. En route back to England, they stopped

in Paris, where her mother purchased for her, at an auction, a pearl necklace that had once belonged to Marie Antoinette. Not believing in worldly ornaments, she declined to wear it.[3]

Lady Bolsover died in 1893, leaving Ottoline inconsolable. She spent six years traveling on the Continent with women companions and studied briefly at St. Andrews University, Scotland, and Somerville College, Oxford. As she matured, however, distinguished men began to find her attractive, including the Swedish writer Axel Munthe and Herbert Henry Asquith, later prime minister; she may have had affairs with both.

It was in Oxford that she met Philip Morrell, son of the university solicitor, who proposed to her. He was not of aristocratic rank, but was acceptable to her brothers as a solicitor (she concealed his Liberal leanings from them). They were married in 1902. Philip stood for Parliament as a Liberal in 1903, but lost the election. At this time, the

Ottoline Morrell on her honeymoon in Paris (1902).

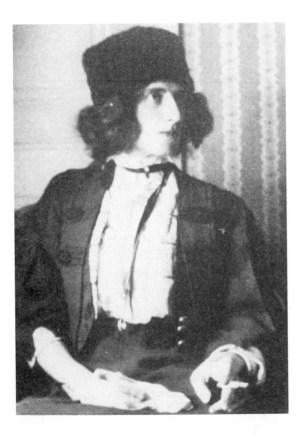

FOUNDING BLOOMSBURY IN FRANCE

Morrells were often guests of Ethel Sands and Nan Hudson at their luxurious country home, Newington, in Oxfordshire.

In 1905, when the Morrells moved into a large house at 44 Bedford Square in the Bloomsbury section of London, "Bloomsbury" had no connotation other than an upper middle-class neighborhood inhabited by solicitors, physicians, editors, and architects. Clive Bell was still studying art history in Paris and had not yet married Vanessa Stephen; Duncan Grant was living in Paris, and so were Augustus John and Henry Lamb. The Stephen siblings had taken a house nearby on Gordon Square, but for the most part the young Cambridge alumni who came to their evening gatherings were still living at home.[4]

By 1907 Ottoline had already met many of Bloomsbury figures in London: E. M. Forster, Roger Fry, Desmond MacCarthy, Maynard Keynes, and Lytton and James Strachey. She began holding "Thursdays" at Bedford Square that became famous. As invitations to these unorthodox gatherings acquired a decided cachet, Ottoline began to realize that she could actively benefit many young artists and writers outside conventional channels by performing introductions and promoting their work. About 1908, she met Vanessa and Clive Bell in London in the home of Augustus John.

Virginia Stephen probably first met her about 1909. At the time, she wrote that she had just gotten to know "a wonderful Lady Ottoline Morrell, who has the head of a Medusa; but she is very simple & innocent in spite of it, & worships the arts."[5] Ottoline was at first labeled a "society hostess" by the Bloomsbury group, which termed her efforts to seek out and entertain young poets, artists, and writers "lion hunting." David Garnett, who attended the Morrells' parties in London at their Bedford Square house, before they acquired Garsington, candidly admitted that Bloomsbury "exploited Ottoline. But it was awfully fun to be invited and one didn't run down invitations."[6] As her parties became more theatrical, with games and masquerades, Ottoline seemed, in the words of her biographer, "to be learning to play Julie de Lespinasse or Madame de Châtelet to perfection."[7] Henry James disapproved of her patronage of bohemian figures, warning her that any wealthy person could purchase the company of artists and writers. Ottoline paid little attention, although she was devoted to him and to his works, writing in her journal that the latter were "lit by the penetrating lamp of love and understanding, and a sincere wholehearted compassion for tangled, shot-silk human nature."[8]

Ottoline was able to hold her own with Bloomsbury intellectually, to some extent, because of her unorthodox year of study with John Cramb in 1904. They had met at a concert, and began having lunches and teas together in London. An extraordinary tutor, he introduced her to the works of Diderot, Rousseau, Zola, Baudelaire, Verlaine, as well as to those of Russian and British writers.

At first glance it may seem inconceivable that Ottoline came to be on terms of intimacy with the Bloomsbury circle at all. A devout Anglican, she had an elaborate wedding in fashionable St. Peter's church, Eaton Square; most members of atheist Bloomsbury married in the St. Pancras Registry Office. When she and her husband first arrived at their country estate, Garsington Manor, in 1915, the village church bells rang to welcome them. Although she was an embroiderer and needlewoman, Ottoline was an artist only in having a vivid sense of color and style (she took great pains to find the perfect Venetian red for one of the Garsington drawing rooms); she was a writer only in her journals. Bloomsbury also objected to Ottoline on somewhat convoluted moral grounds, being offended by anyone devoutly religious who was known to have had many love affairs but then refused to discuss them frankly. They regarded her discretion as hypocritical. Ottoline became, in the words of one critic, a "natural victim" of Bloomsbury.[9]

In 1908 Roger Fry introduced Ottoline to the works of the impressionist master Paul Cézanne, who had died in 1906. At the time his paintings were little known in England, but he urged Ottoline to make a point of seeing his work when she was next in France. Meanwhile, she became a patroness of the Contemporary Art Society, founded to purchase the works of new contemporary artists and lend them to galleries. She offered her house for meetings and exhibitions, and in the course of her volunteer work, educated herself about art. In autumn of 1909 she and Philip were offered an apartment in the Hôtel Crillon by the Chicago heiress Emily Chadbourne, a friend of Augustus John. Philip could not get away and Dorelia John, who would not have been Ottoline's first choice, went instead. While Dorelia went shopping, Mrs. Chadbourne took Ottoline to the Salon d'Automne, to private collections of Manets and Cézannes, and to Matisse's studio. She also introduced her to Gertrude and Leo Stein and Picasso. Ottoline came to concur with Fry that Cézanne was "the master of them all."[10] Philip then came to Paris and he and Ottoline called on Gertrude Stein, who noted in *The Autobiography of Alice B. Toklas* that Ottoline stood on the doorstep looking like some "marvellous female version of Disraeli."[11]

In the summer of 1910 the Morrells set off for southern France. Ottoline was to take a cure at the springs of La Bourboule. They then went to Marseilles, where they saw paintings by Puvis de Chavannes, one of Philip's favorite artists, and on to Provence. They stayed in Aix at the Hôtel de Thermes, waiting for Augustus John and Dorelia, who was pregnant, to come to Aix by donkey cart. Then Augustus and Dorelia escorted them to Cézanne's small house on the outskirts of town. Ottoline became an even more ardent devotee of Cézanne and also an admirer of the work of Gauguin, Van Gogh, and Manet. The Morrells continued their vacation in Venice. Roger Fry sent an urgent invitation there to Ottoline to return to England via Paris so that both of them might assess the paintings he was proposing to bring to England later in the autumn.

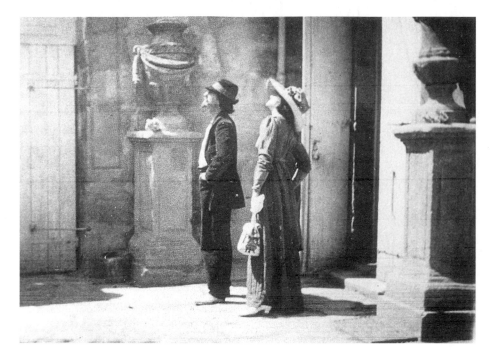

Augustus John and Ottoline Morrell in Aix-en-Provence (1910).

It was natural, in view of Ottoline's friendship with Fry, her developing connoisseurship, and her growing involvement in the London art world, for him to ask her advice about paintings for the exhibition that would introduce the British public to important contemporary artists. In October she accompanied him, Desmond MacCarthy, and Clive Bell on an expedition in Paris to choose the paintings and other artifacts. The exhibition, "Manet and the Post-Impressionists," opened at the Grafton Galleries on November 5 and has been called "an event of momentous importance in the history of British taste."[12]

Philip Morrell was returned to Parliament in January 1911 with a narrow victory over his Tory opponent. Asquith made two speeches on his behalf, and Ottoline and Julian helped by touring cotton mills and speaking at meetings. Ottoline is supposed to have stood before mill workers in Burnley, stretched out her arms, and said, "I *love* the people—I married into the people."[13]

In March 1911 one of Ottoline's most extraordinary affairs began, her liaison with Bertrand Russell. En route to Paris to give a course of lectures at the Sorbonne, he spent the night at the Morrell home in Bedford Square. As Philip was away, Ottoline had invited two dinner guests, Ethel Sands and Ralph Hawtrey, who had been a fellow Apostle at Cambridge with Russell. When the guests had left, she and Russell sat talking. He suddenly seemed to become aware of Ottoline's extraordinary sympathy and personality and fell in love with her. His passion has been described as a force that "changed his entire life. His desire for her was so all-consuming, he later said, that if he had known

that Philip Morrell would have murdered them both, he would have been willing to pay the price for just one night with her."[14] They stayed up until four A.M. embracing, although they did not have full relations at the time. Russell had tired of his wife Alys, sister of Logan Pearsall Smith, whom Frances Partridge has described as "aggressively dull."[15] Ottoline and Philip were planning in April to go to Cliff End, Studland, a charming small resort in Dorset then patronized by writers, artists, and intellectuals. Russell proposed joining her there on April 18, after Philip had left, but Ottoline worried that she might receive a visit "from a Bell or a Strachey, or some other notorious gossip." Actually her fears were justified. Lytton Strachey, staying with Henry Lamb at Corfe, not far from Studland, invited himself to stay with Ottoline. She said no, but had to consent when Logan Pearsall Smith proposed a visit. He left before Russell arrived for a three-day stay and began having an affair with Ottoline. When Logan found out, he was furious; it has been said that "of all the enemies Ottoline made—and for a kind, generous person she made an astonishing number—Logan Pearsall Smith was undoubtedly the most vehement."[16]

In May 1911 Ottoline went to Paris, where she met Henry Lamb, who had become extremely jealous of Russell. Lamb had found it "incredible that any woman would prefer the stiff, desiccated Russell to a man like himself whose beauty, grace and talent were universally admired." Her last night there, she agreed to sleep with him. When she returned to London, Lamb wrote to remind her of 'that incredible little room where you, holy woman, lay … and received me.'"[17] While she was there, Russell wrote her every day, with his "most absolute restful confidence in the permanence of our love … you are what I have sought through the world, and I do believe I am what you need." Russell objected, however, to her belief in God, and wrote, "I doubt if this quality is compatible with a very sharp clear-cut view of things...."[18] Ottoline insisted that her faith was necessary to her. When Russell proposed that she leave Philip and Julian and marry him, she refused. In any case, Russell wanted children, which Ottoline could not provide. In 1921, with Ottoline's approval, he married a young woman named Dora Black; their son, John, was born in November.

Ottoline and Roger Fry had a brief affair before he went to Turkey with a Cambridge friend, Harry Norton, where Vanessa and Clive were to join them. A rumor circulated that Fry was in love with her, which she instantly denied. Believing that Ottoline had been discussing their affair with others, Fry became very angry with her. She wrote in her journal, "After nearly two hours of expostulation on my part and insistence on his, I felt shattered and hopeless and was reduced to tears … one of my most intimate and delightful friendships crumbled to dust that Saturday."[19] From then on, Fry was extremely hostile to Ottoline. He was an unfortunate enemy for her to have made, as he

knew the secret of her affair with Russell and, as Ottoline noted in her journal, "spread abroad to all his friends what I had told him in confidence."[20]

In the spring, summer, and autumn of 1912, Ottoline made several journeys to Lausanne, where she consulted a specialist, a Dr. Combe, about her physical and emotional state. Russell accompanied her in June, and they spent her birthday, June 16, together, going to Geneva and Ferney. There they looked through the gates of Voltaire's house and chapel; Ottoline noted in her journal that "Bertie loved to think he was treading in the paths Voltaire trod." He traveled back with her to Paris, which she recalled: "We went to Versailles, and sat among the statues in the garden of the Trianon, and listened to the birds singing, and imagined all the past life there. On that day, too, we were very happy." Ottoline was sensible enough to realize, however, that even if she left Philip and yielded to Bertie, "he would soon see another moon rising in the sky and begin to cry for it."[21] Combe suggested that she retire to the country and spend no more than a week in London, a proposal most alarming to Lytton Strachey. He wrote Henry Lamb that it would be "desolating. It was the one centre where I had some chance of seeing amusing and fresh people—my only non-Cambridge point of rapport in London. I was looking forward to rushing up from time to time and mingling with the beau monde!"[22]

Ottoline did not retire from social life, however, but in the summer of 1912 returned to 44 Bedford Square and resumed her salons. She entertained Henry James, Ethel Sands, Duncan Grant, Adrian and Virginia Stephen, and Lytton, but not Roger Fry or Clive or Vanessa Bell. This was the summer Sergei Diaghilev brought the Russian ballet to London. Although she had been rather lukewarm toward Nijinsky when she met him in Paris in 1910, she became convinced of his brilliance after seeing him at Covent Garden in July. She admired Stravinsky's music, the Oriental sets, and Nijinsky's "faunlike genius."[23] She attended *Thamar, Scheherazade,* and *Giselle* and often invited Nijinsky and Diaghilev to Bedford Square. One evening they saw Duncan Grant and Adrian Stephen playing tennis; Nijinsky exclaimed, "Quel décor!"

The Second Post-Impressionist art exhibition was, meanwhile, scheduled to open at the Grafton Galleries in October 1912. Roger Fry's purpose in organizing it was to make clear the exchange between French and British artists that he considered extremely significant. In addition to the works of Cézanne, Matisse, Picasso, and Bonnard, he included those of Vanessa Bell, Duncan Grant, Frederick Etchells, Henry Lamb, Wyndham Lewis, and Eric Gill. Clive Bell came to Bedford Square to get some of Lamb's paintings for the exhibition and took the wrong one, which Ottoline did not realize until Lamb wrote her indignantly from Ireland. Clive assured him he was himself at fault, and Lamb apologized. Word of the problem, however, had spread to Molly MacCarthy, who wrote Clive, "What is the Ottoline scandal? I am so distressed if she is being

gossiped about, as I do love her, & don't mind what she does; she is a rare muddler I fear in her intense affairs. Don't let people say unkind things about her."[24]

The summer of 1914 marked the outbreak of World War I. The Morrells, Bertrand Russell, and most of Bloomsbury, including Leonard Woolf, opposed England's entry into the war. As a liberal M.P., Philip gave an antiwar speech in the House of Commons on August 4 that effectively brought an end to his political career. Pacifists rallied at their Bedford Square home. Many of Ottoline's friends disagreed with Philip's stand and ostracized her, including Herbert Asquith. Henry Lamb took up his medical studies again to become an army doctor, and Augustus John helped as a war artist. Most of the Bloomsbury group was in complete sympathy with the Morrells, although E. M. Forster was an exception; he became a Red Cross observer in Egypt. Ottoline continued, during some of the worst years of the war, to entertain in Bedford Square; there were charades, costumes, and dancing. She later regretted sponsoring such gaiety when hundreds of

Group of friends at Garsington (c. 1916–1918?). *Back row:* Julian Morrell, Vanessa Bell, Lady Ottoline Morrell; *front row:* Simon Bussy, Jean Marchand, Duncan Grant, Frank Prewett.

FOUNDING BLOOMSBURY IN FRANCE

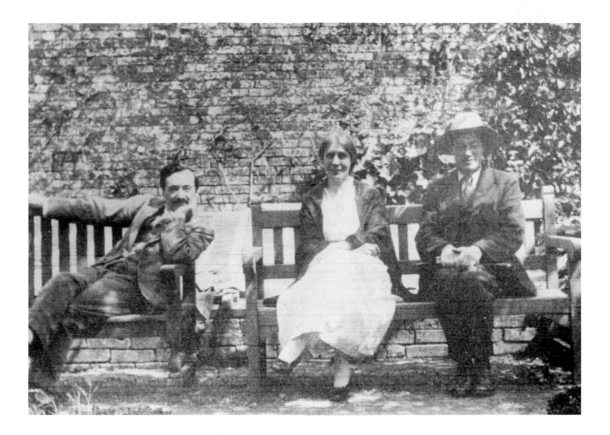

young Englishmen were dying just across the Channel (including one of Leonard Woolf's younger brothers). She contended, however, that it was not so much lack of feeling as an effort to divert their thoughts from the larger tragedy.

In 1915 the Morrells took possession of Garsington Manor, the home outside Oxford they had purchased in 1913. Ottoline decorated it lavishly, with silk curtains, Persian carpets, boxes of incense, oriental china, and patterned hangings. She painted the oak paneling in some rooms and hung paintings by Mark Gertler, Augustus John, Duncan Grant, and others. For the next decade she established, particularly on weekends, what has been called a "cultural legend" and a fashionable "Renaissance court ... the Mecca of all aspiring young writers and artists." There were *tableaux vivants*, plays in a small theater, picnics, concerts, and supper parties. Guests included not only Lytton Strachey, Maynard Keynes, Desmond and Molly MacCarthy, and Duncan Grant, but also Frieda and D. H. Lawrence, Katherine Mansfield, John Middleton Murry, T. S. Eliot, Aldous Huxley, Bertrand Russell, Cecil Beaton, Eddie Sackville-West, Siegfried Sassoon, Henry Lamb, and Augustus John.

For Christmas 1915 Ottoline invited Lytton, Clive Bell, John Maynard Keynes, George

Simon Bussy, Vanessa Bell, and Duncan Grant at Garsington.

ABOVE. Dora Car-
rington, Ralph
Partridge, Lytton
Strachey, Oliver
Strachey, and
Frances Partridge
at Garsington.

RIGHT. Virginia
Woolf at Garsing-
ton.

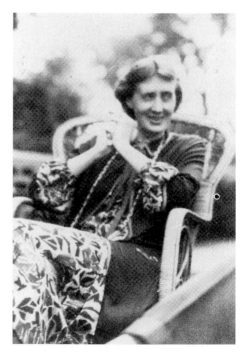

Santayana, John Middleton Murry, Vanessa Bell and her sons, and Marjorie and James Strachey. The entertainments included a charade, "The Life and Death of Lytton," in which Quentin Bell played the baby Lytton.[25] Clive Bell, Mary Hutchinson, Molly Mac-Carthy, and, unexpectedly, Roger Fry were all at Garsington for Easter 1916.

In November 1917 Virginia and Leonard Woolf went to Garsington for the weekend. Virginia described it in her diary: "people strewn about in a sealingwax coloured room…. droves of people moved about from room to room." Ottoline wore pearls and velvet, and held two pug dogs; Lytton was "semi-recumbent" in a large chair. She praised Ottoline's vitality; "in private talk her vapours give way to some quite clear bursts of shrewdness."[26] For Christmas that year Lytton sent Ottoline a spoon dated 1759, reminding her it was the year *Candide* was published.[27] Finding it too expensive to maintain both homes, the Morrells sold their London house in 1919.

In the summer of 1920 Ottoline had an affair with Lionel Gomme ("Tiger"), a gardener at Garsington, who was to die of a brain hemorrhage in 1922. Some critics believe this relationship became known to D. H. Lawrence through Mark Gertler and Dorothy Brett, and that the situation served as the central motif of his novel *Lady Chatterley's Lover* (1928). The character of Constance Chatterley is thought to have been based not on Ottoline but on Frieda Lawrence. It was her fate to have Garsington and her Bloomsbury friends pilloried by a number of writers. Lawrence also represented Ottoline in *Women in Love* and wrote of Mark Gertler's love for Carrington in *Mendel* (a novel dedicated to Carrington). Aldous Huxley, in *Chrome Yellow*, and Walter Turner, in *The Aesthetes*, portrayed Garsington weekends and various houseguests in an unflattering way. Although Virginia Woolf did not portray Ottoline in any of her novels, perhaps out of kindness, she did depict Philip as Hugh Whitbread in *Mrs. Dalloway*.

Garsington was in an economic decline, as were many other working farms in England. Philip felt they were facing financial ruin, but did not oppose Ottoline when she proposed to take her daughter, Julian, then fourteen, abroad. She insisted that by living economically they would spend no more than at home. From November 1920 to May 1921, they toured the Continent in a reenactment of the months Ottoline and Lady Bolsover had spent in Italy in 1892, but on a much-reduced budget. There were no purchases of royal jewelry in Paris or accommodations in elegant hotels. They stayed with friends or in small pensions and traveled on buses in an effort to economize. They went first to Marseilles, staying in a "grubby nice feckless hotel," and proceeded to Paris. There Julian went to the theater with André Gide and visited Picasso one morning. When they arrived in Monte Carlo, Julian was more fascinated by the casino than by the Russian Ballet to which she was invited. In Menton Katherine Mansfield invited them to tea, but Julian refused to go, which precipitated a bitter scene. To her daughter, Ottoline's tour was too educational and too full of obligations; Julian had expected it to be a glorious lark.

In early December they reached the home of Dorothy and Simon Bussy at Roquebrune, taking lodgings in a nearby pension. This was the year Simon Bussy painted Ottoline's portrait, possibly during this visit. Dorothy wrote a revealing letter about Bloomsbury's equivocal attitude toward Ottoline to her sister-in-law, Ray Costelloe Strachey, wife of Oliver Strachey:

> … we are all alive and have so far survived Ottoline's presence without any disastrous results. We consider her in fact a highly maligned character. Nothing can have been more tactful, discreet & retiring than her whole behaviour up to date…. Ottoline has shown complete unobtrusiveness…. She never enters the house unless formally invited, never comes to any meal but tea, really never bothers in the very least. I don't know whether this is owing to my extreme sternness

Group at Garsington Manor (c. 1922). *Left to right*: Ottoline Morrell, Maria Nys (later Mrs. Aldous Huxley), Lytton Strachey, Duncan Grant, Vanessa Bell.

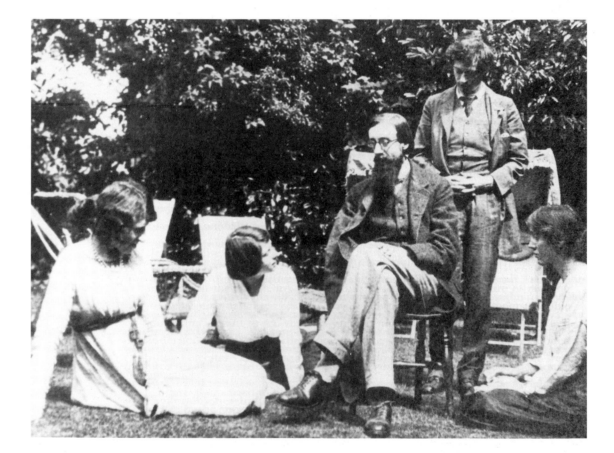

the first few days. You all frightened me so much that I really think I was rather brutal to the poor lady. She seems to me a miserable object, ill, bored, penniless, lonely.

She noted that Ottoline and Julian were staying in a "beastly pension," and continued that the latter was

evidently a most uncongenial companion. In spite of all this however she continues unobtrusive—except in appearance—which is of course highly remarkable. The Vandens have taken a violent loathing to her and are barely polite (owing I believe to Lalla's report of her morals!) but Vincent and Janie declare she is a very nice old thing. Audrey [the Bussys' paying guest] gazes at her as if she were a strange beast or escaped lunatic & occasionally explodes in a fit of giggles. Julian comes to lessons every morning—I can't make anything of her. But I don't object to her at all—and Janie likes her—which is a mercy.[28]

During the 1920s Garsington became more festive than during the war years, even though hospitality was far more frugal. Oxford undergraduates flocked out on weekends (Evelyn Waugh mentioned Garsington in *Brideshead Revisited*), and were often frozen into silence when introduced to Yeats, Virginia Woolf, T. S. Eliot, and E. M. Forster. Gide returned to England in 1920 and stayed briefly at Garsington. This was at a time when Mark Gertler found the atmosphere there almost exclusively, and unbearably, "French." The guests spoke French and kept saying everything was *"horrible, magnifique, exquis, formidable"*; he felt he was in some sort of theater. The company would walk around the lake, "declaiming Verlaine in a melodramatic tone." Although Roger Fry no longer went to Garsington, having quarreled with Ottoline, he was considered to be "the inspiration of this Francophilia, against which only Mark Gertler raised his solitary voice."[29]

At the beginning of 1923 Katherine Mansfield Murry, who had been a close friend of Ottoline's, died in France of tuberculosis. Soon afterward the friendship between ended in a quarrel. Ottoline and Virginia Woolf, consequently, became much closer than before; they visited each other in London and in May 1923 Leonard and Virginia visited Garsington. She claimed she had shared the lawn with thirty-seven students, "which might be harmless in the stir of normal sunlight. Only is the sunlight ever normal at Garsington?" she wrote Barbara Bagenal (formerly Barbara Hiles, one of the Slade "cropheads"). "No I think even the sky is done up in pale yellow silk, and certainly the cabbages are scented."[30]

In 1926 the Morrells went on holiday in France with Julian, who, against their wishes, wanted to marry Igor Vinogradoff, son of an eminent Oxford professor. They began

touring in two cars at the end of July, with Siegfried Sassoon, Robert Gathorne-Hardy, and Kyrle Leng making up the party. They visited Claude Monet, then ninety-six, at Giverny, then went on to see Chartres at moonlight and to tour Versailles. The journey became an endurance contest for Siegfried; Julian and her mother disagreed on sights, food, hotels, and itinerary. After nearly two months, with many automobile breakdowns and a detour into Italy, the exhausted party returned to England. A year later Julian married Victor Goodman and, in 1929, had the first of three children.

For financial reasons the Morrells sold Garsington in 1928; the sale marked the end of an era. Although they kept half of the furnishings and paintings they had intended to auction and installed them at Gower Street, Ottoline felt the loss of the estate keenly. Lytton told her "nothing but pity" would induce him to come to their dreary London home. Soon after Garsington was sold Ottoline was found to have necrosis of the jaw, for which removal of several lower teeth and part of the bone was the only remedy. She was extremely disfigured by the dental surgery, but disguised her condition to some extent with hats and veils. Virginia Woolf wrote of the "recurring discomfort" it was for her to think of Ottoline in pain, and realized how very much she admired her loyalty to Philip and her kindness, wit, and generosity. Although she had been more impressed than some members of the Bloomsbury group by Ottoline's aristocratic background and her childhood at Welbeck, she came to discount it. Unlike Vita Sackville-West, who had needed the setting of Knole House and Sissinghurst to set off her personality, Ottoline could, and did, preserve her idiosyncratic charm even in the mundane surroundings of Gower Street. Virginia became convinced of the limitations of Lytton's perception of Ottoline. When she died in 1938, Virginia and T. S. Eliot composed some lines for a memorial tablet, calling her "A brave spirit, unbroken, / Delighting in beauty and goodness / And the love of her friends." Unfortunately, Philip, who survived her by five years, substituted lines of his own.[31]

Philip Morrell intended to edit and publish Ottoline's memoirs and began having them transcribed. In 1942, Vanessa, knowing of the project, wrote Molly MacCarthy that she felt sure that

> Ottoline's memoirs would be too dull—even if scandalous—for anyone to be able to get up much excitement about them. I'm sure sh'd *never* call a spade a spade.! Also surely Philips publishers won't want a case for libel brought against them. However evidently he sees this for himself on second thoughts. I believe [he] saw some of the memoirs and thought them terribly washy and vague.... yours [have] such a flavor of their own ... perhaps [the] Memoir club cannot be revived but perhaps the younger members will start a new one.[32]

Ottoline's journals were far from dull, but Philip died in 1943 before the transcription

was completed. Robert Gathorne-Hardy took on the task and published them in two volumes.[33] He and her subsequent biographers attempted to correct the false caricature of her they believed had emerged in the letters and diaries of several Bloomsbury figures, in various Bloomsbury biographies, and in the novels of D. H. Lawrence, Aldous Huxley, and Walter Turner. Ottoline's aristocratic connections, zest for theater, passion for art, and attachment to France converged in making her, at varying times, victim, idol, and, as Virginia Woolf said, "enchantress" of Bloomsbury.[34]

Ethel Sands at
the Château
d'Auppegard,
before the fresco
on the loggia by
Vanessa Bell and
Duncan Grant.

Ethel Sands and Nan Hudson

> *Her mind was like her room, in which lights advanced and retreated, came*
> *pirouetting and stepping delicately, spread their tails, pecked their way; and*
> *then her whole being was suffused, like the room again, with a cloud of some*
> *profound knowledge, some unspoken regret, and then she was full of locked*
> *drawers, stuffed with letters, like her cabinets.*
>
> —Virginia Woolf, "The Lady in the Looking Glass: A Reflection"

Two American artists and longtime companions, Ethel Sands and Nan Hudson, achieved a degree of intimacy with many Bloomsbury figures that was rare for their compatriots. Over more than five decades they came to know Vanessa and Clive Bell, Duncan Grant, Virginia and Leonard Woolf, Lytton Strachey, Roger Fry, Desmond and Molly MacCarthy, and Ottoline and Philip Morrell.[1] As late as 1952, the year of his death, Desmond MacCarthy was still calling on Ethel in London to discuss literature. Duncan Grant also was in touch with Ethel and Nan as long as they lived. In 1957, when Nan died, he wrote Ethel to ask for facts for an obituary notice to appear in the London Group catalogue in 1958. Ethel died in 1962, at the age of eighty-nine, having kept up after Nan's death with those Bloomsbury writers and artists who remained.

Both Ethel and Nan were independently wealthy. Ethel was related on her father's side to one of the old mercantile families of New York who traced their ancestry to England. Her family had come to Europe for several years in 1874, following an old tradition of well-to-do Americans. Mahlon and Edith Sands made many English friends, including Henry James, John Singer Sargent (who painted Mrs. Sands's portrait), and the Prince of Wales, who urged them to settle in England permanently. They did so, with the exception of two years they spent in America from 1877 to 1879, sending their two younger sons to Eton.[2]

Nan (Anna Hope) Hudson was an only child whose fortune came from her grandfather, Samuel Carpenter, a partner in a banknote engraving company (later part of the American Banknote Company). She was four years older than Ethel; they met in 1897 in Paris, where both were studying art.[3] The two were devoted friends and serious artists. Their circle included not only the extended Bloomsbury group but also Augustus John, George Moore, Logan Pearsall Smith, Boris Anrep, Arnold Bennett, Percy Lubbock, Bernard and Mary Berenson, and other writers, artists, and critics.

As an artist, Ethel Sands has been associated with the school of Walter Sickert. She was, like Nan Hudson, influenced by Edouard Vuillard. Ethel Sands was particularly known for her domestic interiors. She also painted still lifes and portraits (among her

subjects were Clive Bell, Raymond Mortimer, and Logan Pearsall Smith), as well as decorative screens and cupboards. Nan Hudson focused on landscapes with an architectural interest, interiors, and portraits. Little of their work survives, a consequence of the German bombing of Ethel's Chelsea house and the looting of their home in France by the French themselves, in anticipation of the German occupation.[4]

They were extremely hospitable, frequently entertaining friends in their various residences in England.[5] They then acquired the Château d'Auppegard at Offranville, Normandy, some miles inland from Dieppe, leased for the summer in 1920 and later purchased by Nan. The structure dated from 1672, during the time of Louis XIV, and was one room deep, seemingly transparent with its windows facing north and south; the south facade was made of cowpat. On the walls hung paintings by Augustus John and Walter Sickert, and the loggia would be painted by Vanessa and Duncan in 1927. Many members of the Bloomsbury group visited Ethel and Nan there, particularly between 1920 and 1929. Nan preferred living in France rather than England, and Ethel had a studio in the château after 1926.[6] The couple mixed with the local French inhabitants and contributed generously to a fund for ambulance service for the hospital at Veules-les-Roses, just along the coast from Dieppe.

When in London Ethel and Nan acted as the mediators among several groups of artists who met together informally, collaborated on exhibitions, and squabbled about conditions for membership in the select London Group of painters.[7] Ethel also managed to arbitrate between Fry and her friend Boris Anrep, a Russian mosaicist. In 1926 the latter's wife, Helen Maitland, would leave Boris for Roger Fry. At that time Boris confided in Ethel that Roger was in love with Helen, and that his own career was sadly bound up with the "advanced art group and Roger rules it."[8] Ethel also exhibited with the Women's International Art Club, and, after 1920, with the Goupil Gallery Winter Salons. In 1921 two of her works were accepted by the New English Art Club. Nan painted less as she became increasingly passionate about gardening and executing needlework for the Château d'Auppegard. She later regained her earlier interest in painting, and in 1926 took a studio in Dieppe where she did watercolor flower paintings and French landscapes.[9]

Of the two ladies, Ethel was the more sociable and talkative. Her Chelsea home was near that of Henry James on Cheyne Walk, and she often called on him in the afternoon during the last few years of his life, until his death in 1916. She came to know Desmond MacCarthy and Roger Fry well, frequently entertaining them at dinner. Vanessa Bell was initially somewhat resentful of Roger's friendship with her; in 1911, when he was about to dine with her, she wrote, "Is Miss Sands horribly skilful and do you really think I can ever do anything to make up for my complete lack of skill? There's a fishing question for you to answer."[10] Gradually, however, Vanessa and Duncan became intimates of both Ethel and Nan, frequently entertaining one or both for dinner at 46 Gordon Square.

Ethel Sands, *Sun-lit Room* (n.d.).

Ethel's friendship with Ottoline Morrell continued, and in 1925 Ottoline rented Ethel's house, which had been decorated by Walter Sickert and Boris Anrep, for her daughter Julian's London season.

From October until March Ethel was usually in London, where she had a hectic social schedule; Nan often stayed in France. Ethel was much in demand for parties, concerts, plays, lectures, lunches, and dinners, mixing with people from many literary and artistic circles. Encouraged by Logan Pearsall Smith, she began in 1923 to have "salons" at 15 The Vale. Lytton Strachey, Desmond MacCarthy, and Logan, along with Enid Bagnold, were among the guests at the first one. Virginia Woolf had declined, apparently classing her unfairly, according to Baron, with Lady Sybil Colefax as a "society hostess."[11]

Not wishing their relationship to appear as lesbian, Ethel and Nan avoided the more "outspoken" social circles, such as those around Vita Sackville-West in London and Natalie Clifford Barney in Paris.[12] In 1923, Ethel warned Virginia Woolf that Vita

Sackville-West had similar tendencies, which Virginia recorded in her diary after she and Leonard had a visit from the Nicolsons.

> She is a pronounced Sapphist, & may, thinks Ethel Sands, have an eye on me, old though I am. Nature might have sharpened her faculties. Snob as I am, I trace her passions 500 years back, & they become romantic to me, like old yellow wine. What a vile tongue Vita has, they say.[13]

Ethel regarded it as her mission to bring together literary and artistic figures who might not otherwise have an opportunity of meeting. In February 1924, she invited Virginia and Arnold Bennett to tea, and Virginia revised her preconceived opinion of him, finding him charming (although this did not prevent her attack on him in the essay "Mr. Bennett and Mrs. Brown"). Roger Fry was also present, along with Prince Antoine Bibesco and his cousin, the Romanian-born writer Princess Marthe Bibesco. To Roger the Princess seemed to shine with a certain brilliance that day; however, by May 1925, he was calling her talk "old silly aristocratic gabble." In her diary, Virginia ridiculed him for being impressed by Princess Marthe; "What a cosmopolitan he is—how he dreads the British Parish; how he adores Paris."[14]

Virginia gradually came to appreciate Ethel's sensitivity and compassion. One evening she apparently insinuated to Ethel that she did not altogether like Vanessa's children. The next day she wrote to explain that they were actually an "immense source of pleasure" to her, but also caused in her an extreme resentment that she had not "forced Leonard to take the risk in spite of the doctors" and have her own family, which both had very much wanted.[15]

Since the Bells and Duncan and Roger usually went to Paris via the Newhaven–Dieppe ferry, they often spent a night or two with Ethel and Nan on the way over or back. The Château d'Auppegard became a stopping-off point for the Bloomsbury group. Ralph and Frances Partridge sometimes went for tea, dinner, and the night, and various members of the Strachey family went to stay, or for tea, and were taken back to Dieppe to stay in a hotel if the château had no room.

Although Virginia had planned to visit the Château d'Auppegard in 1926, she did not actually do so until 1927, when she spent July 27–30 with Ethel and Nan. She arrived, after the publication of *To the Lighthouse*, in her Singer. Jacques-Émile Blanche, eager to meet her, came over and was pumped by Virginia in her usual fashion for everything he remembered, until halted by Ethel. Actually, it is debatable as to who was the more inquisitive. Blanche published a sketch of her the next month in a French periodical.[16] There was talk of his writing a book for the Hogarth Press, but Virginia did not encourage the project sufficiently for it to be carried out.

Virginia's diary entry of August 8, 1927, recounts her impression of the house and its

inhabitants in her inimitable prose. Nan read the names of the steamers coming around the bend of the Seine, "showing in all she did a sort of nervous tremulous pride in France." Virginia deduced that Nan liked their life there, alone at Auppegard, better than Ethel did. "'I'm gregarious,' said Ethel a little waspishly, for she is brittle & acid, the spoilt pet of the more dour & upstanding Nan…. It is a very narrow house, all window, laid with pale bright Samarcand rugs, & painted greens & blues, with lovely 'pieces,' & great pots of carefully designed flowers arranged by Loomas [*sic.*][17]

She differentiated between Nan and Ethel. Nan was "stylishly dressed, sews dusters of an evening, & Ethel craves talk. Nessa & Duncan say that the talk skirts & flits & never settles very long; in fact that the house is built upon the finest silver wood ash: so soft so silver you don't at first notice how it gets into your throat & makes your skin dry & dusty."[18] Looking back on the visit several weeks later, Virginia recalled Ethel's "not looking at her letters," and pondered what that might imply.[19] Her stay with Ethel and Nan led to her brief and evocative story "The Lady in the Looking-Glass," based on Ethel's "mothy ways," as she flitted about and finally stood before the mirror, in which was reflected—nothing.

Virginia's thank-you letter to Ethel of September 4, 1928, written from Monks House, Rodmell, extolled their home as a lyric accumulation of elements and as a combination of their personalities: "There's the Seine that day … and the house, and the sea, and Dieppe and the furniture shop, and then the food, and the clothes, and the flowers and the furniture, and in the middle, so exquisite and such a type to my mind of civilisation and rightness." In her letter to Nan, written the same day, she compared the perfection of the food, gardens, and appointments at Auppegard to her more humble and haphazard dwelling at Rodmell. She pointed out the difference between hostesses such as Nan and Ethel and people like herself, not without a trace of the pointed irony she had developed to a fine art: "Instead of controlling life as you and Ethel do, we writers merely contemplate it." She made the mistake of remarking, "Why is my writing table all of a mess (do buy me the next writing table the furniture man has, and a chest of drawers, and I will bless you for ever and I am rather rich at the moment")[20]

Ethel and Nan took her offhand remark literally and embarked on a lengthy search for an appropriate desk, which they found a year later and shipped, via Newhaven, to Rodmell, characteristically refusing all payment. Virginia wrote a rhapsodic letter to both the afternoon it arrived, on September 4, 1927: "But I tell you it is not an ordinary desk … this desk is a sympathetic one, full of character, trusty, discreet, very reserved: more like Nan than Ottoline." Delighted to find it had fourteen drawers and fit her window, she was, she said, sure that the writers she most admired had written upon it: "… what is charming about it is that it does not force me to feel young … if it is trusty and discreet it is also distinguished and slightly scented…. In short you see it combines the two women most aptly Nan and Ethel—Ethel and Nan."[21]

On their two visits to the Château d'Auppegard in July and September of 1927, Vanessa Bell and Duncan Grant decided to paint murals on the loggia facing the back gardens on the south side of the house. They had to revise their original design in accordance with Ethel's wishes, since she had found the two smaller ovals too overwhelming, with a group of musicians painted by Duncan and one of dancers, the work of Vanessa. She wrote Roger that they had to do "landscapes or rather gardens instead," which she thought was better.[22] The new design included pastoral haying scenes with shepherdesses in low-cut dresses, executed by using a thin layer of colours as a foundation, covered by a more solid layer of tempera and wax.[23]

"It is heavenly here," Vanessa continued, admitting she admired American ways "of making things comfortable & pleasant." On the other hand, the extreme tidiness at Auppegard made her uncomfortable, more than it had Virginia: "I daresay 2 days of being extremely tidy, clean, & polite will exhaust my powers—& my clothes."

> Please send us a glimpse of ordinary, rough & tumble, dirty everyday existence. I am beginning to be in danger of collapse from rarefaction here. The strain to keep clean is beginning to tell. Duncan shaves daily—I wash my hands at least 5 times a day—but in spite of all I know I'm not up to the mark. The extraordinary thing is that it's not only the house but also the garden that in such spotless order. It's almost impossible to find a place into which one can throw a cigarette end without its becoming a glaring eyesore. Ethel goes out at night & hunts snails till there are practically none left. Old men come in and polish the floors, women come and cut the grass, others come and wash. Nan makes muslin covers to receive the flies' excrements (I don't believe Nan & Ethel have any—they never go to the W.) Everything has yards and yards of fresh muslin and lace and silk festooned on it & all seems to be washed & ironed in the night…. However none of this is news to you. You've seen it all for yourself. But I remind you of it to make you see how much one wants a breath from one's home dirt.[24]

The painters, of course, were expected to keep a regular schedule, given those surroundings and that atmosphere. They found life far too organized in the château, with times for rising, breakfasting, working, and dining, after which there would be a gramophone concert and a session of reading aloud. Oddly, the wireless was turned on during lunch, a time which at Charleston was enlivened by conversation.

One July day they were invited to tea in Offranville by Jacques-Émile Blanche, who had taught Duncan art during his 1906–1907 residence in Paris. Blanche was surrounded by Sickert's pictures. He had a studio in the town of Dieppe, which had been the subject of many of Sickert's paintings. In spite of his high esteem for Roger, a visit to whom Sickert had considered the main event in his recent life, Vanessa did not alto-

gether like Blanche. She found him prickly and, like their friend Jean Marchand, somewhat bitter about his contemporaries who, he felt, were getting more attention than he.

For Vanessa and Duncan, their visits to and work at the Château d'Auppegard contrasted sharply with the far more informal and messier life in Cassis, where the jumble of paints and clothes made the struggle for space a daily one, and where life was easy, simple, inexpensive, and certainly not covered over by muslin, silk, and veiling. When Nan visited La Bergère alone, on one of her many visits to southern France, driven by her chauffeur, Charles Crosby, Vanessa and Duncan found her somewhat sad and at a loss without Ethel. She was easier to be with in combination with her friend, although the latter frequently filled Virginia with "awe and envy."

Ethel and Nan's close friendships with the leading Bloomsbury figures continued through the 1920s and 1930s. They exchanged Christmas presents with Virginia, who, in December 1929, declared that Ethel's exquisite gloves and pâté de foie gras rendered her "as slippery as an avalanche or an eel or an iceberg" when she was trying, one rainy day, to find an appropriate present for her in Brighton. Ethel required something "dark, glistening, exotic, mothy, luxurious, soft, rich, rare … the sperm of the sturgeon." Apparently Virginia sent caviar to Auppegard, imagining Ethel spooning it onto brown bread and butter, "sitting all alone in her glass green room."[25]

The stock market crash of 1929 reduced the income of Ethel and Nan, as it did that of other wealthy expatriate Americans. Their scale of living was diminished to some extent during the ensuing decade. One modification must have come as a relief to Vanessa and Duncan, who were told they need no longer dress when dining with them at The Vale. Their scale of living was not so reduced, however, as to prohibit travel. Ethel, especially, had an appetite for exploration and traveled widely in the Near East, Scandinavia, and Europe. Nan sometimes accompanied her, but not always.

The 1930s and 1940s brought the loss of several Bloomsbury friends: Lytton Strachey in 1932 and Roger Fry in 1934, Ottoline Morrell in 1938, and Virginia Woolf in 1941.[26] Ethel made a last visit to the Château d'Auppegard in 1958, before Nan's death in 1959. She herself suffered increasingly frail health and died in 1962. In his obituary, Leslie Hartley wrote that "neither her culture, which she wore so lightly, though it was almost a religion to her, nor her untiring sociability prevented her from being the most loyal and understanding and indulgent of friends."[27] Although she and Nan were never part of the inner Bloomsbury circle, they understood and relished the artistic and literary genius of its members and shared with nearly all of them a passion for France. Their milieu was Garsington or Sissinghurst, rather than Charleston or Monks House, yet their unique amalgamation of life, art, travel, and friendship enabled them not only to take the measure of Bloomsbury but to contribute, in an oblique way, to its essence.

Frances Partridge in the mountains; photograph by Ralph Partridge.

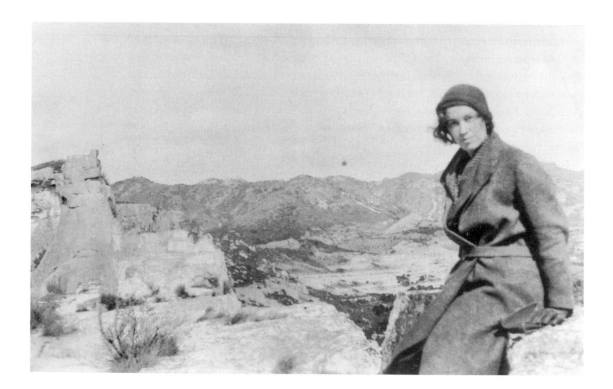

Frances Partridge

[In] January 1924 … I took a week off to meet Ralph and Carrington in Paris, on their way back from Spain…. We stayed in Paris for a week, during three "pleasant but exhausting" days of which Lytton was with us…. Paris restaurants were a new delight; so was the Louvre, Mistinguett, and the Comédie Française mouthing Racine. I noticed with surprise that Lytton never committed himself to speaking a word of French. He left all such practical matters to Ralph.

—Frances Partridge, *Love in Bloomsbury: Memories*

Ralph Partridge, Frances Marshall, Lytton Strachey, and Ralph's wife, Carrington, were close friends for a number of years, although they were also connected in a complex web of relationships. Carrington had been in love with Lytton, whom she knew was homosexual, since about 1916, although in 1921 she married Ralph Partridge, to whom Lytton was greatly attracted (although Ralph was entirely heterosexual). This was the year that Frances Marshall came down from Newnham College, Cambridge, and began working in the London bookshop of Francis Birrell and David ("Bunny") Garnett. She and Ralph met and fell in love. Lytton, Carrington, and Ralph, who were living at Tidmarsh Mill in the Thames Valley, found Ham Spray House, which they believed would be less damp and better for Lytton's health. Lytton and Ralph purchased it jointly in 1924, and Frances visited on weekends. In 1925 she and Ralph began sharing a London flat at 41 Gordon Square, London, spending weekends at Ham Spray; the four often traveled together.[1] Their unconventional but congenial arrangement continued until 1931, when Lytton became seriously ill; he died in 1932. Six weeks after his death, Carrington shot herself.

Ralph and Frances married in 1933. Ralph was one of those rare people, like Frances herself, who was greatly loved without envy, as he was described by Frances's friend Raymond Mortimer. Mortimer noted his "extraordinarily acute intelligence, his taking an interest in everything, the remarkable warmth of his personality making people love him."[2] Frances's view of Carrington is at once generous and precise: "She seems to have been marvellously unresentful and unjealous, marvellously able to fall a little in love with innumerable people as well as cats, birds, and what she called 'visions' or 'images' of the outside world."[3]

Lytton's death and Carrington's suicide were events so terrible that all the couple's friends urged that they leave England for a time in order to distance themselves from the dual tragedy. Their good friends Molly and Desmond MacCarthy implored them to leave Ham Spray House. "Take him away, darling Frances, right, right away at once," Molly urged, and Desmond concurred: "I cannot, dear Ralph, be of any help to you until you are better." The manner of their death, Frances believed, "was not the characteristic thing about them. It was their response to life, and it is by living oneself again that one meets them as they were and keeps in closest touch with them." Frances recalled many years later that "when James and Alix Strachey wondered if we would motor them to Avignon, we accepted."[4]

They returned to the France Ralph had known as a soldier in World War I, visiting the farm on which he had been billeted in Flanders (*see* page 138). Everywhere there were memories of war, as Frances recounts in the following memoir, written especially for this book:

France and Bloomsbury
by Frances Partridge

At the end of the First Great War those who, like myself, had been growing up in its grim ambience felt an immense sense of liberation, coupled with a longing to stretch their wings and explore the world that had been hidden from them since their early teens. In 1921 I came down from Cambridge, but all I could manage in the way of travel was a walking tour in the Tyrolese mountains. True it ended across the border into Italy, where I took a first dazzled look at Brescia, Florence and Venice.

But the next year I had my first job as a bookseller's assistant, through which I got in touch with Bloomsbury, and in January 1924, drunk with the sheer excitement, I agreed to meet Lytton Strachey, Carrington and Ralph Partridge at a modest hotel on the South Bank. As far as that I travelled alone, too breathless to mind that I had

LEFT. Frances Partridge swimming at Cap Brun, Saint Mandrier; photograph by Ralph Partridge (1928).

BELOW. Ralph Partridge and Gerald Brenan near Toulon.

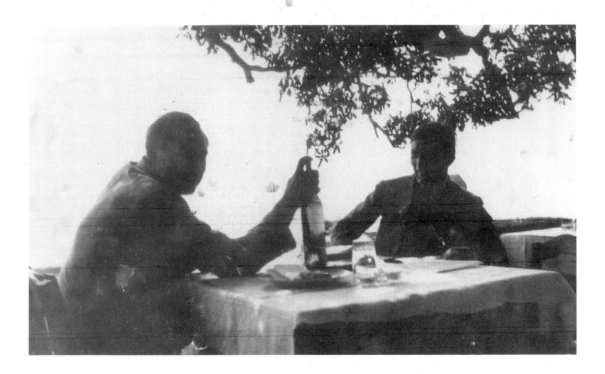

so little French. The others arrived from Spain where they had been staying with Gerald Brenan, and I remember the beautiful present they brought me—a red silk shawl hand-embroidered in yellow, which must have belonged to a gypsy. I have it still. I never wanted to leave Paris again, and vividly remember the thrill of waking to the now-familiar sounds of French taxis hooting, and of French shutters being rolled up. Into a few days we packed so much: the Louvre, the quais, the Palais Royale, the antique shops and old bookshops and our evenings with Mistinguett or the Comédie française mouthing Racine, a French film perhaps. I was somewhat in awe of Lytton because although he refused to speak a word of French (and told us how he had been completely tongue-tied at one of Pontigny's literary get-togethers) I knew that he had read exhaustively in French literature, memoirs and history. So it was left to Ralph, whose convincing-sounding French had been learned in the hard school of war, to speak for us all. But though I had no practice in talking French, my bookshop was bilingual, so that I had already grown to love Flaubert, Stendhal and Diderot, and this would continue after the Paris visit. It was in fact from Proust that I learnt to read French with comparative ease, and I remember the excitement over the first appearance of a new volume in the twenties and how the agreeable smell and look of those pages in the NRF edition made me long to be in France again.

But another country, Spain, was exercising its rival charms. In 1925 Ralph Partridge and I spent our summer holiday there, and returned to start our life together in Gordon Square. After that we tended at first to be drawn to the sea and the sun—in September 1926 for instance we joined Gerald Brenan at Toulon, and afterward found a pleasant little place where one could drop into the sea from the rocks and eat our picnic by the sea. After which we would sunbathe, or walk and talk with Gerald—this became the pattern of our holidays, but we very much wanted to explore every country, and every place that had a special appeal. Lytton and Carring-

George "Dadie" Rylands at Trébeurden, Brittany; photograph by Lytton Strachey (1930).

ton had taken a motor trip with Rosamond Lehmann, her husband Wogan Philipps and Dadie Rylands in the north of France.

Why should we not try Brittany? In 1929 we went to the little Breton fishing town of La Trinité, taking with us the two younger children of our great friends Desmond and Molly MacCarthy, Rachel aged twenty and Dermod eighteen. We were flattered and touched by this sign of confidence in our responsibility, and Ralph planned a little tour, by way of the prehistoric stones of Carnac and finally to the Ile de Groix, of which we knew nothing except the French nursery song: "Il y avait trois matelots de Groix." It was in those days a deserted island of great white beaches between rocky cliffs. Its one small inn put us up, and gave us langouste sandwiches to eat by the shore. Once a week a small cattle boat connected Groix with Lorient: it was the most solitary paradise I have ever visited and in its way the most beautiful we ever hit upon. I think Ralph felt the draw of Spain even more strongly than I did, and in 1931 we set out by train across France without having made up our minds whether we would stop in France or go over the border to Spain. In the event we made our choice for Cadaqués in Cataluña.

Our companions were Rachel again and Janie Bussy, niece of Lytton Strachey; this holi-

Ralph Partridge, Dermod and Rachel Mac-Carthy at Carnac; photograph by Frances Partridge (1929).

FOUNDING BLOOMSBURY IN FRANCE

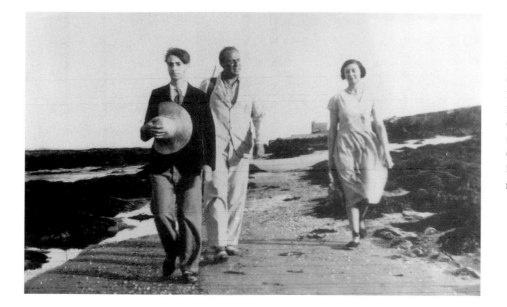

Dermod Mac-Carthy, Ralph Partridge, and Rachel Mac-Carthy on Brittany beach, with German block-house in background.

day was the beginning of a close friendship with Janie, although we already knew the family. It was a curious marriage between the highly literary intellectual Dorothy Strachey, translator of Gide and author of the successful novel Olivia, *and Simon Bussy, painter. Neither of Janie's parents knew the other's language enough to speak easily in it—their conversation was carried on mainly with each speaking their own tongue. Their only child Janie, brought up almost entirely in France, was completely bilingual, an intellectual and a painter with a charming style of her own. The whole family came sometimes to Ham Spray, but Janie was a frequent visitor by herself (as she was at Charleston) and a constant correspondent. She once brought a friend—Christiane, the charming daughter of Roger Martin du Gard—to see us. We enjoyed her father's books.*

In 1932, the "year of catastrophe," Lytton became desperately ill and finally died of cancer. There followed a ghastly struggle to prevent Carrington from committing suicide, which was won by her in the following March. Ralph was left shattered by a sense of failure and nervous strain. We grasped at the offer made by James and Alix Strachey that we should drive their car for them to the South of France (since they wanted to get there more quickly). Ralph (whose mind was full of death and despair) had the idea that a sort of catharsis might result from our confronting another such period of his life—we would visit the French battlefields of the Great War. Eighteen years after the end of hostilities we drove to Ypres—a ghost town, unbelievably wrecked and riddled—then on to the Flanders village of Oesthove where Ralph and Gerald had been billeted for some time, visiting a family to which Ralph believed he might have added an illegitimate child. Memories of the war were lively and terrible still to this family. We walked through sloping fields where I felt Ralph's amazement as

RIGHT. Frances Partridge, Rachel Mac-Carthy, and Ralph Partridge in a cabanon window, Brittany.

BELOW. Ralph Partridge with Madame Le Roy and family, Château Mersault, Oesthove, Normandy; photograph by Frances Partridge (1932).

he saw how tiny were the stripes of early lost and regained at an appalling cost in human
lives; fields where pieces of equipment or human bones were all the time being turned up by
the plough; the place where he had been buried by a shell-burst at Verdun and saw them shed
the shrapnel still deep in their branches. We descended some trenches which had been pre-
served as a living museum, and we looked at one another and asked how it was possible
that anyone who saw what we saw should not utterly renounce War, as we both had done.

In several of her memoirs Frances Partridge discusses her attitude and that of the
other Bloomsbury figures to war. In *A Pacifist's War,* her first publication, she examines
Clive's particular blend of hedonism and optimism.[5] She recalls him as "determined not
to alter his way of life unless he has to, and to go on getting all the enjoyment out of it
that he possibly can."[6] She herself, alarmed by the German devastation of Paris,
expressed her certainty "that France will make peace in a few days. But will we?"[7] It was
always her point of view that human life was worth preserving at all costs. In 1941, she
found it hard to convince even Quentin Bell of her most passionate beliefs: "I tried to
convey the sense of constant disgust I feel weighing on me whenever I think of it, and he
looked at me in surprise and said: 'Oh I see, you are a real Pacifist.' Why are people so
loth [*sic*] to recognize the fact, I wonder. I find no difficulty in recognising their belli-
cosity." If the Bloomsbury group as a whole were, as she points out, not very interested in
politics, by 1939, the surviving Bloomsbury figures except Clive were sufficiently con-
vinced of Hitler's monstrosity to put aside their pacifist convictions.[8]

In her most recent memoir, *Life Regained: Diaries 1970–72* (1998), Frances Partridge
reflects on the notion of diary-keeping, claiming that one of the motives behind it is

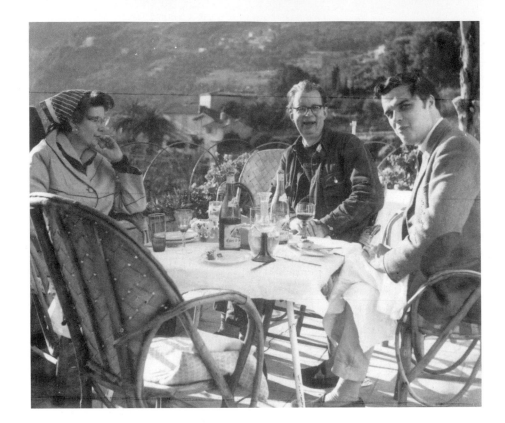

Julia Strachey,
Lawrence Gowing, Burgo Partridge near
Roquebrune;
photograph by
Frances Partridge.

generally a "love of the truth and a desire to record it. Writers who enjoy powers of invention or fantasy will take to another medium and probably become novelists."[9] Even as she wishes she had begun her diary earlier, when life was more cheerful and her feelings more intense, she states that she writes now "out of a deep conviction that life itself is important, is good, is meant to be lived—even if the world as a whole is none of these things) (accepting that life is part of the world.")[10] She reflects, in her own writing, what she describes as "Proust's powers of visual elaboration."[11]

She offers, without malice, sharp thumbnail sketches of her friends, going on, as she puts it, "Like a cow ... chewing the cud of recent experience."[12] In *A Pacifist's War* she describes a visit of Desmond and Molly MacCarthy to Ham Spray House in July 1941. She was obliged to borrow a battery for Molly's earpiece from the cowman, but was amply repaid by Molly's being "brilliantly funny," wildly pitching the black currants they were picking all over the lawn.[13] In May 1942, on another visit, Molly put on, with Desmond, a "fine display of MacCarthyism—the utmost charm and the utmost lack of consideration." In wartime, with rationing a necessity, they arrived as houseguests with "not a speck of butter or sugar, which didn't prevent them from taking sugar in every

David "Bunny" Garnett at his home, Le Verger de Charry in the Lot; photographs by Frances Partridge.

cup they swallowed." When Molly lost her glasses, Julia Strachey and Frances were forced to spend a great deal of time and effort looking for them. They finally discovered her sitting cozily in her bed wearing her spectacles, having neglected to tell them they had been recovered.[14] Molly was, as always, forgiven for the entertainment her talk provided.[15] In May 1945 Molly came once more to visit Frances, this time forgetting her ear trumpet. Frances recalled that she

> had forgotten what an effort it is bawling at her, and how stupid one's bawled remarks sound, while hers are all subtlety, wit and imagination. She is as much out of this world of today as anyone could be, her deafness and her originality combine to prevent her modulating herself to the times.[16]

When Molly had spent a sufficient time in bed, she would come downstairs "waving and blowing kisses, with a bunch of the flowers out of her bedroom vase stuffed rather wildly into her bosom."[17]

Ralph Partridge died of a heart attack at Ham Spray House on December 1, 1960. In *Hanging On: Diaries 1960–1963*, Frances wrote, "Now I am absolutely alone and for

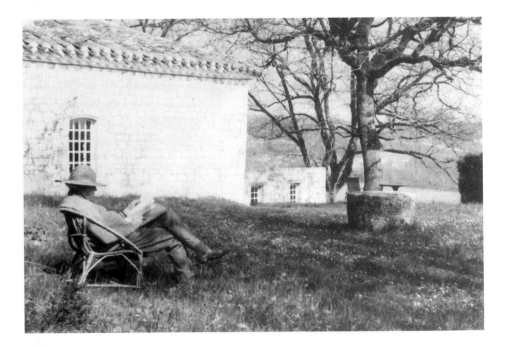

David "Bunny" Garnett at his home, Le Verger de Charry in the Lot; photograph by Frances Partridge.

ever."[18] The Partridges' son, Burgo, who had married Angelica and David Garnett's daughter, Henrietta, also died of a heart attack, on September 7, 1963, aged only twenty-eight. Many years later, in *Life Regained*, she expressed regret that she did not "start diarising earlier when life was full of excitement and thrills, instead of filling so much space with sadness and longing. Perhaps a little in *Good Company* and more now in *Life Regained*, I am aware that I am sending down roots and spreading stems of my own, though I miss Ralph and Burgo and the warm life of Ham Spray not a whit less and never shall."[19]

In April 1960 Janie Bussy died tragically in London in an accident caused by a faulty gas water-heater; her mother, Dorothy, who was senile, was moved to a nursing home and knew nothing about the accident.[20] In December that year, shortly after Ralph's death, Frances was invited to accompany Dorothy Bussy's niece, Julia (Oliver Strachey's daughter), and her second husband, the art critic Lawrence Gowing, to evaluate Simon Bussy's paintings, as the Bussys had died intestate. The paintings had been left at La Souco, their home near Roquebrune, and the problem of their disposition was still unresolved. The eleven heirs had been quarreling among themselves, and an outside opinion was necessary. Frances found La Souco abandoned and dilapidated, a sad reminder of days past. Vanessa Bell and Duncan Grant, who had stayed at La Souco earlier in 1960, hoping to restore Vanessa's failing health, had also found it bleak and depressing.

Frances Partridge and Desmond Shawe-Taylor on a picnic in the south of France.

Many entries in Frances's diaries concern her travels in France. Among the more buoyant memories is one of 1965, as recounted in *Other People: Diaries 1963–1966*, when she spent April in Paris with Eardley Knollys (owner of the Storran Gallery), before they went driving and walking and picnicking over the "pale spring-green plains of northern France." On April 30 they arrived at the "divinely beautiful" town of Nancy, where they stayed in an immense hotel overlooking the Place Stanislas.[21] Roger Fry had once the same square described at length in a letter to Vanessa. Lytton Strachey also visited it in late 1931 on his final journey to France. He wrote of the gourmet meals he consumed at the Café Stanislas and the Grand Hotel in "A Fortnight in France," the memoir written shortly before his death.

In 1962, in the volume entitled *Hanging On*, Frances Partridge writes of her realization that she

> ought now to embark on a new stage: and that is to live *in* my solitary London environment, to allow myself to draw a deep breath *here* in West Halkin Street, to let my foot down through the water till it rests flat, to face what my life is, and try to lead it. For with all my pride in accepting the reality-principle I have not done that hitherto. I have restlessly, feverishly, exhaustedly done anything that offered, snatched up any temporary solace which would get through an hour and prevent my thinking. Why has it taken me so long to realize it?[22]

The last surviving member of the Bloomsbury group, Frances Partridge has carried on the tradition of the Memoir Club, evoking the personalities and atmosphere of the

original community, about which she has always been extremely perceptive.[23] "More and more," she wrote two decades ago, "do I find my satisfaction in relation with friends,… I dislike, and try to avoid any feeling of bungling or even flat pointlessness in a human contact."[24] It is to her that we owe one of our finest and clearest pictures of the original Bloomsbury group. Without her recollections we would have but an incomplete conception of the Lytton Strachey, Ralph Partridge, Carrington, the MacCarthys, Clive Bell, Roger Fry, and David Garnett, and of the critical decades of the Bloomsbury/France intersection.

II Painters Across the Channel, 1910–1938

For over four decades France beckoned, with an undeniable intensity, to the Blooms-
bury artists who make up the center of this book. As a rule they arrived by ferry in
Boulogne or Dieppe, often stopping to see Ethel Sands and Nan Hudson at the Château
d'Auppegard in Normandy. For a few days they would savor Paris, visiting the Louvre,
seeing artists' studios, painting, and meeting long-standing friends in cafés. They would
then move on to the Midi for several weeks or months. They would lease or renovate
houses near the coast, in St.-Tropez, Cassis, and other locations, settle in, and then make
expeditions to visit artist friends in Marseilles, Roquebrune, Vence, and St.-Rémy. Lead-
ing harmonious and productive lives, they reveled in the totally un-English light and col-
ors of southern France. Many of the finest works of Duncan Grant, Vanessa Bell, and
Roger Fry were directly or indirectly inspired by French art; such visual translations are
the subject of the final chapter in this section.

Vanessa Bell, *Le Pont Neuf, Paris* (1921).

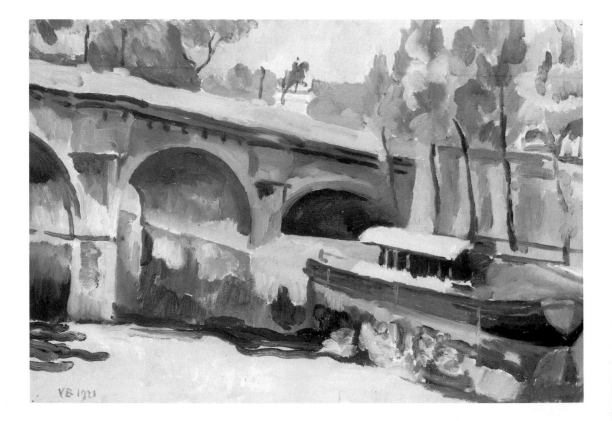

Painters in France, 1910–1921:
Duncan Grant, Vanessa Bell, Roger Fry

The show will be a great affair. I am preparing for a huge campaign of out-raged British Philistinism.
　　　　　　　　　　　—Roger Fry to G. L. Dickinson, October 15, 1910

I have been the centre of a wild hurricane of newspaper abuse from all quar-ters over this show of modern French art.
　　　　　　　　　　　—Roger Fry to Sir Edward Fry, November 24, 1910

1910–1911

In September 1910, Roger Fry and Desmond MacCarthy were crossing to France on the Newhaven–Dieppe ferry, little thinking they were in the vanguard of a project that would be termed "epochal" and have momentous cultural consequences in Britain.[1] Desmond, in fact, had been feeling terrible from a bout of influenza, but Roger lured him aboard the boat with a bottle of champagne, which, according to one account, they began drinking at Victoria Station in London. The two were bound for Paris in order to select paintings for "Manet and the Post-Impressionists," an exhibition of French paint-ings scheduled to open November 8, 1910, and to run through January 15, 1911. It was planned on short notice by today's standards, but the Grafton Galleries had a late-autumn vacancy and invited Roger to arrange an exhibition. He had been thinking for some months of presenting the new French painters to the British public. When the opportunity came, he persuaded Desmond to act as secretary and help assemble the show. He was present while it was open, overseeing arrangements and receiving a com-mission on paintings sold (the number was unexpectedly large).

Robert Dell, the European correspondent of the *Burlington Magazine*, which Roger had helped to found in 1903, had already organized a similar exhibition in Brighton earlier in the same year.[2] Although it had made little impact on the British public, the fact that the paintings were still available facilitated the process of choosing pictures for the new exhibition. Fortunately, Dell, back in Paris and familiar with the location of many works, enjoyed escorting Fry and MacCarthy to galleries and dealers. Within two

MANET
CEZANNE
GAUGUIN
VANGOGH
MATISSE
&c

NOV· 8
TO
JAN· 15·

GRAFTON·GALLERY
MANET AND THE
POST·IMPRESSIONISTS

Exhibition
poster for
"Manet and the
Post-Impression-
ists" (1910).

or three days, they were able to assemble the major part of the exhibition. Desmond recalled Roger's "raptures. He would sit in front of them with his hands on his knees groaning repeatedly, 'Wonderful, wonderful.'"[3] The artists chosen were not, at the time, obscure, but were well-known in Paris: Cézanne, Matisse, Gauguin, Vlaminck, Rouault, Derain, Manet, Van Gogh, Signac, and Seurat. Desmond remarked that he would pose as the British "M. le Publique" and firmly reject any potentially outrageous works.[4] Roger and Desmond returned to London and then, in October, crossed again to Paris in order to select more paintings for the exhibition. This time Clive Bell, who was living in Paris, accompanied them on their search. Ottoline Morrell, who had excellent taste and the eye of a connoisseur, joined them as well and assisted with the final selection. The catalog eventually listed 159 paintings, 52 drawings, 13 sculptures, and 9 pieces of faience pottery.[5]

When Virginia Woolf made her famous assertion that "on or about December 1910 human character changed,"[6] she was arguing for the revelation of character in fiction through internal modes of perception rather than through external details. It is probable, however, that she was also remembering the upheaval in the art world caused by the exhibition, which included artists also concerned with interior vision and not with mimesis of the exterior physical world. On the spur of the moment, Roger had chosen the term "Manet and the Post-Impressionists" to indicate those painters who came after the Impressionists, had been influenced by Manet, and sought to represent their own inner concept of reality. Some of the criticisms leveled against the exhibitions concerned the title, since Cézanne was actually a contemporary of the Impressionists and did not come later, and since there was, strictly speaking, no "post-impressionist" school in France as such. The selections themselves puzzled and angered other journalists, one of whom who called the mixture of styles, forms, and nationalities of artists Fry's "frittura mista," and another of whom saw in the exhibition "a widespread plot to destroy the whole fabric of European painting."[7]

Scandal brought attention, however, and eventually conversion for many visitors. The excitement and the lasting effect of this invasion of insular British culture by these outsiders are incalculable. One historian has termed the exhibition "the definitive introduction of modern difficult art into the English-speaking world," and pointed out that it paved the way for the "modernism of Woolf, Strachey, Keynes, Bell, and Grant."[8] What certainly changed was the way the English were invited to look at art, an invitation many accepted. Confronted by Manet's *Olympia*, the public was startled by the body of the model, flat and undifferentiated, as much as by her direct gaze, the black servant, and the lowering black cat. In Manet's great patches of color, light struck the object frontally, erasing detail.[9] Fry, whose interest in Cézanne had been aroused by Maurice Denis's article on him,[10] had translated the piece for the December 1910 issue of the *Burlington Magazine*. He wanted to link Cézanne's technique of "spatial construction ... and self-referential style"[11] and Manet's modernism as the precursors of a new way of viewing art. This mode of perception was not purely mimetic or reactive (as the Impressionists had reacted to the impressions of nature), but was essentially the creation of form free from "pseudo-literary" association, to be valued in itself. Later, Fry would acknowledge more of a link between the Impressionists and Cézanne, his openness of mind permitting him to shift the angle of his opinions without embarrassment. He bitterly regretted not having recognized the greatness of Cézanne until after his death in 1906. He now spoke clearly of his distrust of any fixed system and determined to retain his practical and provisional aesthetic and the "inlets of fresh experience," even at the price of "making temporary chaos" of his own system. That system would, he insisted, rearrange itself to take in the new impressions.[12]

Roger had chosen these paintings because, as Virginia Woolf described the scene, they were "bold, bright, impudent almost." She recalled Roger's attitude, "gazing at them, plunging his eyes into them as if he were a humming-bird hawk-moth hanging over a flower, quivering yet still. And then drawing a deep breath of satisfaction, he would turn to whoever it might be, eager for sympathy."[13] Her phrase "quivering yet still" perfectly expresses that mixture of intense concentration with which Fry saw, chose, and pointed at what he loved.

The British public failed to show the same enthusiasm for the exhibition as those gathered around Roger Fry.[14] When C. G. Holmes, the director of the National Portrait Gallery, wrote a brief guide for it, *Notes on the Post-Impressionist Painters*, he clearly had reservations about the selections, observing in a lukewarm manner that any sort of stimulus was a good thing. Clive, however, pointed out how little of the revolutionary significance of the exhibition Holmes had realized at that point.[15] The exhibition was, of course, crucial for the development of modernism as we now think of it,[16] but at the time it threw vis-

itors into "paroxysms of rage and laughter," as Virginia Woolf put it. Clive had shared Roger's interest in contemporary French painting and found himself defending it to Lytton, who had considered the two of them "downright silly about Matisse and Picasso." He had drawn Clive aside to ask, "Cannot you or Vanessa persuade Duncan to make beautiful pictures instead of these coagulations of distressing oddments?"[17]

The show was to have momentous consequences in introducing new modes of French aesthetic perception not only to the British public but also to young English artists. Vanessa Bell was one of the young artists profoundly influenced by it, although she had long been familiar with the work of Cézanne and Matisse. Virginia, writing from the perspective of 1939, observed that at the time Vanessa, with all "the ardour of the young for the new movements and the new pictures," was urging Roger "away from the past and onto the future," making him act and seem years younger than he was.[18] Vanessa recalled, "That autumn of 1910 is to me a time when everything seemed springing to new life—a time when all was a sizzle of excitement, new relationships, new ideas, different and intense emotions all seemed crowding into one's life. Perhaps I did not realize then how much Roger was at the centre of it all."[19] In retrospect, for the Bloomsbury group at the time and somewhat later for the public, the season of the exhibition was the turning point Virginia Woolf had detected. The change in human character she spoke of was first perceptible to those closest to this art and its champions, including Roger, Duncan, Desmond, and Vanessa.

After the exhibition closed, Roger had a number of important offers, including the directorship of the Tate Gallery, which he turned down in favor of lecturing, writing, traveling, and organizing other exhibitions. His relationship with Vanessa developed into a romantic attachment in the course of a trip to Turkey in April 1911. He and Harry Norton had joined the Bells en route to the Mediterranean, but at Brusa Vanessa had a miscarriage and was very ill. While Clive stood by helplessly, Roger nursed her until Virginia arrived to take her home by train; by then Vanessa and Roger had realized they were in love.

Four months later, in August, Roger felt he needed a vacation from the tumult and varied enterprises that had succeeded the exhibition. He and Duncan embarked on a bicycle tour around the Berry region in central France: Bourges, Limoges, and Poitiers. At the outset Clive joined them at predetermined train stations, but later he consented to cycle. One day the three were drinking absinthe at the Café de la Rotonde in Poitiers and were somewhat tipsy, except Duncan, "who could only manage to drink it by holding his nose." Roger wrote Vanessa, "When one gets into France and the sun is shining on little towns, all grey brown roofs and grey walls, and the poplars are golden in the autumn light, I must be rather happy at the mere sight...." He called himself a "queer Pagan creature," longing to travel in France with Vanessa, but then he burned a candle

at the shrine of Ste.-Radegonde, presumably hoping for the future.[20]

Roger's unbounded love for France was always contagious. It was a painter's love, ultimately visual, and at times he equated it with his feelings for Vanessa. He wrote her on October 13, 1911, "I've so wanted you to see everything.... I can't draw it but my mind is full of visions of great sloping hillsides with square set farms on top & walnuts & poplars & oxen & peasants dotted down the slopes." They would travel in France together one day, but not until 1914.

When Duncan went back to Paris for a quick trip in 1911, Roger recommended one of the hotels he preferred, the Hôtel Pas de Calais, 59 rue des Saints-Pères, and gave him introductory letters to Gertrude Stein and to Matthew Prichard. He developed friendships with both. Prichard was a specialist in Byzantine art; Roger assured Duncan he could show him "a good many things.... He is a great Bergsonite, so you must either avoid that subject or be prepared to *listen*." Fortunately, Duncan was always prepared to listen.[21] His encounter with Byzantinism, or what Fry considered "proto-Byzantinism," or an emphasis on form, had an obvious effect on the stylized and decorative lines of his *Bathing* mural (1911) for the Borough Polytechnic's student refectory. Commentators have often considered it to be influenced by Signorelli's frescoes at Orvieto as well as by the work of Matisse.[22] Much of his subsequent work also showed the impact of Matisse, who was greatly admired by all the Bloomsbury painters.

The Hôtel Pas de Calais, 59, rue des Saints-Pères; photograph by Sarah Bird Wright (1990).

1912–1914

Roger Fry hoped to build still more permanent bridges between the British and Continental worlds of art. In July 1912 he organized an exhibition to present English artists to a French public, the "Exposition de Quelques Artistes Indépendants Anglais" at the Galerie Barbazanges, Paris. He then organized the Second Post-Impressionist Exhibition of English, French, and Russian artists, also at the Grafton Galleries in London, which ran from October 5 to December 31, 1912. The exhibition was a second attack on

"fatal English prettiness." The preface, which Roger wrote and signed, spoke convincingly of his belief that artists should find a "new and definite reality," independent of outside or literary associations and enclosed in the self-contained space of the canvas.[23] It was the creation of a new form that Fry sought; this was the germ of what was later to become Clive Bell's "significant form," the key to his *Art*. This was written when Roger had lacked the time or the impulse to write his book on Post-Impressionism and suggested that Clive do so.[24]

Fry intended to show the ways in which impressionism had expanded from its French origins and taken root in other countries, specifically Russia and England. In the second exhibition, the French works of art by Cézanne, Bonnard, Matisse, Picasso, Derain, Marchand, and others that Ottoline, Desmond, and Duncan had helped Roger select in Paris were juxtaposed with Russian and English paintings. The Russian paintings were chosen by the mosaicist Boris Anrep, husband of Helen Maitland, who would eventually become Roger's companion until his death in 1934. The English paintings, by Vanessa Bell, Duncan Grant, Frederick Etchells, Henry Lamb, Wyndham Lewis, and Eric Gill, were chosen by Clive. Their purpose was to show the kind of exchange that Fry so firmly believed in, between Great Britain and the continent. By this time, he considered that Matisse had taken on his full import; in 1911 he had written the French painter Simon Bussy that he had become "completely Matissiste." In the new exhibition Picasso and Matisse were the stars, as Cézanne and Gauguin had been in the first one. Matisse's *La Danse*, the culminating image of the 1912 exhibition, was a clear influence on Duncan, especially his *Blue Sheep Screen* of 1913.

During the second Post-Impressionist Exhibition France was again explicitly on display. Roger had invited his friends Jean Marchand and Charles Vildrac to come to London as representative French artists, in addition to Jacques Copeau, one of the founders of the *Nouvelle Revue Française* and a man of the theater. Before the opening, Duncan wrote Maynard Keynes, "A great many of the French painters have already come and are very interesting. The Matisses are radiantly beautiful."[25] Leonard Woolf, who had just returned from his honeymoon on the Continent after his marriage to Virginia Stephen, served as secretary, the position Desmond MacCarthy had held during the first exhibition. In October 1912, just before the exhibition opened, Duncan, Roger, and Clive again went bicycling in France, this time in the Midi.[26] They began in Avignon and continued to Nîmes and the Auvergne, before taking the train up to Paris for a brief visit. The frequency and apparent ease of their cross-Channel excursions gives some indication of the closeness to France felt by the Bloomsbury group.

In March of 1913, Vanessa wrote her friend Molly MacCarthy, Desmond's wife, to invite her to Paris for a few days in November, to see the Salon d'Automne and to renew their respective wardrobes.[27] Vanessa and Clive and, perhaps, Duncan, would be meet-

ing Roger there. "You know the Vildracs and Doucet and all the people we should see & I'm sure you really ought to have a look at the Paris fashions again soon or you'll get too many hundreds of years behind the times."[28] Molly accepted, and with Rose Vildrac, she and Vanessa went shopping at the Galeries Lafayette, where they had clothes made to order, wanting to "change their looks." Gertrude Stein took them to Picasso's studio in the rue Schoelcher near the Montparnasse cemetery. Picasso was always particularly hospitable to the Bells and to Duncan, both in his studio and in his apartment on the rue La Boétie, where he lived with Olga Kokhlova, the former ballerina. Clive had known Picasso for more than a decade, having seen a good deal of him during his earliest months in Paris. Vanessa, too, found Picasso congenial, and was increasingly convinced of his genius. She and Clive purchased, in 1911, a small painting of his, *Cruche, bol et citron* (*Pitcher, Bowl and Lemon*). It was copied by Quentin Bell for Charleston when the real Picasso was sold in the 1960s.

Of all the painters the Bells and Duncan and Roger Fry knew in France, Picasso, Derain, Matisse, and Marchand were the closest. Even so, when Vanessa and Clive were invited to Matisse's studio at 19 Quai St.-Michel in March 1914, they found his work somewhat disappointing after seeing that of Picasso. Whereas Picasso worked and thought rapidly, changing styles from moment to moment, and was impossible to predict, Matisse painted more slowly. His subjects were often similar and his work recognizable, causing Vanessa to say at one point: "one has seen Matisse," meaning he was more likely to paint in the same identifiable style, whereas Picasso's paintings were varied and unique. During their most inventive period, both Vanessa and Duncan were influenced by Picasso's experiments with *papiers collés*. At the same time, Picasso, in all his changing modes, influenced the painting of Duncan and Vanessa less than the more predictable Matisse. The latter's Fauve paintings had an impact long after his Fauve period had ended, as is evident in the flat unmodulated bright shapes of Duncan's *Blue Sheep Screen* and similar paintings.

Vanessa and Duncan were also influenced by André Derain, another close friend and an original member of what critics called "les Fauves" (the "wild beasts") because of their loud colors and unconstrained forms. Derain had spent part of his Fauve period in London, and his paintings of that time were a major influence on their work.[29] After 1915, however, some of Derain's work would be felt by the Bloomsbury artists to have become somewhat derivative and unsure, whereas they retained their absolute admiration for that of Picasso.

Jean Marchand, another close friend of Roger and Clive, exhibited at the Salon des Indépendants and the Carfax Gallery, and was particularly known for his drawings of the Opéra and the stage and his still lives, more solid than luminous. Walter Sickert called his work "dignified and solid in his sombre way."[30] His extensive correspondence

with Roger, marked by gossip, often concerned his feelings of not being appreciated by the public, feelings Roger was all too able to understand. In 1928 Quentin Bell, a student of painting, would work in the Académie Moderne, a Parisian *atelier* that Marchand would visit once a week.[31]

In 1914 Vanessa went on a biking trip with Roger, a trim figure, as he noted, showing her ankles to advantage under her long skirt. "The attitude of prim decorum is a little strange to me," she told Clive, remarking that her relations with Roger were not only established and comfortable, but unalterable. They did not, however, always share the same opinions about architecture. He had told her of the greatness of Chartres Cathedral, enough to bear the entire reputation of the Gothic. It disappointed her, she confessed to Clive, in comparison with Renaissance Italian buildings, except for its windows with their Cézanne colors.[32] But she loved the Châteaux de la Loire and the little church at Germigny with the ninth-century mosaic that they saw on their way to Sens, for Roger never wasted a moment on a trip. Always he would take his companions seeing, learning, sketching, and debating.

The trip, as Vanessa recounted it to Clive in her letters, sounded relaxed and familial. Vanessa and Roger would have their morning coffee and bread at the hotel before setting off on their bikes in the village. They would pedal slowly around the soporific countryside, browse in some morning market, see whatever Roger had thought worth seeing, and return for their evening meal of soup, chicken, omelet, rabbit, peas, cheese, and sponge cakes. In the evenings her "elderly companion," as she called him (Roger was fourteen years older than Clive) would move from game to game, first playing patience and then billiards. His conversational topics fluctuated as rapidly as his pursuits, as she noted in her letters:

> Account of the Great Man's conversation:
> Gothic Art; Origami; My Art. Roger's Art. Duncan's Art.
> The Art of the Theatre.[33]

The Bloomsbury artists and writers were much concerned with the art of the theater. They loved performing and everything connected with it: staging, costumes, and disguise. The Dreadnought Hoax of 1910, in which they dressed in blackface and exotic costumes and embarrassed Her Majesty's Navy, was one of the earliest manifestations of this obsession (*see* the chapter on John Maynard Keynes). The attachment of the group to France intensified their theatrical passion and, to a certain extent, shaped their expression of it. Duncan and Vanessa were professionally involved in the theater, through the director Jacques Copeau, whom they met in London when Roger Fry brought him over in 1912.

Duncan Grant's collaboration with the theatrical producer Jacques Copeau is well-

OPPOSITE PAGE. Letter from Vanessa Bell to Clive Bell, from Le Lude (1914), with sketch of herself and Roger Fry on bicycles.

billiards with him. He declares I am a genius at it.
in order I suppose to make me play. I see it has just
the amount of technique to make him happy.
Our tour as you see is being conducted on terms
of modesty & propriety — how unlike your bachelor
existence in Paris. I suppose you are at this
moment being fondled under the table by some whore
& presently you will go off with her, thankful that
I'm not there to spoil things. Do you think
you or Duncan or both will meet us anywhere?
Roger seems to think we could easily get to Sens
about Monday or Tuesday if you cared to come
there. Do arrange something.

I am hoping to have a truthful account of your doings in
Paris. Mind you tell me as much as I have told you.
I can't give the account you wished for of the Great Man's
conversation but you can imagine our topics. Art. Sitric Art.
Organic Art.
My Art. Roger's
Art. Duncan's
Art. Art of the
Theatre. etc.
This will convey
more eloquently
than words
the spirit
of our
Tour.
VB

documented. He had met him in London in 1912, when he was twenty-seven. Roger Fry had invited Copeau and the painter and writer Charles Vildrac to lecture for the Second Post-Impressionist Exhibition on French literature and art. Copeau, along with André Gide, Jean Schlumberger, Roger Martin du Gard, and others, had founded the important publishing enterprise called the *Nouvelle Revue Française* (*New French Review*). Duncan's reputation was already established in Paris at that point, since he had exhibited at the Exposition de Quelques Peintres Indépendants Anglais in July 1912, at the Galerie Barbazanges.

In the summer of 1913, Jacques Copeau had seen Harley Granville Barker's production of Shakespeare's *Twelfth Night* at the Savoy Theatre in London. Granville-Barker, a critic, dramatist, and director, effected a radical departure from the traditional elaborate staging of Shakespeare's plays and had a considerable influence on the work of Copeau. On October 22, 1913, Copeau founded the Théâtre du Vieux-Colombier (Theater of the Old Dovecote). His theater, although it presented Elizabethan and Jacobean drama, was to become the most important venue for the avant-garde in Paris.[34] In a manifesto about the new theater, published in the *Nouvelle Revue Française* (September 1913), Copeau stated his principles and objectives, under the heading "An Attempt to Renew the Theater." He was against the star system, against "machines" on the stage and all industrialization, and against decorative formulae. He was for a theater of the simple and the natural, "where the classics will be venerated, and presented as a constant example and the antidote to a taste for illusion…. Let everything unnatural fade away, so that, for a new work, we will have a completely bare stage!"[35] The theater was to become the most important Parisian venue for the avant-garde and have an important influence on the French theatrical scene.

Copeau then invited Duncan Grant, whom he regarded as having a "charming and fantastic imagination," to design the costumes and very simple setting for his production of *Twelfth Night* in Paris, based on his own translation of an adaptation by Théodore Lascaris. Copeau wrote Duncan of his desire for an "absolutely neutral setting—all the gaiety of the form and color being produced by the costumes and the actors' gestures." Duncan's sense of fantasy, said Copeau, was sure to rejoice in this particular comedy. "Everything … is in the timing, the rhythm, the movements, the attitude, the sound of the voice. So imagine a setting in front of which the whole play can take place, perhaps with two or three additional backdrops."[36]

By September 1913 Duncan had sent some drawings to Paris. He then went there to work with Copeau, finding it "a time of pure enchantment: I had found the Theatre of my dreams."[37] Fabrics designed by the Omega group were used for the costumes, and also for the backdrop. The restrictions seemed to appeal to Duncan. Thinking of the fifteenth-century costumes in a painting by Pisanello, he worked with an intensity

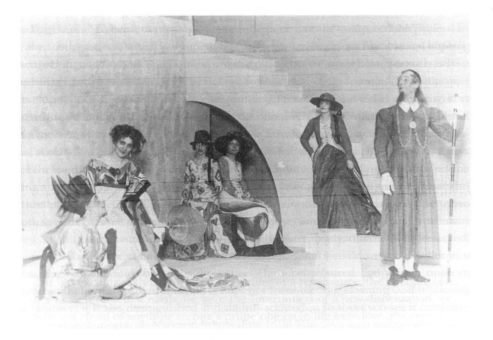

ABOVE. Duncan Grant, costume design for Jacques Copeau's production of Shakespeare's *Twelfth Night* (*La Nuit des Rois*) at the Théâtre du Vieux-Colombier, Paris (1914).

LEFT. Duncan Grant's scenery and costumes for Jacques Copeau's production of Shakespeare's *Twelfth Night* (*La Nuit des Rois*) at the Théâtre du Vieux-Colombier, Paris (1914); the actress at far left is wearing a dress made from an Omega fabric.

Copeau admired. He wanted, he said, to stick to one epoch, rather than using different elements of different times, carnival-style.[38] He went to Paris in April 1914 with his sets in hand to find Copeau, his eager eyes watching everything at the same time, keeping every element of the theater together with a prodigious intensity of effort. People went in and out in silence and André Gide watched from the sidelines, smiling faintly. Even the great actor Louis Jouvet took criticism well. Duncan believed the atmosphere combined good temper, gaiety, and hard work, a climate in which he could himself flourish. He found *Twelfth Night* perfectly played. And, he added, if all the preparations for it made him think of Watteau's painting *L'Embarquement pour Cythère*, he believed, when it was staged, that the actors had indeed arrived in Cythera.[39] Copeau was, in his turn, delighted with Duncan's costumes, finding them "radiant in their fantasy. As for the set: just blue and white cloths, that's all."[40] The play was scheduled to open May 19, 1914, but seems actually to have opened later in the month. (Duncan had already designed Granville Barker's projected production of *Macbeth* for 1914, also for the Savoy, but it did not materialize.) Copeau, who was called "Le Patron," was a man of astonishing energy. He was captivated by Duncan's enthusiasm and wrote him, after the opening, on May 27, 1914: "I have found in you what I so appreciate and what is so rare: a man really in love with his work."[41]

The day after the opening of *Twelfth Night* Vanessa wrote Roger that Duncan still had much to do to the costumes; although she longed to meet him, Duncan was so busy he could not leave for "anywhere—he is much too happy here!"[42] Copeau was understandably delighted by the success of the premiere, writing: "a divine breath came to fill our sail. It was really like setting out and discovering an unknown land."[43] Even Harley Granville-Barker was complimentary about the production, which he found far better than most French productions of Shakespeare.

The Bloomsbury group reveled in their own spontaneous sketches and in elaborate productions of the classics. Members of the group avidly attended the theater in London, being especially attracted to French plays such as seventeenth-century works by Molière and Racine. In 1915 Duncan Grant made life-size marionettes for a reading of Racine's *Bérénice,* staged at the home of the Bells at 46 Gordon Square.[44] Roger Fry attended one party in appropriate dress as the White Knight, and Angelica Garnett and her friends, who, like Janie Bussy, greatly enjoyed costuming, set design, and private theatricals. There were frequent productions at Charleston; often Julian and Quentin Bell took part. They thus carried on a long-standing English tradition frequent during the time of Jane Austen's *Mansfield Park* and, of course, long before. One successful presentation, of which a number of photographs exist, was *Les Précieuses ridicules* (*The Ridiculous Ladies*), Molière's spoof on mannered society and its absurdities. If the Bloomsbury circle loved disguise, their French artist friends enjoyed it no less. In his

early works Picasso sometimes pictured himself as Harlequin (a figure derived from the Italian *commedia dell'arte*), and much later he enjoyed disguising himself for photographs. In 1959 Barbara Bagenal, Clive's companion in later life, took a photograph of the painter in drag, with an indulgent and amused Clive looking on (*see* chapter on Clive Bell).

The stage curtain repeatedly figured in Bloomsbury art, from the domestic to the mythical. It is evident in several still lifes of Vanessa Bell (*Fruit & Vegetables & Bowls on a Table* of 1921, for example)[45] and in such dramatic renderings as Duncan Grant's *Venus and Adonis* in the Tate. The heavily curtained presentations, with drapes at the top or side, framed and distanced like the paintings of Poussin, remind us of how theatrical a scene Duncan Grant could construct and how the performance is being

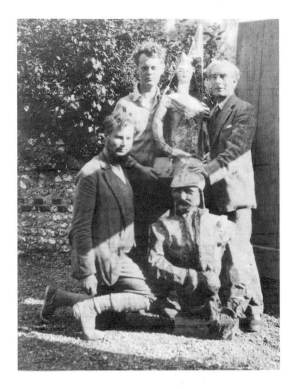

Quentin Bell, Julian Bell, and Roger Fry posing at Charleston, with a friend.

staged for our benefit. The painting is as dramatic as the sets and costumes he did for Copeau's productions of the works of Shakespeare, Maeterlinck, and Gide.

The days Vanessa and Duncan spent in Paris during the halcyon prewar years of 1913 and 1914 followed a set pattern. They would take their time chatting over breakfast in the hotel in the morning and then go out for a leisurely lunch. In the afternoon, they might go to the Louvre, where Duncan, having learned to do so from his early copying of the old masters, would look at his favorite painters with a particularly sharp focus: Poussin, Chardin, and Degas. He had always hoped to meet Degas, an introduction his friend Auguste Bréal had promised to arrange, but it did not come about. Or they might visit the exhibitions in the galleries, or the various dealers with whom they had relations. Once the dealer Percy Moore Turner, at whose Barbazanges gallery Roger would arrange exhibitions of British art, came to look at Vanessa and Duncan's paintings. He said little, but then invited them to send something to his show, and also exhibited Roger's paintings, declaring he was the only English painter he could sell. On some days they would sketch along the quais, or in their hotel rooms, sometimes using Clive's larger room to paint in when he was not in Paris.

Their evenings were spent in cafés with their friends, the way Clive had always spent his in Paris—with the Picassos, the Derains, the Vildracs, Dunoyer de Segonzac, Jean Marchand, and his friend Sofia Lewitska.[46] They might see Moïse Kisling, Ossip Zad-

kine, or Leopold Zborowski (the Polish gallery owner who, in 1921, acted as intermediary to allow Vanessa and Duncan to rent the Vildracs' house in St.-Tropez). After a moment, amid the chat about what colors to use or anything else that arose, Vanessa would usually rummage about in her purse and pull out a pad to sketch with; Duncan would already have his out. The ambience was unhurried and unpressured.

Language rarely seemed to be the issue for Duncan and Vanessa that it had been for Clive in 1904, when the English artists had kept to the English, and he had learned French in order to mingle with the French. Before Clive had known the language well enough to do so, he had spent most of his time with painters such as J. W. Morrice, a Canadian, and Roderic O'Conor, the strange and aggressively opinionated Irish painter. He had frequented Le Pouldu in Brittany, along with Paul Gauguin, Camille Maufra, and the regulars of the Pont-Aven school of painters. After lunching with O'Conor in Paris and seeing his paintings, Roger commented that he was steadily improving, despite the glazes he had begun to put over his work that gave them a "glassy quality."[47] He had, however, become "crankier and odder in his opinions," persuaded that only Delacroix was any good, that Cézanne was "by now a little painter etc. etc." Yet O'Conor retained a fascination for Duncan, who later spent days trying to track him down in the Midi, from Cagnes where he had been, to various other places. O'Conor remained mysterious.

Duncan and Vanessa compensated for any lack of fluency by their total involvement in the life of art. Their conversation with other artists was usually in French, but in a pinch, they could all speak their own languages and be understood.[48] Vanessa and Duncan had strong English accents, but that never impeded communication between painters. Clive, who depended on verbal interchange,[49] delighted in speaking French, but was, by some accounts, a trifle less proficient than he thought himself. Roger's French, both spoken and written, was, as his daughter Pam described it, "inimitable" and fluent. Duncan once read one of Roger's letters to a woman friend, and wrote Vanessa he had found it "a singularly boring letter & not really at all interesting, all these catalogues of events and ideas in French. He has a most peculiar idea … of himself in that language."[50]

The year 1914 was marked by one of the great chance meetings of high modernism, of England, France, Spain, brought about by Gertrude Stein, an American writer who had chosen to live and work in Paris. In February she took Duncan Grant to see Picasso's studio. Duncan discovered that Picasso needed wallpaper for his collages. In his closet at the Hôtel de l'Univers et du Portugal, he found by chance two rolls of wallpaper. The paper looked like a Post-Impressionist painting, with myriad tiny dots. Duncan returned to see Picasso, bearing one of the rolls of paper. He wrote Clive on February 26:

Feb. 26, 1914

Hôtel de L'Univers et du Portugal

Gertrude Stein took me to see Picasso which I very much enjoyed. I promised to take him a roll of old wallpaper which I have found in a cupboard in my hotel and which excited him very much as he makes use of them frequently & finds it very difficult to get. He sometimes tears such pieces off the wall. I think I shall find it difficult to know what to say if I go alone. One wants a Roger's tongue or a Gertrude's bust to fall back onto. I must say I was very much impressed by his new works.[51]

Given the importance of the collage medium in Picasso's work, where the signs no longer refer to the outside world but to each other, and given the striking nature of the wallpaper used in Picasso's collages of February 1914, when he was "finding it difficult to get," the date of Duncan's gift is of notable importance. The stippled paper, probably that brought by Duncan, brings local color as well as the remembrance of things past into Picasso's 1914 collages. It was "a rich mauve, sprinkled with purple and white dots" and seemed to resemble the paintings of Seurat, to "summon up the specter of neoimpressionism, with its pointillist stroke and its chromatic analysis."[52] Light seems to pierce

the collage, playing against the actual opacity of the paper; the intricacies of Picasso's conceptual argument amused the art dealer Kahnweiler.[53]

World War I was declared in August 1914, bringing the end of *la belle époque*.

1915–1918

With the declaration of war came general mobilization and the total disruption of civilian life. Edith Wharton compared Paris on the eve of hostilities to Andromeda "with the monster careering up to her"; in England, Henry James believed that the war threatened "the crash of civilization."[54] It is probable that, at first, members of the Bloomsbury group considered the war a temporary aberration and inconvenience, but this view was discounted early on by the highest British authorities. By the time of the first Battle of the Marne in early September 1914, when the French "taxicab" army was dispatched, it was clear that the fighting would not be over in six weeks as many British and French citizens had hoped and believed.

Clive, whose political leanings were more to the right than those of the others, wrote a pamphlet, *Peace at Once*, that was ordered burned by the Lord Mayor of London. Vanessa, Duncan, and Roger were also on the side of pacifism. Vanessa, writing Roger in May of 1915, was depressed over her painting, and sorrowful that Dorothy Bussy's husband Simon had been conscripted, and would be on duty in a hospital until war's end. "It's all too horrible. How damnable it is that people with ideas utterly different from ones own should have so much power over ones life [*sic*]."[55] Frances Partridge has stated that "none of the group were very interested in ordinary politics. In the early days, they were all pacifists, but later, they would not be able to go along that road any longer. After the first world war, Hitler was too much to swallow."[56] In 1914, however, they listened to Bertrand Russell's pacifist lectures and exchanged letters about militaristic horrors. One of Virginia Woolf's drafts of a plan to ensure world peace was eventually absorbed into the League of Nations.[57]

Duncan and Bunny Garnett appealed to local authorities for exemption on the basis of conscientious objections and were allowed to fulfill their military obligations by doing farm labor. They lived at Charleston with Vanessa and her sons, working on New House Farm near Firle for a farmer, Mr. Hicks.[58] Duncan was not allowed to leave that service to join Jacques Copeau in Paris in November of 1915, where he had been supposed to work on *Macbeth*. The Paris theaters were then closed, with some exceptional stagings only, such as Picasso's *Parade*.

Roger Fry came of a Quaker family long opposed to military service, and, with his sister Margery, joined the Friends' War Victims' Relief efforts in the Marne and Meuse regions. Other longtime Quaker friends, such as Mary Berenson, sister of Logan

Pearsall Smith and wife of Bernard Berenson, also took part in relief efforts at the Front. During his time at the Front Roger wrote a meditation on the land and people and what they had suffered. Thanks to his granddaughter, we have the testimony of an eyewitness to the good works done by the "Mission des Amis," a schoolteacher who saw that the bedding, clothing, furniture, medicine were distributed with total impartiality.[59] He also wrote a memoir of his work at Vitry-le-François, near Châlons-sur-Marne, in war-stricken France. It was a thoughtful piece that he tried, but failed, to publish in the *Nation*.

In May 1915 Roger sought respite from the battlefield at the home of Lytton's sister Dorothy Bussy in her house at Roquebrune (Simon Bussy was away on assignment to a hospital in Paris until the end of the war.) While there, Roger painted several of the more unusual views nearby. In *Roquebrune and Monte Carlo from Palm Beach* (1915–1916), a palm tree thrusts its green leaves high in the air right in front of the towns of Roquebrune, where La Souco sits on the hill, and Monte Carlo with the hills and the Corniche visible behind. Directly against the picture plane, another palm of a light brown color is seen close up, taking up the same space as the two landmasses jutting out. The picture is at once ungainly and enthusiastic, with a sense of the primitive: this is Roger in his Fauve period.

Vanessa, a pacifist, was depressed with her work, in deep disagreement with the political establishment, and angry over the institution of war. She wrote Roger, "It's all too horrible. How damnable it is that people with ideas utterly different from one's own should have so much power over one's life."[60] She was unsympathetic toward the war service of the poet Rupert Brooke, who had joined the armed forces in September 1914 and had been sent to Antwerp. There he had "found his calling as a warrior" on his brigade's retreat, alongside the "white-faced, endless procession in the night" of the old and weak refugees. This was the source of his sonnet sequence "1914," which was widely admired in Britain:

> To turn, as swimmers into cleanness leaping,
> Glad from a world grown old and cold and weary …

Mary Berenson in Quaker attire; she, with Roger Fry and other Quaker friends, took part during World War I in relief efforts at the Front in France.

Henri Doucet,
*Portrait of Julian
Bell* (1912).

In April 1915 Brooke perished aboard a French hospital ship near Lemnos, in the
Dardanelles. At first it was thought he had died of sunstroke, like a mythical figure (as
D. H. Lawrence wrote, "Bright Phoebus smote him down.") He actually died of blood

poisoning. Vanessa wrote Roger that she neither knew him nor cared about him, but supposed it would be terrible for those who might have. His unblemished body was carried in a procession like that of a hero, and was buried with an olive wreath on Skyros. Virginia Woolf, lamenting his death and that of all the British soldiers in France, saw "people dying everywhere."[61] Septimus Smith, shell-shocked and suicidal, haunts her novel *Mrs. Dalloway.*

In 1912, Henri Doucet, a close friend of Roger Fry's, who would be killed in World War I, had painted a portrait of Julian Bell, who was four years old at the time. It is a delicate and gentle rendering. As in many photographs of the young Julian at Cassis, a highly sensitive nature emerges, with a faintly feminine quality. Vanessa had gone with Doucet on a painting expedition to Villeneuve-les-Avignon, and the Bells had several of his paintings. He died in Belgium in 1915. Vanessa lamented: "How terrible a waste that such a charming gentle creature should be killed." Vanessa and Roger, always concerned about their French friends, tried to devise a way of getting his widow over to England in 1917.[62] They hoped she might be able to help with the Omega Workshops, having a French sense of style. But that project was itself in financial trouble, and eventually Roger would give it up as too expensive and time-consuming.

The sense of helplessness was widespread in England. In the larger world, the conflagration provoked more avant-garde manifestations: the Dada movement in Switzerland and Germany, Futurism in Italy and Russia, Vorticism in England. Art changed, as did painters and writers. After the war, in all the arts, a kind of despair translated itself in a "return to order" that would signal the end of a certain sort of experimentation, in Bloomsbury as elsewhere.[63]

In 1917 Jacques Copeau brought the Vieux Colombier troupe to New York as part of a Cultural Mission, with the celebrated actors Louis Jouvet and Charles Dullin. This was the initial presentation of Jean Cocteau's ballet *Parade*, with Erik Satie's music and Picasso's costumes, and of Guillaume Apollinaire's *Les Mamelles de Tiresias* [*The Tits of Tiresias*].[64] Copeau's production opened at the Garrick Theater, 65 West 35th Street, with the support of Otto Kahn and of the French government, for two seasons: 1917 and 1918. Copeau asked Duncan and Vanessa to

Duncan Grant at Charleston wearing a costume of his design for Maurice Maeterlinck's *Pelléas et Mélisande* (1917).

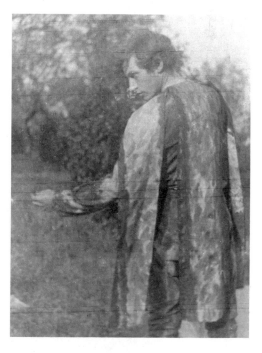

design two screens for the new production of *Twelfth Night*, which they did, and also asked Duncan to "construct" costumes for his production of Maurice Maeterlinck's *Pelléas et Mélisande* of 1918. The costumes would be sewn later, but the construction was done at Charleston, where Barbara Bagenal came down to help.[65] She remembered how, since the mode was at the time for "marbling," they made that kind of costume:

> We mixed the dyes, splashing them on to the large wooden kitchen table, two of us held the material in both hands, laid it on the table, then lifting it up continued until it was marbled....

They "marbled" themselves in the process. She and Vanessa cut out the dresses and tacked them for photographs, and sewed patchwork onto cotton.[66] Duncan had always loved designing costumes as well as wearing them, and he tried on all he made. This time he and Barbara had themselves photographed, their raiment sparkling as they revolved.

The Bloomsbury artists were interested in dance as well as classical theater. On another occasion, Duncan dressed as a Spanish dancer for an improvised sketch of Charleston one hundred years later, with Janie Bussy acting as a visiting American. His rather solemn painting called *The Dancers* dates from the time of his fascination with the ballet.

One of the major events in Roger Fry's life was his meeting with André Gide in Cambridge in August 1918. Not only did Gide seem to like Roger's first translations of the poetry of Stéphane Mallarmé (of which Vanessa said she understood very little), but they hit it off well on a personal level. This new friendship was particularly welcome to Roger at a time when he had not been well and was deeply discouraged about his own art. For once he seemed to gain as much from the relationship as he gave. As he played Roger's virginal, Gide's musical sense was a source of delight for Roger, who wrote Vanessa,

> He played all the old Italian things I have as no one ever played them before & exactly as I have always dreamt they should be played. He's almost too ridiculously my counterpart in taste & feeling. It's like finding a twin.

They shared a way of looking at things:

> He's of course very nice about my work—but quite simple and frank & doesn't try to like the things too much.... But we mostly talk poetry & I've got from him immense quantities of books to read which will keep me going for ages. How I wish I could live in Paris.[67]

Seven weeks after the Armistice, at two o'clock in the morning of December 25, 1918,

Vanessa gave birth to Duncan's daughter, Angelica, at Charleston. She said later she could hear the farmworkers singing carols in the early morning. She, Duncan, and Clive agreed that Clive would be officially considered her father. David Garnett, Angelica's future husband, was staying in the house and probably saved her life a few days later by summoning a knowledgeable doctor when she failed to thrive and was mistreated by the local general practitioner. Maynard, Duncan, and Clive were also at Charleston. Quentin and Julian were with Virginia and Leonard at Asheham, although Clive went on to London to care for them later. Roger had written a worried letter beforehand, anticipating that the baby would consume Vanessa's attention and cause their attachment to decline.[68]

1919–1921

Diaghilev's Ballets Russes had come to London in September of 1918 and stayed nearly a year; Léonide Massine and Lydia Lopokova, who would later marry John Maynard Keynes, were among the stars. Picasso and Derain came over together, having done the sets for *La Boutique fantasque*. Picasso stayed with Olga Kokhlova, his ex-ballerina wife, in the Savoy Hotel. Diaghilev called on Picasso, as he had in Paris in 1917. He put on Picasso's *Parade* at the Alhambra Theatre in Leicester Square once more and mounted the new ballet *The Three-Cornered Hat*, for which Picasso designed both the costumes and the sets, and *La Boutique fantasque*, designed by Derain. Roland Penrose remarks that Derain's designs were as French as Picasso's were Spanish.[69] Duncan and Roger were again on instant terms of friendship with both Derain and Picasso. Derain was at this point renting Vanessa's empty apartment in Gordon Square. He and Picasso came to see Clive's pictures within the first two months. Duncan wrote Vanessa at length about their visit:

> You must see the Derain it is really enchanting & apparently there was a terrific scene of enthusiasm after the first night & a party ... to which Picasso, Derain, Ottoline & all the world went. Derain pretended to be unmoved by his success but was said to be obviously delighted & got very drunk. Lytton sat next Madame Picasso & Ottoline next Picasso. It's so extraordinary to see the scenes & dresses done by a painter. I have never done so before, it's quite a different thing & adds to the triumph of modern art much to the discomfiture of the upper and cultured classes. Met Derain and Picasso last night they were both very friendly indeed & Picasso remembered me at once. I am going to see Derain in your flat Tuesday. They came last week to see Clive's pictures & *you* had a superb triumph—the picture they liked best in the house (they were very enthusiastic about the Cézanne & the Ingres) was your tray picture. "C'est vraiment très fort" they said. ["It's really

very strong."] Isn't it splendid? According to Clive who of course is very suspect they don't really admire Roger's painting. Derain said that with my gifts I ought to attack "des grand problèmes" but I don't really understand what that means.[70]

After the ballet, Ottoline Morrell introduced Duncan to Diaghilev and, he reported to Vanessa,

> We then traipsed round to meet the artistes by the back door & were ushered into a not very large dressing room where we were introduced to Massine the principal male to whom I took rather a fancy. I am going round to see his pictures tomorrow evening. He has a very good collection apparently but most have been left in Rome. He is coming round here one day to see the pictures.[71]

Massine liked Duncan also. Duncan later wrote Vanessa about a subsequent meeting: "I was rather touched by Massine who said 'it's a pity you do not come to London. There are a great many people—but too few.'"[72] Duncan interpreted Massine's remark as meaning the crowds in London did not compensate for Duncan's absence.

Roger Fry, in London for the ballet season, was overwhelmed by the avant-garde art of the stage sets created by the Russian futurist Mikhael Larionov for Massine's ballet *Le soleil de minuit*, which had been presented at the London Coliseum in November of 1918. There was a deep blue background, with red and green sides. The year 1919 marked the pinnacle of excitement over the ballet, when Diaghilev and Massine became household names to Ottoline and to the other members of the Bloomsbury group. Clive Bell and Maynard Keynes gave a celebrated banquet for the company, wearing aprons and serving as waitresses (*see* chapter on Clive Bell). Roger, who had returned to France, wrote his sister Margery from the train en route to Provence that he had met Mikhael Larionov, who was tall and round-cheeked and blond, his wife Natalia Goncharova, brown and equally round-faced, who both showered him with their publications and enthusiasm. Larionov was "so full of ideas that as he can hardly speak French and all has to pass via Gontcha, conversation's almost impossible because before she's translated a phrase, he's gabbling a whole lot more Russian into her ear to the complete distraction of the whole affair." He had also met Dunoyer de Segonzac.[73]

Roger, Duncan, Clive, and Vanessa continued to find Paris alive and exciting after the war. In 1919, Copeau's Théâtre Vieux-Colombier, with Louis Jouvet and Charles Dullin, returned to Paris. The Armistice had been declared in 1918 and the Paris theaters, officially closed in 1915, had reopened. Diaghilev was staging *Le Tricorne*, with de Falla's music and Picasso's costumes and sets. In 1920 Copeau staged Shakespeare's *The Winter's Tale* and Charles Vildrac's *Le Paquebot Tenacity*. Vildrac was a friend of many Bloomsbury figures, and they all seem to have seen the play either in Paris or in London, where

Mikhael Larionov, sketch of Léonide Massine and Sergei Diaghilev at dinner, inscribed "A Duncan Grant, son ami Larionov" (c. 1920).

it was performed at the Lyric Theatre in Hammersmith in June 1920. Roger found it to be, as he wrote to Marie Mauron, "a slice of real life on the stage ... the naturalism of the human soul with all its indecisions, incompetences and incoherencies, and it's precisely for that it's very moving and touching. One senses in it the inherently pathetic nature of the human situation, the utter weakness of man before destiny."[74] *Le Paquebot Tenacity* had little success in England, where it was attacked by critics, as opposed to its reception in Paris. Roger saw this as indicative of why "it's almost impossible for an artist to live in England: one feels so isolated."[75] At this point, Diaghilev was staging Stravinsky's *Le Chant du rossignol* with Picasso's sets and *Pulchinella* with Léonide Massine (performed at the Théâtre National de l'Opéra on May 15, 1920). The Théâtre National Populaire was founded in Paris with a massive government subvention. Rolf de Mare arrived with his Swedish Ballet, and Louise Lara and Edouard Autant created their theater of "Art et Action." Nothing more unlike England could be imagined, and the Bloomsbury artists longed to remain Parisian.

Paris was not, however, to be a place of permanent residence for any of the four. Roger did not live there after the six-year period he spent in art school ended in 1896, and Duncan was in the city full-time only while studying art from 1906 to 1907. Clive

began his life in Paris in 1904, as recounted in *Old Friends*, and enjoyed extended stays in the city for the rest of her life, although he was legally domiciled in England. Vanessa had lengthy visits to Paris, but was never a resident of the city. Although it sometimes seemed to Roger, Duncan, and Vanessa that retaining a studio might be the ideal solution, none of them did so.

Vanessa and Duncan went to Paris as often as they could, staying in hotels on the Left Bank; their favorite hotel was the Hôtel de Londres on the rue Bonaparte. Clive also liked this hotel, and, for his long stays, would be given a large room. They would meet their friends for incessant discussions of art, painting on the quais, visiting the theater, and seeing art in galleries and museums. They were never mere tourists in Paris. After the war, particularly, they had in a sense the best of both France and England, as they saw French art and artists in London with almost the same frequency as they did in Paris. In the off-season of July 1919, they saw the Matisses and Picassos at Heals, followed by an exhibition of works by Roger de la Fresnaye in August; Duncan felt the month to be an inappropriate time to have such superb exhibitions. Clive and Duncan then went to the Sackville Gallery to see Poussin's *Sacrifice of the Golden Calf*, marveling at its condition and color. Their Anglo-French vision was as fruitful for their art as it was for their minds.

Roger visited Derain's studio in 1919, writing Vanessa that it was "extremely simple and unpretentious, just an old garret with a top light."[76] This was of course the kind of studio they would all have liked to find in Paris, thinking they could best paint there: but none of them succeeded in locating such an ideal working space.

As the decade of the 1920s began, Duncan was staying in Paris in a flat he was lent at 45 Quai de Bourbon, at the tip of the Ile St.-Louis, with views of Notre-Dame. A typical day for him is illustrated by a letter he sent to Vanessa on March 16, 1920, soon after his arrival. The flat was "full of large Bonnards & Vuillards & exquisite views over the Seine with an old world French houseservant called Jean. I have only seen it all by the light of the sunset...."[77] That night he dined with Maynard Keynes at Lapérouse, an elegant restaurant on a nearby quai. On her visits to Paris at this time, Vanessa was excited about seeing and discussing everything in the art world: the exhibitions, the colors, the gossip. Conversations about art, the shop talk she adored, were essential to her vitality. In May 1920 she described an evening in Paris to Roger:

> Dined last night with Derains, Braque & Mme, and Satie—sat til 2 am outside Lipps talking in the end only to the Derains—all the others went. It was very hot & got delicious at that hour. Derain was perfectly charming & so was she. In fact the more I see of her the more I like her & the more am I overcome by her beauty. I think she's one of the most astonishing people I've ever met & less terrifying than she was at first.[78]

Generously aware of the beauty of Alice (Géry) Derain, whom Picasso painted on several occasions, Vanessa was clearly unaware of how her own beauty might impress others; this was one of the more endearing characteristics of "la grande Vanessa." It was no wonder that many of the painters were so fond of her, particularly Dunoyer de Segonzac and Picasso. Paris life always agreed with Vanessa more than that of London, because of the shared interests with her friends. She thrived on discussions about painting. Evening after evening, they would all stay up until two or three at the Brasserie Lipp, talking with Derain and Segonzac and Gide and Vildrac and Picasso. They often went to see Copeau and his family. Sometimes they would discuss literature and life with Gide and with the poet André Salmon, Apollinaire's amusing and garrulous friend.[79] The least interesting conversations for Vanessa would be those in which the talk did not turn to painting, as was sometimes the case when Clive talked with the musician Ansermet and the painter Kisling. Clive, not a painter, most enjoyed gossip, but Vanessa always preferred shop talk, or what the Bussys in Roquebrune called "cadmium" conversations.[80] Roger Fry, as one might have expected, seemed to enjoy all conversations, being by far the most expansive of the Bloomsbury group.[81]

Color was of primary importance to Vanessa, as it was for Roger and Duncan. She had loved Picasso's pastels and his sets for the ballet *Parade* of 1917, with its white and gray and brilliantly colored figures. She particularly admired Derain's nudes at the Bernheim show in 1919, two large figures in whites and grays and burnt siena. She found the theatrical sets designed at this time by Derain and Picasso equally appealing in their unconventional use of color. Her opinions influenced Roger, who, under her tutelage, came to appreciate artists toward whom he had previously been lukewarm, such as Delacroix. For example, she admired his murals in St.-Sulpice representing Jacob's struggle with the angel and particularly praised his choice of colors, "so unlike the others at that time."[82] Roger had deplored his "tiresome operative architecture with all its triumphant ornament, melodramatic poses and presentment and the cheap transparent horribly *local* colour ... the opposite of colour which tells far more than it is ... too emphatic not effective, bright not vibrant."[83] Given Vanessa's enthusiasm about the murals, however, he decided to look at them again and found he did agree with her estimate. On the whole he took an immense delight in her constant enthusiasm, although at times their aesthetic opinions certainly differed. As Roger's granddaughter Annabel Cole has pointed out, whatever his disagreement, he was always open-minded and liked hearing another's point of view.[84]

In 1919, Vanessa saw a selection of Vermeer paintings at the Orangerie and wrote Roger that she had been enchanted by "the wonderful landscape with houses with dark blue roofs & water & a great deal of sky" and "the girl with a pearl earring in the blue headdress, and the woman sitting at the table in front of a white wall, and Rembrandt's

anatomy lesson with the foreshortened cadaver." The color, she said, was far lovelier than anyone could have imagined.[85] Roger replied, "How I would love to have seen those Dutch paintings!" Their favorite French writer, Marcel Proust, had seen the same exhibition of Dutch art, including works of Vermeer, and had shaped one of the most celebrated parts of his *In Search of Lost Time* (*Remembrance of Things Past*) around it. In the chapter called "The Captive," the writer Bergotte, getting up from his sickbed to see that "little patch of yellow wall" that he remembers in Vermeer's small painting *View of Delft*, meets his death there, in front of this canvas, and wonders about the worth of art and words, of all his books in relation to life and to death.

It had been Roger Fry who introduced the classic shape of Proust's immense modernist novel and the unremittingly structural nature of his perception to Bloomsbury. Fry's delight in Proust was intense: he inspired the volume of testimonials to him called *M. Proust, an English Tribute*, edited by Proust's translator, C. K. Scott-Montcrieff, in 1923, although he did not contribute an essay.[86] "There are," he wrote Virginia Woolf in 1923, "landscapes in Proust which do certain things painting can't."[87] Certain of Proust's most celebrated descriptions, such as the steeple of Vieuxvicq coming into alignment with the twin church steeples of Martinville, the registering of which marks the beginning of Marcel's writing in the first chapter, "Combray," or that of the uneven paving on the street in the last chapter, "Time Regained," that somehow realigns the entire mental configuration of the narrator, for example, demonstrate how a few visual and verbal rhythms control the entire novel. The various celebrated moments of visionary coherence, which Woolf called "moments of being" and which James Joyce termed "epiphanies," are actually *realignments* of perception and understanding.[88]

When Fry was writing of Seurat and his patterning, or of Cézanne, one of his favorite words, "inevitability," arose again. Cézanne represents, especially in his late paintings of the Mont St.-Victoire, the height of what he meant by nonassociational purity, the classic perception of intervals and parallels. This was the art that called upon the mind and the spirit; it was, for him, the art of France, and of its literature. Roger confessed himself to be "constitutionally anti-romantic,"[89] a classicist, along the lines of his hero Poussin, whose works he went to study every day in the Louvre. What he found thrilling in Poussin was his perfect and "never monotonous equilibrium," justifying his innate passion for a flattening out of vehemence, an absence of emphasis more intense than vehemence could ever be. This was the same argument he made for unemphatic translation.[90]

The best place to see what was going on in the art world as a whole was the Salon d'Automne, held each year in Paris. In 1920, it received particular attention from Roger Fry, who had been displeased by the hanging. He believed that formulaic painting had taken over, with a conventional sort of appearance in a particular group of young painters who

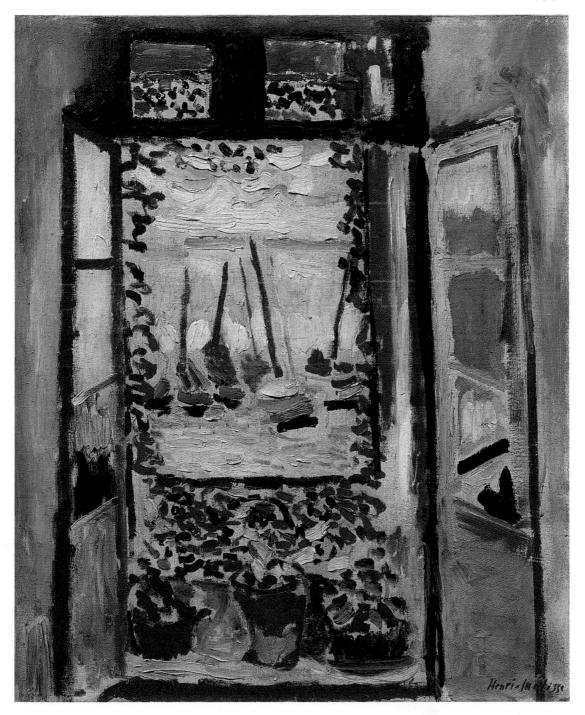

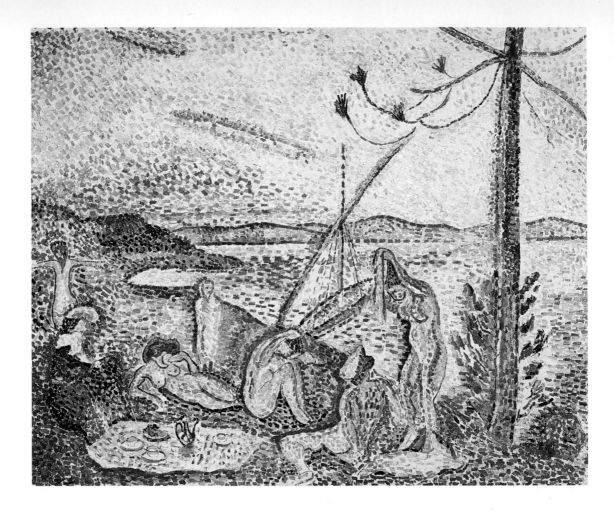

ABOVE. Henri
Matisse, *Luxe,
calme et volupté*
(1904–5).

BELOW. Charles
Vildrac, *Picnic*
(1912).

ABOVE. Vanessa
Bell or Roger Fry,
*Une salle de la
Seconde Exposition
Post-Impressioniste*
(1912).

BELOW. Henri
Matisse, *The Red
Studio,* Issy-les-
Moulineaux
(1911).

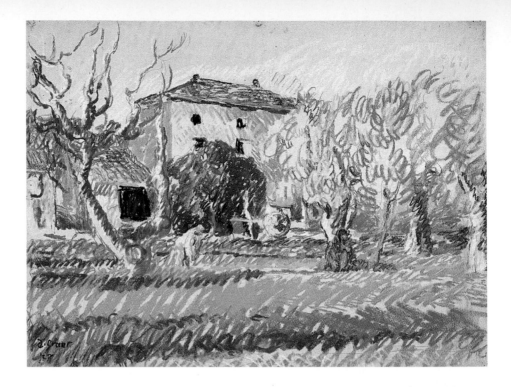

ABOVE. Duncan
Grant, *Farmhouse
and Trees, Near
Cassis* (1928).

BELOW. Vanessa
Bell, *Farmhouse
in Provence*
(1930).

ABOVE. Duncan
Grant, *Lessons in the
Orchard* (1911).

BELOW.
Paul Cézanne,
Mont Sainte-Victoire
(1905–6).

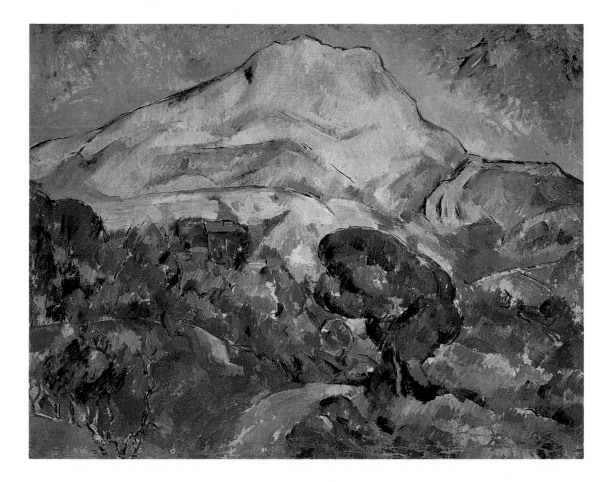

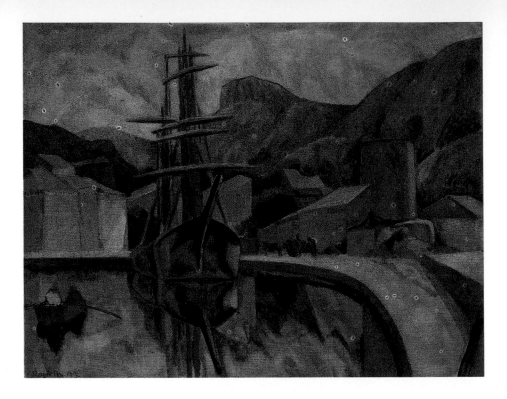

ABOVE. Roger Fry,
Provençal Harbour,
n.d.

BELOW. Roger Fry,
*Roquebrune and
Monte Carlo, from
Palm Beach*, n.d.

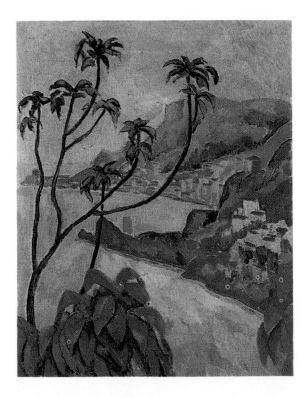

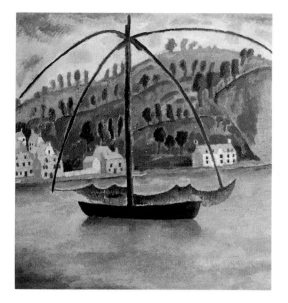

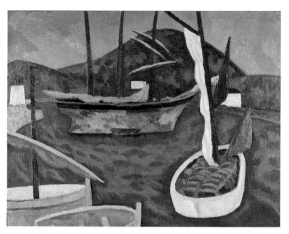

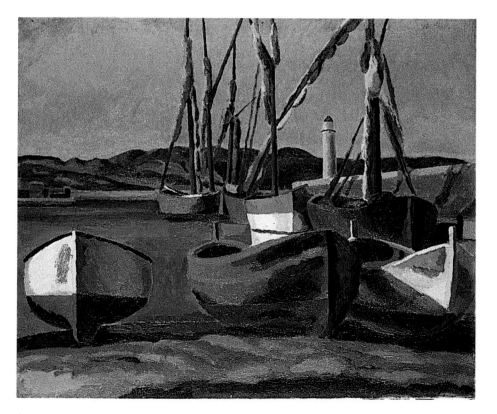

ABOVE, LEFT.
Carrington,
*Fishing Boat in the
Mediterranean*
(c. 1929).

ABOVE, RIGHT.
Roger Fry, *Boats
in a Harbour:
La Ciotat* (1915).

BELOW. Duncan
Grant, *Boats,
St.-Tropez*, n.d.

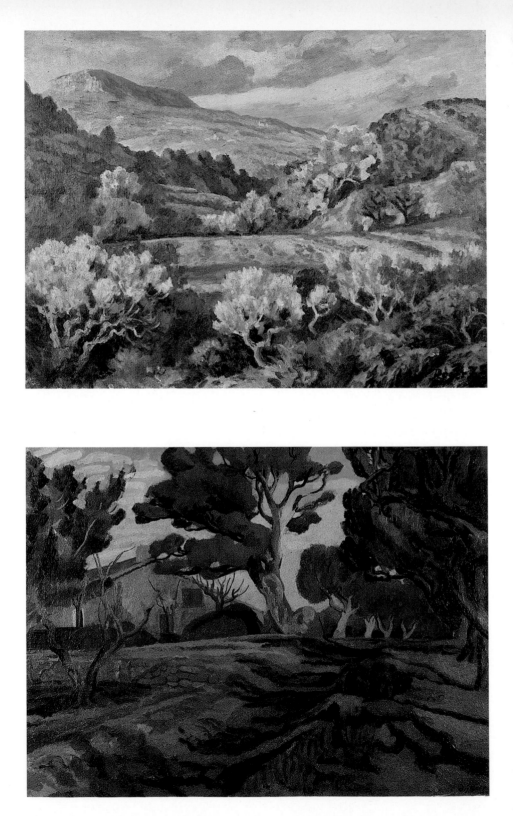

ABOVE. Roger
Fry, *Provençal
Landscape*, n.d.

BELOW. Duncan
Grant, *St.-Tropez*
(1921).

were attempting to imitate Cézanne. Comparing their work to the backwash after impressionism, he lamented that even their friends, judging by this show, were doing uninspired work: "Marchand gets more and more accomplished—by now it is almost entirely dull." In October of 1918, Vanessa wrote Roger that Marchand's way of modeling his still lifes looked "very tight and réaliste."[91] Othon Friesz, Roger believed, was just marking time: "The impulse & passion has faded out." His own contributions, including pictures he had done in the Midi, of Vaison and elsewhere, seemed to him inferior beside the others. He wrote Vanessa about one of his paintings: "I see many things at once which I ought to have done & which I should perhaps never have seen if I hadn't put it on a wall to fight with all those around."[92]

All the fighting was not on the walls. The dislike between such groups as the Vorticists, represented by the essayist and painter Wyndham Lewis, and the Bloomsbury painters had been patent from the beginning. Lewis would later attack Bloomsbury and other artistic coteries in his satiric novel *The Apes of God* of 1930, a work of epic length railing against the avant-garde. He mocks the Bloomsbury group, including Lytton Strachey and Carrington ("Matthew Plunkett" with his instantly recognizable "drooped, limp, swan-wristed hand" and "Betty Bligh, "the doll-woman … the four-foot-ten adult-tot in toto)." He satirizes Clive and Vanessa Bell and their avant-gardism: "Jonathan Bell, Patron of Author and Client of Publisher"; or 'John' Bell, who cannot "alter his views of his *friends*, why that would be for 'John' Bell to alter all that he saw in himself!" Vanessa Bell is "the funny bloomered-tandem of British middle-age and middle-class…. So English, so earliest-bloomered," contributing "a rather mouldy slice of a care-worn smile."[93] Clearly Lewis was fascinated by the group. In his 1921 *Portrait of Virginia Woolf*, Virginia is posed somewhat like Edith Sitwell, a caricature of herself. Lewis was, of course, rabidly right-wing, even fascist, and an admirer of Mussolini.

Grant had had an antipathy to Lewis since 1906, when, as an art student in Paris, he had to see Lewis every morning for breakfast as he was having his brioche on one of the small marble-topped tables at the Dôme. At one noted Parisian dinner party in May 1920, attended by Clive, Duncan, Vanessa, and Lewis, the situation worsened. Lewis had insulted Clive, and when Duncan finally persuaded him to be quiet, he had started in on Roger, at which point Duncan refused to continue the conversation, gesturing for Lewis to leave. "Lewis tried to pump him about the tendencies of modern art but D. said he knew nothing about them," Vanessa reported to Roger.[94]

André Gide, on the other hand, was a friend of many in the Bloomsbury group. He and Roger had many mutual tastes; both were passionate about Poussin. Gide liked the work of Fry's friend Simon Bussy (whose wife, Dorothy, was his translator), and that of Duncan Grant and Picasso; they shared, too, an interest in the ballet, going together to see productions of Sergei Diaghilev and Massine.

Gide and Duncan also became great friends. They had first met in Paris in March 1920, when they lunched at Lapérouse with Marc Allégret, Gide's young lover. They were equally delighted with the encounter. Duncan came to know Gide far better when Copeau invited him to stage his lyric drama *Saül*, with a set as simple as that for *Twelfth Night*. The set is recognizably that of Duncan Grant, with sheets draped over an empty stage, simulating the sails of a ship. A contemporary photograph shows Gide, Copeau, Roger Martin du Gard, and other founders of the *Nouvelle Revue Française* standing in the foreground.[95] Antonin Artaud has described Duncan's talent as being in a "vault opened to the light, a ghostly light in which Copeau was swallowed up."[96]

At the opening of the 1920–1921 season, Copeau wrote an important statement called "The Stage and the Actor," based on his theories, his experiments, and his long-lasting desire for a bare staging, the kind of setting that has had an immense impact on contemporary theater. It serves as a second manifesto about his all-important theatrical experimentation.[97] In February 1921, Duncan came over to France in order to work with Copeau on *Saül*. Gide invited Duncan to stay with him at the Villa Montmorency, on 18 bis, Avenue des Sycamores, Auteuil.[98] Duncan had, unsurprisingly, much the same reaction to Gide's wit and charm as Roger had had a few years before. He was even attracted by Marc, as he wrote to Vanessa from Gide's house, difficult to get to but far more convenient than "cantering about all day.... I cannot help adoring the French while I am here which is a good thing—the men are even more charming—to my mind—than the ladies (!) [*sic*]."[99] Unlike Clive, however, Duncan knew better than to plan a lunch with Marc, in view of Gide's well-known jealous reactions (*see* the chapter on Clive Bell for an account of Bell's misunderstanding with Gide over "Henri").

Vanessa and Duncan continued to have a lively interest in the world of Paris and its art. At the Salon des Indépendants, which they visited every year, the most exciting canvas often seemed to be a Derain. In 1921, it happened to be a new portrait of girl in a white shawl. What a shame, Vanessa wrote Roger, that they never seemed to be in Paris at the same time, so they could see things together.[100] However, she wrote optimistically, "we shall all be living here soon & then we can see plenty of pictures together." Of course, she could not leave Quentin, but perhaps they could apprentice the boys to a painter, perhaps someone like Matisse...." As for Segonzac, she found his color now "fresher & cooler & more luminous," and he in turn found her not to be confused with Duncan: "You see how terrified I am of the usual female fate."[101] Later, Vanessa would reflect with some surprise on Segonzac's behavior during World War II. He, like Derain and Vlaminck, took the infamous "Voyage" or trip to Berlin paid for by Germany and arranged by Hitler's favorite artist, Arno Breker. While Derain quite noticeably took a reticent pose in the photos of this group, remaining half-hidden behind another figure, Segonzac appears to be making little effort to conceal his point of view or posture. The

Vildracs, on the other hand, amazed Vanessa with their patriotism: "they were heroic I believe & that tiresome, grasping, sharp French woman Rose Vildrac, behaved most courageously, while the painter Segonzac, a most easy, friendly, sympathetic creature, only interested in painting as a rule, allowed himself to be whisked off to Germany, & is in disgrace in consequence. So are a lot of others. Thank goodness we didn't have to decide & needn't now judge." Later, reflecting on this incident, Vanessa meditated further on the idea of judgment. In 1944, when Quentin had had a letter from Janie Bussy with a rather grim account of life in Nice under the Gestapo, she wrote Desmond MacCarthy that Segonzac was just a bumbling painter, who cared only for his painting, and a bumbling old man who hadn't figured out what such a trip meant. In any case, she remarked, he was her friend and she could not judge him, not knowing the facts.

Paris continued to be exciting to the Bloomsbury artists throughout the decade of the 1920s. Jouvet was still directing the Théâtre des Champs-Élysées, Diaghilev was producing *Le Train bleu* with Milhaud's music and Cocteau's text, and the members of the Bloomsbury group who came over to Paris never failed to keep up with the Paris theatrical and dance scene. In 1926, the Russian futurist and "rayonist" Mikhael Larionov and his wife Natalia Goncharova, who had moved to Paris and were good friends of the Bells, designed the sets and costumes for Diaghilev's presentation of Mussorgsky's *Night on Bald Mountain*, with Nijinsky dancing. In 1927 Diaghilev presented Stravinsky's *Oedipus Rex*, with Cocteau's text.

While in England, Vanessa continued to ask Duncan and Roger, why could not they all live in Paris and paint? She was interested in everything Roger would recount in his letters to her about the achievements of the Parisian artists. Were Picasso's recent paintings like the pastels she and Duncan had seen in his studio? Perhaps she could find a studio or a few rooms in Paris for her to live in with Angelica? The latter prospect seemed to keep her going, as did Roger's tentative plan to launch an Omega workshop in Paris. She would speak to Picasso and other artists about such a project, hoping they might assist with it financially. However, neither her longing to live for long periods in Paris nor her vision of the workshop was ever realized.

Another possibility she envisioned, however, did come to fruition. This was the establishment of a part-time winter residence in the south of France where she, Duncan, and Roger might maintain connections with the painters they knew, where the children might become fluent in French, and where they could be surrounded by ideal subjects for painting. The Bloomsbury artists did not abandon Paris, but the locus of their lives in France and their painting gradually shifted to the southern coast, first to St.-Tropez, and, later, to Cassis.

Angelica Bell on
the beach,
St.-Tropez.

Painters in Provence, 1921–1938

St.-Tropez, 1921–1927

> *I'm getting more and more sure that one must live in France. I don't know about you writers, but for a painter, even being here is quite different from England. It's difficult to explain why, but the whole attitude towards art is so different and affects one subconsciously.*

> —Vanessa Bell to Clive Bell from
> St.-Tropez, November 1921

Despite the considerable attractions of Paris, with its galleries and contacts with artists, Vanessa Bell had long wanted to acquire a winter residence in the south of France, at least for two or three years. She thought at first of Antibes, where Picasso had a second home; he had frequently written Clive Bell from there. The children, particularly Angelica, could learn French, possibly at first from a curé or governess, and then attend a *lycée*. They would spend summers in England. It would be ideal to have Roger Fry living near them so they might have meals and paint together. Moreover, as she wrote him, the cost of living would not necessarily be more in France than in England, so the only extra expense would be travel.[1] This was always Vanessa's dream, to escape a raw and rainy English winter yet return in good weather. The Anglo-French Bussys followed this pattern, spending part of the year at Roquebrune and the months from May to September in England with the Strachey family.

The Bloomsbury artists would not, of course, cease to visit Paris. It was essential for them to spend time there, as Vanessa said, mixing with "all the best painters ... I think there can be no doubt one would be likely to do one's best there."[2] Clive, she knew, was extremely happy in Paris, seeing his friends such as Picasso, Derain, the Vildracs, Segonzac, and Gide. He had also met Erik Satie and Jean Cocteau and was being asked to contribute to various journals.

Roger, however, had found the south of France best for painting as well as living, and Vanessa believed it would also be perfect for her own work and family. In 1921 Roger wrote her from the Château de St.-Marcellin in Vaison-la-Romaine to describe his life as vigorously as he lived it: up at six, wandering about, drawing until eight, painting a still life, reading and writing until tea, then going out to sketch or paint "sur le motif." Of a painting he was doing of Vaison in 1921, from about two kilometers away, he remarked,

"It's a curious subject, all rather flat & square & rectilinear but I feel interested in it." Even when his hands were too cold to paint in the early morning, at the height of the hill town, he found the country "exquisitely beautiful" and "a perpetual delight [even] when one can't get it to compose."[3] In Vaison Roger was doing the portraits of some peasants in the train station, to their great satisfaction, so that they were constantly inviting him for a drink or placing grapes in his paint box. Wherever he went, always in a hurry because he was so eager to do so much, Roger would make instant and usually lasting friendships.

Vaison was neither the first nor the last location Roger would find aesthetically compatible. For years he had scouted over much of France for promising sites for his painting. Almost every letter to his friends suggests that he has *just* found a place to suit him and is casting an enthusiastic gaze around him. From St.-Tropez, he wrote Vanessa: "You'd hardly believe how happy I am between whiles—just to go about and see the sunlight reflected again and again from the walls & watch the incredibly beautiful gestures of the children."[4] If the heat was overbearing outside, he would sit under the nearest tree and begin to paint. As the angle shifted, so did his perspective. He had the gift of valuing frequent change, so that his positive temperament always had something else to work on. In Normandy, Honfleur was good; Caen left no impression except for two churches, while Dieppe was, both traditionally and actually, a painter's paradise. Jacques-Émile Blanche had his studio in Dieppe and Walter Sickert had painted there for many years, although, as Vanessa wrote Roger in August 1921, the latter was refusing to see anyone except Ethel Sands: "He is hardly painting at all and sounds wretched."[5]

Provence, however, would remain the favorite part of France for Roger and the other Bloomsbury painters. Beaumes-de-Venise, known for its sweet wine made with local muscat grapes, was one of the Provençal places he most loved. All day he would wander through the rocky gorges above the village, looking at the huge plane trees with their shining trunks, their haze of golden branches gleaming in the sun and tossed by the mistral wind. Again, writing Vanessa, who now had become accustomed to the Provençal landscape, but who was never to know it as he did, Roger extolled the region near the majestic windy mountain, the Mont Ventoux, with its incessant thunderstorms. At times, as he was writing from Vaison-la-Romaine, where he was staying with Elspeth Champcommunal, the wind and water of the Rhône would converge "in one universal blackness … so that one sits at midday writing by candlelight in that horrible state of nervous tensions which storms give," until suddenly, at the height of the storm, the house would have tiny streams of water rushing through it.[6]

Even in Roger's beloved pagan Midi, however, there were places and people he disliked. Marseilles, for instance, displayed a "violent egoism" and rapaciousness, like a

kind of siren enticing him to wander in its streets. The Riviera made him queasy, with its art colonies of "uncertain motivation." Frequently his judgments of places bore traces of a kind of puritanical longing for order, understanding, and clarity that accorded with his classicism. In a letter to Helen Anrep of 1925 about Le Havre, for example, he praised the "decent" colour and the "decently logical" buildings, whose inhabitants were "more thrilled by the sensible than the picturesque," the latter term connoting a too-easy display.[7]

Roger continually appealed to Vanessa to flee from English winters and establish a pied-à-terre in the Midi. In September 1921, when he stopped at Hyères on his way to the Hotel Sube in St.-Tropez, he wrote her teasingly,

> If you could feel the sunshine that I'm in now you'd leave nothing undone that could get you South. There's no doubt one is happy here, but happy in a more solid animal way than one can ever achieve in England. Happy even when one's sitting in a squalid little neglected railway station waiting for a train that probably won't come.[8]

The trains in the south of France always seemed about to break down from incompetence, when they were not canceled. On the same trip, Roger had strolled off impatiently to the seaside on a little track through the pines to have a swim and "nearly tripped over the toes of André Gide, also there by a pure accident." They swam, drove to a fishing village Gide had discovered, and swam again at sunrise the next morning, making of the accident a perfect incident, part of the wonders of the south of France.[9]

Roger was good at making wonders out of ordinary contingencies, at finding remarkable places, and at preparing a memorable welcome for friends. It was he who, finally, located a house for Vanessa, her three children, and Duncan. Through Leopold Zborowski, Duncan Grant's Parisian art dealer, he discovered the Maison Blanche in St.-Tropez, a small villa that belonged to the artist Charles Vildrac and his wife, Rose. They had been longtime friends of several Bloomsbury artists, and Vildrac's watercolor of a picnic is today one of the treasures of Charleston Farmhouse.[10] Vanessa and Duncan settled happily into the Maison Blanche from October 1921 until January 1922.

Vanessa and the children, accompanied by Grace Germany, their Charleston housekeeper, and Nellie Brittain, Angelica's nurse,[11] traveled to the Midi by train, via the Newhaven–Dieppe ferry and Paris, on October 11. At the time Julian was thirteen, Quentin eleven, and Angelica three. Vanessa wrote Clive, describing Quentin's first sight of Paris: he was "wild with excitement" over the city and fascinated by the French colors, so different from English ones. Duncan, who had come ahead to spend a few days in Paris, met them at the Gare de Lyon, having reserved their places in the southbound railway carriage. The boys, who had never been on the Continent before, rushed

out at Avignon for coffee and rolls. Vanessa wrote Clive, it was "great fun as I knew it would be taking them abroad for the first time."[12]

At St.-Raphael Roger appeared in the distance "in blue linen trousers and sandshoes, brown and beaming," and took charge of their jumble of belongings, which had fallen out on the platform. Duncan was still asleep and had to be gotten off the train, as if drugged. After a quick meal at a café, they changed to a local train, finally reaching the Maison Blanche about five o'clock.[13] Vanessa loved their rooms, which were large and light with red-tiled floors. Roger had dozens of friends in St.-Tropez, as he did everywhere, including a priest who kept up with the latest writers.

Duncan Grant,
South of France
(1922).

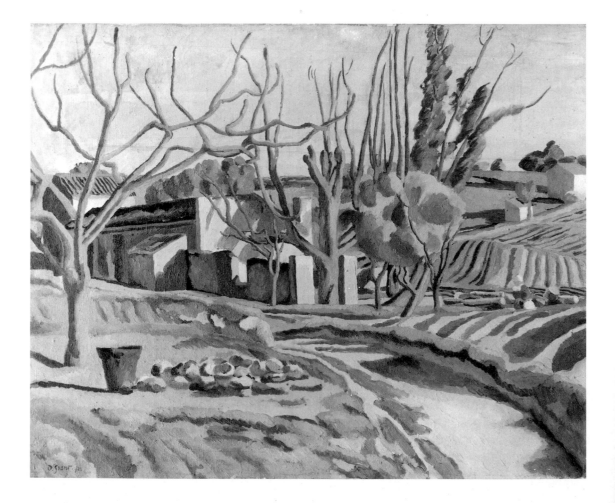

The town was subject to extremes of weather in the autumn and winter, as is typical of the Midi. On a given day, hail might be beating on the windows and flooding every room, the floors deep in water and the nearer hills covered in snow. "The Alps do look most lovely in this clear grey weather," Vanessa wrote Roger in 1921,[14] but admitted that "brooms, buckets, dustpans, everything is used to wipe up the water. In the dining room, at the lowest point of the very irregular stone floor, there is a lake to be bailed out. It is bitter cold in the brightest of sunshines, with the thunderclouds piling up, like some inferno." Another day, a week later, might be warm and sunny, with bright colors contrasted against the bare earth. These would be optimum conditions for painting.

Duncan Grant's *South of France* (1922) perfectly captures the quality of the earth in this region, haunting not through its beauty so much as its strangeness. The trees reach up their branches, jagged in their lines on the left, straight in the middle, toward and against the dwelling in the center. The surrounding earth is heavily cracked and furrowed and the buildings cast their weird shadows, dwarfing the humans like the small figure of a woman on the right. In the left foreground, an empty clay pot stands as bare as the trees. The painting is at once flat and full of depth, at once bare and lined, a witness to an earth and a culture aged and sure, needing no elegance or elaboration.

Roger continued to find Vanessa's work admirable and recognizably different from that of Duncan. He hoped she would appreciate the curious formations and hidden structures he perceived in the southern landscapes. He often biked great distances, with his easel, his colors and his papers on his back, sometimes leaving them in the open, on some level crossing, to pick up the next day. To Clive, who had never been generous in his opinion of Roger's painting (and not always of Roger himself), Vanessa wrote that since she was now so close to the subjects he painted, she admired them less than she had earlier, believing he reduced them "to such a dead drab affair."[15] Although Roger thought he had the praise and sympathy from the French that he had not received from the English, including his friends, several of the French painters confided to Vanessa and Duncan that they actually found him straitlaced, conservative, and behind the times as a painter, while being a delightful friend.

When Roger first painted at St.-Tropez, where he made friends on all sides, as always, his paintings of the boats in the harbor were as bright as a child's might be, with his vision invariably fresh. His representations of boats and harbors in the Midi, such as *Boats in a Harbor: La Ciotat* (1915), are among the most cheerful works he ever produced. In this painting, with a pink sky, blue hlls, and green water, all extraneous elements, have been cropped away. The masts of the boat are cut off at the top and sides, and the boat itself is cropped below, so that only the basic elements remain: the hills in the background, the curve of the bay, the furled sails and oval shapes, the swoop of the largest hull. The small rowboat, sliced off in the foreground, almost extends into the

viewer's space, as does the little sailboat behind it. The colors are somewhat gaudy, free of nuance and of shadow. The small houses on the far bank are simple white rectangles with red roofs; it is a calm and bordered scene. Fry was at his best with paintings of water.

Vanessa was a bit more cautious than Roger about the general ambience of St.-Tropez, but enjoyed knowing she was in a place long congenial to painters. Charles Camoin, who was in St.-Tropez, with his studio on the quai Suffren, was of particular interest to Vanessa and Duncan, as he had engaged in a long correspondence with Cézanne. He had met the artist in Aix in October of 1901, when he was twenty-two and finishing his military service. For Camoin the great painter was "le père Cézanne," who called him in return "le vaillant Marseillais."[16]

The artists Henri Charles Manguin and Paul Signac were not far away, in the hill town of Ménerbes, near Aix, and would come down to St.-Tropez for the day. Finding they could not paint in Paris, Moïse Kisling and André Derain had settled at Saumane. André Dunoyer de Segonzac had come to live in Sancerre, along with Georges Duthuit and his wife Marguerite, who was the daughter of Henri Matisse.[17] Matisse had long known the town and often painted landscapes and other works there. Simon and Dorothy Bussy were in Roquebrune.

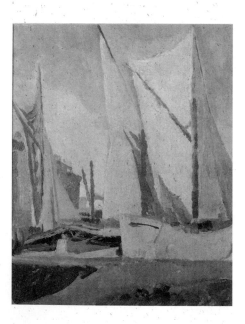

Vanessa Bell, *The Harbor.*

The painters Jacques Raverat and his wife Gwen (who was the author of a delightful Cambridge memoir called *Period Piece* and the granddaughter of Charles Darwin), along with Jean Marchand, were nearby in Vence. Raverat, also a friend of Virginia Woolf, had contracted multiple sclerosis. In December 1921 Vanessa visited him and his wife for three days. She wrote Clive that it was "rather a melancholy household," although Gwen, with her "incredible Darwin virtues," was coping:

She still has Jacques in hand, but they both manage all the same to produce quantities of woodcuts and oil paintings of a most depressing kind. One can only admire them for doing anything but bemoan their lot....[18]

Of course, she continued, Jacques Raverat's works were bound to be depressing, given his illness. He was now almost immobile, reduced to being drawn about in a small cart by a donkey or having to be lifted from place to place by others. Gwen had to look after the donkey and cart, which were based an hour's walk away, as well as their two children. Most discouraging of all, Jacques was

beginning to lose the use of his arms. Virginia Woolf's frequent letters to him must have been one of his major consolations.

Driving along the corniche to Vence, where the Raverats lived, Duncan and Vanessa saw all the colorful sites he had been so enthusiastic about on previous trips, particularly while visiting his aunt, Lady Colvile, in the Villa Henriette at Menton. There were green-silver olive trees, brilliant flowers, and little towns clinging to the hills— actually, there were too many hills for Vanessa, who preferred flatter countryside. St.-Paul-de-Vence, where Picasso and Matisse had painted, and where D. H. Lawrence would live for a time before his death in 1930, was crowded with Scandinavians. Antibes, lovely as it was, seemed to have too limited a view. In Cagnes they visited Jean Marchand and his wife.

Duncan and Vanessa were often invited to see the southern studios of Parisian artists who were their friends. Their encounters face-to-face with the painters'

Henri Matisse, *Paysage à St.-Tropez* (1904).

works could become a cruel test of politeness when they were called upon to express themselves about paintings in progress about which they had a low opinion. At other times, when their judgment was favorable, it was a delight. Comparing a sketch Jean Marchand had just begun with all the works they had been seeing by the Raverats, which she considered depressing, Vanessa wrote Roger in mid-December 1921 that it had given her "a jump of pleasure—it seems so real by comparison. I wish I could have seen more of him." She had been nervous at the prospect of seeing him, realizing his sensitivity and knowing he had been the subject of a derogatory article by Clive, but her fears turned out to be groundless and they got on well. She reported to Roger with relief, "he said nothing of C[live], but talked as if you were the connecting link between us."[19] Roger had always liked Marchand, finding him, as he had written Marie Mauron, "a charming man, serious and simple."[20]

In any case, Roger considered Clive's opinion on artistic subjects unreliable at best. Later that month he tried to reassure Marchand on this point, expressing his reservations about Clive's critical acuity:

Certainly he can be very annoying. I think his criticisms have done me more harm than all the others. But (though I may be wrong) I do not exactly find him spiteful. He hasn't much personal judgment and he is a terrible snob, so he lets himself go impetuously in the direction his snobbism suggests. I mean it is not by

personal antipathy that he castigates a painter but rather by his over-preoccupa-
tion to show himself in the forefront of the trend.... I think a serious critic is
sometimes forced by his obligation to art to say hard things of artists he likes and
that if one knows the sincerity and integrity of a critic one must not feel too hurt
by it. What one could precisely reproach Clive Bell with is that he has not this
solicitude for art, that he does not make a serious effort to understand it but col-
lects hearsay and remarks from other artists, etc. He has no rudder; he simply
floats in the current of avant-garde opinion.[21]

Their visits to La Souco, the Bussys' home at Roquebrune, were particularly trying.
They were expected to comment on Simon Bussy's singular paintings of vivid-hued ani-
mals and birds and his large decorative panels with their flat-hued figures. Vanessa
thought him easily the oddest painter she had ever seen or known. Sometimes, as in his
1919 head of his daughter Janie, he was able to capture the smooth surface and minute
details of an Ingres. At other times, however, the garish colors left Vanessa speechless, a
difficult predicament when Simon, Dorothy, and Janie were eagerly awaiting her reac-
tion. Whereas Marchand and the Raverats had stood by in patient silence so that she
might contemplate their production, the Bussys expected her to summon up an imme-
diate judgment. In fact, she found them intriguing in their very peculiarity, so much so
that she almost managed to forget the kind of climate this family created, on which so
many have remarked: that "thick Strachey atmosphere. They really are most odd."
Simon's zoo animals were everywhere in the house, hundreds of them in pastels, which,
she wrote Roger, because of all the gelatine he added,

> look like tiles. He mixes all his colours before hand & paints them quite directly in
> very thick paint. I think if it doesn't succeed at once he destroys it. The drawing is
> extraordinarily subtle. The sort of colour you probably know, all the most brilliant
> colours used with also a good deal of black & grey. They are horribly like Bakst & all
> sorts of other terrors. He himself obviously realized this & knows he may simply be a
> terror himself.... He seems to me to have got to something different from all his
> early works. Much more solid & definite & uncompromising. One may easily hate it
> but I don't think one can help respecting it, its [*sic*] so extraordinarily complete.[22]

Simon's career had its fluctuations, and he had, understandably, retained a certain bit-
terness. He had been rejected as early as 1907 by the International Society in London,
and was never sure how his work would be viewed: his anxiety translated itself into a cer-
tain unspoken pressure on the viewer. Would his forthcoming show in London be a suc-
cess or a complete failure? Clive, thought Vanessa, would hate it, and "so in
consequence will Mary and Co. but so would they have hated Guido or Ingres in their

day or Raphael I dare say." Duncan himself greatly admired Bussy's work, however, and kept many examples of it in his own studio.

Vanessa and Duncan found St.-Tropez a perfect place to work, so much so that they dreaded returning to London and even Paris, despite their many friends and professional contacts there. The single discordant element was Rose Vildrac, who was talkative and overcareful, visiting and surveying the lives of her tenants. Her impending visits forced Vanessa to scrub and scrape and scour and polish and tidy the house, bundling all the remains of disorder quickly out of sight. She complained to Roger, "Rose shouted at me in a loud shrill voice & seemed so efficient & sharp. It was awful to have her in the house ..."23 As Rose's particular passion was the luxury of being driven about in someone's car, she would play up to neighbors who owned one. The painter Manguin and his wife were so equipped, causing Roger to remark to Vanessa, "The Vildracs or rather Rose make love to the Mangins [sic] because they have a motor car & the Mangins don't like any of us."24 Vanessa loved everything else about St.-Tropez, and regretted it greatly when Roger returned to England without them. He thought seriously of returning to St.-Tropez the following year with his sister Margery and his children and taking an adjoining villa, and he proposed sharing housekeeping expenses and meals with Vanessa and Duncan. Vanessa, however, could see the difficulties inherent in such a scheme and discouraged it.25

When Vanessa was in St.-Tropez, she did not often feel invaded. Clive usually gave her no idea of his plans, so she was on her own, although, if Duncan were not visiting elsewhere, he would be there. What simplicity one had in this kind of French living, she felt; the only welcome interruptions would be, from time to time, the arrival of Charles Camoin and his wife for coffee. Otherwise, she could spend her days painting, teaching the children, and being solitary. Good weather mattered more to Vanessa than to Roger and Duncan, because, as she admitted, she was less enterprising in exploring the countryside than they. As she wrote Roger, she was passive "about painting anything I don't find at my door."26

Although painting indoors was not her idea of working in Provence, the perils of outdoor painting, which Roger had known all along, became increasingly oppressive to Vanessa and Duncan. The worst problem, although natural to the south, was the mistral, the wind known to bring headaches and bad temper to all around, and on whose arrival local people blamed almost every disaster in the south of France. Since it would surely knock down their easels, they reasoned, there was no point in starting a large painting, for one would be unlikely to finish it. Through all the letters between Roger and Vanessa, the mistral frequently blows, as characteristic of the Midi as the frequent storms and flooding.

The plague of mosquitoes at Beaumes-de-Venise in 1930 would be an even worse

calamity. Roger, determined not to give up working, had to cover every inch of himself in newspaper, making it somewhat awkward to paint. But nothing stopped him—not his maladies, not his emotional shifts, and certainly not a disturbance of nature. All his life, whatever his malady, he never stopped thinking, working, and writing. Duncan describes one relatively warm English afternoon, when he had enticed Roger outside, and had returned to find him happily sitting in front of the cow stall and painting, a hot water bottle on his knees.

Apart from such impediments as the weather and insect life, and greatly to Vanessa's surprise, things went rather well when she could paint outside. The children were making great progress with French. Angelica was taught by Mademoiselle Bouvet, who resided at the Pavillon St.-Esprit, and was much admired. Soon she could carry on a conversation in French with anyone. Julian had been staying with the Pinaults, both schoolteachers, and their family, at Gargilesse, just outside Paris, since the fall of 1926. He had taken classes at the Sorbonne and frequently discussed politics with Pinault, who shared his left-wing leanings. He spent much of his time wandering around Paris. The Pinaults had not had the time or energy to provide him with any friends, a fact that Julian's parents much regretted. But he had learned enough French to have the following conversation with Grace Germany, to his mother's delight:

"Julian, what is a chicken?" asked Grace.
"Poule."
"What is 'where are the chickens?'"
"Où est les poules."

Vanessa, recounting this intriguing conversation, said, with some sort of mistaken pride, to his father that he understood and read French just like English. Quentin, their other son, would eventually study with Jean Marchand, the family friend, at the Académie Moderne in Paris, and would become fluent in French, perhaps more so than Julian.

Vanessa, Duncan, and the children stayed in St.-Tropez until January 1922. In December, Vanessa summed up their experience to Maynard:

The experiment of coming here, as far as painting is concerned at any rate, has been such a success that I don't believe Duncan will ever if he can help it spend a winter in London again. We are perfectly happy here. One works all day and isn't tempted to go out at night as one is in London. Everything helps one instead of hindering one. I was afraid Duncan might be bored, but I think he is perfectly contented. We are both miserable at the thought of going back so soon.[27]

France continued to embody a certain way of looking and representing the landscape of light, and was the ideal place for art to be taken seriously.

Jean Marchand,
Still Life.

From October 1921 to January 1922, spent in the Maison Blanche, to 1938, when Vanessa and Angelica returned to La Bergère for the last time, Vanessa's longing to live in the south of France was often, if not permanently, satisfied. For a while, Bloomsbury on the Mediterranean, as she had thought of it, was very much alive. First it was centered in St.-Tropez, then it was linked to the travels of Duncan's aunt Daisy McNeil, and finally, through one of Roger's chance encounters, it became Bloomsbury in Cassis.

The steel auxil-
iary ketch
Arequipa at Mar-
seilles (c. 1927).

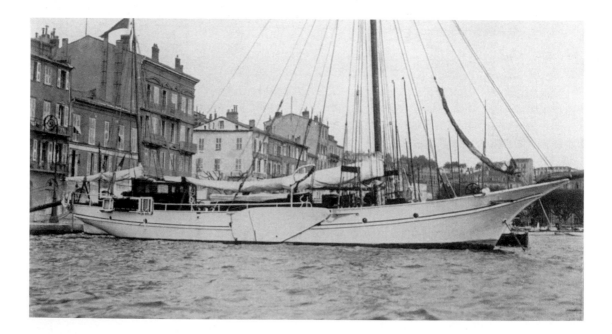

Duncan Grant
Aboard the Arequipa, 1924–1925

[Beaune is] full of things to paint, a perfect place....

Duncan Grant to Vanessa Bell, from the *Arequipa*, January 1925

Duncan Grant had a formidable and accomplished aunt, Miss Margaret M. ("Daisy") McNeil, sister of his mother, Ethel Grant. Miss McNeil was, according to her great-great-niece, Henrietta Garnett, "an extraordinary woman; stories of her behaviour, remarkable and frequently breath-taking, are legion."[1] Sociable and very fond of travel, she was also a guidebook writer, explorer, and a Fellow of the Royal Geographical Society. She had always taken a great interest in her nephew and, when Duncan first began studying art in Paris in 1906, arranged for him to spend a Sunday in the country with a French family. It was not a success, for he found the engagement a tedious experience.[2] Miss McNeil was the proprietor of a private nursing home in Eastbourne, the resort between Brighton and Hastings on the English Channel. One of her wealthy patients, Miss Elwes, was a devoted friend. In 1909 she and Miss McNeil had accompanied Lytton Strachey on his quest for health, going together to a spa at Saltsjöbaden, Sweden (Aunt Daisy spoke Swedish). The treatment resulted in a considerable improvement in Lytton's condition.[3]

Miss McNeil was the owner of a steel auxiliary ketch, the *Arequipa*, designed and built by A. Pannevis in 1907 at Alphen-aan de Rijn, South Holland. First named the *Wilhelmina*, she measured 68.8 feet in length, 16.3 feet in breadth, and 6.6 feet in depth. She was a type of ship called *Klipperjacht*, fitted with a fan-shaped *zwaard* (leeboard) on each side that functioned as a centerboard and made her particularly suitable for both shallow canals and deep water. This type of ship originated in the nineteenth century, being first constructed of iron and later of steel. They were distinctive and, as one authority on the *Klipperjacht* puts it, "flamboyant ... with [a] long overhanging bow and elegant counter stern." The *Arequipa* was registered to Miss McNeil at Shoreham, Sussex, near Brighton.[4]

In December 1924 Aunt Daisy invited Duncan and his mother, along with Miss Elwes, to accompany her aboard the *Arequipa*, for a cruise along French canals and rivers. The party embarked at Dijon, in Burgundy, where Duncan was to join them. He left a Paris of intense cold to meet the ship; it was a city wrapped in a fog even denser than the one he was accustomed to in England. To prepare, he wrapped himself in his leather coat to keep out the cold, had his usual small cup of strong coffee at the Café Deux Magots, dinner at the Brasserie Lipp, and then departed.

It would take the ship a month to cruise, via Verdun and Beaune, to Marseilles and their final destination, Cassis, where Aunt Daisy would take up residence again. On December 28, 1924, Duncan had a chance, as he wrote Vanessa, to see something of Dijon, which he found full of "extraordinary & rather hideous late Gothic churches & most lovely 18th century houses." In the elegant food shops, he found a particular Dijonnais delicacy, a *pain d'épice* flavored with orange peel, and in one of the hidden wine cellars, he discovered a bottle of Marc de Bourgogne, a strong liqueur made with coffee grounds. He saw a production of Donizetti's opera *Fille du Régiment* and then returned to the *Arequipa.*

The ketch progressed slowly, with Duncan documenting various places in a letter to Vanessa. Leaving Dijon, they came to St.-Jean-de-Losne, which he found charming, near Chalon-sur-Saône. He wrote Vanessa that it was, at the end of December, "a perfectly straight canal bordered with tall elms covered with mistletoe for miles. Rather nice low villages in perfectly flat country something like Belgium…. This place is the end of the canals & we join the Saone [*sic*] which runs into the Rhone [*sic*] at Lyon."[5] Money was

sometimes lacking among the passengers and crew, which inhibited frequent dining out. The crew, however, was able to stock up on fresh produce, meat, poultry, and dairy products from the markets along the way: cheeses, cream, geese, and capons. They kept hoping for one or two paying guests, such as wealthy film stars, who might like to join the group. This might have meant there would have been insufficient room for Duncan, but the possibility never actually arose.

After reaching the Sâone River and traveling for some time, they spent New Year's Eve at Verdun, relieved to be on a wide river instead of a canal. Duncan purchased white Burgundy for the engineer and mate and they attended the local celebration at the Salle de la Renaissance.[6] Duncan wrote Vanessa, "one goes at a great rate & with much less noise. In fact I think in fine weather it is a delicious way of travelling. You see a different place every day and always return to your own room and food and objects at night," which was far less exhausting than the constant change of automobile or train travel.

The river was exquisite in the early-morning light, a delicate hue like a Corot painting: "Very pale clear colour very unlike anything but France."[7] Under a large bridge of pale-colored stone, ornamented with obelisks of seventeenth-century construction, they arrived in Chalon-sur-Saône. Along the way, whenever possible, Duncan would leave the docked boat to take refuge in cafés. One such stop was the Café de l'Ecu in Sens, a pleasant provincial town whose cathedral was not so "enormously high" as the ordinary French Gothic ones. He found the Hospice de Beaune, in Beaune, one of the "most lovely sights imaginable, full of superb copper cooking kettles … and an old lady in a white cap peeling carrots exactly like a very lovely Chardin." During Duncan Grant's days as an art student in Paris at La Palette, Jacques-Emile Blanche's art school, beginning in 1906, Blanche would ask Grant and his other pupils to contemplate the "drama" of the kitchen still lifes of Jean-Baptiste Siméon Chardin. Grant was deeply moved by Chardin's depictions of patient, introspective cooks, caterers, and washerwomen. In some of his later still lifes, it is clear that he was aware of the implicit drama of Chardin's apparently simple compositions. (*See* "Visual Translations" for a discussion of Chardin's still lifes and the work of Grant.)

Duncan found being on the ship in such close quarters an odd experience, yet a pleasing one overall. He wrote Vanessa, "If I were rich I should buy the Arequipa I think." Duncan left the *Arequipa* at Beaune and returned to England via Paris. When the rest of the party reached Marseilles, Aunt Daisy sailed on to Cassis, where she had the *Arequipa* anchored in the harbor. She stayed aboard the ketch for several months, dispensing hospitality to Cassis residents and to visitors in the form of parties and short cruises.

Duncan's voyage has something of a dreamlike quality. His letters, in contrast to his unpublished "Paris Memoir" (see "Beginnings: Friends in France, 1896–1910"), contain only vague glimpses of day-to-day life aboard ship and, with few exceptions, of the passing villages and countryside. It seems particularly unfortunate that the cruise apparently did not permit him leisure for painting along the way.

Cassis; photo-
graph by Lytton
Strachey
(c. 1927).

Cassis, 1925–1929

I am waiting to see what form of itself Cassis will finally cast up in my mind.
—Virginia Woolf, *Diary*, April 8, 1925

Hôtel Cendrillon, Villa Mimosa, Villa Corsica, 1925–1927

Cassis had always been a place for painters, having been associated with Charles Camoin, Georges Braque, Albert Marquet, and André Dunoyer de Segonzac. With its semicircular bay and lighthouse, many-hued fishing boats, and harborside row of cafés serving sea urchins and dry white wine, the traditional fare dating from Roman times, it is framed by the reddish rocks of "Charlemagne's Crown" rising high on the left and the pine-covered calanques stretching far out on the right. From the Hôtel Cendrillon, near the harbor, where the Woolfs first stayed in 1925, the clink of the metallic bowls for the favorite game of Provence is audible in the square just by the hotel.

The migration of the Bloomsbury group to this part of the Midi took place gradually. In March 1925 Virginia and Leonard Woolf paid their first visit to Cassis, taking the Newhaven–Dieppe and continuing by train to Paris and Marseilles. They stayed at the Hôtel Cendrillon. Virginia wrote her sister Vanessa Bell they had "sailed" into the bay the day before and thought of the "Dolphin tribe." They were "perfectly happy ... hot, bright, omelettes, coffee in garden. Roger's pictures on every side.... Much literary discussion, we sit out and walk ..."[1] "Dolphin" was Virginia's private name for Vanessa, whose "tribe" would, throughout the ensuing decade, come to spend several months a year, from 1927 to 1931 and from 1937 to 1938, in Cassis.

The first of the painters to come to the area may have been Roger Fry, who, in October 1923, stayed in La Ciotat, a fishing town and port a few miles east of Cassis. He wrote Vanessa Bell from the Hôtel de L'Univers there, urging her and Duncan to come: "I wonder what you'd make of this country. I think it's good for me because it's much more coloured than most of Provence—these queer brown-gold and violet rocks set an intense key of colour."[2]

In the summer of 1925 Fry took his friend Charles Mauron, whom he had met at St.-Rémy, to the Abbaye de Pontigny for one of the *décades*, the ten-day meetings of intellectuals that took place there every year. He went on from the Abbey, on the Yonne, to

11 CASSIS. — Baie de Cassis. - Calanque d'En-Vau. — LL

Bay at Cassis with
Calanques
(1920).

Cassis, staying at the only hotel in the port, the Hôtel Cendrillon, where the Woolfs had stayed the preceding March.

Roger painted Cassis a number of times, and had more success with these scenes than with many other subjects. Five of his paintings from Cassis were hung in the First London Artists' Association exhibition in May 1926, and the art critic for the *Daily Telegraph* alleged that he had never painted so well: "His large picture, entitled *Cassis*, baffles criticism. It illustrates his wonderful power of bringing everything in the scene before him into harmonious relationship with the whole."[3]

Fry found Cassis a more congenial place to paint than many other French places in which he had stayed, such as the bourgeois town of Nancy, where he visited the Coué clinic in 1922 and 1923, and Royat, where he went to take the waters but considered dour. He wrote Vanessa Bell from Cassis in late September, "I'm getting more and more to like this place for painting but as that always happens anywhere one goes along this coast I don't know that it means much. The port is lovely and I've found a motive in the Hotel garden and in a square a few yards off."[4]

The weather, however, could be horrid, with a mistral, which tended to put him in a bad temper, knocking over his easel, or the sirocco desert wind, blowing, colorless, but

filling the air with dust.[5] There were certain compensations, as when André Derain would come over from St.-Cyr-sur-Mer, near La Ciotat, as well as other artist friends. They included Galanis, who worked under Derain, Kataji, Dumerjez, and others.

On one September evening, Roger had spent long hours in discussion at Café du Port with the art critic Roland Penrose. The night was dark as he returned to the hotel, and the scattered lights were dim and scarce. He tripped over a bench under a tree, catching his shin against it so hard that he fell "full length on the asphalt & so suddenly so unexpectedly that I never managed to get my hand out so I took the full force of the blow on my face." When he wrote Vanessa about his mishap, he emphasized that Dr. Emmanuel Agostini, a "most charming and excellent" physician (and one of the pillars of Cassis society) had been extremely kind and helpful.[6]

Penrose, an English collector of surrealist works, a painter, and an authority on Picasso and other painters, had come to know Duncan's aunt, Miss Margaret M. ("Daisy") McNeil, who had come to Cassis in early 1925 aboard her steel auxiliary ketch *Arequipa* (*see* preceding chapter, "Duncan Grant Aboard the *Arequipa*, 1924–1925"). He offered to rent her Les Mimosas, a small villa he had bought in Cassis that had a studio in the garden. It was just outside the town, set in a garden full of mimosa trees, with climbing wisteria. It was, as Angelica Garnett later put it, "hung over and honoured by the prominent and noble Couronne de Charlemagne."[7]

Vanessa wrote Roger about his fall before receiving his letter, having heard about it from Duncan, via Aunt Daisy (nothing was private for very long in their Franco-British circle). "But how did you come to do such a thing? It seems as if you must have been as blind as you always tell me I am if you really fell over a bench as I heard."[8] Yes, he had; he was walking too briskly as always, Roger answered, but there was a more serious problem. What might be done about Aunt Daisy? She did not stay aboard the *Arequipa* (which was anchored in the Cassis harbor), but took all her dinners in the Cendrillon and was a "God Almighty Bore," one of those relatives who ought to be settled in a proper English boardinghouse.[9] Miss McNeil was actually an explorer, guidebook writer, and Fellow of the Royal Geographical Society. Angelica Garnett describes her as "a sort of magic woman, quite formidable, who would sail around the Mediterranean." She would look after all the people who were so peculiar that no one could stand them, and they would "come out of it much better. She was the kind of person who sat on you and squashed you."[10] By this point in 1925, she would have exhausted everyone, yet, at the same time, had made an indelible impression on Cassis society. It was said, cruelly if justly, that she tended to prey upon any visitors she could find. "She gives us a lot of work trying to dodge her and trying to avoid invitations—appalling with her birdlike twitter," Roger continued in his letter to Vanessa.[11] He was particularly susceptible to voices and tones,

as we know from several of his letters on the awfulness of American accents. Aunt Daisy had managed to engage him for several parties, which made him uncomfortable, until he learned to "plead his painting."

When in Cassis, Roger usually rose at six, then worked on one subject before breakfast and on another all afternoon. His painting took precedence over any parties, including those Aunt Daisy would give on the *Arequipa* for "le tout Cassis." Had he responded to all the invitations he received, he would never have had the time to work on the canvases he suspected Vanessa would find as "respectable and as dull as ever." But, for himself, he felt he was learning what he did best, choosing his oils over his watercolors and simplicity over complexity.[12]

After returning to England for several months (she owned a nursing home in Eastbourne), Aunt Daisy returned to Cassis with her sister, Ethel Grant (Duncan's mother), in December 1926, planning to spend the winter there. They again stayed at Les Mimosas, the Penrose villa. Duncan joined them in early January 1927. He contracted bronchitis, which evolved into pneumonia, and it was feared that he might develop typhoid fever, a serious complication. Angus Davidson arrived, was horrified by Duncan's condition, and notified Vanessa, who left immediately for Cassis with Angelica and Grace Germany, who was, according to Angelica Garnett, half-nursemaid, half-cook. She learned in Paris that Duncan had improved, and stayed in the city for two days to be with Julian; they then continued on to Cassis. Before her arrival, Duncan, conscious of the mistral suddenly rising, wrote Vanessa from the Villa Mimosa that in fact he did not yet like the idea of painting in a country whose character he had not yet grasped. Worse, he was not really at ease with Vanessa's coming to Cassis. She insisted on it nevertheless, wanting to be near him in his illness.[13]

When Vanessa, Angelica, and Grace arrived, Angus Davidson met them at the train station. Vanessa could scarcely see Duncan alone, since the Villa Mimosa had only one sitting room to accommodate everyone: Mrs. Grant, Aunt Daisy, Miss Elwes (Mrs. Grant's companion), Angus, herself, and Duncan.[14] Vanessa, Angelica, and Grace initially stayed at the Hôtel Cendrillon, but it was too far away to permit easy visits to Duncan. Not wanting to be in the way, Vanessa rented the newly built red and white Villa Corsica, a house owned by Roger's friend Dr. Agostini, just across the way. He "nearly fell into my arms," Vanessa wrote Roger in February 1927, when he found out she was a friend of his. Vanessa did not spend all her time at the Villa Mimosa, where she felt as though she were an outsider, "afraid of being a Keynes to their Charleston," but instead returned every afternoon to the Villa Corsica for tea with Angelica.

The beauty of the seaside (although Vanessa never bathed in the sea) did much to restore her spirits after her temporary discouragement with painting. In his letters from the Midi Duncan had praised the beauty of it all, of Tarascon and of walking across the

Rhône to Beaucaire, "the most lovely town with a really superb 18th century church & very grand indeed…. It was a great delight to get back to umbrella pines and ilexes and cypress …"[15]

Vanessa arranged for French lessons for Angelica, and began to take stock of Cassis, which had two harbors and was surrounded by rose-tinged rocky hills. She wrote Virginia on February 5, 1927:

> Painting is a different thing here from what it can be in the winter in England. It's never dark even when the sky is grey. The light in the Penrose studio is perfect and even now one could often work out of doors, if one wanted to…. Also the beauty is a constant delight. The people are very friendly and helpful and living is very cheap.[16]

Cassis was a highly sociable town, one particularly hospitable to artists. Painters had always been attracted to the port, and Vanessa came to know many of them. Among them were Charles Camoin, a painter of seascapes, whom Vanessa liked and with whom she often exchanged visits, the rather pale painters Frederick and Jessie Etchells, the now forgotten William Tryon, the outrageous vorticist Wyndham Lewis, and the less vocal but highly talented female Vorticist Jessica Dinsmorr. Staying with Roland Penrose were the Middle European artist Yanco Varda and the Romanian Grigorescu. The latter was strongly attracted to Grace Germany and would, as Angelica Garnett recalls, pop up from behind various rocks and out from behind an olive or almond tree at any moment to propose to her. There was the former cubist painter Georges Braque living at La Ciotat with his wife; Aunt Daisy had made friends with them. The Braques, according to Duncan, were "a strange couple. But perhaps their mutual passion for the sea explains it."[17]

Social life, however, made inroads on the time Duncan and Vanessa wanted to dedicate to their painting. They resolved the problem by deciding they had no real obligation to see others, but could reserve as much time as they wished for their work.[18] They would live as calmly at the Villa Mimosa and the Villa Corsica as they wished, painting the trees and fields, and avoiding the artists' gathering places in the port and town. (This was a resolution they made periodically but rarely kept.)

The climate was a constant topic of worry and conversation for the artists. A "mischievous wind" or a mistral could arise at any moment, and, wonderful though it might be amid the dramatic colored rock formations and water, it made painting outside difficult. Duncan's bedroom at the Villa Mimosa was in a tower, with windows in two directions "overlooking the sea and hills," taking in the sun just as his studio did. Before his illness and Vanessa's arrival, he had described the scene: "at sunset it is icy cold & very dangerous for an hour or so. Also I cannot see what there is to paint. It is all very beautiful but

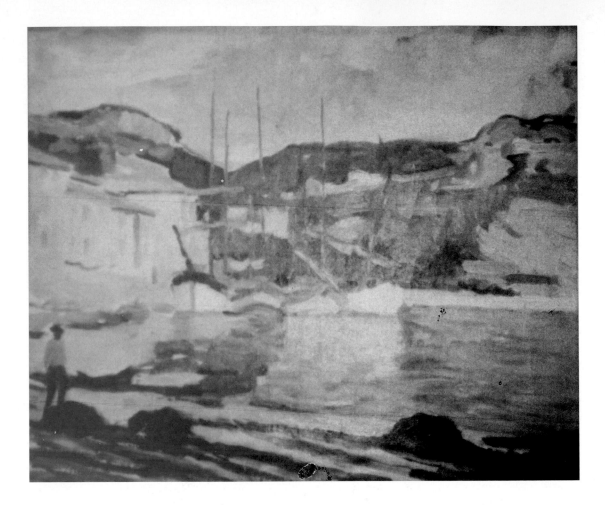

Charles Camoin,
*Quatre Bateaux
dans le port de
Cassis* (1928).

frightfully impressive…. If you were to see me now with the window wide open, lying in a very comfortable bed with an exquisite view of sea and mountains and flys [*sic*] buzzing about—you would think all these complaints very silly …[19]"

From the beginning, Vanessa was delighted with everything. She wrote Virginia, "You'll have to come out here later…. It is really absurd not to for the light & sun are even now astonishing after London & I can see the spring is soon going to burst upon us."[20] Two days later she wrote again, stating that "there is running water and a fire in the kitchen, French books are everywhere, wine is cheap, and life seems wonderfully simple. It's lovely weather & the light is dazzling."[21] The weather was perfect for walks among the olive trees and the vineyards. Whenever Virginia and Leonard chose to come they could stay again at the Hôtel Cendrillon, assuming they booked well ahead; Cassis was becoming extremely popular.

Cassis society held some fascination for Vanessa in the beginning. She wrote Virginia

in February, "It's rather like reading a new Jane Austen. One finds oneself in a new small world with all its characters complete & one is completely detached without relationship to any of them."[22] In fact, as she explained to Roger in May, "the place reeks of painters. One meets them at every turn."[23] Eventually she needed to detach herself in order to make progress with her painting. She knew, as she said, how to make herself "pretty bristly."

It was at the Villa Corsica that Vanessa had an encounter with assorted moths, including a large female of the Emperor species, which she described to Virginia in a letter of May 3, 1927. Moths frame the beginning of the letter ("I sit with moths flying madly in circles round me and the lamp)" as well as the end: ("The moths die around me".) Virginia Woolf's original title for *The Waves*, "The Moths," was inspired by Vanessa's description. On her 1929 stay, this time at La Bergère, Vanessa was still preoccupied with moths: "As usual I will see the Southern hills; write you surrounded by moths. They sit on the floor. They fly round my dream; I will take my mind out of its head."[24]

Vanessa painted a great deal in the Villa Corsica, as did Duncan. Angelica and Grace were learning French together every morning with a teacher held over from the Ancien Régime, the conventional and respectable Mlle Chevalier. She was a retired schoolmistress who taught her yawning pupils in the sweltering heat behind the lace curtains, amid a profusion of furniture. Her shutters were closed, as always in Provence, against the dazzle.

Vanessa and Duncan enjoyed Cassis so much that they began to consider buying or renting a small house to which they could escape and paint, away from the English winter. As Vanessa said of Provence, when she first arrived in Cassis:

> It's never dark even when the sky is grey. The light in the Penrose Studio is perfect & even now one could often work out of doors if one wanted to. It makes so much difference to be sure one won't suddenly be held up in the middle of something by fog or drabness. Also the beauty is a constant delight. The people are very friendly & helpful & living is very cheap.... It seems more & more ridiculous for painters to spend half their lives in the dark.[25]

Eventually Vanessa came to prefer Cassis to every other

Vanessa Bell and Duncan Grant in Cassis; photograph by Lytton Strachey (1928).

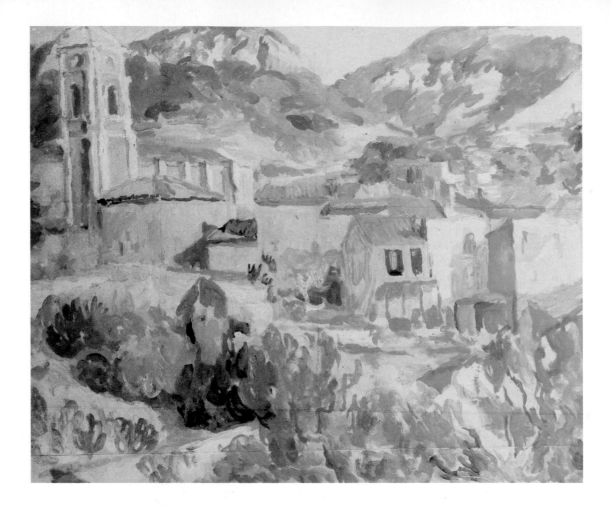

part of France, as had many painters over the years. She wrote Clive from the Villa Corsica in February, happy amid the splashes of color, with marigolds and anemones in profusion, about the way she and Duncan had found themselves chatting with Dr. Agostini at dinner at the Cendrillon until past twelve. She felt they were leading what seemed a perfect life. Clive also came down, tired of quarreling with his companion Mary Hutchinson.

In response to Vanessa's urgent plea, Leonard and Virginia came to Cassis on March 30, 1927. They again stayed at the Hôtel Cendrillon but spent most of their days with the Bells and Duncan at the Villa Corsica before going on to Italy. Virginia wrote Vita Sackville-West about the harmonious scene from their balcony, with Clive writing below and Vanessa and Duncan painting pictures of bread and fruit.

Despite their delight with Cassis and their growing desire to find a house there,

Vanessa and Duncan were never out of contact with Paris. From April 20 to May 5, 1927, the "Exposition d'Oeuvres d'Artistes Britanniques" ("The British Artists' Exhibition") was held at the Galeries Georges-Petit, 8 rue de Sèze, Paris. Roger, Duncan, and Vanessa were all represented, although Roger did not feel the quality of some of the paintings was very high. He wrote Marie Mauron (wife of his friend Charles Mauron) that, provided an artist had "value" in the judgment of at least a few people, it was virtually "a sign of being elect to be completely neglected." Too many artists, in his opinion, succumbed to promoting themselves by propaganda, advertising, and attempting to be "in the forefront."[26] When the exhibition closed, he went on to Cassis, dining en route with the Bussys at Roquebrune and the Bréals at their house, Lamardeto, Ste.-Marguerite, outside Marseilles.

La Bergère, 1927

Roger was able to help Vanessa and Duncan with their search for a suitable dwelling. In 1925 he had met, through Roland Penrose, his friend Colonel Peter Teed. Teed was a retired British cavalry officer, formerly with the Bengal Lancers. He had left his wife in India and now lived at a small château in Cassis, Fontcreuse, with his companion, Miss Jean Campbell, a former nurse. There was a small workman's cottage, called La Bergère, on the grounds of Fontcreuse that might be available for lease. Duncan and Vanessa went to see it, were delighted, and decided that, if possible, they would like to rent it. At first Colonel Teed refused, saying he needed it for farm purposes. He changed his mind, however, and Vanessa was able to acquire a ten-year lease on La Bergère, with the understanding that she would make repairs and additions; these were completed toward the end of 1927.

One evening, Duncan walked over the hill from the Villa Mimosa and came upon the cottage, seeing it as surprising lovely in its setting. Taking measurements for the windows, making decisions about the sinks to be placed in the corners of the bedroom and the position of the linen cupboard in Grace's room, and realizing that they would not have to get much furniture for it, he was delighted with the entire idea. There would be enough firewood on the estate for heating and cooking. Jean helped to get cooking equipment, put things in order, and stock their kitchen with her special cherries preserved in brandy. Peter Teed and Jean Campbell were, it soon turned out, the ideal neighbors for Duncan and Vanessa and the children. If they had too many houseguests, guests could sleep at Fontcreuse and take their meals at La Bergère. Vanessa had engaged Elise Anghilanti from the village to do the cooking, and always brought Grace along for general housekeeping. She wrote Roger on April 3, 1927:

One looks due south from one's windows down the valley & hardly sees the

ABOVE. La Bergère, Cassis; photograph by Sarah Bird Wright (1990).

RIGHT. Angelica Bell in an olive tree, Cassis (1927).

FAR RIGHT. André Derain at St.-Cyr-sur-Mer, Provence (c. 1925).

heights on the left. There are lovely groups of trees nearby…. At one's door are all the most paintable bits of Cassis which no painter yet seems to have found. They all stick to the port & the town. One is surrounded by Teed land & another friendly farmer is between us & the road so Angelica can wander about at will quite safely.[27]

Vanessa and Duncan could never quite believe their good fortune in acquiring La Bergère. Duncan went down to inspect progress on the renovation in October 1927 and wrote Vanessa that the "whole effect goes beautifully with the landscape which is extraordinary now with all the vines orange red and yellow." He continued, "It really is the most amazing country. I cannot see that one is to be pitied being within easy reach of it—it's far more extraordinary than St.-Rémy. In fact I was overcome this evening on coming back at the beauty of the position of La Bergère."[28]

Peter Teed and Jean Campbell at Fontcreuse (1928).

La Bergère, 1928

Early in 1928 Vanessa, Duncan, Angelica, and Grace went to Cassis for their first visit to La Bergère. The newly renovated house had been prepared for their arrival by Elise Anghilanti with flowers, fires, a meal, and table wine.[29] What used to be a ramshackle shell of a dwelling, though one with possibilities, had now become a cheerful cottage, and no landlords could have been kinder or more helpful than Peter Teed and Jean Campbell. They sent their wine, offered hospitality to their guests, and promptly loaned apparel when the clothes Vanessa had bought in Paris for herself and Angelica were stolen. Vanessa exclaimed to Roger, "It seems to me sometimes incredible that we should be in our own house, having managed somehow to set up practically another Charleston in France."[30]

As Angelica Garnett has described Vanessa and Duncan's usual day at La Bergère, they would work all morning, have a leisurely lunch, and then, at about five, begin working again to take advantage of late-afternoon light. Duncan painted in his large bare studio,

which was of course by far the bigger one of the two ... taking up the whole of the top of the house, and she worked in her bedroom, which was rather nice because it was cut off from the rest of the house. It didn't have a door through, you had to go outside to get to it, which was another reason people couldn't get to her. It wasn't quite as big or as light as Duncan's, but it was a very good arrangement.[31]

Vanessa's studio had a good north light and a window looking south. She could have privacy there, unless it rained and was needed as shelter for others. They trained vines to grow up the pillars and over the terrace to shelter them from the mistral; a tall glass screen also offered protection. La Bergère was not altogether free of defects. The chimneys smoked, the baths did not always work, and the painting was not finished. Never mind, said Vanessa, with her usual calm and mild irony, God has arranged it very nicely.

Angelica had everything a child's heart could desire in Provence: a donkey to ride on and play with, and a small hut for herself, with its own fireplace, shelves, cupboard, and furniture. Aunt Daisy even gave her a piano. She was rapidly learning French. Each morning she would climb in the little wooden cart behind the donkey, Coquet, at nine o'clock, and, accompanied by Grace Germany, go to Mlle Chevalier for her French lessons.

The joy of living in Cassis was intense. Vanessa wrote Roger on January 25, 1928:

> the quality of the light is always a surprise. Why don't we all live here? ... I must say when we got here on a hot, sunny day, to find Elise in the kitchen, luncheon ready, fires lit, wine on the table, almond blossoms coming out, daffodils (I hear Helen snorting, but I like them in spite of her) in Angelica's room it seemed almost incredibly nice.... You alone, Roger, could keep me from this setting for the major part of the year: please feel complimented."[32]

At first, by choice, Duncan and Vanessa saw few people except Colonel Teed and Jean Campbell. They had already met Dr. Agostini, who then inoculated Angelica and Grace

against smallpox. In the beginning visitors were welcome, especially Judith Bagenal, daughter of Barbara Bagenal, who often came to stay and was an excellent companion for Angelica. Yet, as more and more friends found their way to Cassis, Vanessa began to feel invaded by the collision of her responsibilities toward them and her passionate desire to paint. The frequency of visitors could be oppressive. In March 1928 Nan Hudson announced that she was arriving in her chauffeured Fiat to stay nearby for two weeks, which was a trial for Vanessa. She offered her several cups of tea and polite conversation, finding it rather a strain, since Ethel Sands, a closer friend and more convivial companion, was not along. At this point she would greatly appreciate the presence of Clive, who was about to arrive. He would be able to "choke her off a bit …"

Vanessa and Duncan were, of course, always eager to have Leonard and Virginia. The Woolfs drove to Cassis in March 1928, staying at Fontcreuse. Virginia wrote Gwen Raverat from Fontcreuse on April 7 that the trip down by car had been "absolute heaven" and she would like to buy a barn in a vineyard near La Bergère. Nothing came of this until their 1929 visit, however. Much of the charm of Cassis for Virginia was, apparently, the absence of pressure and the obligations she and Leonard had in London. "One does exactly what one likes here," she reported to Gwen.[33]

Angelica Bell in Cassis at La Bergère (1927).

After the Woolfs left, Vanessa and Duncan noticed how very remote from ordinary life their present life had become. In June she wrote Roger, "Virginia says both Maynard and Lytton complain that we have retired from the world! If only you were here too, I should feel just sufficiently retired or almost so."[34] Roger, however, was far from retiring from the world. He continually rushed about from Paris to Monte Carlo, to Auxerre, to London, making friends, giving lectures, seeing the old and the new, rendering expert opinions, and arranging exhibitions. His life as a critic was undeniably successful, even if his life as an artist had its vicissitudes. His emotional life was also far from being all he would have wished, as he still loved Vanessa.

In April 1928 Roger was invited to lecture at Monte Carlo on "Form and Sentiment," and arrived to visit La Bergère with Marian Dorn, the companion of E. McKnight Kauffer, an illustrator and Roger's good friend. Vanessa and the others found her somewhat tiresome. Roger's lectures, always popular, brought in

whatever he was reading at the moment, and he had the gift of making instant contact with his audience. Vanessa had repeatedly pointed out how she and Lytton, particularly, had enjoyed his lectures, and how much they also appealed to the public. They both considered Roger the leading art critic of the day. It was he whom they most hated to see leaving La Bergère, and it was his conversation that most enlivened any meal, whether in Cassis, Paris, London, or at Charleston. Vanessa always enjoyed his staying with her and Duncan.

Vanessa's clothes were highly suitable for the Midi, though they would have been inappropriate for London. The colors blended perfectly with the surroundings: a red dress, a pair of bright espadrilles, a blue hat, amid the bright green summer vines, dull-green olive trees, apricot trees, wisteria, almonds, and cherries. The terraced hillsides were juxtaposed against the parched red earth, streaked with the small channels cut for irrigation. "Merely to be here makes one happy," she wrote Roger.[35]

At the end of April 1928, Vanessa hired Sabine de Fondeville as a governess for a few months. She was less tiresome than might have been feared, giving Angelica and Judith their lessons outside and taking them to the sea in the afternoon. In the evenings Sabine

Judith Bagenal, Angelica Bell, and Sabine de Fondeville, Cassis (1928).

learned English with Grace or made dresses with her in front of the small fire, while Clive flirted and kept up a steady badinage with everyone. It was still hard to paint outside in April because of the variable weather, so Vanessa only made small *pochades*, sketches that would fit in the *poche*, or pocket. Sometimes, however, it was warm enough to paint out of doors, and Sabine could chat in French on the beach with a neighbor and her little boy. Frequently Vanessa, who had never loved talk for the sake of talk as much as many members of the Bloomsbury group, found herself dreading dinner. She wrote Roger that Clive would drink a good deal and carry on "such elaborate flirtations in French with Sabine that one was simply on tenterhooks as to what he'd say next."[36]

Working in Duncan's studio, Duncan and Vanessa painted portraits of Colonel Teed. Wanting to devote as much time as possible to their painting, they found it trying to entertain ordinary visitors. Other painters, however, were an exception. Seeing them refreshed their own vision, and they welcomed visits with such artists as Charles Camoin, Moïse Kisling, Georges Braque, Henri Matisse, Pablo Picasso, and Jean Marchand. Marchand was renowned for his still lifes, but his "tight modeling" impressed Duncan, and Roger liked him for his simple and serious character. Vanessa and Duncan had much the same artistic community in the Midi as in Paris. They also enjoyed seeing Auguste Bréal in Marseilles, who had been responsible for introducing the Bussys to the Stracheys, when both Simon and Pernel Strachey were staying with him. Vanessa and Duncan drove their newly purchased Citroën over to lunch with him and his incomprehensible but lovely Spanish wife in Marseilles at his favorite retreat, the Bar Idéal, and found him, as always, charming and amusing. They considered his pictures oddly weak, however.

In May of 1928, Lytton Strachey, traveling with his companion Dora Carrington, fell ill at Aix, after they had taken tea with Duncan and Vanessa at La Bergère. Since Dr. Agostini was away and they had no car available, they simply commiserated with Lytton on the phone. Carrington was, grumbled Vanessa to Roger, "unable I suppose to talk much French, so why do they want to travel? It was absurd to send for us, what could we do? So we didn't go."[37] Her irritation was unusually strong:

> I think I can't have done my humane qualities justice—for we felt we had put our-selves out as far as only one could. We spent hours, telephoning from Agostini's

Vanessa Bell at La Bergère (1928).

white sitting room to Aix…. Carrington has a funereal effect on Lytton, who loses all interest in her presence…. Literati must be miserable out of their own studies.[38]

Carrington's own notes about her travels, whether with Gerald, Lytton, or Ralph, reveal no such misery; she seems to have enjoyed herself immensely. Lytton recovered, Carrington's French failed to improve, and Vanessa's irritation was temporary, but the incident was indicative of a certain impatience not in evidence when she dealt with Roger.

In September of 1928 Vanessa reported to Roger from La Bergère about their visitors. She urged him to come:

> you & Helen could be put up there with no one else but me & D(uncan) in the house & Elise to cook you very wholesome food & as many fires and stoves as you like. What a pity you don't like the place, for you and she could stay there as long as you liked & you'd have a studio to work in …"[39]

She pointed out that they would not have to see anyone but Colonel Teed and Jean Campbell, and that, not often. But, she teased, "I know you won't … such is your horror of red rocks." (Roger in fact was a passionate admirer of the redness of the rocks at Cassis.) In October, she again urged him to come down. He ought to find the arrangements perfect. The pergola, roofed over with cane, was like another room, and Elise provided superb meals and made practical matters run smoothly. He would relish the indescribable color of the valley in the Bouches du Rhône, among the hills and near the boat harbor. Nothing was lacking for happiness: "warmth, hot water, books, chairs one can sit in…. I know it all leaves you cold, but I must rub it in," she repeated.[40]

Vanessa also observed that someone could drive Roger about the area. At the time he did not actually drive, which may have been a good thing, given his noted impatience with trains. When he did learn to drive, his energetic mode of doing everything caused him to frighten passengers, other motorists, and passersby. In conditions causing others to hesitate, he would plunge ahead. During one October mistral, he was driving his Citroën, as Vanessa described it to Clive, "with great anxiety & constant hoots. He nearly went over the edge at Fontcreuse."[41] Colonel Teed, said Vanessa to Virginia, thought him "none too safe," apparently a mild understatement. Considerations of safety were not always compatible with the characteristic enthusiasm that endeared him to his friends and enabled him to absorb endless amounts of new information and remain open to new points of view.

Desmond MacCarthy had gone down to Cassis to see Duncan and Vanessa. He was charming, like Angus Davidson, but in fact, Roger was the only guest Vanessa was really

ABOVE, LEFT.
Duncan Grant
and Vanessa Bell
at La Bergère
(1928).

ABOVE, RIGHT.
Angelica and
Quentin Bell, La
Bergère (1928).

LEFT. Elise
Anghilanti and
Grace Germany
at La Bergère
(1928).

sorry to see leaving. She longed to have him nearby as much as possible, as she wrote him in September 1928.[42] He, even more than Duncan, was the person with whom she could best discuss painting problems. Roger did go to Cassis in October 1928, continuing on to Brantôme, Dordogne.

In autumn 1928 Duncan invited his mother and her companion, Miss Elwes, to accompany him to Cassis for what became for them a memorable holiday. He treated them to a few days in Paris, after which they went by train to Marseilles, where Colonel Teed met them. Elise had opened La Bergère and made a welcoming lunch. Ethel Grant was delighted with the house, although Duncan had to forestall Miss Elwes's elaborate plans for herbaceous borders around the new terrace by buying roses and honeysuckle to plant. He drove them about the countryside and treated them to quantities of Colonel Teed's Fontcreuse wine, which had such a buoyant effect on them that he began offering preprandial Vermouth and postluncheon Cointreau.[43]

For several years, Vanessa and Duncan enjoyed this manner of existence, spending from six weeks to two or three months at a time in Cassis (usually March, April, and May, although they sometimes returned together or separately in the fall). Vanessa wrote Roger: "I don't know how one will ever face London again. I think I am getting quite unsuited to it, I so much prefer this really & it seems so much more sensible an existence."[44] She found it "a great relief to be in the country without a garden. It seems to give one many more moments of leisure & I see that I am really of a very lazy disposition & enjoy nothing so much as pottering about looking about me with no particular engagement ahead."[45] Elise would cook the lunch & do the shopping, which was simple and inexpensive, like the wine, which was all Grace and Vanessa drank. Vanessa and Duncan would continue to work inside or out, in all varieties of weather and at all hours; they would lunch outside when feasible.[46] There seemed little point in returning to a gray England, except when necessary for Angelica's schooling.

Sometimes Vanessa and Duncan explored other towns in Provence, including Marseilles, Aix, and Aubagne. Taking public transportation was preferable to their driving, although they had various old cars while in Cassis and experienced many of the joys and dangers of motoring in France. In Marseilles they might buy furniture and painting materials, while in Aubagne they could find the famous local pottery with its old forms and white glaze, and in Aix, search for antiques. Vanessa often wrote Virginia about their epic struggles with various cars, including her accidents and near accidents, such as their experience one day in Marseilles:

> In the baking sun & over the crimson earth, Duncan drove with great skill—managing the hills & hairpin bends with great competence, but when we got into the town he became terrified of the policeman's eye, nearly ran into a lamppost, & made me take the wheel …

Marseilles is said to be far worse than Paris to drive in which I think is true. No one observes any rule, there are tram lines everywhere, large horse drawn lorries walk slowly down the middle of every street & thousands of people on foot rush in & out & are always off the pavement."[47]

It was easier to drive in Aix, which Vanessa called "a large sleepy town with rows of open horse-drawn carts & some rather lovely buildings where we saw pictures by Ingres & others & were very happy in the sun."[48] Naturally it was more difficult to manage their car in the towns than on the rural roads. It was hard to drive in the narrow passages between shops on one side and carts on the other. Their car would sometimes stall and hold up the crowd, while people would shout their advice on all sides. Motoring in Cassis itself was, and still is, extremely difficult. Vanessa thought Quentin should get his permit at Marseilles and then exercise great caution, because of the "twists and turns"; the tiny roads "always had poplars or plane trees lining them" and were particularly dangerous because of shadows."[49]

Angelica Garnett recalls vividly the struggle Vanessa and Duncan had with automobiles as well as the trials the Woolfs had on their motor trips to Cassis:

Vanessa got a car, a Renault, before Leonard and Virginia, and then Leonard became totally autocratic about his car. I mean whenever they came to see us, there were great tales of how the engine had been behaving. After the Singer, they had a Lanchester, which was much grander, a wonderful green color all over, a *décapotable* (convertible). They wouldn't have left it anywhere. I remember they had many punctures ... you have absolutely no idea how different it was. It was quite an adventure: everyone always had massive punctures, one was always out of petrol or out of tires, and it was such an effort to undo the screws.... I know that Bunny and Duncan once did it together, motoring down to Cassis, and Vanessa did it on several occasions, and increasingly Leonard did ... we had always done that.[50]

La Bergère, 1929

In April 1929 Vanessa, Duncan, Grace, Angelica, and Judith Bagenal returned to Cassis by train. After a comfortable journey, with croissants and coffee between Avignon and Marseilles, they were met by a taxi from Jourdan's garage in Cassis that drove them on to La Bergère for lunch. The freezing weather that still lingered in the area had blighted much of the vegetation and created hazardous roads; everything looked dismal to Vanessa. She wrote a discouraged letter to Roger: "The awful cold has killed many

things, no one knows yet how much, but the olives are a misty brown and are losing all their leaves. I am sure it would be awful to live all the year in Cassis, rather poor and without a car."[51] (The olive trees would recover, as they would after the even worse spring frost of 1937, which local wine growers still recall vividly.)

Clive and Julian were already in residence at Fontcreuse; Quentin was with them but had a bedroom in Cassis, as space was limited at the chateau. He took his meals and worked at La Bergère, painting diligently in spite of what Vanessa believed was his "evident enjoyment of his success with the young ladies of Cassis." In some respects, however, it was not a good time. Julian hung about, critical and silent. The chatter of conversation with Clive and the boys grated on Vanessa's nerves, although she greatly enjoyed the feminine presence of Angelica. She wrote Roger,

> Duncan and I really intended this house as a place to come to more or less alone to work in, but whenever one has succeeded in making a house habitable even rather in the teeth of difficulties as at Charleston people are inclined to come like a flight of locusts and complain that there isn't room enough![52]

Quentin Bell at La Bergère (1929).

Luckily, Clive's room in the main house at Fontcreuse was heated, so that Vanessa's studio, which was also her bedroom and the common sitting room, was not "quite so much invaded."[53]

Although Clive went to Paris for a month to write his book on French art, the problem of sufficient space was never to be really solved. There were so many people at Fontcreuse and La Bergère that, when they were unable to gather on the terrace because of the weather, they were forced to intrude on Vanessa's studio. She had regarded it as a private utopia in her early letters, but it was now mitigated by days of rain and cold evenings. The amount of room required for painting remained an undeniable problem at La Bergère, a difficulty that never arose at Charleston, which was far more spacious. Evening visits to local cafés provided occasional relief from the overcrowding.

Vanessa continued to believe that there was a clear correspondence between the ambience of one's living arrangements and the creative person-

ality. Freed from the sense of responsibility she always had in England, she felt a great relief at living through the senses only, as she believed a painter should be able to do. Angelica Garnett has described the *somnifère* Vanessa took to facilitate each ferry crossing as a possible haze-producing ingredient in her French existence, effecting a freedom from responsibility. At times, however, she debated with herself about how much time they could spend in the Midi in view of Angelica's schooling in England. She realized that if Angelica was unhappy there, the long spring sojourns in Cassis might have to be curtailed.

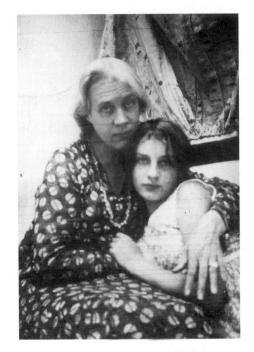

Later in the month Duncan and Vanessa drove their Citroën to visit the Bussys in Roquebrune for a week. Their visit was not an unmitigated pleasure, for they were again invited to view Simon's sketches and his curious pastels, so finished and so glossy, some with garish and unpleasant colors, and some quite attractive. Vanessa found herself, as she wrote Roger, horrified and fascinated, as always, especially in the Bussys' tiny house. It had seemed to Lytton almost like an illustration for a children's book but was graced with "the best view in Europe."[54] Everything Simon did seemed fantastic to Duncan and Vanessa, particularly the "zoo" of animal paintings now gracing his studio, the fruit of his months of work at actual zoos in London and elsewhere. Vanessa had been ambivalent about his work for a long time; in 1921 she had written John Maynard Keynes, "I think there is a great deal to be said for it, though I daresay the cultured world in London will hate it."[55]

Vanessa and Angelica Bell.

As on previous visits, Vanessa and Duncan were expected to offer their professional opinions about Simon's work. "I don't think I have ever been so puzzled by an artist or had such opposite feelings, both admiration and horror," Vanessa remarked. Simon, she felt, was "tremendously gifted. I suppose it's not odd that he should feel rather bitter that with such gifts he should not have had more success."[56] Had he had more money, it might not have mattered, Vanessa thought.

En route to Roquebrune, they had driven through Aix, Arles, and Aigues-Mortes. Vanessa wrote Roger of Aigues-Mortes and its high tower: "What a grim place, rather splendid, but not to my taste." Each view seemed as good as the next, she said. And it was too extreme, whereas her taste ran to the "tame as regards scenery."[57] She explained that she judged places "aesthetically only"; she disliked too much sea and wind as well as

mountains and extreme temperatures. Her abhorrence of emotional scenes and of violent scenery corresponded with her lament to Roger in one letter that she was too inexpressive. She and Roger would tease each other about their preferences regarding landscape. Roger considered the mountains and the sea as "unavoidable" in any list of his favorite places. He often painted mountain views in which he juxtaposed trees against the highest peaks. Their relative mass and shadows in the planes would play against each other, as in his *Provençal Landscape*. The drive to Roquebrune also took them through Toulon, which all three painters loved. Roger, the first to know the town, had written Vanessa about it in 1927 and advised them to see it:

> Those places across the bay that Duncan went to are the dullest things of all. What's good is to go eastward along the coast to Cap Brun where there are a series of small bays & rocky creeks with fir trees leaning down the rocks and almost touching the water, a kind of immensely glorified Studland with something Chinese added.... The great bother is the excessive brilliance and colour of the sea which tends to upset things rather.

What he loved were the tiny churches in the town, with all their altar lights and flowers:

> ... the blue and white hangings and artificial flowers and all the naive bondieuseries [religiosities] of these parts.... This wouldn't suit you as well as Cas-

Toulon; photograph by Frances Partridge.

sis though I think it infinitely more beautiful…. Vast carloads of carnations of all colours come in every day, the marché is a blaze of colours.[58]

Several years later Duncan would write Vanessa from the Hôtel de la Rade in Toulon that it had taken him a long time to get used to the south:

> … at first everything seems a bit colourless in a way after the North, but that is only because one has not got one's eye in.
>
> The sort of thing I feel I would like to do in this town are the people and the little shop fronts and interiors one passes in the narrow streets. (A crowd collected when I tried to do a little sketch on the port). I am sitting outside a cafe … now a blue black ink background and an endless stream of rather fascinating people walking up and down against it. If I was grave I should paint at night. One day I took a train to St. Hélène a little suburb by the sea and bathed.[59]

Virginia and Leonard made their fourth visit to Cassis in early June 1929. This time Virginia's offhand comment to Gwen Raverat about wanting "a barn in a vineyard" evolved into a more determined search for a seasonal home near Vanessa and Duncan. There is no question but that Virginia and Vanessa missed the proximity to each other they enjoyed in England, both in London and in Sussex, where Monks House and Charleston were within a few miles of each other. Vanessa found them a possible cottage nearby, La Boudarde, and they began negotiations, but eventually dropped the idea. Leonard believed a third residence, in addition to Monks House and their Tavistock Square house, would present too many problems to be workable (*see* "Virginia Woolf, Leonard Woolf, Vita Sackville-West").

Despite periodic resolutions to restrict their social life, Vanessa and Duncan actually saw many friends in Provence, as they had done in previous years. They drove over to Roquebrune to see the Bussys; to Vence to see Jacques and Gwen Raverat; to Marseilles to see the Bréals. En route to Marseilles they enjoyed the marine views at La Ciotat, "attractive, like your paintings of it," as Vanessa wrote Roger.[60] They also attended exhibitions in Aix and Marseilles. They might be found sitting by the sea in a café at St. Raphael, in their thinnest summer clothes, listening to the men playing and singing.

Other visitors during the early years included Lytton (who was, Duncan told Vanessa, "I suspect rather attracted by Quentin"); Angus Davidson, Barbara Bagenal (who had to be taken about to Toulon, Aubagne, and the Calanques), Freddie Mayor, and Desmond MacCarthy. The cumulative effect was a considerable strain for Vanessa. The need to be hospitable when she desperately wanted to work made Cassis begin to feel like Charleston all over again, a problem she had foreseen earlier in the year, while still in England, and confided to Roger.[61]

Vanessa had become more prudent about her painting by 1929, mindful of the rapid changes from light to dark and the likelihood of sudden wind. She had been, she wrote Roger, making only

> small quick sketches from nature…. But one gets all kinds of different ideas about space & colour I think here which gradually affect what one wants to do & make it different from what it would be in England or the north. [She was trying] to paint without paying much attention to any but the essential things…. One can't go for qualities of detail and small exquisitenesses at least I can't on that scale and so one is forced to attend more to the main design.[62]

This was precisely what Roger had done in his large-scale painting of Vaison-la-Romaine: the experiment proved revealing in both cases.

Roger, meanwhile, had been in Paris visiting exhibitions and galleries. "How I wish I could have seen the Chantilly pictures with you," Vanessa wrote of one show he had seen with many paintings by Gustave Courbet. She herelf was often discouraged: "One gets so tired of one's own works after a show that one wants to throw them all overboard so to speak and start anew on something quite different. I am afraid my success is just with those who know something about painting."[63]

When Vanessa and Duncan returned to England in July 1929, they stopped in Paris and went to the Luxembourg Museum. Vanessa had wanted to see a particular Matisse again that had captured her imagination. She wrote Roger she was "bowled over" by the still life with a blue checked napkin, blue wall, and green table. "When he does things like that I am quite overcome. Only Picasso can stand beside him. I wonder if the feeling would last. *His* feeling seems to have been so direct and tremendous that everything has to give way to it but I suppose one may be too much overcome by the immediate impression…. I should like to have a work of his of that kind—they are very rare I think—to look at for a long time and see whether it went on impressing one.[64]

Roger's thoughtfulness and his ability to organize were both legendary. He had insisted, for example, that they have a perfect meal while in Paris at his expense. They accepted his offer, and Vanessa wrote again to enumerate its delights: melon, trout, wood strawberries, delicious wine—consumed in a heavenly park. Like the cat in the story who invisibly provides everything, she wrote, "you seemed somehow to have got us together & sent us to that particular place & even chosen the food."[65]

After two months in England Duncan and Vanessa returned to Paris in October 1929, staying again at the Hôtel de Londres in the rue Bonaparte. Paris seemed relatively empty, which had advantages, as Vanessa wrote Roger: "I have a good back room, usually given to Clive, so it's comparatively grand." Angelica Garnett has described this hotel in

The Eternal Moment, as small and unpretentious, "with a red plush staircarpet and stuffy bedrooms straight out of Vuillard." It had become, over the years,

> a familiar refuge from which to saunter out, as a preliminary tonic, to the Louvre just over the Pont des Arts, with its Ingres, Chardins and Veroneses. Vanessa and Duncan visited all the significant exhibitions, which then offered havens of peace and quiet in which to examine work either new or loved for its familiarity which, however, always presented some new aspect.... And there was always the café, usually Les Deux Magots, where one could sip coffee, wait for friends, and consider what to do next. Hours were spent there, looking, watching, and often secretly sketching under the table so as neither to offend nor provoke unwanted interest. Tiny sketch books were filled with rapid portraits in thick black pencil ...[66]

Vanessa and Duncan took time to be lazy, talking for hours and enjoying a late breakfast until nearly noon, when they would consider where they might have the best lunch. One day after lunch they visited the Chardin exhibition at the strange new underground Pigalle Théâtre. The harsh lighting did little for the paintings, and the steel bars made the gallery seem like an operating room. She wrote Roger that she felt modern architects ought to introduce more color, which would make the bareness palatable. Even so, the building had poor proportions. She was keen to hear about his celebrated series of lectures in London. "I heard last week from the Woolves," she wrote, "& was as usual amazed by its goodness. I can't help wondering what effect you may not have upon obscure natives in the provinces. As for its effect upon *me*, I wish I could get my notions half as clear as you can get yours. What a battle we would have."[67]

Duncan and Vanessa did not return to Cassis until the spring of 1930. Angelica Garnett has summarized the ambience at La Bergère: "Under a fiercer sky and in a hotter climate, it was Charleston reconstituted."[68] It was, however, a far more luminous Charleston, particularly good for the English painters. The largesse and ease of life at La Bergère offered Vanessa and Duncan, as well as Roger, the continuation and consolidation of their loving companionship. To all three, art and friends were essential, and they flourished with immense vitality in Vanessa and Duncan's pied-à-terre in Cassis.

Duncan Grant,
Fontcreuse
(1934).

Last Years in the Midi, 1930–1938

> *I sometimes have a bout of wanting to think things over. Perhaps think is rather a strong word but to dream things over ... The terrace at Fontcreuse is like the most marvellous setting for* Twelfth Night *—real and marvellous at the same time.*
> —Duncan Grant to Vanessa Bell, December 1930

In Duncan Grant's *Fontcreuse* (1934) there is a feeling of imminent spring. Craggy peaks stretch toward a flat sky behind a thick clump of trees that dominate the middle ground and reach the top of the frame. The foreground is empty, with a spindly pair of short trees on the right almost escaping notice, like the orchard. The pastoral setting could well be the stage for a performance of *Twelfth Night*, in which Duncan had a particular interest, having designed sets and costumes for Jacques Copeau's 1913 Parisian production. The stone terrace of the château (*see* "Painters in Cassis, 1925–1929," page 209), would certainly have been an ideal locus for such a production, but it never materialized.

Duncan suggests, in his letter to Vanessa, a somewhat pensive state of mind. In fact, the autumn months at Cassis were bittersweet for Vanessa. She had begun planning a visit to Cassis as early as August 1930, and had written Roger Fry she longed to go with Duncan to "our own house that can be heated, and books to read in the evenings, with our car—we would like to go then.... Please write & please come. *Do keep our autumn plans secret.* It would be fatal if they got out. Your loving V."[1] Roger responded in September, from Tours, where it was wet and cold, and from Beaumes-de-Venise, where he was staying with a Madame Lapaque.

In October Roger wrote from Paris that the city was a misery and his teeth giving him a great deal of trouble. He was planning to go to St.-Rémy to see the Maurons and hoping to learn a bit of Provençal. On October 10, Vanessa wired him that she and Quentin were going straight to Cassis; their journey had been delayed because of passports. Quentin had departed for Dinard and would meet her in Paris for the trip down to Cassis. "He very much wants to go to Cassis for a short time so I thought I had better go with him & then if you're still at Beaumes (which does sound a little mosquito ridden however) I could easily come there later. Or in fact I could come anywhere within reasonable distance." (Roger had been wrapping his limbs in newspapers, as the peasants did, to protect themselves.) Vanessa urged him to come to Cassis, because otherwise, she would "have to come even to the mountains. But do please make it a valley."[2]

Vanessa was particularly eager to see Roger at this time. Duncan was continuing an

affair with George Bergen, a young American artist of Jewish/Russian origins, which had begun in 1929. He brought George to Cassis soon after Vanessa and Quentin arrived; she struggled to be civil to him, but apparently this was not always easy. She planned to stay only two weeks. It was the first time Grace Germany had not come to Cassis with them, and Elise Anghilanti's son was critically ill with tuberculosis; she was unable to do the cooking. The situation was extremely painful for Vanessa, although there were cheerful times when she, Duncan, Quentin, and George were all painting.[3]

Early October brought the feast of the *vendange*, with all of Cassis society attending. The grape-picking, as Vanessa described it to Roger, was a lovely spectacle with "great wooden tubs full of blue grapes looking almost turquoise in the sun…. Here we are in the midst of a vintage—one of the loveliest sights I've ever seen. A chattering crowd of people, some Arabs or Turks, some natives here, all in the highest spirits. Gobbling grapes, laughing, singing. Duncan & I have been trying desperately to sketch them."[4] Gathering and sorting grapes is heavy work, but it can be agreeable. Meals are taken in common and small problems forgotten. At vintage time, the residents of Fontcreuse bottled their wine, 250 or so bottles, until the house was overflowing. All reports have it that the wine was very good that year. The wine of Fontcreuse has still a fine reputation, particularly the white wine, as is true of Cassis in general.

Roger would stay at Fontcreuse, taking his meals with Vanessa and Duncan, and painting alongside them when it was possible outside. Fontcreuse and the nearby hills, the orchards, the olive groves, the boats in the harbor—everything lent itself to painting.

Roger Fry and Helen Anrep arrived the same month, and urged Vanessa to go with them on a driving tour of Provence. In her absence Duncan and George gave a party at La Bergère with musicians playing on the terrace.[5] George then went to Marseilles to meet a former lover, and Duncan stayed on alone in the house, returning to England in time to spend Christmas with his mother.

After Vanessa and Duncan's 1930 stay at La Bergère they did not return in the intervening years until 1937. It is uncertain whether this hiatus in their visits was because of Angelica's schooling or another reason. The Bloomsbury group as a whole, however, continued to visit and work in France. Clive Bell was now seeing a great deal of a young German woman, then living in London, Benita Jaeger, although he did not live formally with her. They stayed at Cannes for six weeks in 1930, in a villa belonging to Madge Garland in the rue d'Antibes. Clive continued to read and write diligently and to encourage Benita to read history and biography. She went with him to Cassis and began an autobiographical novel, which Raymond Mortimer encouraged her to show to Virginia Woolf. Virginia's reaction was apparently sufficiently discouraging for Benita to give up writing it.[6]

Virginia herself was missing France; she and Leonard did not go there again until April 1931. Just before they departed for the ferry, she wrote Ethel Smyth she was think-

LEFT. *Vendange* at Fontcreuse.

BELOW. *Vendange* at Fontcreuse (pouring wine into barrel).

ing of a table in front of an "Inn at La Rochelle where all the boats have green and purple sails as a heaven scarcely to be reached…. O but think of new hills, and French towns, and rolls, and views, and the sea…."[7] The Woolfs visited Montaigne's tower west of Castillon but did not go to Cassis.

In January 1932 Lytton Strachey died of stomach cancer and Carrington, Ralph's wife, who had been deeply in love with Lytton, shot herself six weeks later (*see* chapter on Lytton Strachey, Dora Carrington, and Ralph Partridge). The two deaths were extremely difficult for Ralph as well as for Frances Marshall, who was soon to marry him. Roger reported to Vanessa that Ralph and Frances had dined with Clive and stayed until one A.M., and were in better spirits.

In May 1932 Vanessa and Duncan prepared sets for the Camargo Ballet in Paris. Duncan's "sacred grove" would be used, along with a new *Swan Lake* for which Duncan had done the decor. Vanessa was painting a tropical scene with animals and fruits. She had learned that hurry was self-defeating: "I haven't done anything much but have simply sent what I'd do anyway. I know it's no use my working against Time—it's always fatal."[8] She needed leisure for her art, and her aversion to exterior pressure is implicit in her best paintings.

In March 1930, Roger had been living in the town of Cagnes, on the Riviera. He was lodging in a small pension in the old part of the town, surrounded by artists of many nationalities (although few of them were French). Often the painters lived in elaborately artistic villas. He hoped to move to Draguignan, farther inland, in order to escape the "snobbery which we have I suppose done a good deal to create." He wrote Vanessa about St. Paul's church in the nearby town of Vence, "crowded with frescoes and fabulous riches…." He added that he had only had six cigarettes since his arrival. He spent a significant part of his time looking at architecture and painting galleries, and making side trips to Nice: "much more of a town on its own footing & less merely a ville d'eau than most." He observed that if he, Vanessa, and Duncan were to stay in Cagnes they could easily get models, take a studio, attend concerts, and profit from their surroundings. Roger's optimism was, as always encouraging to Vanessa and Duncan, but they did not take him up on his proposal that they all move to Cagnes.[9]

Roger continued to grow professionally. He experimented with lithography, and in 1930 the Architectural Press published a set of lithographs he had executed of French church interiors, *Ten Architectural Lithographs*. Another technique he tried was using the new medium recently discovered by the artist Maroger. This was an *impasto* that approximated the technique of the Old Masters, although it was difficult to use. "The medium," he wrote Vanessa, "makes the paint so very transparent that the under paint always shows through a bit … it's one of the ways of making one's texture rich and vital if one can only prevent the details from sticking out of their envelope."[10] Maroger counseled him to use it on special white paper in order to show off its transparent black glaze.[11] At

one point Roger had hoped Maroger might give his formula to Charles Mauron, who had a background as a chemist, so that he might prepare and sell it in order to augment his income, but the plan never materialized.

When visiting Cassis Roger would stay at Fontcreuse, taking his meals with Vanessa and Duncan and painting alongside them when it was possible outside. Fontcreuse and the nearby hills, the orchards, the olive groves, the boats in the harbor—everything lent itself to painting. Roger once wrote Vanessa that he would never "make anything that will give you or anyone else the gasp of delighted surprise at a revelation," but that he believed he could "tempt people to enjoy a quiet contemplative kind of pleasure."[12] His landscapes at Cassis, La Ciotat, and other places in France are, for the most part, harmonious and serene. Until his death in 1934 he remained a vital presence in Vanessa's life. On January 30, 1933, he wrote her, "I don't think I shall ever stop being in some queer profound way in love with you, my dear. But that's no good."[13]

One of Roger's most melancholy paintings, *Spring in Provence* (1933), was conceivably his last. He completed it in the *mas* he shared with his friends Charles and Marie Mauron in St.-Rémy; it almost presages his death. The viewer is looking out from the Mas d'Angirany toward the Alpilles, through the frame of a door. An empty armchair, placed in the shadow of an upright pole, faces right, equidistant from the pole and a large urn. The top of the pole is as unfinished and useless, touching nothing, as the urn is empty. The three objects are the opposite of the full-branching light-colored olive trees and the darker mass of trees behind, with the bare peaks of the Alpilles rising in the distance.

Roger Fry,
Spring in Provence
(1933).

The peaks, however, are not as high as the pole. The middle ground of dry earth shows the shadows of furrows carved out for irrigation of the parched earth. Light bounces from the right door beam, striking the east side of the urn also; the chair faces this source of light. The painting suggests the harshness of human life compared with the abundant spring foliage beyond the arid furrowed earth. This desolate view seems a perfect embodiment of Roger's loss and the ensuing emptiness for Vanessa and Virginia.

During the years after Roger's death, Augustus John's family was renting a *mas* in St.-Rémy behind the Roman ruins called the Antiques. They were not far from the Maurons, and their daughters had become good friends of Charles and Marie.[14] In a discussion of the beauty of the Alpilles, the hills behind St.-Rémy Roger Fry had painted, John once told Marie Mauron of his inability to paint their particular colors. They needed "their" artist, he said (i.e., Fry), and that he could not be. He was positive he would never attempt to paint them again. The next day, however, he did paint the Alpilles, as Marie had rightly predicted.

Roger's death was entirely unexpected. In the summer of 1934 he drove from Dieppe to St.-Rémy to stay in the Mas D'Angirany. On the way back he stopped at Royat for treatment of an artery problem in his leg. Back in London, he slipped on a rug and

injured his hip. He was moved to the Royal Free Hospital at Hampstead and died three days later, on September 9.[15] He left Vanessa a Matisse painting of ships in a harbor, which she hung on her wall.[16] Roger had always been one of the liveliest and best-loved among the Bloomsbury circle. They remembered his multifaceted talents as he lectured, painted, wrote, played chess, and drove his car "in a way to frighten everyone," as Julian Bell described him to Charles Mauron. Angelica Garnett recalls that the time of Roger's visits to Charleston each summer was when they were all the gayest and noisiest and most talkative.[17] "My poor mother," Julian wrote Mauron at the time of Roger's death, "is more unhappy than I have ever known her, so is Virginia Woolf.... I think very few of us knew Roger as well as you did.... I always thought Roger was one of the finest and most complete representatives of European civilisation, one of those extraordinary people who have really combined the gifts of artist and scientist and philosopher— besides being the most charming human being I have ever known."[18]

Julian Bell visited Cassis at various times in the early 1930s while still at Cambridge. He published poetry and essays and was regarded as extremely promising, not only by the Bloomsbury group but by his contemporaries and the faculty at Cambridge. He had known and admired the brilliant young Cambridge philosopher Frank P. Ramsey, who died in 1930 at the age of twenty-six, leaving his widow, Lettice (who was a gifted photographer), and two small children. Julian and Lettice had a lengthy affair; in 1932 she visited both Charleston and Cassis, making several noted photographs of him. After he graduated, he was offered, in July 1935, a position teaching English at Hankow, China, at the National University of Wuhan. He departed to Paris, went on to Marseilles, and there boarded the *Fushimi Maru*, a Japanese ship, in order to reach China. Vanessa wrote him she had no regrets about not having taken "a house at St.-Rémy, beautiful as the country is, as evidently one would be blown to pieces by the wind. Besides I think Cassis is perhaps more liveable in, with the Teeds next door, etc., and bathing to be got."[19]

In early 1937 Julian resigned from Wuhan, writing Vanessa that his future must involve one of his three principal interests: "travel, politics, Spain." He returned by ship to Marseilles and went immediately to see the Maurons in St.-Rémy to discuss his determination to take part in the Spanish Civil War. Charles Mauron persuaded him to go to Charleston and discuss the matter with Vanessa; he did so in March. He applied to join the Spanish Medical Aid organization and was accepted as an ambulance driver. His ambulance was damaged by a bomb in Spain, and he was then given the dangerous duty of helping to evacuate the wounded. He was fatally wounded while attempting to repair roads to carry out this task and died July 18 at the Escorial hospital. Vanessa was, of course, devastated; Virginia was unsure whether she would ever recover from the "perpetual wound." Their brother Adrian and Helen Anrep brought the Maurons to see her in England; they were among the few visitors she could tolerate. Maynard Keynes com-

Julian Bell in
Cassis; photo-
graphs by Lettice
Ramsey (1932).

RIGHT. Group at table in Cassis, with Janetta Woolley (c.), her father, Geoffrey Woolley, V.C. (l.), and her brother, Rollo Woolley (r.), who was shot down in the R.A.F. in World War II.

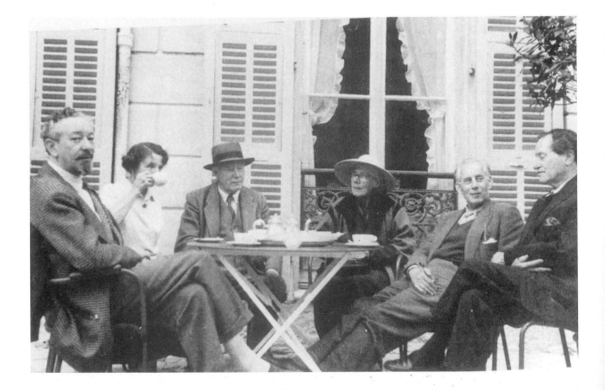

forted her very much by writing an article about Julian for the *Nation* as well as an obituary for the King's College Annual Report. He wrote her that Julian was "fated to make his protest, as he was entitled to do, with his life, and one can say nothing."[20] (*See* the chapter "The Maurons, E. M. Forster, Julian Bell, and Bloomsbury.") By October 1937 Vanessa was able to go to Paris with Duncan, Angelica, and Quentin to attend some exhibitions; they again stayed at the Hôtel de Londres.

In December 1937 Vanessa and Angelica went by train to Cassis, staying at Fontcreuse because there were tenants at La Bergère. They had a small sitting room in the château tower, taking their meals with Peter Teed and Jean Campbell and, together, managed to get through the Christmas season. Quentin, along with Duncan, who had been with his mother in Paris, came down to join them, and they went to see the Maurons at St.-Rémy. Charles had written an introduction to a volume of Julian's letters and essays, which Quentin translated. During this visit Vanessa found she could work to some extent, and produced several designs for book jackets.

On their return to England, Vanessa and Duncan came to realize the seriousness of Bunny Garnett's attachment to Angelica. He was married and the father of two young sons; his wife, Ray (Frances Marshall Partridge's sister), had been ill with cancer. Duncan wrote him inquiring whether he had "honorable" intentions. He thought him unstable and unsuitable for his daughter. Vanessa perceived that Bunny's love might be beneficial to Angelica, coming just at the time of Julian's death. The affair between Bunny and Angelica continued for several years. Ray Garnett died in March 1940, and in the spring of 1942 Angelica and Bunny were married. They became the parents of four daughters.

Vanessa and Duncan returned once more to La Bergère in 1938, for the last time, re-creating their former existence. They looked through old papers and other possessions, assisted by Elise. Despite the devastating losses the decade had brought, and the threat of war, they felt the charm of old associations, friendships, and memories. The Midi had engendered some of their finest work and enriched their lives in ways they could not have imagined when Vanessa, Grace, and Angelica had rushed from England to Duncan's bedside in Les Mimosas in 1927.

Vanessa Bell,
Studland Beach
(1912).

Visual Translations

… in my own view, it's not so much the perceptible world that is so wonderful and adorable, as the activity of the perceiver.

—Frances Partridge, *Julia Strachey*

The aesthetic revolution of the two Post-Impressionist Exhibitions in 1910 and 1912, for which Roger Fry was largely responsible, struck a receptive chord with the British public, but in particular with the Bloomsbury painters. Vanessa Bell had intended to accompany Roger and Duncan Grant and Clive Bell to Paris in October 1910 to help make the final selection of paintings for the first exhibition, but had instead remained at home with the infant Quentin, who was not gaining weight. Ottoline Morrell went in her place (*see* "Painters in France, 1910–1921"). When exhibited in London, the paintings by Paul Cézanne, André Derain, and Henri Matisse, as well as those of other artists, not only made a lasting impact on the British public but also transformed the approach of many British painters to art.

A few examples of French-to-English aesthetic translation are discussed and illustrated in this chapter. Others, which are well known, are mentioned for reference. Certain paintings are specifically related to the two exhibitions, while others exemplify the general Anglo–French crossing of cultures. Such visual translations, mental and material, are apparent in color scheme, form, or theme, or, in some cases, in all three. For example, Duncan Grant's delicate line drawings of Vanessa Bell arranging her hair at Charleston are reminiscent in theme of the *coiffure* paintings of Degas, Matisse, and Picasso, although their form is closest to those of Matisse. Some of Grant's and Bell's paintings of their studios are equally reminiscent of Matisse's depictions of his own studio. Grant's *Lessons in the Orchard* (*see* color insert), although painted in England, recalls a French sky and trees. The three figures curved into French chairs bend over their work as they might over a meal in a Bonnard painting, gathering all the glory of the afternoon into their collective consciousness. As Duncan Grant's granddaughter Henrietta Garnett has observed, nothing as French as this was being painted at the time.[1]

When the French artist Simon Bussy stayed with the Strachey family in England, he befriended his wife's cousin, Duncan Grant, and became his mentor. Bussy frequently took Grant on copying expeditions to the National Gallery in London. The paintings of Piero della Francesca made an indelible impression on the young artist. The frontal

pose, the understatement, and the statuesque and grave rendering of the central figure influenced the young painter's early work, as did the paintings of Poussin he later copied in the Louvre.

Bathers

Edgar Degas, who, in the words of the poet Paul Valéry, "missed nothing [and] enjoyed and suffered from everything," had a strong influence on both Grant and Bell. In his ballet paintings, such as *Ballet Rehearsal (La Salle de Danse)*, Degas deliberately emphasizes empty space by placing a diagonal line or object (such as a musical instrument) in the foreground, in front of a dense grouping of figures. Vanessa Bell's *Studland Beach* (1912) replicates this technique. The tall hieratic figure of the woman in front of the white bathing tent is majestically set off from the blue of the water by a diagonal line. The blue of her dress echoes the color of the sea. She might be a priestess before a temple; the four squatting figures to her left and right set off her exalted stance. The group is divided from two other watching figures in the left foreground. These observers are distanced from the mysterious woman and her acolytes by the sweep of whitish-yellow beach. Here Bell uses space geometrically, as Degas does. There is also a hint of Gauguin's *Tahitian Women Bathing*, in which a statuesque female figure stares out to the sea between women seated right and left. The secondary figures accentuate the height and power of the central woman. Gauguin's painting was shown at the First Post-Impressionist exhibition and made an indelible impression on Bell. The Celtic atmosphere of Brittany, especially of the beach at Le Pouldu where Gauguin stayed before going to Tahiti, is evident in certain elements of Bell's British beach: the bathing tent, the attitude of the figure, and the atmosphere of waiting and watching. As a result this painting is far more

impressive than an earlier version, called *The Bathers, Studland Beach* (1911), which too crudely absorbs the form of Cézanne's *The Large Bathers* (1898) without integrating the figures; the composition is at once lifeless and contrived. *Studland Beach*, on the other hand, retains the air of reserve that is characteristic of the work of Degas and Gauguin, yet is clearly a Bell composition. Although the diagonal line would be used much later in her large painting *Nursery* (1930, now lost), where it injected a jarring note, none of Bell's other paintings quite recaptures the air of mysterious isolation evident in *Studland Beach*. This work, which was one of the most revolutionary of the period, also introduces a non-Western perspective. We think of the flat swashes of color as Japanese, and associate them with the influx of Oriental trade with the West after the 1850s. "To Gauguinize" or "to Tahitize" was to translate this vision into a Western work, as Bell has done.

Degas's fascination with bathing scenes is reflected in the bathing paintings of Duncan Grant. Heavy with eroticism, they are among his most noted works. *The Tub* (1912) recaptures the primitive quality of Picasso's *Demoiselles d'Avignon* (1907) with the hatching strokes of the decor behind the front-facing bather. The mirror reflects the back of the bather's hair and echoes the oval shape of the tub, like the two halves of a melon or an almond shell. The lineaments of the bathing boudoir seem allied to the bark of trees; the mirror and tub appear linked to nourishment and gestation.[2] In Grant's *The Bath* (1914), the omega-shaped tub again resembles a giant almond shell, and the hatch strokes on the background are repeated on the body of the bather, who faces away from us. The bather's left arm makes a circular handle like that of the pitcher alongside, while her right hand hugs her body, just visible in the semicircle. Her pear form fits into that of the tub. The towels on the drying rack hang in a closed form, as if leading into the floor. Many of these elements are also present in a 1919 painting on the same theme in which the bather's right arm circles to become a handle, balancing her raised left knee. Dramatic curtains hang over the interior bathing scene, with a towel draped to form the side curtains; a window links the inner space with the outer. The bather and onlookers look into the trees, part of an erotic natural drama.

Vanessa Bell produced two works on the theme of the tub: a painting, *The Tub* (1912), and a woodcut, also called *The Tub* (1919), published in the Omega Workshop's selection of images of that year. Both have a solitary naked woman plaiting her hair beside the upended omega shape. Mary Hutchinson, Clive Bell's mistress for several years, served as the original model, clothed in a nightshirt. In both works the bathing woman gazes downward, in a contemplative mode that suggests an unusual interior depth. Such paintings belong to a long tradition of bathers depicted in art. Camille Pissarro's *Baigneuses* (*Bathers*, 1894), for example, hangs at Charleston, witness to an abiding interest in the theme. At the same time, the ordinary act of bathing assumes, in the works of

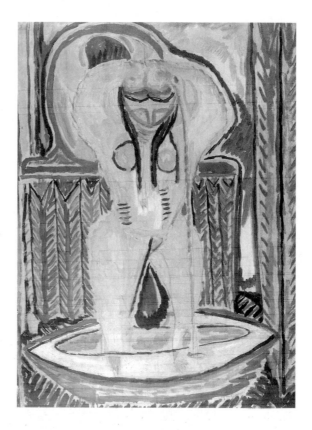

ABOVE. Duncan Grant, *The Tub* (1912).

BELOW. Duncan Grant, *The Bath* (1914).

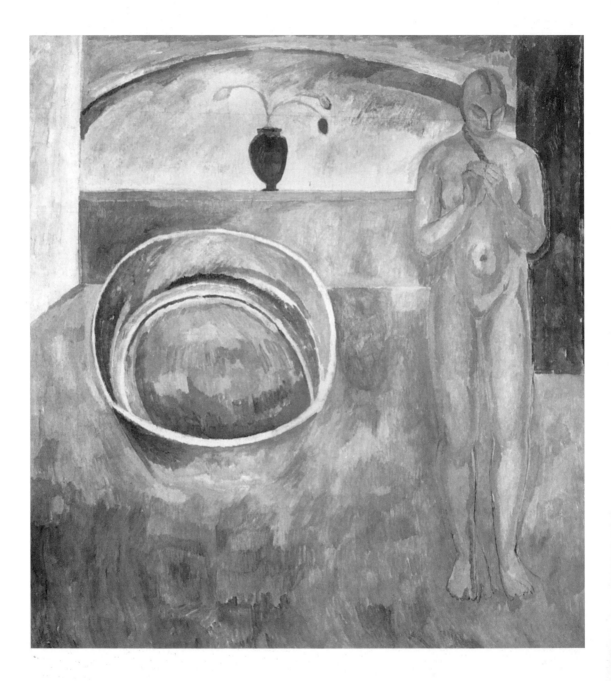

OPPOSITE PAGE.
Vanessa Bell,
The Tub (1912).

LEFT. Vanessa
Bell, *The Tub*
(1919).

BELOW. Camille
Pissarro, *Bathers*
(1894).

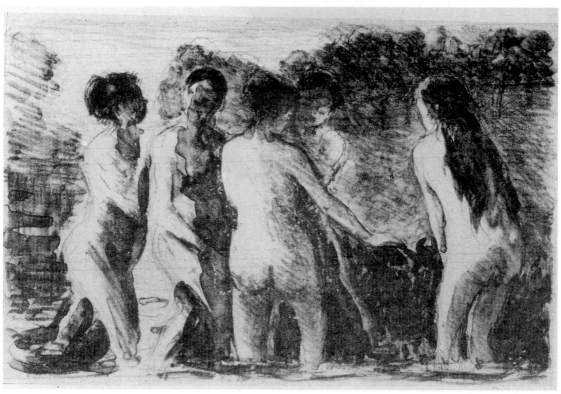

RIGHT. André
Dunoyer de
Segonzac,
*Two Boxers
in Action.*

BELOW.
Duncan
Grant, *Bathing*
(1911).

Grant and Bell, an almost mythic quality, as if implying another dimension of deed or concept.

In 1911 Duncan Grant painted a large mural for the student refectory at the Borough Polytechnic. Called *Bathing*, it was tempera on canvas and is now at the Tate Gallery, London. Here Grant focuses not on the interior contemplation of an individual bather but on a group of men. In a collective male-to-male eroticism they plunge into a joyous pagan rhythm against a background of Byzantine lines, their twisting pattern echoed in the hair of the naked swimmers. This mural is said to have been influenced by Luca Signorelli's frescoes at Orvieto as well as by Matisse, who had been initiated into the Byzantine through his son-in-law, Georges Duthuit, who knew the Byzantinist Matthew Prichard. It was Prichard who introduced Duthuit to the Bloomsbury group.[3] The abandon of the figure in the front with gigantic pectoral muscles, the splayed legs of the figure climbing into the boat at the upper left, the display of the male bodies against the highly stylized waves, and the dots of the sky combine to give a certain rhythm and ten-

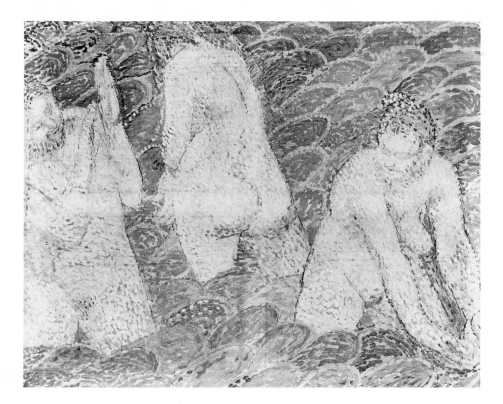

Duncan Grant,
The Red Sea.

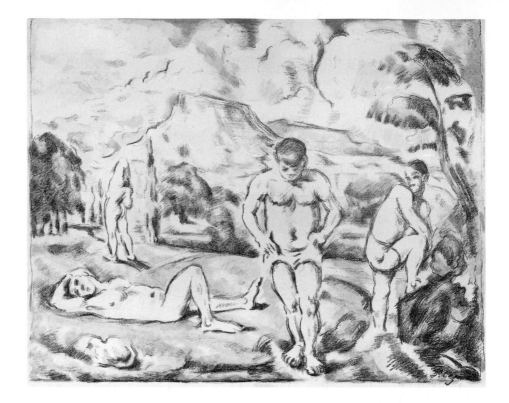

Paul Cézanne,
The Large Bathers
(*Les Grands
Baigneurs*).

sion to the work. They were evident also in the parallel mural called *Football*. Both were similar to André Dunoyer de Segonzac's *Two Boxers in Action* (also 1911). From the same period, Grant's heavily stylized *The Red Sea* shows naked women instead of men, plump and voluptuous among the semicircular shapes of the waves. This was another experiment in the adaptation of Byzantine decorative techniques. The three forms, larger and less erotic than the sinewy male bodies in *Bathing*, seem to be actual presences rather than idealized shapes.

Cézanne's *The Large Bathers*, included in the 1910 "Manet and the Post-Impressionists" exhibition, often seems to be the prototype for the bathing scenes of Bell and Grant. The Cézanne painting caused a furor at the time, however. Henry Holliday, writing to *The Nation* on December 21, 1910, complained that Cézanne's *Large Bathers* was

> nearly as formless as possible—feeble and flabby, painted with patchy colour, expressing nothing. The man on the right has a black eye and a great blobby nose, suggesting that he has just come out second-best at a prize fight.... I have sometimes seen bathers, but not being a Post-Impressionist, I failed to see thick, black lines around their limbs.[4]

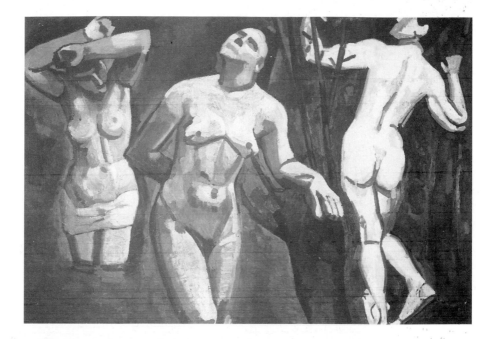

ABOVE. André
Derain, *Bathers*
(1907).

LEFT. Vanessa
Bell, *Bathers*
(1913).

In the Cézanne painting, muscular male forms stand or lie against a background of natural elements. They echo the leaning attitude of the tree and, in their bare torsos, the bare mountain. The twist of the head and body on the right, in its mannerist *contrapposto* position, is repeated in Duncan Grant's *Bathing*, and their statuesque demeanor evokes the silent calm of Vanessa Bell's *Studland Beach*.

The French artist André Derain had a strong influence on Bell as well as Grant. His *Bathers* (1907), a work of his Fauve period, shows three female forms moving or dancing among rushes. The twisting green and mauve bodies are vivid against the fronds. The threesome almost suggest a religious triptych, as if evoking a ritualistic dance. The brutal cropping of the head to the right and the radically different poses of the arms in the three figures call attention to the rapt expression on the uplifted face in the center. Their jerky yet sinuous gestures, sensuous and mournful, may have influenced Vanessa Bell's *Bathers* screen (1913). Bell's stylized, somewhat Byzantine, heads and bodies, their vacant expressions, and their conjuncture with the abstract geometric designs in the background, recall the stressed design of the Derain painting. Bell's *Design for a Screen: Adam and Eve* (1914, now in the Courtauld Galleries), shows a similar departure from realism into a primitive world of private meaning. In that screen a man and woman bend under heavy branches with awkward, fixed motions, like symbolic figures working age-old land.

Duncan Grant, *Still Life with Matisse* (1971).

Incorporations

When in Paris, Duncan, Vanessa, and Roger Fry visited their artist friends' studios as often as possible. Derain's studio was, according to Roger, "extremely simple and unpretentious, just an old garret with a top light."[5] Both Roger and Duncan had been to see Matisse's studio outside Paris in Issy-les-Moulineaux. Simon Bussy had provided Duncan with a letter of introduction, and Duncan called on him when Matisse was painting *Nasturtiums and the "Dance," I* in 1911.[6] He observed that Matisse had inserted a portion of his earlier painting *The Dance* (1909–1910)

into the current work. An empty chair turns to the left, cropped by the edge of the canvas, so that the observer would not feel invited to sit, although he might notice the chair. Duncan followed suit, often including passages from other paintings in his own work. For example, he might bring in a Japanese scroll by Shuraku, a head from a work by Velázquez, or the work of Matisse himself. In his *Still Life with Matisse* (1971) he inserted Matisse's *Blue Nude I*. The simple cutout beauty of this painting was reminiscent of an earlier, more openly voluptuous *Blue Nude* that had once brought Duncan to tears. In the later version (*Blue Nude I*), the figure fits perfectly behind the flowers, her arm raised to coincide with the top of the canvas, a red and white checked cloth setting off the contrasting blue. By incorporating this painting, Duncan is paying double homage to Matisse and to one of Matisse's favorite techniques.[7] Grant's frequent references, both implicit and explicit, to other painters and works add a secondary layer of motifs and patterns beneath the surface.

Duncan Grant,
Self-portrait.

Grant's *Self-portrait* (Scottish National Portrait Gallery), one of his strongest works, refers explicitly to another painting, Matisse's *Woman Seated in an Armchair*. This painting, with part of the frame visible, is behind the subject's head. However, since he is seeing himself in a mirror, the reflection of the painting is reversed; in the Grant painting her left arm actually appears on the left side, whereas in the Matisse painting, it is on the right, as in our ordinary perception of a person. Grant actually sets up a more complicated vision. There is a confrontation between the artist and the observer. The artist-as-sitter faces us in the full-scale mirror, whose shape extends past the picture frame. He presents, just above his head, a woman like a surrogate self. Matisse's woman stares out at us like a re-representation of the artist's other personality, with only half her torso showing. The painting can be read as clever, confrontational, and cross-dressed (a statement about Grant's homosexuality). It is about performance as well as reversal.

The influence of Matisse upon Vanessa Bell and Duncan Grant cannot be overestimated, especially his genius for using simple shapes and plain colors along with cutout

Henri Matisse,
*Woman Seated in
an Armchair.*

forms. Matisse and Picasso were the stars of the Second Post-Impressionist Exhibition, at the Grafton Galleries in 1912, as Cézanne and Gauguin had been of the first exhibition in 1910. Roger Fry wrote Simon Bussy in 1911 that he had become "completely Matissiste"; the same could have been said of Bell and Grant.

One of the more interesting paintings stemming from the second exhibition, tradi-

tionally attributed to Roger Fry, seems now to be the work of Vanessa Bell: *The Matisse Room of the Second Post-Impressionist Exhibition, at the Grafton Galleries, London.*[8] It dates from 1912, as does her *Studland Beach*, and shows, in the foreground, a man sitting on a sofa. Directly behind his left shoulder is a painting of Matisse's *Red Studio*, a work shown in the second exhibition. It is cropped to the right; only about a quarter of it is visible. The entire space of the painting within the painting glows red, with little demarcation of wall from floor. The wall paintings, table with flowers and plate, and striped canvas chair from Matisse's work are all included, suggesting a sort of domestic chaos. The composition as a whole pays homage to Matisse, to the energizing vitality of his use of color, and indirectly to the exhibition and its organizers. Here Bell uses the same documentary technique the nineteenth-century French painter Gustave Courbet used in *L'Atelier du Peintre.* Courbet was one of her favorite artists, and she particularly liked this painting, in which a crowd of people visits the painter's studio and watches as he works on a large canvas. Clive Bell also praised this painting in *Landmarks of Nineteenth-Century Painting.* He reproduced it in a chapter called "The Realist," terming it "marvelously painted" but "marred by the shocking incoherence of the design."[9]

Gustave Courbet, *L'Atelier du Peintre.*

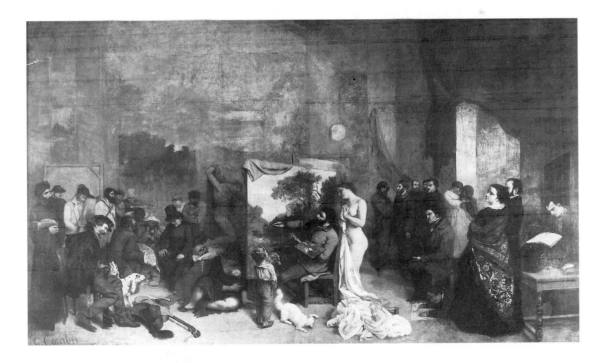

The Open Window

Window paintings often reveal the position taken by the artist in relation to the inside and outside worlds. Matisse's *Open Window, Collioure* (1905; see color illustration) is emblematic of the Fauve period, with its violent colors and rollicking movement. In this significant painting, there is a riot of colorful greens and pinks and reds; flowers and cloths, field and room, are joined in gaiety. Here the boats on the sea advance into the room, over the tops of the flowerpots, between French windows. Duncan Grant followed Matisse in painting open windows, such as *Window in the South of France* (cover of this book). Duncan's window ledge has flowers, as the Matisse painting does, and reflections of the vase in the right-hand window. In Grant's work, the reds and yellows, the green of the olive groves and vines, and the profusion of flowers in the cloth beneath the window ledge, are kept in a state of tension because the window frame slopes down slightly from left to right. In the Matisse painting, however, the window frame is upright. Grant places an empty chair by the ledge, inviting the viewer to be seated. In another of Matisse's window paintings, *Nasturtiums and the Dance I*, there is no room for the observer because the chair is turned away. This painting had impressed Duncan on his first visit to Matisse's studio. Duncan's painting, however, is far closer to Vanessa Bell's *Window at St.-Tropez*, which has a chair that seems to be recently vacated.

Duncan Grant,
Cup and Glass
(1914).

Still Lifes

Many of the still lifes of Grant and Bell reveal the influence of French painters. Duncan Grant's *Cup and Glass* (1914), with its curves and zigzags, its clumsy mockery of a hand, its suggestion of canvases just beyond reach, almost makes sport of the work of Braque and Picasso (both of whom were friends of his). His *Flowers in a Glass Vase* (1918–1919) recalls the work of Matisse. Here the colors and circles echo each other, juxtaposed against the sharper, more angular leaves, and the textured background with its scrolls. Vanessa Bell's *46 Gordon Square* (1911) has much the

LEFT. Duncan Grant, *Flowers in a Glass Vase* (1918–1919).

BELOW. Vanessa Bell, *46 Gordon Square* (1911).

feeling of Matisse's Paris paintings of the same period, such as *Notre-Dame*. The iron railings suggest an enduring order; the carefully placed fruit hints of pleasant meals to come.

During Duncan Grant's days as an art student in Paris at La Palette, Jacques-Émile Blanche's art school, beginning in 1906, Blanche would ask Grant and his other pupils to contemplate the "drama" of the kitchen still lifes of Jean-Baptiste Siméon Chardin.

Duncan Grant,
The Coffee Pot
(c. 1916).

Grant was deeply moved by Chardin's depictions of patient, introspective cooks, caterers, and washerwomen. He brought the intense colors of copper, china, cloth, and vegetables into his own renderings, losing none of the drama. His backgrounds are as neutral as those of Chardin; his vessels as luminous. This is evident in Grant's *The Coffee Pot* (c. 1916, Metropolitan Museum), which seems a theater of the kitchen. Here the everyday world holds out a particular depth. The metal of the coffeepot gleams against its wooden handle, just as the handle of the *bain-marie*, or double boiler, cuts across the glass to the left. The table juts out almost into our own space, taking us into the world of those objects.

Perhaps the most joyous of all the paintings and sketches at Charleston is the simple watercolor done by Charles Vildrac of a picnic, catching just the mood of a Provençal repose after two bottles of good wine shared among the three. Vildrac, who was a poet, playwright, painter, and gallery owner, was a good friend of all the Bloomsbury artists. He dedicated this painting to Duncan Grant, "in all humility" (see color insert).

The French painter Jean Marchand, Roger Fry's good friend, exhibited at the Salon des Indépendants and the Carfax Gallery. He was known for his drawings of the Opéra and the stage. His severely geometric still lifes were more dense than luminous; one of them hangs at Charleston. The planes of the fruit, pot, and cups make them seem grave and centered. As Vanessa wrote Roger Fry, Marchand's modeling looked "very tight and realistic"; it was even austere.[10] The heavy tone of some of his paintings is at odds, however, with his gossipy, witty letters to Fry. He admitted, however, that he often felt unappreciated. Marchand's paintings contrast with the more joyful and brighter still life of Roderic O'Conor that also hangs at Charleston, in the dining room. He was Clive Bell's close friend during his earliest days in Paris, a friend of Duncan's, and Quentin's teacher at the Académie Moderne in Paris. Another French friend, Georges Duthuit, to whom Clive Bell dedicated his *Account of French Painting* (1932), often visited Charleston. One of these visits is commemorated in a photograph album, just as his Byzantinism is remembered in Duncan Grant's *Bathers* in London. He and his wife Marguerite (daughter of Henri Matisse), were partly responsible for the preservation of the dining room at Charleston.

Portraits and Groups

The work of various French artists is evident in the Bloomsbury painters' portraits and depictions of groups. For example, Duncan Grant's *Lytton Strachey* (1913, Charleston Trust) is posed in the same position as Cézanne's *The Gardener Vallier* (c. 1906, Tate Gallery, London). Cézanne's figure sits serenely, with crossed legs, against the vivid

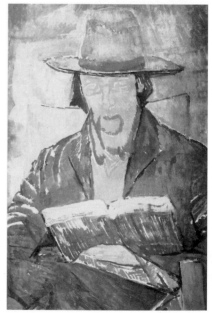

ABOVE. Paul
Cézanne, *The
Gardener Vallier*
(*Le Jardinier Val-
lier*).

BELOW, LEFT.
Duncan Grant,
Lytton Strachey
(1913).

BELOW, RIGHT.
Vanessa Bell, *Por-
trait of Lytton
Strachey* (1913).

ABOVE. Paul Cézanne, *The Card Players* (*Les Joueurs de Cartes*).

BELOW. Duncan Grant, *Card Players, St.-Tropez.*

colors of the background, colors his labors have helped create. Duncan's Lytton is similar in pose and attire. He is reading, as in all his portraits, and most of his photographs; it is said that he usually refused to be painted without a book. Lytton's armchair is more substantial. He, like the gardener, wears a hat to protect him from the blazing sun; he is outlined in yellow. In the background lines from a series of concentric half-circles radiate, replicating the lines of the pages that fan out. The semicircles establish a kind of rhythmical harmony in the heat of an English summer afternoon ("summer afternoon" was Henry James's favorite phrase). In each painting light strikes the countenance of the subject, whose gaze is sheltered. Each face portrays a deep calm and ease of concentration. Vanessa Bell's *Portrait of Lytton Strachey* (1913), painted the same year as Grant's portrait, is a close-up view. She captures Lytton's intense focus, although in some respects it seems less evocative of his presence than Grant's depiction. His lanky frame is not, of course, evident, and his eyebrows and beard seem almost washed-out. At the same time, her grave portrait is similar in tone to that of Cézanne.

Cézanne's gardener, Grant's Strachey, and Bell's Strachey are self-absorbed, as are the figures in Grant's *Card Players at St.-Tropez*. The title is a deliberate reference to the many versions of Cézanne's Provençal *Card Players*, who are usually depicted in groups of two or four. Duncan's painting has a feeling of openness and generosity. The chair to the side suggests that a player has risen and will return shortly; it invites the viewer to sit down. There is a feeling of informality, with a coat hanging above some bottles.[11] By contrast with these rough-and-tumble cardplayers, those of Cézanne seem tidier, their cards more carefully held, their clothes better tailored. The table has a cloth and they have a rustic view through the window.

In 1912, Henri Doucet, who would be killed in World War I, painted a portrait of Julian Bell, who was four years old (*see* "Painters in France," page 166). This portrait hangs at Charleston, along with other pictures done by friends, such as Derain's *Head of a Woman* (*see* "Clive Bell and His Circle," page 78). The woman in this work, with her slightly crossed eyes, is exotic yet classic and enigmatic. She has a suggestion of a face, but not a face filled out, reminiscent of the Fayum portraits from the ancient tombs.

Harbors and Boats

Of all the French subjects selected by the Bloomsbury group or artists, harbors and boats might be thought the most likely. For well over half a century members of the group traveled to the southern coast. In 1897 Roger Fry, who had studied art in

Paris, went to Avignon on his honeymoon with Helen Coombe. In 1901 Lytton Strachey visited his aunt, Lady Colvile, in Menton, followed by her nephew Duncan Grant a few years later. In 1903 Dorothy Strachey married the French artist Simon Bussy, and Sir Richard Strachey gave them a villa at Roquebrune, which became a much visited pied-à-terre for many of the group. As late as 1959 Clive Bell lunched with Pablo Picasso, again in Menton. In the intervening years members of the group came to know artists and writers along the coast, from St.-Rémy to Cassis and La Ciotat; they wrote, painted, and lived there intermittently for over seven decades.

Bridges, boats, and harbors were a congenial subject. The Bloomsbury artists knew Charles Camoin's *Quatre Bateaux dans le port de Cassis* (1928; *see* "Painters in Cassis: 1925–1929," page 202), which is tranquil in the same way as Vanessa Bell's paintings of boats and bridges. Her 1911 painting, *A Bridge—Paris* (*see* "Painters in

James Abbott McNeill Whistler, *The Thames* (1859).

France, 1910–1921") echoes the architecture of Maurice Vlaminck's *Le Pont,* bought by Clive Bell in 1910. In her painting *The Harbour, St.-Tropez,* the masts rise toward the sky, their vertical lines as clear and unblurred as those in James McNeill Whistler's *The Thames* (1859). She was trained in the tradition of Whistler, and this painting hangs at Charleston. Roger Fry believed Whistler's work lacked an underlying design, but Vanessa and Virginia Woolf disagreed with his criticism. In 1905, Virginia wrote of Whistler: "Oh Lord, the lucid colour—the harmony—the perfect Scheme. This is what matters in life."[12] By contrast, in Roger Fry's delightful *Boats in a Harbor: La Ciotat* (*see* color insert), of which a study also hangs at Charleston, the small oval boats are almost like children's shoes in the blue bay, while the sails reach toward the pink-orange sky. They cut across bridges and crop off the foreground in a reminder of the Oriental technique of which Whistler often wrote and which he practiced.

Othon Friesz,
Landscape
(c. 1920–1922).

Vanessa Bell,
*Olive Grove in
Provence* (1930?).

Roger Fry,
Auxerre (1925).

In the fall of 1923, Roger wrote Vanessa Bell, describing the "queer mad landscape" of La Ciotat; he included a rough sketch of his painting. It shows the *calanques*, the cliffs deeply indented in the shoreline like fantastic sculptures. They seem to him "pure Chinese," in a deep rich orange-brown,

> going to violet in the rocks and the pines a very rich yellow-green on it. But perhaps *à la longue* one will get most out of the port, which is very different from St.-Tropez, much less picturesque—very up-to-date machinery everywhere, huge cranes and immense workships and great transatlantics all muddled up with small sailing-boats and rather jolly old houses.[13]

Fry's port paintings have a more cheerful air than many of his others, perhaps because he perceived not only the element of leisure but the economic and industrial implications of the port as a whole.

Farmhouses and Landscapes

Despite their strong attachment to coastal scenes, the Bloomsbury artists expended considerable energy on landscapes and rural scenes. A painting called *Landscape* (c. 1920–1922) by Othon Friesz, one of the artists' friends, hangs at Charleston. It has a feeling of plenty in its V-shaped trees and massed foliage, with a village nestled below a high mountain range. Such a feeling is also evident in many paintings by Fry, Grant, and Bell of farmhouses and fields. Vanessa Bell's painting *Olive Grove in Provence* has a similar profusion of swirls and upward sweep of foliage and hills. Her *Farmhouse in Provence* (1930) leads the viewer's eye to the house by a great sweep of fields. Both paintings set the bare and the dry against the fruitful. Similarly, in Duncan Grant's *Window in the South of France* the sparse empty chair against the window opening draws the eye toward a productive flowering land of vines and paths leading seaward. By contrast, in Simon

Roger Fry, *Figure Reclining Under a Tree, St. Agnès.*

Bussy's *Jura Landscape* (*see* "Simon and Dorothy Bussy, André Gide"), his native country-side of the Jura mountains is haunted by heavy shadows. This landscape is as dark as his extraordinary depictions of animals (those "self-portraits," as Lawrence Gowing put it so perceptively) are bright, and yet replies to Roger Fry's description in a letter to the editor of *The Burlington Magazine*, in March 1908, about Bussy's "singularly poetical interpretation of landscape." [14]

Roger Fry's *Auxerre* (1925) might almost be a classic French drawing, with the delicate lines of the buildings massed at the top, above its generous space and its feeling of distance. Writing to Vanessa, on August 17, 1925, he describes the town:

> I've rather tumbled into scenic and romantic motives. The town builds itself up rather theatrically over the Yonne with two huge Gothic Churches dominating all. They're so magnificently placed and so frightfully successful from a dramatic point of view that I rather succumb to them though I believe your rather more inflexible taste would disapprove and that you'd also not like my subjects.

One of his more interesting paintings is *Figure Resting Under a Tree, St. Agnès*, painted during his wartime visit to the Midi in 1915, on his way to help his sister Margery with her work for the Quaker War Victims' Relief. Every inch is filled with brush strokes and with luminous color; the lines show great force of design. The tree just catches the mountain in the right place, sectioning the center of the canvas, and rising against house and mountain in order to spread out fully, occupying the entire breadth of the top of the painting. The figure reclining under a bright tree is like that in Brueghel's famous *Harvest*, but far livelier than most of his figures. This painting is an example of Roger Fry at his best, somewhat Fauve-like, and as cheerful as André Derain in his early work. In contrast, Duncan Grant's landscape *St.-Tropez* (1921) is full of twisted trunks and threatening shadows reaching like human hands. They accentuate the lack of distance, forcing the observer toward close involvement in the scene. Everything seems to be moving in opposite directions, as opposed to Fry's more classic static landscapes.

In a more joyful vein, one of Grant's most notable works, the pastel *Farmhouse and Trees, near Cassis, South of France* (*see* color insert), shows the small structure La Bergère set against the Château Fontcreuse at Cassis. The blue walls are bright against the plenteous foliage, rendered in rapid hatching strokes. The painting evokes the many idyllic months Duncan and Vanessa spent at La Bergère, where Roger often visited. Grant, Bell, and Fry were all, in varying ways, influenced by the tradition and example of French artists, ranging from Courbet and Poussin to those represented at the two Post-Impressionist Exhibitions to their contemporaries. They produced studies of bathers and beaches, still lifes, portraits, harbor scenes, open windows, townscapes,

and landscapes. Their work was not derivative but infused with their unique vision, in which convention might be abandoned, emphasis shifted, form refocused, color transmuted. Above all they were, to use the phrase of Frances Partridge, "perceivers." Their legacy, it is safe to say, would have been greatly altered had they not spent a considerable portion of their most productive years in the Midi.

III Writers and Thinkers

The final section of our book deals with the impact of the Bloomsbury writers and thinkers on French letters. A significant interchange took place between Roger Fry, E. M. Forster, and Charles and Marie Mauron of St.-Rémy, who became close friends of the Bloomsbury group as a whole. Fry put Mauron, a Provençal critic and translator, in contact with the founders of the influential journal *Nouvelle Revue Française*; they were also the leaders of the intellectual colony at Pontigny in Normandy. Among the latter group, Roger Martin du Gard and André Gide were in close touch with the Strachey family and with Lytton Strachey's sister Dorothy Bussy, Gide's translator, and her hus-

band, the artist Simon Bussy. We devote a chapter to the meetings at Pontigny, attended by Strachey and several of his sisters, Fry, Mauron, and Julian Bell. A subsequent chapter examines the work of the Bussys and Dorothy's relationship to Gide, following their story from the early part of the century through the ordeal of World War II. Our final chapter on literary translations explores the Bloomsbury introduction of the seminal French poet Stéphane Mallarmé to England, with translations by Fry and Bell and commentaries by Mauron. The final chapter takes up representative French translations of the works of Bloomsbury writers such as Virginia Woolf and E. M. Forster.

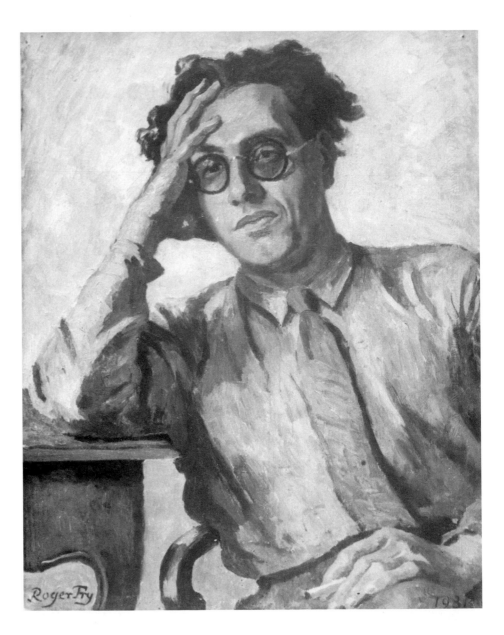

Roger Fry,
Portrait of
Charles Mauron.

The Maurons, E. M. Forster, Julian Bell, and Bloomsbury

Charles Mauron … might have been described by Bloomsbury as "our man in France."

—Francis King

It is October 1919, on a warm evening in a barn at Les Baux, high above St.-Rémy. Roger Fry, who has spent the day painting the castellated formations but found them too dramatic to be a congenial subject, has been invited to attend a local gathering, where a visiting Breton entertainer is to perform. The spectacle concludes with Breton songs. The energetic young village schoolmistress persuades the elderly peasants making up the audience to sing indigenous Provençal songs for the English guest. In this way Roger meets Marie Mauron, the initial contact for his long acquaintance with Provence.

The Maurons and Roger Fry

Marie and her husband, Charles Mauron, a young chemist, welcomed the personable British artist, who was fluent in French, and extended their hospitality to him. At the time Charles Mauron was twenty and Roger fifty-three. The evening marked the beginning of a close friendship between Fry and the Maurons that endured for the remaining fifteen years of Fry's life. It led eventually to Mauron's translation of E. M. Forster's novel *A Passage to India* in 1925 as well as other British novels, and ultimately introduced the extended Bloomsbury group to the delights of Provence. Replying to a warm letter from Marie a month after their meeting, Fry wrote to express his gratitude for

> the glimpse you gave me of the life of your friends, the poets and bards of Provence…. There I saw life as it should be, a life where poverty and wealth are accidents of little importance, where one can enjoy the things of the spirit without ceasing to be a peasant…. I like all of Provence, and my joy at being in the Midi is so great that once here I am not very hard to please. By what quirk of the laws of heredity I do not know, but I always find myself at home here; I always feel as if I had come back from exile …[1]

It was through his epistolary, personal, and professional relations with Marie and

Les Baux,
Provence; photograph by Frances
Partridge.

Charles Mauron that Fry, who initially was better acquainted with the art circles of Paris and London than with those of Provence, became intimately associated with the region.[2]

Until Fry died in 1934 the two men maintained contact, exchanging ideas on aesthetics and philosophy, translating each other's works as well as the poems of Stéphane Mallarmé, and visiting with families and friends. Fry painted Mauron's portrait, played chess with him, and secured various commissions for him to translate the works of various modern British authors. He also arranged lectures for him in England before the Second World War as well as an invitation to one of the intellectual gatherings in Pontigny in 1925. He also translated two of his books for the Hogarth Press: *Aesthetics and Psychology*, and *The Nature of Beauty*.[3] Roger Fry arranged these projects after Mauron retired from his scientific career. Fry was noted for the generous enthusiasm that impelled him to persuade his friends to help other friends, to an extent relatively rare in any intellectual circle. Charles Mauron seems to have had the same kind of spirit. The two shared many of the same values, energy, and curiosity.

In 1949 Charles Mauron lectured at Oxford and in London, and mentioned their long exchange. He pointed out the central reason for his attraction to Roger Fry, and the basis for their long friendship: "One of the most remarkable traits of his personality was certainly a rare combination of scientific spirit and esthetic sensibility. In Roger Fry, they had formed a sort of symbiosis, and I do not think that his contemporaries, even those who loved and admired him, entirely grasped the importance of this fact."[4] In 1954, he repeated his impression:

By a stroke of chance, I encountered Roger Fry, who joined to a scientific cast of

mind the most vast of cultures in the matter of art and poetry. His example helped me understand how much the evolution of human sciences had augmented the difficulty of any honest criticism. In order to be a professor of esthetics, as Roger Fry was in Cambridge, it took an immense amount of information, but subject to value judgements of a simple sensitivity. I owe to Roger Fry, among other things, the feeling that the crucial human problem—that of the relations between scientific truth and the values of the spirit—can be studied experimentally at this crossroads of our knowledge: the psychology of creation. My humble work has meaning only in this perspective.[5]

Mauron's friendships with Edward Morgan Forster and Roger Fry were the most intense of any he had. Mauron had translated *A Passage to India* in 1925, but Forster did not meet him until he went to St.-Rémy in 1927, at Roger's suggestion. He later translated a number of Forster's other works, and Forster frequently visited the Maurons. In a sense, they were all refugees from conventional society, the consumer culture, and the herd mentality against which each made his own particular form of protest. This was one of the reasons Fry gave for preferring France to England, where it seemed harder to hold out an individual mode of life and art.[6] Although Fry first asked Marie Mauron to translate his early articles, her English was not equal to the task. It was Charles Mauron who would actually translate Fry's work, and vice versa.

Charles Mauron, talking with a friend on a height in Provence.

Mauron had been a research chemist until, wounded in a chemical explosion, he found himself going blind, in 1924–1925; by 1942, he could no longer see. He had one operation, and in 1939 was to have one more by the celebrated Dr. Vogt in Lausanne, Switzerland. The journey there became impossible when World War II broke out and the Nazis occupied France. He was said to be tubercular and unable to leave his house, lest he be captured. From his home he continued his links with the partisans through the radio; he had been working with the Comité de Vigilance des Intellectuels Français, established by François Walter, as Pierre Jérôme. He also carried on his development of psychocriticism, the school he founded.

Marie Mauron was a celebrated teller of Provençal tales and, with her husband, spoke, wrote, and published in Provençal. Both had been, from the time of their youth,

fervent defenders of the language and the culture of Provence, and remained so all their lives. Both were winners of the Prix Mistral. (Charles and Marie Mauron enjoyed sharing their knowledge; Edward Playfair, Julian's best friend from Cambridge, who was a polyglot, learned whole stanzas of Mistral's *Miréio* in Provençal with the Maurons.)[7] Charles Mauron kept a weekly chronicle in a daily newspaper, *Le Provençal*, from 1952 until his death in 1966, and also wrote a textbook for the study of the language, *Lou Prouvençau a l'escolo*.[8] Both he and Marie pursued their very different writings in Provençal, defending and encouraging the bilingualism to which they remained faithful.[9]

Early in their relationship, Fry, staying with Elspeth Champcommunal in the old town of Vaison-la-Romaine, found the Maurons there. The three of them set off on an excursion "all round" by bicycle. Roger thought Charles had the face of someone "intelligent, rather erudite and bookish." Later he would find Marie "more *farouche* & strange than ever and violently disgruntled by the bad weather." In their triple relationship, however, the weather was always good.

After the tragedy of his wife Helen's mental illness and hospitalization, the Maurons became Fry's closest friends, with the exception of Vanessa Bell and Helen Maitland Anrep. They lived together a good part of the time, first in the village of Mas Blanc, where he came to know Marie's parents, whom he found delightful. He exclaimed of Charles Mauron to Vanessa Bell: "He is really brilliant."[10] For a number of years they shared the Mas d'Angirany, on the Avenue Van Gogh in St.-Rémy, which Fry and the Maurons had bought together; it was on the road to Les Baux, just before the ruins at Glanum. Charles Mauron furnished the *mas* in local style, not entirely trusting that what he called "the English taste" would fit into the Provençal region.

Getting the *mas* set up had its own difficulties, but neither man lost his sense of humor. Mauron wrote E. M. Forster of their labors:

> In a week we had to rush the workers, buy furniture, wash everywhere, put the vases on their pedestals, put a rope in the well, cut wood, get the WC closed, paint the beams, go get the salt, take care of Roger who had a liver ailment, write to Bon

Marché to send the blankets, rectify the electricians' mistakes, without forgetting to discuss the art of Akhnaten in every moment of respite. But everything settled down, all is well, everyone is laughing, happy.[11]

For Fry, the *mas* in St.-Rémy was a refuge and anchoring point. He had not had a settled home for a number of years, owing to his wife's unstable mental condition. The joint Fry/Mauron household provided a warmth that he greatly missed when he was in England. He purchased a three-speed bicycle, recalling the day trips the three of them had undertaken soon after they met. Laden with his easel, paintbrushes, coffeepot, and other supplies, he would set off to paint in the nearby mountains, reveling in the colors of the Provençal landscape.

Other members of the Bloomsbury group shared Fry's affection for the Maurons. Vanessa Bell and her children were entirely at home with the Maurons, both in the village of Mas Blanc and in St.-Rémy. She described a visit made in 1938, four years after Fry's death, to the Mas d'Angirany. There is a striking difference between Vanessa Bell's mode of seeing and that of Fry. She found them charming and was delighted that Charles knew English so well, yet marveled at what she saw of their stoic style of living

Le Mas d'Angirany, St.-Rémy; photograph by Sarah Bird Wright (1990).

(this, paradoxically, was exactly what had appealed to Roger). Vanessa found it remarkable that there was no light by the bed, so guests had to get up shivering, "if one's so made that one has to read in bed."

> It's an extraordinary life…. We lived entirely in the kitchen & she did all the cooking, making delicious dishes apparently with no trouble or hurry, keeping up a flow of talk all the time. I think in hotter weather it would be a perfect existence of its kind, but in the winter it had its drawbacks. One couldn't sit anywhere except by the stove—one's bedroom was an icebox simply. So one was never alone.[12]

During their stay in St.-Tropez in 1921, Vanessa and Duncan Grant had noted that Roger always preferred to find modest restaurants frequented by the local workers instead of the ones she and Duncan normally choose (to say nothing of Clive Bell, whose taste was even more elevated than theirs.) For Roger, never feeling alone was ideal. Having felt "so isolated in England," he now felt very much a part of France. Charles Mauron and his "kingdom of the mind" represented the best of France and Provence for him as well as for Vanessa and Duncan.

It was indicative of his feeling for his friends in St.-Rémy that after his disastrous affair with Josette Coatmellec and her suicide in 1924 (*see* "Roger Fry's France"), he went to stay with the Maurons, knowing their presence would be the means of restoring his spirits. In this stressful time he wrote his "Histoire de Josette." A decade later, he reiterated

to Charles that he would have been "terribly alone and morose, alas! without you and our discussions. Don't forget to finish the work on your ideas on scientific and artistic discovery," he added, realizing the value of Mauron's thought in these fields.

In 1925 Fry had finished translating an essay of Charles Mauron on aesthetics, a study concerned with relations, as was his own work. Both men were concerned with the way in which things fit together and, particularly, with discoveries of a sense of relation. Having read Mauron's essay on the notion of chance, Fry commented on his unusual way of writing:

> When I began to read "chance" I started enjoying it when I should have been doing a thousand other things and, Lord! I am in ecstasy before the style, the charm, the humour of it. Here we are once more in the 18th century when people knew how to appreciate intellectual delight. And how different its style is from all the weighty, the heavy accent, the serious feeling to say nothing of the willed obscurity of our thinkers. I will make good old Leonard Woolf produce it at the Hogarth Press in a translation I shall enjoy doing. That will be a pure joy. Really I can't tell you how exquisite I find it.[13]

Fry repeatedly expressed his admiration for Mauron's intellect, courage, originality, and sensitivity to art. In 1924, having finished the essay on aesthetics, he wrote Charles:

> I just received your charming letter and the photos of an admirable Khmer sculpture. Yes, it's very curious because it's an art where two very different elements contrary in tendency mix with a happy effect, Hindu sensuality and the Chinese sense of style. That's the best way for me to approach Hindu art.[14]

Because of Mauron's particular way of perceiving works of art, Fry advanced, in a tactfully worded letter of July 10, 1926, an idea that he and Forster had developed jointly. This was a proposal that Mauron should, before his eyesight failed further, experience as much as he could of Italian art, so as to remember the high points later. Convinced that such a trip would bear rich intellectual fruit, it would be as if they were investing in the future, like a gallery owner and an artist, he said. They planned for him to visit Genoa, Florence, Siena, Orme, Viterbo, to see "the most distinctive things of the Italian genius …"

This scheme was abandoned when Fry and Forster realized it would be more advantageous to Mauron to accept Fry's invitation to accompany him to the summer *décade* at Pontigny in late August of 1925 (August 27–September 6), putting off the Italian trip until the next year. There he could meet Charles Du Bos, one of the leaders of the discussions at Pontigny (*see* "Intellectuals at Pontigny.")[15] Du Bos considered himself the protector of English literature in France and had the task of overseeing a series of trans-

lations from English literature published by Plon, who would eventually become Mauron's own publisher.

Fry's great affection for Mauron enabled him to retain a light, humorous note in their correspondence. They would exchange poems, those Mauron wrote and Fry's translations of Baudelaire and Mallarmé and Rimbaud. Fry believed, understandably, that translation was the best way of getting to the spirit of a poet, and, less understandably, that the French alexandrian (twelve syllables) could be rendered by the English blank verse (ten syllables) if certain liberties were taken with the syllable count. Given this exchange, Fry could be certain to amuse Mauron when, in October 1927, he forwarded poems by Edith Sitwell, whom he teasingly called England's "great poetess," suggesting, with heavy irony, that the Provençal poet might write in the same way. In October 1928 he arranged for André Dunoyer de Segonzac, a good friend of the Bloomsbury group, to make a series of lithographs illustrating Mauron's poetry.[16]

André Dunoyer de Segonzac, illustration for poems of Charles Mauron.

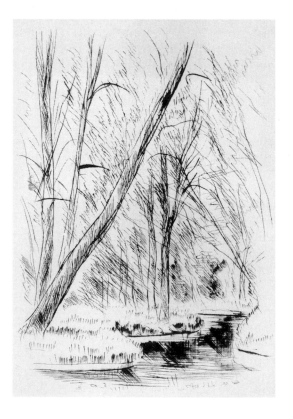

Within a decade of their first meeting, Fry had not only painted a portrait of Mauron but had sent Vanessa an incisive verbal sketch of him. The two had taken the ferry across the Channel for the lectures Roger had invited Mauron to give in England. He wrote Vanessa:

I came over from Paris with Charles Mauron, his wife couldn't come. He is a delightful creature & I wish you had been here. He has such extraordinary sensibility of all kinds which makes it delightful to show him things. Perhaps I enjoy him more than anyone because in so many ways our reactions are exactly similar to music & literature as well as to painting. I've introduced him to Gerald Hopkins and at last found someone who shares my enthusiasm. I'm sure I'm right about him.[17]

Subsequently, Mauron dined with Quentin Bell, then nineteen, who was quite taken with him. Fry continued his description of Mauron's encounter with the English a few days later:

Mauron has been here till a day ago & that's meant a lot of society etc…. Mauron has fasci-

nated everyone. His lecture on Mallarmé was amazing. How I wish you'd been here and how he would have admired you. He thinks V[irginia] very marvellous rather like Dante to look at & is I think generally impressed with London.[18]

In 1930 Mauron gave a second series of lectures, on aesthetics, philosophy, and French literature, one of which Virginia Woolf chaired.[19] He had translated her novels *Orlando* and *Flush,* as well as the middle part of *To the Lighthouse.* The latter appeared in the journal *Commerce* before the translation of the entire book, for which Mauron was not commissioned. In 1949 E. M. Forster arranged a third set of lectures for Mauron, and outlined the basic theory of his *L'Homme triple* (1947) for the audience of the French Institute in London, who were about to hear Mauron's lecture "Art and Psychoanalysis." During this stay in England Mauron also lectured at Oxford on "Man and his Creative Freedom." He was introduced by Margery Fry, one of Roger Fry's sisters.

Roger Fry painting at Le Mas d'Angirany, St.-Rémy; Marie Mauron watching.

In October of 1933, Fry was, by his own account, having a decided *annus mirabilis,* having painted a few studies "which seem to me to show a progress—a coloration richer and sustained." He was, however, worrying about public misapprehension of his works: "It's funny, a man of letters can be a writer but a painter who knows and says what he thinks is straight off an uninspired person—a real painter is supposed to be stupid and romantic or romantically stupid to gain the public's admiration." As late as 1965, when writing Mauron about one of Roger's lectures in French, given in Brussels ("La Double nature de la peinture"), Fry's daughter Pamela Diamand pointed out that a friend of hers, a specialist in language and translation, Hermine Priestman, finding some of Roger's expressions peculiar, had "reconstructed" some of his sentences.[20] What is remarkable is that the terms Priestman found odd are actually the most useful ones from the point of view of modernism: *espace imagé, picturale,* and *chromatique,* all of them indispensable now in critical language. It is another example of Fry's having been in advance of his time. Pamela once asked Mauron if Roger had discussed them with him, and also, more important, if he had consulted Mauron on the question of the significance or insignificance of the subject, about which Fry had been softening his position. It is more than probable that their discussions had, as she suspected, some influence on this major

development in Fry's thought, which was always as flexible as it was enthusiastic.

Charles Mauron knew not only Roger Fry, Duncan Grant, and Vanessa Bell, but also came to know both Quentin and Julian Bell quite well. He had first known Julian in 1927 when he was staying with the Pinault family near Paris. M. Pinault and his wife were schoolteachers. Julian loved visiting the Maurons, as Fry had. In 1928 Quentin Bell was living in Paris, studying art at the Académie Moderne under Jean Marchand. Julian had gone up to King's College, Cambridge, where he became a close friend of Edward ("Eddie") Playfair and Francis Cornish, a nephew of Molly MacCarthy. Vanessa visited him at Cambridge in October 1928, writing Quentin that he had complained about "the complete lack of interest in aesthetics and all abstract subjects among his friends."[21] Both Quentin and Julian enjoyed visiting the Maurons at St.-Rémy. In February 1935 Julian wrote Charles Mauron from Cambridge:

> Good Lord, how I long to see a Midi landscape—for two years I have been in the English fogs—15 months of London. Now a whole month of completely exhausting work on Pope. Now I understand why Marx wrote in such an anxious, complaining tone. He was always working the Reading Room of the British Museum.... [How I long] to come back to this country so perfectly civilized, without typhoid or dysentery or civil wars carried on by imbeciles, but perfectly endowed with peaches, figs, melons, and especially cafés, cool caves and wine.

Julian Bell in Cassis; photograph by Lettice Ramsey (1932).

Here's to wine!… If I don't see Provence again, my life will have been a waste, for the only justification of traveling is to get nearer to one's friends….[22]

Julian Bell also attended a *décade* at Pontigny. Writing Mauron, he compared it with St.-Rémy and declared, "For intelligence, I prefer St.-Rémy."[23] After a visit to the ruins at Pompeii, Julian wrote Marie Mauron from Naples to say they had reminded him "of the antiquities under your St.-Rémy pine trees. All beauty is meridional for me."[24]

Julian sometimes took girlfriends down to see the Maurons. Marie teased him in one letter, imploring him to remain celibate three days before he knocked over the entire female population of St.-Rémy. She could tease and Charles Mauron could be serious, because he and Julian had, over the years, been good friends, corresponding about philosophy, life, and problems of reality and aesthetics. One of the more interesting philosophical exchanges among Mauron, E. M. Forster, and Julian concerned a cow. The first sentence of Forster's *The Longest Journey*, the subject of one of Julian's Cambridge essays, raised a philosophical question about whether there was or was not a cow in the garden (the underlying problem is whether there can be proof of reality).

Julian had read much of Mauron's aesthetic/philosophic writing. After some correspondence about it, he wrote Mauron: "Roger came to see us with a new esthetic theory, almost completely based on your essay, but giving more importance to the emotions, I think."[25] Fry was bothered about his teeth, Julian reported, but had transferred all his sickness to the spark plugs of his Citroën.[26]

Julian kept Mauron in touch with Fry's activities, which provoked mixed admiration, wonder, and bafflement. Fry's enthusiasms could be exhausting to his friends. As Julian wrote the Maurons in the same letter, he had found Roger "enthralled, astonished, by the secret of the great masters of painting with *huile cuite*, forgotten since Fragonard, that produces such amazing effects, about everything every five minutes."[27]

At another time Julian assured them Roger was fine; "he gives lectures on all the arts, does portraits, plays chess and drives his car in a way to frighten everyone." On one occasion, Fry had shut himself out of his house, climbed up a rickety ladder to a window on the side of the house, and expressed his gratitude to the lightning which showed him the way. Julian, hearing of this, exclaimed to Charles: "Quel homme!" Julian was clearly writing the Maurons and Roger Fry as an adult friend, despite the difference in age. He was shaken by Roger's death in 1934, and had much compassion for his mother in her grief. He wrote Mauron:

My poor mother is more unhappy than I have ever known her, so is V[irginia] Woolf … I think very few of us knew Roger as well as you did … I always thought R[oger] was one of the finest and most complete representatives of European civilisation, one of those extraordinary people who have really combined the gifts

of artist and scientist and philosopher—besides being the most charming human being I have ever known."[28]

After going down from King's College, Cambridge, Julian was uncertain as to his future occupation. He had failed to obtain a Fellowship at Cambridge, and in 1935 decided to accept a position teaching English at the National University of Wuhan, near Hankow, China. On November 24 he wrote Marie Mauron, "I'm answering you, because I think you'll be a slightly less erratic correspondent than Charles the philosopher. But I know perfectly well that in writing you, I'm writing you both." He asked for two favors:

1) first of all, to answer me. 2) to tell me, quite frankly, how well I write and speak French. This isn't sheer vanity. Now I'm correcting English essays that my students write, and I want some standard to know if their errors will keep them from writing easily and intelligibly. I know, after three weeks with you, I *think* French, and feel myself as free as in English. But I also think I make a great number of grammatical and spelling mistakes, etc., and also that you know right away I'm not French; that even when I'm not making mistakes, I still keep an English turn of thought. But tell me how much, because then I'll know a little more exactly where my students stand.... What a funny profession teaching is, don't you think, dear confrère (you don't say "consoeur," do you?). I have ten advanced students, rather shy but very gifted, rather intelligent, three or four of them with talent as writers, I think. Like all Chinese, they are charming.

He found the Chinese, as a people,

meridionals—completely provençal. The town of Wuchang—I suppose it has a quarter of a million inhabitants—is just like Mont-Paon. The president of the missionary university told us he made statistical inquiries very French in their minutiae, just like those made by the secretary of the Mairie of Mas-Blanc. The workers who came to put my antenna in place made a hole in the wall, and left, without being paid, etc., etc.—a laissez-aller of the nicest kind.[29]

He found the countryside to be like the Alpilles, with small steep bare hills, "completely Northern as a country. But of an astonishing beauty: I never stop marvelling: it's worth ten times London and the ghost of M. under the dome of the British Museum." He went on to say that Wuchang had only white missionaries from the other Christian university, but he found them "rather nice" with

wives who aren't too bad.... If they get boring, I will put in my "receiving room" a pretty picture I just got of Tony naked. If that doesn't protect me, it will corrupt them and they will end up by being bearable. But, for the most part, I see only

Chinese. They take time, and many visits to get to any serious discussion. Generally, they lack any intellectual passion. But that doesn't keep them from being charming—and from having a true goodness that I've never seen anywhere else to such a degree.[30]

He informed them he had had, on the boat,

> the joy to be elected as an honorary Frenchman—your compatriots are less stupefied by the Indes than mine. Above all, there was a very curious man, a M. de Marquette—who knows people in St.-Rémy: perhaps you've heard of him? He is a theosophist, a humanitarian, a vegetarian Buddhist (or almost)—a Boyscoutist, a nudist, and so on. He belongs to the movement of the "trait d'union." I suppose that really he is a religious imbecile, but on a boat he was a real find: we spoke about everything, with really very little held back; he had a kind of mental tolerance, a real benevolence. And he had travelled a great deal, permitting himself just one vice—luxury—which made him human. He kept me from being bored.

He concluded by saying that he had a "desperate need of news, and I think continually about my friends: your letters bring back to me all of it: you, Charles, the Mas, and the creeks and the olives—I am very happy here, but how glad I'd be to see you again."[31]

Julian resigned from Wuhan in 1937 and returned to England, convinced he must take part in the Spanish Civil War. After landing in Marseilles, he went to St.-Rémy to discuss the matter with Charles Mauron, who was unable to convince him that his participation would make little difference in the outcome of the war. He joined the Spanish Medical Aid organization and was accepted as an ambulance driver. In July 1937 he was killed while trying to evacuate some wounded soldiers (*see* "Last Years in the Midi").

Vanessa had a very slow recovery from the shock of his death. Julian had had much affection for Roger Fry. Prompted by her sense of their close friendship, Vanessa wrote Charles Mauron after the deaths of both Roger and Julian about the poems Mauron had written in homage to Roger:

> I read them with a strange feeling of Roger's voice sounding as I read. Since Julian's death he had seemed to me, except for rare moments with you and Marie, very remote. Julian had for me driven everyone else away, but you have brought him nearer again…. I think that Roger must have created more, through making others create as well as by his own work than anyone else could have done …[32]

Mauron also knew the kind of pagan lesson Provence can teach: how to drink in the sun and then confront the mistral and the icy rain, how to be at once cynical and happy,

how to alternate between nature and creation. He wrote Roger Fry in early 1934, the year that would bring Fry's death:

> I've lost all respect for science, that I love, and I just think about the next frost—or the first burst of sun, now it's art's turn: neither art nor science will be harmed, me either. In any case I take great pleasure in meditation just as lively, scanned by the noise of my sabots, while I go out to get wood, always more wood, to stick in the fireplace ... I like our happiness, even a bit heavy ... we'll stretch out a hammock under this heaviness, I will sit down anywhere, and we will remain for a while, all mingled in the universe's absurdity.[33]

A special kind of pagan intellectual, Mauron had a forthright wit and wisdom that endeared him not only to the Bloomsbury friends who saw him often, but also to their friends. Julian Bell's Cambridge friend, Edward Playfair, had met Charles and Marie Mauron in Cambridge in the early part of 1936, when they had gone to England to visit a mutual friend, Harry Lintott, after which they called on the Fry family. Eddie Playfair wrote Julian of his impression, having found the Maurons

> absolutely delightful. I was prepared—you know how one is in those circumstances—after having heard so much praise of them, to be rather disappointed; but my conclusion was that their niceness, wit and intelligence had only been understated. It is a long time since I have liked people so much—they are all that is best about French people, both of them.... Harry and I also extracted (rather unwillingly) a promise from Charles that if both of us went to Pontigny one year, he would come too; which would be great fun.[34]

In August Eddie did visit them for lunch in St.-Rémy on his way to Cassis. They were in top form, with Charles telling anecdotes and describing a recent left-wing procession with all the principal personages of St.-Rémy. The Conseiller-Général was pinching the pleasantly rounded bottom of one of the John girls as they went along: "le front populaire," said Mauron.[35]

On their return trip Eddie and his friend had car trouble and stopped off again in St.-Rémy, where they spent "three delicious days." The Maurons' large dog, Lila, hurled herself around their legs; Eddie pronounced her a fine dog. They eventually drove Marie to Paris to see an exhibition of Cézanne paintings. He wrote Julian that she was "one of the most fascinating people I've ever met; I adored my time at St.-Rémy; it's a perfect place. The amount we ate and talked there was prodigious; its so pleasingly Bloomsbury as well as being French, too."[36]

Virginia Woolf had the highest regard for Mauron both as a translator and an intellectual. She wrote him on April 28, 1940, on the subject of her biography of Fry (who had

died in 1934). She observed that a recent letter from him had given her encourage-
ment. She had, she assured him, great respect for his opinion: "Partly because you are
French,—and also because you are so fine a thinker—I feel I could learn more from you
about writing than from any English critic."[37] This was high praise.

Charles Mauron and the Development of Psychocriticism

Charles Mauron wrote invaluable commentaries on the poems of Stéphane Mallarmé
that Roger Fry, with the occasional assistance of Julian Bell, translated into English. Not
only do they form a coherent body of interpretation of one of the most difficult collec-
tions of texts in the French language (or in any language) but they serve as a prelude to
the all-important theory for which Mauron was responsible, that of psychocriticism.
Proficient in English, he had been able to use the work of the English-speaking psycho-
analysts before and after World War II, such as Otto Fenichel, Ernst Kris, Melanie Klein,
and others. By the time he completed his major works, he had already published an
essay on "Nerval et la psychocritique" in the journal *Cahiers du Sud*.

By about 1947 he had developed his theory of psychocriticism, which is concerned
with the obsessive metaphors that haunt an author's work and his unconscious. Such
metaphors, or fixations, recur in certain patterns—as knots or clusters on the surface of
the text—that allow the reader to perceive the origins and intricate phases of the devel-
opment of the creative work from its origins or "unconscious sources."[38] These
metaphors are detected through repetitions, which can be convincingly mapped. His
study of the many ways in which obsessions lead to creation, *Des métaphores obsédantes au
mythe personnel* (*From Obsessive Metaphors to Personal Myth*, 1964), has long been consid-
ered a basic critical text.

Mauron's critical works, especially those on Mallarmé, Racine, and Baudelaire, are
crucial to the understanding of psychological criticism as a whole, as well as to his own
variety of study. He discovered significant unconscious patterns linking the life and work
of the playwright Jean Racine to his tragedies. His doctoral thesis, *L'Inconscient dans l'oeu-
vre et dans la vie de Racine* (*The Unconscious in the Work and Life of Racine*), published in Aix
(1957) and reprinted in Paris (1969), is still essential reading for students of literature
in France. (The novelist Jean-Louis Curtis once said that not to know Racine is not to
know France, a judgment with which many people would concur today.) Roland
Barthes's own study of Racine begins with an homage to Mauron, who brought to his
study of the life and work of Racine the same passion as to his writings on Mallarmé,
Baudelaire, Nerval, and Valéry. That Mauron should have chosen these writers for his
analysis tells us as much about the depth and workings of his own mind as about the
intricate and brilliant poetic structures he detected.

At first Mauron found it hard to persuade readers of the validity of his new approach to poetry. His *Mallarmé l'obscur* (1941) revealed the importance of the deaths of Mallarmé's sister and mother to the composition of his "Hérodiade," connections for which Mauron made a convincing case.[39] (To this work, in a second edition, he added his essay on Lao-tse. This was a lyrical study of water and its reflections, about which it is sometimes said that it comes as close as any work by a Westerner ever has to understanding oriental philosophy.) He found it difficult to locate a publisher for his second book on Mallarmé and his obsessions, which he finished in 1947–1948, *Introduction to the Psychoanalysis of Mallarmé*. It was finally published by La Baconnière in Switzerland in 1950.[40]

Mauron believed in the essential inseparability of sensitivity and intellect. This concept was a crucial one for Roger Fry, and was in part responsible for his gradual abandonment of his dry formalist theory of art to a more relaxed one that combined representational elements with more purely abstract ones.

Edward Morgan Forster and the Maurons

"After India, it was France," E. M. Forster's mother, Lily (Alice Clara), once remarked about her son's ruling passion.[41] In 1927 Forster went to St.-Rémy to meet Charles Mauron, who had, two years earlier, translated *A Passage to India* into English. The same year he dedicated his *Aspects of the Novel* to him. For many years they discussed various strategies of writing and imagining fiction and exchanged visits. A genuine affection developed between the Maurons and Forster. On June 8, 1928, Charles Mauron wrote him from the village of Mas Blanc, "I'd like to offer you twelve robes of honor and magnificent feasts. But in vain do I look around me, I see neither robes nor solemnity. So you have to accept just my poor friendship all by itself...."[42] That, it turned out, was quite enough.

The Maurons came to know Forster in a domestic context, just as they had known Roger Fry. Lily Forster once sent the Maurons her special "recipe of gelée" because, they said with a twinkle, they had so many eggs from their hen. Forster supplied a phonograph for the sitting room and then proposed, in 1929,

E. M. Forster and Charles Mauron at the Mauron home on the Ave. Van Gogh, St.-Rémy; photograph by Alice Mauron (1963).

that he furnish them with a piano. Mauron began searching for one on the rue St. Fer-réol in Marseilles, a street with many musical shops offering pianos for sale. In one of them he had heard at least two thousand basses, two thousand trebles, and five hundred thousand trills. But in the center of the showroom they never sounded the way they did against the wall or door, so he continued to search. Finally, as he reported to Forster, "I rushed (Marie right after me) into another building of the Rue St. Ferréol with the sign 'good pianos' ... I have wrestled, I have struggled, I have done my very best, I reserved three. One Erard at the top of the street, a Gaveau in the middle, a Pleyel at the end. And now I have to choose." He finally chose the Erard because, he explained, it "just happens" to produce the same melody Forster used to play, from Beethoven's Sonata Opus 90.[43]

After Roger Fry's death in 1934, the friendship between Mauron and Forster continued throughout their lives (Mauron died in 1966 and Forster in 1970). Mauron was the translator of works by Virginia Woolf, Laurence Sterne, T. E. Lawrence, D. H. Lawrence, and Henry James,[44] but it was as the sensitive, nuanced, and careful translator of E. M. Forster that he was best known. In addition to *A Passage to India*, he translated *A Room with a View*,[45] *Howards End*, *The Longest Journey*, and *Where Angels Fear to Tread*. His work was highly challenging for both writers. Mauron's intellectual approach to Forster's books, together with his gift for friendship, made him an invaluable companion. Their friendship was completely different from that between Mauron and Fry; Forster was less engaged in the philosophical exploration of aesthetics, and in need of a different kind of relationship. Although we lack a record of their conversation, the tone of Mauron's letters implies that he had at once the solemn humor of someone who would plunge into Mallarmé with a Provençal twinkle, totally unlike what Pontigny intellectuals such as Charles du Bos and André Gide were accustomed to. His letters leave a verbal trace of exactly the person Fry had described as intense, intellectual, and warm. Forster would storm the tiny town of St.-Rémy, Mauron noted, only to find me waiting humbly, "keys in hand." Above all, he cautioned, do not think you know Provence through reading one of its vulgarizers: "how dreadful Daudet is ... you could have no idea of Tarascon through him or any writer." The converse is also true. For example, "English authors are read silently, the Provençal air refuses to transmit any British sounds. We will speak French for you. Otherwise, we speak Provençal."[46] Mauron praised Forster for avoiding "epicureanism," one of the attitudes he criticized for its arrogance and scorn of sentiment:

> The epicurean acts as if he knew everything. But in the realm of feeling he knows almost nothing; that's why he so often claims in practical life that feelings don't exist. But they do, and that's what causes us to act.... If you question in me the man who does esthetics, he will tell you that sentiment isn't art, just like the man

of science will tell you that your knowledge isn't psychology; me, I believe them. But I also know that sentiment is a reality ...[47]

In 1935 E. M. Forster was invited to speak at the International Congress of Writers in Paris. Charles Mauron accompanied him. *A Passage to India*, Forster's last novel, had been published in 1924. In succeeding years he published essays and became a journalist and broadcaster, but wrote no more fiction. He evolved into a "liberal thinker," to use Christopher Isherwood's term, or a "sage," taking part in meetings of intellectuals, and becoming increasingly concerned about world politics.[48]

The Maurons made a visit to England in 1936 and stayed at Charleston. In July Vanessa received the proofs of an edition of Mallarmé's *Poems*, which Roger Fry had translated; Charles Mauron had provided commentaries. Vanessa, who was to design the jacket, wrote Julian it seemed "the most exciting book"; she planned to do a still life.[49]

In 1937, Mauron was invited to lecture at the French Institute in London. He wrote Forster, hoping he would not have to stay in the Institute but could stay with friends. An alternative would have been to stay in lodgings where he might be anonymous. Mauron loathed the superficial relations attendant on staying at the Institute, where he would have to make casual conversation. He explained to Forster, "In your house, I'm sure to find a whole scale of joys from Beethoven to the baby chicks."[50] His lecture was to be on the echoes and resemblances between the work of Baudelaire and modern French poetry. He shared, with the Bloomsbury group, a basic uninterest in such contemporary poetic movements as surrealism.

Roger Fry, a number of years before, had written Vanessa Bell about meeting and disliking the surrealists, and about the general arrogance, as he put it, of the avant-garde. Mauron agreed; in 1929, before Fry's death, he had written Forster on the subject. He objected to such poetry on the grounds that it did not know how to "remember." Rather, it either forgot or chose to forget

everything, everything. One sentence doesn't even remember the one before it. I will salute Proust *en passant* and see that if he often remembers in a magnificent

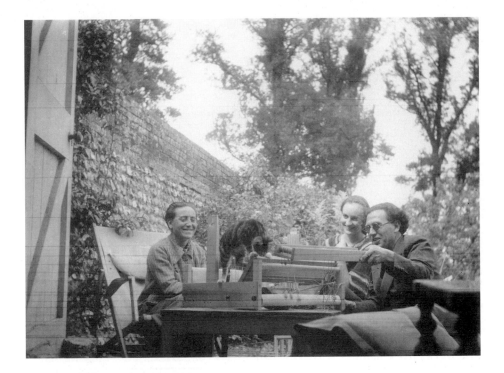

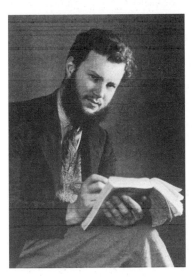

ABOVE. Marie Mauron, Angelica Bell, and Charles Mauron at Charleston (1936).

BELOW, LEFT. Julian Bell; photograph by Lettice Ramsey (c. 1931–1932).

BELOW, RIGHT. Charles and Marie Mauron at Charleston (1936).

way, he also has strange lapses of memory. In Valéry I show he remembers, but takes no pleasure in it—those memories don't count in art. I end with the group Duhamel, Romains, Vildrac who are often moved by everything else except echoes.[51]

Charles Vildrac was known to Vanessa Bell, Duncan Grant, and Roger Fry in his roles as fellow artist, gallery owner, and landlord of the Villa Blanche at St.-Tropez, where Vanessa and Duncan had stayed in 1921 (*see* "Painters in St.-Tropez, 1921–1927"). He was also a playwright; his *Le Paquebot Tenacity* (*The Steamer Tenacity*) had been presented in Paris in 1920. Roger Fry had praised its humanism and naturalistic presentation of the human predicament.[52] Vildrac was not only well-known as a playwright, but also had a reputation as a poet.

Memory itself was always of primary importance to Mauron, not just in literature, but in life: to forget was to lose. Layers of experience, of emotion, and of memory redoubled for him the value of the place as of the poem. Mauron became, in a way, a mentor to Forster just as he was to Julian Bell, a counselor in things of the mind. Before Forster's 1929 trip to Africa, Mauron praised the "truth" of his mind, so different from the snobbishness and artificial values of "the other intelligentsia of London." He reminded him to keep his eyes open about things he had not noticed previously, lest he feed on what he had already seen. He warned, "you have too much respect for people and human relations: love them, if you want to but don't respect them. Respect is sad and heavy. Read some Aristophanes every evening and above all don't give a twig for the intelligentsia which really doesn't matter."[53] Mauron advocated a firm independence that he himself knew how to practice.

Mauron's wisdom was no less sharp than his wit. When Julian Bell was trying to decide whether or not to go to Spain in January 1937, it was Mauron whose counsel he sought. Mauron was determined not to undermine the young man's integrity in making his own decision, yet to be as persuasive as possible, invoking the good Julian could do with the Comité de Vigilance in England as well as the probable uselessness of the risk he was tempted to run. "Once your mind is made up," he wrote, "I won't permit myself to intervene, naturally." No matter how excellent the grounds on which he could dissuade Julian, he admitted that he himself knew how tenuous was the rule of reason over the emotions. Without "stupid emotions" life wouldn't be worth living, he conceded. With a prescience of the tragedy to come, he tactfully pointed out weaknesses in Julian's arguments, knowing that his advice could be critical to his decision:

Your political position will not be particularly reinforced by your action, in my opinion. The force of a political position is in its concrete and actual correctness;

this correctness is based on a theoretical and practical competence. The rest matters little. There are now 30 thousand conscientious antifascists in Spain: you will be just *one* among them.[54]

Should Julian believe that Madrid's fate would be decided in Madrid, he would be wrong. "Let Paris or London waver on one side the other, and the fate of Madrid is determined in two weeks." Julian could serve the cause they both believed in if he were in England or France:

> You are the person I would have needed in England. I am not talking about spectacular or secretive action—that is, romantic. I mean efficacious action. I don't doubt, if you continue with your projects, that your action will be efficacious in Spain! But mine will certainly be less there. That is why, egotistically, I would regret that decision.[55]

Mauron sent this letter to Vanessa, with love. After Julian was killed, he wrote Quentin Bell, calling it "a disaster, after so many other disasters, before other disasters—all useless, naturally."[56] He expressed his belief that Julian had needed to live in his own way, and had always thought of himself as a soldier: "But I am under no illusion: no war was worth his life—his more than any others."[57] After Julian's death, E. M. Forster wrote Vanessa that he could say nothing, that it was "Mauron, who knew him so well and so justly" who could find the words.[58]

Cognizant of the close friendship that had existed between Mauron and Julian Bell, Julian's family invited Mauron to write a preface to the posthumous collection of his writings. Mauron wrote Vanessa that he was honored that she should have thought of him for the edition. "I think I grew near to the feeling that your sons have always had for you, whom I have known as long as I have known them, and that seemed to me a relation so rare and so beautiful, such a success in the art of living."[59] His preface was centered on the idea of Julian's nobility. He wrote Forster that "Julian was a barbarian aristocrat. Through a thousand traits he rejoins the Iliad or the Vikings." It was, he said, this force of nature colliding with the Bloomsbury aesthetic that determined the stiffness and fatality of his trajectory: Julian was a man of action, who needed physical and spiritual elbow room, as opposed to the Bloomsbury painters, who, as he put it, "think, amuse themselves, and suffer in the peaceful qualitative land of tastes and colours."[60] Writing to Quentin in November of 1938, about Julian's writings and death, Mauron succinctly summed up the loss of Julian: "The flavour of the words, and the explosion of life, and friendship and regret."[61] No one phrase could better describe the intimate, deep, and lasting relation between Mauron and the Bloomsbury friends in England who had found their home, so often, with him.

Over the years, Mauron found that writing to Forster was one way to put things in a larger perspective. In 1939, on the eve of World War II, he wrote, "So dear Morgan, here we are. Our poor stories and our big worries, which already had very little importance, have no more at all. But these ills I have under my eyes assure me that civilization remains civilisation."[62]

After his divorce from Marie in 1949, Charles Mauron married Alice, who had come from Switzerland to work with him, and who came from a distinguished family of psychoanalysts, including Théodore de Flournoy, famous for his work with the medium Hélène Smith. They went to live not far from the Mas d'Angirany, on the same road, in the house of Charles Mauron's father, who had formerly been the mayor of St.-Rémy. On occasion, he and Roger Fry had painted side by side, their easels set up across from the excavations of Roman ruins at Glanum.

Vanessa Bell painted Forster's portrait in 1940. That fall, when Forster was having an operation in London, Mauron wrote him of his present life and recalled their years of friendship: "Why can't we become two dear old dreamers side by side?… Days here are rushing on—very hard work and calm happiness. A strange November, very grand, unmoved by the falling of leaves…."[63] The war years prevented their meeting, although they corresponded often. After the war, their close friendship resumed.

Lily Forster, with whom Morgan had lived his entire life, died in 1945, and he was forced to give up the lease to the house they had occupied, West Hackhurst, in Surrey. In 1946 King's College, Cambridge, offered him an honorary fellowship and a large room, which he gladly accepted. After a three-month stay in the United States in early 1947, he went to St.-Rémy and visited the Maurons and then returned to King's, where he would live for the next 23 years, dividing his time among travel, writing, and seeing friends. Roger Fry's sister Margery also visited the Maurons in the late 1940s.

In January 1959 there was a splendid celebration of Forster's eightieth birthday in Cambridge. Charles and Alice Mauron were honored guests, along with Vanessa and Clive Bell, Leonard Woolf, Angelica Garnett, Quentin Bell, and Eddie (later, Sir Edward) Playfair, Julian's good friend and frequent correspondent. It was a highly emo-

tional experience for Mauron, returning to England for the first time since Julian's death in 1937 and since he had lost his vision completely. In 1963 Forster visited the Maurons in St.-Rémy, returning in 1964 with his friend Bob Buckingham and the latter's wife, May. Later the Buckinghams brought their grandchildren to St.-Rémy. The Buckinghams' only child, Rob, had died of Hodgkin's disease in 1962 at the age of twenty-nine, leaving two sons, both of whom had been given "Morgan" as a middle name. Forster provided a monthly allowance for these children and regarded them almost as grandchildren. Forster continued to live at King's College, Cambridge, where, in 1969, he celebrated his ninetieth birthday. He died in 1970. Charles Mauron kept up his chronicle in *Le Provençal*, and continued to write and publish until his death in 1966.

Cistercian
Abbaye de
Pontigny, in
the Yonne.

Intellectuals at Pontigny

> *... même les méchants se portent bien à Pontigny.*
> [*...even the nasty types get along at Pontigny.*]
> —Letter from Edward Playfair to Julian Bell, 1932

One of the more celebrated meeting places of French intellectuals from about 1910 through the 1930s was the medieval Cistercian Abbaye de Pontigny, in the Yonne. Here many of the Bloomsbury group had an occasion to mingle with writers, critics, and other noted figures. Paul Desjardins had initiated the conferences on an estate he had inherited; Pontigny was to be a place for international meetings on topics of aesthetics, politics, and institutions such as the law. He had previously had experience with a group called "L'Union pour la Vérité," dedicated to furthering discussions among several interlocutors, an experience that served him well in this new venture.

Desjardins's project was, from the beginning, on a grand scale.[1] The ten-day meetings at Pontigny, beginning in 1910, offered an opportunity for scholars from other countries to meet the French specialists or generalists interested in the same topics. The length of the *décades* deliberately recalled the gatherings of Boccaccio's *Decameron*. There were leisurely breakfasts with long discussions, reading time afterward until the equally conversational lunch and postprandial coffee outside, weather permitting, followed by serious afternoon debates about abstruse problems. This pattern continued until 1940, when World War II forced the closure of Pontigny. Such an intellectual marathon was easy to mock, particularly by the English, who sometimes ridiculed the hothouse atmosphere, the intense seriousness, and the rather staid expositions by highly cultivated participants. Yet what Pontigny represented—and still represents, in its latter-day avatar at Cerisy-la-Salle near St.-Lô in Normandy—is a compendium of French intellectual life, particularly when it allows itself an international flavor. The colloquium held there in 1977 on Virginia Woolf was a model of its kind.[2] The Cerisy-la-Salle meetings were founded by Anne Heurgon-Desjardins, daughter of Paul Desjardins.

After the closure, one of the most assiduous intellectuals who had frequented Pontigny, the highly respected philosopher Jean Wahl, re-created the atmosphere for a few days in America at Mount Holyoke College in New England, with a stellar cast of intellectuals in attendance, including Wallace Stevens, Marianne Moore, and Edmund Wilson.

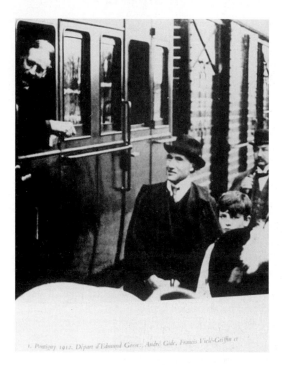

1. Pontigny 1912. Départ d'Edmond Gosse., André Gide, Francis Vielé-Griffin et

In order to be invited to Pontigny, it was necessary for foreign participants to be known to the French for their general erudition and for their knowledge of the particular topic under consideration. From the outset a heavily Roman Catholic preserve, it was dominated by Paul Desjardins, the founder, who opened the *décades* as the president; by Charles Du Bos, the vice president, who acted as the moderator; and by André Gide, Jacques Rivière, Jean Schlumberger, Jacques Copeau, and Roger Martin du Gard, who, in 1909, had founded the influential *Nouvelle Revue Française* (which evolved into the Gallimard publishing house). Jacques Heurgon, the translator of Lytton's *Elizabeth and Essex* and *Eminent Victorians*, and the husband of Desjardins's daughter Anne, frequently participated in the meetings. Julian Bell's friend Edward Playfair wrote Bell about Jacques, describing him as

Departure of the poet and man of letters Edmond Gosse from Pontigny; André Gide on platform in front, and the poet Frances Vielé-Griffin in rear (1912).

rather a butterfly; handsome (if a trifle fat); gay, clever, & utterly without any sense of prudence or responsibility: all that is left to his wife, Desjardins's daughter … capable, ambitious, managing, & at first rather forbidding—but extremely amiable, long-suffering, & I think, likeable. She talks little, but it is said that her brains are very much above the ordinary: she has written a novel, not yet published…. If I went again, I would make a more strenuous effort to know her better.[3]

Like Bloomsbury Central itself, this principal core of intellectuals attracted other figures over the years. At Pontigny, the tradition was the very French one of a serious gathering to talk and talk, and take walks talking, in a spot isolated from normal concerns. There was an animated, intense atmosphere of vigorous conversation that is apparent in much of the correspondence among participants: Gide, Dorothy Strachey, and Roger Martin du Gard; Roger Fry and Charles Mauron; Julian Bell and Eddie Playfair. Some of the more amusing legends of Pontigny have to do with the Strachey family. In 1922 three of Lytton's sisters visited Pontigny: Pippa, Pernel, and Dorothy Strachey Bussy, wife of the French painter Simon Bussy. Dorothy was there for the *décade* August 17–26, 1922. She was painfully enamored of André Gide and a great friend of Roger Martin du Gard (*see* "Simon and Dorothy Bussy, André Gide"). There is a photograph in the Cerisy archives of Dorothy breakfasting with both men. Yet, characteristically, in the

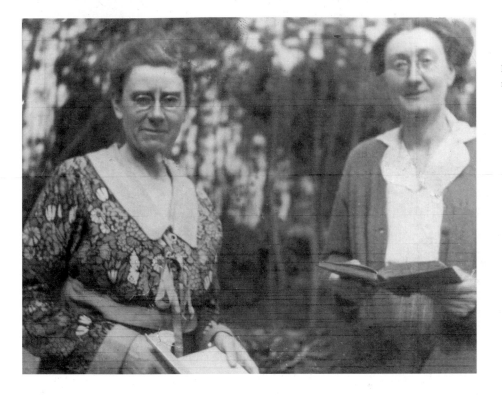

publication devoted to the *Entretiens* on André Gide at Cerisy-la-Salle, Dorothy is omitted from the picture, except for her coffee cup.

Dorothy once observed that a little of the Stracheys went a long way. Vanessa Bell remarked that it would be "a terrible fate to be shut in at Pontigny with other members of the family in that thick Strachey atmosphere." She was thoroughly acquainted with this "atmosphere," of course, having known the Stracheys all her life. She also encountered it, as did the others, in their frequent visits to the Bussy home at La Souco.

The next year, in 1923, Lytton Strachey attended a literary *décade* (August 16–27). It was centered on the somewhat improbable topic of "Le trésor poétique réservé ou de l'Intraduisible" ("The Hidden Poetic Treasure or about the Untranslatable"). Among the participants, besides Gide, were André Maurois, Jean Schlumberger, Roger Martin du Gard, and Jacques Heurgon, as well as Mme Théo van Rysselberghe, "la petite dame," the mother of Elisabeth van Rysselberghe, who, in April, had given birth to Gide's daughter, Catherine. (He was, and remained, married to Madeleine Gide.) Called upon to pronounce what he cared about most, Lytton piped up in his squeaky voice: "Passion!" This was a response all the more entertaining in its contrast with dry atmosphere usually prevailing at Pontigny. On another occasion, Lytton was invited to express himself about the idea of confessional literature. He rose and said simply, "Les

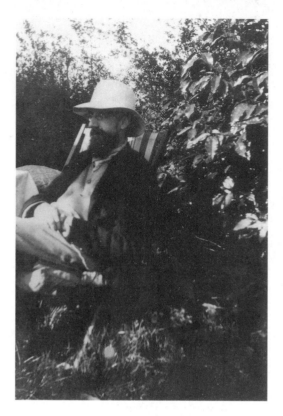

Lytton Strachey.

confessions ne sont pas dans mon genre" ("Confessions are not my sort of thing.") During a discussion of the gratuitous act, he responded with a question: "Est-ce qu'un acte gratuit est toujours ennuyeux?" ("Is a gratuitous act always boring?")[4] Lytton suffered terribly from the absence of his usual egg at breakfast, and disliked the discussions, far preferring the mornings when he could read in the library. Long after, he would have nightmares about the place, which was essentially alien to his nature and his personal taste. When he sent Gide Thomas Love Peacock's novel *Nightmare Abbey*, Gide assumed it was a joke, referring to Lytton's state of mind at Pontigny.[5]

One tradition at Pontigny, which endures at Cerisy, was the long walk taken in solitude or for conversation in the surrounding pastoral atmosphere. Others were a swim in a nearby body of water, and intellectual evening entertainment, such as charades, word games, a concert, or a reading by one of the authors in attendance. Evenings were also enlivened by an abundant supply of calvados from the Norman apple trees, or by various wines. Lack of caution often sent the unsuspecting novice to bed with a headache. When Gide was in attendance, as was often the case, he used to read from his latest writings, in a tone so sepulchral that Eddie Playfair once compared it to an extremely dull sermon. Not everyone agreed. Klara Fassbinder remembers Gide reading once, in English:

> It was a fantastic spectacle for me. You would have said he was savoring a great wine, and I thought of the face of one Dutchman who had tried to make me understand the way you had to turn the red wine around slowly on your tongue really to taste this divine draught. Suddenly I understood why you use the same verb "to enjoy" when you are speaking of a spiritual delight or a physical one.[6]

For someone like Lytton, it must have had the makings of a hellish ordeal.

It may have felt nightmarish to Dorothy Strachey Bussy also. It had been during the last night of the 1922 Pontigny *décade* that Gide informed her he was having a child by Elisabeth van Rysselberghe. At first, she told him, "the radiance of your presence was lighting me." A few days afterward, however, she felt only darkness. Nevertheless, she

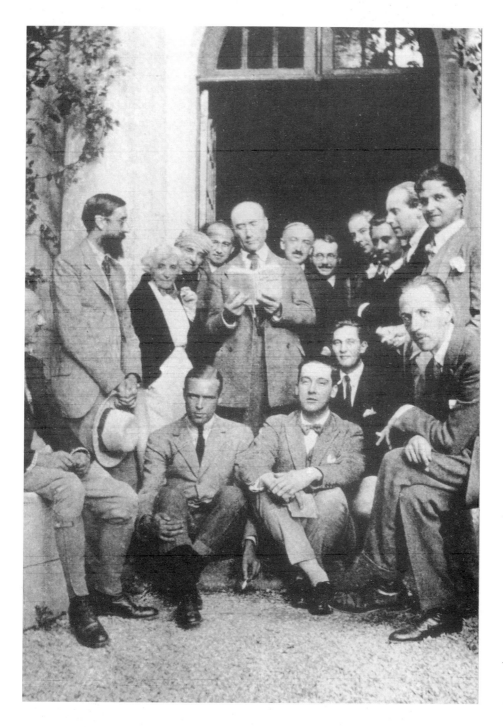

Pontigny (1923). *Left to right, standing*: Lytton Strachey, Maria van Ryssel-berghe, Loup Mayrisch, Boris de Schloezer, André Gide (reading), André Maurois, Johan Tielrooy, Roger Martin du Gard, Jacques Heurgon, Theodore Funck-Brentano, Albert-Marie Schmidt. *Left to right, sitting*: Pierre Viennot, Jean Schlum-berger, Jacques de Lacretelle, Pierre Lancel.

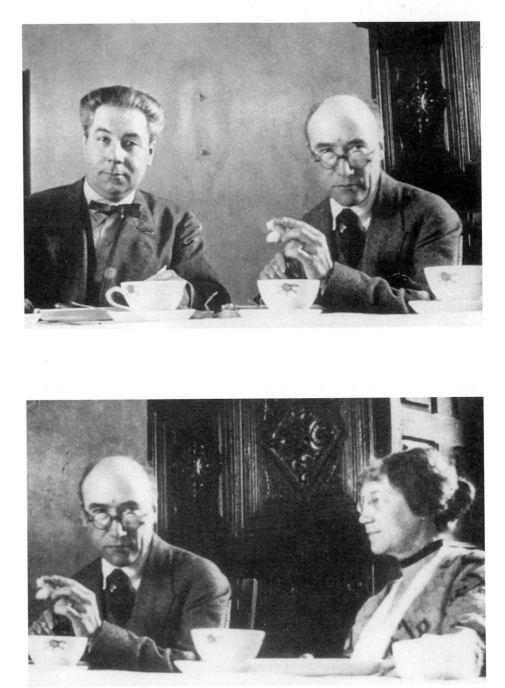

ABOVE. Roger Martin du Gard and André Gide at breakfast, Pontigny (1922).

RIGHT. André Gide and Dorothy Strachey Bussy at same breakfast, Pontigny (1922).

returned to Pontigny with him in the summer of 1926, longing for the priority it placed on the intellect and the sort of companionship it nourished. She wrote him, "I really do always enjoy it very much—in spite of the horrors!"[7] There were years when Gide did not attend, but he could be called upon to come when it was important that he do so. For example, in August 1939 he felt obliged to be present at two consecutive *décades*. One was organized by the *Times Literary Supplement* with a group of English critics, followed by one on the question of refugees, an issue of particular importance to him. The Pontigny meetings were the centers of his social and professional life. Roger Fry once described him as he intoned his texts. Although he was not always approachable, he epitomized the French intellectual of the Pontigny sort.[8]

In September 1910, Gide reflected in his journal about the beginning of the "Décades of Pontigny." He was at his best, satirizing his own narcissism, so often celebrated by himself and others:

> How absurd we are—I already have enough difficulty taking myself seriously when I'm alone…. Each of us seems here as if in the fitting room of a tailor surrounded by mirrors reflecting each other and looking in the mind of the other men for his own image multiplied many times. In spite of yourself you take on a posture, throw out your chest a bit, and wish you could see yourself from behind.[9]

In her memoir of Gide at Pontigny, Anne Heurgon-Desjardins reflects on her friend, who was in part responsible for her being able to continue the meetings at the Foyer de Cerisy in the 1950s. She gives abundant testimony about his well-deserved reputation as a skinflint. He would be dilatory about getting out his wallet, so that she would pay their bus trips, and would offer to pay for her ticket for a film if it was good. Otherwise, he would purchase only his own, gloating if it were less than meritorious. She states that he never gave Christmas presents or toys to his grandchildren, nor did he present candy or flowers to the hostess who had sheltered and fed him in Algeria from June 1943 to April 1945, with the exception of six months he spent in Morocco in the middle of his lengthy stay. In spite of that, she knew how generous he could be: it was he who helped support the unemployed writers who came to Cerisy, and who once offered a manuscript for sale in order to provide more funding. He was terrified lest someone he had known at Pontigny or Cerisy try to contact him in Paris. Once he departed from the pastoral atmosphere of the retreat, he was careful not to respond to autograph hunters. He laboriously typed his letters to avoid giving them that joy, and waited to mail them lest it seem he had answered right away. He had numerous odd habits. One was his practice of saving anecdotes to read from his notebook at meals so as "to shine in the world," not believing his conversation to be interesting enough. He would hide behind the curtains in her drawing room so as to surprise the dinner guests who might, thinking themselves unob-

served, be seen fixing their hair or tying a shoelace or adding a bit of powder to their noses.[10]

Dorothy Bussy's voluminous correspondence with Gide was at times affected by the atmosphere of Pontigny. For example, she wrote Gide in October 1944, "the only person to whom I can talk about *everything*":

> I am longing to hear what Latin you have been reading—Poetry I expect, but that is too difficult for me, but I too have been reading it diligently and made one of the most pleasurable discoveries of my life—namely Cicero's letters to Atticus. Thrilling from every point of view, drama, *psychology*, modernity, etc. etc. How wrong of all those highbrows at Pontigny to despise Cicero. I was deceived by them for a long time.[11]

Pontigny clearly had its own dogmatic beliefs and exerted immense influence over those who attended.

Roger Fry, who had been greatly respected by the French intellectuals of Pontigny, and Charles Mauron, his Provençal friend, went to Pontigny for the decade from August 27 to September 6, 1925. He had invited Mauron, knowing how welcome his seriousness and brilliance would be. They were housed in an annex at the end of an enclosure, and found themselves deeply involved in, yet somewhat amused by, the proceedings. Roger, delighted with his guest, believed he and Mauron represented a new mode of thinking compared with the metaphysical mode of thought that was habitual there. Pontigny had always been deeply Christian and took itself very seriously, as reflected in some of the topics participants had investigated. Jacques Heurgon, for example, had written on the French theologian Nicolas Malebranche. Jacques Raverat, a painter from Prunoy, had kept up an intense correspondence with James Strachey, to whom he wrote an amusing note about having discoursed at Pontigny on his favorite topic of eunuchry, on which he had done his dissertation.[12] Raverat revered the young and old thinkers at Pontigny, finding them "all honest men here, of great understanding, freedom from any fanaticism, and yet devotion to their several ideas—which, as a matter of fact, go hand in hand."

Roger Fry, being more of an agnostic than a believer, did not share Jacques Raverat's opinion. He determined to "put a spoke in the Christian prayer wheel," as he wrote to Helen Anrep on August 19, 1925. "I certainly thought that among all these fierce young Christians and mystics and metaphysicians I was making a very bad impression here, but Jane Harrison assures me that they are quite delighted to have an Englishman who will respond and will laugh." He described Charles du Bos and Desjardins as

> ecclesiastics (in spirit) who haven't got a pulpit and who manage here to get the occasion to develop and round off grand oratorical phrases and lick their lips over abstract words.

Du Bos, who speaks most of all, speaks with the extreme slowness and deliberation and the unctuous emphasis of a born preacher. He loves every kind of analytic subtlety and metaphysical abstraction and at each pause in the discussion manages to *embrouiller* things completely and leave the question in a fine metaphysical mist. Both he and Desjardins are continually finding things "*qui me paraît particuliêêêèrement frappant* [*sic*]."[13]

Fry's detailed descriptions of the *décade* in his letters to Marie Mauron, as well as to Helen, are eloquent testimony to a classic debate between the "scientific" mode Charles Mauron represented and the arguments of the metaphysicians gathered at Pontigny. Fry found Mauron's paper on literary beauty a perfect example of the scientific spirit and its precision, "a great triumph" of the disinterested spirit and the artistic vision on the one hand, and the empirical modest statement on the other, over abstraction and metaphysical generalities, as he called them, remaining as it did independent of the uncertainties of belief. Mauron was, he believed, easily able to undercut the staid and stale arguments of the metaphysicians on aesthetics. This was the topic under discussion in for their *décade*: "What is the nature of beauty? What is nature of the humanities?" The cogency of Mauron's arguments, coupled with his scientific rationalism, was able, Fry's opinion, to rout that "damned Christianism so in evidence there." The listeners applauded, a rare tribute. Roger felt as though he had sponsored a prize racehorse. The triumph was all the sweeter for being totally unexpected. Both Fry and Mauron were able to deal in specifics rather than abstractions, unlike many participants in the Pontigny meetings at that time.

By 1930, members of the younger Bloomsbury generation and their friends were attending the Pontigny meetings. Eddie Playfair, Julian Bell's close Cambridge friend, had corresponded with him extensively about French literature and politics. They had exchanged suggestions for French reading, and Eddie asked Julian to petition Charles Mauron for a list of things he should read, ranked in order of importance. Eddie considered many writers in the canon tedious, from Jean Giraudoux's "bad nonsense" to André Gide's prolixity to André Suarès's disconnected platitudes. The fault, Eddie argued, was Julian's enthusiasm for the French and his seriousness about them: "For all your British workman's corduroys, your real natural dress, your Geistanzug, is the pale suit bought in Paris: for heaven's sake, do not model yourself on the French literary man."[14]

Eddie delighted in visiting Pontigny and returned in 1930, accompanied by two girls with whom he had enjoyed the gastronomic delights of North Burgundy just before arriving for one of the August *décades*. In a September letter to Julian, however, he lamented the change of atmosphere at Pontigny. The stars who had been in attendance at the first décade were no longer present:

Group of undergraduates at Cambridge. *Left to right*: Anthony Blunt (later director of the Courtauld Institute Galleries, London, and Keeper of the Queen's Pictures), Francis Warre-Cornish (nephew of Molly MacCarthy); Dickon Steele; George ("Dadie") Rylands; Eddie Playfair (later, Sir Edward Playfair).

... one or two novelists of repute: Valéry, Copeau and Jacques Dalcroze were all expected to ours, but none could come. All the same it was perfectly delightful, and we all regretted terribly that you weren't there; I think you would have loved the discussions, and thrown yourself into them with the greatest zest; aesthetics, of course, was the mot d'ordre, and prosody the chief interest; we badly wanted an authority on English prosody.[15]

He had recommended Julian to all the professors, publishers, and translators of Lytton,[16] who

talked an incredible amount of rubbish; most of what they said was completely déplacé, but it was funny all the same. Besides, you must admit a certain fascinating quality in the conception of French intellectuals solemnly sitting down for ten days to two and a half hours' discussion on rhythm a day.[17]

Yet the place itself was delightful, full of wines that should not be mixed, and that Eddie mixed, until he was carried off to bed. The report, accurate no doubt, gives a vivid sense of Pontigny, its peculiarities, and the nature of the discussions.

Eddie Playfair longed to return the next year for the Baroque *décade*, which many of his friends would be attending. He wrote Julian in May 1931, to say that he hoped Julian was finally going. He assured him that the Baroque meeting would be less dull than the previous one he had attended, because all the experts would be coming. Moreover, it would probably help Julian in the future by permitting him to make "numerous friends and acquaintances." Jacques Heurgon would take him around, if he was there; other-

wise, as Virginia Woolf's nephew, and someone who knew something about poetry, he would have no trouble. He should, above all, speak in the discussions, but not too freely "in front of the older people: the atmosphere of Pontigny is decidedly moral."[18]

Eddie Playfair's reflections, when juxtaposed beside those of André Gide, give opposing pictures of Pontigny, which was hated or beloved by all who attended. Only in France could this kind of intellectual gathering take place. The seriousness and the humor, the preposterous and the pompous, are mingled with the daily and the simple. Strangely, it works well even now at Cerisy, just as it did in 1910 at Pontigny, one of the original meeting places of international minds.

Roger Fry, *View
on the Côte d'Azur.*

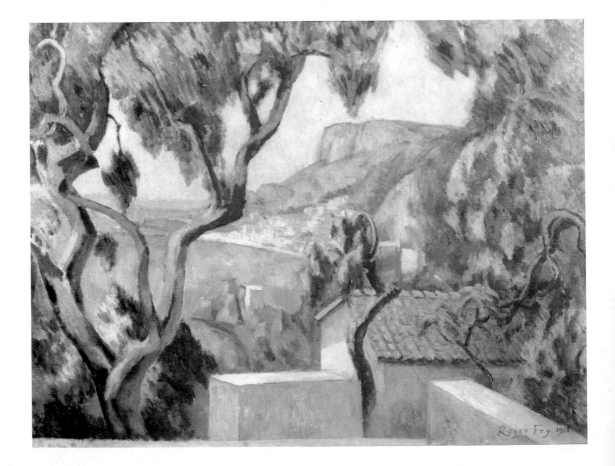

Roger Fry's France

So Roger appeared. He appeared, I seem to think, in a large ulster coat, every pocket of which was stuffed with a book, a paint box or something intriguing; special tips which he had bought from a little man in the back street; he had canvases under his arms; his hair flew; his eyes glowed.

So Roger appeared. He had more knowledge and experience than the rest of us put together.

—Virginia Woolf

Roger Fry in France

In an early letter to Vanessa Bell, written in August of 1911, Roger Fry described his feeling about France: "When one gets into France and the sun is shining on little towns, all grey-brown roofs and grey walls, and the poplars are golden in the autumn light, I must be rather happy at the mere sight."[1] Fry had, of course, long known France, having studied art in Paris at the Académie Julian in 1892. By 1904 he had written about the French Primitives exhibition in Paris for the *Burlington Magazine*. In the world of art criticism Fry was the most persuasive and influential figure among the Bloomsbury group, and it was he who eventually had the closest and most lasting contacts with France and the French. This affinity was far from evident, however, in his earliest days at the Académie Julian. While there he shared lodgings with Lowes Dickinson, but, according to one critic, "between them they managed to miss almost every exciting gesture of the nineties in Paris."[2] They heard performances of Wagner and frequented Le Chat Noir, the principal artistic café at the time, owned by the cabaret singer (and later novelist) Aristide Bruant. Fry failed entirely, however, to see any pictures by Paul Cézanne, a source of bitter regret when he discovered his works in 1909 (three years after the artist's death). He became a tremendous admirer of his paintings, establishing a spiritual link with him that was extremely illuminating for both the painters and writers of Bloomsbury. As Vanessa Bell points out, it was Roger Fry whose extraordinary energy and persuasive intellect changed their way of seeing and conversing in the early days of Bloomsbury: "We stopped talking about 'the good' and started talking about Cézanne." Fry's relationship with France was enlarged further when, in 1919, he met Charles and Marie

Mauron in St.-Rémy and established a friendship that would become the most crucial and fruitful of the personal and professional relations between the Bloomsbury group and France.[3]

Vanessa Bell remarks on his easy rapport with others in her "Memories of Roger Fry," written for the Memoir Club.[4] After studying art in Paris, he had begun painting in the French provinces, and continued to spend a good part of his time in France, even during his tenure of the Curatorship of the Department of Paintings at the Metropolitan Museum in New York, between 1906 and 1909.[5] Fry remained perfectly attuned to the colors of France, and to its light, in Paris as well as in the Midi. Writing to Helen Anrep in 1927, he summed up his delight in the capital: "I think it's rather scandalous how much I enjoy myself, my dear. I seem to get more and more pleasure out of all the small things, just to walk about Paris and come on an old doorway, or a Louis XV balcony that one had never noticed...."[6] His continual excitement about France, and particularly Paris, also had to do with the way in which his own painting, which had been snubbed in England and disparaged by critics, was appreciated and purchased there.

Fry felt little sympathy for certain Frence people, and there were places in France he loathed. He thought one should "cut out the whole of the centre of France," for example. During his stay in Royat in Puy-de-Dôme, just before his death in 1934, the well-to-do middle class depressed him unutterably. He dispatched Lyons with a scathing comment, "the higher you go, the uglier it gets." Parts of France were much better, however. "The north all down to the Loire is delightful and then south of Valence but inbetween it's a fraud."[7] He found Toulouse and Albi in Languedoc unintelligible to the mind and eye, especially disliking the brick red of the "fierce nightmarish churches." He believed they expressed "a troubled, disordered imagination without balance." He could not understand the outlook of the inhabitants of Burgundy. "I can't grasp the spirit of this land," he observed. "Provence is always Pagan (praise God) not a trace of paganism here—on the contrary there is something violent, absolute, ascetic and overbearing."[8]

Like his fellow painters and friends Vanessa Bell and Duncan Grant, he possessed a visual consciousness especially alert to the Provençal landscape, with its simplicity and continuity. They were all inspired by the towns and coastal villages of the Midi: Marseilles, Aix, and especially Cassis, near Marseilles, where there was a colony of painters. Fry spoke and wrote at great length of the Provençal colors. Very few English art critics had as intimate an acquaintance with France as Roger Fry, and as sure a knowledge of the red baked earth of the Midi ("colors, light, space, and everything baked through"). He always felt that France appreciated him and his work in a way that England never could, and, in return, had a love for and understanding of France. He was particularly attached to Provence, and had a rare understanding of its inhabitants, poets, and land-

scapes. "My dear," he wrote Vanessa, "it's too exciting to see this southern colouring again. Every bit of old wall, every tiled roof seems as though it were exactly right and only needed to be painted."[9]

As Fry repeatedly described his excitement over the south of France, it was always linked to his painter's sense of color and form. When he was staying at Roquebrune one year, the Belgian artist Jan Vanden Eeckhoudt, staying nearby, encouraged Roger to use brighter colors: orange, magenta, ultramarine, and pure vermilion, which he did.[10] From the beginning of his close relationship with the Midi until the end of his life, Fry's

Roger Fry, *Carpentras.*

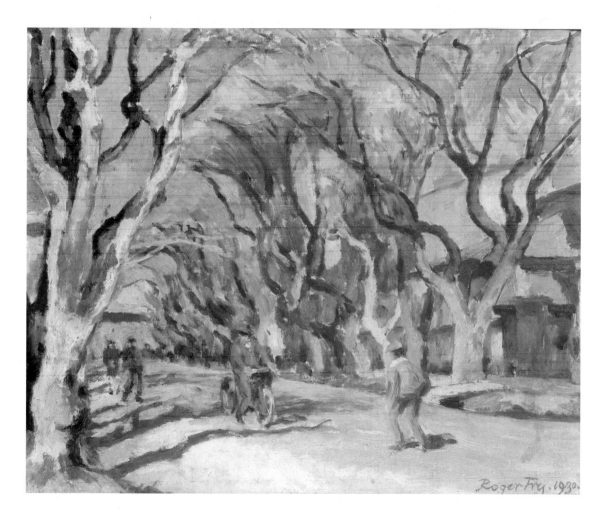

Provence was as nourishing to his art as to his sight. Writing to Vanessa Bell from the Midi in 1919, he exclaimed that it was "ridiculous not to spend most of one's life in this kind of place.... But, oh Lord, the colour; There's no doubt I enjoy being alive almost every minute of the day."[11] A month later he wrote her of the colors he most loved to paint: "Only you must imagine the mountain all white with blue shadows and dull pink rocks and then all the rest, lovely degraded grey-greens and yellows and browns." Later, it is all pink and green-gray, with the intense colors of the mountains, "the middle mountain intense violet, the roof earth-red very pale, the rocks almost blue and spotted with nearly black green tufts of dwarf oak, and then the river bed filled with all kinds of pale brown, red, orange and grey bushes."[12]

He did not, however, come to Provence seeking bright colors. In 1922 he wrote his friend Marie Mauron in St.-Rémy that it was "for the grey and delicate tones I come to the south. The fact is my sensuality for colour is surfeited by the excesses of the north and I seek subtler stimulations, for the essence of Provence, even under its brilliant sun, is grey and pearly-colouring."[13] He had also commented to his daughter Pamela Fry on the secret of painting in Provence:

> The colour is amazing and the secret of it is that there are no bright colours. I find I use almost entirely black, yellow ochre, venetian red, raw umber, burnt umber, indian red and terre verte. Terre verte pure is too bright for the sky and has generally to be toned with black or red and yet the effect is always of colour. It's just the purity and beauty of the greys that makes it seem more colored than England.[14]

Roger was always to feel at home in the Midi. Shortly before his death, he reminisced about the joys of its food and architecture and recalled the happy times he had spent painting there. From his earliest trips to Avignon, whose towers and whose walls he could not remove from his paintings, until the end of his life, the Provençal landscape was the one closest to his heart. Writing to Winifred Gill, he said: "I know quite well whenever I get back to this mediterranean country that I ought never to leave it.... It all seems just right, the right kinds of colours and shapes everywhere."[15] No one in the Bloomsbury group reacted with more intensity and delight to this section of France. He wrote Helen Anrep that life had "twice its value" in the Midi.

The Energies of Roger Fry

Roger Fry's emotions often loomed larger than life in Provence. His energies, both emotional and visual, were responsible for his extraordinary ability, remarked upon by all who knew him, to accomplish more, and in more fields of endeavor, than was even

Fontaine de Vaucluse; photograph by Frances Partridge (1932).

conceivable. His flexibility, his eagerness to learn much about many things, and his intensity made his relations with others at once complicated and exceptionally valuable. His ceaseless travels by train, bicycle, or foot are exhausting to contemplate. Often, while traveling, he would strap his oils and easel to his back and start out by bicycle, leaving his equipment at a level train crossing at night if it seemed too burdensome to carry home. The next day, he would simply pick it up and continue. If he planned an arduous climb, he would take only his watercolors with him, in spite of his distrust of that medium for his own artistic gifts.

Quentin Bell's portrait of Fry remains one of the most convincing we have of those who knew him. He writes of Fry's endless optimism, and the fact that, in spite of his considerable fame, he struck all who knew him as lacking in arrogance. To Quentin as a child, he was "simply, unaffectedly and beautifully 'there.' ... He was, I now perceived, a person for whom doors were opened, curtains drawn, cupboards unlocked, a man of power...."[16] Clive Bell parodied Roger Fry's ceaseless motion, intellectual and physical, in *Old Friends*, commenting on his

insatiable lust for continuous strenuous activity: "I remember one occasion when Roger got up at, I think five in the morning, in order to catch a steamer which

would take him across a lake to a railway station, from which he could travel further for an hour or so to catch a bus which would take him to a place where he would be near a church which might or might not have been decorated by Tiepolo....[17]

Clive Bell observed that, when traveling, Roger would exhaust his companions, such as Helen Anrep, by arriving at galleries when the doors opened and, after two hours, insisting they had just arrived. With luck the gallery would close at two o'clock; then they might look for the "little place" Roger had noticed as having a Magyar name and perhaps Hungarian goulash. After lunch Helen might persuade him to take a rest, but there were still churches to be visited and then perhaps a concert and finally the opera.[18]

Yet even Roger Fry's energies were not always sufficient. His health was a constant worry to him. In November 1922 he sought treatment at the Coué clinic in Nancy, having heard that it was successful for many kinds of maladies. Credulous as well as curious, he often experimented with remedies for various ailments. His digestive tract, for example, was often in such turmoil he would subject himself to virtually anyone who promised to "manicure" his intestines or work a miracle on them, whether it was "Jesus Christ or Mrs. Eddy." For a time the treatment proposed by Dr. Coué in Nancy seemed to be a miracle cure.[19]

Roger's encounter with Dr. Coué was of considerable importance for him. He wrote Vanessa Bell from Nancy, on November 5, 1922, that he had

> given me a certain confidence in the possibility that he will do the trick. He is just a quaint little intelligent French bourgeois but so full of good sense so entirely without any humbug or pretention of any kind that the whole thing which is rather like a Quaker's meeting is impressive. He makes everyone gay and confident and all these dismal faded vague personalities gathered together in a stuffy little room begin to laugh and behave quite differently under his influence.[20]

It was really the person who mattered more than the method, Roger said. The latter simply consisted in shutting one's eyes & saying "ça passe" whenever one felt a pain, and saying mechanically, twenty times night and morning, "Tous les jours de tout point de vue je vais de mieux en mieux" ("Every day in every way I am getting better and better"). He added, "He comes round and asks everyone in turn what's the matter & then at the end we all shut our eyes & he suggests to us the way of getting well. It sounds absurd but somehow it isn't.... As usual a journey seems to have made me much better."[21] Roger Fry was clearly a born traveler.

In a letter to a French acquaintance, a M. de Brabis, Fry presented the psychological

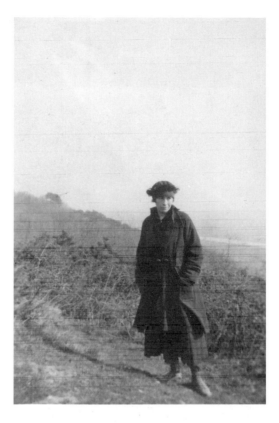

importance of the cure as "*becoming the master of myself.*" He conceded that overcoming his own skepticism was especially difficult for a materialist like himself. Coué had discovered how to share with others the key to a power over their own weakness, even with the most distrustful; his approach was that of moral beauty, he added, "and Lord knows moral beauty is even rarer than morality."[22]

In time the clinic came to seem too stuffy, the "bourgeois commercial" practices increasingly irritating, and the people ugly after those of St.-Tropez. Moreover, Dr. Coué and his method had paled. Roger thought he had either "the most extraordinary power of suggestion or his system really works—but it's very hard to believe that such a pure mumbo jumbo really influences all one's inside mechanism."[23] He returned to eating normally and drinking wine; all seemed well.

It was at the Clinique Coué that Roger met Josette Coatmellec, a Breton woman, in her thirties, who suffered from tuberculosis as well as various mental complexes. Although she was initially more interested in Fry than he was in her, they become close.

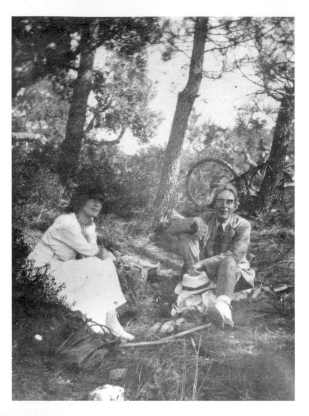

ABOVE. Josette
Coatmellec and
Roger Fry on a
biking expedi-
tion.

RIGHT. Roger
Fry's design for
Josette Coatmel-
lec's tomb.

He visited her sister, a schoolteacher, in Le Havre, and the relationship seemed to be progressing. It became clear, however, that Josette was subject to mental trouble. Roger imagined that he might be of assistance, writing Vanessa, "I don't say I did save you at Brussa [Brusa] but I helped you to pull round a very awkward corner...."[24] Josette had fallen in love with him, and the affair had become serious; she had appeared in Paris to be with him. Roger found her "very fascinating, immensely clever & quick and a delightful wit. Very gamine in fact she makes everything the greatest possible fun so that we are certainly not bored together."[25]

Roger was scheduled to testify as an expert at the celebrated Duveen trial, in which the English art dealer Joseph Duveen was sued for having denounced a painting purportedly by Leonardo da Vinci as a fake (*Hahn* v. *Duveen*). An odd scene ensued. Josette, knowing no English, sat for all four hours of Roger's testimony next to Angela Lavelli, his former mistress. This was, Roger wrote Vanessa teasingly, "more than you would ever have done for me."[26] The affair ended tragically, however. Roger had written her to explain that, with all his varied occupations and preoccupations, he could never have had enough time for her. She had been deeply troubled by the reproduction of an African mask he had given her, thinking it "mocked her." In April 1924 Josette shot herself on a hill at Le Havre, looking toward England. Roger, consumed with guilt, went to stay with his friends the Maurons in St.-Rémy. There he wrote "Histoire de Josette," the long and moving tale of the affair, in French, the language in which they had communicated. He decided to publish it and eventually revised it to include his initial commentary on Dr. Coué and his clinic. He decided on the layout and page arrangement, retyped it several times, and in April 1924 sent it to Vanessa, "whom I still love I think more than any other human being but it's different. All the intensity of passion had gone into my feeling for Josette.... Just now nothing has any taste in it."[27]

Vanessa understood. She replied that she cared so much for him that she could never have minded his "getting happiness from anyone else, if only that happiness could have lasted longer. But the great thing is to have it I think—not the length of time it lasts.... But I should like to see what you write about her some day."[28] In his "Story of Josette" Fry states that he had, from the first moment, "realized that there was a sick side in her love for me, [but] that ... I was inspired by a great attachment to her, that I was very seriously devoted to her." He reflected on their unfortunate relationship:

> There was something feverish in her excited state. I often told her that she would love me less once she had regained her health again. And she would say: "in another way perhaps, but no less" and it was towards this end that I was working with all my strength. She exaggerated too. As inebriating as such an attitude could be, it bothered me. I kept protesting against her idolizing. I tried to show her my imperfections—that I was rather weak, without a great deal of confidence in

myself, had been cowardly many times, and was often flippant. But that I was inspired by a great attachment to her, that I was very seriously devoted to her. That for me it was a supreme duty to be of some help to her and that although I didn't love her immediately as she deserved, I had no doubt that I would arrive at just that if only she could be patient and indulgent with me. Then I showed her how our situation required a calm and reasonable love—that we had to try to contain it, so that she would not suffer too much from our long forced absences. I sketched out for her the idea of a liaison which would secure the greatest mutual pleasure with the least possible pain. I told her that with our intelligence, our psychological understanding of ourselves such an Epicurean love was not unattainable. I was afraid of the romantic and feverish side of passion. I wanted, even at the price of a certain renunciation, to manage a solid construction. I told her we would have to create our love, not submit to it. To create it and direct it as we chose....

I see now that every act of belief is essentially an act of folly. For pure reason, there are only two possible attitudes. Certainty and a greater or lesser probability, according to the case. But belief implies an interior crystallization which does not correspond to anything in the outside world. Belief always implies a lack of adaptation. And also Love is an interior crystallization around the idea of a being. So is it also Madness? But we cry aloud with our whole strength that alone it is truth....

Saturday morning my sister received a letter in which Josette said she was going to kill herself, and that her last prayer was that my sister would protect her sister against me. That set us into a frenzy, showing us just how far madness had taken her. I sent right away a long telegram to Mlle Modeste trying not to reveal the truth to everyone. Her answer gave us the fatal news.[29]

Marriage, of course, had never been an option, as Fry's wife, Helen, was still living, although she was confined to a mental institution. The "liaison," however, never came to fruition as Fry envisioned it.

Roger's disillusionment with the Coué Clinic, based on his assessment of it as "bourgeois," was exactly the point of view he would take about Royat and the baths there a few years later. In July 1929 he arrived there with his Provençal cooking equipment clutched to his chest. He described it to Vanessa as

most unbelievably ugly & characterless [with] something of Switzerland something of Yorkshire and of course the peculiar dismal *luxe* of all *villes d'eau*. The bath & the rest after it takes up all the morning and in the afternoon I try to paint in the Hotel garden—when it isn't raining...."[30]

In Nancy, the plans for which had been laid out by Stanislas Lezynski, the Polish duke of Lorraine, he wrote, "there are vast squares with quite good rococo buildings and one goes from one to another through arcades & archways to reach a lovely path where there stands Rodin's statue of Claude." In the Nancy museum, he had copied treasures by Rubens, Raphael, Tintoretto, Ribera, and Elsheimer ("the best thing I've ever seen of that tiresome and original man").[31] On Lytton Strachey's last trip to France, in 1931, he also visited Nancy and described it in "A Fortnight in France."[32] In 1934, just before his death, Roger returned to Royat with some trepidation. He wrote Vanessa, "I fear Royat will be a grim experience. It's stuck up among those bloody volcanoes and everything will be black granite and a ville d'eau on top of that. However I hope I shall find something I can work at...."[33]

Roger's principal goal was always to discover a place with a certain amount of charm where he might pursue a vigorous schedule of painting, seeing the local sights, visiting museums, and reading. Even as he longed for the domesticity he found in the Mas d'Angirany with the Maurons (*see* "The Maurons, E. M. Forster, Julian Bell, and Bloomsbury"), he realized that his restless energy and compulsive need for work and travel, combined with his feeling for Vanessa, inhibited him from forming a permanent liaison. In 1926, however, he fell in love with Helen Maitland Anrep, who began living with him at 48 Bernard Street, Bloomsbury. She was his companion until his death in 1934.[34]

Roger Fry on French Art and Literature

Although Fry labeled himself an antiromantic (thus his dislike of Delacroix, whom Vanessa Bell valued so highly), he leaned toward a certain classicism in his aesthetics. As he wrote his friend André Gide, he particularly liked Paul Valéry's long poem of 1917, *La Jeune parque* (*The Young Fate*), concerning the awakening of consciousness, tinged with an eroticism scarcely concealed:

> Toute? Mais toute à moi, maîtresse de mes chairs,
> Durcissant d'un frisson leur étrange étendue,
> Et dans mes doux liens, à mon sang suspendue,
> Je me voyais me voir, sinueuse, et dorais
> De regards en regards, mes profondes forêts.
>
> J'y suivais un serpent qui venait de me mordre.
>
> (All? Yes, all mine, mistress of myself,
> Hardening my strange flesh with a quiver,
> Caught in my mesh, within my blood,

I saw me seeing myself sinuous, gilding
From glance to glance my deepest woods.

I followed a serpent there who had bitten me.)[35]

To Fry the poem seemed beautiful "in the Miltonic Poussinesque direction that hardly any modern work possesses. I enjoy it more each time I read it. It is difficult but its difficulty seems to be inevitable."[36] The term "inevitability" recurred frequently in his writings in its relation to that purity of form without outside reference or association, that nonmimetic stress on repetition, on intervals and parallels that he praised in such artists as Seurat and Cézanne. This was an art calling upon the mind and the spirit, instead of the outside world. Fry directed this type of formalist enthusiasm toward the art of France and, to a lesser degree, its literature.

Fry's sustained admiration of Gide contrasted with his gradual disenchantment with Valéry, whose acceptance speech upon being received as an "immortal" in the Académie Française in 1925 seemed to certify "something hollow about his present immense reputation." He wrote Gide,

> I can't help thinking that the immense richness of definite and positive experience in your work will continue to give off emanations like radium for a much longer time than Valéry's ingenious but terribly unlived (I have to coin the word) fabrications. More and more I see that art is not a performance, or a contemplation but the successful record of an actual experience and that nothing matters like that.[37]

He longed to have a lengthy chat with Gide, whose intellectual dynamism he found so appealing. He wrote him that in the fall of 1927 he would be on his way to Normandy to visit Ethel Sands at the Château d'Auppegard, and hoped perhaps he might meet Gide there. He would be accompanied by his new companion, Helen Maitland Anrep, an "arrangement by which I have at the grotesque age of sixty stumbled into a domestic happiness which has escaped me all through my past life. I doubt if I have ever been so happy."[38]

Roger's wide-ranging curiosity, together with his abundant energies, resulted in what he used to call "the desolating variety" of his own work, which he believed more congenial to the French spirit than to the English.[39] The classicism and austere restraint of the French painters he most admired, from Poussin, Chardin, and Ingres to Manet, Seurat, and Cézanne, were diametrically opposed to the romanticism and sentiment he considered characteristic of English taste. As he once said to his friend Gertrude Stein: "But the difficulty with an English audience is that they haven't got the sensibility to form."[40]

Fry's enthusiasm about words and forms was always kept in sharp focus. His own ordering was never fuzzy, even if his opinions remained open to sudden change under the impulse of his various enthusiasms. He might get the large picture, but he also knew how to narrow his focus toward the telling detail. His informal tone, in remarks written to his friends, in no way detracts from his overall perceptiveness. As Vanessa Bell wrote of him in her memoir of Bloomsbury: "His quick eyes saw possibilities everywhere and communication between him and other human beings seemed to happen when he wanted it. He could skip every unnecessary step and arrive at understanding and being understood in some apparently miraculous way."[41]

His literary judgments were as clear as his more celebrated analyses of art. Their validity is evident today, when contemporary critics take up the same passages on which he focused. Writing to his sister Margery from St.-Tropez, in October 1922, Fry told her of reading some new stories by Somerset Maugham, a writer he felt had been unjustly overlooked, "because he belongs just to the period that's 'gone dark.'" He remarked on Balzac's "ponderous omniscience," which both delighted and disgusted him. He insisted that Marjorie take down Baudelaire's *Fleurs du mal* from the poetry bookcase, since he had just been reading his poetry and wanted her to read the sonnet "Les Chats," which he then wrote out for her. This sonnet has occasioned much learned commentary:

<div align="center">Les Chats</div>

Les amoureux fervents et les savants austères
Aiment également, dans leur mûre saison,
Les chats puissants et doux, orgueil de la maison,
Qui comme eux sont frileux et comme eux sédentaires.

Amis de la science et da la volupté,
Ils cherchent le silence et l'horreur des ténèbres;
L'Erèbe les eût pris pour ses coursiers funèbres,
S'ils pouvaient au servage incliner leur fierté.

Ils prennent en songeant les nobles attitudes
Des grands sphinx allongés au fond des solitudes,
Qui semblent s'endormir dans un rêve sans fin;

Leurs reins féconds sont pleins d'étincelles magiques,
Et des parcelles d'or, ainsi qu'un sable fin,
Etoilent vaguement leurs prunelles mystiques.

(Lovers, scholars—the fervent, the austere—
grow equally fond of cats, their household pride.
As sensitive as either to the cold,
as sedentary, though so strong and sleek,

your cat, a friend to learning and to love,
seeks out both silence and the awesome dark ...
Hell would have made the cat its courier
could it have controverted feline pride!

Dozing, all cats assume the svelte design
of desert sphinxes sprawled in solitude,
apparently transfixed by endless dreams;

their teeming loins are rich in magic sparks,
and golden specks like infinitesimal sand
glisten in those enigmatic eyes.)[42]

Fry exclaimed, "That's poetry, isn't it? And what perfect style and the beauty of the long prepared close like the end of a Bach. Also, I like the way the sand which the sphinxes have already suggested gets into their eyes."[43] His intuitive judgment accorded with his wit, in poetry as in art, yet never obscured the fact that others might not react to a work as he did. "But you won't read all this, my dear," he continued, "you'll either be keeping order in a gaol or playing Bach."[44]

Fry had a passion for geometrical form, as befitted such a self-designated classicist. He praised the work of the French painter Paul Signac, often regarded as the founder of neo-impressionism. Signac had deliberately invented what he termed a "restraining formula" of rectangular blobs of paint in order to escape the anarchy of Impressionism, as Fry thought of it at this point. Fry's emphasis on restraint, which he often reiterated,[45] was a plea for deliberate structure against the spontaneous and casual, for the kind of powerful coordination and stress on *relation* that he detected and discussed in the work of Cézanne.[46] Cézanne's values and design, so much in advance of those of Monet, would later arouse Fry's most impassioned writing. In 1925, he had studied the Cézannes in the Pellerin Collection in Paris in order to write a long piece for *L'Amour de l'art*, which then became his brief, yet immensely influential, study of the development of the Master of Aix (1927).

For Roger Fry, a formalist, morality in art consisted in caring for each part of a whole. It did not depend, as it did for Diderot or for Ruskin, on any narrative suggestion. Insisting on the order the objects made, on the feeling of inevitability it gave, he discussed the formal relation between them in such works as those of the neo-Impressionist Seurat and of the symbolist poet Paul Valéry. He found in both a certain classicism he admired.

The same perception of inevitability inspired his excitement over the still lifes of Cézanne. The most memorable example of it occurred in the often-recounted Bloomsbury story of Cézanne's small painting of apples. In 1918, at Duncan's urging, John Maynard Keynes had purchased it along with other paintings at the Degas auction in Paris and returned with it to England. He left it in the hedge near Charleston while he walked up to the house to tell Vanessa, Duncan, and the others about it (*see* "John Maynard Keynes" chapter). At Charleston the group stood about commenting on it, as Vanessa Bell told the story, conveying their collective ecstasy over it. Fry maintained that in Cézanne's still lifes, as in those of any creator, "we frequently catch the purest self-revelation of the artist."[47] Recent work on the genre of the still life shows that Fry was ahead of his time in his argument.[48] Cézanne's still lifes were a new way of envisioning the genre, and a departure for him. "Nothing else but still-life allowed him sufficient calm and leisure, and admitted all the delays which were necessary to him for plumbing the depths of his idea," Fry argued.[49] They gave him time. To enlarge on his word "delays," we might now suggest, extending his intuition, that what the still life permits in its grouping of unlike objects—i.e., according to relations not relevant in the ordinary world, only in the world of art—is also the contemporary sense of *delay* or deferral of meaning.

Fry pointed out the "pure" geometrical shapes in the still lifes of Cézanne: the pyramids, spheres, rounded oblongs, and rectangular shapes that Cézanne had found in nature. In speaking of the *Compotier*, for example, he showed that Cézanne deforms the oval, which harmonizes badly with the circle and the straight line, to make it into an oblong with rounded ends. "This deformation deprives the oval of its elegance and thinness and gives it the same character of gravity and amplitude that the spheres possess."[50]

Virginia Woolf's geometrical meditation in *The Waves*, also a questioning of representation, illustrates the concern of Cézanne, who wanted to bring art back to the cones and cylinders he perceived in nature:

> "Like" and "like" and "like"—but what is the thing that lies beneath the semblance of the thing?... let me see the thing. There is a square; there is an oblong. The players take the square and place it upon the oblong. They place it very accurately; they make a perfect dwelling-place. Very little is left outside. The structure is now visible; what is inchoate is here stated; we are not so various or so mean; we have made oblongs and stood them upon squares. This is our triumph; this is our

consolation…. Wander no more, I say; this is the end. The oblong has been set upon the square; the spiral is on top…. A square stands upon an oblong…. The structure is visible. We have made a dwelling-place….[51]

This sense of shape held firm, apart from and more profound than the representation of actual objects. These *shapes* are ultimate refusals of representations outside themselves, standing against the impressionistic flux Roger Fry so often condemned and against Virginia Woolf's all-enveloping waves. They are also the building blocks of a self-referential strain in high modernism. As such they are visible in the works of authors singled out by readers like Virginia Woolf and Roger Fry as the moments of a heightened sense of life, of an intense consciousness, of energy concentrated in a small space and visible in seemingly unimportant scenes.[52] Fry extolled Cézanne's dramatic sense even in what would seem least dramatic: "though it would be absurd to speak of the drama of his fruit dishes, his baskets of vegetables, his apples spilt upon the kitchen table, none the less these scenes in his hands leave upon us the impression of grave events."[53] Similarly, Simon Bussy, teaching Duncan Grant to look at the high drama in the still lifes of Chardin, was conveying the same lesson.

Fry observed that the placing of objects arranged according to a purely *sensual logic* against the flux and chaos of the living world would always hold firm:

Here that simplicity becomes fully evident. One has the impression that each of these objects is infallibly in its place, and that its place was ordained for it from the beginning of all things…. One suspects a strange complicity between these objects, as though they insinuated mysterious meanings by the way they are extended on the plane of the table and occupy the imagined picture space.[54]

These profound complicities weave themselves between daily objects, since the still life is a modest everyday construction.

In Cézanne's late work, the construction works differently, by suggestion rather than statement, particularly in the last renderings of the Mont St.-Victoire. Fry terms the very few markings, which are mere suggestions rather than anything fuller, regional touches,

indications rather than definite affirmations … here, part of the contour of a mountain; there, the relief of a wall, elsewhere, part of the trunk of a tree or the general movement of a mass of foliage. He modeled the scene around these directing rhythmic phrases of the total plasticity.[55]

He himself had once been more drawn to Cézanne's earlier and more fully stated *Card Players*, "that masterpiece of genre painting,"[56] that Duncan Grant had recalled in his *Card Players at St.-Tropez*.

Fry realized, however, that future viewers might well prefer the understatement of Cézanne's late works, in which "every particle is set moving to the same all-pervading rhythm."[57] His admission that succeeding generations might develop opposing tastes indicates his extraordinary openness. He noted that in Cézanne's late works there was

Walter Sickert's caricature of Roger Fry lecturing.

> in fact, a kind of abstract system of plastic rhythms, from which we can no doubt build up the separate volumes for ourselves, but in which these are not clearly

enforced on us. But in contradistinction to the earlier work, where the articulations were heavily emphasized, we are almost invited to articulate the weft of movements for ourselves.[58]

The drama is supplied by the observer; nothing is fixed.

Fry's continual insistence on the spontaneous and the open ruled out any imposition of a previously established contour or shape upon his vision, which remained continually fresh. His point of view was deliberately, as he put it, that of a young child in a so-called primitive culture: "First I think, and then I draw a line around my think."[59] The exterior object could not take precedence over human thought, whether in the young or the old, or in the "primitive" or "cultured" realm. This essential attitude explained his intense dislike of watercolor as a medium. It imprisoned the brush strokes too rapidly for his temperament: "It isn't suited I fear to my positive way of feeling. I must be able to do exactly what I want at each moment and water-colour never leaves one time for that."[60] Rapid concretization would stand in the way of the work's potential complexity, as he saw in the art of Cézanne:

> For him, as I understand his work, the ultimate synthesis of a design was never revealed in a flash; rather he approached it with infinite precautions, stalking it, as it were, now from one point of view, now from another, and always in fear lest a premature definition might rob it of something of its total complexity.[61]

For Fry, such independence from any outside reference was an essential element in his own art. He expressed an intensely modern concentration upon the matter of painting itself, upon *process*. He believed that art must discard the heavy weight of the kind of moral statement Ruskin had favored and align itself with the symbolist aesthetics of Walter Pater and James Abbott McNeill Whistler. Mallarmé, one of Fry's favorite poets, had translated Whistler's celebrated "Ten O'Clock" lecture.

Roger Fry was the perfect lecturer on Cézanne, since he preferred, as Cézanne himself had, not to spell things out. In one of his *Last Lectures*, "Vitality," Fry explains that he left question marks in all his texts and talks in order to permit them to open out. His mingling of humility and enthusiastic curiosity contributed to his stupendous success as a lecturer. Kenneth Clark considered him not only the most important English art critic since John Ruskin, but the only one to whom people listened. His public lectures sometimes attracted more than two thousand people. They inspired Carrington at times when she had been unable to work. She wrote Gerald Brenan on January 29, 1923, "I am painting fairly regularly now. I found Roger's lectures very inspiring—they fairly set me on my lost tracks again."[62] Walter Sickert's caricature of Fry is accompanied by his

confession: "No sooner do I see the feet of Mr. Roger Fry on the mountains, than I scamper, bleating to sit at them."[63]

Virginia Woolf describes Fry as a "fasting friar" with a rope around his waist, comparing his fervor to that of his preaching Quaker forebears:

> And the lecturer pointed. His long wand, trembling like the antenna of some miraculously sensitive insect, settled upon some "rhythmical phrases," some sequence, some diagonal. And then he went on to make the audience see … somehow the black-and-white slide on the screen became radiant through the mist, and took on the grain and texture of the actual canvas.
>
> All that he had done again and again in his books. But here there was a difference. As the next slide slid over the sheet there was a pause. He gazed afresh at the picture. And then in a flash he found the word he wanted, he added on the spur of the moment what he had just seen as if for the first time. That, perhaps, was the secret of his hold over his audience. They could see the sensation strike and form; he could lay bare the very moment of perception. So with pauses and spurts the world of spiritual reality emerged in slide after slide—in Poussin, in Chardin, in Rembrandt, in Cézanne—in its uplands and its lowlands, all connected all somehow made whole and entire, upon the great screen in the Queen's Hall. And finally the lecturer, after looking long through his spectacles, came to a pause. He was pointing to a late work by Cézanne, and he was baffled. He shook his head; his stick rested on the floor. It went, he said, far beyond any analysis of which he was capable. And so instead of saying, "Next slide," he bowed, and the audience emptied itself into Langham Place.[64]

Fry preferred the positive to the negative, with a disarming simplicity. For example, he said of the Italian Futurists: "What the Futurists have yet to learn … is that great design depends upon emotion, and that, too, of a positive kind, which is nearer to love than hate."[65] This attitude, which is unsurprising from someone with a firm Quaker background, spoke clearly of his own energies and enthusiasm. Gertrude Stein once remarked on his personality in relation to his background: "His being a Quaker gives him more penetration in his sweetness than is usual with his type. It does not make him more interesting but it makes him purer."[66] Fry never abandoned his advocacy of emotion based purely on form:

> It also seemed to me that the emotions resulting from the contemplation of form were more universal (less particularized and coloured by the individual history), more profound and more significant spiritually than any of the emotions which had to do with life (the immense effect of music is noteworthy in this respect

though of course music may be merely a physiological stimulus). I therefore assume that the contemplation of form is a peculiarly important spiritual exercise … the contemplation of Truth is likewise a spiritual function but is I judge entirely *a*-moral.[67]

In its freedom from literary or subject-oriented association, such a singular and self-willed "spirituality" meant that exterior reality mattered less than the shapes and colors expressing it upon the canvas. Such expression was not to be mimetic, but, rather, self-referential. The source of emotion was to be the form itself, not anything to which it referred. In the most extreme of his commentaries on this all-important topic, for example, Fry would point to a crucifixion and discuss "the heavy mass in the center" as what mattered, not that the heavy mass was the body of Christ.

In view of his insistence on form, Fry's repeatedly expressed dislike of all avant-garde movements might seem especially surprising. This dislike was based on his preference for a "classic" concentration of feeling and his parallel disdain for what he considered the too loosely woven aspects of surrealism. He disliked, for instance, the work of such artists as Joan Miró and André Masson. After meeting Masson in the Hôtel de Londres in November 1925, he commented to Vanessa Bell about the "beastly young Surrealist Masson" and the "foul art nouveau" that appeared to be coming into fashion. He also detested the counterparts of surrealism in "mysticism, obscurantism, symbolism, expressionism," considering them contrary to all he had been trying to establish in England. He believed them to be the revenge of Germany upon France (!), barbaric notions of ideography and "-isms" aimed at exploiting the public. "The positive classic spirit is dead for a moment," he remarked. "And with everything is mixed an element of violence and fascism."[68]

This is not to say, of course, that Fry was unable to appreciate anything contemporary. On a visit to Picasso, who was, as always, very friendly to him, and on whose latest work he was to comment in the art magazine *L'amour de l'art*, he found the last paintings

> astonishing stuff. Rather what I hoped might be coming. Vast pink nudes in boxes. Almost monochrome pinkish red flesh & pure grey fronds which enclose it. They're larger than life and vast in all directions & tremendously modelled on academic lines almost. They're most impressive almost overwhelming things. I said "Mais vous commencez une nouvelle école, l'école des invendables" ["But you are starting a new school, the school of the unsaleable"], for one can't conceive who on earth would ever find a place for them.[69]

In his last years, Fry had hoped to explain the implications of his ideas about Post-Impressionism (i.e., the nonrepresentational, abstract, and universal). The book he was

contemplating was to be titled, rather ambitiously, *Vision in Literature*. It would have dealt with poets from Charles Baudelaire and Stéphane Mallarmé to Gerard Manley Hopkins, and with novelists from Gustave Flaubert and Henry James to Marcel Proust and Virginia Woolf. Rather prophetically, he chose figures who would be championed by recent critics of modernism and postmodernism. Because of his emphasis on formalism, i.e., on meaning as related to structure and not to sense, it is arguable that Fry was the English art critic most congenial to current critical thought. He began his "Essay on Aesthetics," published in *The New Quarterly* of 1907, with a summary of a celebrated quotation from Maurice Denis about paint on a flat surface: "the art of painting is the art of imitating solid objects upon a flat surface by means of pigments."[70] Fry's concern with flatness seems remarkably contemporary. He never abandoned this preoccupation, even as he modified it according to his subject. His remarks on British painting, for example, often seem to anticipate the American critic Clement Greenberg's analysis of *flatness* in the Modernist medium, or, as Fry would have said, "Post-Impressionist."[71] Greenberg wrote of modernism as the intensification, even the exacerbation, of a self-critical tendency, citing the philosopher Kant as a source for the way in which forms of modernism use the methods of the discipline to criticize the discipline itself. This mode claims a sort of purity in the determination to eliminate from the medium any characteristics from another discipline. If illusionist art conceals art, Greenberg continues, then modernism calls attention to art itself: to its necessary flatness, the shape of the support, and the properties of the pigment. It refuses any exterior associational and illusionistic traits, limiting itself to the actual matter and technique of its own art.[72] As Greenberg puts it, "Modernist painting asks that a literary theme be translated into strictly optical, two-dimensional terms before becoming the subject of pictorial art."[73] In a sense, Greenberg's influential formalism and critical power resemble Fry's, while his admittedly violent style of living and looking and exercising that power are the exact opposite of those of Fry, with his Quaker heritage. If, as a recent critic has written, "Good criticism leaves a halo around its objects, like a ring around the moon" (as opposed to crude or power criticism, leaving just a "residue, like a ring around a bathtub"), Fry's flexible formalism fits those criteria.[74] He was the most informal of thinkers, which did not detract from his power as a critic.

In his 1926 essay "Some Questions of Esthetics" Fry opposed I. A. Richards's *The Principles of Literary Criticism* (1924). Since, for him, the aesthetic experience had to be seen as totally different from life, in its special focusing of attention, only an impure work of art could move us by its literary and psychological appeal. The most long-lasting effect would spring from pure form. He asserted his credo:

> I believe that ... wherever a psychological appeal is possible this is more immediately effective, more poignant than the plastic, but that with prolonged familiarity

it tends to evaporate and leave plasticity as a more permanent, less rapidly exhausted, motive force. So that where pictures survive for a long period their plastic appeal tends to count more and more on each succeeding generation.[75]

Here Fry was less dogmatic than he had been in *The Artist and Psychoanalysis* (1924), where he had maintained that for "one who feels the language of pictorial form all depended on how it was presented, nothing on what." In the pure work of art, we are acted upon only through form, not through substance.

Later in his life, Fry would give more credit to the subject represented than he had earlier, but he would never lose his sensitivity to what is peculiar to the French mind and art. In his later criticism, partly owing to the influence of his friend and fellow aesthetician Charles Mauron, he stressed the double importance of both illusion and form.[76] He became still more liberal. By 1933, when he wrote "The Double Nature of Painting," he permitted associated ideas, such as those in Opera, to interact with the formal harmonies of the Symphony.

Roger Fry's openness was genuine, and he was unembarrassed to change his opinions. This was certainly one of the attributes of a superior critic. As Vanessa Bell once remarked, he was "the only great critic" she knew. If it is true that Fry did not always give what we might consider proper credit to the avant-garde movements of his time, he did recognize much else that has proved essential, in the long run, to the French spirit in art and literature. Many of his views have been absorbed into contemporary art criticism. Many of the artists and writers he most admired are already the monuments of high modernism. Consequently, we may lose sight of the critical acumen he demonstrated with his prescient and positive appraisals of Hopkins and Mallarmé, of Seurat and Cézanne, of James and Woolf.

Vanessa Bell once described Roger Fry as he made a circuit of the National Gallery with her:

> He would look and very often wait to hear his companion's first impression—at any rate he would be in no hurry to give his. Sometimes of course it would come quickly, spontaneously—he would be overcome by the beauty or splendour of some work, but often he would wait, consider, look. Gradually he would seem to see new meaning, new relations: he would talk about them, asking, questioning, saying what he thought, but always anxious to know what you thought…. It was a delight to share his feelings and have him to express them—but it was not undelightful to differ, to stick perhaps to one's own stupid prejudices but to try to understand why he felt as he did.[77]

It is apparent that those who were privileged to view works of art with Roger Fry felt dou-

bly enlightened, not only by the work but also by his impassioned opinion of it. It is easy to understand how he and Flaubert, children of the movement called Romanticism, shared what Fry called, in *Cézanne,* "the sublime and heroic faith in art which that movement engendered, its devotion and absolutism."[78] Fry also maintained his faith in the "thrilling epic of individual prowess against the herd which marks the history of French art in the nineteenth century."[79]

In spite of his forward-looking essays on African and native American art, and in spite of his early and enduring adherence to formalism, Roger Fry has not always been considered a spokesman for the twentieth century. Rather, he has seemed by many critics to be the voice of the nineteenth, as he himself predicted. With what Virginia Woolf termed his "large soul," however, he envisioned the direction of much twentieth-century criticism. His perception of the coherence, rhythm, and gravity of Cézanne's still lifes and landscapes has a parallel in the novels of Virginia Woolf. Her prose still lifes, landscapes, and seascapes, with their own suspension of meaning, add another dimension to our understanding of the modernism of these giants of art. It was Fry's illumination that situated the modernism of Bloomsbury in its truest light: the light of France and French art.

Simon Bussy,
*Portrait of Dorothy
Strachey Bussy.*

Simon and Dorothy Bussy, André Gide

It is 1897, in the Ecole des Beaux-Arts, Paris. Henri Matisse and his short and feisty friend Simon Bussy are both studying art under Gustave Moreau, known as the "Socratic midwife." He sends them out to copy paintings in the Louvre (Bussy copies Leonardo, Holbein, and Rembrandt), so that they may learn to find and follow their own style, to work for a period every day, and, above all, to care about color: "Color must be thought, dreamed, imagined." These are lessons that Bussy will pass on four years later to his own student, Duncan Grant, who, in 1945, will say, "His lessons remain with me as the best I have ever received."[1]

In 1886, Albert Bussy put his sketching materials in his backpack and set off from his birthplace, Dole in the Jura, to walk through the Jura and Germany. He was gathering material he would exhibit at Durand-Ruel in Paris in 1897, "the only successful exhibition I ever had," he later remarked. Degas, not a man given to compliments, said of his work, "You draw your landscapes like human beings, I like that. Millet used to draw humans just like trees!"[2] By 1896 Albert Bussy had changed his name to Simon and arrived in Paris, where he entered the Académie Carmen in the Passage Stanislas. This was James McNeill Whistler's old teaching school that he had turned over to his favorite model, Carmen Rossi. He then studied at the Ecole des Arts Décoratifs and moved on to the Ecole des Beaux-Arts, studying under Gustave Moreau. Bussy later said of Whistler that he was "very distinguished, very authoritarian, but not as stimulating as Gustave Moreau."[3]

Bussy lodged in the home of Emma Guyiesse, the mother-in-law of a fellow art student he met in Moreau's class, Auguste Bréal. Bréal was a friend of both André Gide (from the Ecole Alsacienne) and Roger Fry, whom he had met in 1893 at Christ's College, Cambridge. He was a writer as well as an artist and, in 1899, would write a preface to a volume of Bussy's pastels.[4] Another lodger was Pernel Strachey, sister of Lytton, who was studying in Paris. When Simon, "little Bussy," as Lady Strachey was to call him (he was short, and had been compared, unkindly, to a little frog), went to England to art school, he took along an introduction to the Strachey family from Auguste Bréal. In 1901 Bussy leased a studio in Kensington. There he gave lessons to several pupils, including Dorothy Strachey and her cousin Duncan Grant.

While Bussy was studying and painting in London, a spirit lamp exploded and threatened his eyesight; fortunately, he suffered no permanent aftereffects. After a stay in the hospital, he went to the Strachey home, where he was nursed by Dorothy Strachey, who

Simon Bussy.

was then in her late thirties. They fell in love and became engaged, much to the consternation of the Strachey family, who collectively accused him of mopping up his plate with his bread (a French custom, granted, but not in England) and of being a penniless French artist. Dorothy was unfazed; she wrote her brother Lytton, thirteen years younger, "we'll live in a tiny house on two cents a year." They were married in 1903.

Sir Richard Strachey gave the couple a handsome wedding present of La Souco, a villa perched in the hills at Roquebrune, near Menton, on the French Riviera and surrounded by brightly flowering trees. Lytton, who went to visit while Dorothy was pregnant (a condition he found excessively distasteful), was delighted by the terraced gardens and impressionist pictures and pronounced it "perfectly divine" with "the best view in Europe"[5] (*see* "Lytton Strachey, Dora Carrington, Ralph Partridge"). Jane Simone ("Janie") Bussy, their only child, was born in 1906, and grew up completely bilingual.

La Souco would, over the next half-century, become a pied-à-terre for all of the figures in the Bloomsbury group, including, of course, Lytton and other Strachey siblings, Duncan Grant, Vanessa and Clive Bell, and John Maynard Keynes, and, to a lesser extent, Ottoline Morrell, her daughter Julian, and Virginia and Leonard Woolf. Roger Fry had a brief affair with another Strachey daughter, Pippa, when they were staying there together in 1915, and was greatly impressed by her knowledge of Mallarmé, whose poetry was a lifelong passion for him. Vanessa and Clive's children would eventually think of it as a second French home. At times there were practical difficulties characteristic of life in the Midi, particularly the problem of water supply. One October Dorothy wrote her sister-in-law, Ray Costelloe Strachey (wife of her brother Oliver) about the problem: "Here we can do nothing but gasp and pray for rain. Not one drop since last May and all our trees will be dead." There was also a cloud of mosquitoes and flies.

The Bussy family would usually escape the hot summers in the Midi by traveling to England. There they would occupy the top floor of one of the Strachey homes in London (first in Lancaster Gate, then in Hampstead, and then in Gordon Square), or, alter-

Simon Bussy,
*Lytton Strachey in
1904*, (painted at
La Souco).

natively, share accommodations with her family elsewhere in England. As the Bell children and Janie grew up they became close friends, and she was a frequent visitor to Charleston, where she helped with some of the interior and exterior decoration. About 1912 Simon discovered an unusual talent for rendering brightly colored animals, which gave an added dimension to the family summers in England. He made lengthy sketching expeditions to the London zoo and, at home, began spending most of his time "plunged in owls & eagles & tortoises," as Dorothy put it.[6]

World War I blighted the lives of the Bussys to a certain extent (although World War II was far more devastating to them). When Simon appeared before the medical commission, one of the doctors wanted to propose him for the auxiliaries, which would have meant being let off entirely, but another one interjected: "Oh no. Certainly not. Painter are you? Oh very well. You can paint in the barracks" with a roar of laughter at his own wit." So he was qualified "inapt" for service, and had little to do until the end of the war.[7] He went to live with his family outside Paris and did his military service in the American hospital, from 8 to 12 and 2 to 4:30. He contributed precious little, according to Dorothy, but everyone was polite and friendly to him. Their friend Jacques Raverat was also turned down, although he believed in the absolute necessity of the war and had wanted desperately to serve his country. Vanessa Bell believed the war was a stupid thing, bungled into by politicians, but others, such as Desmond MacCarthy, thought differently. (He volunteered for service, and was assigned to the Red Cross, since he spoke French).

Jane ("Janie") Bussy.

As Sir Richard Strachey had predicted, the Bussys were permanently impoverished. They had some income from Simon's pastels and Dorothy's translations (she translated Camille Mauclair's book on Watteau, as well as most of Gide's writings). She also gave English lessons. Later they took in paying guests, including André Gide and, at one time, Julian Morrell, Ottoline's daughter. They also let the house while they were away; George Mallory, Rudyard Kipling, and André Malraux were among their tenants. Dorothy was considered an expert both on grammar and on the teaching of language, and later prepared a few programs for the BBC on those topics.

There were many compensations for their poverty, however, They knew many illustrious French intellectuals, including the writer André Gide, the poet Paul

Valéry, and the writer and critic Roger Martin du Gard. Gwen and Jacques Raverat were also frequent visitors, coming over from their home in the Alpes Maritimes. Jacques, being a painter, had much in common with Simon. Of all their friends, André Gide was to have the most enduring impact on their lives. He had met them indirectly in England when he began studying English with Dorothy Strachey Bussy in 1918, while she was staying with her family in Cambridge. She went on to become his translator and lifelong devotee.

Gide often visited La Souco, each time causing both anguish and delight for Dorothy. She was soon in love with him, and would treasure their very few moments alone together, when she longed to reach out for his hand or kiss the lapel of his jacket. Less dramatically, they might read together, discussing the translations he was doing of Shakespeare and she of his work. The sharp sense they both had of the intricacies of the French and English languages, on which their original contact had been based, never faltered even in the tensest moments. Some of their exchanges about French translations of the works of Shakespeare (particularly *Hamlet* and *King Lear*), or of Dorothy's superb renderings of Gide's writings, are among the most valuable documents in the history of translation. They discussed at length various ways of conveying the complexities of *Hamlet*, and Gide, who had just translated *Antony and Cleopatra*, suggested they might "go over the passages in the first four acts" which she appeared to find faulty. In 1938 Gide took her to La Roque at Braffy, where Dorothy commented on the latter translation. In 1942 he sent her his translation of *Hamlet* and wrote, "Would that I were near you to talk to you about them!"

In the Bussy household, Simon spoke only French to Dorothy and Janie. Dorothy, although she had a detailed knowledge of the French language, both spoken and written, spoke English to Simon. Lytton, who disliked speaking French, also spoke to him in English, although he understood French and had a wide knowledge of French literature.[8] Gide and Dorothy each had such a fine sense of language that they corresponded in their respective languages. Although it was Dorothy who had schooled Gide in the subtleties of English, his letters to her were, with few exceptions, always in French. As a rule she wrote him in English. At the outset she had begun a letter to him with "My dear Friend," remarking how unusual was the expression in English, how ordinary in French, and how she liked it.[9]

André Gide at Pontigny (1922).

Dorothy's communications to Gide were, over many decades, permeated with such emotion that on almost every occasion she would regret the unrestrained passion she exhibited on her first letter, then write another one to correct herself. She exhibited the same pattern with other correspondents, first expressing warm feeling, then immediately suffering concern over it. For example, in 1921 she wrote Ray Costelloe Strachey to say how important Ray was to her and then apologized:

> I don't know why I feel impelled to say this which is of course quite contrary to all the most sacred rules of friendship—one which it is generally disastrous to transgress and which at any rate should not be transgressed except at the most once a year. I meant to say—"with extreme rareness" and then I suddenly remembered that it's exactly a year ago since I first transgressed it as regards you.[10]

Such diffidence seems odd, considering that she was writing her sister-in-law.

Gide, who had become used to Dorothy's erratic emotional rhythm, commented on it with some amusement. For her, however, there was little amusing in the affair at first. By the early 1920s, she imagined it might be preferable not even to encounter him: "some day," she promised herself, "I shall be able literally to enjoy the *outside* of you—your talk, your charm—without any arrière-pensée [mental reservation]."[11] The intellectual imbalance between them might seem so great as to rule out any reasonable mental exchange. Dorothy's rational judgments, however, like those of all the Stracheys, took precedence over her passion, whether the subject was politics, literature, translation, or theatrical performance. Her strength was clearly in her mind and not in her emotions—and part of that strength was her realization of that fact.

Dorothy and Gide frequently discussed theatrical matters, sometimes on a highly theoretical level. Her opinions of the advantage of the practice of masking the actors and actresses are relevant here and in fact serve as a metaphor for their own mode of communication. She and Gide were once arguing about how a Western temperament might utilize that technique for the drama. Dorothy pointed out that in the Japanese Noh theater, which "is entirely a thing of shades and subtleties so infinitely attenuated that we gross Europeans can only be aware that we have no organs sufficiently delicate with which to apprehend them," masks brought about the very distance and calm that theater demands. Her relation to Gide also became far more "a thing of shades and subtleties" than it might have appeared to be early on, disguised as it was by politeness, custom, and necessity.

Dorothy had a certain wisdom regarding her affair with Gide that has often been overlooked, for over the years she had finally decided against anguish and in favor of understatement and friendship. "I am not going to torment myself any more," she wrote. "I am not going to worry … I will go on liking you. It is sometimes a divine pleasure to like you.

And sometime I will tell you about it, since you give me leave. That ought to be enough for anyone. It shall be enough for me."[12] It was enough in a way, but not altogether. She contemplated "this strange aura" that seemed to hover over her Dionysian "chameleon poet," his lips, "sweet, austere, incredibly mysterious."[13] He was one of the most evasive of men, as Auguste Bréal, lying in the bottom of his boat and writing his friend Lytton Strachey about it, had pointed out. Gide had "wavered" over the question of whether or not France should erect a statue by Epstein honoring the poet Oscar Wilde.

Simon Bussy seems to have been excessively tolerant of Dorothy's attachment to Gide and even enjoyed describing his work to him. In January 1922 he wrote him from Roquebrune:

> I believe I have been successful in a small painting just finished, in overall blue, with blue birds and an orange pheasant in a gold architectural landscape, actually rather marvelous. Vanessa Bell and Duncan Grant have just come to see us, and I think they were really interested in my paintings.[14]

Simon Bussy, *Blue Jay.*

Mark Gertler, an artist who had been in love with Dora Carrington, had been encouraging Bussy to exhibit in London. André Dunoyer de Segonzac, a close friend of the Bells, who had not been able to come to the London opening of one of his exhibitions, wired that he had purchased a small landscape with a view of Antibes and its tower, impressed as he was by the "sensitivity and acuity" of Simon's works, all so personal and of such "grandeur in their restrained dimensions." Segonzac stated that Georges Besson had called Simon "the most English of French painters."[15] Duncan Grant also admired his work and wrote an introduction to one of his exhibitions. Throughout his life Duncan valued Bussy's early tutelage. In 1945, Bussy had an exhibition in Lewes, Sussex, England; at that time Duncan called him "the most severe and *juste* of teachers." He kept several of his pastels in his studio until his dying day.[16] Vanessa observed that it was a good thing Simon's pastels sold for high prices, since few were sold and the Bussys needed the money very much. His portraits sold for high prices also, but commissions were difficult to secure.

ABOVE. Dorothy Bussy.

BELOW. Dorothy and Simon Bussy at Ham Spray House.

Frequently during their journeys to England for the summer the Bussys would stop for a few days in Paris, staying at the Hotel Lenox, on the rue de L'Université. Dorothy would try to have some time alone with Gide. Simon, as she knew, would probably be at the zoo, observing animals and painting portraits of them. One year, probably in the early 1920s, Dorothy wrote Gide that if she could see him, even for a short time, it would restore her

> comfort, courage, hope. You would give them to me again if I could only see you alone, in peace, for just a few minutes, for just once. Please let me when we come to Paris, please dear Gide, please. Try to arrange it for me. Simon knows, understands perfectly that I like talking to you alone, that I like keeping your letters to myself. It is quite natural.[17]

They would have lunch, and perhaps walk afterwards in the Luxembourg gardens, reading and reciting poetry. Gide once asked her to let him recite Keats's "Nightingale" so that she could correct his pronunciation.

Pippa Strachey.

> He put his arms through mine & we walked up & down as he repeated it—in that same sweet low trembling voice, which was the first thing I fell in love with. And once his voice faltered & broke. "Je n'ai plus du tout de voix he said. C'est l'émotion" ["I don't have any voice it all, it's the emotion"] and we looked at each other & smiled & his face was quivering with emotion."[18]

Dorothy treasured all meetings with Gide, even when others were present. In September 1927, as she was enroute from England to Roquebrune, they lunched with his close friend Roger Martin du Gard in the buffet of the Gare de Lyon in Paris.

Gide, although homosexual, was married. When Dorothy met his wife, Madeleine, in Paris in 1921, she was impressed by her sweetness. She wrote Gide that she had taken the precaution of reading Proust all the way from Dover to London in order to dry up her tears over the meeting.[19] That may seem to be an eccentric application of the Proustian novel, but he was clearly an important reference point for many members of the Bloomsbury group.

During their summers in England, the Bussys sometimes went to Garsington, home of Ottoline and Philip Morrell (*see* "Ottoline Morrell"). In July 1921 she described Ottoline to Gide:

> She had on the most wonderful bright yellow dress with voluminous billowy skirts. She sat on the sofa in her little room with orange & tomato coloured cushions behind her and I was alone with her. She began to talk about you in her sprawling aristocratic voice. She often tries to pump me but doesn't extract much. This time however, she suddenly said, "How passionately he loves that boy!" So I answered 'Yes' … and was silent.[20]

Dorothy's love for Gide continued unabated, and, early in 1922, she declared, as she had before, that she would rather be able to love him than to have his love. One of the greatest strains on their relationship, however, was Gide's conceiving of a daughter, Catherine, not by his wife but by Elisabeth van Rysselberghe. When Madeleine, who had suffered humiliation and deception since the outset of their marriage, burned all his letters, Gide took this as an unimaginable tragedy for himself. Elisabeth had had an affair with Rupert Brooke before World War I, but had not had a child. In 1916 Gide had passed Elisabeth a note: "I shall never really love more than one woman, and my only true desires are for young boys. But I cannot resign myself to seeing you childless, or myself either."[21] Brooke died during World War I. In 1920 Gide's adopted son, Marc Allégret, fell in love with Elisabeth. He was a film director, and had accompanied Gide to Cambridge in 1918, when Gide had studied English with Dorothy. Marc and Elisabeth hoped for a child also, but in vain. In 1922 Elisabeth became pregnant by Gide. Catherine, their daughter, was born in April 1923.

In August 1922 Gide informed Dorothy of the forthcoming event while they were at one of the *décades* at Pontigny, the most scholarly of gathering places (*see* "Intellectuals at Pontigny"). The news caused Dorothy excruciating pain, which she recorded in a special journal she and Gide called her Black Notebook. "You," she wrote, "who do not know what jealousy is." She turned this journal over to Gide, who published his version of the story slightly disguised (he called her simply "T***"). He then used her remark and gave the notebook to their mutual friend Roger Martin du Gard. Both the quotation and the delivery to du Gard were taken by her—understandably—as betrayal. Gide did not publicly acknowledge Catherine as his daughter until after Madeleine's death in 1938.[22]

In January 1923, after the dire news he had given her at Pontigny, Gide spent ten days at La Souco. Her account of the visit, recorded in her usual journal, is heartrending. She explains that she had never thought she would lose him to another woman. How could you lose me, Gide had asked, then continued with devastating frankness: "Why should

my affection for you change? It isn't the kind of affection that changes, because it is without passion, without ardor, without impulse, without incandescence."

I burnt what I had written about Pontigny—about our two evenings in Paris, about our afternoon in the Luxembourg. He has obliterated all that—effaced it—forgotten it—literally forgotten it, I expect. Was it merely pity then—that made his face—his voice—so beautiful?

No. No. No. He is more cruel to me than he has ever been to anyone—he refuses me everything that he lavishes on the others—because I am his worst temptation. "*Sans élan*"—it is not true. "*Sans passion*," not true. "*Sans ardeur*" not true. "*Sans brûlure ...?*" Yes I think his love always is "*sans brûlure.*" But it is to himself that he says all that—it is his own soul that he is defending—gainst the strength of his feeling for me. Does he hate me because of what I wrote and showed him? I don't regret it even if it is so. Had I said that, had I done this" ... no, there is nothing to regret. It was to please him that I wrote—because he encouraged me—urged me. I might have burnt it, but that would have hurt him still more than my showing it. And if I didn't burn it I was obliged to show it him out of loyalty. I might have waited—speculated on the chance of my dying first, but it would have been cowardly and dangerous—for him I mean to risk that.[23]

Therefore, Dorothy wrote, because of her honesty with him and herself, all her former happiness was turned "to dust and ashes." As a result, perhaps, of her Strachey heritage, she then had the fortitude to continue their friendship on an intellectual plane, knowing him to be

elusive—*insaissable*. He hates to be caught, to be bound by anything—be it feelings or thoughts—by the past or by the future. He never makes a promise or an engagement frankly without leaving himself some loophole, some means of escape—lest the constraint should be intolerable to his mind or his heart, or just simply to the humour of the moment. And so it seems often that he promises more than he performs. *Décevant?* Yes. Afraid of compromising himself. Not *vis à vis* of the opinion of the world but *vis à vis* of himself. He wants to be, as he says, *disponible* entirely and at every moment of his life.[24]

The tension between Dorothy's personal writings and the letters to Gide was enormous. In 1924, two years after the terrible time at Pontigny, he had come to stay with them at Roquebrune for a month in the spring. He was, he told Dorothy, giving up a journey to Morocco in order to pay separate extended visits to herself and Elisabeth. Dorothy reflected: "What pleasure could I *give up* to be with him? Duties yes. I could give them up. But there are no pleasures that don't shrivel to nothing compared with the

pleasure—or the torture of being with him. He expected me to be pleased with his self sacrifice. But I don't want him to sacrifice his pleasures for me & Elisabeth." Comparing Gide's present visit with his previous ones, she could not help but notice how, this time, he never once relaxed but continued to be absorbed

> in his novel, his letters, his multifarious correspondence…. He had no time for friendship—no wish for intimacy. There were no talks, no walks. Not once I think not once did he soften into tenderness. I begged him once or twice. I even wept! He pretended not to understand. I thought on the last evening he would give me half an hour and let me—what? sit beside him for a moment or two alone—hold his hand perhaps—hear his voice grow soft. But no—he went away for ever most likely, without a word, a sign.

On the back of the page, written in tiny letters in pencil, she remarked that there had been no pretence in this, no acting of a part, only genuine absorption in his work: "The smallest character in his novel was more real to him than me." She realized that her imagination had woven "fantastic wreaths," and, courageously, reverted to the only kind of friendship Gide was able to offer. "Yes, finished! It's all finished," he had said. She perceived that, when she spoke of Marc Allégret, his face would light up, and he would be at ease once more. Dorothy pondered what sacrifice could possibly mean for him, engaged as he was "in his novel, his letters, his multifarious correspondence … he had no time for friendship—no wish for intimacy."[25] At one point, however, Gide did reassure her: "I have felt, I have known, for a long time that you understood me without explanation…."[26]

Despite the birth of his daughter and her doubts about the depth of his feelings for her, she still saw him as often as she could. It was, above all, Gide's writing that inspired Dorothy. She appreciated his evolving and complicated political stances, but embraced, particularly, the Dionysian impulse evident in much of his work. He sometimes hesitated to sign his more overtly homosexual writings, and published them as clandestine works. This was the case in the dialogues of *Corydon*, an outspokenly homosexual text he had published anonymously as C.R.D.N., printed without a publisher's name by the Imprimerie Sainte-Catherine in Bruges. This firm had also published his autobiography, *Si le Grain ne meurt* (*If it Die*). Dorothy admired him for making his homosexuality public. At this point, he considered asking Sigmund Freud to write the preface for the German translation of the autobiography, as well as putting forth the book as having been "'translated from the German.'"[27] He could always speak best with Dorothy about such difficult issues and others, discussing them until it became clear what he had to do. Dorothy inquired, "Is it that you want to be a martyr?" No, Gide replied, I want not to be dishonest.[28] He did publish them, and she defended him, as she had in the past.

Dorothy Bussy's conception of Gide's stature as a writer justified the sort of hyperbole that Duncan Grant sensed in some of Lytton Strachey's outpourings of admiration and affection for him. A typical letter of thanks from Dorothy to Gide for his having paid a visit may sound excessive, given his relative lack of feeling for her. Yet, as she pointed out, it had made a difference "to what remains to me of life…. I was astonishingly happy all the time you were with us. I hadn't expected ever to be so happy again …"[29]

In March 1925 the poet Paul Valéry visited them. Dorothy described him to André Gide as

> … at times inhuman, desiccating, terribly fatiguing and horribly depressing — at others touching and "exquis." He read us poetry, explained why he couldn't write any more: he was chained to his own task. "M'approcher de la vérité" ["Nearing the truth"], and he made the gesture of a man bowing over his oar and rowing doggedly and painfully. Pauvre galérion![30]

Valéry's visit coincided with Simon's preparations for an exhibition at the Galerie Drouet and with a visit by Janie's best friend, Zoum Vanden Eeckhoudt (later Zoum Walter). Another frequent visitor was Roger Martin du Gard, in whose home, Le Tertre, the Bussys often stayed. His daughter, Christiane, frequently visted the Strachey family in England. He was perhaps André Gide's closest friend.

Although the approach of World War II was alarming, neither the Bussys nor most of the Bloomsbury group perceived the true threat Hitler posed. The Bussys spent the summer of 1936 in England, as they had for many years, and took part in the memorable festivities at Charleston on August 30. At a party organized by Vanessa Bell, Janie gave a recitation in "fast and unintelligible French," followed by one in which Angelica pretended to be a young writer visiting Virginia Woolf and finding her manuscript being eaten by Leonard's marmoset.[31] In June 1937 Julian Bell was killed in Spain while fighting in the Civil War (*see* "The Maurons, E. M. Forster, Julian Bell, and Bloomsbury"). His death was a devastating blow to Vanessa and also to the Bussys. In August, in a letter that proved to be prophetic, Vanessa wrote a girl who had been close to Julian, "Fascism wants to destroy intelligence—we must not let it do so."[32]

As the political situation in Europe worsened in the later 1930s, the financial situation of the Bussy family grew bleak. They moved out of La Souco and rented the house. In 1937 they took an apartment in the Sémiramis on the rue Verdi, in Nice, where Henri Matisse, Simon's old friend, was their neighbor. He lived nearby in the Régence. He had taken tea at La Souco every Sunday since the 1920s, and continued, in Nice, to arrive each Sunday at their apartment at exactly four-thirty, when Janie had put the kettle on the stove. He would devour pastries, quince jam, orange marmalade, scones, and plum cake, but never invited them to see his apartment and never brought anything but

his complaints about his wife. He seemed entirely oblivious of the financial worries that permeated the letters Dorothy and Janie wrote their English friends, including Vanessa Bell.

Janie described at length the character of Matisse, in whom her father had, she wrote, very early discerned "that rare blend of virtuosity, daring and charm that was to make him famous, but he was never taken in by the extreme seriousness and reverence with which already in those early days Matisse was wont to regard Matisse."[33] He was, she said, the most complete egoist she had ever known. She quoted Auguste Bréal's remark that Matisse could never get over the fact that he was Matisse. "He can hardly believe his luck." The egoism, according to Janie, was so "colossal and so childishly simple and natural that one cannot call it vanity." Other people existed for him only in relation to himself. Oddly, he seems to have perceived this, and sometimes admitted, "I only take an interest in myself." At the same time, he had a sense of humor about his reputation. On one occasion, at the restaurant La Coupole, the waiters rushed toward him and the other diners appeared to be delighted and impressed by his entrance. He said to his companion, "They must take me for Picasso."

In the fall of 1938, Dorothy Bussy visited the Gide home at Cuverville. Gide, unlike Matisse, was adept at extracting what Dorothy termed the "essential flavor" from all relationships, for anyone else's nerves would have been sorely tried at the Gide home. She found it acutely uncomfortable and claustrophobic, crammed with people, seemingly heedless of the nation being on the brink of war, except for Gide's struggles with the radio. As Dorothy described it, "Gide in his excitement generally got hold of it and hadn't the faintest idea which button to turn, so that all we heard were incomprehensible fragments…. They talked a great deal very loudly and all at once and were obviously perturbed but not at all intelligently interested."[34]

In 1939, menaced by nearby Italian Fascists, the Bussys went to stay in Gargilesse with the Vanden Eeckhoudts, close friends whose daughter, Zoum, a painter, was Janie's best friend. The author of *Pour Sylvie*, Zoum later married François Walter, who, as Pierre Jérôme, founded the Comité de Vigilance des Intellectuels Français. Charles Mauron was closely connected with this organization. Walter was an intimate friend of the Maurons, Angelica Garnett, and other Bloomsbury figures.[35] It was clearly a strain for the Vanden Eeckhoudts (known as the Vandens) to feed the Bussy family in addition to their own, however, and they returned to Nice.

Gide then came to Nice and stayed with the Bussys there for seven months, from October 5, 1939 to May 7, 1940. This was a visit he greatly enjoyed: "How happy I was in their company," he wrote in his journal. The months had passed like a dream; yet of course, their all-too-comfortable company kept him from the proper isolation he needed to write: "The too agreeable companionship of the Bussys … and the impossibil-

Paul Hyslop, Lytton Strachey, Janie Bussy, and Arthur Waley at Ham Spray House.

ity of isolating myself cut short my impetus." His visit, however, had been valuable to him: "Only the all-enveloping affection of my friends the Bussys warms me a bit and keeps me from despair."[36]

In 1940, at the urging of Gide, the Bussys had let La Souco to André Malraux, who with his wife, Josette Clotis, and their small son, Pierre-Gauthier, preferred not to stay with Josette's family in Hyères. They lived there for two years, from the fall of 1940 to December of 1942 except for a period of six months, when the Bussys returned to La Souco. The Malraux family then moved to the Camellias, a nearby residence. As Jean-François Lyotard described La Souco, it was perfect for the harassed André Malraux. Instead of writing novels, he was now reflecting on aesthetics and on the death and resurrection of art.[37] Malraux remembered La Souco as having "a great belvedere with five bay windows looking out on the Riviera and Monaco, its several levels of terrace arranged in a park impregnated with immemorial scents, stretching out along the Mediterranean from the Cyclades to the Cemetery by the Sea" (Malraux here evokes Paul Valéry's poem "The Seaside Cemetery"; Valéry was also a close friend of the Bussys). He recalled hearing "the sound of my son's little shoes in the garden full of flowering Judas trees (and I thought I would hear the beating of my heart in just such a way when I came to die)."[38] In 1942 Mussolini's troops began occupying the southeast. The Bussys feared that Malraux, strapped for funds under the occupation, might not be able to pay the rent. The crisis was averted, owing to the generosity of Random House, his American publisher, which provided emergency funds on which to subsist.[39] During this Dorothy wrote her sister Pippa Strachey that, "having some slight knowledge of his reputation and character," they imagined there was "very little chance of his ever paying

the rent now that his wife has departed." (Josette Malraux had died in a terrible accident, stepping off a train. She left two small sons.)[40] Later, when another tenant was in possession of La Souco, the Bussys had to sue to regain their right to occupy it.

England also was on the brink of World War II. Depressed about her writing and about their situation, in view of Leonard's being Jewish, Virginia Woolf drowned herself in the Ouse River, near Monks House, their home in Rodmell, on March 4, 1941. A few weeks earlier, Leonard had written the socialist and pacifist Margaret Llewelyn Davies an optimistic assessment of the Bussys' situation. He reported that they had had some interesting letters from the Bussys in Nice; "they are quite well and cheerful now though the food shortage is very bad there too," he noted. Although they had suffered from anti-British sentiment, that had changed and Dorothy felt their "popularity" was "now greater than it was before the war."[41]

As the war went on, the Bussys eventually moved to Vence, Cabris, and Figeac. Their situation worsened. They became more and more nervous, exhausted, and impoverished. They cherished each gift of a lemon, a pot of honey, or other small item. Vanessa Bell wrote Molly MacCarthy of her constant concern about the Bussys in occupied France. Sometimes she and Quentin tried to smuggle letters over to them, but much of the time they remained beyond reach of any communication.

Janie Bussy was one of the nicest and most intelligent of the younger generation, as Vanessa Bell wrote Molly MacCarthy in October 1944. Dorothy, however, seemed convinced that her daughter had inherited what she calls her own "inarticulateness." Neither, of course, suffered from such a disability. They were both highly articulate about what could be talked about, but emotions were not in that category. Janie was by that time an established artist whose work had been exhibited. The influence of French painters may be seen in her work; her *Still Life* (1930) shows an unfinished flower bouquet in a vase, with

Janie Bussy, *Still Life* (1930).

some blossoms still to be inserted. The light strokes and suggestion of decoration on the vase recall the work of Manet; the circles and cross-hatches are also typical of the Omega Workshops pottery. This painting, inscribed to Angelica, is presently at Charleston.

Janie was also endowed with a sharp mind and an ability to write incisively. In 1947 she read her recollections of France under the Gestapo at one of the meetings of the Memoir Club. This was an informal assemblage of Bloomsbury figures, meeting periodically over many years, before which members of the group presented essays recalling various events and periods in their own lives. Vanessa wrote Molly MacCarthy about a letter Janie had sent to Quentin Bell concerning their situation. This was a personal account, "fairly grim," of their dealings with the Gestapo. They were, she reported, so extremely stupid "that they didn't investigate such centres as the Bussy household where they would have found plenty of evidence of the kind wanted."[42] As Janie told Quentin, the food situation was very bad; sometimes they had nothing to eat but bread and raisins. During this crisis, the Americans entering Nice looked like Hollywood heroes, since at least they were not Nazis. Dorothy Bussy's letters to her sister Pippa and to her sister-in-law, Ray Strachey, during this period describe in some detail the difficulties of wartime living. Everything was in drastically short supply, so that they had just enough to keep alive, with their "clothes literally in rags and ribbons. No soap…. The gas won't light or lights just not enough to boil water. Locks and doorheads out of order and can't be repaired. Watches, clocks ditto. No spectacles—which I badly need."[43] Simon had to use the canvas from his pastel zoo pictures for his oil paintings.

In November 1944 Vanessa again wrote Molly MacCarthy about the plight of the Bussys:

> It's difficult not to wonder what one would have done if one *had* been taken and tortured…. Janie evidently ran great risks, tapping away on her typewriter and helping Jews etc. though she makes very light of it all … I admire it enormously but at the same time I can't condemn people who behaved weakly as so many of our friends especially the painters seem to have done.

She reported that the Vildracs were "heroic," whereas André Segonzac had gone to Germany and was, consequently, disgraced (*see* "Painters in France, 1910–1921").[44]

After the war, the Bussys returned as best they could to their prewar lives. By 1945, Simon was seventy-five years old, Dorothy was seventy-nine, and Janie, who had not married, was thirty-nine. Simon and André Gide, who, almost inconceivably, had always been good friends, had exchanged letters during the war. Gide arranged several exhibitions for him after the war, hoping Simon would not discover that he was responsible. For example, in 1948 he managed to organize one for him at the Galerie Charpentier in

Paris, when Simon was virtually penniless. In 1949 he held one in Paris attended by the Bussys, Roger Martin du Gard, and Jean Schlumberger.

Gide still regarded Dorothy with affection, which seems to have grown over the years.[45] He confessed to Roger Martin du Gard, a close friend of both, that he loved looking at Dorothy and felt great attraction "for her face, and always more so, truly, with the years…. I look at her now, with more emotion than ever."[46] On January 22, 1946, Gide wrote Dorothy from Cairo: "I don't think about anything…. My life is only near you, with you — and all your amiable pessimism doesn't prevent you from knowing it." He reiterated his affection in a letter written February 2, 1948: "I think of you constantly." A month later, he wrote her, "How much there is to say to you!"[47] In a strange sense theirs was an inexhaustible relationship, in which things were neither so simple nor so unbalanced as many readers and critics have assumed. Gide always attracted women, exhibiting patience and tolerance even when he could not reciprocate their affection. This was the case with a secretary, Yvonne Davet, who fell in love with Gide about 1947. Dorothy sympathized with her, invited her to tea, and continued to write to her through the Red Cross when she went to Germany.[48]

Dorothy was an excellent writer, although her skill at writing fiction was largely unrecognized during her lifetime. To a large extent Gide was responsible for this lack of recognition. In 1934 she gave him a short manuscript of a novel, *Olivia*, written in French, which he skimmed and found "not very engaging," to her dismay. Actually she had excellent grounds for distrusting his judgment. In 1909, as one of the founding editors of the *Nouvelle Revue Française*, an influential and prestigious journal, he had turned down part of Marcel Proust's *A la recherche du temps perdu* (*In Search of Lost Time*, or *Remembrance of Things Past*). *Olivia* was about the suggestively lesbian atmosphere of a French girls' boarding school, "Les Avons." The establishment was based on Les Ruches, a boarding school Marie Souvestre had run near Fontainebleau. Lady Strachey, a friend of hers, had sent two of her daughters, Elinor and Dorothy, there. Natalie Clifford Barney, a noted lesbian, had also attended the school, as had her sister, Laura. ("Olivia" had been the name of one of Dorothy's sisters who had died in infancy.)

Gide's assessment of *Olivia* hurt Dorothy deeply and prevented her from seeking publication. The novel was finally recognized as a minor masterpiece when, in 1948, she published it anonymously as *Olivia* (by "Olivia"). She translated it into English, but was persuaded by Roger Martin du Gard that her translation was not good enough. He reworked it, though his English was poor and his translation was hastily done and clumsy. Nevertheless, *Olivia* became a raging success in England and was made into a highly popular film starring Edwige Feuillère. At the time of its publication in France Dorothy was eighty-two, almost eighty-three, and Gide was seventy-nine. She could not resist attacking his literary acuity: "You'll have had the honor of rejecting Proust and

me," she wrote. Gide answered by telegram: "As repentant and embarrassed as with Proust," to which Dorothy replied: "Thus I shall go down to posterity bracketed in one of your immortal sentences with Proust!"[49] This, in fact, has been the case. *Olivia*, Dorothy said, had at last touched him as she would have wished. There is a double irony in the story of *Olivia* and its long-delayed publication. The French public assumed it was Gide himself who had written it, as they habitually attributed anything Dorothy (sometimes called the "old octogenarian") accomplished to his influence on her. The assumption was in some ways a natural one, as Gide had been awarded the Nobel Prize in Literature in 1947.

That Gide should have failed to appreciate Dorothy's novel, charged with the same-sex passion, may seem bewildering, or, perhaps, a revelation of his own nervousness or insecurity. When he finally did read it thoroughly, however, he termed it an "extraordinary tale." His reaction was that of a gourmand: "I read, I devoured the whole thing in two long sittings of several hours." He praised it as one of the most accomplished and perfect works ever written, with its mixture "of emotion, measure, and tact, of secret lyricism, of *reserve* in its indiscretion, its wisdom acquired upon reflection, its moderation in ardor," with a reserve "both of modesty and avowal."[50] He then wrote Dorothy a highly significant letter. After a typically French complaint of his tiredness, he finally uttered the English words, "I love you."[51] Dorothy replied in a postscript, modest as always: "I do believe those three English words in your letter. I believe, I know, you understand, you mean them."[52] The exchange is perfect in language, wit, and concept; the underdog wins, the overdog makes amends. Some critics have been mystified that Dorothy, raised as an emotionally and intellectually independent Strachey and married to an artist, should have endured Gide's failure to reciprocate her feelings. Sheridan characterizes her as a "poor woman ... at sea about the emotional as well as the sexual promiscuity of her soul's idol," and questions why she was not more "subtle in her views on human relationships."[53] It may be argued that Dorothy was far from naive and that, in time, she developed a claim on Gide's affections that was both subtle and profound. They had understood each other from the beginning of their long relationship as excruciatingly sensitive translators. As this exchange suggests, however, there was now a conjunction of their work and their emotions. It came late in their lives, but, for Dorothy, Gide's words justified her behavior, sanctioned her enduring trust in his affection and made the issue of her feminine pride irrelevant.

It is worth noting that in the Bloomsbury group there were several relationships between a woman and a homosexual man. It might be said that they formed a pattern: Dorothy's love for Gide, made complex by their dual roles as translators and writers; Vanessa Bell's lifelong attachment to Duncan Grant; Dora Carrington's to Lytton Strachey. Before her own involvement with Gide, Dorothy Bussy exclaimed about Carring-

Simon Bussy, *The Jura Mountains.*

ton and Lytton: "So much adoration on one side, so much affection on the other—and the whole thing hopelessly unsuitable." In each case, a strong-minded and artistically oriented woman, married to a heterosexual, reserves her most profound love for her relationship to a homosexual man. The husband tolerates it for reasons of his own, and because it will, they both know, lead nowhere. Yet, in each case, it is the singular relation that is the enduring and central one. There is a symbiotic relationship between the beloved one and the loving person, each of whom fulfills the other's most profound need.[54] A first reading of the letters between Dorothy Bussy and André Gide may provoke outrage toward him and sympathy for Dorothy. A second one, however, results in a fuller understanding of her motivation and rewards, as well as those of Gide.

After World War II ended, the Bussys returned to England, where things continued to be difficult. As a foreigner Simon was not allowed to stay in the country without special permission, but was forced to make frequent journeys to France. He had a prostate operation in London, from which he recovered. Gide came over to see him in the hospital and Dorothy offered to have him meet "Morgan Forster, the author of a *Voyage to India* [*sic*] … or a ravishing beautiful youth lately picked up by Duncan Grant and

preparing to be a monk, or perhaps Saint Denis and Laurence Olivier and have a talk with them about *Saül* and the English stage...."[55] Simon obtained a few portrait commissions in England and France, but they never brought in enough income to support the family. It was actually the proceeds of Dorothy's *Olivia* that saved them from financial calamity.

On January 9, 1951, a few weeks before Gide's death, he wrote Dorothy, "I need to write to you, without however having anything to say."[56] His need for her transcended the years of despair and frustration on her part. He died in Paris of tuberculosis on February 19, 1951, at the age of eighty-two (he had struggled throughout his life with respiratory problems.). Simon died in London in 1954, aged eighty-four. Since his death, several important retrospective exhibitions have been held of his work, which has acquired increasing value. Janie and Dorothy lived on together at La Souco; Dorothy was becoming increasingly infirm mentally.

Dorothy's niece, Julia Strachey Tomlin (daughter of Oliver Strachey and his wife, Ruby) had once taken refuge at La Souco in order to write her 1932 novel *Cheerful Weather for the Wedding*. At the time she complained to her first husband, Stephen Tomlin, about the food, particularly the "horrid teas! Nothing but marmalade and something they call cake, but is really condensed mosquito-netting with currants in it."[57] After the deaths of Gide and Simon Bussy, the villa had become an extremely depressing place. In 1954 Julia visited Janie and her mother, and recounted to Frances Partridge how "Janie and little bowed old marmoset Dorothy ding-dong along here together in a rather scarifying manner.... Janie, who is at her wits' end, and patience quite exhausted, never fails to come back with crushing contradictions of everything her mother says, as you know."[58] Clive Bell was also concerned about Janie's situation, although he wrote Frances Partridge she "bears up nobly."

Janie and Dorothy planned to spend the

Vanessa Bell, *Dorothy Bussy at La Souco* (1954).

winter of 1960 in London. Janie realized that La Souco would deteriorate unless it were occupied, and offered it to Vanessa and Duncan, hoping Vanessa's poor health might improve in the Midi (she died later that year). Vanessa was reluctant to make the journey, but, accompanied by Duncan and Grace Higgens, managed to go down. They stayed in the house from January through April. She surveyed Simon's paintings and completed a painting, *The Garden Window, Roquebrune.* Meanwhile, Clive Bell and Barbara Bagenal arrived to stay in a hotel in Menton; they found the atmosphere at La Souco depressing. Vanessa refused to venture out, much to Duncan's disappointment. Angelica came down from England and hired a car, which enabled them to make short excursions and to dine out. Her stay, although limited by family obligations, was, Clive Bell wrote Frances Partridge, "a great pleasure to everyone … [she] gave extensive orders for desirables and much needed comestibles and appliances … in fact made things hum and attracted numerous admirers."[59]

On their return to England, Vanessa and Duncan had planned to meet Janie Bussy in London to report on La Souco, but, the day before their planned meeting, she died tragically in London as a result of an accident with a gas water heater. Dorothy, who was senile, was not told of her death but was moved to a nursing home where she died shortly afterward, on May 1, 1960. Janie's death was a loss to everyone. As Spalding puts it, "Her astute mind, caustic humour and love of painting had caused both Clive and Vanessa to regard her with ever-increasing affection."[60] Pippa Strachey had enjoined Dorothy to burn her diaries because they made her love of Gide so clear. Fortunately their sister Marjorie had intervened, hiding them with a friend. They were eventually auctioned by Sotheby's for a considerable sum. Dorothy and Janie had died intestate, but there were many other Strachey family members, including Oliver Strachey's descendants, among whom the estate was to be apportioned. Angelica Garnett went to see the paintings remaining at La Souco. On another occasion Oliver's daughter, Julia, accompanied by her second husband, the critic Lawrence Gowing, and Frances Partridge traveled to Roquebrune in order to survey and evaluate the remaining works. As recorded in Frances's diary of December 19, 1960, they had all spent

> a hard day's work in Simon Bussy's dank mouldering studio. Lawrence enjoys his role as general, ordering Julia and me kindly about, dictating names and measurements of the pictures while striding about with a stalking movement like a large bird that seemed to be going to lay him flat on his nose at any moment, and making a running commentary, something like this: "A *marvelous* painter, *what* a marvelous painter! … This is simply terrible … Simon's sense of humour!… Grisly!… Ah, I see what it is, every bird or fish is a self-portrait."[61]

Simon had translated his animals into his art, as he did the subjects of his portraits.

Dorothy had translated the highly symbolic works of one of France's great writers into her own language, even as she left Simon to the world of his animal and human subjects and to his odd and strangely colored landscapes of the mind. On some fundamental level, even if one skewed by conventional standards, Gide reciprocated Dorothy's long and intellectually fruitful passion for him. The tripartite relationship between Simon and Dorothy Bussy and André Gide, marked as it was by unconventional, divided loves and notable achievments, had an unusual depth and holds its own fascination today.

One of the most enduring of all the Anglo-French attachments was that between the Bloomsbury figures, particularly the artists, and the Bussy establishment at Roquebrune. For nearly sixty years the house served as a colorful outpost on the Riviera, giving the Bussys a central, though little known, position within the perimeter of Bloomsbury.

Virginia Woolf
gazing into her
hat (1930s).

Literary Translations

… there is nothing in the world that raises such fierce passions as the question of how to scan a line.

—Roger Fry, 1926

The critical reception of Bloomsbury writers in France, as of French writers in England, has depended on the work of a number of translators. The works of E. M. Forster were translated by Charles Mauron and Christian Bourgois, and those of Virginia Woolf by Clara Malraux, Hélène Bokanowski, Pierre Norden, Charles Vildrac, Marguerite Yourcenar, and Cécile Wajsbrot, as well as Mauron. To a lesser extent, the writings of Clive Bell and Roger Fry were also translated into French, the latter often by Charles Mauron. Those of Lytton Strachey were translated by Jacques Heurgon, the son-in-law of Pontigny's founder. Conversely, several members of the Bloomsbury group were themselves translators of French works: Roger Fry, Dorothy Bussy, and Frances Partridge. Particularly in the early decades of this century, there was a keen excitement about such linguistic exchanges.

Charles Mauron and Roger Fry, Virginia Woolf and Stéphane Mallarmé

Reflecting on the complex problems of translation, Roger Fry was fascinated by the mental recasting it forces on the mind. In 1927 he wrote Robert Bridges, with whom he frequently discussed such matters, about the texture of language in the poetry of Gerard Manley Hopkins and other poets. Fry spoke of "the dangerous ease of French," arguing that it could eclipse a person's original ideas because of the "many attractive and ready-made moulds into which one's thoughts can flow …"[1]

Fry had a genius for matching projects and people. He believed that Henry James and Virginia Woolf were two authors representing the highest form of the novel,[2] to whose linguistic and conceptual difficulty the talents of Charles Mauron would be particularly well suited.[3] It is no accident that James and Woolf have the same French translators during this period, and that they pose problems, although very different, of parallel difficulty. With both writers the translator must convey interior states of mind, usually protracted for James and far more evanescent for Woolf, who invented the novel as poem. Fry was convinced that it would take two persons, English and French, to trans-

late James, who was, he believed, so given to circumlocutions and complexities that he should be read aloud in order to be properly understood.[4]

Fry greatly admired Charles Vildrac's translation of James's work as well as in his translation of Woolf's "The Mark on the Wall." Having originally suggested that Charles Mauron translate Virginia Woolf, Fry was favorably impressed by his success in capturing her atmosphere. He made many suggestions during the period in which Mauron was translating the middle part of *To the Lighthouse*, published in the French literary journal *Commerce*.[5] He considered Woolf's rendering of character splendid but that of material things sometimes overemphasized: "When she tries to give her impression of inanimate objects, she exaggerates, she underlines, she poeticizes just a little bit. Several times I felt it was better in the translation, because in translation everything is slightly reduced, less accentuated and in general better...."[6] His stress on an impersonal equality of varied phenomena seen and translated leads him to the suggestion in his famous "Essay in Aesthetics" about looking out at the sidewalk *into a mirror* to reduce one's personal involvement:

> If we look at the street itself we are almost sure to adjust ourselves in some way to its actual existence ... but, in the mirror, it is easier to abstract ourselves completely, and look upon the changing scene as a whole. It then, at once, takes on the visionary quality, and we become true spectators, not selecting what we will see, but seeing everything equally, and thereby we come to notice a number of appearances and relations of appearances, which would have escaped our notice before, owing to that perpetual economising by selection of what impressions we will assimilate, which in life we perform by unconscious processes.[7]

It is the frame of the mirror that marks the scene as imagined. Fry's admiration of Mauron's "neutral rendering" is an artist's view of translation. This is just the point when we see Fry's view as singularly his own, his gaze as unselective and unaccentuating. This outlook is associated with the puritanical part of his personality that contrasts so sharply with his enthusiasms. He stresses his desire for "evenness" by referring to Cézanne, in whose work there are no sections of less significance than others: "There may be parts where the emphasis falls, but those things that one might consider insignificant are analyzed with the same care and stated with the same conviction as those which play a leading part in the composition."[8] Fry commended Charles Mauron's translations of Virginia Woolf as smoothing out her unevenness. Many readers today, recognizing the poetic stresses of Virginia Woolf's individualizing view, will not share his regret over her failure to be the classicist he envisioned as ideal.[9]

The French have a special affinity for the works of Virginia Woolf and E. M. Forster,

who have been the most frequently translated of the Bloomsbury writers. Their legacy has fortunately been preserved in a few superior translations.

Virginia Woolf in French Translation

Virginia Woolf's work was of great interest to leading writers, critics, and translators in France, a fact she often deplored.[10] Charles Mauron translated *Orlando* and *Flush* as well as the central portion, "Time Passes," of *To the Lighthouse*. The latter was published in a French journal even before the novel appeared in England. Charles Vildrac translated "The Mark on the Wall" and Clara Malraux *A Room of One's Own*. Marguerite Yourcenar initially translated *The Waves*, which was translated again by Cécile Wajsbrot and published in 1993.

Elizabeth Bowen comments in the postface to the Signet edition of *Orlando* that it is a pure and light "fantasy"; yet, after the perfection of *To the Lighthouse*, it served to "shatter some rigid, deadening, claustrophobic mould of so-called 'actuality.'" It prepared the way for the poetic prose of *The Waves* of 1931.[11] Mauron's translation perfectly fits its tone, playful and ever mindful of wordplay. For example, in translating "Hail! natural desire! Hail! happiness! divine happiness!" he gives: "Salut! ô désir naturel! Salut! Bonheur! divin bonheur!" This means that the subtext of the English ("Hail Mary") survives in the French translation ("je vous salue Marie"), leading to a play on salvation itself. For the English phrase "but hail not those dreams ...," he chooses "Salut!... point de salut ...").[12] Mauron is not afraid to risk being overly literal, as is evident in his translation of *Orlando*. In a baroque and comic passage based on three words beginning with P—"pink," "pearl," and "perfection"—he selects "prodigious" for "pink" so as not to lose the alliteration. The phrase becomes "le Prodige, la Perle et la Perfection de son sexe."[13]

As a rule, however, Mauron avoids any heaviness, opting instead for elision, as in passages reading "and ... and" in English, where the French would be the weighty: "et ... et": he simply eliminates the conjunctions. In the same way, he elides reference to gender when it is unnecessary, as in the key passage about the selves "sick of themselves," like Orlando out in the country "and needing another self":

> "Orlando?" still the Orlando she needs may not come ... So Orlando, at the turn by the barn, called "Orlando?" with a note of interrogation in her voice and waited. Orlando did not come.[14]

Fortunately, the French language does not have to specify gender here, and so retains the desirable ambiguity:

> car l'on peut dire, comme Orlando ... "Orlando?" mais ne pas voir l'Orlando

désiré … Ainsi donc Orlando, au contour près de la grange, appela "Orlando?" avec un accent interrogateur dans la voix et attendit. Orlando ne vint pas.[15]

Mauron takes care to use all the available ambiguities of French. Thus in the original gender-marked and conjunctive sentence: "Reading it over she blushed and repeated, 'Life and a lover,'[16] he chooses a brief rapid sentence where the gender is unmarked and the conjunction is elided: "En le relisant, Orlando rougit, répéta: 'La vie et un amant.'"[17] Furthermore, he manages to underplay the language for Orlando's switching of sexes, opting for the stress on the name Orlando itself, rather than on the gender of the person speaking. In a passage describing the effect of a change of clothing on the psychology of the person making the change, that is, "the odd effect it had in the particular case of Orlando herself," Mauron says simply "dans le cas particulier d'Orlando." There is no need to specify sexes when the clothes are, so to speak, making the man. In the concluding passages of the final chapter, Orlando shouts her joy at the sight of her husband's brig "rising to the top of the wave!"[18]

"Ecstasy!" she cried, "ecstasy!"

This response prepares the way for the final sight of the "single wild bird":

"It is the goose!" Orlando cried. "The wild goose …"

Whether or not Woolf is alluding to Ibsen's *Wild Duck*, Mauron adds for the French reader a reminder of Pascal's ecstatic text, his "Testament."[19] Mauron's Orlando remembers, with a shout, and without stressing the female pronoun,

"Pleurs de joie, cria Orlando, pleurs de joie!"

This line prepares the rhyming recall of the cry:

Orlando vit … monter d'un seul coup d'aile un oiseau sauvage, seul. "C'est l'oie! cria Orlando, l'oie sauvage …"[20]

In his original preface to the translation, Mauron comments that *Orlando* is not a "roman à clef," which a single key might unlock, but a work of many genres: "novel, revery, fantasy, poem," with many keys and many locks. There are, in fact, many Orlandos, from the initial portrait of 1590 to the final one, befitting the "secret corridors, hidden stairs, and doors covered with tapestries."[21]

The Waves is a totally different case, and has received two widely different translations. The earlier version, by Marguerite Yourcenar, gives a classicizing view. She sees it as one of those light and lovely "tapestries full of flowers and birds, never exposing indiscreetly in the work the fatigue, and the secret of the often painful sap in which the

lovely wool has been dipped."[22] Yourcenar's surprisingly literal rendering veers toward the novelistic and the narrative as opposed to the poetic and deliberately "subjectless" and rhythmical text that Woolf wanted for her poem-novel. Yourcenar's language is heavy, unsuited to Woolf's subtlety. She delights in the pointing word and the situating adverb, elements that can impede the lyric flow. In like manner, her view of Lily Briscoe in *To the Lighthouse* is pedestrian and unimaginative: "la pauvre Miss Briscoe, dont la terne existence s'est usée à peindre d'assez médiocres toiles qu'elle ne parvient jamais à finir" ("poor Miss Briscoe, whose dull existence has worn itself out in painting rather mediocre canvasses she never manages to finish.")[23] A translator who views Lily Briscoe in such a literalizing fashion is, understandably, unable to translate what Virginia Woolf called the "poetic drama" of *The Waves*. For Cécile Wajsbrot, the second translator of *The Waves*, Woolf plumbed the depths of emotion, whereas Yourcenar's conception remains on the surface: "Le regard de Virginia Woolf plonge, celui de Marguerite Yourcenar parcourt." ("Virginia Woolf's gaze dives down, Marguerite Yourcenar's skims along.")[24]

The two translations give an entirely different interpretation of certain passages. Woolf describes Susan's gait and Bernard's and Susan's outlook: "Now she walks across the field with a swing, nonchalantly.... There is agitation and trouble here. There is gloom...." Bernard remarks: "Now we have fallen through the tree-tops to the earth." And: "I see the lady writing. I see the gardeners sweeping, said Susan."[25] In Yourcenar's version, the swing of the gait is reduced to a plodding step and the elusive atmosphere rendered word by word: "Voici qu'elle traverse le champ avec un balancement nonchalant ... Tout ici est plein de trouble et d'agitation. Tout est lugubre." She has Bernard say: "Et maintenant, nous voilà tombés à travers les hautes branches des arbres, sur la terre ..." Susan continues, heavy as before: "Je vois la dame qui écrit. Je vois les jardiniers qui balayent ..."[26] Wajsbrot's translation of the entire passage is far lighter: "Maintenant, elle traverse le champ d'un air dégagé ... Il y a de l'agitation et du chagrin. Une mélancolie."[27] Bernard says: "Maintenant, nous sommes tombés des arbres." We then hear Susan, freer in tone than in Yourcenar's version: "'Je vois la dame écrire. Je vois les jardiniers balayer,' dit Susan."[28]

Jinny's simple statement of hereness, nowness, and imminent action reads: "'This is here,' said Jinny, 'this is now. But soon we shall go.'"[29] Yourcenar spells out her remark at repetitious length: "'Ce que vous dites, c'est vrai ici où nous sommes,' dit Jinny, 'c'est vrai en ce moment. Mais il faudra bientôt nous en aller.'"[30] In Wajsbrot's version, the perception retains, in its brevity, the immediacy and simplicity of the original: "'Nous sommes ici,' dit Jinny, 'et maintenant. Mais nous allons partir.'"[31] The difference is in the rhythm. The earlier, heavier version slows down Virginia Woolf's delicate and rapid sense of the moment to a tedious gait.

Yourcenar makes things unnecessarily explicit. After one of the all-important table scenes, Bernard speaks:

> Now the meal is finished; we are surrounded by peelings and bread-crumbs. I have tried to break off this bunch and hand it you; but where there is substance or truth in it I do not know. Nor do I know exactly where we are.[32]

Yourcenar gives:

> Et maintenant, le repas est terminé; nous sommes entourés de pelures de fruits et de miettes de pain. J'ai essayé de cueillir cette grappe (ma vie?) et de vous l'offrir: mais je ne sais pas moi-même ce qu'elle contient de réalité. Et je ne sais même pas exactement où nous sommes.[33]

Wajsbrot sees no need to spell out the fruit under the peeling, nor the bread in the crumbs. She gives the original and specific gesture of holding out the fruit (Woolf's "hand it you" instead of a more general "offer it you"), saying no more than is necessary:

> Maintenant, le repas est fini; nous sommes entourés de miettes et d'épluchures. J'ai essayé de détacher la grappe, de vous la tendre; contient-elle une substance, une vérité, je ne sais pas. Pas plus que je ne sais exactement où nous sommes.[34]

Such translations as those of Wajsbrot and Mauron do full justice to Woolf's texts.

One of Woolf's most noted works, the literary essay *A Room of One's Own*,[35] was translated by the novelist Clara Malraux, the first wife of André Malraux. Competent but somewhat stolid, her rendering sometimes loses the flow of Woolf's argument and occasionally flattens, like Yourcenar's translation, the subtle play of the text.

In a key passage near the beginning, Malraux makes a seemingly trivial misjudgment that skews the entire perspective. Woolf writes:

> As I have said already that it was an October day, I dare not forfeit your respect and imperil the fair name of fiction by changing the season and describing lilacs hanging over garden walls, crocuses, tulips and other flowers of spring. Fiction must stick to facts, and the truer the facts the better the fiction—so we are told. Therefore it was still autumn and the leaves were still yellow and falling, if anything, a little faster than before, because it was now evening (seven twenty-three to be precise) and a breeze (from the south-west to be exact) had risen ... (25)

Here she mocks those writers who permit themselves to be confined by fact, disallowing the play of invention.

Clara Malraux's translation adds a comma and eliminates a "that," thus changing

writerly intention into seasoned fact, and puts in quotes the first reference to the "fiction" of Woolf's straightforward and unpunctuated fiction, thus trivializing it from the start. Her translation reads: "As I have already said, it was an October day."

> Comme je vous l'ai déjà dit, c'était un jour d'octobre. Je ne veux pas risquer de perdre votre estime, ni mettre en danger ce joli mot de "fiction" en changeant de saison …

In the original, the play of fiction/fact leads to a passage of high lyricism. Clara Malraux, by eliminating Woolf's deliberate repetition of the key phrase—"the beauty of the world"—deemphasizes its importance:

> It was the time between the lights when colours undergo their intensification and purples and golds burn in window-panes like the beat of an excitable heart; when for some reason the beauty of the world revealed and yet soon to perish (here I passed into the garden, for, unwisely, the door was left open and no beadles seemed about), the beauty of the world which is so soon to perish, has two edges, one of laughter, one of anguish, cutting the heart asunder. (25–27)

In Malraux's French translation this beauty appears only once:

> C'était le moment où la beauté du monde, éclatante mais prête à périr—ici j'entrai dans le jardin, car la porte en avait été imprudemment laissée ouverte et, selon toute apparence, il n'y avait pas d'appariteurs dans les alentours—, montre ses deux visages: visage riant et visage d'angoisse, qui partagent également notre coeur. (25–26)

It is a loss that counts.

Any translator of Woolf must surely try to preserve her sense of humor, particularly in scenes as celebrated as that of the meal at a women's college (Newnham) in *A Room of One's Own*. Woolf develops an analogy between the actual menu and the disparity in university offerings to men and women. As so often in her work, the humor depends on slight details, such as a transition from the expectant and hopeful expression "my soup" to the disappointment of the boring and plain: "the soup," "a soup."

> Here was my soup…. Here was the soup. It was a plain gravy soup.

The French version omits the phrase "my soup," simply repeating "the soup," undoing the personal hope, and slows the verb tense from "apporta" to "apportait," so that the expectation centers on the bringing and not the eager anticipation implied by "my soup."

> On apporta la soupe…. On apportait la soupe. C'était un simple bouillon.

The plainness of the soup is paralleled by Woolf's short squat sentences:

> But there was no pattern. The plate was plain. (28)

In French, however, the sentences flow, diminishing the intense disappointment shown, in English, by the language:

> Mais aucun dessin ne se trouvait dans l'assiette qui était tout unie. (27)

These are details, yet on such details hangs the feeling of the text.

"Only Connect": French Translations of E. M. Forster

Of all E. M. Forster's works, it is surely the novel *Howards End* (1910) that most clearly offers the reader buried treasure and a "light in the heart," to use Woolf's phrase.

Forster's motto, "Only connect …," on the title page, addresses questions of inner sustenance, of inheritance, and of ultimate values.

The novel is one long triumph, from the presentation in Helen's letter of Mrs. Wilcox and her trailing garment to the final realization of what that dying lady has metaphorically brought along, her legacy to Helen's sister Margaret. This legacy is made palpable by Helen's joyous final shout: "The field's cut! … the big meadow! We've seen to the very end, and it'll be such a crop of hay as never!"

Mauron's translation is no less a triumph. The French reader must be grateful that Roger Fry insisted that his friend Charles Mauron become Forster's French translator. As Mauron told Alice, soon to be his wife, he found Forster's work much harder to translate than that of Virginia Woolf. Since Mauron's version of *Howards End, Le Legs de Mrs. Wilcox,* was not published until 1950, Fry did not live to read it.[36] Mauron translated the work in 1949; Alice read it to him in English while they were at L'Isle sur Sorgue, not far from the Mas d'Angirany in St.-Rémy, and typed the French text as he dictated it. This method of translation necessitated by his not seeing the words, meant no diminution in sensitivity to the text: rather, the contrary.[37]

At the opening of the novel Helen Schlegel writes her sister Meg (Margaret) about Mrs. Wilcox, the heroine and heart of the house called Howards End, in a passage that sets the tone for the entire text:

> … Mrs. Wilcox trailing in beautiful dresses down long corridors…. Trail, trail, went her long dress over the sopping grass, and she came back with her hands full of the hay that was cut yesterday—…. And finally Mrs Wilcox reappears, trail, trail, still smelling hay and looking at the flowers. (3–4)

As with the final realization of Mrs. Wilcox's legacy, the prolonged trailing of the dress is essential to the picture of the person at the heart of the drama. It is Mrs. Wilcox whom Margaret will replace, marrying Mr. Wilcox after his wife's death, and it is her heritage she will save in both the material and spiritual senses. On a larger scale, she is safeguarding part of England's past, as it trails behind. For this crucial setting, Mauron gives:

> Mrs. Wilcox en somptueuses robes à traîne parcourant des couloirs interminables…. J'ai vu sa longue robe qui traînait, traînait derriere elle sur l'herbe mouillée, puis elle est revenue les mains pleines de foin coupé d'hier— … Enfin Mrs. Wilcox revient et sa longue robe traîne, traîne, tandis qu'elle hume son foin et surveille ses fleurs. (16–17)

Both Forster and Mauron loved music and played the piano; it was one of their many points of contact.[38] An early passage in *Howards End* delineates the different characters of the Schlegel sisters. A concert takes place in the Queen's Hall, London, opening with

Beethoven's Fifth Symphony. Here a signal distinction is drawn between the calmer and more introspective Margaret, who hears only the music itself, and the "ramshackly" Helen, who extrapolates a narrative theme as she hears the music, a drama of heroes and gnomes, of panic and reassurance. Forster uses reactions to music as formulations of character:

> Whether you are like Mrs. Munt, and tap surreptitiously when the tunes come—of course, not so as to disturb the others; or like Helen, who can see heroes and shipwrecks in the music's flood; or like Margaret, who can only see the music … (32)

Mauron's passion for music and skill at playing the piano permeate his translation of the key passages in the scene. Here he offers a witty direct address to the reader:

> Lecteur, pareil à Mrs Munt, tapotez-vous sournoisement les thèmes pour saluer leur arrivée (sans gêner personne bien sûr)? Dans le flot musical, voyez-vous héros et naufrages comme Hélène ou comme Margaret rien que de la musique? (46)

Helen invests her surroundings with her own romantic outlook:

> Much did she censure the attentuated Cupids who encircle the ceiling of the Queen's Hall, inclining each to each with vapid gesture, and clad in sallow pantaloons, on which the October sunlight struck. "How awful to marry a man like those Cupids!" thought Helen. (33)

Mauron's translation perfectly conveys Forster's Helen. There is no lessening of the color of the description in his version of Helen's musing, a triumph in itself.

> Avec sévérite, elle critiqua les Cupidons amoindris qui, autour du plafond du Queens' Hall, s'inclinent l'un vers l'autre, couples fades, vêtus de pantalons blafards, que le soleil d'octobre caressait. "Quelle horreur! Epouser un homme comme eux!" pensa Hélène. (47)

Helen explains to her aunt Juley Munt, on whom her own sensitivity is entirely lost, about the way she should listen. She is then swept away by her own reception of the music:

> "… look out for the part where you think you have done with the goblins and they come back," breathed Helen, as the music started with a goblin walking quietly over the universe, from end to end. (34)

Mauron captures her nervous submersion in the music:

"ce qu'il ne faut pas rater c'est le moment où les gnomes, qu'on croit partis à jamais, reviennent."

Déjà, précisément, l'orchestre s'ébranlait: solitaire, le pas d'un gnome parcourait en paix l'univers d'un bord à l'autre. (47)

Like a test case, the goblins seem to threaten imminent catastrophe, put off once, before a reprise of danger that leaves room for the recognition of authority:

For, as if things were going too far, Beethoveen took hold of the goblins and made them do what he wanted. He appeared in person. He gave them a little push, and they began to walk in major key instead of in a minor, and then—he blew with his mouth and they were scattered!... Any fate was titanic; any contest desirable; conqueror and conquered would alike be applauded by the angels of the utmost stars....

But the goblins were there. They could return. He had said so bravely, and that is why one can trust Beethoven when he says other things. (35–36)

Mauron's translation renders Forster's interpretation of Beethoven's authority and insight without missing a beat:

Car Beethoven—la chose allait décidément trop loin — avait résolu de reprendre en main la situation et de faire obéir les gnomes à sa guise. Il apparut en personne, Beethoven. Une chiquenaude et ils marchèrent en majeur, puis en mineur; un grand souffle et ils furent dispersés! ... Tout destin était titanesque; exaltante, toute bataille; des étoiles les plus lointaines, les anges, avec équité, applaudissaient conquérants et conquis.... Mais les gnomes étaient là. Ils pouvaient reparaître. Avec courage Beethoven l'avait reconnu et c'est pourquoi on peut le croire quand il dit davantage. (48–49)

In 1959 Mauron published a memoir of Forster in *Le Figaro littéraire* in which he recalled him sitting at the piano in the *mas*. One passage, translated, reads:

He plays well, skipping freely from page to page, excusing himself when Beethoven goes a bit too much like the wind.... He is completely at home in the musical world.... He admires Beethoven, who admits, amongst superhuman splendours, the reality of the negative goblins—"panic and emptiness." The secret worm, the chaos, the muddle are never wholly exorcised in this world.... Music more than reason has inspired in Forster the art of seeing, in order better to connect through exquisite relations and to triumph laughing over Chaos Conquered.[39]

Having known Forster intimately for many years and exchanged thoughts on music as well as writing and literature, Mauron was clearly the ideal translator for his work.

Howards End is, finally, about the heart of a house and its relevance to the future of its inhabitants. One house must be deserted, its heart emptied, before another is found:

> Houses have their own ways of dying, falling as variously as the generations of men, some with a tragic roar, some quietly, but to an afterlife in the city of ghosts, while from others—and thus was the death of Wickham Place—the spirit slips before the body perishes. (271)

Mauron's translation captures this spirit:

> Les maisons ont leurs façons de mourir aussi diverses que celles des hommes. Les unes croulent, avec un cri tragique ou dans la paix, pour revivre ensuite au sein d'une cité de fantômes, cependant que d'autres—et ce fut le cas de Wickham Place—voient leur âme s'enfuir avant que leur corps ne périsse. (284)

The sense of generations that is part of the legacy of *Howards End* is implicit in the central lament of the book, the desire for a language shared by all:

> Why has not England a great mythology? Our folklore has never advanced beyond daintiness, and the greater melodies about our countryside have all issued through the pipes of Greece. Deep and true as the native imagination can be, it seems to have failed here.... England still waits for the supreme moment of her literature—for the great poet who shall voice her, or, better still, for the thousand little poets whose voices shall pass into our common talk.[40]

Forster finds his most meaningful expression in the connections between land and living, seeing and speaking. The tradition of things and feelings joined, their contraries combined, is at the heart of the matter for him, as for Woolf. They form a continuum that will pass through such places as Howards End:

> Here had lived an elder race, to which we look back with disquietude. The country which we visit at week-ends was really a home to it, and the graver sides of life, the deaths, the partings, the yearnings for love, have their deepest expression in the heart of the fields. All was not sadness. The sun was shining without. The thrush sang his two syllables on the budding guelder-rose. Some children were playing uproariously in heaps of golden straw. It was the presence of sadness at all that suprised Margaret, and ended by giving her a feeling of completeness. In these English farms, if anywhere, one might see life steadily and see it whole,

group in one vision its transitoriness and its eternal youth, connect—connect without bitterness until all men are brothers. (283–284)

Mauron's feeling about Provence was so like Forster's feeling about England that he was the perfect translator and perfect friend. For him, too, this passage was about connection and brotherhood, and he was able to seize its lyricism without falling into sentimentality. His language remains as forceful as that of Forster himself:

Là vivait naguère une race d'aînés vers laquelle nous nous tournons avec inquiétude. Cette campagne que nous visitons dans nos week-ends, ils y étaient vraiment chez eux; et c'est au coeur des champs que les plus graves aspects de la vie—morts, séparations, recherches de l'amour—trouvent leur expression la plus profonde. Tout n'était pas tristesse. Le soleil brillait au dehors. La grive chantait sa double syllabe sur les boules-de-neige en boutons. Des enfants se roulaient, avec de grands éclats de rire, sur des montagnes de paille dorée. Le surprenant, c'était d'abord que la tristesse fût là, mais, à la longue, le sentiment d'une totalité envahit Margaret. Nulle part mieux qu'ici, dans ce fermes anglaises, on ne pouvait appréhender la vie dans une calme et unique vision, unir sa fuite et son éternelle jeunesse, relier enfin—relier sans amertume, jusqu'au moment où tous les hommes seraient frères. (297)

At the end of the novel, forgiveness and reconciliation are joined: connected, "reliées," with the awareness of and the silencing of an acknowledged fault—Mr. Wilcox's not having taken seriously his wife's legacy of Howards End to Margaret. This legacy is, nevertheless, eventually realized and the final connection made:

Margaret was silent. Something shook her life in its inmost recesses, and she shivered.
"I didn't do wrong, did I?" he asked, bending down.
"You didn't, darling. Nothing has been done wrong." (362)

Mauron translates this passage with a twist:

Margaret se tut. Quelque chose venait d'ébranler sa vie au plus profond d'elle-même et elle frissonna.
—Je n'ai pas mal fait, n'est ce- pas? demanda-t-il en se penchant.
—Non, chéri. On n'a rien fait de mal. (379)

The translation manages here to suggest the essence of the novel by shifting the passive to the active, taking the blame away from the "I" initially and moving to the all-inclu-

sive "on." Margaret's acceptance of Mrs. Wilcox's heritage in all senses guarantees that no one is finally at fault; ultimately they are all joined in Forster's most lasting legacy.

Presenting Stéphane Mallarmé in England

Roger Fry was an early English translator of Mallarmé's dense and complex poetry. His effort to make the work at least partially available to an English public was highly significant in laying the groundwork for its appreciation of French symbolist poetry. His collaboration with Charles Mauron and their continual discussions of the texts had an invaluable impact on later Mallarmé studies.

For Fry only the poet Mallarmé could equal the great modernist novelists, breaking the theme to pieces, as Fry said, then reconstructing it in a cubist fashion. Since art and poetry were always indissolubly linked in Fry's imagination, he compared Mallarmé's unequivocal intensity with that of Cézanne. Mallarmé, he wrote Vanessa Bell, was "certainly almost the purest poet that ever was in the same sort of way as Cézanne was, in the end, the purest of painters."[41]

In his literal translations of Mallarmé, Fry tried to approximate the verbal sequence and to echo the rhythm. As opposed to Fry's utter devotion to the symbolist poet, whose works he carried with him constantly, Vanessa Bell was totally mystified by Mallarmé in either language. She wrote Fry on January 4, 1916, to say that she did not understand the Mallarmé and to ask whether he had done others. She had the French version and had been trying to decide "whether I understood yours or the original best but both are almost hopeless." She looked forward to having him explain them to her. In his commentaries Mauron was better able to take on the task of explaining the poetry of Mallarmé; this was one of his principal critical achievements.

Writing to Marie Mauron, Roger Fry admitted that: "The translations are nearly as difficult as the original, but since I always have an explanation in my head I think the translation will be a kind of commentary on Mallarmé which might be interesting—I don't know if I shall dare to add notes."[42] Once Mauron had added his commentaries, there was no further need for notes, of which only a very few survive; they are less rewarding than Mauron's commentaries.

Fry's practice of literalizing made more intellectual than poetic sense, lending some credence to Clive Bell's frequent indictment of Fry's work as "what he pleases to call translations of Mallarmé." At other times, Fry's intuitive sense of Mallarmé's spirit comes through the language. The poem "Apparition" is such a case, with its understated opening. "La lune s'attristait" is rendered simply and subtly by Fry's "The moon was saddening"; the rarity of this verb, as opposed to the more usual "growing sad," makes it an ideal choice. For two later lines:

Ma songerie aimant à me martyriser
S'enivrait savamment du parfum de tristesse

Fry gives

My dreaming loving to torment me
Was drinking deep of the perfume of sadness

Here the repeated active ending of the present participles: "-ing, -ing, -ing" reinforces the ongoing torment, while the "drinking deep" has an appropriately Baudelairean echo. The radiance of the central apparition itself:

Quand avec du soleil aux cheveux, dans la rue
Et dans le soir, tu m'es en riant apparue

is undulled in the English version:

When with the sun in your hair, and in the street
In the evening, you in laughter appeared to me[43]

In 1918 Fry had discussed the first draft of the translations with André Gide and was delighted to have Gide's approbation of them. Mauron, who had not seen Fry's translations until 1920, when two-thirds of them were in their final shape, described the process: "Every three months or so, a word would be scratched out, another inscribed, thoughtfully, in the little book I was to see so often—until that day when, oh horror! it was filched at the Gare St. Lazare by an unlucky thief …"[44] In other versions of the story the station is at Avignon, near St.-Rémy. In any case, Fry began again, and completed the final version at Royat (Puy-de-Dôme) only a year before his death.

The collaboration of Fry, Mauron, and Julian Bell, son of Vanessa and Clive Bell, had resulted in a translation that introduced an English audience to the foremost French symbolist poet. When Mauron, who had been invited by Fry in 1930 to write commentaries on the poems, completed the "edifice," as Fry put it, translator's notes were not necessary, just a preface.[45] Mauron's long preface gave an overview of Mallarmé's method, remarking on his constant search for "something else" and on "what the psychoanalysts call 'sublimation,' a way of poetic life, a way of using reality instead of repulsing it."[46] Long before the arrival in France of psychoanalysis as we know it, he had pointed out the unconscious potential that can be mined, composed of obsessions both erotic and literary, as in "The Afternoon of a Faun."

Given Mauron's attachment to and knowledge of music, it is no surprise to see him quoting Mallarmé's meditation on music in *Divagations*: "See how, to express the forest, merged in twilight green horizon, there needs only such a chord, where the chase barely

is remembered…. A line, a few brief vibrations, the suggestion is complete."[47] Musical transitions merge meaning with sound, so that the mind and spirit may live by finding a "system of relations" in all their richness. Mauron's commentary on "The Canticle of St. John" compares it with the music of Johann Sebastian Bach.

Mauron remarks of his translation of the difficult "Tomb of Verlaine," "I set out from the idea that in a poem by Mallarmé all the words are necessarily related, either by the plain sense or by relations of overtones; to explain the poem is the same thing as to make apparent his system of relations."[48] In his original preface, Roger Fry had insisted that the reverberation of these relations, forcing a "closer opposition than an ordinary statement would allow," would become obvious only over time. The resonance of a particular word, for example, would last until "its vibration can be taken up by another word," occasioning what we would now call a delay.[49] Later, in Mauron's psychocriticism, the obsessions of a given writer would be mapped by their frequencies and meeting points.

Just as relevant for Mauron's later development of psychocriticism are his remarks on the poet's obsession with absence, silence, nothingness, and "the final victory of whiteness" in the poems "Saint" and "This Virgin, Lively and Lovely Today."[50] Commenting on the "sail's white solicitude" of "Salutation," he stated that, at heart, he preferred this "'whiteness'" to the poem.[51] Of the long poem *Hérodias*, he said that a psychoanalyst would explain it

> better than a literary critic. I believe, to be more precise, that the nurse symbolises, vaguely, the natural life and its temptations; not directly, but, as in Freudian theory, by an evocation of early childhood. For the Mallarmé of *Hérodias* the earthly paradise is in the past….

The poem contains, for him, many of the concepts familiar in modern psychological thinking, with its phallic serpent confronting Hérodias' "inviolate reptile" and her invocation of the moon. If "esthetic one day becomes a branch of psychology," he observes, this poem will provide a testing ground for its exercises.[52] Mauron calls a poet's obsessions the keys to his true nature, Mallarmé's being "the supremacy of the imaginary over the real, of the possible over that which has been, of absence over presence."[53]

Mauron discussed his own theory of translation in his weekly column for *Le Provençal*, under the title "Plaisirs du langage" ("Pleasures of Language"):

> To translate more or less well, for instance, from English into French, you first have to … translate from English into nothing, then from nothing into French…. So the spirit of the translator returns to the impulse, from the sentence towards the state of mute spirit which was its origin. In so doing, he abandons the original

tongue; then having tried to have his intention converge with that of the author, he starts out upon another path and tries to say all at once, in the second language, what the author said in the first.[54]

Here it is clear that for Mauron the idea of nothing and nothingness had evolved into a conclusion both positive and workable. Translation and interpretation had become one.

Bloomsbury in French Translation

Although we have dealt in detail with translations of only a few works by Virginia Woolf and E. M. Forster, we would like to note that there were other translations of their works as well as those of Clive Bell, Roger Fry, Lytton Strachey, John Maynard Keynes, and Vita Sackville-West. The following partial list of translations is intended to be representative rather than comprehensive.

Clive Bell:
English: "English Literature Since the War" (1945); **French**: "La littérature anglaise depuis la guerre" (1945); **English**: "The Umbrellas of Auguste Renoir in the National Gallery, London"; **French**: "Auguste Renoir: Les parapluies dans les National Gallery, London" (1945).

E. M. Forster:
English: *Howards End* (London: Edward Arnold, Ltd., 1910); **French**: *Le legs de Mrs Wilcox*, trad. Charles Mauron (Paris: Plon, 1950); **English**: *A Passage to India* (London: Edward Arnold, Ltd., 1924); **French**: *Route des Indes* (Paris: Plon, 1947); **English**: *The Longest Journey* (London: 1907); **French**: *Le Plus long des voyages*, trans. Charles Mauron (Paris: Union générale d'editions, 1983); **English**: *A Room With A View* (London: Edward Arnold, Ltd., 1908); **French**: *Avec une vue sur l'Arno* (Paris: R. Laffont, 1970); **English**: *Aspects of the Novel* (London: Edward Arnold, Ltd., 1927); **French**: *Aspects du roman* (Paris: Christian Bourgois, 1993).

Roger Fry:
English: "Henri Matisse" (essay; London: A. Zwemmer, 1930); **French**: "Henri-Matisse" (Paris: Editions des Chroniques du jour, 1930); **French**: "Cézanne" (essay written by Fry in French for French journal *L'Amour de L'Art*, 1926 translated by Fry into English to form part of his book on Cézanne); **English**: *Cézanne: A Study of His Development* (London: Hogarth Press, 1927; rpt. Chicago: University of Chicago Press, 1989).

John Maynard Keynes:
English: *The Economic Consequences of the Peace* (London: Macmillan, 1919); **French**: *Les conséquences économiques de la paix* (Paris: La Nouvelle revue française, 1920); **English**: *The General Theory of Employment, Interest, and Money* (London, 1936); **French**: *Théorie générale de l'emploi, de l'intérêt, et de la monnaie,* trad. Jean de Largentaye (Paris: Payot, 1942).

Vita Sackville-West:
English: *Passenger to Teheran* (London: Hogarth Press, 1926); **French**: *Une anglaise en Orient,* trad. Marie-Claude Peugeot (Paris: Anatolia Editions, 1993); **English**: *Pepita* (London: Hogarth Press, 1937); **French**: *Pepita, danseuse gitane; ou, Cinquante années de la vie d'une grande famille anglaise,* trad. Paule de Beaumont (Paris: Les Editions de France, 1939); **English**: *The Edwardians* (London: Hogarth Press, 1930); **French**: *Au temps du Roi Edouard,* trad. Alice Turpin (Paris: B. Grasset, 1933); **English**: *The Letters of Vita Sackville-West to Virginia Woolf* (New York: William Morrow, 1985); **French**: *Vita Sackville-West et Virginia Woolf: leur correspondance 1923–1941* (Paris: Stock, 1985).

Lytton Strachey:
English: *Eminent Victorians* (London: Chatto & Windus, 1918); **French**: *Victoriens Éminents* (Paris: Gallimard, 1933; **English**: *Elizabeth and Essex: A Tragic History* (London: Chatto & Windus, 1928); **French**: *Elisabeth et le comte d'Essex; histoire tragique,* trad. Jacques Heurgon (Paris: Gallimard, 1929); **English**: *Queen Victoria* (London: Chatto & Windus, 1921); **French**: *La Reine Victoria,* trad. F. Roger-Cornaz, F. (Paris: Payot, 1937).

Leonard Woolf:
English: *The Village and the Jungle* (London: 1913); **French**: *Le Village dans la jungle,* trad. Bernard Kreise (Lausanne: l'Age d'homme, 1991).

Virginia Woolf:
English: *A Room of One's Own* (Hogarth Press, 1929); **French**: *Une Chambre à soi,* trad. Clara Malraux (Paris: Denoël, 1977); **English**: *The Diary of Virginia Woolf,* ed. Anne Olivier Bell and Andrew McNeillie, 5 vols. (London: Hogarth Press, 1975–1980); **French**: *Journal,* 8 tomes., trad. Colette-Marie Huet (Paris: Stock, 1983–1993); **English**: *The Death of the Moth* (London: Hogarth Press, 1942); **French**: *La Mort de la phalène,* trad. Hélène Bokanowski (Paris: Seuil, 1968); **English**: *The Years* (London: Hogarth Press, 1937); **French**: *Années,* trad. Germaine Delamain (Paris: Stock, 1938); **English**: *The Essays of Virginia Woolf,* ed. Andrew McNeillie, 2 vols. (New York: Harcourt Brace, 1988); **French**: *Essais/Virginia Woolf,* trad. Claudine Jardin et Florence Herbulot (Paris: Seghers, 1976); **English**: *Jacob's Room* (London: Hogarth Press, 1922); **French**: *La Chambre de*

Jacob, trad. Jean Talva (Paris: Stock, 1973); **English**: *Mrs. Dalloway* (London: Hogarth Press, 1925); **French**: *Mrs. Dalloway,* trad. S. David (Paris: Stock, 1973); **English**: *To the Lighthouse* (London: Hogarth Press, 1927); **French**: *La Promenade au phare,* trad. M. Lanoire (Paris: Stock, 1973); **English**: *Orlando: A Biography* (London: Hogarth Press, 1928), **French**: *Orlando,* trad. Charles Mauron (Paris: Stock, 1973); **English**: *The Waves* (London: Hogarth Press, 1931); **French**: *Les Vagues,* trad. Marguerite Yourcenar (Paris: Stock, 1973); **English**: *Between the Acts* (London: Hogarth Press, 1941); **French**: *Entre les actes,* trad. Charles Cestre (Paris: Stock, 1973).

RIGHT. Alice Mauron in St.-Rémy; photograph by Mary Ann Caws (1996).

BELOW. Angelica Bell Garnett in St.-Étienne-les-Orges; photograph by Sarah Bird Wright (1990).

Conclusion

In this volume we have examined the vital exchange between members of the Bloomsbury group and France that was particularly evident in the first three decades of the twentieth century. The French travels of Roger Fry, Lytton Strachey, Dora Carrington, Ralph and Frances Partridge, Virginia and Leonard Woolf, Vita Sackville-West, John Maynard Keynes, E. M. Forster, and Ottoline Morrell enriched their lives even as they provided a welcome respite from their work. Members of the group often began or ended the channel crossing at the Château d'Auppegard near Dieppe, in Normandy, owned by the artists Ethel Sands and Nan Hudson, where the loggia was painted by Vanessa Bell and Duncan Grant. Their hospitality played an important part in many journeys to and from France.

Henrietta Garnett in Reillanne; photograph by Mary Ann Caws (1998).

The frequency and ease with which members of Bloomsbury, particularly the artists, established and inhabited part-time residences in France was an extension of the sort of life they already led in England. Many in the group, including John Maynard Keynes, E. M. Forster, the Woolfs, Vanessa and Clive Bell, and Duncan Grant divided their time among houses, flats, and apartments in Sussex, London, and Cambridge. What seemed natural to them remained so when the locus of their lives and work shifted to Paris and the Mediterranean.

The numerous letters exchanged between Roger Fry and Vanessa Bell, Clive Bell and Pablo Picasso, Duncan Grant and Vanessa Bell, and between E. M. Forster, Roger Fry, Julian Bell and Charlie and Marie Mauron, illuminate aesthetic and cultural concerns of the times. Correspondence between Carrington and Gerald Brenan about Carrington's travels with Lytton Strachey, between Vita and Harold Nicolson about Vita's travels with Virginia Woolf, and between Dorothy Bussy and André Gide about translation, constitute an invaluable archive for literary historians.

Such documents have a more long-lasting effect than the more immediately engaging gossip and anecdotes that have become clichés. They suggest the climate of France and England during this period, confirming the multiple possibilities of translating, both visually and verbally, the Anglo-French connection.

The art criticism of Roger Fry and Clive Bell about such artists as Paul Cézanne and Jean-Baptiste Siméon Chardin assumes a new importance here, as do Duncan Grant's theatrical designs and his costumes for Jacques Copeau's staging of plays by Shakespeare and Gide. French art, as well as the way in which French artists and writers lived, had an intense impact on the work of the Bloomsbury painters and writers. The translations of French into English art were as significant as the literary translations of the works of Virginia Woolf, E. M. Forster, Lytton Strachey, and Vita Sackville-West. The presentation by Roger Fry, Julian Bell, and Charles Mauron of the poetry of Stéphane Mallarmé was essential to the appreciation of symbolism in the English-speaking world. The two Post-Impressionist Exhibitions, arranged by Roger Fry, with the aid of others in the Bloomsbury group, were a major step in the recognition of modernism by the British public.

Although, after the 1930s, Vanessa Bell, Clive Bell, Duncan Grant, E. M. Forster, and Frances Partridge frequently traveled to and from France, we believe the most significant relations between the countries occurred during the lifetimes of Lytton Strachey, Roger Fry, Virginia Woolf, and Julian Bell, all of whom had died by 1941. Throughout World War II, the English family and friends of the Bussys repeatedly expressed their concern about their well-being in war-torn France; at the same time, the Maurons kept in close touch with E. M. Forster and their other friends in England. After the war, the visits between Bloomsbury and France resumed.

France brought a certain clarity and *joie de vivre* to what, in order to tease Virginia Woolf, her friend Vita Sackville-West once called "Gloomsbury." The way the artistic life was lived abroad carried over into the works of these English writers and artists. The French experience was an essential part of the creative atmosphere of Bloomsbury, on both sides of the English Channel.

The Anglo-French connection illustrated here began as early as the 1890s and continues today, a century later. Bloomsbury descendants Angelica Bell Garnett and Henrietta Garnett still live in the Midi of France, as does Alice Mauron, and the spirit that brought about the early interrelations between Bloomsbury and France is in no sense a dead one.

List of Major Figures

These are a few of the major figures associated with the Bloomsbury/France exchange:

Agostini, Dr. Emmanuel
A Corsican who had moved to Cassis, and named the Villa Corsica, his property, after his native country. He served as mayor of Cassis from 1945 to 1971, and there is still a street in the town named for him.

Allégret, Marc
Film director, adopted son of André Gide, whose friend he became in May 1917. Accompanied Gide to Cambridge in 1918, when Gide studied English with Dorothy Strachey Bussy.

Anghilanti, Elise
A young woman who did the cooking and helped with the La Bergère household of Vanessa Bell and Duncan Grant in Cassis in 1927 and thereafter.

Anrep, Boris
Celebrated Russian mosaicist who came to England in 1899, and whose work can be seen in the floor at London's National Gallery, Tate Gallery, Westminster Cathedral, and the Greek Cathedral. Studied at the Académie Julian in Paris in 1909. He was married to Helen Maitland. They had two children, Anastasia (Baba) and Igor.

Anrep, Helen Maitland
The wife of Boris Anrep, she lived with Roger Fry from the mid-1920s until his death in 1934.

Bagenal, Barbara and Judith
Barbara Hiles ("little Barbara"), studied at the Slade School of Art in London with Dora Carrington. She was beloved by Saxon Sydney-Turner, but married Nicholas Bagenal in 1918. Her daughter Judith was a close friend of Angelica Bell and often stayed at La Bergère in Cassis. She was Clive Bell's last companion.

Bell, Anne Olivier Popham
Wife of Quentin Bell; art historian and editor of Virginia Woolf's diaries.

Bell, Clive
Critic, author (*Proust, Old Friends, Art, Civilization, An Account of French Painting*), and good friend of many French artists, musicians, writers. Married Vanessa Stephen, and was involved with a number of women, including Mary Hutchinson and, at the end of his life, Barbara Bagenal. Awarded the Légion d'Honneur in 1936.

Bell, Julian
Writer, poet, teacher, son of Clive and Vanessa Bell. Translated the works of Stéphane Mallarmé with Roger Fry. He was killed in 1937 while driving an ambulance in the Spanish Civil War.

Bell, Quentin
Son of Clive and Vanessa Bell; artist, writer, memorialist (*Bloomsbury, Julian Bell: Essays, Poems and Letters; Virginia Woolf: A Biography, Elders and Betters* [U.S. title, *Bloomsbury Recalled*]). Professor of Fine Art, Sussex University, and author of acclaimed biography of Virginia Woolf.

Bell, Vanessa
Née Vanessa Stephen, she was a painter, writer (*Notes on Virginia's Childhood*), and sister of Virginia Woolf. In 1907 she married the art critic Clive Bell; they had two sons, Quentin and Julian. They lived in London, on Gordon Square, but came often to Charleston Farmhouse in East Sussex, which served as their holiday house until World War II. After a love affair with Roger Fry, she lived with Duncan Grant until her death; they had a daughter Angelica. The Bell family and Duncan Grant were, along with Roger Fry, the members of the Bloomsbury group who were closest to the French.

Blanche, Jacques-Émile
Teacher of Duncan Grant at Paris art school La Palette; painter, had a studio at Bas Fort Blanc in Dieppe, near Nan Hudson and Ethel Sands at the Château d'Auppegard; friend of Duncan Grant, Vanessa Bell, and Ethel Sands; also a writer (*Portraits of a Lifetime*).

Bréal, Auguste
Painter, art historian (*Vélasquez*, translated by Dorothy Bussy, *Rembrandt*), and writer (*Cheminements*). Childhood friend of André Gide, at the Ecole Alsacienne. Specialist in Eastern Languages (Sanskrit, Hindi) and researcher at Christ's College, Cambridge. Friend of Lowes Dickinson, Walter Richard Sickert, Roger Fry. Studied at the Ecole Beaux Arts under Gustave Moreau with Matisse and Simon Bussy. Married Louise Guiyesse, with whose mother Pernel Strachey lodged, as did Simon Bussy. Introduced Simon Bussy to the Strachey family. Organized la Maison de la Presse. He and his wife lived at Lamardeto at Ste.-Marguerite outside Marseilles.

Brenan, Gerald
Writer, memorialist (*A Personal Memoir, South of the Border*). Loved Carrington, with whom he was involved over many years. Lived in Yegen, a mountain village in Spain, where he was visited by Lytton Strachey, Carrington, Leonard and Virginia Woolf, Frances and Ralph Partridge. Married an American, Gamel Woolsey.

Bussy, Dorothy (née Strachey)
Sister of Lytton, who was fifteen years younger than she. Author of *Eugène Delacroix* and the anonymously

published novel *Olivia*. Translator of Auguste Bréal's *Vélasquez*, Camille Mauclair's *Antoine Watteau*, and the major part of André Gide's works. Expert on language, giving learned broadcasts for the BBC.

Bussy, Jane Simone ("Janie")

Painter and translator, the daughter of Simon and Dorothy. She was a pupil of Jan Van den Eeckhoudt. A frequent visitor to Charleston Farmhouse, she translated Clive Bell's book on Matisse into French and taught Virginia Woolf French.

Bussy, Simon-Albert

French painter from Dole, known for his animal studies and portraits. Known as "Albert" until 1898, then took the name "Simon." Studied at the Académie Carmen, founded by James Abbott McNeill Whistler, then with Gustave Moreau at the Ecole des Beaux-Arts, along with Henri Matisse and Auguste Bréal. "Little Bussy" married Dorothy Strachey at age thirty-three. Friend of André Gide, Roger Martin du Gard, and Valéry. The Bussys lived half the year at "La Souco," Roquebrune, near Menton, and in England the other half. Lived in Nice during World War II, near his friend Henri Matisse.

Campbell, Jean

A former nurse, she became the companion of Colonel Peter Teed and lived with him in Cassis at Fontcreuse, the estate on which Vanessa Bell and Duncan Grant remodeled a farm workers' cottage, La Bergère. They also had a vineyard and made excellent wine. She, Peter Teed, Duncan, and Vanessa were close friends.

Carrington, Dora

A painter who preferred to be called "Carrington," she was the daughter of a railway engineer. She studied art at the Slade School of Art in London and was one of the "cropheads," wearing her hair short. She met Lytton Strachey in 1915 and fell passionately in love with him, to the disgust of the painter Mark Gertler, who loved her. She lived with Strachey at Tidmarsh, then at Ham Spray. She married Ralph Partridge, but was also involved with Gerald Brenan, Henrietta Bingham, and "Beakus" Penrose. She committed suicide six weeks after Strachey died of cancer.

Champcommunal, Elspeth

Lived at Vaison-la-Romaine in the Vaucluse, where Roger Fry and Charles and Marie Mauron visited her.

Derain, André

A French painter (one of the "Fauves") and stage designer. He painted in London in 1906. In 1919 he returned to England with Picasso as the designer of *La Boutique fantasque* for Sergei Diaghilev's Ballets Russes, presented at the Alhambra Theatre, London. He was a friend of the Bells and of Roger Fry.

Doucet, Henri

A promising young French painter, killed in World War I. He had been a close friend of Roger Fry.

Duthuit, Georges

French art critic and a specialist in Byzantine art, as was his friend Matthew Prichard. He married the daughter of Henri Matisse, Marguerite. The dining room at Charleston Farmhouse was sponsored by the late Marguerite Duthuit, her son Claude, and the late Pierre Matisse in memory of Georges Duthuit, who often visited there.

Forster, E. M. ("Morgan")

Member of the Apostles at Cambridge. Novelist and essayist (*Passage to India, Howards' End, A Room with a View*). Lived at King's College, Cambridge; close friend of the Bloomsbury group, including Roger Fry, and of the Mauron family in France. His works were translated into French by Charles Mauron. Involved with Bob Buckingham ("the Major.")

Friesz, Achille-Emile-Othon

Painter, friend of the Bells and Roger Fry, and much admired in England. He was a frequent visitor to Cassis.

Fry, Roger

Art critic, lecturer, and painter. Member of the Apostles at Cambridge University. Studied painting at the Académie Julian in Paris in 1882. Curator of the Department of Paintings at the Metropolitan Museum of Art, New York, 1906–1909. Became Slade Professor of Art at Cambridge University in 1933. Through his initial contact with Charles and Marie Mauron at St.-Rémy, the Bell and Woolf families became closer to Provence. His wife, Helen Coombe, with whom he had two children, Pamela and Julian, was committed to a mental institution with a brain tumor, dying after Fry's death. Fry was passionately involved with Vanessa Bell, with whom he remained friends; then, among others, with a Breton woman, Josette Coatmellec. He finally lived with Helen Maitland (wife of Boris Anrep).

Garnett, Angelica Bell

Artist and writer (*Deceived with Kindness: A Bloomsbury Childhood, Vanessa Bell's Family Album, The Eternal Moment*), daughter of Vanessa Bell and Duncan Grant. Married David Garnett in 1942; they had four daughters. Angelica moved to France in 1984 and settled in Forcalquier; eventually she and "Bunny" Garnett were legally separated.

Garnett, David

Writer (*The Golden Echo, The Flowers of the Forest, The Familiar Faces, Great Friends*), many of which evoke early Bloomsbury. Married Ray Costelloe Marshall, sister of Frances Marshall (who later married Ralph Partridge). After Ray died of cancer, he married Angelica Bell, daughter of Duncan Grant and Vanessa Bell; they had four daughters. David Garnett moved to France in 1970, living in Montcuq, near Charrey in the Pyrenees, where Frances Partridge often visited him.

Germany, Grace (*see* Higgens, Grace Germany)

Gide, André

Prolific and celebrated French writer (*The Counterfeiters*, *Strait Is the Gate*, and other novels and works of nonfiction). He was an early apologist for homosexuality in *The Immoralist* and *Corydon*. Playwright and amateur musician, editor of *Nouvelle Revue Française*. Lived with his wife, Madeleine, at Cuverville in Normandy; loved Marc Allégret, whom he legally adopted. Went to England in 1918, with an introduction from Auguste Bréal to Lady Strachey, with whose daughter Dorothy he took English lessons. She became his translator and fell in love with him. Had a daughter, Catherine, with Elizabeth Van Rysselberghe, daughter of Maria Van Rysselberghe, known as "la petite Dame," who kept a journal about him.

Gimond, Marcel-Antoine

French sculptor whose work is represented at Charleston. Friend of Vanessa Bell and Roger Fry.

Goncharova, Natalia

Stage designer and painter; studied at the Moscow School of Fine Arts. Exhibited in St. Petersburg and Moscow. Goncharova designed sets and costumes for Diaghilev's *Coq d'Or*. She and her husband, Mikhael Larionov, were co-founders of the Russian school called Rayonism. They moved to Paris, and constructed costumes and marionette designs for the ballet. On meeting them in Paris, Duncan Grant commented on their "extraordinary charm."

Gowing, Lawrence

Artist, art critic, and second husband of Julia Strachey (daughter of Oliver Strachey). He was one of the "Euston Road" school of painters with a naturalistic bent (named for the School of Drawing and Painting on Euston Road); he later became Curator of the Royal Academy collections. In 1960 he accompanied his wife and Frances Partridge to La Souco, Roquebrune, after the deaths of Simon, Janie, and Dorothy Bussy, to assess the paintings of Simon Bussy.

Grant, Duncan

Painter and decorator, of Scottish descent. Studied with Simon Bussy, with Jacques-Émile Blanche at La Palette, Paris, and with Gustave Moreau at the Ecole des Beaux-Arts. He was Lytton Strachey's cousin and lived with the Strachey family as a child. A homosexual, he was in love with Lytton, Maynard Keynes, George Bergen, and Paul Roche. He was the lifelong companion of Vanessa Bell, with whom he had a daughter, Angelica, later Angelica Garnett. He designed costumes and sets for Jacques Copeau, and collaborated with Roger Fry in producing work for the Omega Workshops. Between the wars many people regarded him as the major English painter.

Heurgon, Jacques

French critic and translator. He was the biographer of Cardinal Manning and the translator of Lytton Strachey. He was married to Anne Heurgon-Desjardins and attended most *décades* at Pontigny, the literary conferences founded by her father.

Heurgon-Desjardins, Anne

Wife of Jacques Heurgon and daughter of Paul Desjardins, founder of the Pontigny *décades* and inspirer of L'Union pour la Vérité, whose tradition she carried on at Cerisy-la-Salle, near St.-Lô, Normandy, with her daughters.

Higgens, Grace Germany

Called "the angel of Charleston," she came to work for Vanessa and Clive Bell in London in 1920 when she was only sixteen. A maid at first, she served later as the children's nurse, family cook, and housekeeper. She usually accompanied the family to France, becoming fluent in the language. In 1934 she married Walter Higgens and eventually they lived at Charleston permanently with their son, John. She remained with the household for over forty years, caring for Duncan Grant after Vanessa's death in 1960.

Keynes, (Baron) John Maynard

Member of the Apostles at Cambridge. Economist, patron of the arts, and writer (*A Treatise on Probability*, *The Economic Consequences of the Peace*); editor of the *Economic Journal*. Lecturer in Economics at Cambridge; lived partly at Cambridge, partly in London, and partly at Charleston Farmhouse, which became the repository of a number of valuable paintings. He married the Russian ballerina Lydia Lopokova and lived at Tilton, near Firle Place and Charleston.

Larionov, Mikhael

Stage designer and painter; married to Natalia Goncharova, with whom he frequently worked. They founded the futurist school in Russia called "Rayonism," then moved to Paris, where they were friends of Clive and Vanessa Bell.

Le Bas, Edward, R.A.

Professional painter with studio in Glebe Street, site of frequent parties. In 1946 he went to Dieppe with Vanessa and Duncan, and in June 1961, after Vanessa's death, he took Duncan to France. He had a fine collection of pictures, including a Bonnard. He posed for Christ in the Crucifixion fresco at Berwick Church, painted by Duncan Grant and Vanessa Bell. Diana Holman-Hunt was his companion at the end of his life.

MacCarthy, Desmond

Journalist "(Affable Hawk")," secretary for Roger Fry's first Post-Impressionist exhibition in London, "Manet and the Post-Impressionists" (1910), for which he wrote the introduction to the catalog. He was dramatic critic of the *New Statesman*, literary editor of the *New Quarterly*, and held other editorial posts. He was married to Mary ("Molly"); two of their

children, Dermod and Rachel, were close friends of Frances and Ralph Partridge and went to Brittany with them.

MacCarthy, Molly

The former Mary Warre-Cornish, she was a painter and the wife of Desmond MacCarthy; involved with Clive Bell at one time. She was a close friend of Vanessa Bell, Virginia Woolf, and Frances Partridge. Afflicted with increasing deafness toward the end of her life, she still took part in Bloomsbury gatherings.

McNeil, Margaret M. ("Daisy")

Aunt of Duncan Grant (his mother's sister). An explorer, guidebook writer, and Fellow of the Royal Geographical Society, Aunt Daisy was the prosperous owner of a nursing home near Eastbourne, Sussex. She owned the seventy-foot steel auxiliary ketch, *Arequipa*, which she sometimes moored in the harbor at Cassis, and was a friend of Georges Braque.

Marchand, Jean

French painter with whom Quentin Bell studied at l'Académie Moderne in Paris, and good friend of Roger Fry and the Bloomsbury group. He lived in Vence, painted in Cagnes-sur-Mer, and was loved by Gwen Darwin Raverat.

Massine, Léonide Fedorovich

Russian dancer, choreographer, and ballet master. He was a member of Sergei Diaghilev's company and created many important ballets, including *La Boutique fantasque*. He and Lydia Lopokova (wife of Maynard Keynes) often performed together, although at times Lydia felt ill-treated by him.

Mauron, Charles

French chemist by training. When he lost his eyesight he took up literary criticism, encouraged by Roger Fry, for whose translations of Mallarmé he wrote psychological commentaries and with whom he had lengthy discussions about aesthetics and philosophy. He founded the school of psychocriticism, a method that deals with obsessive metaphors recurring in an author's work as unconscious revelations of personality. He was the translator of E. M. Forster, Virginia Woolf, and others, and wrote a column for a Provençal newspaper. With Marie, his first wife, he lived in the Mas d'Angirany at St.-Rémy, purchased with Roger Fry. With Alice, his second wife, he had three sons.

Mauron, Marie

Schoolteacher and writer of Provençal stories and tales. She was the first wife of Charles Mauron. Roger Fry encouraged her to publish her first work (*Mont Paon*, translated by Peter Lucas).

Morrell, (Lady) Ottoline

Distinguished, unconventional, generous wife of Philip Morrell, who was twice a Liberal Member of Parliament. They had one daughter, Julian. She gave flamboyant parties in London and at Garsington, their country manor house outside Oxford. She was involved for many years with Bertrand Russell, briefly with Roger Fry, and with Charles Lamb. Many members of the Bloomsbury group attended her parties and entertained her in turn; in later years she was close to Virginia Woolf and to the Bussys.

Mortimer, Raymond

Literary critic; shared a house at one time with Edward Sackville-West, Desmond Shawe-Taylor, music critic, and Eardley Knollys at Long Crichel, rectory in Dorset. He traveled to France with Frances Partridge, as did Desmond Shawe-Taylor.

Nicolson, Sir Harold

English diplomat, historian, and writer (*The Development of English Biography, The Congress of Vienna, The Evolution of Diplomatic Method, The Age of Reason*). He was married to Vita Sackville-West.

Partridge, Frances (Marshall)

Cambridge graduate, translator, and writer (including *A Pacifist's War, Memories, Julia: A Portrait of Julia Strachey, by Herself and Frances Partridge, Hanging On: Diaries 1960–1963*, and *Other People: Diaries 1963–1966*). Was very close to the unconventional ménage of Dora Carrington, Lytton Strachey, and Ralph Partridge; married Ralph after Carrington's suicide. Their son, Burgo, married Henrietta Garnett.

Penrose, Roland

English painter and patron of the arts. Lived in Cassis, where he was a friend of Yanco Varda and the owner of the Villa Mimosa. Beakus Penrose, his brother, was Carrington's last lover. He was a collector of surrealist art.

Philipps, Wogan (later Lord Milford)

Artist, Cambridge friend of many in the Bloomsbury group, including Frances Partridge and Lytton Strachey. Rented a studio in Fitzroy St. above that of Vanessa and Duncan. Married to the novelist Rosamond Lehmann; they traveled in France with George (Dadie) Rylands and Lytton Strachey.

Prichard, Matthew

Byzantinist, friend of Gertrude Stein, Duncan Grant, and Roger Fry. He was influential in establishing the Boston Museum of Fine Arts and was a close friend of Georges Duthuit.

Raverat, Gwen Darwin

Granddaughter of Charles Darwin and wife of the French painter Jacques Raverat. She was the author of *Period Piece: A Cambridge Childhood*. She was a painter and wood engraver, and was in love with Jean Marchand.

Raverat, Jacques

French painter who studied mathematics at Cambridge, where he became involved with Ka Cox before marrying Gwen Darwin and settling in Vence. They were close friends of many members of the

Bloomsbury group; Jacques and Virginia Woolf had an extensive correspondence. He was a victim of multiple sclerosis and died early.

Rendel, Dr. Elinor

The niece of Lytton Strachey (daughter of his eldest sister, Elinor) and a physician who treated Roger Fry and several other members of the Bloomsbury group.

Roche, Paul

A Roman Catholic priest, he called himself "Don" when he met Duncan in London in 1946 while waiting to cross the street with his bicycle. He left the priesthood a few years later and remained Duncan's close friend and, often, his model until Duncan's death in 1978. He was married to the former Clarissa Tanner, by whom he had three children; he had an illegitimate son by another woman. He translated works from Greek and was a professor at Smith College, Massachusetts, in the United States.

Rylands, George (Dadie)

Poet, Cambridge don, and theater director. Attended King's College, Cambridge; in 1922 elected an Apostle. Friend of many in Bloomsbury group; traveled in France with Lytton and Carrington. Worked for the Hogarth Press in 1924.

Sackville-West, Mary Victoria (Vita)

English novelist, critic, celebrated gardener, and poet (*The Edwardians, All Passion Spent, The Land,* and *Knole and the Sackvilles*). She grew up at Knole Castle and was the wife of the writer and diplomat Sir Harold Nicolson; they had two sons, Benjamin and Nigel. She had love affairs with Violet Trefusis and Virginia Woolf, among others, and was the subject of Virginia Woolf's novel *Orlando.*

Sands, Ethel

American-born painter, generous hostess, and friend of many members of the Bloomsbury group. A naturalized British subject, she was also a friend of Henry James. She studied art with Eugène Carrière in Paris, and was associated with the school of Walter Richard Sickert. She lived with Nan (A. H.) Hudson, also an American-born painter. They spent part of each year in London and also owned the Château d'Auppegard at Offranville, near Dieppe, where the Bloomsbury group visited, and where Duncan Grant and Vanessa Bell decorated the loggia. Ethel had a studio in Dieppe and was a friend of Jacques-Émile Blanche, one of Duncan Grant's teachers.

Satie, Erik

French composer and pianist; created, with Picasso and Jean Cocteau, the ballet *Parade,* which Vanessa Bell described with enthusiasm to Clive Bell. She and Duncan Grant knew him in Paris, as did Roger Fry.

Segonzac, André Dunoyer de

A French painter and admirer of Vanessa Bell, whom he called "la grande Vanessa." He was a friend of Winston Churchill and was much admired in England.

Senhouse, Roger

Friend of Lytton Strachey's, with whom he had an affair from 1925 until about 1931. Educated at Eton and Oxford, he frequently stayed at Ham Spray House and traveled with Lytton on the Continent. Later he became a partner in the publishing firm Secker & Warburg.

Shawe-Taylor, Desmond

During the late 1940s and early 1950s shared Long Crichel, a Georgian stone house fifteen miles from Salisbury (Dorset), with Edward Sackville-West, Eardley Knollys, and Raymond Mortimer. They had an ample library, a croquet lawn, dogs, a terrace, and a large collection of French and English paintings. He and Frances Partridge were friends and traveled to France together. During the 1960s, he was music critic for the *Sunday Times.* He and Vita Sackville-West sometimes visited Charleston before attending opera performances at Glyndebourne.

Sickert, Walter Richard

A British painter and etcher, born in Munich of German ancestry. A member of the Camden Town Group of artists in London, he was a friend of Roger Fry and of Ethel Sands.

Strachey, Lady Jane Maria

The daughter of Sir John Peter Grant and Henrietta Chichele, she married Richard Strachey and became the mother of thirteen children, ten of whom survived infancy. Lytton was the eleventh child. She read aloud to her family every night in French and exerted a strong influence over their intellectual development. She was a friend of Robert Browning, George Eliot, Virginia Woolf, and Marie Souvestre, founder of the distinguished school for girls called Les Ruches, at Fontainebleau. Her daughters Elinor and Dorothy attended this school (as did the American expatriate lesbian writer Natalie Clifford Barney). Dorothy Bussy later wrote a novel, *Olivia,* about "Les Avons," her pseudonym for the school. In 1920 Carrington painted a well-known portrait of Lady Strachey.

Strachey, Lytton

A member of the Apostles at Cambridge, he was a critic and biographer (*Landmarks in French Literature, Eminent Victorians*). He was a central member of the Bloomsbury group, a close friend of Virginia Woolf and Vanessa Bell, and the longtime companion of Dora Carrington. A homosexual, he was at varying times in love with Duncan Grant, Maynard Keynes, and other men. "A Fortnight in France" recounts his last trip before he died of cancer.

Strachey, Pernel

One of the scholarly sisters of Lytton Strachey, she became the principal of Newnham College, Cambridge, and was a close friend of Roger Fry.

Strachey, Philippa ("Pippa")

A sister of Lytton Strachey, she became an influential member of the Women's Suffrage Movement and a close friend of Roger Fry. She and Roger had a brief love affair at Roquebrune.

Teed, Lt. Col. A. S. H. (Peter)

Retired British cavalry officer, formerly with the Bengal Lancers. He owned Fontcreuse, an estate in Cassis, where he lived with his companion, Miss Jean Campbell. She was a former nurse who had cared for his first wife. They had a vineyard at Fontcreuse and made excellent wine. They let La Bergère, a farmworkers' cottage on the property, to Vanessa Bell and Duncan Grant, who remodeled it and spent periods of time there from 1927 to 1931, revisiting it in 1937 and 1938.

Turner, Percy Moore

British art dealer and owner of the Independent Gallery, 7a Grafton Street, London. He held exhibitions of the works of Friesz, Marchand, and Segonzac, respectively, in 1921, 1922, and 1923, and also showed works by Roger Fry and Duncan Grant.

Varda, Yanco

Romanian artist who made his home in Cassis; friend of Roland Penrose.

Vildrac, Charles

Poet and playwright (*Le Paquebot Tenacity*), occasional painter, member of L'Abbaye, and Unanimiste. An art dealer, he was the owner of the Galerie Vildrac, 16 rue de Seine, which moved to 11 rue de Seine. He handled the works of Segonzac, Friesz, Camoin, Derain, and Vlaminck. In 1921 he let his villa in St. Tropez, the Maison Blanche, to Vanessa Bell and Duncan Grant, at the suggestion of Roger Fry.

Walter, François

Writer; in the 1930s, as Pierre Jérôme, founded the Comité de Vigilance des Intellectuels Français. Married the painter Zoum Vanden Eeckhoudt, closest friend of Janie Bussy. Friend of the Maurons and Angelica Garnett.

Walter, Zoum

Painter and writer; author of *Pour Sylvie*. Formerly Zoum Vanden Eeckhoudt, best friend of Janie Bussy. Her parents were close friends of Simon and Dorothy Bussy. Before going to the London Theatre School, Angelica Bell Garnett had lived with the Walters in Paris.

Woolf, Leonard

A member of the Apostles at Cambridge, Leonard Woolf was one of the initial members of the nucleus of friends who later formed the Bloomsbury group. A novelist and political writer (*The Village and the Jungle, The Wise Virgins, Principia Politica*), Woolf wrote a multivolume autobiography. He was a member of the Fabian Society. With his wife, Virginia Woolf, he founded the Hogarth Press.

Woolf, Virginia

Novelist, essayist, biographer, and critic, Virginia Woolf is the best known of the Bloomsbury group. Her novels include *The Waves, To the Lighthouse*, and *Mrs. Dalloway*; she was also the author of a biography of Roger Fry and several collections of essays, including *The Common Reader*. The daughter of Sir Leslie Stephen, she was the sister of Vanessa Stephen Bell and the wife of Leonard Woolf. She and her husband founded the Hogarth Press. They divided their time between a town house in London and Monks House, Rodmell, Sussex. She had several nervous breakdowns throughout her life, and drowned herself in 1941.

Zborowski, Leopold

Parisian art dealer of Polish extraction. He handled the work of Duncan Grant. With the Sitwells, he organized the Mansard Gallery (Heal's) exhibition of French art in 1919. He lent Vanessa Bell and Duncan Grant a room in Paris to serve as their studio.

Chronology

Dates of Principal Associations Between the Bloomsbury Group and France

Abbreviations

CB	Clive Bell (1881–1964)
JB	Julian Bell (1908–1937)
QB	Quentin Bell (1910–1996)
VB	Vanessa Stephen Bell (1879–1961)
DB	Dorothy Strachey Bussy (1865–1960)
SB	Simon Albert Bussy (1870–1954)
DC	Dora Carrington (1893–1932)
EMF	Edward Morgan Forster (1879–1970)
RF	Roger Fry (1866–1934)
ABG	Angelica Bell Garnett (1918–)
DG(B)	David Garnett (Bunny) (1892–1981)
AG	André Gide (1869–1951)
DG	Duncan Grant (1885–1978)
DM	Desmond MacCarthy (1878–1952)
NH	Nan Hudson (1869–1957)
JMK	John Maynard Keynes (1883–1946)
LL	Lydia Lopokova (1891–1981)
CM	Charles Mauron (1899–1966)
OM	Ottoline Morrell (1873–1938)
FP	Frances Marshall Partridge (1900–)
RP	Ralph Partridge (1894–1960)
VSW	Vita Sackville-West (1892–1962)
ES	Ethel Sands (1873–1962)
LS	Lytton Strachey (1880–1932)
LW	Leonard Woolf (1880–1969)
VW	Virginia Stephen Woolf (1882–1941)

1892 RF spends two months in Paris studying art at the Académie Julian.
OM (then Lady Ottoline Violet Anne Cavendish-Bentinck) visits Paris with her mother, Lady Bolsover, who buys her a pearl necklace that had belonged to Marie Antoinette.

1893 SB meets Roger Fry at Christ's College, Cambridge.

1896 VB and VW to northern France with their half brother George Duckworth and his aunt, Minnie Duckworth.
RF leaves Paris after six years of art study; does not reside there again, though often visits. Marries Helen Coombe; they go to Paris and Avignon en route to Tunis and Bizerta on wedding trip.

1897 ES and NH meet in Paris, where they are both studying art.
SB and Henri Matisse study art in Paris at the Ecole des Beaux-Arts under Gustave Moreau;

SB exhibits at Durand-Ruel in Paris.

1898 LS to Paris, Tours and Loches, where he stays with Renon family.

1899 CB to Trinity College Cambridge; has large photographic reproduction of Degas painting on his wall.
LS, LW, CB meet at Trinity College.
SB publishes volume of pastels; Auguste Bréal writes preface.

1900 LS misses fall term at Cambridge; goes to St.-Jean-de-Luz near Biarritz (Hôtel d'Angleterre) for his health.

1901 LS and his sisters Dorothy (later DB) and Marjorie visit their aunt and uncle, Sir James and Lady Colvile, at the Villa Henriette, Menton.
SB takes studio in Kensington; gives art lessons to Dorothy Strachey and her cousin, Duncan Grant.

1902 LS and LW introduce JMK, first-year Cambridge student, to writings of G. E. Moore.
Ottoline Cavendish-Bentinck marries Philip Morrell; they honeymoon in Paris.

1903 SB given letter of introduction to Strachey family in London by Auguste Bréal.
SB and Dorothy Strachey marry; her father, Sir Richard Strachey, gives La Souco, villa on the French Riviera at Roquebrune, as wedding gift; for most of their married lives, SB and DB live at La Souco, Roquebrune most of the year, spending summers in England with the Strachey family, usually going there in May and returning to France in late September or early October. Their stays in England have not been listed separately. They spent the years of World War II in Nice.

1904 **Jan.**: CB arrives in Paris to work on political dissertation; visits Louvre and finds art to be of more interest.
LS visits DB and SB at La Souco, Roquebrune; SB draws a pastel of him writing.

1905 DG finishes studying art in London; meets VB through Pippa Strachey; goes to France on vacation.
Virginia Stephen and her brother Adrian stop at Le Havre and Rouen en route to Portugal.

1906 Virginia and Vanessa Stephen travel through France en route to Greece.
Jan.: RF accepts curatorship of Department of Paintings, Metropolitan Museum, New York; Feb.: arrives in New York.
Aug.: RF visits Calvados in Normandy to see

house and chapel for possible purchase by Metropolitan Museum.

Feb.: DG goes to Paris, using £100 coming-of-age gift from his aunt, Lady Colvile; LS, who is in love with him, accompanies him. They stay at the Hôtel L'Univers et du Portugal, where DG continues to stay for a number of months. LS goes on to Menton, staying with Bussys at La Souco, Roquebrune.

Mar.: Jane Simone Bussy born, only child of DB and SB (called "Janie").

VSW writes three plays in French between 1906 and 1908.

May: OM gives birth to twins; son dies; daughter, Julian, survives.

1907 **Feb.**: Vanessa Stephen and CB marry.

Mar.–Apr.: CB, VB, Virginia and Adrian Stephen in Paris.

DG continues to study art in Paris; begins watercolor copy of Rubens in the Louvre; LS still in love with him.

Mar.: JMK comes to Paris to visit; in love with DG; July: goes mountaineering in Pyrenées and on to Biarritz, losing at gambling.

April: RF goes to Paris to purchase Renoir's *La Famille Charpentier*.

OM meets many Bloomsbury figures in London, including EMF, RF, JMK, LS, DM, and James Strachey.

1908 **Feb.**: JB born to CB and VB.

JMK accepts lectureship in economics at Cambridge.

Summer: JMK and DG vacation together in the Orkneys.

VB probably meets OM this year in the home of Augustus John.

RF introduces OM to the works of Cézanne (who had died in 1906).

DG writes article on SB, published in *The Spectator*.

1909 Virginia Stephen probably meets OM this year. OM and Philip Morrell accept offer of apartment in the Hotel Crillon, Paris.

RF visits "Exhibition of Fair Women" at gallery of London dealer Agnew, writing acerbic review of SB's works for the *Burlington Magazine*. Accepts joint editorship of the magazine (with Lionel Cust).

VSW goes to France with mother, who orders dresses for her at Worth's.

1910 **Jan.**: VB, CB, RF, who have met briefly, converse again on railway platform, Cambridge, marking beginning of lifelong friendship. Virginia and Adrian Stephen, DG, and others take part in the *Dreadnought* Hoax.

Feb.: RF's association with the Metropolitan

Museum, New York, is terminated.

Mar.: JMK elected fellow of King's College, Cambridge; he and DG go to Marseilles and on to Greece and Asia Minor.

Summer: OM and Philip go to Marseilles and Aix (Hôtel de Thermes); Augustus John and Dorelia take them by donkey cart to Cézanne's former house on the outskirts of Aix.

Nov.: "Manet and the Post-Impressionists," first Post-Impressionist Exhibition, opens at the Grafton Galleries, London; RF arranges it, DM writes unsigned preface; CB, OM help select pictures for it in Paris.

OM meets Nijinsky in Paris; not impressed at the time.

July: Sergei Diaghilev brings Russian ballet to London; OM dazzled at Nijinsky's performance at Covent Garden.

Aug.: QB born to CB and VB.

Summer: Ten-day intellectual meetings (*décades*) held at Pontigny for the first time; organized by Paul Desjardins.

1911 **April**: CB, and VB travel to Turkey, meeting RF and Harry Norton there; VB has miscarriage at Brusa; falls in love with RF.

Oct.: VB, CB, DG, RF in Paris. VB and CB purchase Pablo Picasso's 1908 painting *Cruche, bol et citron* (*Pitcher, Bowl and Lemon*) for £4 (sold in the 1960s but copied first by QB for Charleston).

1912 **Spring**: JMK spends Easter holiday at Beaulieu, on the French Riviera, with Gerald Shove.

Spring, summer, fall: OM makes several trips to Lausanne to consult doctors about various maladies. Bertrand Russell accompanies her in June; they visit Voltaire's house at Ferney and continue on to Paris, touring Versailles.

July: RF organizes exhibition at the Galerie Barbazanges, Paris, the "Exposition de Quelques Artistes Indépendants Anglais," to present English artists to a French public; DG exhibits his work.

Aug.: Virginia Stephen and LW marry; tour Continent on their wedding trip, going to France, Italy, Spain.

About this time, VB and CB come to know Henri Matisse and Charles Vildrac in Paris.

Oct.: RF, DG, CB travel in France (RF and DG by bicycle; CB by train); RF organizes Second Post-Impressionist Exhibition, which runs at Grafton Galleries, London from Oct. to Dec.; purpose is to promote exchange between British and French artists.

RF brings theater director Jacques Copeau to England from Paris and introduces him to DG and VB.

SB discovers talent for painting brightly colored animals and birds, which become his specialty.

Henri Doucet paints picture of JB, then four years old.

Dec.: JMK and DG stay at La Souco, home of DB and SB at Roquebrune.

1913 **Mar.**: LS to France via Folkestone and Boulogne; made notes about his fellow passengers.

Summer: Jacques Copeau sees Harley Granville-Barker's production of *Twelfth Night* in London; invites DG to design costumes and scenery for a Paris production of *Twelfth Night*.

Sept.: DG sends drawings to Paris.

Oct.: Jacques Copeau founds the Théâtre du Vieux Colombier (Theater of the Old Dovecote) in Paris.

Nov.: VB invites Molly MacCarthy, wife of DM, to spend a few days in Paris and see the Salon d'Automne.

VSW to Paris; visits Rodin Museum.

VSW marries Harold Nicolson.

OM and Philip purchase Garsington Manor, outside Oxford; do not occupy it for two years.

1914 **Feb.**: Gertrude Stein takes DG to meet Picasso, who needs wallpaper for his collages. DG finds suitable paper in his hotel closet.

Apr.: DG goes to Paris to help Copeau with production of *Twelfth Night*; play opens in May. VB and DG spend several weeks in Paris painting and meeting with artist friends.

June: VB and RF go on biking trip through France.

Aug.: World War I declared; DG, DG(B), CB are pacifists; do farm work; JMK with Treasury; LS excused because of health; LW opposes war, loses favorite brother in France; RF, with his sister Margery Fry, assists Friends' War Victims Relief; RP fights in France.

Philip Morrell, M.P., gives antiwar speech in the House of Commons.

SB, who has built studio above La Souco, begins concentrating on small animal and plant compositions, the former based on observations at the London Zoo and elsewhere.

1915 OM and Philip move into Garsington Manor.

Henri Doucet, French artist friend, killed in Belgium.

Feb.: LS and DC meet through DG(B).

CB and Mary Hutchinson, wife of barrister, begin affair that will last until about 1927.

Apr.: English poet Rupert Brooke dies of blood poisoning aboard hospital ship at Lemnos.

May: VB writes RF that SB has been assigned to

duty in a hospital, not allowed to be war artist.

May: RF seeks respite from war at La Souco, Roquebrune.

June: JMK goes to Nice to negotiate financial matters with Italians.

DG makes life-size marionettes for a reading of Racine's *Bérénice*, staged at the home of CB and VB at 46 Gordon Square.

Nov.: Paris theaters closed; DG not allowed to go to Paris to assist Jacques Copeau with production of *Macbeth*.

Dec.: JMK travels to Versailles to visit physician brother Geoffrey, on medical duty there.

Dec.: OM invites LS, CB, JMK, VB and sons, George Santayana, John Middleton Murry, and Marjorie and James Strachey to Garsington for Christmas. QB plays the baby Lytton in a charade, "The Life and Death of Lytton."

1916 OM invites CB, Mary Hutchinson, Molly MacCarthy, and RF to Garsington for Easter.

Summer: LS kisses DC, who considers snipping off his beard as he sleeps; he awakes; she falls violently in love with him.

Sept.: JMK moves to flat at 46 Gordon Square, where VB and CB have several rooms also.

Sept.: VW discovers Charleston Farmhouse in Sussex, which is available; VB rushes down to let it; DG and DG(B), conscientious objectors, work there as agricultural laborers.

1917 **Nov.**: VW and LW go to Garsington for the weekend.

1918 **Mar.**: JMK attends auction in Degas's studio; buys several paintings for the National Gallery and some works for himself, including a Cézanne. Returns to Charleston; leaves paintings in the hedge by the road temporarily; DG rescues them; they are all delighted.

AG begins studying English in Cambridge with DB, who becomes his English translator and falls in love with him; she begins correspondence, making her anguish explicit, that lasts until his death in 1951.

Jacques Copeau invites DG to "construct" costumes for his production of Maurice Maeterlinck's *Pelléas et Mélisande* (he designs them at Charleston).

Sept.: Sergei Diaghilev's Ballets Russes, almost penniless, arrives in London to perform at the Coliseum; stays nearly a year. Léonide Massine and LL (later to marry JMK) are among the stars.

Oct.: JMK meets LL.

Nov.: Armistice Day; World War I ends.

Nov.: VSW and Violet Keppel Trefusis leave their husbands, go to France together, stay until late March 1919. Harold and Denys Tre-

fusis pursue them; bring them back to England.

Dec. 25 A daughter, Angelica (later ABG) born to VB and DG; CB agrees to become nominal father.

1919 **Jan**.: JMK attends Paris Peace Conference, Versailles, as representative from England. Leaves in despair.

Feb.: JMK flees conference for a week; goes to La Souco to stay with the Bussys.

Mar.: RP, DC, her brother Noel, and RP's sister Dorothy make trip to Spain. RP then invited to Tidmarsh, where LS becomes attached to him. CB in Paris, enjoying company of Pablo Picasso, André Derain, Rose and Charles Vildrac, and AG .

June: Treaty of Versailles signed June 28, deplored by JMK. He has left conference and is at Charleston writing *The Economic Consequences of the Peace.*

Summer: Sergei Diaghilev's Ballets Russes continues performing in London; accompanied by Léonide Massine, Igor Stravinsky, Ernest Ansermet, Pablo Picasso, and André Derain. Derain admires work of DC. Company returns to Paris in the fall.

Oct.: RF meets CM and wife at Les Baux, near St.-Rémy.

RF visits André Derain's studio.

Jacque Copeau's Théâtre Vieux Colombier reopens in Paris.

OM and Philip Morrell sell London home; too expensive to maintain in addition to Garsington.

1920 DG staying in Paris in a flat at 45 Quai de Bourbon, on the Ile St.-Louis, with views of Notre Dame (house is owned by Prince Antoine Bibesco).

May: VB visits Paris and DG as often as possible; writes RF about dining with André Derain, Erik Satie, George Braque, and their wives.

May: DG, VB, CB attend Parisian dinner; CB insulted by Wyndham Lewis but quieted by DG.

ES and NH lease Château d'Auppegard at Offranville, Normandy, for the summer.

OM has affair with Lionel Gomme ("Tiger"), gardener at Garsington; relationship may have served as motif for D. H. Lawrence's *Lady Chatterley's Lover* (1928).

RF displeased by annual Salon d'Automne exhibition.

1921 DC and RP marry.

Feb.: DG comes to Paris to work with Jacques Copeau on production of André Gide's play *Saül.*

RF painting at Château de St. Marcellin in Vaison-la-Romaine.

Easter: JMK, DG, VB go to Rome.

Diaghilev returns with his company, including LL, to London; GMK invites her to take a flat at 41 Gordon Square.

Two paintings by ES accepted by New English Art Club.

Oct.: VB and DG rent Maison Blanche, home of Rose and Charles Vildrac in St.-Tropez (Leonard Zborowski, Parisian gallery owner, is intermediary); stay there with JB, QB, ABG until Jan. 1922.

DB meets Madeleine Gide, wife of AG, in Paris.

1922 **Jan**.: VB, DG, and children in St.-Tropez at Maison Blanche.

Aug.: DB, Pippa, and Pernel Strachey at Pontigny for *décade* (Aug. 17–26). Gide informs DB he is having child by Elisabeth von Rysselberghe; she is devastated.

Nov.: RF enters Coué Clinic, Nancy; meets and is attracted to Josette Coatmellec, tubercular, mentally disturbed Breton woman, with whom he has affair.

Dec.: VW and VSW meet at London dinner party given by Clive Bell.

RP and DC, with Gerald Brenan, go to France; visit Valentine and Bonamy Dobrée in Larrau; DC paints mountain church.

JMK begins serious courtship of LL.

1923 **Jan**.: AG visits Bussys at La Souco, despite DB's knowledge of his impending child.

Mar.: LS, DC, RP go to France, Tunis, and Italy.

Mar.: VW, LW go to Spain to visit Gerald Brenan at Yegen; they go via Paris and return via Perpignan and Montauban.

LW becomes literary editor of the *Atheneum,* ed. by JMK.

ES begins having "salons" at her Chelsea home, 15 The Vale; LS attends first one.

Apr.: AG has daughter, Catherine, by Elisabeth van Rysselberghe, increasing suffering on part of DB.

May: VW and LW visit Garsington.

Aug.: LS at Pontigny for literary *décade* (Aug. 16–27).

1924 **Jan**.: Frances Marshall, DC, RP go to Spain; Frances Marshall and RP are in love. They return via Paris, where LS joins them; he refuses to speak French, leaving it up to RP. Mill House damp and bad for health of LS; Carrington finds Ham Spray House and LS decides to buy it; needs much renovation.

Spring: AG spends month with Bussys at Roquebrune.

Feb.: ES invites RF, VW, and Arnold Bennett to tea; VW revises her opinion of him, Bennett.

Mar.: RF sends Josette Coatmellec a reproduction of an African mask that he finds beautiful; Josette shoots herself on hill at Le Havre, believing he does not love her and is mocking her.

RF, terribly distressed, goes to stay with the Maurons in St.-Rémy; writes "L'Histoire de Josette."

Apr.: LL goes to Paris for ballet engagement.

Apr.: LS takes possession of Ham Spray House; DC decorates, but house not yet habitable.

May: JMK joins LL in Paris for two-day visit.

July: LS to Brittany with sister Pippa for two weeks while DC works on Ham Spray House.

July: LL and JMK to Tilton, farmhouse near Charleston, also owned by Lord Gage, they were able to lease; they stay two months.

LS, RP, DC move into Ham Spray House.

Dec.: DG joins his mother, Ethel Grant, his aunt, Miss Daisy McNeil, and her companion, Miss Elwes, on cruise aboard steel auxiliary ketch *Arequipa*, owned by Miss McNeil, for cruise through Burgundy to Marseilles and Cassis.

1925 **Jan.**: *Arequipa* arrives in Cassis; Miss McNeil stays aboard for several months, enjoying social life of Cassis.

CM translates EMF's novel *A Passage to India*.

RP and Frances Marshall vacation in Spain; return to start life together in Gordon Square, London, frequently spending weekends at Ham Spray House.

VW and VSW begin brief sexual relationship; plan French holiday (does not occur until 1928).

OM rents London home of ES for daughter Julian's London season; house had been decorated by Walter Sickert and Boris Anrep.

Jacques Raverat dies.

Mar.: VW and LW pay first visit to Cassis, staying at Hotel Cendrillon.

Apr.: DC, Frances Marshall, RP go to Paris and on walking tour of Provence.

Aug.: RF accompanies CM to *décade* at Pontigny (Aug. 27–Sept. 6); CM meets Charles du Bos there.

Aug.: JMK and LL, whose divorce is final, marry at St. Pancras Registry Office; DG is one of the witnesses.

1926 **Apr.**: EMF sails from Tower Bridge, London, to Bordeaux, where he stays at the Hôtel du Chapin-Fin. Visits and becomes friend of CM, who has translated *A Passage to India*.

May: RF has five paintings of Cassis in First London Artists' Association exhibition.

June: LS and sister Pippa go to Paris; DC misses LS greatly.

July: OM and Philip take Julian on holiday in France; she wants to marry Igor Vinogradoff, against their wishes; they tour in two cars with Siegfried Sassoon, Robert Gathorne-Hardy, and Kyrle Leng; visit Claude Monet (aged eighty-six).

Helen Maitland Anrep leaves husband, Boris Anrep, for RF; lives with him until his death in 1934.

Aug.: DB returns to *décade* at Pontigny to be with André Gide.

Sept.: Frances Marshall and RP meet Gerald Brenan at Toulon, where they walk, swim, and picnic.

JB stays with Pinault family, both teachers, at Gargilesse, outside Paris, studying and exploring Paris.

Nov.: RP lends DC money to make first trip alone to Paris to meet Gerald Brenan.

1927 **Jan.**: DG joins Ethel Grant and his aunt, Daisy McNeil, at the Villa Mimosa in Cassis; becomes ill with bronchitis; VB, ABG, and Grace Germany come to Cassis to help nurse him; stay at nearby Villa Corsica.

VB writes VW that Cassis is ideal for painting; urges her to come down.

Mar.: VW and LW come to Cassis; stay at Hôtel Cendrillon but spend days at Villa Corsica.

Apr.–May: RF, VB, DG represented in the "Exposition d'Oeuvres d'Artistes Britanniques" ("The British Artists' Exhibition"), Galeries Georges Petit, Paris.

July: VW goes to Offranville for visit with ES and NH at Château d'Auppegard.

July and Sept.: DG and VB visit Château d'Auppegard and decide to paint murals on the loggia.

VB, DG acquire ten-year lease on La Bergère, small cottage on Fontcreuse estate of Colonel Peter Teed and his companion, Jean Campbell; renovations begin; VB engages Elise Alighanti from the village to cook.

Oct.: DG to Cassis to inspect renovations; is delighted.

1928 **Jan.**: VB, DG, ABG, Grace Germany arrive at La Bergère, which has been finished and is charming; LS and friend, Roger Senhouse, go to Paris to meet Norman Douglas.

Mar.: NH arrives by car to stay nearby for fortnight; VB reluctant; welcomes CB.

Apr.: VW and LW arrive in their Singer after

motoring through France, a delight for VW; RF comes to visit while lecturing at Monte Carlo; VB engages Sabine de Fondeville as governess for Angelica.

May: LS and DC have tea at La Bergère; continue to Aix-en-Provence, staying at the Hôtel Nègre-Coste; LS falls ill; DC distraught and telephones VB, who is unable to help, being without car.

Sept.: VB urges RF and Helen Anrep to visit La Bergère.

OM and Philip Morrell forced to sell Garsington; take town house in London.

DM visits VB and DG at La Bergère.

Sept.: VW and VSW take six-day holiday in France together, visiting Paris, then Burgundy (Saulieu, Vézelay). On their return to Dieppe, ES sends car to meet them; they dine with her and NH at the Chateau d'Auppegard; spend night in Dieppe.

Oct.: RF visits La Bergère; late in month VB goes to England to take Angelica to boarding school; DG takes his mother and her friend Miss Elwes to Paris and on to La Bergère; plies them with Fontcreuse wine.

1929 **Apr**.: VB, DG, Angelica, Judith Bagenal go to Cassis by train; discouraged by cold weather. Frances Marshall and RP go to Breton fishing town of La Trinité, taking along Rachel (twenty) and Dermod MacCarthy (eighteen), two younger children of DM and Molly MacCarthy.

June: VW and LW go to Cassis by train, staying at Fontcreuse but taking meals with VB and DG at La Bergère; consider buying cottage in Cassis.

July: VB and DG return to England via Paris, visiting Luxembourg Museum.

RF goes to Royat, which he dislikes, and Nancy, where he copies paintings in the museum by Rubens and other artists.

Sept.: DC go to France with Dorelia John for luxurious tour of the Côte d'Or, visiting cathedral towns; they have champagne for breakfast and DC paints as they travel.

Oct.: VB and DG to Paris (Hôtel de Londres), painting, meeting with artists, visiting museums.

1930 **Jan./Feb**.: CB at Cannes with companion Benta Jaegar.

VW and LW give up idea of cottage in Cassis.

RF painting at Beaumes-de-Venise; must cover himself with newspapers because of mosquito plague.

CM gives series of lectures in London on philosophy, aesthetics, and French literature; VW

chairs a session.

Oct.: DG at Cassis with George Bergen; VB distressed but comes down with QB; RF joins them, staying at Fontcreuse; feast of the *vendange* (grape harvest).

1931 CB and QB at Cassis; VB and DG travel through Italy, returning through Paris.

Apr.: RF, CM, and Marie Mauron buy and furnish the Mas d'Angirany at St.-Rémy.

VW and LW to France, driving through the Dordogne.

Frances Marshall, RP, Rachel MacCarthy, and Janie Bussy go by train across France to Spain.

VSW and her friend Evelyn Irons visit Provence, walking from Tarascon to Les Baux and going to Arles and Nîmes.

Sept.: LS to France alone, staying principally in Paris and Nancy.

1932 **Jan**.: LS dies of stomach cancer.

Frances Marshall and RP, devastated by death of LS, agree to drive Alix and James Strachey's car to the south of France; they go via Ypres, where RP served during World War I.

Feb.: DS tells VW of the diary he kept in Nancy, which she found comforting to read.

Mar.: DC shoots herself, in despair over death of LS.

Apr.: VW, LW, RF and his sister Margery Fry travel by train to Greece, stopping in Paris.

May: VB, DG prepare sets for the Camargo Ballet in Paris.

1933 RF accepts Slade Professorship of Art at Cambridge.

Frances Marshall and RP marry.

May: VW and LW drive through France to Italy, stopping at Carpentras and at Roquebrune to see the Bussys.

1934 **Sept**.: RF drives to St.-Rémy; goes to Royat to seek trouble for artery problem in leg; breaks pelvis in a fall in his London flat, and dies of resulting complications.

DB completes short novel, *Olivia*, and sends it to AG, who dismisses it, hurting her deeply.

1935 JB accepts post teaching English at Hankow, China, at the National University of Wuhan.

May: VW and LW go on long continental holiday through Austria, Germany, Italy, and France.

EMF and CM speak at International Congress of Writers, Paris.

Lytton Burgo, son of FP and RP, born.

1936 CB made a Chevalier of the French Légion d'Honneur.

Mar.: CB meets Henri Matisse in Nice through the SB and DB (Janie has translated a favorable article he has written about him); the Bussys

have also introduced him to ABG.

SB and DB sublet La Souco to take flat in Nice; it is next door to Henri Matisse.

1937 **Spring**: JB resigns from National University of Wuhan; returns to England via France, where he discusses his wish to serve in the Spanish Civil War with CM; CM discourages him, to no avail.

July: JB dies of wounds suffered while serving as ambulance driver in Spanish Civil War.

Oct.: VB, still grief-stricken over death of JB, goes with DG, ABG, and QB to Paris to see exhibitions.

CM invited to lecture at the French Institute, London.

Dec.: VB and ABG go to Cassis, staying at Fontcreuse because La Bergère has tenants.

1938 **April**: OM dies of heart disease.

DG invited to exhibit in Salon d'Automne.

VB and DG return to La Bergère for the last time, sorting through papers and possessions. VB, ABG, QB visit Maurons at St.-Rémy.

1939 JMK and LL go to Royat on last continental holiday.

June: VW and LW go to Brittany and Normandy, VW's final journey to France.

SB and DB menaced by Italian fascists; leave La Souco; spend war years in poverty and distress in various residences.

1940 **Mar.**: DG(B)'s wife Ray Marshall Garnett (sister of Frances Marshall Partridge) dies of cancer.

VB paints portrait of EMF.

Oct.–May: Bussys let La Souco to André Malraux and his family; find accommodations in Nice; André Gide stays with them there. World War II forces cessation of Pontigny meetings.

1941 VW drowns herself in the river Ouse at Rodmell.

1942 CM loses all vision, which has gradually deteriorated.

Spring: DG(B) and ABG marry; have four daughters.

DG paints portrait of VB, now at the Tate.

1945 SB has exhibition of work in Lewes, Sussex; praises DG as his early teacher.

1946 **Easter Sunday**: JMK dies of heart disease at Tilton.

EMF offered honorary fellowship and living quarters at King's College, Cambridge.

1947 CB, living with Barbara Bagenal in Menton, invites Picasso, who lives with Jacqueline Roque, to dinner in Antibes (he sees him frequently over the next few years).

EMF visits Maurons in St.-Rémy; spends three months in the United States; takes up residence at King's College.

1948 AG organizes exhibition for SB, greatly impoverished, at the Galerie Charpentier, Paris, one of several he secretly arranges.

DB publishes her novel anonymously as *Olivia* (by "Olivia"); it is recognized as a minor masterpiece in France and, the next year, in England; AG apologizes for not having appreciated her novel, *Olivia*, fourteen years earlier.

1949 CM lectures at Oxford and in London; series arranged by EMF; CM introduced by Margery Fry, sister of RF; CM's divorce from Marie Mauron is final; he marries Alice Mauron.

1951 **Feb.**: AG dies in Paris of tuberculosis.

LW returns to Cassis; depressed by coastal development. Lt. Col. A. S. H. (Peter) Teed dies.

1952 DM dies; in his final year he was still calling on ES in London to discuss literature.

CM begins chronicle in daily newspaper, *Le Provençal*, which he continues until his death in 1966.

1953 Mary (Molly) MacCarthy dies.

1954 **May**: VB at La Souco; she, Janie Bussy, and others go to Antibes to see the Musée Picasso and Vence to see Chapel of the Rosary, decorated by Henri Matisse.

May: SB dies in London as result of a stroke. Henri Matisse dies.

1957 NH dies.

Gwen Raverat dies.

1958 ES makes last visit to Château d'Auppegard.

CB and Barbara Bagenal invite Picasso for lunch.

1959 CM and Alice Mauron attend EMF's eightieth-birthday celebration at King's College, Cambridge; VB, DG, CB, and AGB also attend.

CB photographed with Picasso in drag (by Barbara Bagenal) at Mougins.

1960 **Jan.–Apr.**: VB and DG stay at La Souco, Roquebrune, former home of the Bussy family, for VB's health; find it depressing.

May: Janie Bussy dies tragically in London from water heater accident; DB, senile, dies two weeks later.

Dec.: RP dies of heart attack at Ham Spray House; FP invited to accompany Julia Strachey, niece of DB, and Lawrence Gowing, her second husband, to Roquebrune to evaluate the paintings at La Souco; she found it abandoned and derelict.

1961 ES dies.

CB has fall at Menton, breaks leg, is flown to London Clinic; DG visits him there; VB too weak to go.

Apr.: VB dies of heart failure at Charleston while CB is in hospital; he is grief-stricken.

1962 Henrietta Garnett, daughter of AGB and DG(B), marries Lytton Burgo Partridge, son of FP and RP.

1963 EMF visits CM and family in St.-Rémy.

Aug.: Sophie born to Burgo Partridge and Henrietta Garnett (Sophie will later name her daughter Julia Frances).

Sept.: Burgo Partridge dies of heart attack at age twenty-eight.

1964 EMF returns to St.-Rémy with Bob and May Buckingham.

CB dies in London nursing home.

1965 **Apr.**: FP to Paris and northern France with friend and gallery owner Eardley Knollys.

1969 LW dies at Monks House after a day showing visitors around his garden.

1970 EMF dies in the home of Bob and May Buckingham four days after suffering a stroke in his room at King's College, Cambridge.

DG(B) moves to Montcuq, in the Lot, France.

1978 DG dies at Charleston.

1981 LL dies at Seaford, Sussex; lived at Tilton until 1977.

Feb.: DG(B) dies in Le Verger de Charry, Montcuq, in the Lot, France.

1984 AG moves to France.

Notes

Introduction

1 *LVW:* III, 23.

2 Brenan contrasts Spain, his country of residence, with France, where "things are beautiful only as the result of a certain particular effort" (March 7, 1924; HRCR, Univ. of Texas, Austin).

3 Miranda Seymour, *Ottoline Morrell: Life on the Grand Scale* (New York: Farrar Straus Giroux, 1992), 26.

4 Vanessa Bell, *Sketches of Pen and Ink: A Bloomsbury Notebook*, ed. Lia Giachero (London: Hogarth Press, 1997), 14. Vanessa's great-grandmother, whose first name was given to Virginia Woolf, was Adeline de l'Etang. She reportedly could speak only one English sentence: "If you don't like it you must lump it" (Frances Spalding, *Vanessa Bell* [London: Weidenfeld and Nicolson, 1983], 360). Recent research by Jean-Claude Feray at the Sorbonne has revealed that Adeline de l'Etang's father, Ambroise Pierre Antoine de l'Etang, was a French aristocrat and supposedly one of Marie Antoinette's pages; her mother, Thérèse Josèphe Blin de Grincourt, was born in Pondicherry, India (1768). The beauty of the Pattle and Stephen women, including Vanessa and Virginia, may derive in part from their matrilineal Indian heritage through Thérèse de Grincourt. Her ancestry has been traced to Marie Monica or Marie Monique, a Bengalee woman "*de caste gentille,*" whose religion was originally Hinduism. We are indebted to Patricia Laurence, CUNY, and Sarah (Sally) Greene, UNC Chapel Hill, for

this information.

5 Michael Holroyd, *Lytton Strachey: The New Biography* (London: Chatto and Windus, 1994; New York: Farrar, Straus and Giroux, 1995), 15.

6 As recounted by Peter Fawcett in his talk "Bloomsbury et la France" for the *décade* Virginia Woolf at Cerisy-la-Salle (*Colloque de Cerisy: Virginia Woolf* [Paris: Union générale d'éditions; Editions 10/18, 1977]), 58. The discussions at Cerisy are the successor to those at Pontigny (*see* "Intellectuals at Pontigny").

7 Jean Guiguet, *Colloque de Cerisy: Virginia Woolf* [Paris: Union générale d'éditions; Editions 10/18, 1977]), 14.

8 Peter Fawcett, "Bloomsbury et la France," 57–82.

9 The *Nouvelle Revue Française* was a highly influential journal within the French literary world.

10 Letter to the authors, February 1998.

11 Angelica Garnett, interview with M.A.C., July, 1997.

12 Roger Fry to Gerald Brenan, April 30, 1925; HRCR, Univ. of Texas, Austin (quoted in Frances Spalding, *Roger Fry: Art and Life* [London: Granada Publishing, 1980], 250).

13 Angelica Garnett, interview with M.A.C., August, 1997.

14 Our thanks to Mason Cooley for suggesting the resemblance to the tradition of Matthew Arnold, and much else.

15 Recounted by David Garnett, *The Flowers of the Forest* (New York: Harcourt, Brace, 1955), 21.

16 The sixteen-volume work, in seven parts, was published between 1913 and 1927. Proust died in 1922, before the last three volumes were published.

17 *LVW:* III, 166.

18 *LVW:* III, 365.

19 *LVW:* II, 565–66 (October 3, 1922). For the Woolf/Fry/Proust adventure, *see* the amusing account in Alain de Botton, *How Proust Can Change Your Life: Not a Novel* (New York: Pantheon Books, 1997), 203–5.

20 *DVW:* III, 7.

21 Guiguet, *Colloque de Cerisy: Virginia Woolf,* 75.

22 RFAG, December 15, 1922 (*LRF:* II, 530). Fry became less enthusiastic about Proust toward the end of his life, however; the volume appeared without his contribution.

23 Clive Bell, *Proust* (London: Hogarth Press, 1928), 9–11.

24 Art (1914); *Since Cézanne* (1922); *Landmarks in Nineteenth-Century Painting* (1927); and *An Account of French Painting* (1931).

25 David Garnett to Maynard Keynes, March 1918 (Roy Forbes Harrod, *The Life of John Maynard Keynes* [New York: Harcourt, Brace and Co., 1951]), 226.

Beginnings: Friends in France, 1896–1910

Epigraph: Unpublished memoir, Tate Archives, London.

1 This attitude is what the noted art critic Richard Shone calls the "relaxation of respect" and "mischievous anarchy" that had marked their lives in England. See Richard Shone, "A General Account of the Bloomsbury Group," *Keynes and the Bloomsbury Group: The Fourth Keynes Seminar Held at the University of Kent at Canterbury 1978*, ed. Derek Crabtree and A. P. Thirlwall (London: Macmillan, 1980), 23.

2 Michael Holroyd, *Lytton Strachey: The New Biography* (Lon-

don: Chatto and Windus, 1994; New York: Farrar, Straus and Giroux, 1995), 67. Lytton actually employed himself writing a tragedy in three acts to be presented in the Lent term at Cambridge by the Midnight Society.

3 *Ibid, loc. cit.*

4 *Selected Letters of Vanessa Bell*, ed. Regina Marler (New York: Pantheon, 1993), 17.

5 Letter to Leonard Woolf, April 13, 1904, Strachey Papers, British Library.

6 Leon Edel, *Bloomsbury: A House of Lions* (Philadelphia: Lippincott, 145).

7 Duncan Grant to Lytton Strachey, March 1, 1906, Strachey Papers, British Library.

8 Edel, *Bloomsbury: A House of Lions*, 145.

9 Duncan Grant, "Paris Memoir."

10 Duncan Grant to Lytton Strachey, May 11, 1906, Strachey Papers, British Library.

11 Duncan Grant, "Paris Memoir."

12 Duncan Grant to Lytton Strachey, February 20, 1907, Strachey Papers, British Library.

13 Duncan Grant to Lytton Strachey, March 10, 1907, Strachey Papers, British Library.

14 Duncan Grant to Lytton Strachey, March 1, 1906, Strachey Papers, British Library.

15 Duncan Grant to Lytton Strachey, February 20, 1907, Strachey Papers, British Museum.

16 Duncan Grant, "Paris Memoir."

17 Duncan Grant, "Paris Memoir."

18 Denys Sutton, *The Letters of Roger Fry (LRF)*, I, 34.

19 Clive Bell, "Bloomsbury," *Old Friends* (Chicago: University of Chicago Press, 1973), 136.

20 J. Pierpont Morgan had wanted, for his own collection, a piece that Roger Fry had gone to great lengths to purchase for the museum and not a private owner. This was an oil painting originally attributed to Fra Angelico. It had been sold in the summer of 1909 by the Kleinberger Gallery, London, to Morgan, with the understanding that it was for the museum. Upon learning the truth, Fry was angry and protested vigorously. His association with the Metropolitan Museum was terminated a few months after the incident, in February 1910.

Lytton Strachey, Dora Carrington, Ralph Partridge

1 Michael Holroyd, *Lytton Strachey: The New Biography* (London: Chatto and Windus; New York: Farrar, Straus and Giroux, 1995), 58. He observes that the Strachey and Stephen families had been friends for two generations and had many mutual friends.

3 Holroyd, *Lytton Strachey: The New Biography*, 62.

4 Auguste Bréal to Lytton Strachey, August 15 (n.d.), off Martigues, Bouches du Rhône (Strachey Papers, British Library).

5 Mlle Marie Souvestre was a daughter of the French writer Emile Souvestre, author of *Un Philosophe sou les Toits*. Les Ruches was a renowned and fashionable school. In 1935 Dorothy Strachey Bussy wrote a novel based on her experiences there, *Olivia*. Full of same-sex suggestions, it was published anonymously in 1949.

6 Holroyd, *Lytton Strachey: The New Biography*, 96.

7 Holroyd, *Lytton Strachey: The New Biography*, 238.

8 Michael Holroyd, *Lytton Strachey by Himself: A Self-Portrait* (London: Vintage, 1994), 134.

9 Michael Holroyd, *Lytton Strachey and the Bloomsbury Group: His Work, Their Influence* (Harmondsworth: Penguin, 1971), 35.

10 Gretchen Holbrook Gerzina, *Carrington: A Life* (New York: Norton, 1989), 61. Garnett would edit Carrington's letters fifty-five years later, in 1970.

11 Dora Carrington to Lytton Strachey, April 3, 1918. Quoted in Mary Ann Caws, *Women of Bloomsbury: Virginia, Vanessa, and Carrington* (New York and London: Routledge, 1989), 136.

12 David Garnett states that "physical love" was difficult, since Lytton had a sense of inadequacy and Carrington disliked being a woman and felt inferior; they compensated by having love affairs with other people. He deplores Lytton's lack of interest in Carrington's art, and believes that her suicide after his death might have been avoided had the men she loved after her affair with Mark Gertler understood the importance of art in her life. There was, he says, no Duncan Grant in her life, as there had been for Vanessa Bell. She knew much older artists, such as Augustus John and Henry Lamb, but lacked the fellowship and encouragement of contemporary male artists. "I think this is the greatest harm that Lytton did her, except by dying when he did," Garnett remarks. (Preface, *Carrington: Letters and Excerpts from Her Diaries*, ed. David Garnett [London: Jonathan Cape, 1970], 11–13).

13 Gerzina, 145.

14 Holroyd, *Lytton Strachey: The New Biography*, 474.

15 Dora Carrington to Gerald Brenan, March 1923.

16 Dora Carrington to Gerald Brenan (Gerzina, 199).

17 *Carrington: Letters and Excerpts from Her Diaries*, ed. Garnett, 258–59.

18 Dora Carrington to Gerald Brenan, August 27, 1923.

19 Gerzina, 200.

20 Gerzina, 205.

21 Dora Carrington to Gerald Brenan, January 14, 1924.

22 Dora Carrington to Gerald Brenan, April 16, 1925.

23 Dora Carrington to Gerald Brenan, April ?, 1925.

24 Dora Carrington to Gerald Brenan, April 16, 1925.

25 Dora Carrington to Gerald Brenan, April 15, 1925.

26 *Carrington: Letters and Excerpts from Her Diaries*, ed. Garnett, 316.

27 Gerzina, 237.

28 Holroyd, *Lytton Strachey: The New Biography*, 546.

29 Dora Carrington to Gerald Brenan, May 10, 1928.

30 *Carrington: Letters and Excerpts from Her Diaries*, ed. Garnett, 493.

31 *See* Jane Hill, *The Art of Dora Carrington* (New York: Thames and Hudson, 1994), 88–89.

32 Noel Carrington, *Carrington: Paintings, Drawings and Decorations* (London and New York: Thames and Hudson, 1978), 18.

33 Gerzina, 26.

34 "A Fortnight in France," *Lytton Strachey by Himself*, 161–63.

35 "A Fortnight in France," *Lytton Strachey by Himself*, 161–63.

36 Lytton worried that Alastair MacDonald's appearance would spoil the tone of his tour—but, on the other hand, reflected that it might add "the required accent" to it. MacDonald spent the night; Lytton wrote that "everything that I wanted I had—without any fuss at all. Charming, really!"

37 "A Fortnight in France," *Lytton Strachey by Himself*, 162.

38 *Carrington: Letters and Excerpts from Her Diaries*, ed. Garnett, 492.

39 *DVW:* IV, 81–83 (March 12, 1932).

40 *LVW:* V, 28; March 2, 1932.

Virginia Woolf, Leonard Woolf, Vita Sackville-West

1 *DVW:* III, 9; April 8, 1925.

2 "Going to France," *Nation and Athenaeum*, May 5, 1923.

3 *LVW:* I, 78.

4 *LVW:* I, 141.

5 *LVW:* I, 290.

6 *LVW:* I, 369.

7 *LVW:* II, 6–8.

8 *LVW:* II, 379.

9 *LVW:* III, 23.

10 *DVW:* II, 241.

11 *DVW:* II, 308.

12 *DVW:* III, 9.

13 Leonard Woolf, *Downhill All the Way: An Autobiography of the Years 1919 to 1939* (New York: Harcourt, Brace & World, 1967), 180.

14 *LVW:* III, 176.

15 *LVW:* III, 177.

16 *DVW:* III, 40–41.

17 VBVW, n.d. (1927).

18 Clive's manuscript, a study of the philosophic background and consequences of war, was published as *Civilization* in 1928. It was dedicated to Virginia, who, "alone of my friends were in at the birth and have followed the fortunes of this backward and ill-starred child" (Clive Bell, *Civilization*, Chicago: University of Chicago Press, 1956, 9; first published in 1928 by Chatto and Windus, London).

19 *LVW:* III, 358–59.

20 *LVW:* III, 363.

21 *DVW:* III, 150–51.

22 "Entretien avec Virginia Woolf," *Nouvelles Littéraires*, Aug. 13, 1927.

23 *LVW:* VI, 516.

24 *LVW:* III, 452.

25 Vanessa Bell letters, King's College, Cambridge.

26 *Downhill All the Way*, 182.

27 *Downhill All the Way*, 181.

28 *LVW:* VI, 520.

29 *LVW:* III, 482.

30 *LVW:* III, 483.

31 *Downhill All the Way*, 183–85.

32 *LVW:* IV, 65–66.

33 *DVW:* III, 232.

34 *LVW:* IV, 91.

35 *LVW:* IV, 120.

36 *Downhill All the Way*, 181.

37 Frances Spalding, *Vanessa Bell* (New York: Harcourt Brace Jovanovich, 1983), 232.

38 Interview by Mary Ann Caws and Sarah Bird Wright with Angelica Bell Garnett, Forcalquier, France, July 21, 1990.

39 *LVW:* IV, 315.

40 *The Letters of Leonard Woolf* (New York: Harcourt Brace Jovanovich, 1989), 239.

41 *LVW:* IV, 320.

42 *LVW:* IV, 324.

43 *DVW:* IV, 17–18.

44 *LVW:* V, 49.

45 *DVW:* IV, 154.

46 *LVW:* V, 185–86.

47 *Downhill All the Way*, 186–95.

48 By "Corges" Virginia probably meant "Carcès," according to Anne Oliver Bell and Andrew McNeillie, editors of the diary.

49 October 6; *LRF*, 459.

50 *RFVB* 412, Hôtel du Palais, Fontainebleau, June 21, 1929.

51 *LVW:* V, 395.

52 *DVW:* IV, 316–17.

53 *LVW:* VI, 128–30.

54 *DVW:* V, 218.

55 *LVW:* VI, 337–38.

56 *LVW:* VI, 340–41.

57 "Pictures," *The Essays of Virginia Woolf*, ed. Andrew McNeillie (London: The Hogarth Press, 1994), IV, 245.

58 Leonard wrote several books about the prevention of war, including *The Intelligent Man's Way to Prevent War* (1933) and *The League and Abyssinia* (1936). His trilogy *After the Deluge* dealt with the history of democracy and democratic psychology; two volumes were published during Virginia's lifetime: Vol. I (1931), and Vol. II (1939).

59 *DVW:* III, 323.

60 *DVW:* III, 302.

61 *DVW:* III, 208–9.

62 *LVB*, 314.

63 *DVW:* III, 209.

64 Victoria Glendinning, *Vita: The Life of V. Sackville-West* (New York: Alfred A. Knopf, 1983), 21.

65 Vita Sackville-West diaries, The Lilly Library, Bloomington, Indiana.

66 Vita Sackville-West diaries, The

Lilly Library, Bloomington, Indiana.

67 Vita Sackville-West diaries, The Lilly Library, Bloomington, Indiana.

68 Quentin Bell, *Virginia Woolf* (New York: Harcourt Brace Jovanovich, 1972), II, 116, 120.

69 Bell, 119.

70 *DVW*: III, 197.

71 VSWHN, September 23, 1928.

72 Vita Sackville-West, "Diary of a Journey to France with Virginia Woolf in 1928" (Berg Collection, New York Public Library).

73 Many French families furnished their homes, whether luxurious or modest, from the Bon Marché. It was here that Charles and Marie Mauron purchased the bedding for the Mas d'Angirany, a home in St.-Rémy that they owned with Roger Fry.

74 *LVW*: III, 533.

75 *VSWHN*. Translation M.A.C.

76 In 1935 Marcel Boulestin gave the Woolfs' cook, Mabel, culinary lessons. He invited them to lunch, which Virginia declined, signing herself "with gratitude" (*LVW*: VI, 531).

77 *Vita and Harold: The Letters of Vita Sackville-West and Harold Nicolson*, ed. Nigel Nicolson (New York: G. P. Putnam's Sons, 1992), 203–4.

78 Vita Sackville-West, "Diary of a Journey to France with Virginia Woolf in 1928," *op. cit.*

79 *LVW*: 534–35.

80 Vita Sackville-West, "Diary of a Journey to France with Virginia Woolf in 1928," *op. cit.*

81 VSWHN, Thursday, September 27, 1928.

82 "Diary of a Journey to France with Virginia Woolf in 1928," *op. cit.*

83 *VSWHN*, Friday, September 28, 1928.

84 *LVW*: III, 539.

85 *LVW*: III, 533.

86 "Diary of a Journey to France with Virginia Woolf in 1928," *op. cit.*

87 *LVW*: III, 541.

88 *LVW*: III, 574.

89 Shakespeare's Sonnet 129. Quoted in Louise De Salvo and Mitchell Leaska, eds., *The Letters of Vita Sackville-West to Virginia Woolf* (New York: William Morrow, 1985), 286.

90 *LVW*: III, 540.

91 Quentin Bell, *Virginia Woolf, op. cit.*, Vol. II, 183.

92 *DVW*: IV, 287.

93 Diary of Vita Sackville-West, Lilly Library, Bloomington, IN.; Victoria Glendinning, *Vita: A Biography of Vita Sackville-West* (New York: Quill), 275–281.

94 After Peter Teed died in 1951, Jean Campbell was in a nursing home in Aubagne, near Cassis. A friend of hers, Julia Knowlton, was the script girl for Jerome Hill's film about Albert Schweitzer. Julia indicated to him that Jean Campbell needed pocket money. He went over to Fontcreuse, sold some of the furnishings to aid her, and kept some for himself; a few of those pieces are now at the Camargo Foundation in Cassis. In the 1970s M.A.C. discovered an Omega table at the Camargo Foundation as well as two cabinets in the style of Duncan Grant. Angelica Garnett and the late Quentin Bell went to the Camargo Foundation to see them; Quentin Bell identified the cabinets as his own work.

Clive Bell and His Circle

Epigraph: Clive Bell, *An Account of French Painting* (New York: Harcourt Brace, 1931), 10.

1 David Garnett, *The Flowers of the Forest* (New York: Harcourt Brace, 1955), 24.

2 Quentin Bell, *Elders and Betters* (in the U.S., *Bloomsbury Recalled*, New York: Columbia University Press), 1966, 27–28. Bell is uncertain as to the origin of the reproduction, which would have been an uncommon possession at the time. He believes it might have come from Vanessa through her brother Thoby, who was also at Trinity, to Clive. Or it might have been given him by Annie Rogers while he was still at Marlborough, his public school, which was not far from the Bell family home, Cleeve House, Seend.

3 During the time of the surrealists, in the 1920s, the Olympia featured the chanteuse Yvonne Georges, the first love of Robert Desnos, who composed many poems for her.

4 *Old Friends*, 166.

5 Jean Moréas was the author of the "Manifeste symboliste," an early but dull publication.

6 *LVW*: I, 290(April 2, 1907).

7 Leon Edel, *Bloomsbury: A House of Lions* (Philadelphia: J. B. Lippincott, 1979), 203.

8 Conversation with M.A.C. in the summer of 1997, about pacifism and Clive's political leanings. Clive, according to Frances Partridge, was, like the rest of his circle, never very interested in ordinary politics. He was a pacifist in the early days, but none of them "could go that road any longer, after the first world war. Hitler was too much to swallow." The two things he cared most about were friends and painting. It is from that conversation that the subtitle of our book is taken.

9 *Old Friends*, 170.

10 Quoted in Michael Holroyd, *Lytton Strachey: The New Biography* (London: Chatto and Windus, 1994; New York: Farrar, Straus and Giroux, 1995), 452. Clive Bell described the occasion in *Old Friends*, 172. Lady Ottoline Morrell had invited Picasso to Garsington, but he declined, since Clive and Maynard Keynes had already planned the special dinner.

11 *Old Friends*, 147–48.

12 Tate Archives, 8010.2.408.

13 *Old Friends*, 11–12, 138.

14 *Old Friends*, 82.

15 Clive and Mary Hutchinson, wife of the barrister St. John Hutchinson, had begun an affair in 1915 that lasted about twelve years, coming to an end in 1927 (*Selected Letters of Vanessa Bell*, ed. Regina Marler [New York: Pantheon Books, 1993]), 176, 304.

16 *CBPP*, June 18, 1920.

17 *CBPP*, Dec. 20, 1920.

18 *CBPP*, Oct. 10, 1923.

19 On this most complicated issue, see the works of Michèle Cone (*Artists Under Vichy: A Case of Prejudice and Persecution* [Princeton: Princeton University Press, 1992]) and Laurence Bertrand Dorléac (*L'art de la défaite* [Paris: Seuil, 1993]).

20 *Old Friends*, 181.

21 *VBL*, 266.

22 Richard Shone, *Bloomsbury Portraits*, new edition, 210–11.

23 EP to JB, 2 June 1936 (Playfair/Julian Bell correspondence, King's College, Cambridge University).

24 Henri Matisse to Clive Bell, March 2, 1936. Tate Archives, no. 8010.2.407. Translation M.A.C.

25 *CBPP*, n.d. Translation M.A.C.

26 *CBPP*, Dec. 27, 1958. Translation M.A.C.

27 *CBPP*, Dec. 3, 1959.

28 *An Account of French Painting*, 13.

29 *Since Cézanne*, 104.

30 Christopher Reed, however, terms much of Bell's writing on art "felicitously phrased exaggeration" (*A Roger Fry Reader* [Chicago and London: University of Chicago Press, 1996], 306).

31 *An Account of French Painting*, 30–36.

32 *An Account of French Painting*, 27.

33 Clive quotes two of the Aixois' favorite sayings about impressionism, both of which show a certain ambivalence in regard to the movement: "Je veux faire de l'Impressionnisme quelque chose de solide et de durable comme l'art des Musées" and "Il faut se méfier des Impressionnistes: tout de même, ils voient juste" (*An Account of French Painting*, 203).

34 We should add here, however, that the French enthusiasm for the delights of the bath and the female bather are continued not just in the work of Degas and Bonnard, but in the *Tub* scenes by Vanessa Bell and Duncan Grant. In one of the latter, the influence of Degas is clear.

35 *An Account of French Painting*, 120.

36 *The Development of French Art*, 66.

37 *An Account of French Painting*, 29.

John Maynard Keynes

Epigraph: Personal communication with Michael Holroyd, 1965 (quoted by Michael Holroyd in *Lytton Strachey: A Biography* [New York: Holt, Rinehart and Winston, 1971]), 1018.

1 Robert Skidelsky, *John Maynard Keynes: A Biography* (London: Macmillan, 1983), I, 93.

2 Leon Edel, *Bloomsbury: A House of Lions* (New York: Avon Books, 1979), 43.

3 J. M. Keynes, "My Early Beliefs," *The Collected Writings of John Maynard Keynes* (London: Macmillan, 1972), X, 435–36.

4 Paul Levy, "The Bloomsbury Group," *Essays on John Maynard Keynes*, ed. Milo Keynes (Cambridge: Cambridge University Press, 1975), 63–64.

5 Skidelsky I, 192.

6 Roy Forbes Harrod, *The Life of John Maynard Keynes* (New York: Harcourt Brace, 1951), 126.

7 Richard Shone, "Maynard Keynes as a Picture Buyer," Notes for BBC talk by Grant. (Skidelsky, I, 198).

8 Skidelsky I, 202–5.

9 Peter Stansky, *On or About December 1910: Early Bloomsbury and Its Intimate World* (Cambridge: Harvard University Press, 1996), 18.

10 Skidelsky I, 253.

11 Skidelsky I, 251.

12 Stansky, 248.

13 Skidelsky I, 251.

14 Leonard Woolf, *Beginning Again: An Autobiography of the Years 1911 to 1918* (London: Hogarth Press, 1964), 35–37.

15 Harrod, 158–59.

16 Skidelsky, I, 252–63.

17 Harrod, 201.

18 Harrod, 298.

19 To use Edel's phrase, he was "in possession of the 'matrix' of Bloomsbury" (Edel, *Bloomsbury: A House of Lions, op. cit.*, 234).

20 Edel, 234–35; Harrod 225.

21 Richard Shone with Duncan Grant, "The Picture Collector," in *Essays on John Maynard Keynes, op. cit.*, 283–89. Shone states that Keynes's paintings were "an essential and invigorating part of his life, a visible representation to him of an ingredient in the civilisation to which his gifts were dedicated" (280).

22 *DVW*: I, April 18, 1918, 140–141.

23 *Ibid.*, 284–85.

24 Skidelsky I, 36.

25 Skidelsky I, 372.

26 Dorothy Bussy to Ray Strachey, Lilly Library Archives, Bloomington, IN.

27 Skidelsky I, 374.

28 Harrod, 318.

29 Richard Shone with Duncan Grant, "The Picture Collector," *op. cit.*, 286.

30 Richard Buckle, "On Loving Lydia," *Essays on John Maynard Keynes*, ed. Milo Keynes, 51–52 (plate opp. 106).

31 *Lydia and Maynard: The Letters of Lydia Lopokova and John Maynard Keynes*, ed. Polly Hill and Richard Keynes (New York: Charles Scribner's Sons, 1989), Introduction, 17–18.

32 Harrod, 369.

33 *Letters, op. cit.*, 215.

34 *Ibid.*, 224.

35 *Ibid.*, 211.

36 *Ibid.*, 228–29.

37 *Ibid.*, 232.

38 *Ibid.*, 339.
39 Harrod, 399–401.
40 *Letters, op. cit.*, 287.
41 Shone and Grant, "The Picture Collector," *op. cit.*, 287.
42 *VBL*, 483–84.
43 *Ibid.*, 546.

Ottoline Morrell

1 Miranda Seymour, *Ottoline Morrell: Life on the Grand Scale* (New York: Farrar Straus Giroux, 1992), 90.
2 Sandra Jobson Darroch, *Ottoline: The Life of Lady Ottoline Morrell* (New York: Coward, McCann & Geoghegan, Inc., 1975), 44.
3 Seymour, 11–26.
4 Seymour, 66.
5 Darroch, 70.
6 Darroch, 16.
7 Seymour, 75–76.
8 Robert Gathorne-Hardy, ed., *The Early Memoirs of Lady Ottoline Morrell 1873–1915* (London: Faber, 1963), 70.
9 Seymour, 78.
10 Seymour, 88.
11 Darroch, 74.
12 Robert Skidelsky, *John Maynard Keynes: A Biography* (London: Macmillan, 1983), I, 250.
13 Darroch, 83.
14 Ray Monk, *Bertrand Russell: The Spirit of Solitude, 1872–1921* (New York: Free Press, 1996), 201.
15 Monk, 177.
16 Monk, 212.
17 Monk, 210–18.
18 Monk, 219.
19 Monk, 219.
20 *Ottoline at Garsington: Memoirs of Lady Ottoline Morrell 1915–1918*, ed. Robert Gathorne-Hardy (London: Faber & Faber, 1974), 274.
21 *Ibid.*, 280.
22 Michael Holroyd, *Lytton Strachey: The New Biography* (London: Chatto and Windus; New York: Farrar, Straus and Giroux, 1995), 325–26.

23 Darroch, 125.
24 Darroch, 129–30.
25 Darroch, 166.
26 *DVW:* I, 78–79.
27 Darroch, 132.
28 Dorothy Bussy to Ray Costelloe Strachey, December 9, 1920, Lilly Library, Bloomington, IN.
29 Peter Fawcett, "Bloomsbury et la France," *Colloque de Cerisy: Virginia Woolf* (Paris: Union générale d'éditions; Editions 10/18, 1977), 67.
30 Seymour, 331.
31 Seymour, 361.
32 Vanessa Bell to Molly MacCarthy, November 12, 1994; Lilly Library, Bloomington, IN.
33 *The Early Memoirs of Lady Ottoline Morrell 1873–1915*, 1963; *Ottoline at Garsington*, 1974.
34 *LVW:* III, 565.

Ethel Sands and Nan Hudson

Epigraph: *The Complete Shorter Fiction of Virginia Woolf* (New York and London: Harcourt Brace, 1989). Written in July, 1927, immediately after her visit to the Château d'Auppegard, home of Ethel Sands and Nan Hudson in Normandy.
1 Ethel may have met Ottoline before her marriage, as early as 1889, and certainly campaigned for Morrell when he stood for Parliament in South Oxfordshire in 1902.
2 Henry James declared that his Madame de Mauves was a "prevision" of Mrs. Sands. Ethel Sands's grandfather had founded a prosperous drug importing firm, and her family were part of the New York Knickerbocker society, spending winters in New York and summers in Newport. She was believed to have been descended from the Elizabethan Archbishop of York, Edwin Sandys. Her mother was a descendant of the *Mayflower* pilgrims; her uncle had served

as vice president of the United States as well as U.S. Minister in France (Wendy Baron, *Miss Ethel Sands and Her Circle* [London: Peter Owen Limited, 1977], 1–4).
3 Baron, 31–33.
4 Baron, 52.
5 These included a country house at Newington, near Oxford, which Ethel owned from 1898 until 1920, and a house at 42 Lowndes Street, London, which Ethel acquired in 1906; the latter was succeeded by a town house at 15 The Vale, Chelsea, purchased in 1913 and sold in 1937.
6 For information about the Château d'Auppegard, *see* Wendy Baron, *Miss Ethel Sands and Her Circle* (London: Peter Owen, 1977). Chapter XI concerns the Bloomsbury group and their relations with Miss Sands and Nan Hudson.
7 When the London Group of painters was formed in 1913, both were charter members. This organization, of which Harold Gilman served as president, also included Walter Sickert, Madame Renée Finch, and others. Initially it encompassed both the Fitzroy Street, the meeting place on Saturday afternoons, and Camden Town groups of artists, although it was soon decided that membership must be by election. Roger Fry, who had quarreled with Wyndham Lewis over management of the Omega Workshops, belonged to the Grafton Street group of artists, although in 1917 he joined the London Group (from which Duncan Grant and Augustus John had been excluded).
8 Baron, 186. In September 1928 Roger and Helen come to stay with her, without embarrassment on either side.
9 Baron, 181–82.
10 *Selected Letters of Vanessa Bell*, ed. Regina Marler (New York: Pan-

theon, 1993), 101.

11 Baron, 171.
12 Baron, 179.
13 *DVW*: II, 235–36.
14 She was pleased, however, when another guest, Logan Pearsall Smith, congratulated her on publication of her recently published review of Hazlitt's five-volume edition of Montaigne's *Essays* (*DVW*: II, 290). The review had appeared in January 1924.
15 Baron, 179.
16 "Entretien avec Virginia Woolf," *Nouvelles Littéraires*, 13 Aug. 1927.
17 His name was Henry Lomas.
18 *DVW*: III, 151.
19 *DVW*: III, 157. Baron suggests that Virginia implies that Ethel must have been in an "extraordinary mental state" to have failed to do so. Possibly she was reluctant to permit other matters to intrude on her visit with Virginia.
20 *LVW*: III, 404–6.
21 *LVW*: III, 527–28.
22 Regina Marler, *Selected Letters of Vanessa Bell*, 321.
23 Spalding describes their work as done "in the spirit of light-hearted pastiche, in a style sympathetic to the age of the château" (Frances Spalding, *Vanessa Bell* [London: Weidenfeld & Nicholson, 1983], 220). According to Baron, the frescoes were "rollicking, buxom figures, representing the Seasons" (163).
24 Baron, 188–89.
25 Baron, 204–5.
26 Logan Pearsall Smith, whose niece, Karin Costelloe, was married to Virginia Woolf's brother Adrian, died in 1946. Baron terms Smith "possibly the last survivor of that generation which fully appreciated Ethel and Nan" among the group of what he had described as "'opulent, fastidious, free-spoken spinsters—the modern Queen Elizabeths—who are the real Queens of what still remains of

good society in England'" (Baron, 259).
27 *The Times*, March 26, 1962 (Baron, 278).

Frances Partridge

Epigraph: From Frances Partridge, *Love in Bloomsbury: Memories* (London: Victor Gollancz; Boston: Little, Brown and Company, 1981), 97.

1 Frances Partridge, "Bloomsbury Houses," *A Cézanne in the Hedge and Other Memories of Charleston and Bloomsbury*, ed. Hugh Lee (London: Collins & Brown Ltd.; Chicago: University of Chicago Press, 1992), 128–35, *passim*.
2 *Love in Bloomsbury*, 165.
3 *Hanging On: Diaries 1960–1963* (London: Collins, 1990, rpt. Flamingo, 1994), 95.
4 *Love in Bloomsbury*, 211.
5 *A Pacifist's War* (London: Hogarth, 1978; rpt. Phoenix, 1996).
6 *Ibid.*, 45.
7 *Ibid.*, 46.
8 In a telephone conversation with M.A.C., July, 1997.
9 *Life Regained: Diaries 1970–1972* (London: Weidenfeld & Nicolson, 1998), v.
10 *Ibid.*, 41.
11 *Ibid.*, 63.
12 *Ibid.*, 40.
13 *A Pacifist's War*, 101.
14 Julia Strachey was the subject of Frances's book *Julia, a Portrait of Julia Strachey / by Herself & Frances Partridge*.
15 *A Pacifist's War*, 134.
16 *A Pacifist's War*, 212.
17 *A Pacifist's War*, 213.
18 *Hanging On*, 7.
19 *Life Regained*, v.
20 Frances Spalding, *Vanessa Bell* (New York: Harcourt Brace Jovanovich, 1983), 359.
21 *Other People: Diaries 1963–1966* (London: HarperCollins, 1993), 125.
22 *Hanging On*, entry for September 24, 1962, 245.

23 In Lytton Strachey, for example, she detected an "unbridled cruelty" about members of his own circle, particularly about Clive Bell. He once called Morgan Forster "a mediocre man who will come to no good," termed Julian Bell "half-witted," and said of Desmond MacCarthy that "dullness exuded" from him "in a concentrated stream." Seeing the excellence of Carrington's letters made Frances herself doubt the intelligence of assembling those of Desmond MacCarthy, and left her relieved that this task would not be done, for the present at any rate.
24 *Good Company: Diaries 1967–1970* (London: Flamingo, 1995), diary entry for October 28, 1969, 222.

Painters in France, 1910–1921: Duncan Grant, Vanessa Bell, Roger Fry

Epigraph: From *LRF*, quoted in Simon Watney, *English Post-Impressionism* (London: Studio Vista, 1980), 3.

1 The word "epochal" is used by Peter Stansky, *On or About December 1910: Early Bloomsbury and Its Intimate World* (Cambridge: Harvard University Press, 1996), 176.
2 The exhibition, "Modern French Artists," was held at the Brighton Public Art Galleries from June to August 1910.
3 Quoted in Frances Spalding, *Roger Fry: Art and Life* (London: Granada Publishing, 1980), 131.
4 Quoted in Stansky, 177.
5 Stansky, 194.
6 Virginia Woolf, "Character in Fiction," *The Essays of Virginia Woolf, Volume III, 1919–1924*, ed. Andrew McNeillie (New York: Harcourt Brace Jovanovich, 1989), 421. (Reprinted as *Mr Bennett and Mrs Brown* [London: The Hogarth Press, First Series,

1924].)

7 Robert Ross, quoted in Spalding, *Roger Fry*, 136.

8 Stansky, 210.

9 *See,* among many writings on Manet's *Olympia* and its impact on the art world, Eunice Lipton, *Alias Olympia* (New York: Scribner's, Maxwell Macmillan, 1992). This is an engaging study of personal involvement with her search for the character of this model, Victorine Meurent, who was primarily a painter.

10 From *L'Occident,* Sept. 1907. See Richard Shiff, *Cézanne and the End of Post-Impressionism* (Chicago: University of Chicago Press, 1984) and his introduction to the reprinting of Roger Fry's *Cézanne: A Study of His Development* (Chicago: University of Chicago Press, 1989) for details.

11 Watney sees in this use of Cézanne a "troubled ambiguity" and in the resultant Francophilia in Great Britain the "obverse side of Fry's Anglophobia," related to Pre-Raphaelite art and not to the art contemporary with Roger Fry (7). About self-referentiality, he reminds us of Duncan's 1908 article on Simon Bussy in *The Spectator,* showing that in his work the individual elements did not refer to the exterior world but mattered "only for the sake of their relationship to one another" (*op. cit.*, 87).

12 Roger Fry, "Retrospect," appended to *Vision and Design* (London: Chatto and Windus, 1920; repr. Pelican Books, Harmondsworth, 1937), 230.

13 Virginia Woolf, *Roger Fry: A Biography* (London: Hogarth Press, 1940), 152.

14 In his essay "Retrospect," Fry recalls this moment sadly: "In fact, I found among the cultured who had hitherto been my most eager listeners the most inveterate and exasperated ene-

mies of the new movement" ("*Retrospect, op. cit.*, 234).

15 Stansky, 189.

16 *See* Frances Spalding, *Duncan Grant: A Biography* (London: Chatto and Windus), 98.

17 Clive Bell, "Bloomsbury," *Old Friends* (Chicago: University of Chicago Press, 1973), 134.

18 Virginia Woolf, *Roger Fry,* 153–62, *passim.*

19 Frances Spalding, *Vanessa Bell* (New York: Harcourt Brace Jovanovich, 1983), 92–93.

20 Roger Fry to Vanessa Bell, August 1911. In Denys Sutton, ed., *Letters of Roger Fry* (London: Chatto and Windus, 1972; New York: Random House, 1972), I, 350.

21 Matthew Prichard was a close friend of Georges Duthuit, Matisse's son-in-law; they were both sponsors of the dining room at Charleston Farmhouse. Gertrude Stein, whom Vanessa wanted to meet, had known Roger for some years; she welcomed Vanessa and Clive as warmly as she did Duncan. My introduction to Prichard was through Rémy Labrusse, to whom many thanks. (M.A.C.)

22 *See* Stansky, 61.

23 Fry, "The French Post Impressionists," preface to catalogue, Grafton Galleries, 1912, reprinted in *Vision and Design.* Frances Spalding gives an interesting account of the Second Post-Impressionist Exhibition in *Duncan Grant: A Biography.*

24 In his essay "The Artistic Problem," written for *The Athenaeum* in 1919 and reprinted in his *Since Cézanne* of 1922, Bell brings up the useful notion of "passionate apprehension" as the source of the creative impulse (*see* S. P. Rosenbaum, *The Bloomsbury Group: A Collection of Memoirs and Commentary* [Toronto: University of Toronto Press, 1995], 103.) The idea of *holding* as being present in the etymological formulation of the word is of particular interest

when we consider the efforts of Virginia Woolf's Bernard in *The Waves* to hold on to the moment, in a post-Proustian impulse.

25 Duncan Grant to J. M. Keynes, Sept. 28, 1912, British Library; quoted by Frances Spalding, *Vanessa Bell,* 113.

26 Spalding, *Duncan Grant,* 123.

27 The Parisian Salon d'Automne was an event with great prestige in the art world, exerting considerable influence on the reputations of the artists who participated. Duncan Grant was invited to exhibit in the 1938 Salon d'Automne (Spalding, *Duncan Grant,* 364).

28 Vanessa Bell to Mary (Molly) MacCarthy, n.d., Lilly Library, Bloomington, IN.

29 In Derain's *Barges on the Thames* (1906), the riotous red tones of boats and sky are just visible through London's mist and fog. Just as the crane is cropped off, leaving only the hook, so the bridge blocks out the full sight of the sky behind. The effect is similar to that of the Japanese prints then so much appreciated in London and Paris. *Barges* represents the very essence of Fauve landscape or waterscape, a Frenchman's tribute to England.

30 Denys Sutton, *Walter Sickert* (London: Michael Joseph, 1976), 133.

31 Spalding, *Vanessa Bell,* 226–27.

32 Some of Vanessa's judgments may surprise us, such as her reactions to Virginia's writing. Vanessa wishes, for example, that she wouldn't write such long novels but confine herself rather to short sketches of people talking (*VBRF,* June 6, 1914.)

33 *VBCB* (n.d.), 1914.

34 It has been reopened, on the rue du Vieux Colombier, and is, at the moment, the theater where such productions as Tom Stoppard's *Arcadia* are staged.

For information on the Copeau–Grant connection, *see* the letters of Jacques Copeau to Duncan Grant.

35 This is Duncan Grant's translation, quoted in Denys Sutton, "Jacques Copeau and Duncan Grant," *Apollo*, vol. 1, Number LXXXVI, No. 66 (New Series), August 1967, 138–41. Sutton's information comes, appropriately, from the Bibliothèque de l'Arsenal in Paris, but he is wrong in stating that there was no further collaboration between Copeau and Duncan Grant after the making of these costumes. Duncan in fact continued to work with Copeau, most notably on André Gide's *Saül.*

36 *Les Régistres du Vieux Colombier*, 216.

37 *Ibid*, 193.

38 *Ibid.*

39 *VBDG*, n.d. [1914].

40 Letter to Gignoux, *Régistre*, 197. The next year, Copeau would write a clear description of what he had been aiming at in his sets, an aim with which Duncan's talents concurred. He wanted "an abstract set. Neither place nor epoch. But of a form perfectly appropriate to the spirit of theater. A combination of lines, levels, and depths which will be the efficacious basis for drama in all its movements, a support, a linear schema for the gymnastic of Drama, of its dance" (*Théâtre du Vieux Colombier*, 1913–1993, Editions Norma, 1993 [1916 text], 37). Commenting on Duncan's set, he called it "as simple as it is ingenious: a few hangings constitute a central path to backstage, while the orchestra pit, covered over, permits two levels of stage play. A few props, cubes instead of chairs, constitute the setting for an action taking place in a joyful rhythm" (285).

41 "Jacques Copeau and Duncan Grant," *op. cit.*,140.

42 *VBRF*, May 15, 1914.

43 "Jacques Copeau and Duncan Grant," 140.

44 Recounted by David Garnett, *The Flowers of the Forest* (New York: Harcourt, Brace, 1955), 21.

45 Painted in St.-Tropez; bought by Professor T. Marshall from the artists in 1922; information courtesy of Sandra Lummis.

46 Roger found Marchand "serious and simple," as he remarked in a letter to Marie Mauron, Dec. 12, 1919.

47 *RFVB*, Aug. 19, 1922.

48 The extreme of this case seems to have been the Bussy family at La Souco, where Dorothy Strachey Bussy, whose French was perfect, would always address her husband Simon in English, although he addressed her in French. Similarly, she wrote André Gide in English while he answered her in French.

49 *See* his *Old Friends*, which makes clear Clive's amazement at his compatriots who chose not to speak the language of their adopted country.

50 *DGVB*, Jan. 21, 1921.

51 Duncan Grant to Clive Bell, February 26, 1914 (*DG*). For the importance of this wallpaper, probably the stippled paper, with the light piercing through, which Picasso used in seven collages of this date, among his most significant creations, see Rosalind E. Krauss, *The Picasso Papers* (New York: Farrar Straus Giroux, 1998), 159–62.

52 Krauss, *op. cit.*, 160.

53 *Op. cit.*, 170. *See* Krauss for further detail about the bringing of local color into collage and the play of meaning and of mirrors.

54 R. W. B. Lewis, *Edith Wharton: A Biography* (New York: Harper & Row, 1975), 36.

55 *VBRF*, May 21, 1915.

56 Telephone call with M.A.C., June 26, 1997. Clive Bell was more to the right than the oth-

ers, and during World War I wrote a pamphlet, *Peace at Once*, which was ordered publicly burned by the Lord Mayor of London. He was also opposed to the Second World War. When we were debating how to handle this point, Frances Partridge said of Clive that the two things he loved were "friends and paintings"—it is that statement that furnished the subtitle for this book.

57 Testimony and manuscript in the 1994 film produced by John Fuegi and Jo Frances, *The War Within: Virginia Woolf.*

58 *LVB*, 100n.

59 Letter given by Annabel Cole, August 1997.

60 *VBRF*, May 21, 1915.

61 Brooke was also admired for "The Soldier," which Dean Inge recited in a sermon at St. Paul's Cathedral in London. Rupert Brooke was loved also by Elizabeth van Rysselberghe, to whom André Gide gave a child to make up for the one she had never had with Rupert (Paul Delany, *The Neo-Pagans: Rupert Brooke and the Ordeal of Youth* [New York: The Free Press, 1987], 209–15).

62 Doucet's widow (Mrs. Crompton) became attached to Roger Fry. He wrote Vanessa Bell from Ste.-Maxime (Auzeville, near Roquebrune) to say he now knew how irritating it was to be with someone in love with him, whose feelings he could not reciprocate. He could understand how Vanessa must have felt (*LRF*, 184).

63 *See* Peter Stansky, *op.cit.*, 95.

64 Information from *Le théâtre en France*, vol. 2: *De la révolution à nos jours* (Paris: Armand Colin, 1989).

65 People were not always kind about Barbara Bagenal. Frances Partridge remembers her as "brisk, efficient, and boring," and Vanessa wrote Roger Fry April 30, 1915, about "miss Bag-

ginal [*sic*] whom you may have seen at Ottolines parties dancing that queer looking creature with no chin."

66 *Loc. cit.*, 141.

67 *RFVB* August (n.d.), 1918.

68 Spalding, *Vanessa Bell*, 176.

69 Roland Penrose, *Picasso* (Paris: Flammarion, 1982), 269.

70 *DGVB*, Saturday (n.d.), 1918.

71 *Ibid.*

72 *DGVB*, Sept. 23, 1918.

73 *LRF*. II, 478 (April 12, 1920).

74 *LRF*. II, 482 (June 20, 1920).

75 *Loc. cit.*

76 *RFVB*, Oct. 6, 1919.

77 *DGVB*, March 16, 1920. The house at 45 Quai de Bourbon, on the Ile-St.-Louis, was owned by Prince Antoine Bibesco (who died in 1951). Mina Curtiss, editor of the letters of Marcel Proust, describes it as "the most heavenly house on the prow of the Ile-St.-Louis, with a view of both sides of the Seine . . . [with] a room so beautiful it took my breath away—full length Vuillard panels obviously painted to fit on the walls . . . a princely residence . . . all elegant, ancient stone. . . " (Mina Curtiss, *Other People's Letters: A Memoir* [Boston: Houghton Mifflin, 1978], 82, 88).

78 *VBRF*, May (n.d.), 1920.

79 Their friendship with Copeau was lasting. In July of 1931, Julian Bell's friend Eddie Playfair wrote Julian about meeting the people connected with the Vieux Colombier at a tea given by Duncan and Vanessa in London, to which Janie Bussy and other cross-Channel travelers were invited (*EP*, July 4, 1931).

80 Angelica Garnett, "The French Connection," *Charleston Magazine*, Issue 6 (Winter/Spring 1992), 11.

81 This, no doubt, is why Vanessa Bell's children enjoyed Roger Fry so much over the years. He could see through what Vanessa called their "outer dirt" and believe they were "almost the nicest creatures on earth."

82 *VBRF*, May (n.d.), 1920.

83 *RFVB*, May 18–20, 1921.

84 Conversation with M.A.C., August 1996.

85 *Ibid.*

86 He pointed out to Goldsworthy Lowes Dickinson that if he, Fry, were a Proustian, Dickinson was bound not to be one (*LRF*, 464). He wrote André Gide about the volume of essays on December 15, 1922 (*LRF*, 530).

87 *LRF*, 534 (May 13, 1923).

88 Despite his initial appreciation of Proust, Roger later considered him to be "too persnickety and silly . . . a second-rater man altogether." He believed, nevertheless, that Proust "had the power to use his hyperaesthesia as an artist—that's *au fond* the only important or interesting thing about him" (*LRF*, 583). Perhaps it was Roger's Quaker heritage that prevented him from retaining his powerful primary intuitions. As Angelica Garnett puts it, speaking of Fry's lament over watercolor not leaving him enough time to do what he wanted to do, because of the impossibility of correcting it, "Fry simply couldn't give way to the unconscious and the intuitive. His Quaker inheritance, deprived of religion as a means of transcending the ego, kept its intellectual, painful hold over his will." Letter to M.A.C., October 30, 1995.

89 *RFVB*, May 18–20, 1921.

90 Fry's taste for Poussin's style is implicit in his advice to Charles Mauron when he was translating Virginia Woolf. He should, Fry advised, take care not to accentuate any one element over another. It is also evident in his praise of Jean Marchand's paintings (*Vision & Design*, 225–27).

91 *VBRF*, Jan. 9, 1918.

92 *RFVB*, Monday (n.d.), 1920.

93 Wyndham Lewis, *The Apes of God* (San Francisco: Black Sparrow Press, 1981), 60–81 (*passim*), 542, 635–36.

94 *VBRF*, May (n.d.) 1920. Lewis, self-cast as "The Enemy of the People," was the editor of *BLAST*, an avant-garde journal. He was an admirer of Mussolini, and his right-wing views were so extreme, as William Rothenstein tells us in his memoirs, as to oblige his dinner hosts to ask the other guests if they would mind having him at the table.

95 The photograph is from *Le Théâtre*. Louis Jouvet had already left the Vieux-Colombier at this time for the Théâtre des Champs-Élysées. Denys Sutton must not have seen these photographs of *Saül* at the time of writing his article for *Apollo* ("Jacques Copeau and Duncan Grant," *op. cit.*). This was the last collaboration between Grant and Copeau, who closed his theater in 1924 and left for Burgundy, after writing his memoirs (*Critiques d'un autre temps*).

96 *Théâtre du Vieux-Colombier, op. cit.*; Marie-Françoise Cristout, "Jacques Copeau et le théâtre du Vieux-Colombier, 1913–1924," 92.

97 The text is as follows: "The stage as I have conceived of it and as we have begun to live into being, that is, totally naked, as bare as possible, waiting for something and ready to receive its form from the action itself to be played out upon it, this stage is never so lovely as in its natural state, primitive and empty, when nothing is happening upon it and it is resting, silent, dim in the weak half-light of day. It is thus that I contemplated it and understood it better once the season was over: real, in its flat surface, with just its construction like some premature hypothesis of the needs of the representation, an accomodation to its necessities as they are conceived now, that still shackle our mind which is not yet free of them.

When I saw this stage restored to itself, last July, I understood that everything that took place upon it in season: actors, props, lights, had deformed it. So it is from the stage we have to start.... But this is really our stage, and we have to use it without adding anything: neither steps or bleachers or lighting effects, in its implacable truth.... We have to give our pupils the knowledge and experience of the human body. The actor must know from inside the passions they are expressing, either through personal experience or through that kind of divination that is proper to the artist." Much of the information about Jacques Copeau and the Vieux-Colombier comes from *Le théâtre en France*, vol. 2: *De la révolution à nos jours* (Paris: Armand Colin, 1989), and from *Jacques Copeau*, coll. *Critiques d'un autre temps* (Paris: NRF, 1923). This text is from Copeau's "La Scène et l'acteur" ["The Stage and the Actor"], 219–21, translation M.A.C.

98 February 2, 1921.
99 *DGVB*, n.d.
100 Angelica Garnett, who remembers being with Segonzac, Derain, and others in Paris, never remembers being there with Roger (conversation with the authors, 1997).
101 *VBRF* (n.d.), 1922. Segonzac had, according to Roger, a very happy personality, which, he added, one would certainly not suspect from his paintings. Angelica Garnett points out that Segonzac would take charge in cafés, and it is clear in Vanessa's letters how much he liked her, often flirting and dancing with her.

Painters in Provence, 1921–1938

St.-Tropez, 1921–1927
Epigraph: Vanessa Bell to Clive Bell, November 21, 1921 (*Selected Letters of Vanessa Bell*, ed. Regina Marler [New York: Pantheon Books, 1993]), 261.
1 *VBRF*, September 12, 1919.
2 *VBRF*, Nov. 15, 1919.
3 *RFVB*, Aug. 16, 1921.
4 *RFVB*, Sept. 21, 1922.
5 *VBRF*, Aug. 16, 1921.
6 *RFVB*, Dec. 3, 1921.
7 *LRF*: II, 565.
8 *RFVB*, Sept. 6, 1921.
9 *Ibid.*
10 Charles Vildrac was a playwright and poet as well as an artist (*see* "The Maurons, E. M. Forster, Julian Bell, and Bloomsbury.")
11 Grace Germany (190–1983) was their principal domestic in France and England; in 1934 she married Walter Higgens. She was part of Vanessa's household for forty years.
12 *VBCB*, Oct. 12, 1921 (*Selected Letters of Vanessa Bell*, ed. Regina Marler, 255).
13 *Ibid.*
14 *VBRF*, Dec. 3, 1921.
15 *VBRF*, Nov. 21, 1921.
16 Charles Camoin (1876–1965), a young friend of Henri Matisse and Albert Marquet, had studied at the Paris Academy, with Matisse and Simon Bussy, under Gustave Moreau. *See* the catalogue *Charles Camoin: Rétrospective 1879–1965*: Musées de Marseille/Réunion des musées nationaux, prepared for the exhibition at the Musée Cantini, Marseilles, 1997. There is a superb sketch of him by Albert Marquet in 1905, painting, as Duncan and Vanessa would later do, in the garden of the Hotel Cendrillon in Cassis.
17 Georges Duthuit, a friend of Matisse and of the Byzantinist Matthew Prichard, was also friendly with Roger Fry and with the entire Bloomsbury group. He was a frequent visitor to Charleston Farmhouse. During the Nazi occupation his wife, Marguerite (daughter of Matisse), was deported from France because of her work in the Resistance.
18 *VBCB*, Dec. 14, 1921; *LVB*, 262.
19 *VBRF*, Dec. 14, 1921.
20 *RFMM*, December 12, 1919.
21 Roger Fry to Jean Marchand, December 19, 1921. In Denys Sutton, ed, *Letters of Roger Fry* (London: Chatto & Windus, 1972; New York: Random House, 1972), II, 519–20.
22 *VBRF*, Dec. 14, 1921.
23 *VBRF*, May 20, 1921. Roger was as exasperated as Vanessa every time they collided. Rose's eulogistic explanations of everything she had done set his teeth on edge: "Vous voyez comme la décoration est simple ... mais c'est que nous laissons notre marque où nous habitons, ("see how simply I decorate ... we leave our mark on any place we live in"), etc. etc.—she gets worse and worse every year," he remarked.
24 *RFVB*, Sept. 21, 1922.
25 She wrote him in April that she would find it difficult to live next door to Margery, "not being so ready to mix every sort of combination as you are! Think of Clive. You know he's not always very easy to live with.... Nor do I really think that Clive and Margery would get on at all well. We'd all be at daggers drawn in a few days, what with you, me, Clive, Duncan, Margery, Pamela, my 3 children, Nelly, Chloe & other servants. I hope the whole plan of going to France won't fall through for us." It seemed to do so.
26 *VBRF*, Jan. 25, 1928.
27 To John Maynard Keynes, Dec. 19, 1921 (*LVB*, 261).

Duncan Grant
Aboard the Arequipa, 1924–1925
Epigraph: Duncan Grant to Vanessa Bell, January 3, 1925 (*DGVB*).
1 Correspondence with S.B.W., October 1998.
2 Frances Spalding, *Duncan Grant: A Biography* (London:

Chatto and Windus), 1997, 47. Spalding observes that the family gathering, "a perfect image of the French bourgeoisie," was not repeated.

3 Michael Holroyd, *Lytton Strachey: The New Biography* (New York: Farrar, Straus and Giroux, 1994), 207; *Selected Letters of Vanessa Bell*, ed. Regina Marler (New York: Pantheon, 1993), 85n.

4 Information provided by Bart Lahr of the Netherlands Maritime Museum (the photograph is from H.C.A. van Kampen and H. Kersken Hzn, *Schepen die voorbijgaan* [ANWB or Dutch Touring Association], 1927). Others who were helpful in our research about the *Arequipa* were Philip L. Budlong, Associate Curator, Mystic Seaport Museum, Mystic, CT, Miss Alison J. Lindsay of the Scottish Record Office, National Archives of Scotland, and Miss Meredith Sampson of the National Maritime Museum, Scotland.

5 *DGVB*, Dec. (n.d.), 1924.

6 Spalding, *Duncan Grant*, 262.

7 *DGVB*, Dec. (n.d.), 1924.

Cassis, 1925–1929
Epigraph: *DWV*: III, 8 (Apr. 8, 1925).

1 *LVW*: III, 175.

2 *LRF*: II, 545 (Oct. 1, 1923).

3 Frances Spalding, *Roger Fry: Art and Life* (London: Granada Publishing, 1980), 251. Ten of his works were included, and seven were sold. This success went far toward healing his wounded spirits, since in several exhibitions in which his work was represented none of his paintings had been sold.

4 *RFVB*, Sept. 23, 1925.

5 The sirocco is the southern wind from the desert, which brings sand and leaves grit in everything in its path. It reputedly causes ill temper, and is far more unpleasant than the mistral.

6 *RFVB*, Sept. 23, 1925.

7 "The French Connection," Part 1, *The Charleston Magazine*, Issue 6 (Winter/Spring 1992), 9.

8 *VBRF*, Sept. 25, 1925. Roger's letter to her, which she had not yet received, was written September 28. Vanessa and Roger were quite comic in their letters to each other about their respective accidents. In October 1928 Vanessa had just reached La Bergère in time for the grape harvest and Duncan had retired, which he always did immediately upon arrival. She tried to move a large cupboard and was struck on the nose and forehead. She wrote Roger about the mishap, adding, "I am hideous. I never admired my nose so much as I do now when I see how much worse it can be than God made it" (*VBDG*, Oct. [n.d.], 1928).

9 *RFVB*, Sept. 28, 1925.

10 Conversation with the authors, 1994.

11 *RFVB*, Sept. 28, 1925.

12 *RFVB*, Oct. 9, 1925.

13 Gerald Brenan made a note to himself in his diary, in November 1925, exasperated with Carrington's treatment of him: "Do you know what would suit me perfectly? to go to Cassis and have typhoid." He would be treated, he says, to the ironic spectacle of Carrington's indifference to someone she claimed to love with such ardor—the exact opposite of Vanessa's treatment of Duncan.

14 Angelica Garnett points out that this was near what is now the autoroute, originally near a sort of park. The Villa Mimosa, she says, was across from the Villa Corsica, and was a much older house, behind a wall. The Hôtel Cendrillon, where Virginia, Leonard, and Roger all stayed at different times, is about a mile away in the town of Cassis, near the harbor.

15 *DGVB*, Oct. 10, 1927.

16 *VBVW*, Feb. 5, 1927.

17 *DGVB*, Nov. 22, 1927. Georges Braque, with his olive skin and shock of white hair, dressed often in pale gray corduroy and was considered to be highly attractive. Mme Braque, short and plump, was apparently less so. It is possible that this contrast explains Duncan's remark.

18 *VBRF*, April 3, 1927.

19 *DGVB*, Jan. [n.d.], 1927.

20 *VBVW*, Jan. 26, 1927.

21 *VBVW*, Jan. 29, 1927 (Villa Corsica).

22 *VBVW*, Feb. 5, 1927.

23 *VBVW*, May 3, 1927.

24 *VBVW*, June 27, 1929.

25 *VBRF*, Feb. 5, 1927.

26 *LRF*, I, 602 (April 24, 1927).

27 *VBRF*, April 3, 1927.

28 *DGVB*, Oct. 17, 1927.

29 Frances Spalding, *Vanessa Bell* (New York: Harcourt Brace Jovanovich, 1983), 223.

30 *VBRF*, Jan. 23, 1928.

31 Conversation with the authors, 1994.

32 *VBRF*, Jan. 25, 1928.

33 *LVW*, III, 483.

34 *VBRF*, June 5, 1928.

35 *VBRF*, March [n.d.], 1928.

36 *VBRF*, May 10, 1928.

37 *VBRF*, May 23, 1928.

38 *Loc. cit.*

39 *VBRF*, Sept. [n.d.], 1928.

40 *VBRF*, October 8, 1928.

41 *VBCB*, Oct. 1, 1928. Julian Bell repeatedly described the terrors of Roger at the wheel in his letters to the Maurons.

42 *VBRF*, Sept. 13, 1928.

43 Spalding, *Duncan Grant*, 291.

44 *VBRF*, March 17, 1928.

45 *VBRF*, March 17, 1928.

46 Elise Anghilanti, from the village of Cassis, taught Grace Germany (later Higgens), Vanessa's cook, how to make Boeuf en daube, a Provençal dish that figures in Virginia Woolf's *To the Lighthouse* as the center of the dinner presided over by Mrs. Ramsay, a meal crucial to the book. It is frequently said that this is Roger Fry's recipe, and there are several descriptions of his arriving in England laden with the cook-

ware with which to make various dishes from Provence. This equipment included the very large cone-shaped vessel called the "diable."

47 *VBVW*, Feb. 20, 1928. At one point, driving with Duncan, Vanessa met a large lumbering bus, swerved to the right into the ditch, then to the left, and finally, right into the bus, with the result that they had to abandon the car and return by train. This long account was, she wrote Virginia, to warn her about the perils of driving in France.

48 *Ibid.*

49 *Ibid.*

50 Interview with Angelica Garnett by Mary Ann Caws and Sarah Bird Wright, July 1990.

51 *VBRF*, April 17, 1929.

52 *VBRF*, April 13, 1929.

53 *Ibid.*

54 Michael Holroyd, *Lytton Strachey: The New Biography* (London: Chatto and Windus,1994; New York: Farrar, Strauss and Giroux, 1995), 96.

55 *LVB*, 262 (December 17, 1921).

56 *VBRF*, May–June, 1929.

57 *VBRF*, April 25, 1929.

58 *RFVB*, June 2, 1927.

59 *DGVB*, May 5, 1937.

60 *VBRF*, Jan. 25, 1928.

61 *VBRF*, Jan. 23, 1928.

62 *VBRF*, June 15, 1929.

63 *VBRF*, April 2, 1929.

64 *VBRF*, July 29, 1929.

65 *VBRF*, July 29, 1929.

66 Angelica Garnett, *The Eternal Moment: Essays and a Short Story* (Orono, Maine: Puckerbrush Press, 1986), 88–89.

67 *VBRF*, Oct. [n.d.], 1919.

68 "The French Connection," Part 1, *The Charleston Magazine*, Issue 6 (Winter/Spring 1992), 10.

Last Years in the Midi, 1930–1938
Epigraph: *DGVB*, Dec. 5, 1930 (from La Bergère), quoted in Frances Spalding, *Duncan Grant: A Biography* (London: Chatto and Windus, 1997), 302.

1 *VBRF*, Aug. 15, 1930.

2 Beaumes-de-Venise is in the foothills of the Mont Ventoux, in the hills, but could scarcely be termed "the mountains," which, of course, Vanessa knew.

3 Spalding, *op.cit.*, 292–303, *passim.*

4 *VBRF*, Oct. 5, 1931. (1930?)

5 *Ibid.*, 301.

6 Frances Spalding, *Vanessa Bell* (New York: Harcourt Brace Jovanovich, 1983), 242–43.

7 *LVW:* IV, 312–13 (Apr. 15, 1931).

8 Their differing personalities were obvious at such times. Vanessa had suddenly been asked to paint scenery for a ballet starring Lydia Lopokova (Keynes). "I find it's rather terrifying, having so little experience of such things. D. seems to do his so light-heartedly but I get into a terrible stew. However I rather enjoy the behind the scenes world for a time…" (*VBRF*, May 31, 1932).

9 *RFVB*, March 7, 1930.

10 *RFVB*, Aug. 30, 1932.

11 *RFVB*, Aug. 20, 1933. He continued with the reason that only black would do: "pure burnt sienna tells as a brilliant opaque red almost like vermillion would in the tone scales we use."

12 *LRF:* II, 526–27.

13 *RFVB*, January 30, 1933.

14 Eddie Playfair, a friend of Julian's, wrote him of a journey to Cassis in which he stopped for lunch in St.-Rémy ("a most charming place") with the Maurons, who were in top form, and Helen Anrep.

15 Spalding, *Vanessa Bell*, 267.

16 Spalding, *Vanessa Bell*, 269.

17 In conversation with the authors, July 1997.

18 *JBCM*, Feb. 17, 1936.

19 *VBJB*, May 5, 1935.

20 *Ibid.*, 293–300, *passim.*

Visual Translations

Epigraph: Frances Partridge, *Julia Strachey, by Herself and Frances Partridge* (Boston and Toronto: Little Brown, 1983), 268.

1 Henrietta Garnett, letter to M.A.C., October, 1996.

2 About 1975 Duncan Grant, then about ninety, was interviewed on the British radio program "Desert Island Discs" and was asked which of his paintings he would choose to survive, if he could choose only one. Responding that it was a difficult question, he stated that *The Tub* had been "satisfactory" when painted and still seemed so (Spalding, *Duncan Grant*, 518).

3 Our thanks to Rémy Labrusse for his information on this topic; he has edited the French edition of Georges Duthuit's work on Byzantine art. Roger Fry believed the Byzantine, with its stylized and decorative patterning and line, to be associated with pure form. This was the opposite of the "literary" or associational, referential art he disliked at this period.

4 *Post-Impressionists in England: The Critical Reception*, ed. J. B. Bullen (London: Routledge, 1988). Rpt. in Anna Gruetzner Robins, *Modern Art in Britain: 1910–1914* (London: Merrell Holberton in association with the Barbican Art Gallery, 1997), 25.

5 *RFVB*, Oct 6, 1919.

6 Matisse trusted Bussy's opinion of his work. He told the story of one painting, in which he himself had reservations about a red floor. Bussy remarked on this and left. When he returned, Matisse had repainted the floor, to Bussy's satisfaction.

7 We would like to thank Jack Flam for identifying the Matisse.

8 The re-attribution has been made by Richard Shone in his authoritative study *Bloomsbury Portraits* (London: Phaidon, 1976 and 1993).

9 Clive Bell, *Landmarks in Nine-teenth-Century Painting* (Freeport, NY: Books for Libraries Press), 132.

10 *VBRF*, Jan. 9, 1918

11 We would like to thank Sandra Lummis for a reproduction of this painting.

12 Virginia Woolf, quoted in S. P. Rosenbaum, *The Bloomsbury Group: A Collection of Memoirs and Commentary* (Toronto: University of Toronto Press, 1995), 207.

13 *RFVB*, fall [n.d.], 1923.

14 *LRF*, II, 301.

The Maurons, E. M. Forster, Julian Bell, and Bloomsbury

Epigraph: Francis King, *E. M. Forster and His World* (New York: Charles Scribner's Sons, 1978), 76.

1 *RFMM*, Nov. 8, 1919 (*LRF*: II, 467). All translations of letters from Roger Fry to the Maurons not included in the edition of Roger Fry's letters edited by Denys Sutton, and translated by Pamela Diamand (designated as *LRF*), are by M.A.C., as are all their letters to him and to or from E. M. Forster.

2 It was Roger Fry who encouraged Marie Mauron to publish her first book about Provence, *Mont-Paon*, which Oxford accepted; it was eventually translated by Peter Lucas. Of her sequel to *Mont-Paon*, *Edward Playfair*, Julian Bell's Cambridge friend, wrote him: "It comes closer home than the first book, and most of the relatives are in it; Charles is terrified of this narrowing circle, and fears that her third book will be all about himself, in the same style" (*EP*, [n.d.]).

3 Neither *Aesthetics and Psychology* nor *The Nature of Beauty* appeared in French. Fry was translating the former during his last stay at Royat, a short time before his death. The translation was completed by Katherine John and published in London in 1935 (reprinted in 1970).

4 Charles Mauron lecture, December 1949, first given at Oxford, then in London, and published in *Psyché* (Paris: No. 63 [January 1952]).

5 Charles Mauron, *L'Inconscient dans l'oeuvre et la vie de Racine*, his *thèse d'université*, defended in June 1954, at Aix-en-Provence, published in 1957 by the Annales de la Faculté des Lettres, and often reprinted. In the Preface to this thesis Mauron evokes his scientific mentors, and then Roger Fry. The quotation is from pages 8–9.

6 *RFCM*, January 27, 1925.

7 Information from Alice Mauron, letter to the authors, January, 1998.

8 First published in 1951; rewritten with Camille Dourguin (Saint-Rémy-de-Provence, Association pédagogique "Lou Prouvençau a l'Escolo"), 1966.

9 See the *Estudi Prouvençau* (the *Etudes Mistraliennes*), which bring together all of Charles Mauron's writings in the Provençal language.

10 *RFVB*, June 18, 1924 (from the village of Mas Blanc).

11 *CMEMF*, April 28, 1931.

12 *VBCB* n.d., 1938.

13 Unpublished essay.

14 *RFCM*, May 19, 1924.

15 *RFCM*, July 20, 1925.

16 *RFVB*, Oct. 28, 1928.

17 *RFVB*, May 1, 1929.

18 *RFVB*, May 16, 1929.

19 See the article on this latter version in the journal *Twentieth Century Literature*, vol. 29, fall 1983, no. 3.

20 There are differing opinions on the subject of Roger's letter-writing talents. Even as he was increasingly sure of his competence in the French language, he was still convinced he was a mediocre letter writer. Duncan Grant, writing to Vanessa about one of Roger's letters to Angela Lavelli, thought the picture Roger gave of himself an odd one. He considered Roger's catalogue of buildings and paintings he had seen uninteresting. Duncan's opinion is, however, suspicious, since he wanted, as he said openly, to reassure Vanessa that Roger's relationship with Angela was no cause for concern.

21 *Selected Letters of Vanessa Bell*, ed. Regina Marler (New York: Pantheon Books, 1993), 338n.; 339.

22 *JBCM*, Feb. 21, 1935.

23 *JBCM*, n.d., from Charleston.

24 *JBMM*, Aug. 21, 1935. He goes on to compare the ruins of Pompeii to those of Glanum at St.-Rémy.

25 *JBCM*, n.d. Our gratitude to Alice Mauron for supplying Bell's letters. On Forster and on *The Longest Journey*, see "E. M. Forster's Refutation of Idealism," in S. P. Rosenbaum, *Edwardian Bloomsbury: The Early Literary History of the Bloomsbury Group* (New York: St. Martin's Press, 1994), 226–57. The pertinent passage is on p. 257. Bell had entitled his fellowship dissertation for King's "The Good and All That," opening with a discussion of the problem of the cow, who reappears in Mauron's essay "The Cow." T. S. Eliot published this essay in the *Criterion* (1933). The title of Rosenbaum's essay refers to G. E. Moore's "The Refutation of Idealism"; this novel is, says Rosenbaum, "the first piece of fiction to be written about Bloomsbury's Cambridge origins, the first to use Moore's philosophy, the first to represent certain values of the Group" (226).

26 *JBCM*, Feb. 16, 1936.

27 *JBCM*, n.d.

28 *JBCM*, n.d.

29 Julian Bell to Marie Mauron, n.d.

30 *Ibid.*

31 *Ibid.*

32 *VBCM*, Jan. 14, 1934.

33 *CMRF*, Jan. 14, 1934.

34 *EP*, Jan. 12, 1936.

35 *EP*, Aug. 7, 1936.

36 *EP*, Aug. 9, 1936.

37 Letter to Charles Mauron, from Monks House, Rodmell, Lewes, Sussex, April 28, 1940.

38 *See Des métaphores obsédantes au mythe personnel: Introduction à la psychocritique* (Paris: José Corti, 1963). *See also* Linda Hutcheon, *Formalism and the Freudian Aesthetic: the Example of Charles Mauron* (New York and Cambridge: Cambridge University Press, 1984), and Jeffrey Mehlman, "Entre psychanalyse et psychocritique," *Poétique: revue de théorie et d'analyse littéraires*, No. 3, (1970), 365–85.

39 See Jeffrey Mehlman's formulation: "It was Charles Mauron's tracing of the intertextual arabesque running from poem to poem of Mallarmé and its surprising link to the early Mallarmé prose text of 1857 that launched the serious psychoanalytic study of literature in France." (In "Mallarmé and the 'seduction theory,'" *Paragraph*, Vol. 14 (Oxford University Press, 1991), p. 97.

40 *Introduction à la psychanalyse de Mallarmé* (Neuchâtel, La Baconnière), 1950.

41 Alice Mauron reminded M.A.C. of this remark in the summer of 1997.

42 *CMEMF*, June 8, 1928.

43 *CMEMF*, Feb. 22, 1929.

44 Roger Fry had agreed with Princess Bassiano, the patroness of the journal *Commerce*, that Mauron should translate a story of James, since the French knew so little about him (*REFCM*, Nov. 11, 1925), 585.

45 Mauron translated this novel in 1947 as *Avec vue sur l'Arno*, a title that omitted the context of the view from a particular room. Forster then wrote a sequel, "A View without a Room" (Rosenbaum, 332).

46 *CMEMF*, Feb. 28, 1925.

47 *CMRF*, 16 January, 1928.

48 Nicola Beamman, *E. M. Forster* (New York: Alfred A. Knopf, 1994), 354–55.

49 *LVB*, 418.

50 *CMEMF*, n.d., 1937.

51 *CMEMF*, June 11, 1929 (from Raphaele-les-Arles).

52 Roger Fry was delighted with Vildrac's play. He commented, "What, indeed, is so admirable is that Vildrac has presented a slice of real life on the stage—it's not the extreme naturalism of Zola or the Goncourts, etc.—but the naturalism of the human soul with all its indecisions, incompetencies and incoherencies, and it's precisely for that it's very moving and touching. One senses in it the inherently pathetic nature of the human situation, the utter weakness of man before destiny" (*RFMM*, June 20, 1920; *LRF*: III, 482).

53 *CMEMF*, n.d., 1929.

54 *CMJB*, Jan. 27, 1937.

55 *Ibid.*

56 *CMJB*, n.d., 1937.

57 *Ibid.*

58 *EMFVB*, Sept. 9, 1937.

59 *CMVB*, Aug. 30, 1937. (King's Modernist Archives, Cambridge).

60 *CMEMF*, Oct. 26, 1937. Virginia Woolf pointed out the same attitude of the painters who formed Julian's "spiritual home": "All they can do when Europe blazes is screw their eyes up and complain of a temporary glare in the foreground."

61 CMQB, November, 1938.

62 *CMEMF*, Sept 9, 1939.

63 *Ibid.*

Intellectuals at Pontigny

Epigraph: Letter from Edward Playfair to Julian Bell at King's College (Modernist Archives), May 8, 1932.

1 *Décades de Pontigny* (Paris: Presses Universitaires de France), 403.

2 The meetings at Cerisy-la-Salle are somewhat modified, the traditional full-length *décade* being sometimes replaced by shorter meetings. The essence of the original gatherings at Pontigny continues, however, with an international body of scholars convening to discuss topics ranging from the writings of Stéphane Mallarmé and Jacques Derrida to sociology and politics.

3 *EP*, Sept. 5, 1930.

4 Michael Holroyd, *Lytton Strachey: The New Biography* (London: Chatto and Windus; New York: Farrar, Straus and Giroux, 1995), 526-27. (The *acte gratuit* is a Gidean theory, exemplified in *Les Caves du Vatican*, in which one traveler pushes another out of his railway car, for no reason.)

5 *Ibid.*

6 Klara Fassbinder, "Gide at Pontigny," *Entretiens sur André Gide* (September 6–14, 1964 [The Hague: Mouton, 1967], 265–70. The quotation comes from p. 267, translation M.A.C.

7 Dorothy Bussy to André Gide, July 5, 1926 (*Selected Letters of André Gide and Dorothy Bussy*, ed. Richard Tedeschi [New York and London: Oxford University Press, 1983]), 115.

8 Gide was so important a figure in the legend of Pontigny/Cerisy that, when I attended my first *décade* in 1966, his bed was still shown to first-time visitors. It was kept as a religious talisman. This was still the epoch when Anne Heurgon-Desjardins, with her thick Bourgignon accent, was the tutelary presence, Maurice Gandillac the guiding spirit and main discussant, and Clara Malraux one of the principal attendees (ed. note, M.A.C.).

9 André Gide, *Journal: 1889–1939*

(Paris: Gallimard). Quoted in Claude Mahais, *La Vie d'Andre Gide* (Paris: Gallimard, 1955), 307.

10 "Introduction—Gide à Alger," in *Entretiens sur André Gide, op. cit.*, 1–12.

11 *Letters*, 232.

12 Jacques Raverat to James Strachey, Aug. 10, 1924 (Strachey Papers, British Library). Raverat was educated at Bedales in England and then studied at the Sorbonne and Cambridge before he decided to be an artist and entered the Slade. He had married Gwen Darwin, Charles Darwin's granddaughter, in May of 1911; they settled at Vence, where he died of multiple sclerosis in 1925.

13 *RFMM*, Aug. 28, 1925; *LRF*, 577–78.

14 *EP*, n.d. Eddie, always curious and observant, was intrigued by some of the details of the Dreyfus case, in its more bizarre refinements. He loved the story of the "staff major communicating with the villain of the piece through his highly disreputable mistress, or meeting him in the Parc Montsouris dressed in a false beard and blue spectacles," while the chief of the Secret Service was also wearing a beard and blue spectacles.

15 *EP*, n.d.

16 Jacques Heurgon-Desjardins, translator of Lytton's biography *Elizabeth and Essex*.

17 *EP*, Sept. [n.d.], 1930.

18 *EP*, May 30, 1931. (A personal reflection, on reading Sir Edward Playfair's letter: The first times I attended Cerisy, Anne Heurgon-Desjardins herself took me in tow, but I made the same mistake as Sir Edward Playfair, and said nothing during the *entretiens*. It makes all the difference. As for the *propos libres*, or slightly risqué speech, one of the last things I remember during a meeting when Anne Heurgon-Desjardins was

still alive was the attempt of one speaker to be especially shocking, thinking, as he spoke of masturbation as "what the left hand doeth" that "the police might come at any moment," even as both Anne Heurgon-Desjardins and her large dog snored peacefully. M.A.C.)

Roger Fry's France

Epigraph: Quoted in Frances Spalding, *Roger Fry: Art and Life* (London: Granada Publishing, 1980), 127.

1 *RFVB*, Aug. [n.d.], 1911; *Letters of Roger Fry* (*LRF*), ed. Denys Sutton (London: Chatto and Windus, 1962), I, 350.

2 Paul Levy, *G. E. Moore and the Cambridge Apostles* (Oxford, 1981), 114.

3 Quentin Bell, *Bloomsbury Recalled* (New York: Columbia University Press, 1995); originally published in England as *Elders and Betters* (Murray, 1995), 52. *See* Linda Hutcheon, *Formalism and the Freudian Aesthetic: the Example of Charles Mauron* (New York and Cambridge: Cambridge University Press, 1984), and Jeffrey Mehlman, "Entre psychanalyse et psychocritique," *Poétique: revue de théorie et d'analyse litteraires*, No. 3, (1970), 365–85.

4 Vanessa Bell, *Sketches in Pen and Ink: A Bloomsbury Notebook*, ed. Lia Giachero (London: Hogarth Press, 1997), 136.

5 His dispute with J. Pierpont Morgan concerned a work of art that Roger Fry had secured, he thought, for the Metropolitan, until the moment when Morgan appropriated it for himself. This ended Fry's association with the museum.

6 *LRF*, Aug. 31, 1927; 609.

7 *LRF*, Aug. 14, 1934; 609.

8 *Ibid.*

9 *LRF*, Oct. 6, 1919; 459.

10 Letter to Winifred Gill at the

Omega Workshop, London. Quoted in Frances Spalding, *Roger Fry*, 197.

11 *LRF*, Oct. 21, 1919; 462.

12 *LRF*, Nov. 3, 1919; 470.

13 *LRF*, April 12, 1922; 523.

14 *LRF*, Oct. 27, 1919; 643.

15 Spalding, *Roger Fry*, 197.

16 Quentin Bell, *Bloomsbury Recalled*, 110.

17 Clive Bell, "Bloomsbury," *Old Friends* (Chicago: University of Chicago Press, 1973), 85.

18 *Ibid.*, 112.

19 *RFVB*, Sept. 1, 1922. Clive Bell was amusing, and not a little cutting, about Roger's maladies; he related anecdotes about the varied medicines Roger would try, taking them about in a small black box.

20 *RFVB*, Nov. 5, 1922.

21 *Ibid.*

22 RF to M. de Brabis, n.d.

23 *RFVB*, July [n.d.], 1922.

24 *RFVB*, [n.d.], 1922. In 1911 the Bells, Roger Fry, and Harry Norton had traveled to Turkey together. Vanessa had had a miscarriage at Brusa (the original Ottoman capital); Clive was unable to be of much help, but Roger nursed her and offered psychological assistance. *See* "Painters in France, 1910–1921."

25 *RFVB*, [n.d.], 1922.

26 *RFVB*, [n.d.], 1922.

27 *RFVB*, April 18, 1924.

28 *VBRF*, [n.d.], 1922.

29 *RFVB*, "L'Histoire de Josette," translated M.A.C.

30 *RFVB*, July [n.d.], 1929.

31 *Ibid.*

32 In *Lytton Strachey by Himself: A Self Portrait*, ed. Michael Holroyd (London: Vintage, 1971).

33 *RFVB*, [n.d.], 1934.

34 Regina Marler, ed., *Selected Letters of Vanessa Bell* (New York: Pantheon Books, 1993), 286n.

35 Paul Valéry, fragment of "La Jeune parque" (1917), translation M.A.C. Roger Fry's friend Charles Mauron analyzed this poetic fragment in particular, in

his commentary on Valéry.

36 *LRF*, 446 (to André Gide, Feb. 19, 1919). In fact, as Fry found out in Cassis, in 1927, Dorothy and Janie Bussy were also devoted to Valéry.

37 *LRF*, II, 616 (Sept. 27, 1927).

38 *Ibid.*

39 Spalding, *Roger Fry*, 199. Vanessa said, however, that the French artists they knew were too fond of Roger as a person to let it be known how unenthusiastic they were about his work.

40 *LRF*, I, 365.

41 Vanessa Bell, *Sketches in Pen and Ink*, 112.

42 Charles Baudelaire, "Les Chats," in *Les Fleurs du Mal*, translation by Richard Howard (Boston: David R. Godine, 1982), 69–70; 246–47.

43 *LRF*, II, 528 (letter to Margery Fry, Oct. 2, 1922).

44 *Ibid.*

45 *LRF*, 298n. and 300 (letter of March 1908 to the *Burlington Magazine*).

46 *LRF*, 300.

47 Fry, *Cézanne*, 39.

48 *See* Norman Bryson, *Looking at the Overlooked* (Cambridge: Harvard University Press, 1995).

49 *Ibid.*, 37.

50 *Ibid.*, 46.

51 Virginia Woolf, *The Waves*, (London: Hogarth Press, 1931), 177–78.

52 The Alpilles, the small Alpine hills behind St.-Rémy, strike Fry as the essence of mountain, their power condensed in their small scale. We are reminded of his small landscapes in his sketchbook: his *pochades*, which perfectly catch the unconscious.

53 *Cézanne*, 40.

54 *Ibid.*

55 *Cézanne*, 22, 61.

56 *Cézanne*, 37.

57 *Cézanne*, 65.

58 *Cézanne*, 74.

59 Roger Fry, "The Art of the Bushmen," *Vision and Design* (London: Chatto and Windus, 1920; rev. ed., repr. Pelican Books, Harmondsworth, 1937), 85.

60 *RFVB*, Sept. 27, 1924.

61 *Cézanne*, 3.

62 *DC* (to Gerald Brenan), Jan. 29, 1923.

63 *The Morning Post*, June 9, 1923.

64 Virginia Woolf, *Roger Fry, A Biography* (London: Hogarth Press, 1940), 263.

65 *LRF*, I, 45.

66 Quoted in Brenda Wineapple, *Sister Brother: Gertrude and Leo Stein* (Baltimore: John Hopkins University Press, 1996), 358.

67 *LRF*, II, 230 (to Robert Bridges, Jan. 23, 1924).

68 Spalding, *Roger Fry*, 250.

69 *RFVB*, March 15, 1921 (*RFL*, II, 501).

70 Roger Fry, *Vision and Design, op. cit.*, 22.

71 Annabel Cole points out, quite rightly, that in his *Reflections on British Painting* (1934; Freeport, NY: Books for Libraries Press, 1969), Roger Fry "emphasizes throughout the primacy of three-dimensional as against two-dimensional art." His point of view, of course, will change with his context.

72 Clement Greenberg, *The Collected Essays and Criticism*, ed. John O'Brian (Chicago: University of Chicago Press, 1986–1993), Vol. 3, *Affirmations and Refusals, 1950–1956*. Manet is then one of the heroes of modernism for having used no underpainting or glaze, thus emphasizing the two-dimensionality of the painting. His was a *peinture claire*, working from light to dark instead of the other way around in a more academic practice. This enabled him to seize the fleeting effects, as in photography, "suppressing local color in order to follow the play of light and dark by tinted tonalities of grey." This guarantees the *independence* of painting from anything sculptural. As an extreme example given by Greenberg, the paintings of Mondrian echo the enclosing shape of the picture.

73 Greenberg, *op. cit.*, 8.

74 Adam Gopnik, "The Power Critic," on Clement Greenberg, in *The New Yorker*, March 16, 1998, 70–78.

75 Roger Fry, *Transformations: Critical and Speculative Essays on Art* (London: Chatto and Windus, 1926), 25.

76 *See* Roger Fry, *Henri-Matisse* (London: A. Zwemmer, 1935); repr. in Christopher Reed, ed., *A Roger Fry Reader* (Chicago: University of Chicago Press, 1996); and *The Artist and Psychoanalysis* (London: Hogarth Press, 1924), repr. in *Inscape*, No. 6, *Journal of the British Association of Art Therapists*; also repr. in Reed, *A Roger Fry Reader*, 351–65. *See also* Richard Shiff, *The Artist and Psycho-analysis* (London, 1924), xix, on this transformation. Shiff discusses the moderation of such statements as Fry made about the importance of the *how* of presentation, not on the *what* (Introduction to Roger Fry, *Cézanne: A Study of His Development* [London: Hogarth Press, 1927; repr. Macmillan and Harcourt Brace, 1950; and Chicago: University of Chicago Press, 1989]).

77 Bell, *Sketches in Pen and Ink*, 132–33.

78 Fry, *Cézanne*, 52.

79 *Ibid.*

Simon and Dorothy Bussy, André Gide

1 Information from Philippe Loisel, *Simon Bussy: l'Esprit du Trait: du Zoo à la Gentry* (Paris: Somogy Editions d'Art, 1996); Frances Spalding, *Duncan Grant: A Biography* (London: Chatto and Windus, 1997), 25.

2 Loisel, 28.

3 Simon Bussy, letter to Gabriel Hanotaux, October 29, 1912,

quoted in Loisel, 28.

4 Bréal wrote books on Velázquez, translated by Ellen Heath, a friend of the Stracheys, and on Rembrandt, translated by Dorothy Strachey Bussy.

5 Michael Holroyd, *Lytton Strachey: The New Biography* (New York: Farrar, Straus and Giroux, 1994), 96.

6 Dorothy Bussy to Ray Costelloe, Sept. 9, 1920.

7 Dorothy Bussy to Ray Costelloe Strachey from the Pension Sollar, rue des Beaumettes [n.d.].

8 Her extensive correspondence with Gide fills three volumes of the *Cahiers André Gide* (nos. 8–10; Paris: Gallimard, 1980–1982.)

9 DBAG, Oct. 31, 1918 (*Selected Letters*, 4). The quotations from Dorothy Strachey's letters to André Gide come from *Selected Letters of André Gide and Dorothy Bussy*, ed. Richard Tedeschi (New York: Oxford University Press, 1983; cited as *Selected Letters*), and from the unpublished letters and journals in the Bibliothèque Nationale. Our thanks for permission to publish them, and to the Bibliothèque Nationale. Her letters have been translated into French with portions omitted.

10 September 1, 1921.

11 Dorothy Bussy, journal entry, March 11, 1922.

12 DBAG, n.d.

13 DBAG, Sept. 17, 1920 (*Selected Letters*, 57.)

14 Simon Bussy to André Gide, Jan. 1922 (Bibliothèque Nationale).

15 André Dunoyer de Segonzac, letter to Simon Bussy, Bibliothèque Nationale.

16 Correspondence with Henrietta Garnett, January 1998.

17 DBAG, n.d.

18 Dorothy Bussy, journal entry, n.d.

19 DBAG, May 22, 1921 (*Selected Letters*, 70).

20 DBAG, July 5, 1921 (*Selected Letters*, 70).

21 Paul Delany, *The Neo-Pagans: Rupert Brooke and the Ordeal of Youth* (New York: Free Press, 1987), 220.

22 Alan Sheridan, *André Gide: A Life in the Present* (Cambridge: Harvard University Press, 1999), 359.

23 Dorothy Bussy, journal entry, n.d., unpublished.

24 *Ibid.*, n.d.

25 DBAG, Nov. 6, 1928. Dorothy, however, had learned to judge the rare moments Gide did permit her a degree of intimacy as remarkable. "I hadn't expected ever to be so happy again. I know! but then if the grapefruit really ripens, isn't it more delicious, more wonderful, more precious than if one had counted on it, like some ordinary potato? but of course one can't, one mustn't count on grapefruits. An extraordinary concourse of stars and seasons is needed to produce them." Gide, she realized, had the good fortune to find potatoes as sweet as grapefruits; consequently he was never disappointed. "You can extract juice and flavour from everything–even thorns and brambles, let alone potatoes," she observed.

26 AGDB, Jan. 30, 1929 (*Selected Letters*, 43).

27 DBAG, April 26, [1921] (*Selected Letters*, 67).

28 Dorothy Bussy, Journal entry, n.p., n.d.

29 DBAG, Nov. 6, 1928.

30 DBAG Mar. 20, 1925 (*Selected Letters*, 113–14).

31 Frances Spalding, *Vanessa Bell* (New York: Harcourt Brace Jovanovich, 1983), 290–91.

32 *Selected Letters of Vanessa Bell*, ed. Regina Marler (New York: Pantheon Books, 1993), 440n.

33 Jane Simone Bussy, "A Great Man," *Burlington Magazine*, January 1986, 1; for the Memoir Club in 1927.

34 DB to Pippa Strachey, Nov. 17,

1938 (Strachey Letters, British Library).

35 An excellent painting of Charles and Alice Mauron by Zoum Walter now hangs in Alice Mauron's home in St.-Rémy.

36 André Gide, *Journal*, 828, 970.

37 *See Les Noyers de L'Altenburg* (1943; *The Walnut Trees of Altenburg*, trans. A. W. Fielding [N.Y.: H. Fertig, 1989]). *See also The Voices of Silence* (1951, trans. Stuart Gilbert [Garden City, N.Y.: Doubleday, 1953]).

38 *See* the biography of Malraux by Jean-François Lyotard, *Signé Malraux* (Paris: B. Grasset, 1996), 272. Luigi, the majordomo of the villa, whom the Bussys had left there, was fond of the Malraux, and fed them fresh fish and moussaka encased in white sauce.

39 Drieu la Rochelle had procured the permission for Malraux to enter the free zone of the Midi. The Italian government, then occupying Italy, had ordered Malraux's Parisian publisher, Gallimard, not to pay him (*see* Lyotard, 270–74). Through the intervention of Varian Fry, head of the Emergency Rescue Committee, executives at Random House were persuaded to send him much-needed funds every month. Malraux was surprisingly relaxed during this period, seemingly unconcerned and free of his usual nervous tic. He was writing *Les Noyers de l'Altenburg* (*The Walnut Trees of Altenburg*).

40 DB to Pippa Strachey, March 25, 1945. Malraux's two sons were later killed in an automobile accident.

41 Leonard Woolf to Margaret Llewelyn Davies, *Letters of Leonard Woolf*, ed. Frederic Spotts (New York: Harcourt Brace, 1989), 249.

42 Vanessa Bell to Molly MacCarthy, Nov. 2, 1944 (Lilly Library, Bloomington, IN).

43 Dorothy Strachey to Ray Costel-loe Strachey, n.d. (Lilly Library).

44 Vanessa Bell to Molly Mac-Carthy, Nov. 25, 1944 (Lilly Library).

45 As Gide's son-in-law Jean Lambert puts it in his introduction to the second volume of the Bussy-Gide correspondence, "On the emotional level ... exceptionally important in this friedship, we notice another evolution: on his part, a tenderness more and more eager to show itself; on hers, the same love, but taking fewer and fewer risks of showing itself, for fear of losing everything" (*Cahiers André Gide*, no. 10: *Correspondance André Gide—Dorothy Bussy* II, janvier 1925-novembre 1936[Paris: Gallimard, 1981, 8]).

46 André Gide to Roger Martin du Gard, May 1945, Bibliothèque Nationale, Paris. Translation M.A.C.

47 AGDB, Feb. 2, 1948 (*Selected Letters*, 276); AGDB Mar. 8, 1948 (*Selected Letters*, 281).

48 Sheridan, *André Gide*, 590–91.

49 AGDB [telegram] June 4, 1948 (*Selected Letters*, 283); DBAG, June 9 or 10, 1948 (*Selected Letters*, 285). *Olivia*, by "Olivia," was later reprinted (Harmonds-worth, Middlesex, Penguin, 1966).

50 AGDB, June 5, 1948 (*Selected Letters*, 283–84).

51 AGDB Aug. 22, 1948 (*Selected Letters*, 286).

52 DBAG Aug. 28, 1948 (*Selected Letters*, 287).

53 Sheridan, 359.

54 This is one of the main points of M.A.C.'s *Women of Bloomsbury: Vanessa, Virginia, and Carrington* (London and New York: Rout-ledge, 1989).

55 DBAG, May 12, 1947 (*Selected Letters*, 264). Dorothy was referring to Paul Roche, Duncan's priest friend, and Michel St.-Denis, a friend of Jacques Copeau, who was Angelica Gar-nett's drama teacher. No documentation has been found about Gide's play *Saül* having been performed in London; it was translated by Jackson Matthews.

56 *Ibid.*, 302.

57 Julia Frances Strachey, *Julia, a Portrait of Julia Strachey/by Herself and Frances Partridge* (Boston: Little, Brown, 1983), 116.

58 *Ibid.*, 245 (Dec. 24, 1954).

59 Information from Angelica Bell Garnett (October 1998); also Spalding, *Vanessa Bell*, 358–59.

60 Spalding, *op. cit.*, 360.

61 Partridge, *Julia Strachey, op. cit.*, 269.

Literary Translations

Epigraph: *LRF*, 592 (letter to Lady Fry, March 7, 1926).

1 *LRF*, 606 (August 23, 1927).

2 *LRF*, 476.

3 James Joyce would have been another; however, he had the good fortune to find a superb translator in Pierre Leyris.

4 *LRF*, 586. He wanted all of James's stops to be exaggerated and all his parentheses hurried over. Fry had done frequent "battle for James" in literary and artistic discussions.

5 *See* discussion of this interchange in *Twentieth Century Literature*, Vol. 29 (Fall, 1983), no. 3.

6 *LRF*, 598 (letter December 21, 1926, to Charles and Marie Mauron). Many readers will disagree heartily with Fry's point of view on Woolf and his emphasis on nonemphasis.

7 Roger Fry, *Vision and Design* (London: Chatto and Windus, 1920; repr. Pelican Books, Harmondsworth, 1937), 25–26.

8 *Vision and Design*, 42.

9 Mauron translated the middle portion of *To the Lighthouse* as "Le Temps passe" (*Commerce*, no. 10 [Winter, 1926], 89–113). His translation of *Orlando* was published in Paris (Stock, 1931), as was *Flush* (Stock, 1935). When Woolf's friends said Mauron was not a very good translator, she insisted that she wanted him to continue, and asked Janie Bussy about his translation of *Orlando*; Bussy reassured her it was very good.

10 Virginia Woolf was wary of being typecast in France. She wrote in her diary on Thursday, March 24, 1932, "Two books on Virginia Woolf have just appeared—in France & Germany. This is a danger signal. I must not settle into a figure" (*DVW*: IV, 85).

11 Elizabeth Bowen, "Afterword" to Virginia Woolf, *Orlando: A Biography* (New York: New American Library [Signet Editions], 1960), 221.

12 Charles Mauron, translation of Virginia Woolf, *Orlando* (Paris: Stock, 1931; rpt. 1974), 183.

13 Mauron, *Orlando*, 117.

14 Virginia Woolf, *Orlando*, 201–2.

15 Mauron, *Orlando*, 191.

16 Woolf, *Orlando*,.

17 Mauron, 120–21.

18 Woolf, *Orlando*, 214–15.

19 Mauron carried this text with him, between two sheets of gold leaf. It read, "Joie. Joie. Pleurs de joie," which means, literally, "Joy, joy, tears of joy." Pascal is also the subject of Mallarmé's poem "When the Shadow Menaced with Its Fatal Law"; *see* Mauron's commentaries to the 1951 edition of Roger Fry's translations of Mallarmé, 227–28.

20 Mauron, *Orlando*, 202–3. After preparing this chapter, we read this corroborating passage in Mauron's own preface to the original edition (Charles Mauron, "Translator's Preface" to *Orlando* [Paris: Stock, 1931, xiii]): "just see to what marvelous things the word 'Ecstasy' alludes—the only thing, she says, which matters in the world. I translated 'Ecstasy' by 'Tears of

joy' (it's Pascal, of course, but one key more or less does not matter) because these words held a little of the text's resonance for me. But, obviously, each reader should choose his own formula" (Original preface in Stock edition, 1931, xiv). Translation M.A.C. Thanks to Alice Mauron, this original preface was sent to the authors, confirming the suspicion that the "tears of joy" came from Blaise Pascal (M.A.C.). In the 1974 edition of Virginia Woolf's *Oeuvres romanesques* (vol. 2), Mauron's preface has been replaced by that of Diane de Margerie.

21 *Op. cit.*, xiii. The quotation by Mauron cited in note 37 refers to the metaphor of these keys.

22 Margaret Yourcenar, preface to *Les Vagues*, in Virginia Woolf, *Oeuvre romanesque*, II, 212.

23 Yourcenar, *op. cit.*, 211.

24 Virginia Woolf, *Les Vagues* (Paris: Calmann-Lévy, tr. Cécile Wajsbrot, 1993), 31.

25 Woolf, *The Waves*, 11–14.

26 Yourcenar, *op. cit.*, 220–21.

27 Wajsbrot, *op. cit.*, 42.

28 *Ibid.*, 43.

29 Woolf, *The Waves*, 19.

30 Yourcenar, *op. cit.*, 24–25.

31 Wajsbrot, *op. cit.*, 47.

32 Woolf, *The Waves*, 288.

33 Yourcenar, *op. cit.*, 413.

34 Wajsbrot, *op. cit.*, 242.

35 Virginia Woolf, *A Room of One's Own* (London: Hogarth Press and New York: Harcourt Brace, 1929); *Une chambre à soi*, traduction par Clara Malraux (Paris: Ed. Denoël, Bibliothèque 10/18, 1997; 1992 pour la trad. française). Page numbers in parentheses refer to these editions.

36 E. M. Forster, *Howards End* (London: Edward Arnold, Ltd., 1910). E. M. Forster, *Howards End* (*Le Legs de Mrs. Wilcox*), traduction par Charles Mauron (Paris: Plon, 1950). Page numbers in parentheses refer to these editions.

37 Information given by Alice Mauron to M.A.C., August 2, 1998. Mauron's translation was used when a film was made of the novel.

38 At the suggestion of Forster, Roger Fry once gave Mauron a piano on which in later years he played scores in Braille (*see* "The Maurons, E. M. Forster, Julian Bell, and Bloomsbury").

39 Charles Mauron, "Orpheus and Morgan," in J. H. Stape, ed., *E. M. Forster: Interviews and Recollections* (New York: St. Martin's, 1993), 193–96. First published as "Quelques traits de E. M. Forster," *Le Figaro littéraire*, 10 Jan. 1959; trans. J. H. Stape.

40 Virginia Woolf, *The Common Reader, First Series* (New York: Harcourt, Brace & World, 1925), 282.

41 *RFVB*, June 20, 1933.

42 *RFMM*, July 3, 1920; *LRF*, II, 484.

43 Translation by Roger Fry. In Stéphane Mallarmé, S*elected Poems and Prose*, ed. Mary Ann Caws (New York: New Directions, 1982), 4–5.

44 *Op. cit.*, 3.

45 Bell and Mauron first published *The Poems of Mallarmé* in 1936, two years after Fry's death, with Chatto and Windus. This edition included many commentaries by Mauron as well as the twenty-six translations Fry (with Bell's assistance) had completed out of the sixty-four poems in Mallarmé's *Poésies*. It was so successful that in 1951 New Directions reissued the original Chatto and Windus publication. This edition included a lengthy preface by Mauron that replaced the "Early Introduction" Fry had left in a rough state; it also had a fuller set of Mauron's commentaries. Those not translated by Fry were translated by Julian and Quentin Bell. Stéphane Mallarmé, *Poems*, trans. Roger Fry with commentary by Charles Mauron (New York: New Directions, 1951). This edition adds the remaining untranslated French texts to Fry's translations, as well as the stunning and typographically revolutionary text of *Un coup de dés jamais n'abolira le hasard*, which was first published in the journal *Cosmopolis* in 1897. Mauron's commentary on this all-important text shows how the filmic fading in and out of the words can also be read with each page as a picture.

46 *Ibid.*, 23.

47 *Loc. cit.*

48 *Op. cit.*, 252.

49 *Op. cit.*, from Roger Fry's original or "Early Introduction," pieced together from notes by Julian and Quentin Bell, in which he thanks Pippa Strachey, "who has, I think, deciphered more of Mallarmé's riddles than any other one person" (300). This comment predates Mauron's commentaries, of course.

50 *Op. cit.*, 198, 229. The translation of this first line has provoked almost as much controversy as the opening line of Proust's great novel, *A la recherche du temps perdu* (*In Search of Lost Time / Remembrance of Things Past*).

51 *Op. cit.*, 234.

52 Charles Mauron, commentaries on Mallarmé, *op. cit.*, 190–91.

53 *Op. cit.*, commentary on "My Old Books Closed on Paphos' Name," 282.

54 September 25, 1955.

Selected Bibliography

Baron, Wendy. *Miss Ethel Sands and Her Circle.* London: Peter Owen Limited, 1977.

Bell, Clive. *Art.* London: Chatto and Windus, 1914.

———. *Civilization* and *Old Friends.* Chicago: University of Chicago Press, 1956.

———. *Landmarks in Nineteenth-Century Painting.* London: Chatto and Windus, 1927; New York: Harcourt Brace, 1927.

———. *Proust.* London: Hogarth Press, 1928.

———. *Since Cézanne* (1922). Freeport, N.Y.: Books for Libraries Press, 1969.

Bell, Quentin. *Bloomsbury.* London: Weidenfeld and Nicolson, 1968.

———. Virginia Nicholson, and Alen MacWeeney. *Charleston: A Bloomsbury House and Garden.* New York: Henry Holt and Co., 1997.

———. *Elders and Betters* (in the U.S., *Bloomsbury Recalled*). New York: Columbia University Press, 1996.

———. *Vanessa Bell's Family Album.* Compiled by Quentin Bell and Angelica Bell Garnett. London: J. Norman & Hobhouse, 1981.

———. *Virginia Woolf: A Biography.* Vol. I, *Virginia Stephen* 1882–1912. London: Hogarth Press, 1972.

———. *Virginia Woolf: A Biography.* Vol. II, *Mrs. Woolf* 1912–1941. London: Hogarth Press, 1972.

Bell, Quentin, Angelica Garnett, Henrietta Garnett, and Richard Shone. *Charleston: Past and Present.* London: Hogarth Press, 1987.

Bell, Vanessa. *Selected Letters of Vanessa Bell,* ed. Regina Marler. New York: Pantheon, 1993.

———. *Sketches in Pen and Ink: A Bloomsbury Notebook,* ed. Lia Giachero. London: Hogarth Press, 1997.

Bryson, Norman. *Looking at the Overlooked.* Cambridge: Harvard University Press, 1995.

Bullen, J. B., ed. *Post-Impressionists in England: The Critical Reception.* London: Routledge, 1988.

Bussy, Dorothy. *Olivia by "Olivia."* London: 1949. Rpt. Harmondsworth, Middlesex: Penguin, 1966; New York: Arno Press, 1975.

Carrington, Noel. *Carrington: Paintings, Drawings and Decorations.* London and New York: Thames & Hudson, 1978.

Caws, Mary Ann. *Carrington and Lytton: Alone Together* (London: Cecil Woolf, 1996).

———. *Colloque de Cérisy: Virginia Woolf.* Paris: Union générale d'éditions; Editions 10/18, 1977.

———. (Ed.), *Stephane Mallarmé, Selected Poems and Prose.* New York: New Directions, 1982.

———. *Women of Bloomsbury: Virginia, Vanessa, and Carrington.* New York and London: Routledge, 1989.

Cone, Michèle. *Artists Under Vichy: A Case of Prejudice and Persecution.* Princeton: Princeton University Press, 1992.

Copeau, Jacques. "An Attempt to Renew the Theater." *Nouvelle Revue Française,* September 1913.

———. "The Stage and the Actor," *Théâtre du Vieux Colombier, 1913–1993.* Paris: Editions Norma, 1993.

Crabtree, Derek and A. P. Thirlwall, eds. *Keynes and the Bloomsbury Group: The Fourth Keynes Seminar Held at the University of Kent at Canterbury 1978.* London: Macmillan, 1980.

Cristout, Marie-Françoise. "Jacques Copeau et le théâtre du Vieux Colombier, 1913–1924." *Théâtre du Vieux Colombier, 1913–1993,* Editions Norma, 1993 (1916 text).

Curtiss, Mina Stein, *Other People's Letters: A Memoir.* Boston: Houghton Mifflin, 1978.

Darroch, Sandra Jobson. *Ottoline: The Life of Lady Ottoline Morrell.* New York: Coward, McCann & Geoghegan, Inc., 1975.

De Botton, Alain. *How Proust Can Change Your Life: Not a Novel.* New York: Pantheon Books, 1997.

Décades de Pontigny. Paris: Presses Universitaires de France (various dates).

Delany, Paul. *The Neo-Pagans: Rupert Brooke and the Ordeal of Youth.* New York: The Free Press, 1987.

DeSalvo, Louise and Mitchell Leaska, eds. *The Letters of Vita Sackville-West to Virginia Woolf.* New York: William Morrow, 1985.

Dorléac, Laurence Bertrand. *L'art de la défaite.* Paris: Seuil, 1993.

Edel, Leon. *Bloomsbury: A House of Lions.* Philadelphia: Lippincott, 1979.

Fassbinder, Klara. "Gide at Pontigny," *Entretiens sur André Gide* (September 6–14, 1964). The Hague: Mouton, 1967.

Forster, E. M. *Howards End.* London: Edward Arnold, Ltd., 1910. *Le Legs de Mrs. Wilcox.* Traduction par Charles Mauron. Paris: Plon, 1950.

———. *A Passage to India.* London: Edward Arnold, Ltd., 1924. Traduction par Charles Mauron. *Route des Indes.* Paris: Plon, 1925.

Fry, Roger. *The Artist and Psychoanalysis.* London: Hogarth Press, 1924.

———. *Cézanne: A Study of His Development.* London: Hogarth Press, 1927; Chicago: University of Chicago Press, 1989.

———. *Henri-Matisse.* London: A. Zwemmer, 1935.

———. *Reflections on British Painting* (1934); Freeport, N.Y.: Books for Libraries Press, 1969.

———. *Transformations: Critical and Speculative Essays on Art.* London: Chatto and Windus, 1926.

———. *Vision and Design.* London: Chatto and Windus, 1920; repr. Pelican Books, Harmondsworth, 1937.

Gadd, David. *The Loving Friends.* London: Hogarth Press, 1974.

Garnett, Angelica. *Deceived with Kindness: A Bloomsbury Childhood.* London: Chatto and Windus,

1984; New York: Oxford University Press, 1985.

———. *The Eternal Moment: Essays and a Short Story*. Orono, Maine: Puckerbrush Press, 1986.

———. "The French Connection," Part 1, *The Charleston Magazine*, Issue 6 (Winter/Spring 1992), 9–13; Part 2, *The Charleston Magazine*, Issue 7 (Summer/Autumn 1993), 9–14; Part 3, *The Charleston Magazine*, Issue 8 (Winter/Spring 1993/4), 5–11.

Garnett, David, ed. *Carrington: Letters and Excerpts from Her Diaries*. London: Jonathan Cape, 1970.

———. *The Familiar Faces* (New York: Harcourt, Brace, 1962; Vol. 3 of *The Golden Echo*).

———. *The Flowers of the Forest* (New York: Harcourt, Brace, 1955; Vol. 2 of *The Golden Echo*).

———. *The Golden Echo* (New York: Harcourt Brace, 1954; Vol. 1 of *The Golden Echo*).

Gathorne-Hardy, Robert, ed. *The Early Memoirs of Lady Ottoline Morrell 1873–1915*. London: Faber, 1963.

Gathorne-Hardy, Robert, ed. *Ottoline at Garsington: Memoirs of Lady Ottoline Morrell 1915–1918*. London: Faber & Faber, 1974.

Gerzina, Gretchen Holbrook. *Carrington: A Life*. New York: Norton, 1989.

Gide, André. *Cahiers André Gide* (nos. 8–10; *Correspondance André Gide / Dorothy Bussy*), ed. Jean Lambert. Paris: Gallimard, 1980–1982.

Grant, Duncan. "Paris Memoir." Unpublished manuscript, Tate Archives, London.

Greenberg, Clement. *The Collected Essays and Criticism*, ed. John O'Brian. Chicago: University of Chicago Press, 1986–1993. Vol. 3, *Affirmations and Refusals, 1950–1956*.

Guiguet, Jean. *Colloque de Cérisy: Virginia Woolf*. Paris: Union générale d'éditions, 1977. (Chapters by Jean Guiguet, Peter Fawcett, Anthony Inglis, *et al.*)

Harrod, Roy Forbes. *The Life of John Maynard Keynes*. New York: Harcourt Brace, 1951.

Heilbrun, Carolyn, ed. *Lady Otto-line's Album*. New York: Alfred A. Knopf, 1976.

Hill, Jane. *The Art of Dora Carrington*. New York: Thames and Hudson, 1994.

Hill, Polly, and Richard Keynes. *Lydia and Maynard: The Letters of Lydia Lopokova and John Maynard Keynes*. New York: Scribner, 1989.

Holroyd, Michael. *Lytton Strachey: The New Biography*. London: Chatto & Windus, 1994; New York: Farrar, Straus and Giroux, 1995.

———. *Lytton Strachey and the Bloomsbury Group: His Work, Their Influence*. London: Harmondsworth: Penguin: 1971.

———, ed. *Lytton Strachey by Himself: A Self Portrait*. London: Vintage, 1994.

Hutcheon, Linda. *Formalism and the Freudian Aesthetic: the Example of Charles Mauron*. New York and Cambridge: Cambridge University Press, 1984.

Keynes, John Maynard. *The Economic Consequences of the Peace*. New York: Harcourt, Brace and Howe, 1920.

———. *A Treatise on Probability*. London: MacMillan and Co., Ltd., 1921.

Keynes, Milo, ed. *Essays on John Maynard Keynes*. Cambridge: Cambridge University Press, 1975.

King, Francis. *E. M. Forster and His World*. New York: Charles Scribner's Sons, 1978.

King, James. *Virginia Woolf*. London: Hamish Hamilton, 1994.

Le théâtre en France, vol. 2: *De la révolution à nos jours*. Paris: Armand Colin, 1989.

Lee, Hermione. *Virginia Woolf*. London: London: Chatto and Windus, 1996.

Lee, Hugh, ed. *A Cézanne in the Hedge and Other Memories of Charleston and Bloomsbury*. Foreword by Michael Holroyd. Chicago: University of Chicago Press, 1992.

Lemaire, Gérard-Georges. *Un thé à Bloomsbury: autour de Virginia Woolf*. Paris: Ed. Veyier, 1990.

Lewis, Wyndham. *The Apes of God*. San Francisco: Black Sparrow Press, 1981.

Lipton, Eunice. *Alias Olympia*. New York: Scribner's, Maxwell Macmillan, 1992.

Loisel, Philippe. *Simon Bussy: l'Esprit du Trait: du Zoo à la Gentry*. Paris: Somogy Editions d'art, 1996.

Lyotard, Jean-François. *Signé Malraux*. Paris: B. Grasset, 1996.

Mallarmé, Stéphane. *Poems*. Trans. Roger Fry with commentary by Charles Mauron. New York: New Directions, 1951.

———. *Selected Poetry and Prose*, ed. Mary Ann Caws. New York: New Directions, 1982.

Malraux, André. *Les Noyers de l'Altenburg* (*The Walnut Trees of Altenburg*, 1943), trans. A. W. Fielding. N.Y.: H. Fertig, 1989.

———. *The Voices of Silence*, tr. Stuart Gilbert. Garden City, N.Y.: Doubleday, 1953.

Mauron, Charles. *Aesthetics and Psychology*. Translated from the French by Roger Fry and Katherine John. Port Washington, N.Y.: Kennikat Press, 1970 (reprint of 1935 ed.)

———. *Le dernier Baudelaire*. Paris: José Corti, 1966.

———. *L'inconscient dans l'oeuvre et la vie de Racine*. Annales de la Faculté des Lettres, 1957.

———. *Mallarmé l'obscur: l'oeuvre et la vie*. Paris: Denoël, 1941.

———. *Des métaphores obsédantes au mythe personnel: introduction à la psychocritique*. Paris: José Corti, 1963.

Mini, Pieri V. *Keynes, Bloomsbury and the General Theory*. New York: St. Martin's Press, 1991.

Monk, Ray. *Bertrand Russell: The Spirit of Solitude, 1872–1921*. New York: Free Press, 1996.

Nicolson, Nigel. *Portrait of a Marriage*. London: Weidenfeld and Nicolson, 1973.

——— (ed.). *Vita and Harold: The Letters of Vita Sackville-West and Harold Nicolson*. New York: G. P. Putnam's Sons, 1992.

Partridge, Frances. *A Bloomsbury Album: Friends in Focus*. Boston: Little, Brown, 1987.

———. *Everything to Lose: Diaries, 1945–1960*. Boston: Little, Brown, 1985.

————. *Good Company: Diaries 1967–1970*. London: Flamingo, 1995.

————. *Hanging On: Diaries 1960–1963*. London: Collins, 1990; Flamingo, 1994.

————. *Love in Bloomsbury: Memories*. London: Victor Gollancz; Boston: Little, Brown and Company, 1981.

————. *Memories*. London: Robin Clark Ltd., 1982.

————. *Other People: Diaries 1963–1966*. London: Harper-Collins, 1993.

————. *A Pacifist's War*. London: Hogarth Press, 1978; New York: Universe Books, 1978.

Penrose, Roland. *Picasso*. Paris: Flammarion, 1982.

Reed, Christopher. *A Roger Fry Reader*. Chicago and London: University of Chicago Press, 1996.

Robins, Anna Gruetzner. *Modern Art in Britain: 1910–1914*. London: Merrell Holberton in association with the Barbican Art Gallery, 1997.

Rosenbaum, S. P. *The Bloomsbury Group: A Collection of Memoirs, Commentary annd Criticism*. Toronto: University of Toronto Press, 1975.

Sackville-West, Vita. *Challenge* (London: 1923; rpt. Collins, 1974).

————. "Diary of a Journey to France with Virginia Woolf in 1928." Berg Collection, New York Public Library.

Seymour, Miranda. *Ottoline Morrell: Life on the Grand Scale*. New York: Farrar Straus Giroux, 1992.

Shiff, Richard. *Cézanne and the End of Post-Impressionism*. Chicago: University of Chicago Press, 1984.

Sheridan, Alan. *André Gide: A Life in the Present*. Cambridge: Harvard University Press, 1999.

Skidelsky, Robert. *John Maynard Keynes: A Biography*. London: Macmillan, 1983.

Souhami, Diana. *Mrs. Keppel and Her Daughter*. New York: St. Martin's, 1997.

Spalding, Frances. *Duncan Grant: A Biography*. London: Chatto and Windus, 1997.

————. *Roger Fry: Art and Life*. London: Granada Publishing, 1980.

————. *Vanessa Bell*. London: Weidenfeld & Nicolson Ltd., 1983. New York: Harcourt Brace Jovanovich, 1983.

Stansky, Peter. *On or About December 1910: Early Bloomsbury and Its Intimate World*. Cambridge: Harvard University Press, 1996.

Stape, J. H., ed. *E. M. Forster: Interviews and Recollections*. New York: St. Martin's, 1993.

Strachey, Julia Frances [and Frances Partridge]. *Julia, a Portrait of Julia Strachey/by Herself and Frances Partridge*. Boston: Little, Brown, 1983.

Strachey, Lytton. *Books and Characters: French and English*. London: Chatto and Windus, 1922.

————. *Landmarks in French Literature*. London: Williams and Norgate, 1922.

Sutton, Denys. "Jacques Copeau and Duncan Grant," *Apollo*, vol. 1, LXXXVI, No. 66 (New Series), August 1967, 138–41.

————, ed. *The Letters of Roger Fry*. 2 vols. London: Chatto and Windus, 1972.

————. *Walter Sickert*. London: Michael Joseph, 1976.

Tedeschi, Richard, ed. *Selected Letters of André Gide and Dorothy Bussy*, ed. Richard Tedeschi. New York and London: Oxford University Press, 1983.

Trefusis, Violet Keppel. *Broderie Anglaise*, trans. from the French by Barbara Bray. San Diego: Harcourt Brace Jovanovich, 1985.

————. *Violet to Vita: The Letters of Violet Trefusis to Vita Sackville-West, 1910–1921*, ed. Mitchell A. Leaska and John Phillips (New York: Viking, 1990.)

Turnbaugh, Douglas. *Duncan Grant and the Bloomsbury Group*. Secaucus, NJ: L. Stuart, 1987.

Watney, Simon. *The Art of Duncan Grant*. London: John Murray, 1990.

————. *English Post-Impressionism*. London: Studio Vista, 1980.

Wilson, Jean Moorcroft. *Virginia Woolf: Life and London, A Biography of Place*. New York: W. W. Norton, 1987.

Wineapple, Brenda. *Sister Brother: Gertrude and Leo Stein*. Baltimore: Johns Hopkins University Press, 1996.

Woolf, Leonard. *Beginning Again: An Autobiography of the Years 1911 to 1918*. London: Hogarth Press, 1964.

————. *Downhill All the Way: An Autobiography of the Years 1919 to 1939*. London: Hogarth Press, 1967.

————. *The Letters of Leonard Woolf*. New York: Harcourt Brace Jovanovich, 1989.

Woolf, Virginia. *The Complete Shorter Fiction of Virginia Woolf*. New York and London: Harcourt Brace, 1989.

————. *The Common Reader, First Series*. New York: Harcourt, Brace & World, 1925.

————. *The Diary of Virginia Woolf*. 5 vols. Ed. Anne Olivier Bell. London: Hogarth Press, 1976–1982.

————. *The Essays of Virginia Woolf*, ed. Andrew McNeillie. London: The Hogarth Press, 1994.

————. *Kew Gardens and Other Short Stories*. Traduction par Pierre Norden. Paris: Livre de Poche, Les Langues Modernes, 1993.

————. *La Mort de la phalène*. Traduction par Helene Bokanowski. Paris: Seuil, 1968.

————. *The Letters of Virginia Woolf*. 6 vols. Ed. Nigel Nicolson and Joanne Trautmann. London: Hogarth Press, 1975–1980.

————. *Moments of Being*. London: Triad Granada, 1978.

————. *Orlando: A Biography*. London: Hogarth Press, 1928.

————. *Roger Fry: A Biography*. London: Hogarth Press, 1940.

————. *A Room of One's Own*. London: Hogarth Press and New York: Harcourt Brace, 1929. *Une chambre à soi*. Traduction par Clara Malraux. Paris: Ed. Denoêl, Bibliothèque 10/19, 1997; 1992 pour la trad. française.

————. *To the Lighthouse*. London: Hogarth Press, 1927.

————. *The Waves*. London: Hogarth Press, 1931.

Wright, Sarah Bird. "Staying at Monks House: Echoes of the Woolfs." *Journal of Modern Literature* 11.1 (March 1984).

List of Illustrations

Alfred A. Knopf, 1983]; used with permission, 64

Clive Bell and His Circle

Clive Bell and Barbara Bagenal, with Rosetta, at the Clos du Peyronnet, 1960; photograph by Frances Partridge (Courtesy Frances Partridge), 72

Roderick O'Conor, *Flowers*, 1911 (Courtesy Charleston Trust, Lewes, E. Sussex), 74

Letter from Henri Matisse to Clive Bell, Nice, March 2, 1936 (Tate Gallery Archives, London), 76–77

André Derain, *Head of a Woman*, c. 1922; in Clive Bell's bedroom at Charleston Farmhouse (Courtesy Charleston Trust, Lewes, E. Sussex), 78

Henri Matisse, *Portrait of André Derain*, 1905 (Tate Gallery, London/ Art Resource, New York), 78

André Derain, *Portrait of Henri Matisse*, 1905 (Tate Gallery, London/Art Resource, New York), 79

Letter from Pablo Picasso to Clive Bell, February 25, 1920 (Tate Gallery Archives, London), 81

André Derain and his Bugatti at his house in Chailly-en-Bière, c. 1925–26 (Courtesy Germaine Taillade), 83

André Derain and his car "la Lorraine" in Provence, c. 1927 (Courtesy Germaine Taillade), 84

Clive Bell at the Hôtel des Anglais, Menton, 1960; photograph by Barbara Bagenal (Courtesy Frances Partridge), 88

Clive Bell and Janie Bussy near Menton (Courtesy Frances Partridge), 88

Pablo Picasso (l.) and Clive Bell (r.) at Mougins, 1959; photograph by Barbara Bagenal (Courtesy Richard Shone), 89

The Avignon *Piétà* (Alinari/ Art Resource, New York), 91

Jean-Baptiste Siméon Chardin, *Still Life* (The Louvre, Paris/ Art Resource, New York), 92

John Maynard Keynes

Gwendolen Raverat, *John Maynard Keynes (Baron Keynes)*, 1908

(National Portrait Gallery, London), 94

Paul Cézanne, *Still Life with Apples* (Fitzwilliam Museum, University of Cambridge), 100

Lydia Lopokova practicing, probably at 46 Gordon Square, London, 1925 (From *The Letters of Lydia Lopokova and John Maynard Keynes*, ed. Polly Hill and Richard Keynes [New York: Charles Scribner's Sons, 1989; used with permission), 103

John Maynard Keynes and Lydia Lopokova, probably 1925 (Courtesy Dr. Milo Keynes), 104

Ottoline Morrell

Simon Bussy, *Lady Ottoline Morrell*, 1920 (Tate Gallery, London), 106

Ottoline Morrell on her honeymoon in Paris, 1902 (From *Lady Ottoline's Album*, ed. Carolyn G. Heilbrun [New York: Alfred A. Knopf, 1976]; used with permission), 108

Augustus John and Ottoline Morrell in Aix-en-Provence, 1910 (From Miranda Seymour, *Ottoline Morrell: Life on the Grand Scale* [New York: Farrar Straus Giroux, 1992]; used with permission), 111

Group of friends at Garsington, c. 1916–18? *Back row:* Julian Morrell, Vanessa Bell, Lady Ottoline Morrell; *front row:* Simon Bussy, Jean Marchand, Duncan Grant, Frank Prewett (From *Ottoline at Garsington: Memoirs of Lady Ottoline Morrell 1915–1918*, ed. Robert Gathorne-Hardy [London: Faber and Faber, 1974]; used with permission), 114

Simon Bussy, Vanessa Bell, and Duncan Grant at Garsington (From *Lady Ottoline's Album*, ed. Carolyn G. Heilbrun [New York: Alfred A. Knopf, 1976]; used with permission), 115

Dora Carrington, Ralph Partridge, Lytton Strachey, Oliver Strachey, and Frances Partridge at Garsington (From *Lady Ottoline's Album*, ed. Carolyn G. Heilbrun [New York: Alfred A. Knopf, 1976]; used with permission), 116

Virginia Woolf at Garsington (From *Lady Ottoline's Album*, ed. Carolyn G. Heilbrun [New York: Alfred A. Knopf, 1976]; used with permission), 116

Group at Garsington Manor, c. 1922; l. to r.: Ottoline Morrell, Maria Nys (later Mrs. Aldous Huxley), Lytton Strachey, Duncan Grant, Vanessa Bell (From Francis King, *E.M. Forster and His World* [New York: Charles Scribner's Sons, 1978]; used with permission), 118

Ethel Sands and Nan Hudson

Ethel Sands at the Château d'Auppegard, before the fresco on the loggia by Vanessa Bell and Duncan Grant (From Wendy Baron, *Miss Ethel Sands and Her Circle* [London: Peter Owen Ltd., 1977]; used with permission), 122

Ethel Sands, *Sunlit Room*, n.d. (The Phillips Collection, Washington, D.C.), 125

Frances Partridge

Frances Partridge in the mountains; photograph by Ralph Partridge (Courtesy Frances Partridge), 130

Ralph Partridge swimming at the Grotte des Eaux Marins, Corsica; photograph by Frances Partridge (Courtesy Frances Partridge), 132

Frances Partridge swimming at Cap Brun, Saint Mandrier, 1928; photograph by Ralph Partridge (Courtesy Frances Partridge), 133

Ralph Partridge and Gerald Brenan near Toulon (Courtesy Frances Partridge), 133

George "Dadie" Rylands at Trébeurden, Brittany, 1930; photograph by Lytton Strachey (Courtesy Frances Partridge), 143

Rachel MacCarthy on sailboat, La Trinité-sur-Mer; photograph by Frances Partridge (Courtesy Frances Partridge), 135

Dadie Rylands and Wogan Philipps in the north of France, 1930; photograph by Lytton Strachey (Courtesy Frances Partridge), 135

La Trinité-sur-Mer; photograph by

List of Color Illustrations

Index

Post-Impressionist Ball, 97
Post-Impressionist Exhibition
(1910), 26, 97, 248; critical reaction to, 150–52; influence of, 152–53, 235; selection of works for, 9, 149–50
Post-Impressionist Exhibition (1912), 248; influence of, 44, 235; Leonard Woolf as secretary of, 51; organization of, 9, 153–54; purpose of, 113
Poulenc, Francis, 75
Pour Sylvie (Zoum Walter), 340
Poussin, Nicolas; Roger Fry and, 174, 175; Duncan Grant on, 23; work of, *Sacrifice of the Golden Calf*, 172
Précieuses ridicules, Les (Molière), 160
Prichard, Matthew Stewart, 76, 153, 243, 394*n*21
Priestman, Hermine, 275
Primaticcio, Francesco, 90
Principia Ethica (G. E. Moore), 95
Principles of Literary Criticism, The (I. A. Richards), 323
Prix Mistral, 270
Proust (Clive Bell), 12–13
Proust, Marcel, 11–13, 174; Clive Bell and, 12–13, 85; Dorothy Bussy and, 335–36; Roger Fry and, 174, 396*n*88; Virginia Woolf and, 63; work of, *A la recherche du temps perdu*, 12, 344
Provençal Landscape (Roger Fry), 218
Provençal, Le, 366
Psychocriticism, 269, 281–82, 365–66
Pulcinella (ballet), 171

Quai de Bourbon, Paris, No. 45, 172
Quatre Bateaux dans le port de Cassis (Charles Camoin), 257
Quatz-arts Ball, 25

Racine, Jean, 11, 29; Mauron's psychocriticism of, 281; work of: *Bérénice*, 10, 160; *Phèdre*, 23
Ramsey, Frank P., 230
Ramsey, Lettice, 230
Random House, 341
Raverat, Gwen (*née* Darwin), 51, 219; Bussys and, 331; correspondence, with Virginia Woolf, 54, 57, 209; work of, *Period Piece*, 184; J.M. Keynes, 94
Raverat, Jacques, 219, 402*n*12; Bussys and, 331; correspondence,

with Virginia Woolf, 3, 51–52, 104; death of, 54, 402*n*12; illness of, 184; at Pontigny, 298; World War I and, 330
Reading Club (Trinity College, Cambridge), 29
Red Sea, The (Duncan Grant), 243
Red Studio (Henri Matisse), 249
Reims, 44
Renoir, Pierre, 89; work of, *La Famille Charpentier*, 25
Renon family, 29
Richards, I. A., 322
Rinder, Olive, 70
Ritchie, Philip, 40
Rivière, Jacques, 8, 291
Robertson, A. J., 29
Roche, Paul, 405*n*55
Rodez, 62
Rodin, Auguste, 75
Rodmell, Sussex, 60, 67, 127, 342. *See also* Monks House
Romeo and Juliet (ballet), 104
Room of One's Own, A (Virginia Woolf), 353, 356–58
Room With a View, A (E. M. Forster), 283
Roque, Jacqueline, 87, 89
Roquebrune, 21, 118, 173, 217–19, 305, 328, 333, 335. *See also* La Souco
Roquebrune and Monte Carlo from Palm Beach (Roger Fry), 165
Rossi, Carmen, 327
Rouault, Georges 150
Rouen, 34, 50, 70
Rouge et Le Noir, Le (Stendhal [Henri Beyle]), 51
Roussillon, 87
Royat, 27, 105, 198, 229, 304, 312, 365
Rumpelmayer's, 25
Ruskin, John, 320
Russell, Alys Smith, 112
Russell, Bertrand; Ottoline Morrell and, 111–13, 114; World War I and, 114, 164
Russell, Dora Black, 112
Russell, John, 112
Rylands, George ("Dadie"), in Brittany, 134, 135, 136, 300
Rysselberghe, Elisabeth van, 293, 294, 336, 337, 395*n*61
Rysselberghe, Mme Théo van, 293

Sackville Gallery, 172

Sackville-West, Edward, 115
Sackville-West, Lionel (father of Mary Victoria [Vita]), 65
Sackville-West, Lionel (grandfather of Mary Victoria [Vita]), 65
Sackville-West, Mary Victoria (Vita), 70, 120; background of, 65; correspondence: with Vanessa Bell, 204; with Harold Nicolson, 66–69; with Virginia Woolf, 55, 56, 59, 62; in France with Violet Keppel Trefusis, 65–66; French language and, 6; marriage of, 65; on *Orlando*, 69; translations of, 367–68; Violet Keppel Trefusis and, 65; Virginia Woolf and, 65–70, 126; on Virginia Woolf, 67, 68
Sacrifice of the Golden Calf (Nicolas Poussin), 172
"Saint" (Stéphane Mallarmé), 366
Salmon, André, 84, 173
Salon d'Automne, 174–75, 394*n*27
Salon des Indépendants, 155, 176, 253
"Salutation" (Stéphane Mallarmé), 366
Sanary, 54
Sancerre, 184
Sand, George, 63
Sands, Edith (mother of Ethel), 123
Sands, Ethel, 14–15, 111, 122, 123–29, 314, 393*n*14; art of, 123–24; background of, 123, 392*n*2; Clive Bell and, 84; death of, 129; Morrells and, 109, 392*n*1; properties of, 392*n*5; Virginia Woolf and, 54, 55, 69, 126–28; work of: *Sunlit Room*, 125. *See also* Château d'Auppegard
Sands, Mahlon (father of Ethel), 123
Santayana, George, 117
Sargent, John Singer, 74, 123
Sassoon, Siegfried, 115, 120
Satie, Erik, 75, 167
Saül (André Gide), 25, 176, 395*n*35
Saulieu, 66, 67
Saumane [Saumane-de-Vaucluse], 184
Savoy Hotel, 169
Savoy Theater, 158, 160
Schlumberger, Jean; *Nouvelle Revue Française* and, 158; at Pontigny, 291, 293